A STUNNING LIFE OF THE ICONIC AMERICAN ARTIST KEITH HARING, BY THE ACCLAIMED BIOGRAPHER BRAD GOOCH

I n the 1980s, the subways of New York City were covered with art. In the stations, black matte sheets were pasted over outdated ads, and unsigned chalk drawings often popped up on these blank spaces. These temporary chalk drawings numbered in the thousands and became synonymous with a city as diverse as it was at war with itself, beset with poverty and crime but alive with art and creative energy. And every single one of these drawings was done by Keith Haring.

Haring was one of the most emblematic artists of the 1980s, a figure described by his contemporaries as "a prophet in his life, his person, and his work." Part of an iconic cultural crowd that included Andy Warhol, Madonna, and Jean-Michel Basquiat, he broke down the barriers between high art and popular culture, creating work that was accessible to all and using it as a means to provoke and inspire radical social change. To this day, his influence on our culture remains incontrovertible, and his glamorous, tragically short life—Haring died of AIDS in 1990 at the age of thirty-one—has a unique aura of mystery and power.

Brad Gooch, noted biographer of Flannery O'Connor and Frank O'Hara, was granted access to Haring's extensive archive. He has written a biography that will become the authoritative work on the artist. Based on interviews with those who knew Haring best and drawing from rich archival history, *Radiant* sets out to capture the magic of this visionary and timeless icon.

Radiant

Also by Brad Gooch

Rumi's Secret: The Life of the Sufi Poet of Love

Smash Cut: A Memoir of Howard and Art and the '70s and the '80s

Flannery: A Life of Flannery O'Connor

City Poet: The Life and Times of Frank O'Hara

Scary Kisses

Zombie00

The Golden Age of Promiscuity

Godtalk: Travels in Spiritual America

Finding the Boyfriend Within

Dating the Greek Gods

Jailbait and Other Stories

The Daily News

Radiant

The Life and Line of Keith Haring

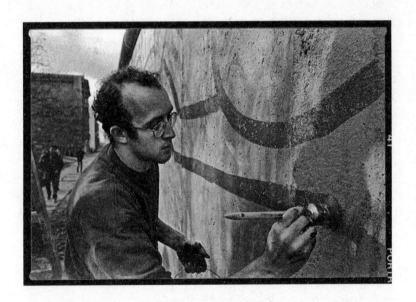

Brad Gooch

HARPER

An Imprint of HarperCollins*Publishers*

HarperCollins books may be purchased for educational, business, or sales promotional use. For information, please email the Special Markets Department at SPsales@harpercollins.com.

FIRST EDITION

Designed by Leah Carlson-Stanisic
Photograph frame throughout © Arian Hoorn/Shutterstock, Inc.
Title page photograph © ullstein bild/Getty Images
Endpaper photograph © NewYorkDailyNewsArchive_GettyImages
Full illustration credits begin on page 481.

Library of Congress Cataloging-in-Publication Data
Names: Gooch, Brad, 1952- author.
Title: Radiant: the life and line of Keith Haring / Brad Gooch.
Description: First edition. | New York, NY: Harper, [2024] | Includes index.
Identifiers: LCCN 2023027845 | ISBN 9780062698261 (hardcover) | ISBN 9780062698285 (ebook)
Subjects: LCSH: Haring, Keith. | Artists—United States—Biography.
Classification: LCC N6537.H348 G66 2024 | DDC 709.2 [B]—dc23/eng/20230901
LC record available at https://lccn.loc.gov/2023027845

23 24 25 26 27 LBC 5 4 3 2 1

For Glenn

Your line is your personality.

—KEITH HARING

Contents

Prologue: The Baby | 1

I Chapter 1 Kutztown | 7

Chapter 2 The Art Room | 25

Chapter 3 Pittsburgh | 49

Chapter 4 "The Next Part of the Trip" | 69

II Chapter 5 SVA | 87

Chapter 6 Club 57 | 110

Chapter 7 Chalkman | 133

Chapter 8 "Love Sensation" | 162

III Chapter 9 Art for Everybody | 189

Chapter 10 Party of Life | 221

Chapter 11 A Political Line | 250

Chapter 12 The Pop Shop | 279

IV Chapter 13 "In This Life" | 311

Chapter 14 Tokyo | 339

Chapter 15 Silence = Death | 367

Chapter 16 "You Use Whatever Comes Along" | 398

Epilogue | 429

Acknowledgments | 435

Notes on Sources | 441

Illustrations 481

Index | 483

Radiant

The Baby

When *Keith Haring* arrived in downtown Manhattan in 1978, he took to the streets. The streets were darker then, especially in the distressed East Village, to which he found his way within months of starting his first semester at the School of Visual Arts. Yet, within this darkness, an insistent smatter of messages was being sent. As a poet and fiction writer, also young and living downtown at the time, I found these messages extremely urgent. They were stamped on asphalt sidewalks, taped as announcements to the blank walls of buildings on the Bowery, or spray-painted on the sides of vans and buses rumbling by—all illuminated fitfully by the amber light of dim streetlamps operating at half power. When you rode the subways, as we all did, you were transported not only uptown and downtown but also into an immersive display of "wildstyle" graffiti at its height. Twenty years old and absorbing these same names and numbers; these scratchy images of cars, crowns, and shadows; bubble lettering as solid as columns; cryptic poems and shouts of protest, Keith wished not only to ponder but also to take part in all the visual dialogue, the chat. Yet it took him another two years to discover how. Finally, during one hot summer week, unpremeditated, he began drawing the original images that were to become his

basic alphabet—flying saucers and pyramids, batons sticks and glowing penises, ziggurat stairways, nuclear reactors, and barking dogs. Among them were crawling humans. The more he drew these human figures, the larger their heads grew, until the figures turned into crawling babies.

Taking the baby as his mark, or "tag," Keith redrew it in a single, continuous line with a thick Magic Marker, which graffiti artists used, over and over, in locations where it would surely be seen. Careful not to violate anyone's space, finding spots in between other tags or on previously disregarded territory, he manifested the babies, subtly and persistently, on lamppost bases, police barricades, plastic coverings for subway maps, and the sides of metal dumpsters. I remember seeing these headlong babies and audible dogs popping forward on the sides of ready-made newsstands in SoHo and sensing that they were poetry in motion, or implied motion. Graffiti artist Futura 2000 has spoken of "first seeing the crawling babies on a concrete wall on the south side of Canal, by Pearl Paint. There were about five of them crawling. *Damn, what is that?* It was kind of interesting." That same year, at Christmastime, Keith, fascinated by subway ads as mass messaging for a popular audience, noticed a new Johnnie Walker holiday ad depicting train tracks disappearing into a snowy landscape. The white space of the snow inspired him to pull out his handy marker and draw a row of the unstoppable babies he had been repeating aboveground. One corner of sky lent itself to a flying saucer that beamed its rays down onto a baby, endowing it with special power—the origin of his now-iconic radiant baby. "At this time, the crawling person—the baby with the rays—became almost like a kind of signature," Haring said. "In the beginning, it appeared on almost all of the drawings—instead of signing my name, the baby would appear." Within a year, the American poet Rene Ricard titled a piece in *Artforum* introducing Keith Haring and Jean-Michel Basquiat to a larger audience "The Radiant Child," and the nickname stuck.

The crawling baby was in perpetual motion. After tweaking more glossy subway ads, Keith moved on to vacant ad spaces covered with soft, black matte paper, which he began to fill with babies and, then, entire storyboards of his figures rendered in chalk—fragile, impermanent, yet passed by millions of subway riders daily. Enjoying the audi-

ences that often gathered as he dashed off the subway works—turning the act of drawing into performance art—he gave away little white buttons depicting the radiant baby drawn in black, roughly at first and more stylized as time went on. As the buttons became cool accessories downtown, people would stop to see who was doing the speedily multiplying chalk drawings in the subway, recognizing both the style and the symbol. "They became this amazing catalyst," said Haring, who found an audience for his work without needing to carry around slides to gallery dealers. When he had his one-artist exhibition at Tony Shafrazi Gallery in 1982, the crowds overflowed onto the SoHo street because he was already so well known. His radiant baby was a trademark, a brand, yet also a warm compress of meaning that established his key signature.

Haring's humanism, unusually so for the period, was unironic. "The reason that the 'baby' has become my logo or signature," he wrote, "is that it is the purest and most positive experience of human existence. Children are the bearers of life in its simplest and most joyous form." One art critic wrote of the baby's rays as "the first believable twentieth-century halo."

Throughout the eighties, as Keith Haring became a global artist, showing in exhibition spaces and museums in Europe, Australia, and Japan, the radiant baby likewise went international, helped by its legibility as a universally understood pictograph—"Factory-fresh," as Rene Ricard had written in "The Radiant Child." Spending more time in the museums of Europe than the subway stations of New York City, Keith evolved more painterly styles and approaches. His work hinted at the blocks of color and overlaid black lines of Fernand Léger, the biomorphic shapes of Hans Arp, and the surreal waking dreams of Magritte. Yet the radiant baby thrived in Haring's hopeful "art for everybody." Even more extremely than his own model as a living artist, Andy Warhol, Keith Haring occupied a space in both high fine art culture and low demotic street art. When Haring opened his Pop Shop in SoHo in 1986, the store window was filled with white inflatable baby pillows, and among the merchandise at bargain prices were radiant baby T-shirts, buttons, prints, and posters. The week of the opening of the Tokyo Pop Shop, in 1988, he was drawing large babies in thick chalk on the sidewalks of

Japan. Diagnosed HIV-positive later that year, he initialed the pages of his last will and testament with babies. "I'd never seen that before," his lawyer says. Prior to his death on February 16, 1990, as he became too weak to hold a marker, his final drawings were of the radiant baby.

Two years earlier, when Haring was still one of the "worried well," convinced of his HIV status while not yet showing definitive, fatal symptoms of AIDS—still, as he would put it, having dreams of the future—he took a meeting about a project in Tama City, Japan. While he eventually designed a peace ceremony and painted a mural with schoolchildren, the original proposal was for a far more ambitious land art piece involving *all* the children of Tama holding mirrors to reflect the morning sunlight to create an image of his crawling baby, visible from the sky and photographed by airplane and satellite. An "extended concept" then involved adding in children around the globe—in Moscow, Paris, Tokyo, Shanghai, New Delhi, New York, and Los Angeles—holding up mirrors as a NASA satellite passed overhead at nine o'clock in the morning in each city to photograph them. The scheme felt outlandish—though, perhaps less so as the decades have unfolded and a Keith Haring exhibition is usually open at one or another gallery or museum worldwide and as Haring's licensed images, or simply his signature, can be spotted on T-shirts, sweatpants, low-top sneakers, tote bags, jewelry, and even tattoos on the streets of most international cities. Early critics accused Haring of wishing to scribble his line over the entire world. Within a decade, he nearly had. "Imagine my crawling baby . . . created by light from the sun in mirrors held by children in several different cities all over the world," he wrote in his journal of the tag he called "a condensed logo for my entire life" and that others interpreted as "an idealized self-portrait." "My baby would actually crawl around the globe." Then, he added, putting quotation marks around all the excitement, with his usual street smarts and saving good humor, "Sounds like a great project . . . can you imagine the organization?? Anything is possible. Or, is it?"

I

Kutztown

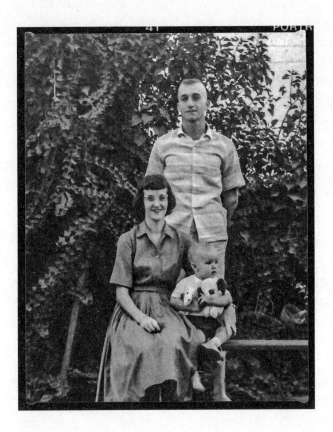

K<i>eith Allen Haring</i> could finally hold a pencil well enough to draw pictures. The year was 1962; he was four years old. Helping him along, as always, was his dad, Allen Haring, at twenty-four, one of the youngest fathers in their small neighborhood in Kutztown, Pennsylvania. His father's routine was to draw a circle first and then coax Keith to add a curvy line to make a balloon; or a triangle to evoke an ice-cream cone; or to fill in a face, adding ears or feet for all sorts of animals. They

would move on to dragons, of which they could create fierce variations from circles alone; and then worms, from ovals with little feet sticking out. Keith often asked to draw dogs, as his father used to delight him with his own totally made-up, funny-looking, cartoonish dogs.

They had been playing around with art together since Keith could barely walk. "We would sit at home, and Allen can't sit still too long without doing something with his hands," Keith's mother, Joan Haring, remembers. "He would doodle on scraps of paper he brought home from work. Keith was watching. Allen would turn a circle into a pumpkin, or a lollipop. This would be after supper, and Keith was in his high chair, and I would be up doing the dishes. Allen soon started holding him in his lap for drawing." The first box of Crayola crayons the couple bought their son, to teach him basic colors, was a twenty-five-cent eight-pack. (A musical decades later turned the moment into a scene about sixty-four crayons, though Allen Haring insists, "We couldn't have afforded more than eight.")

By the time Keith was four, his family was living in an unprepossessing two-and-a-half-story apartment house, painted green, on a corner a softball lot away from Kutztown Junior High School. They rented the first floor, and Allen kept the basement for his workshop. Keith shared a front room with his sisters, Kay Adele Haring, two years younger, and Karen Aileen, who had recently been born at home. (He later found "completely hysterical" his parents' decision to name all their children using the first letters of their alma mater, Kutztown Area High.) That winter, instead of a snowman, Allen Haring cleverly built a snow elephant Keith could sit on. A couple of blocks away, down an alley, lived Keith's grandmother, who had a how-to-draw manual from the Walt Disney Company. When he was a few years older, Keith learned to draw Mickey Mouse from ovals and circles. Two of his father's brothers were also amateur artists—one did scissor papercutting, or scherenschnitte—so, there was always art in the family.

Allen's prime gift to his son was do-it-yourself inventiveness. Rather than relying on ready-made coloring books, he would pull out a sheet of white paper with markers, crayons, or pencils and let him begin. "Instead of teaching me to copy other cartoon characters or comics," Keith

Haring later said in an interview broadcast on Spanish television, "he wanted me to invent my own characters." His father had a knack for such creativity. Working by day as an electronics technician at a Western Electric (later called AT&T) plant in Allentown, after having completed a four-year enlistment in the Marine Corps, Allen Haring was still a fully engaged amateur cartoonist. Just six years earlier, he had been art editor for the Kutztown High School yearbook, enlivening the frontispiece and many pages throughout with clever sketches fitting that year's circus theme: a strongman lifting a barbell, striped tents, a Ferris wheel, and a performing seal in spectacles.

The two illustrators to whom his father first introduced Keith at an early age, as inspirations or models for drawing, were Walt Disney and Dr. Seuss. When he was stationed in Southern California in the marines, Allen (along with his wife and an infant Keith) had taken full advantage of free passes for men in uniform to Disneyland, which had opened in Anaheim just a couple of years earlier. He was a fan of the three-dimensional, kinetic cartoon of an amusement park, a folly dedicated to the power of wishing on a star. Micky, Minnie, or Pluto would occasionally find their way into the margins of his sketches. More open-ended was the influence of Dr. Seuss, whose books Joan Haring knew by heart from reading them to her son during his quiet time on the couch while his sisters napped. "Perhaps in our drawing we were both influenced by the crazy drawings of Dr. Seuss," says Allen Haring. "You could make cartoon characters go wild with the hair, hats, and noses." His son later spoke of his attraction to the "weirdness and absurdity" of Seuss's daffy foxes in socks. His father also taught Keith the invented game of "Stop," where each drew on a sheet of paper until someone shouted "Stop," and then they would trade drawings and begin adding to each other's lines. Sometimes they made drawings at the same time with their eyes tightly closed shut.

By the time he was six years old, and in first grade, Keith was adept at his crayon colors, circles and shapes, and above all, his line. "The emphasis on the line started with my interest in cartooning," he later said. That year for a grade school exhibition, he made his most engaging drawing to date: a clown (a subject already taken up by his father in his

high school yearbook) with circles for stomach and head and ovals for legs, feet, and buttons, and he colored in stripes of bright crayon pastels, with a shock of Seussian daffy lime-green hair; the clown was riding atop a brown mare scribbled over in orange and looking like a top-heavy and more broadly jovial (with a nearly vertical red smile) Don Quixote. The untitled drawing was awarded a blue-ribbon prize, his first.

Pennsylvania has a surprising history of producing great artists from some of its unlikelier small towns as well as from its larger, though hardly bohemian-leaning, industrial cities. Alexander Calder, whose lilting mobiles Haring admired for their "simple, clear, poetic," and kid-friendly qualities, was born in Lawnton, near the state capital of Harrisburg. Growing up in the northeastern coal-mining city of Wilkes-Barre, the abstract expressionist painter Franz Kline included anthracite swathes of black, or references to local place names, in canvases such as *Shaft*, *Charcoal Black and Tan*, and *Luzerne*. The son of a construction worker, Andy Warhol grew up in the Oakland neighborhood of Pittsburgh, the same neighborhood where Haring would live during his two years studying art in the steel town. Closest in age to Haring, Jeff Koons, from York County, claimed the fauna of the backyards of Pennsylvania as inspiration for his stainless steel *Rabbit* sculpture.

Kutztown was just such an outlying and insular place to be from. (A New York friend said Keith always reminded him of the eighties ballad "Smalltown Boy," by Bronski Beat.) With a population of never more than five thousand, this "typical little American rural white conservative place," as Haring neatly described it, was almost exclusively settled by Pennsylvania Dutch—a bit of a misnomer, as they were mostly Palatine Germans. Surrounded by open farmland, verdant woods, and rolling hills, Kutztown (named after the founding Kutz family) was remote, nestled in a limestone valley in Berks County, in Southeastern Pennsylvania, not far from the small cities of Allentown and Reading, yet ever connected by a hunting trail that eventually turned into Route 222 to New York City, one hundred miles away. During Haring's adolescence, the local Bieber commuter bus rolled through the town daily on

its way to New York City, a mere two-and-a-half-hour ride—an escape route he often used for both fun and art education.

Although Haring's ancestors, all Germans, stretched back several generations in the state, he came to shrug off or positively disdain his German ancestry. As he told a journalist in 1982, "After visiting Germany this summer, I don't think there's anything German about me." Yet a Germanic accent—if not imprint—would have been hard to miss in Kutztown, at least into the middle 1960s. As the spoken language had been German, and church services were conducted in German into the twentieth century, the *Patriot* newspaper, which Keith later delivered, printed sermons in both German and English until the end of World War I. "As kids there were a lot of old people around us who still conversed in the language," Allen Haring remembers. "Often they did it when they didn't want the kids to understand what was being said." One of Keith's sisters recalls her parents using words she did not realize were German until she went away to college, such as *rutsch*, for "squirm," as in "Stop rutsching in your pew!" Or *Nichtsnutz*, which could be translated as "bad little kid." During Keith's childhood, Pennsylvania German-speaking Old Order Mennonite farmers were still riding through town in their horse-drawn black buggies.

The Kutztown that Keith Haring was born into was generally less Old World than it was Main Street, America, or, to be even more period precise, *American Graffiti*. By night, teenage boys (often known as "motorheads") cruised Main Street in their cars or trucks. By day, workers at the local factories—such as the Saucony shoe factory beside the Saucony Creek, on the edge of town—toted their lunches to work in aluminum buckets, while young women could be seen walking the sidewalks wearing pedal pushers. On Sunday morning, the pews of the dozen churches in town were filled with families worshiping together and hearing traditional Christian values preached from the mostly Protestant pulpits. The majority politics of Kutztown was Democratic, because of the blue-collar, union tenor of the town, yet it was often interpreted with a rigid, conservative bent. "I grew up in Pennsylvania in a small town," Haring later complained to Andy Warhol in the pages of *Interview* magazine. "Real small, like one high school and one movie

theatre. Well, there was a state college there, that was the only good thing about it."

Kutztown State College, its campus commencing just beyond Keith's grandmother's yard, was a lucky neighbor to have. During the 1950s, its president was an arts educator, Italo deFrancesco, who maneuvered the college into becoming the main arts center among the thirteen state colleges and helped its ascendance, for a brief period, into one of the top dozen arts schools in the country. (One of the few extant lending cards from the Kutztown Public Library with a record of Keith Haring has him taking out a biography of deFrancesco while in high school.) Keith never attended the college as a student, but during his years growing up, the college arts program added an idiosyncratic element to the "typical" small-town mix. Not only would he befriend student teachers, visiting them in their dorm rooms, but he also routinely saw art students, with their big black portfolios, trudging to class or, on warm days, perched on front stoops along Main Street doing their plein air work, or sketching the steeple of Trinity Lutheran Church. The art supply store down Saucony Alley, near his house, existed thanks to the art undergrads.

When describing his boyhood in Kutztown, Keith Haring reached for all the usual metaphors. "I was a square in a round peg," he said, scrambling the cliché. His father's artistic flair aside, Haring's family on both his father's side, the Harings, and his mother's, the Wentzels, was very much made up of round pegs whose stories fit easily into the story of the town and surrounding farmlands they had called their own at least as far back as the 1800s. "The Harings weren't among the founding families of the borough per se," says Kutztown historian Brendan D. Strasser. "Yet they were an early establishing family, and they have always been a relatively large and prominent family, and would have been German speaking, scattered in the countryside of Maxatawny Township, Lyons, and Bowers. And there were Wentzels (and Wetzels, who may well be distantly related) in Kutztown by the late 1800s, though they are not as large a family."

Bowers, where Allen Haring's family moved when he was fifteen—from another town he simply identifies as "out in the sticks"—was situ-

ated three or four miles outside Kutztown. Among its humble cluster of thirty or forty homes, the most imposing would have been the Harings', with fourteen rooms to accommodate their dozen children. Their father worked as a licensed electrician. Keith Haring would later exaggerate by saying that all the men in his father's family were marines. Yet four of his father's eight brothers *were* marines, and another served in the army. "I guess it all started with my older brother," said Allen Haring. "He was a very good and very faithful marine. We all thought it was quite the thing to be." Allen would often go with another of his brothers down to a stream a mile from their home to trap muskrats, whose pelts they would then sell for two or three dollars. Making unusual use of his cash, he then bought an oil painting set and a couple of canvases: "I never had any formal training in the use of oil paints. I ended up using oil paints much the way people use watercolors—simply to color an area of the canvas."

Joan Wentzel's family was less sprawling; she grew up on Baldy Street in Kutztown with her parents, one sister, and two younger brothers. Her grandfather Byron Stein was a prominent presence in town, and his music store on Main Street a popular spot for buying records, sheet music, guitars, harmonicas, and radios. (Keith would keep an advertising poster for a 1931 RCA Victor radio from his great-grandfather's store taped to the wall of his dorm room in Pittsburgh.) Joan's father, Grover, worked in the boiler room of the college, and Keith's first memories of the campus were of bringing his grandfather lunch with his grandmother May Bailey. Keith and his maternal grandmother were always close, and he often made gifts for her as a boy, such as a mobile of cut-out handprints hung from a coat hanger. Joan's two younger brothers, Jay and Jimmy, were closer in age to Keith and influenced him with rock 'n' roll record collections that included Kiss, Iron Butterfly, the Rolling Stones, and early Grateful Dead.

As a town girl, Joan Wentzel attended Kutztown public schools from kindergarten through high school. As a country boy, Allen Haring transferred into the high school as a ninth grader. (Even when Keith was in high school, kids from the outlying areas still commuted to school in trucks with full gun racks.) Allen and Joan never dated in high school.

"In high school, she was dating my best buddy," Allen explains. "And he always told me what a nice guy Allen Haring was," Joan adds. Although they may not have been an item, as members of a senior class of only 120 graduates, the two were certainly around each other—he as art editor of the *Cougar* yearbook and she as its business manager; he as a member of the band color guard and she as a cheerleader and majorette. They looked the perfectly matching couple for the 1950s all-American set—Allen in his chinos and flattop, with a serious pencil stuck behind one ear; Joan in her round eyeglasses, long skirts to the ankles, and, as the yearbook immortalized, "a smile for everyone."

Joan and Allen did not date until six months after graduation, after he had joined the U.S. Marine Corps. Allen had endured fourteen weeks of boot camp at Parris Island, South Carolina; four weeks of infantry training at Camp Lejeune, North Carolina; and six weeks of "Fundamentals School" at Jacksonville, Florida, when he finally came home on holiday leave to Bowers. He and Joan got together with classmates to go to the Reading State Fair. Their first true date was a Christmas Eve service at the Wentzel family church, St. John's United Church of Christ. "I wanted to go to Christmas Eve service, and I didn't have anyone to go with, so I called him, and he said, 'Yeah, I could do that,'" Joan Haring says. The choice didn't signal any special piety, at least not on Allen's side. As he later wrote Joan from abroad, "This morning I went to 'Bible Class' and church!!!!! That's right, church—c-h-u-r-c-h!! I'm really reforming, eh??!!"

That January 1957, Allen left Kutztown to report to Aviation Electronic Technician School in Memphis, where he stayed for six months. The high point there—spotting Elvis Presley joyriding around town in his white Lincoln. He was given leave to return to Pennsylvania in July 1957—a family snapshot captures the uniformed Allen with his arm firmly around his girlfriend Joan's waist—before traveling cross-country to California to sail to Japan in August. Allen's assignment to the Marine Air Control Squadron 1, in Atsugi, Japan, was his most memorable. "Boy, this country is really nice," he wrote home. "Went for a little train ride again today and saw the 'Great Buddha' that's always associated with Japan. Really something to see." His daughter Kristen says, "Japan had a

big presence in our household. There were chopsticks in the house, and Dad would tell stories about Japan." His son Keith would become so involved with the country and its culture, both traditional and pop, that he imagined he might have been a Japanese painter in a past life and spoke on occasion of his father's personal history there.

Allen wrote several letters a week to Joan from Japan, which she assiduously arranged sequentially and numbered as she received them. In one exchange, Allen received startling news. His July leave in Kutztown had been even more consequential than he felt: Joan was pregnant. The two decided to get married as soon as possible. "Under these conditions, I could get authorization for 'emergency leave' in order to get back home and marry," Allen Haring explains. Borrowing marine dress blues from his mate in the upper bunk, though disappointed he did not yet have his corporal stripes for the wedding, he flew home. He and Joan Wentzel were married on October 16, 1957, at St. John's UCC, she in a dress she made herself; afterward, they went on a brief honeymoon in New York City. Within ten days, Allen flew back to Japan, now passing the time looking through books titled *A Treasury of Names* and *Naming Your Baby*. When a buddy showed a snapshot of a baby nephew, Allen asked, "What do you think of the name 'Keith'?" They did not make their baby boy a "Junior," but they did give him "Allen" as his middle name.

Their rushed marriage was not discussed in the family during Keith's childhood. No one did the obvious math to figure out the discrepancy between the date of the wedding and the date of Keith's birth. Keith was quite amused when his mother finally told him the facts of his life no more than a year before his death. "I don't think I was really a planned event," he then revealed. "In fact, the last time I was home, my mother and I were talking about why I existed and whether I would have existed in other circumstances. My mother said that if my father had been more afraid of her father and had gone home when he was supposed to and hadn't stayed overnight, I would not have existed."

Keith Haring was born at 12:41 p.m. on May 4, 1958, a cloudy spring day with temperatures in the sixties, at Community General Hospital in

Reading, as Kutztown was too small to support its own hospital. Weighing seven pounds, fifteen ounces, he measured twenty and a half inches and, according to the delivering physician, Dr. Calvin C. Widener, was born "sunny side up," a supposedly auspicious sign. "During the last minutes of labor, he turned and was born face up," Joan Haring explains. "It made the birth longer." As Allen was in Japan, Joan sent the news in a Red Cross cablegram, inspiring him to smoke three cigars. Widening the lens on the historical and cultural context of his birth, Keith Haring said, "I consider myself a perfect product of the space age not only because I was born in the year that the first man was launched into space, but also because I grew up with Walt Disney cartoons."

With her newborn boy, Joan Haring returned to her parents' home on Baldy Street, where they lived for the next ten months. Allen had to wait until Christmas 1958 to meet his infant son and to attend the baptism performed by the Reverend Bruce D. Hatt at St. John's on December 28, 1958, almost exactly two years after Allen and Joan's first church date. Allen had been transferred to a marine base in Santa Ana, in Southern California, and the plan was for him to drive ahead and scout an apartment and then to send for his wife and son. He stuffed his Rambler station wagon with boxes of clothing and household goods and set off. When he stopped for gas in Reading, the attendant said, "You'll never make it." "But I did," Allen Haring says. "That was a real vote of confidence." Around Valentine's Day 1959, Joan flew to California with nine-month-old Keith. "They were on a TWA jet before I was," Allen recalls.

As in high school, so into adulthood, the Harings appear, in stories and snapshots passed down, a quintessential family for times that were at once conservative (with a Republican president, Dwight D. Eisenhower, himself a military man, in the White House) and guardedly optimistic (as uneven postwar economic growth promised middle-class families the goal of a car in every garage and a TV in every living room). In Santa Ana, they lived on the second floor of a four-unit apartment house with palm trees in the backyard, and Joan usually passed the afternoons taking Keith, in the white patent leather shoes that toddlers uniformly wore, to local parks and libraries. Keith once fell down the back stairs. Even more terrifying to him were the dogs he heard barking

at the bottom of those stairs at night. "I imagined that they were like wolves," said the future purveyor of countless images of barking dogs. "I must have been only two. I had these dreams about these dogs at the bottom of these stairs that I was petrified of."

The small family's ultimate recreation was the twenty-minute drive to Disneyland. Allen in uniform was by then a regular and could guide his family around. Some of the more popular rides in 1959 were literarily inclined: the Mark Twain Riverboat, inspired by *The Adventures of Tom Sawyer*; Mr. Toad's Wild Ride, from *The Wind in the Willows*; and the twirling cups of the Mad Tea Party out of *Alice's Adventures in Wonderland*. Rising with forced perspective above it all, both landmark and trademark, was the pastel Sleeping Beauty Castle, looking like a thin cutout against the sky. "Allen could buy a ticket for me on base, which was a lot cheaper," Joan Haring says. "There was no fee for Keith." They cut corners by parking their car some nights—as they did their last night in California—at a gas station near the amusement park's outer fence to watch hand-lit fireworks.

During their sixteen months in California, the Harings had grown into a family of four. Daughter Kay was born in June 1960. Allen's enlistment was drawing to a close, so they put into motion a reverse plan to return to Kutztown. Joan flew home with two-year-old Keith and newborn Kay to stay with her parents. Once again taking advantage of the Interstate Highway System commissioned by President Eisenhower, Allen loaded his light-blue station wagon and drove back across country. The Harings soon afterward moved into their starter home, the apartment building on a corner of South Whiteoak Street, and following a protracted job hunt, Allen landed his position at Western Electric in Allentown. When not working at electronics by day, he liked to tinker in the basement with his ham radio, and his son often looked on with great curiosity. Those memories would coalesce into a three-minute video, *Tribute to My Father (Da-Di-Di-Da-Da)*, Keith made while at the School of Visual Arts—stuttering a simulated Morse code message wittily akin to baby talk (*da-da*), his teeth, pimples, pink lips, and big black eyeglass frames looming into the wide fish-eye lens, he blurted out some facts, too: "My father's into ham radio."

Keith spent as much time at his grandmother's house as his own. Even as a preschooler, he was drawn to a setting that offered him more freedom and permission, the greater license often given by grandparents. "When we lived in the apartment, Keith would walk over to my mother's," remembers Joan Haring, who soon enough had a second baby girl, Karen, four years younger than Keith, to care for. "He only had to cross one half street. He would wave, and I would go back in the house to the girls. He often called on my mother's phone when he was maybe four." For Keith, the most exciting perk was free access to his grandparents' television: "It was really my place of refuge. I could do things in her house which I could never ever do in my own home—like eating while watching television. My mother knew I was doing it, but she said I could do it there, but not at home." His grandmother also had subscriptions to *Life* and *Look* magazines, and he would flip through the issues. As he later put it, "My grandmother was my media center."

A memorable TV event for him, as for most Americans at the time, was the assassination of President John F. Kennedy on November 22, 1963. Five years old, Keith was at his grandmother's house that Friday afternoon as he watched the shocking events reported live from Dallas, Texas, in this first instance of a simultaneously televised, breaking news event, an interruption not only of all regular programming throughout the long weekend but also of national life. Even the Harings stayed tuned, and on Sunday, after church services, the family was back in front of their black-and-white set when Kennedy's assassin, Lee Harvey Oswald, was himself shot to death while being led from a Dallas jail cell, all startlingly caught on live TV. "That's Ozzie!" Allen Haring shouted, having just recognized the face of Oswald, who had served in his same marine outfit in both Japan and California. In one letter home from Japan, Allen had written of Oswald trying to kill himself, an incident later explained as the result of his cleaning an unauthorized handgun in the barracks that accidentally discharged and hit his left elbow. "Man, we really had some crackpots, no??!!," Allen had written to Joan.

That same fall, Keith began kindergarten at the Lab School, an unusual choice, as it was customarily attended by the children of faculty of Kutztown State College, required a fee, and was never attended by

any of his sisters. He attended for only a year before transferring into the public school. In sending him to the Lab School, Joan Haring had been responding to a son who liked to draw and who was already exceptionally single-minded about his art. "That's when he was becoming interested in art and drawing all the time," she says. "Kutztown did not have a kindergarten; it wasn't mandatory. Because he liked art, I enrolled him. If they wanted to draw, use scissors or paste, they could. There was always someone to help them." At Kutztown Elementary School, on Normal Avenue, where Keith entered first grade the next year, his art teacher was Mrs. Blefgan, who loved the color purple, owned a purple refrigerator, and burned vanilla-scented candles in her Art Room—a revelation to kids from frugal Pennsylvania Dutch homes who did not know about scented candles. "Her whole idea of being more extravagant or dressing differently gave me a first look at not being ordinary," Haring would later reflect. "I was growing up in a place steeped in convention and in living the same way over and over again."

By second grade, Keith was wearing corrective lenses. He was thin, slight. "I was already a little nerd, I guess," he later said, of a look he maximized, branded, and made powerful as an adult artist. Yet, at age eight, his appearance felt less a choice than a given. Insecure about being the last kid chosen for athletic teams, as well as being simply bored by them, he was not much of a participant in sports, the great mixer among boys in small towns like Kutztown. He briefly tried Little League Baseball and quit, and he never joined Boy Scout Troop 101, two activities paired by boys his age: "One thing I specifically remember was being pushed to play basketball because both my mother's brothers were star basketball players on the high school team. I wasn't into basketball that much, and she pushed me or dragged me into it. I was more interested in doing silly or creative things." He was thankful that his father never took him hunting, another popular Pennsylvania sport. That his heart lay elsewhere was evident in a remarkable little four-line essay he wrote as a fourth grader on the topic "When I Grow Up," mixing a boyhood dream with precocious practicality: "When I grow up, I would like to be an artist in France. The reason is because I like to draw. I would get my money from the pictures I would sell. I hope I will be one."

At home, his mother could never get enough pencils and paper for him, and he went through tablets so quickly that he would draw on any available surface. She made him promise not to be naughty and draw on the walls, but one day, when he was a few years older, while painting the home's gutters in silver paint with his father, he made silver handprints down the cellar stairwell wall.

When Keith was in fourth grade, the Harings moved into the home he would know until the end of his life, which showed up in some of his SVA videos—230 South Whiteoak Street. The "white-shuttered and brick study in middle-class respectability," as one journalist would describe it, built in 1904, was just across the street from the apartment they had been renting. Its three bedrooms on the second floor—Keith's, the middle room on the side—were apportioned among him, his parents, and his two younger sisters. Most attractive in the new setup was a small garden toolshed in the backyard that Keith soon transformed into a clubhouse and an occasional play store. "I was always obsessed with making clubs and building clubhouses," said Haring, obsession being a steady theme in his detailing of the chain of boyhood passions that replaced sports for him, like "riding bicycles and pretending I was in the Indy 500." He even devised an "Oath" for the club members, its most important vow being "Do not tell anyone but my parents or relatives about the club." (He would later describe Club 57 in the East Village, where he organized lots of group art shows as well as doing plenty of pop-up performances, as "my clubhouse.")

Keith's number one obsession through all his school years remained the magic box of television with its vantage to popular culture and the look and feel of a world outside Kutztown. He was constantly watching cartoons. "At that time, in the early sixties, they were of incredible quality," Haring said. "Even Daffy Duck and Bugs Bunny were becoming really sophisticated—and with the advent of Technicolor, even more so. It was incredible—those pop colors!" (Keith's grandmother switched to a color set in the mid-sixties; the Harings, not until Keith was in junior high.) And he watched sitcoms. As he acutely observed of sixties TV, "Everything on television seemed like cartoons": "The sitcoms I grew up with, like *I Dream of Jeannie* or *Mr. Ed*, the talking horse, or *Car 54*

and *The Munsters* and *The Addams Family*—all those amazing stories which were totally ridiculous." He would sometimes dress up for TV watching—his mother sewed him a little bat-eared hat he wore while watching *Batman*.

All this excitement stirred by the hyperreality of sixties television reached its peak for Haring with *The Monkees*, a synthetic made-for-TV band meant to mimic, parody, adulate—and cash in on—the Beatles, whose first American tour, in 1964, had changed music and hairstyles across the country. By third grade, Keith was a junior Beatles fan, with his own Beatles wig in faux fur, in spite of his mother—he had once heard Joan say that the boat that brought the Beatles over should have sunk. Keith's clubhouse also served as a local fan club for the Monkees. "We performed as the Monkees on his parents' back patio, and we put up posters," one childhood friend remembers. Keith was a card-carrying member of the Official National Monkee Club: "It was one of the first times I began to frighten my parents, especially my father, because I was in the fourth grade, and I would buy these teen magazines, which were really for girls, about the Monkees and Herman's Hermits. I would cut out the pictures of the Monkees, especially Davy Jones, who was the cute, young one. I'd cut these pictures out and make collages and books." (Making his mother "furious" in the same period was his desire to have a Ken doll from the Barbie collection rather than a more butch G.I. Joe doll, so his grandmother bought it for him instead.)

Keith's fourth-grade drawings were standard classroom work. In one, a farmer with pitchfork, his wife, a dog, and two horses stand by a brown fence—the wife, her posture askew, dressed in blue jean shorts, her black hair in two big flips. Her lookalike shows up on the ninth page of a far fresher, Monkees-themed notebook Keith began creating the same year. Now in a striped green turtleneck, she answers her own thought balloon of a question "Who are the Monkees?" On others of its pages—some of white construction paper, some blue-lined notebook filler, Scotch Tape blatantly stuck everywhere—Keith drew with colored pencils a mop-haired Davy Jones with a graphite pencil confession, "Davy is the one I like best," and pasted the head of bass guitarist Peter Tork snipped into a swooning heart shape. Silliest was "Who is it? It's Davy in

Descise," as he gave the teen idol a makeover with a blue crayon French beret, mustache, and goatee. The two dozen pages in this artifact of gender teasing, a smashing together of crayon and fanzine textures, were nothing like the ordinary coloring book farm life he was doing for Mrs. Blefgan. Haring later took the work in the Monkees notebook seriously as "probably some of my earliest collages."

The year of the Monkees drawings and collages was 1968, a signal year in American history as well, with the assassinations of both Robert F. Kennedy and Martin Luther King Jr., demonstrations against the Vietnam War, and much attention in magazines (such as his beloved *Life* and *Look*) to a youth culture of hippies, flower power, and student shutdowns of universities. Entering the fifth grade in the fall, Keith was ten years old. Yet he was a precocious ten, made so in part by his avid attention to television and any other messages from the outside world he could discover. The more he saw and heard, the less satisfied he was with his homelife. He enjoyed puttering and building with his dad in the basement, but he resented his father's control: "There was always something really frustrating for me with my father, because he always wanted to show me things, but then he always did it, instead of letting me do it and make a mistake." With his mother, the domestic conflicts grew more pronounced: "What I *do* remember is being extremely disciplined and feeling extremely restrained by my parents' expectations—mostly from my mother."

Fashion was a memorable example for Keith of "the Generation Gap"—the subject of a cover story in *Life* magazine in May 1968. He chafed from a mismatch between the groovy colors and patterns, the wire rims and Nehru jackets, that he saw on *Laugh-In* and his own outfits: "I remember having a trauma because I wasn't allowed to wear bell-bottoms when I was in fifth grade. I was forced to wear my uncle's hand-me-downs for school. And I remember the total horror of going shopping with my mother and being forced to go to the bargain basement—I mean, looking at the regular stacks, but then having to go downstairs where things were substantially cheaper—and less interesting clothes." (He was also annoyed at Joan for labeling his socks with monograms so they would not be lost.) Politics was another test: "I

remember watching the Democratic convention and being sent to bed when they began showing the riots. They were trying to censor or protect me, but the next week I could see all the pictures in *Life*."

Keith Haring came to recall these late 1960s events as a clear dividing line running through his family life: "My parents weren't part of the sixties cultural revolution at all. They were on the other side of it—the redneck side of it. They supported Nixon and were on the side of what a lot of people were opposing. I never really felt a part of that. So, as I grew up, this became more and more of a problem at home." Yet Haring's archives contain two letters dated 1968 and 1972 from the Richard M. Nixon campaign thanking him for "helping make possible our victory." As one friend recalls, "We were active slapping Nixon bumper stickers on everything, including his dog, and running around with bars of soap writing Nixon's name on the sides of buildings. Keith or his dad shot a Super Eight with Mumbo, their Weimaraner, with Nixon stickers all over it." But another friend recalls Keith handing him a pin for Nixon's opponent, George McGovern, because they were "more funky, psychedelic pins." At age ten or fourteen, Keith came across as being less interested in the messaging than in the bright graphics of stickers and pins.

Agitating him in equally unclear ways in those same years was the question mark of early adolescent sexuality. As with his drawings—caught between the ordinary and the edgy—so were his feelings about girls and boys. In the fourth, fifth, and sixth grades, Keith had Valentine-style crushes on girls in his classes: "I had obsessions. And there were little parties, and I was always very good at choosing presents for girls—and making cards. There was the whole note-sending thing—writing love notes back and forth. Getting caught with love notes and breaking up with girls." He even "went steady" with Julie Kaiser, who lived down the street and was very much favored as a nice girl by his parents. "We would walk to elementary school together," Kaiser recalls. "I had a little cedar chest with drawings Keith would make in school. At one point, we called each other 'boyfriend' and 'girlfriend,' and so, back then, we would call them little 'love letters.'"

Keith was simultaneously experiencing more private moments of

dark excitement around men and boys—often enough on the campus of the college. He was stimulated, when bringing his grandfather's lunch to him, by the crew of laborers with their pinups and by his grandmother's tales of the crew sunbathing naked on the roof. He rolled around during sleepovers with two boys whose father was the college wrestling coach and who sometimes let them swim naked in the pool with his wrestlers: "We'd be these little boys swimming with these hot wrestlers." He befriended one student teacher who let him work on his collages, made from glossy picture magazines, in his dorm room, "with guys walking around in towels."

This mix of not only the erotic and artistic but also the political was heady. In 1970, Keith attended an event on campus for the first Earth Day with his student teacher friend. A month later, on May 4, his twelfth birthday, he witnessed campus protests over the shooting of unarmed students at Kent State. As ever, his strongest takeaway watching the students marching was visual: their black armbands.

The Art Room

K*eith's junior high* school, where he began classes in the fall of 1970, was a classic granite edifice built in 1916 catty-corner to the Harings' home on South Whiteoak. Right next door to the Harings' place was an ornate Victorian schoolhouse known as "the Annex," where some of Keith's seventh-, eighth-, and ninth-grade classes were held. The proximity of this distressed structure, with its bell tower, dormers, and blue marble steps, led to lots of obvious jokes about Keith's

not having an excuse for being late to class. (The Annex has since been refurbished as the Kutztown Area Historical Society; on a visit home at Thanksgiving 1982, Haring stopped by his old school to make subway-style chalk drawings on four blackboards that are now preserved behind Plexiglas.)

During his middle school years, Keith grew from being simply the boy who could not stop drawing, including doodling in the margins of school papers, to envisioning a vocation for himself as a fine artist. Influential in enabling this growth was his art teacher Lucy DeMatteo, a short, feisty, white-haired woman remembered by her students as a "fireball." (Her husband, "Beauty" DeMatteo, named for his looks and athletic prowess, was perhaps the only Italian American in Kutztown.) Mrs. DeMatteo ran an "open game" of an Art Room, where students were free to use any materials they wished. As Keith wrote in a school essay, "In seventh grade, I drew all the time and was almost permanently connected to the art room." While in all his classes he was a fidgeter, hyperactive, legs constantly moving, in the Art Room, he was not required to sit still. He appreciated the freedom, though he already resisted taking any advice from his art teachers, an attitude he traced back to the control he resented from his father when they did their woodworking projects.

"The thing about Keith was that he always liked working alone and on his own," Lucy DeMatteo said of her famous student. "I thought that if I squelched that he'd lose interest. And he was stubborn. I'd say, 'Keith, why not try this or that,' and he'd say, 'I don't want to.' Finally, I'd say, 'OK, OK, do what you want.'" She was keen that he try oil painting, as she felt he might enjoy the process. "Try it, Keith," she coaxed. "It's another medium." He tried it, but never finished the canvas. One day, when he started drawing some figures and little pictures she found beautiful, she tried to guide him to not give up, telling him he might be good at book illustrating, especially children's books. "Oh, I don't know," he shrugged. Yet she grew only more encouraging of her shy, almost secretive young student as she came to sense that "Keith's family never really understood what he was up to. They couldn't relate to his art." Around the time of the Monkees collages, the direction of his art had begun to mystify them.

In seventh grade, Keith found not only a nurturing art teacher, but also a best friend, a fellow artist, a compatriot, named Kermit Oswald. Keith and Kermit had known each other slightly since first grade. Their families attended the same church, and both enjoyed the same Sunday school class taught by Keith's dad, with an emphasis on doing over praying. "Allen was super creative and had us carve Jerusalem houses out of a bar of Ivory Soap," Kermit Oswald reports. A group photo of Kermit's eighth birthday party reveals Keith's among the bopping heads of the boy guests. "What interested me about Keith was that he was just a crazy kid," said Oswald. "When you're eight or nine or ten, you look across that classroom, and there are people who stand out as real dorks and some who turn out to be kind of interesting. There was always something interesting about Keith . . . A lot of it was that we had a common interest in art."

Mrs. DeMatteo's Art Room truly brought him and Keith together. Not only Keith's smirks and eye rolls, or his knack for getting out of trouble as quickly as he got into it, caught Kermit's notice but also his driven artwork, done with a focus that only Kermit shared. From the start, the two boys were competitive with each other, though their work was quite different. Technically, Kermit was more developed in traditional arts and could draw a plant, a barn, or a black-and-white birch tree with the drafting skills of a landscape painter. Keith's talent was inventive, as he was still more immersed in cartooning than in fine art. "Keith was very oriented into making cartoon things," said Oswald, "and he'd create little name tags and everything he was writing at that time wasn't in the classic Keith Haring print style that we know today, but in these enlarged balloon letters that look like they were carved out of a block of granite. It was stuff he had picked up from his father who did these really incredible drawings of little dogs and things—and cartoon characters."

At age twelve, they set up a studio together, above a garage behind Kermit's uncle's home on Main Street, a half block from the Oswalds' house. "They had this really beautiful garage," says Oswald. "It had a great upstairs, maple floors. It was a pretty big room, like four hundred square feet, so we could go there and draw." They were both working

with technical fountain pens and making lots of work with India ink and watercolor, or India ink and colored inks. The great discovery for Keith at the studio was the Rapidograph, a technical pen with an ink cartridge that did away with the need, in quill pens, to dip and refill, interrupting the flow: "I used a Rapidograph," Keith later said, "and it opened me up to using a consistent line that could go on and on." The only other viable artist from class they allowed near their stash of pens was Kelly Ryan, remembered by Keith for pushing harder with a pencil on matte than anyone he knew, with the caveat "He had imagination, but he wasn't in the same league as Kermit." Ryan remembers the studio as a "private clubhouse": "One year—this was Kermit and Keith's initiative—we had a Valentine's Day party and hired a high school band to perform there. So, we had live music at a kids' junior high school Valentine's Day party."

Keith and Kermit likewise shared a newspaper delivery route—same after-school schedule, same blocks, different sides. For Keith, the front pages of the newspapers he was delivering were another exciting source of information, especially the headlines. He delivered papers from age twelve through sixteen, from 1970 to 1974, the years around the ending of the war in Vietnam and the Watergate scandal. The paper route was another outlet, too, for the natural competitiveness between him and Kermit. "Kermit and I seemed to be in competition from birth!" Haring later said. "We'd get on our bikes and race to the end of Noble Street to finish our deliveries first," Oswald remembers. "Whoever got to the end would have to buy the other an ice-cream sundae at the Quality Shoppe. It went on for years. Sometimes he'd win, sometimes I'd win." As one local resident puts it: "They were the Beavis and Butt-Head of Kutztown." Yet Keith always felt their differences, too. He deemed Kermit the more "dominant" in his artistic talent, as well as being "more butch than I was. He was more aggressive with girls. And he was into hunting a lot."

On Sunday mornings, the newspapers were thicker with the Comics section. Keith's dad would get up at six o'clock to drive him around to deliver his papers. The two of them stopped at the Airport Diner for breakfast, seated at the counter, and then joined the rest of the family

and hundreds of parishioners at the main event of the day, the church service. Keith and Kermit sat together in the same pew, where they took "rutsching" to a new level. "A lot of the things that Keith would do in the late seventies that were very William Burroughs–esque, in terms of crossing out or rearranging words or cutting up headlines, he started doing in church, sitting in the pew with me," Oswald says. "He'd be sitting with the program, crossing out the words or letters of the sequence of events in the service and turning them into funny things. The two of us would sit there doing this, usually at his inspiration, and then pass them back and forth, and we'd be giggling, with our annoyed parents in the row behind slapping us on the backs of our heads."

A bright spot for Keith when he was twelve was the birth of his youngest sister, Kristen. Because the Haring home's three bedrooms were in use, Kristen's crib for a year or two was against a wall in Keith's bedroom. He loved the opportunity to be around a baby, and his exuberant openness whenever children were present, and all his public collaborating with kids, was first displayed with Kristen, enough so that she was often asked later in life if she was the inspiration for her brother's original tag, his crawling baby. "For the first twelve years, it was just me and my sisters Kay and Karen," Haring later explained. "I was encouraged not to spend too much time with them—I was supposed to be out playing with boys. So, my sisters and I weren't really that close. Then when my third sister came, I had a real affinity toward her, because she was a baby and because I was starting to go in my direction and become independent." Kristen admits that "in some ways, he treated me like his child." Later, as an adult, she would witness him giving the same attention he had showered upon her to other children. "I saw him sing lullabies to my nieces and put them to sleep. He loved doing that. If there was a baby around, he loved to put it to sleep. He found that moment magical—the release that happens in a child, that softness."

Less clear were Keith's feelings about his parents. He and his dad had strong opportunities for bonding, such as drawing, arts and crafts, and their Sunday newspaper deliveries. When Keith was younger, they even had been members of a father-and-son group, the YMCA Indian Guides, where their "Indian" names were Big Fish and Little Fish—as

the organizers did not realize that their last name, "Haring," was not spelled like the fish, herring. The conflicts with his mother were more fraught: "My own uncomfortableness with my mother was about her always telling me what to do—and she'd do this to my father, too," Keith explained. "He had a way of being quiet, of avoiding arguments." A companion piece to his "Tribute to My Father" video was a videotape he made on a visit home in the fall of 1978, titled *Now, Now, Now* and featuring his dad with military haircut, in a sweater, saying "All right," intercut with little Kristen frisking off to sit on a couch and their mom's voice saying, "Now, Now, Now," repeated on a loop, in a warning tone.

In the spring of 1972, fourteen-year-old Keith took a sharp turn that caught friends and family by surprise. With all the ardor he had once mustered for Davy Jones and *The Monkees*, he suddenly became devoted to Jesus. Not the meek and mild Jesus of the mainstream Protestant churches, but the far more demanding and apocalyptic Jesus Christ of the Jesus Saves movement, whose followers—popularly known as Jesus freaks—preached the need to be born again, to follow the One Way and to look for signs of the imminent, fiery end of the world. Keith had read about the movement in *Life*. With his grandmother, he watched Billy Graham on TV. She would send away for Graham's magazine, *Decision*, which would arrive with bonus sheets of round orange stickers reading "One Way," the logo a single graphic black finger rising from a fist into a sky of crosses.

After a March of Dimes walkathon his church youth group joined in March 1972, Keith had his own born-again experience, as described in an earnest paper he wrote in the ninth grade: "We were all sitting there in a group and a tall Black man walked over to us and started talking to us about Jesus. At first, most of us were turned off by his talk but when we listened, we found that it really made a lot of sense. I had been a good churchgoer before, but I guess I hadn't really found Jesus like he said we could. He said we had to personally give over our lives to him and so I decided to, and I did. I have been living for him ever since. That day was the day that changed the entire course of my life. Now I know what I want to be and do, I want to preach the word of God to all the people I can. I can use my artistic ability toward this cause, also." (Keith received

an A-plus for the essay from his English teacher, Mrs. Bodnyk.) His mother recalls, after the march, of their mailbox's being "bombarded" for weeks with Jesus Saves flyers and stickers: "He got a bunch of things and stuck them around. He persisted in handing these out."

Keith Haring later emphasized that his attraction was to "the paraphernalia and the surrounding symbols and images more than the idea." He liked "the whole presentation." Yet, surviving notebooks with drawings and writings suggest a sincere passion for the person of Jesus and for some of the extreme ideas behind the Jesus Saves movement. He excitedly read *The Late Great Planet Earth*, a book by Hal Lindsey (which sold more than twenty million copies) verifying biblical predictions of the restoration of Israel, the destruction of the earth by fire, the Rapture, and the Second Coming. (The title of the school essay in which Keith testified to his rebirth, "The Crystal Ball Reading," was taken from *Late Great*'s final chapter, "Polishing the Crystal Ball.") His devotion was at its most intense the next summer, at Camp Mensch Mill, his church camp notebook filled with "One Way" and "God Is Love" colorings as well as notes to self such as "The Answer is God!" and "'Do Unto Others as You Would Have Them Do unto You'—I Got to Try to Follow Those Rules!" He wrote a note to one fellow camper, calling her "one of the cutest girls at camp" and drawing a long-haired man carrying a Bible; the note ended with a postscript: "DON'T EVER FORGET . . . JESUS IS COMING!" "He insisted I read *Late Great Planet Earth* and gave me a copy to take home and read," the camper recalls. "It took months, but I finally complied with his wish!"

A personal journal Keith kept in the early 1970s charts his trajectory from playful kid to true believer. Its first pages are taken up with a secret code, self-developed ciphers (cryptic signs and letters) for his entries, a very junior semiotics. "That was the double-O-seven spy influence," says Kelly Ryan. "James Bond was big, the whole Cold War and spies, and *Get Smart*. Using radios and writing in code was all that spy culture." The notebook changes tone after Keith pastes in a flyer for the March of Dimes walkathon. Its ensuing pages are devoted to sheets of One Way stickers; smiley faces with "Jesus Loves You" penciled into the smiles; and a drawing of a Nativity scene with a baby Jesus in a halo of

radiating lines that is not far from the Nativities in Haring's later Christmas subway drawings nor from one of his final works, the 1990 *Altarpiece* installed in cathedrals in Paris, San Francisco, and New York City. He copied out the lyrics of a favorite song, Cat Stevens's "Morning Has Broken," but added his own finale: "One Way for God & Jesus / God is Love / Help someone you love today!!" And he composed and signed a twenty-five-line poem in prophetic tones that is pure *Late Great Planet Earth*:

> *We must repent now and devote our*
> *lives to Jesus Christ!*
> *The time is now, time is running out,*
> *It can happen any time!*
> *Be prepared for God!*
> *Be prepared for judgment day!!*
> *Be prepared for your choice of eternity!!*

Even more public and unforgettable around Kutztown was the preaching Haring practiced with pen, crayon and paper, stickers, T-shirts, and bumper stickers. For a year, all the drawings he created in Mrs. DeMatteo's class were crowded with religious symbols. "At the time, he was into his Jesus phase, so he made a lot of drawings with crosses in them," she said. "I didn't argue with him about those drawings. Keith was in the top section of the class—he got A's—and he was always working on something." In her class, he made a drawing of Christ on the cross, with the caption "For Christ's Sake." He also took to the streets. "Keith had these sheets of fluorescent orange stickers about the size of a fifty-cent piece that said, 'One Way,' with a finger pointing up," Kelly Ryan remembers. "He was sticking these things all over town—on street signs, telephone poles, windows on Main Street. He was already doing public art in junior high school. It was like graffiti." Letting his hair grow longer only added to the Jesus aura he was cultivating. "It's easy to call someone a Jesus freak when he kind of looked like Jesus," Kermit Oswald says. "He had long friggin' wavy hair and little wire-rim glasses, which became his trademark way before he got to New York. But I didn't take it all that seriously. It was a year."

The shock to his parents was palpable but not simple to reckon with. Why wouldn't these churchgoing Christians be pleased that their son was embracing Jesus Christ and the golden rule? At issue was the more radical brand of Christianity Keith was proselytizing and the public spectacle he was creating in their small, gossipy town. "My parents didn't like it because it was too intense," Haring's sister Kay says. "That was super evangelistic. We were just chocolate or vanilla United Church of Christ. You go to church, and you take part in their activities. That was beyond the teaching going on in our church." At least as an adult, Haring understood some of his family's dismay: "It was confusing for my parents, my being a Jesus person. I mean, it was along the lines of what they wanted me to believe in, but they wanted to keep it under control—they didn't want me to be obsessive, and they were frightened because I *was* obsessed with it."

His heartfelt impulse for "coming forward"—Billy Graham's invitation to be born again in his televised stadium rallies—was at first a desire to belong to something larger, especially something larger than Kutztown, where he didn't belong to much. "When I turned thirteen or fourteen, I remember, for whatever reason, wanting to be part of something," Haring said. "Well, the first thing that became available to me was the Jesus movement . . . Finally, I myself became bored with it. I had done it for about a year, and it seemed to make less and less sense to me, and it became less pressing . . . I don't know that I ever, really believed in all those things. It wasn't as exciting as it appeared to be at first." Yet the Apocalypse and a few powerful religious images remained fixed in his head, and his art, for the rest of his life: the crosses and shining stars, angels and devils, baby Jesuses, and multiheaded monsters of doom.

Keith next turned hippie, though hippies and Jesus freaks were far from mutually exclusive. The Jesus movement was composed as much of former drug users from the counterculture as it was of fundamentalists— the phrase "Getting High on Jesus" was one of its popular slogans. Followers often lived in communes and spread the word in coffeehouses, many in the surrounding woods and neighboring towns of Kutztown. Their major publication, *The Hollywood Free Paper*, distributed free on

the local streets, even adapted an irreverent, raw, R. Crumb style in illustrations, such as "Keep on Truckin' for Jesus!" that Keith broadly copied, supporting his friend Kelly Ryan's notion that all his art at the time was influenced by the latest trends in popular culture: "R. Crumb and Zap Comix with Keep on Truckin' were a big influence. Keith took to the *Mad Magazine* style of cartooning, too—a little countercultural, very political, a lot of social commentary in those pages. Those cartoonish, kind of graphic things." Another childhood friend, Tom Wessner—whose skateboard Keith insisted on painting with Tom's initials after a sleepover when they were not yet twelve years old—points out, "When Keith was going through his Jesus phase, *Godspell* had just come out, and *Jesus Christ Superstar.*"

Other pages in Keith's junior high notebook reflect a lighter mood. No longer rating the 150 Psalms ("good," "ok," and "ugh!") as if they were contesting records on *American Bandstand*, Keith began to write and illustrate his own "Swinging Fairy Tails." Among the dozen in the collection he billed as "Updated Fairy Tails Perfectly Fit for Our Times!" the most self-consciously hip of the titles were "Goldilocks and the 3 Bears Waterbed," "The 3 Little Pigs Get Psyched," "Soul Brother Hansel and Soul Sister Gretel," and "Rapunzel Lets It All Hang Out." He illustrated his Goldilocks as a tumble-haired hitchhiker in a miniskirt, a top with a plunging neckline, and knee-high go-go boots. (Her belt buckle punctures the bears' waterbed.) A sign he drew for "Magic Seeds 35¢" in "Fred and the Beanstalk" has a druggy feel. The Old Lady in the Shoe lives in a combat boot from an army surplus store. These countercultural allusions may feel dated at times, yet, says town historian Brendan D. Strasser, "The best time to be a hippie in Kutztown was the mid-seventies. After it had been everywhere else, it was still thriving here."

Provoking nearly as much attention as Keith's townwide "Jesus Saves" campaign was an either maximal or minimal work (depending on the perspective) he entered in a junior high school student art exhibit—a fifteen-foot roll of three-inch-wide adding machine tape onto which he drew in black ballpoint pen an entire fantasia of invented charac-

ters. He titled the work *Peterson & Co. & Friends*, describing it as "a groovy pop name for a rock band," and hung it along the perimeter of the school gymnasium. The tape reads from left to right and unrolls into a very busy parade of protestors with lots of headbands, Afros, bell-bottoms, and beards. The lineup is broken only by a lone cop car: in the parlance of the day, the hippies versus the pigs. Tilted signs are held aloft advocating "Black Power," "Women's Lib," and "Love Your Neighbor." Bras are burned, peace signs are both worn and flashed with two fingers. Popping out from the crowd is a busty naked young lady, her own bra evidently burned. (Keith and Kermit had lately been tracing over similar bikini-clad Vargas Girls in a bartending guide at the Oswalds' house.) The nude drew lots of comments and ire. "Mrs. DeMatteo didn't make me take it out," Haring later said. "But she was mad, and it was a scandal."

At the end of junior high school, Mrs. DeMatteo gave out her annual Best Artist award. That year, she decided to change the award to "Art Service," using the name change to avoid stepping into the fierce competition between Keith and Kermit. She presented the prize instead to Kelly Ryan, who had no illusions about her motives: "I was the well-behaved one. Mrs. DeMatteo said, 'Draw a horse,' and I'd draw a horse. I did what I was told."

A decade later, Lucy DeMatteo saw a profile of Keith Haring in *Self* magazine that caused her to write him a letter expressing her feelings about him as a junior artist and bringing up *Peterson & Co. & Friends*:

> I said to myself, "Well that little squirt, he sure has made a name for himself." . . . It reminds me of the figure drawings you did on adding machine tape (I wish I would have kept it), remember that you had dirty little things hidden throughout—remember that I would always tell you to draw larger—never thinking you eventually would do wall size art. I know your little creatures have made you famous—but do the people know what a great talent you really are. I always knew you were one of a kind.
>
> I used to get so mad at you, I always thought you should do more . . .

You little stinker made them all sit up and take notes—you always did like adventures—yours paid off.

A less distinct landmark in Keith Haring's adolescence than the Annex was Kutztown Area High School. The 1961 standard suburban school building was not particularly memorable. As Kristen Haring describes it, "Our high school was post-Sputnik classic, low, boring, somewhat influenced by the International Style, with rectangular glass, but not enough to be interesting. It just looked like a school building." Though Keith's participation in the school's classes and activities had been un-remarkable, his grades in junior high were respectable. In high school—except for As in Art and in senior seminars in the Short Story and Journalism—he managed quite a few Cs and even Ds (in Algebra II). His list of activities in the yearbook was among the thinnest for a class of 180: "Arts Club 10. Drama Club 11. Projector Club 12."

The Art Room this time was even larger—"spacious," according to the copy in the yearbook—and guided by Mrs. Dietrich. Like Mrs. DeMatteo, Nita A. Dietrich was a devoted art teacher, though more soft-spoken and with a quieter demeanor. While Kutztown Area High was stronger in the sciences and mathematics than the humanities, her art depart-ment was quite elaborate. Students could concentrate in ceramics, jew-elry making, graphic arts, drawing, painting . . . or work on their own. Keith predictably chose independent study. "When Keith came into my class, he was sort of quiet, and as far as I was concerned, he was never a troublemaker," Mrs. Dietrich recalled. "He was diligent and often off in a corner by himself, concentrating on his work." Like Mrs. DeMatteo, she discovered that Keith was entirely disinterested in rendering realistic, three-dimensional drawings or creating oil paintings; instead, he stuck to pen and ink: "He had such imagination. I felt that anyone who liked to explore line the way he did shouldn't be pushed into areas he didn't care for. So, I just left him alone."

Unlike Lucy DeMatteo, Nita Dietrich dared to take sides in the on-going art contest between Keith and Kermit. "Nita and I were like *this*," Kermit Oswald claims. Her relations with Keith were a bit more

"stressed," according to Haring's sister Kay, starting with a prank Keith played as her newspaper boy, once scrawling his initials into freshly poured concrete in front of her house. Mrs. Dietrich revealed her favoritism in their junior year, when she awarded Kermit his own six-hundred-square-foot studio in the rear of the classroom, where he could close the door and paint. "That pissed Keith off," Oswald says. "He was annoyed with me because I had my own studio for two years." Another student in the class, Andy George, concurs: "I went in there one day, and Keith was frustrated. 'What the fuck!' he kept saying. Kermit's work was all over the walls." Yet Oswald clarifies that "We were both teacher's pets. But I think Keith was thought of as a little bit shifty or untrustworthy back then. He had that funky John Lennon appeal about him." Mrs. Dietrich did treasure a batik Keith made in class—a hanging piece of whole cloth onto which he dripped hot wax with a jaunting pen to draw patterns of fine lines—an item she kept on her closet door until she retired, and she spoke of being "really fascinated" by him, especially his rolled-ink monoprints.

The slight did not keep Keith out of the Art Room. He was a constant presence, and he and Kermit were allowed to work there anytime they were not in class. "We were both super active in it," Oswald says. "He was drawing furiously all the time." Keith's commitment in high school was even more intense than in junior high school, if possible, as he had matured, and his ambition had grown into becoming an artist with a capital A, as he was conceiving the difference: "When I started going to high school, I became less and less interested in cartooning for cartooning's sake. I was wanting to become an 'Artist' . . . I was more and more convinced that I was going to be an artist, and, in fact, I thought I already *was* an artist." Kermit was sharing with him sophisticated reading lists that he was receiving from James Carroll, an art professor at Kutztown College. And Keith was dropping by the local Kutztown Library, where he read heavily about art and took out biographies of artists. While his knowledge of the New York art scene still came mostly from *Life* and *Look* magazines, on a high school church trip to Washington, DC, his group visited the Smithsonian's Hirshhorn Museum, and he saw his first Warhols—a group of *Marilyns*. No living artist was to become more

of an influence on Haring than Warhol. "Andy's life and work made my work possible," one of Keith's journal entries from 1987 reads.

For a boy aching to be hip, one essential ingredient was missing—drugs. As a "Jesus freak," Keith stepped into the sandals of a hippie without needing to get high on anything except life and service to others. In the catalog of obsessions that defined his adolescence, drugs were next on the list, and they carried with them some of the hope and belief in belonging, revelation, and access to a bigger world that religion had earlier promised. Yet the segue was awkward, even comic, as Keith's mind outpaced his maturity. Before he ever set his lips on a joint, he was an aficionado of Spencer's Gifts, a local head shop, where he admired black-light posters from the sixties, inflatable Peter Max pillows, hash pipes, and rolling papers—again, the paraphernalia luring him first. Missing was knowing how to obtain marijuana. He lived in a strict household, with curfews. So, he bought a kit (complete with a little pipe, rolling papers, and a pipe screen) and then purchased ten tins of different exotic, loose teas from a gourmet deli. He kept the stash padlocked in a wooden box—although, when he tried to smoke the tea, the effect was nil.

Finally, one memorable Halloween in 1973, when he was fifteen years old and a tenth-grade student, he got high. All Hallows' Eve had been a major holiday throughout the largely German regions of Southeastern Pennsylvania for over a century, with the exchange of postcards featuring witches and talking pumpkins. An annual parade the length of Main Street in Kutztown was an infamous overturning of normalcy by ghouls, goblins, and menacing devils; even when living in New York City, Keith would drag home friends to witness its excesses. ("Keith brought me to Kutztown for Halloween of 1979," artist Kenny Scharf recalls. "We did acid and ate shoofly pie.") Following the parade in 1973, Keith went to a party at the Armory, next to the college campus, where he smoked his first joint. He was delighted with the results. Walking up a hill, he experienced the sidewalk as an escalator going in the wrong direction. The more he walked, the more he felt he wasn't getting anywhere, his sense of space distorted. "It was great," he said, "because it was a totally visual experience and my whole orientation to everything was visual."

He quickly moved on to trying all available drugs, many far less mellow than marijuana. From the start, he was experimenting with hypnotic barbiturates such as quaaludes, Tuinal, and Seconal; painkillers such as Percodan; and speed pills known as "Black Beauties." He was even taking angel dust (or PCP) with a friend by spraying the liquid on parsley or mint and smoking it. Known on the street as a "Superman" drug, it induced a feeling of no pain, especially in the muscles, but could lead to risky delusions. Haring felt as if he could climb poles. "Keith was the kind of kid at that time who would experiment with anything," Kermit Oswald says. "If someone had something to give him, he'd do it. That started to annoy me with him." Keith's manic drug taking led to distance between the friends for a year or two. Says Oswald, "I was into athletics, and he was into, like, angel dust." For Keith, drugs were the logical next step: "I always became obsessed with everything I started— whether it was starting the Monkees fan club or being a Jesus freak. I wanted to do these things as fully as possible. So, I treated drugs like a new obsession."

Around the time Keith began experimenting with marijuana and pharmaceuticals, his parents tried to cope with his increasingly rebellious behavior by allowing him to move down to his own bedroom on the first floor, into an addition built onto the back of the house—perhaps to appease him, perhaps to protect his sisters. Keith quickly calculated that the move made it strategically possible for him to sneak out of the house at night, and he lost no time making the bedroom his own. He painted the walls a dark, rich navy blue that was the envy of all his friends; Kermit soon painted his own room the same shade. Kelly Ryan recalls, "It was gorgeous. I was living in an old house on Noble Street. My room still had the 1920s wallpaper. We weren't allowed to paint on anything." At Spencer's Gifts, Keith found a beer can wastebasket, and from the supermarket, he lugged home a seven-foot-tall Jolly Green Giant display and a Chiquita Banana poster. His father helped him build a radio from a Heathkit, and Keith began to pump up the volume on his music. (He kept this radio in his New York City apartment, and Kenny Scharf later custom-painted it.) His room also allowed for surreptitious pot smoking. He and a friend reportedly would "stuff a towel under the

door for hours and smoke marijuana while Keith just drew and drew and drew."

It was in this room, at age fifteen or sixteen, that Keith first took LSD. As with marijuana, his response was largely visual and was translated instantly into his drawing. All through high school, he kept on his desk a blotter with removable sheets situated next to a round bulletin board his father had made him. While he was tripping for the first time, he began making a drawing that departed from his cartooning style entirely and veered into abstraction: "I remember the first time that I was drawing on the desk pad when I took LSD and I started doing the abstract shapes. I started doing stream-of-consciousness drawing and shapes melting one into another. And then really figuring out the way the shapes fit together and building this structure of complex drawings, where one thing leads to another. I didn't always have to be high to do the drawings, but it was the seed or the beginning of being more aware of chance and of the idea of letting things happen because they were meant to happen, investigating more my inner self."

In a significant letter written during a brief layover at the Delhi airport in 1986, Haring spelled out this connection between his first experience with acid and its triggering effect on his art most clearly to the perfect listener, and a friend later in life, Timothy Leary—the great advocate of psychedelics as a gateway to the unconscious and as a quasi-divine sacrament:

> There is too much to explain to put in writing: my first LSD experience at 15 and consequent trips in the fields surrounding the small town where I grew up in Pennsylvania. The drawing I did during the first trip became the seed for *all* of the work that followed and that now has developed into an entire "aesthetic" view of the world (and system of working.)
>
> The effect that the re-programming had on my life at 16-17-18, which made me find new friends, leave Kutztown, see "God" and find myself (with complete confidence) inside myself and believe in this idea of "chance," change and destiny.

Not only would Haring understand the importance of his acid trip as sparking the discovery of a new style, but he talked elsewhere of this style and approach as marking the border between thinking of himself as a cartoonist and thinking of himself as an "Artist": "For me, this meant making abstract things. So, I started making little shapes that together would fill whole areas. It was a little like automatic writing. Like, the negative shape of one shape would lead to the next one."

These mazework puzzles he began drawing to follow the urges of a single line—his own meandering paths into abstraction—became his recognizable style for at least the next five years. In an insouciant comic strip of an autobiography he drew in Rome in 1984, *The Story of My Life in 17 Pictures*, a frame picturing a cross-legged figure emitting a puff of thought, "LSD," is followed by a frame of a perfect parody of a Keith Haring abstract drawing from the period. Not all his high school works were of this kind, but most were at least intricate, busy, and purposely disorienting. On the same blotter pad where he made his first acid drawing, peeling off pages as he completed them, he accomplished in 1974–75 a brightly colored series of more than twenty felt-tip pen drawings that have the look of collages because of their lettering and crowding, like pastel cities seen from the air. Close up, they are built from teeny icons of hippie life (rainbows, Chinese ideograms, sunflowers, guitars) and, in graphic letters, the names of favorite current bands (Mott the Hoople, Black Sabbath, and Aerosmith; the last played Kutztown College during 1975).

Keith's quest for a neo-hippie lifestyle, enhanced on weekends by driving in smoke-filled vans to rock concerts in Hershey, Allentown, Reading, or Philadelphia, led him to find his new set of friends. Those he chose were of a certain ilk. As one of them, Tyr Floreen, explains, "We were kind of a group of kids in our class who had long hair, smoked pot, partied and stuff. Most of the other kids didn't." Another, Andy George, recalls, "When I met him the first thing that he said to me was that he wanted to smoke pot." Within the group, Keith's "friend-girlfriend, not a girlfriend I slept with," was Janice Eshleman, the daughter of a creative writing professor at Kutztown. The two bonded over their love of Alfred Jarry's *Ubu Roi*, Kurt Vonnegut, and rides back from New York

City on the Bieber bus sharing a bottle of tequila. "I believe the first time he wrote on a subway wall was a field trip in high school," Eshleman says. "We slipped away from a tour of the Museum of Natural History, went down a stop, and he wrote his name on one of the posters." A ringleader of sorts—his house a favorite spot for parties—was a dropout, a year or two older, who had braided hair, wore a long trench coat, and drove a blue Volkswagen station wagon he called the Blueberry. Soon, Keith himself was wearing a long trench coat to school.

This latest reinvention (or "reprogramming," as he termed it) was too much for Keith's parents, and simmering tensions within the household turned into open conflict, with some despair as his father and mother watched their only son devolve into a delinquent student, lost to them in a group of self-styled "druggies" beyond their ken. "We were worried about it, and that's probably how we started tightening the screws," Allen Haring says. "'No, you can't do this. No, you can't do that.' Knowing he was with people we didn't think he should be with. Did it work? I don't think so. We've learned enough to know it was probably the opposite with Keith." Joan Haring concurred: "At fifteen, sixteen, we thought he was wasting his abilities, not making the most of his school years, spending too much time messing around. We felt we were failing, yet we didn't know how to cope with it. We didn't know how to change him." They tried to insulate their three daughters. Yet Kay occasionally had to deliver Keith's newspapers when he was too spacey to follow through. Karen once found him at the kitchen table staring at one of his hands, which was covered in blood: "He had been playing with an X-Acto knife and sliced his finger and was so high that it didn't register." Even Kristen wondered aloud why Keith and all his friends smelled "like skunk."

Keith's antics were at least as obvious at school as at home. Before school, he would often slip into his playhouse in the backyard, now retooled as a hiding spot to smoke a joint, even as his mother, unaware, hung laundry on the clothesline. "I'll never forget—I was in the principal's office one morning, and in walks Haring—late again," Kermit Oswald recalled. "Now, of all the people we went to school with, Keith was the one who lived closest to the high school—only one block away. But Keith would get to school late day after day after day. Well, on this

particular day, he marched into the principal's office and, in all earnest-
ness, told them that he had been taken prisoner by these rabbits—these
terrorist rabbits! Maybe this was Keith high on angel dust or something,
but I'll never forget his having this flippant attitude. He could use what-
ever extravagance was at his disposal to kind of gloss over the whole
thing." His youngest sister, Kristen, remembers one morning when their
mother received a call that Keith was missing from class and took Kris-
ten along in the car with her to retrieve him from a spot in the woods
where he was partying with his friends: "I saw him coming back to the
car, and he looked annoyed, with hands in pockets. We took him directly
to school. She marched him into the office. He was not happy." As Har-
ing later admitted to *Rolling Stone* magazine, "I was a terror when I was a
teenager. . . . I got arrested for stuff like stealing liquor from a firehouse,
on my newspaper route, no less."

The nadir of all this drug-related drama occurred on the front lawn
of the Harings' house around dinnertime a few days after Keith had
run away from home and spent the weekend at a friend's house without
telling his parents his whereabouts. On this evening, they invited the
church pastor, Reverend Shults, a tall, white-haired rector beloved by
all. They believed he might get through to their son, as Keith had been
enthusiastically active in Shults's youth group, ministering with arts
programs to mostly Black kids in center-city Reading. Yet, all that after-
noon, Keith had been taking "reds," powerful downers, and his friends
had dropped him off and sped away as he stumbled into the bushes and
some neighbors came running. When his alarmed parents appeared,
Keith began screaming uncontrollably at his mother. "It all just came
out," Haring later said, "and I don't think she ever got over that. When I
finally came to, she was really, really crying." At his wit's end, his father
punched him—the only time Allen ever hit his son.

The next summer, following the lawn incident, and having outgrown
summer church camp as an escape from the daily round of family and
small-town life—"I felt suffocated by the town, because everything I
did was in the spotlight," he complained—Keith asked his parents if

he could go to the Jersey Shore. They said no—as they were saying to many of his requests. His workaround was to sneak out the window of his bedroom into the waiting car of a couple of friends bound for Long Beach Island. He left his parents a note saying he was going to the shore for the summer, but he didn't reveal his destination. And he cashed in a thousand-dollar savings bond from his newspaper delivery money to buy a half pound of marijuana. A passenger in the car, Ricki Kunkle, remembers their being stopped by the police on the ride down, though, thankfully, they were not arrested: "Keith was in the back, shaking like a leaf. Then the car wouldn't start again, and we had to wave the cop down, and he gave us a jump to get going." Keith spent the summer at the Pillars, a sizable boardinghouse near the beach run by a married couple, Ted and Trudy, and filled with teenagers, many of them Jewish kids from New York and Pittsburgh, a novelty to Keith, because he had grown up in such a Waspish town. He stayed in one of the cheaper rooms in the basement, with the car's driver, Mark Badders, the son of a Kutztown College art professor, and later confessed to himself, "I was probably in love with Mark, but I didn't even know it."

Mark Badders is credited with giving Keith his two nicknames that summer—"Swee'Pea" and "Alice." (Swee'Pea was the darling crawling baby of popular culture decades before Keith was born, discovered by Popeye on his doorstep in a 1930s cartoon strip and adopted by him as his "boy-kid.") The nickname stuck for several years and fit the boyish, sweet, innocent, immature qualities Keith projected—not quite grown-up. The second nickname, "Alice," did not stick but was even more apt. Haring was remembered that summer for his countless elaborate drawings from *Alice's Adventures in Wonderland*, especially Alice confronting the hookah-smoking caterpillar. "All the girls said, 'Oh, make me one, Keith,'" Ricki Kunkle remembers. Haring's special relation to the book persisted. Two years later, he sent Kristen *The Annotated Alice*, with a note that was somewhat surprising coming from a juvenile TV addict: "These are two good stories. 'Through the Looking Glass' is my favorite. I hope you will read this book and enjoy it . . . Keep on reading and painting and try not to watch T.V. There is always something better to do than watch T.V. Except if you watch Animal World or educa-

tional television. I grew up watching T.V. and I know you like it, but don't be afraid to be different. You are Kristen. Everybody is different. You are living the best life possible."

The summer of 1975 was the "Summer of Alice" for Keith, as he discovered his rabbit hole or looking glass of escape from his childhood world. Although he was working as a dishwasher and was lonely—incapable, according to him, of attracting girls and unwilling to act on his attraction to boys—he always described the summer in the most magical of terms: "I remember several incredible times; taking acid on the beach and staying up all night, having amazing conversations with friends and watching the sun come up at six in the morning, and sitting on the lifeguard chair. It was just heaven! It was this totally artificial world, because nothing mattered except the day-to-day life. I didn't have to worry about my parents, and I was making a lot of drawings." The escape seemed to have a salutary effect, and Keith returned to Kutztown feeling more mature, self-reliant, and focused: "I spent the summer just growing up." His parents welcomed him back with a tearful reunion. He felt that because he had gone away, they had surprisingly developed "a kind of respect for me." During his last year of high school, though they had never trusted him with the family car, and despite his having run away from home for a summer, he was finally allowed to obtain a driver's license.

He and Kermit reconciled, too, meeting each other somewhere in the middle of their differences. Kermit had begun smoking some grass and doing some drugs, and Keith was happy to have a more intellectual friendship, as the two seventeen-year-olds engaged in classic late-adolescent conversations about the universe and the meaning of life. Kermit was experimenting with different art styles as he mimicked the contemporary artists he was discovering. For instance, he would tape blocks of color onto raw canvas to try to imitate Frank Stella. Alone or with Kermit, or with a friend from the college, Keith would take acid and practice seeing "artistic things": "I'd lie in the fields and see these beautiful patterns and colors and shapes, and how the sky and the trees turn to different colors—and there were just these beautiful geometric shapes." Kermit Oswald insists that Keith was always intent on relating

his drug experiences to the content of his art: "He had a drive very few people had, and he knew how to steer the difference between using it for something productive rather than just seeking a better high."

Just as sincere was his social consciousness. Even as a Jesus person, Keith had associated the apocalyptic messages of the Book of Revelation with the warnings of an emerging environmental movement. In the same notebook with his earliest One Way finger-pointing-skyward stickers, he drew in pencil an alarmed globe with curly hair, labeled "MOTHER EARTH!!" and pleading "HELP!!" Nearly as revelatory to him as *The Late Great Planet Earth* had been *The Limits to Growth*, published in 1972, a likewise harrowing mass market paperback full of predictions of the effects of population growth on a planet of limited resources, a book grounded in computer simulations rather than religious prophecies. An awareness of the rights of Native American populations was often linked to these ecological movements, as in a poster on many college dorm room walls of the era (introduced on Earth Day 1971) showing a noble Native American shedding a tear for the pollution of the earth. "I remember specifically getting a lecture from him about Native Americans because he had just gotten the poster," Kristen Haring says. As early as ninth grade, he wrote an essay (graded A) on Geronimo that included a paragraph about the nobly depicted Apache chief riding past the newly inaugurated president Theodore Roosevelt, who was described contemptuously by Keith as "the Chief Executive of all conquering Anglo Saxons."

He was also conscious at an early age of race relations. Growing up in a completely white town, Keith had a surprising history of making significant friendships with Black people whenever he had the chance—the boy he befriended at camp; the Black man who introduced him to the Jesus Saves movement; the kids in center-city Reading for whom he bought art supplies from his paper route savings. He also had an early attraction to Africa, albeit even the most distorted images. He would watch the weekly TV series *Tarzan* and even more dated black-and-white Tarzan films at his great-grandfather's. "So, I had all the fake images of Africa," he said. His most substantial exposure to Africa and African culture was given to him by a white-haired lady in her seventies who attended his

church and had been a missionary in Ghana. Keith would visit her at her home, where she shared a more realistic picture of the actual life she had known in Africa—an awareness that would be focused for him, when an adult, in his anti-apartheid posters and painting.

When Keith wasn't lost in the lines of his experimental abstract drawings—or their obverse, his *Alice in Wonderland* illustrations or cartoony graphics of funny pigs—he would make drawings so filled with hidden imagery as to approach abstraction by requiring extreme, up-close engagement. The most successful of these—at least as far as finding an appreciative audience among his teachers and other adults was concerned—were maps of Berks County and the United States. (For his peers, says Andy George, he made designs rich with other sorts of pay-offs: "He used to put pot leaves in mine so small you could barely see them.") In his junior year, Keith made a Berks County map that won a $100 Honorable Mention in the 1976 Berks County Bicentennial Exhibition at the Reading Museum and was bought by a customer on his paper route. "The first thing I sold I got $135," he recalled in *Interview*. "That was when I was seventeen. It was a little ink drawing of a map of Berks County." Senior year, he returned with a map of the United States, twenty-two by twenty-eight inches, full of lines and patterns colliding into recognizable symbols—Mickey Mouse for Disneyland, or smoke-stacks for Pittsburgh. The piece won an Honorable Mention citation in a competition sponsored by the local Kutztown Women's Club.

Most of Keith Haring's high school artworks are lost. The summer following graduation, he returned to the Jersey Shore, this time to Wild-wood, where he hitchhiked to try to sell a few pieces at a boardwalk art exhibition. He brought with him his portfolio filled with all the ink drawings he had made during high school, including the U.S. map. He sold one or two drawings for fifteen dollars apiece and won a prize. On his way back, he decided to return to the scene of his idyllic breakaway the summer before, catching a ride with a driver who said he was going all the way to Long Beach Island. "Then we got to the Atlantic City Ex-pressway and at the last minute he said he's going to do a different way back to Philly and he's going to turn off here," Haring recounted the incident in an interview five years later. "We were drinking wine and

smoking hash or something and we got off the exit and there were a lot of cars behind us and I had to get out in a hurry and my portfolio was in the back. I got out and forgot the portfolio until he had driven away." Haring ran after the car, unsuccessfully. The portfolio was marked with his name and address, but he never heard from the driver again. His reaction was panicked: "I freaked out."

Within a day or two, Keith reconciled himself to the loss, by way of a big thought—his dawning belief in "'chance,' change, and destiny." The words *chance* and *accident* always tended to carry quotation marks, either visible or invisible, in Keith Haring's conversations and writings as an adult. Beginning around the time of the lost high school artwork, he grew convinced that all was part of a bigger design, much as he often hinted that his drawings, which he compared to automatic writing, were reliant on spontaneity for their energy and authenticity. This trust in the unmediated hand and in the meaning of random events was key to his life and art—the lesson he took from some very challenging teenage years for himself and those around him, especially his family. His response to the lost art was to rapidly replace it with new work:

My first reaction was just disbelief and then almost immediately I turned to what had been a growing feeling for a long time that whatever happens is for a reason. There is always some other side to it. Very quickly, the next day almost, I made a whole new group of work that was much better than the first. I redid them very quickly and got to a whole other step. I used it as a positive thing. That became a sort of cornerstone of the philosophy that continued into the whole way I dealt with everything else for the rest of my life.

Pittsburgh

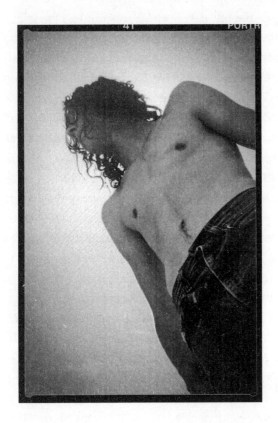

L ate in the spring of 1976, nearing the time of his graduation from high school, Keith and one of his high school friends, Tom Kriske, hitchhiked to Pittsburgh. Like Keith's, Kriske's hair was down to his shoulders, and his list of high school activities was equally thin—he played on the football team during his junior year and was a member of the Card Club. Tom was in Keith's close circle—a yearbook photo shows him and Kermit Oswald joking around in a library study hall. Kermit

even expressed jealousy when he discovered that Keith had taken acid with Tom before him. Just along as a traveling companion, Tom knew of some family friends with a house where they might crash. Keith was on a casual mission to check out an art school. In March, he had chosen, sight unseen, to enroll for the fall semester at a school with a serious-sounding name on the opposite side of the state, the Ivy School of Professional Art. "It's like a six-hour drive, which was not too far away," he later recounted in the documentary *Drawing the Line*: "But it was far enough that I was away from my hometown and away from my parents."

The choice had clearly been a compromise. Keith held out for the fantasy of his eight-year-old self: to live on the Left Bank and sell pictures. "My parents and my guidance counselor convinced me that if I was still serious about being an artist, the only way I could realistically think about it would be if I went to study commercial art," he later said. "In that way I could make a living from it. I wasn't totally excited." A small school of about three hundred students on the North Side of Pittsburgh, Ivy marketed itself as combining fine art with commercial art. Relying on brochures and classroom visits, the school (opened in 1960) targeted small towns around the state, and in nearby Ohio, as an alternative to the well-known fine arts program at Carnegie Mellon University, viewed by Ivy's founders as "exclusive, expensive, hard to get into, and basically for rich kids." (Though Andy Warhol and Philip Pearlstein, both from working-class homes, had attended "Carnegie Tech" in the 1940s.) "Keith and I used to talk about how we came from these third-category cities in Pennsylvania," recalls Ivy student Corliss Cavalieri, from Altoona.

If initially reluctant, once Keith decided on Ivy, he threw himself into raising money to help defray the costs. He knew his own ambivalence was more than matched by his parents': "They weren't too excited about the idea of me trying to pursue my life as an artist, especially after I had already proven my wonderful stability up to that point." He calculated that he would need $8,940 for room and board and $2,000 for supplies. (By age fourteen, Keith was already keeping a diligent "Money Records" notebook, with some expenditures marked "SECRET!!!," and he remained a lifelong list maker.) "I've decided to go to Ivy, and this will be

my down payment," he said to his mother in the spring, handing her the one-hundred-dollar prize check he had received for his Berks County map. "He was very proud that it was his money," Joan Haring says. In his application to the School of Visual Arts two years later, he noted a five-hundred-dollar scholarship from the Wyomissing Institute of Fine Arts "applied to first three months at Ivy." He had kept enough in savings bonds from his paper route and a side job as a dishwasher that he was able to pay for art school mostly himself, with "a little bit of money from my parents to help with some books."

His scouting of Ivy did not leave much of an impression on Keith, in keeping with his later shrugging attitude toward this period in his life, pivotally significant as it truly was. He would have trouble remembering when and how he found himself in Pittsburgh that season, and he had no recollection of having investigated the art school. More indelible was the accidental lodging the two young men managed at the home of a friend of Tom Kriske's father—an old farmhouse outside the city with a player piano, several guest rooms, and a heated outdoor pool. Living at home was the friend's teenage daughter, Suzy, who was the same age as Keith. "Suzy was fun-hearted in the same way that Keith was," Tom Kriske says. "And that was their fateful night." The two went skinny-dipping in the pool, and one thing led to another. "That was probably my first time," Haring later said. "It's embarrassing but true. It was the first time." He not only lost his virginity, but according to a mutual Pittsburgh friend, he and Suzy remained together as a "demonstrative, lovey-dovey" couple during the next two chaotic years.

Following high school graduation, Keith let his hippie aspirations blossom. He wore his hair even longer, in a braid or ponytail. Suzy was likewise presenting herself, said one friend, as a "hippie chick." Even in his later gay relationships, Haring tended to size up matters with visuals, to see himself and a partner from the outside. "I liked her because she had really great curly blond hair," he would say, "and was thin and small and the right size for me." Insecure about his looks throughout high school, he was thrilled to have found someone so taken with him: "Before Suzy, it was very difficult to find a girl who thought I was attractive or cute. I always knew that I could make someone fall in love with me if

they saw some other side of me. No one had ever given me that chance. But Suzy saw that other side of me, and she thought I was cute." Says Suzy—now Susan Maskarinec—who still lives in Pittsburgh, with her husband, a design artist, and is the mother of three children, "We just always got along. We were really good friends. He was such a nice guy, people gravitated to him. There was a lot of physical attraction, for sure. No question he enjoyed himself, or I would have noticed." Said Haring, "I liked the sex, and I was good at the sex, and we had sex all the time . . . Suzy was the first girl I ever slept with—and I fell in love with her."

Suzy would come to understand that "he preferred men," but only as Keith evolved to that understanding himself. The two learned together. As an eighteen-year-old, Keith arrived in Pittsburgh having kept an emotional double ledger during his adolescent years—common enough for a gay boy in a small town such as Kutztown, where no friends of his identified as gay. At the time the word *gay* was banned in the *New York Times* and Pennsylvania state sodomy laws criminalizing same-sex activity and denying jobs and housing to gay people were still on the books. The unspoken rule was not so much "Don't Ask, Don't Tell" as "Don't Even Think About It, Don't Tell." Yet Keith definitely had boyhood inklings. He once found a stack of *Playgirl* magazines on his paper route that he brought home and hid under his bed, until his father discovered them and made him throw the pile out. He occasionally veered to the wild side by secretly trying on his sisters' dresses. Although he was at Christian summer camps as a teenager, he felt freer to explore there. At age eleven or twelve, he performed a striptease as a fully made-up woman, popping out of a cardboard cake he had built. He was most excited by one camp counselor he used to watch while in the outdoor shower. As an adult, Haring still remembered the aroma of those woodsy showers, and showers retained an erotic charge for him. At camp, too, when he was thirteen or fourteen, he felt his first genuine attraction to another boy, a light-skinned Black kid who became his best friend. "We never really *did* anything," Haring later explained. "But it was the first time I felt something different. We became inseparable."

That summer of 1976, though, Keith and Suzy were in the first blush of romance, and the couple was mostly untroubled by doubts or cen-

tripetal pulls for at least another year. Keith and Tom Kriske returned home, but some back-and-forth travels took place between Pittsburgh and Kutztown over the next few months. In early September, on Labor Day Weekend, Suzy visited Keith for the Kutztown Good-Time Arts and Music Festival, a countrified Woodstock held on the Kutztown Fairgrounds over three days, with about 22,000 attending daily and an impressive lineup of country, folk, and blues acts, including Emmylou Harris, Earl Scruggs, Bonnie Raitt, and Tammy Wynette. According to Haring, he and Suzy camped out on the grounds and slept wrapped together in a single sleeping bag. "It was out of control," Susan Maskarinec recalls of the concert. "I think they overbooked it, and for the size of Kutztown, it was insane." Besides acts that played well beyond midnight, college students taking tickets helped their friends skirt the eight-dollar admission fee, bankrupting the event. Town historian Brendan D. Strasser deemed it a "magnificent failure."

The second week in September, Keith left Kutztown for the fall quarter of Ivy. At his high school graduation in June, his sister Kristen had cried. When her mother asked why, the six-year-old answered, "Because Keith is leaving." As Kristen Haring explains, "He was my world when I was young." Their mother's turn to cry came on the morning of his departure. Allen Haring and Keith packed the car tightly with his boxes and bags, and they were set to leave before dawn. "I remember standing at the kitchen door, crying and crying and crying," Joan Haring has said. "I was just so relieved that when he left, he wasn't the problem he had been six months earlier. After he made the decision to go to Pittsburgh and study art, he, sort of, settled down a little. I'll confess it was also a relief not to have the loud music going all the time. But I missed Keith terribly."

As Keith understood in his smokestacks drawing in the Western Pennsylvania corner of his U.S. map, senior year, Pittsburgh in 1976 was *the* American steel city. The industry that Andrew Carnegie had secured for his hometown in the nineteenth century with his Carnegie Steel Company was a few years off from the closing of many of the plants in the 1980s that would lead to massive layoffs. Still hovering was the

same cloud of smoke and smog that Andy Warhol had complained, in the 1940s, could turn a white shirt black in a day. The steel plants even appeared to at least one of Keith's friends as an American-style version of William Blake's "dark Satanic mills." "If you were in a car on your way out of Pittsburgh, you would turn this longish curve, and the Jones and Laughlin steels mills were there, and they were frighteningly huge," says Corliss Cavalieri. "The massive smokestacks seemed thirty yards in diameter. It was terrifying."

When Haring's art school classmates are asked about mid-seventies Pittsburgh, a complex pattern of adjectives emerges: "dirty, exciting"; "smoky, but beautiful"; "gritty"; "dreary and creative." A lot of the city was grand. It had good bones. Especially "the Point," where the Allegheny, Ohio, and (increasingly toxic) Monongahela Rivers converged, a focal confluence described in *The Mysteries of Pittsburgh*, by novelist Michael Chabon, who first came to the city in the mid-seventies, as "the black wishbone of rivers and the stadium on the other shore." The gilded families of yesteryear—the Carnegies, the Mellons, the Heinzes—had left behind a wealth of cultural institutions. Keith spent hours in the lobby of the new Sarah Mellon Scaife Gallery at the Carnegie Museum of Art studying Jean Dubuffet's wall-size *Free Exchange*. He availed himself often of the Carnegie Library nearby, housed in an impressive Beaux-Arts building, to keep up his practice of reading about the lives of artists and books on art. Less aspiring was the snarky response of the eighteen-year-old to the Heinz Hall for the Performing Arts. "Someday I'm going to go to the balcony and piss on the audience," Keith told a friend, mixing class warfare with the high tantrums of the French poet Arthur Rimbaud at about the same age.

A familiar fit for Haring and most of his classmates at Ivy was the working-class sensibility that pervaded the city at the time, along with distressed cityscapes and a bare-knuckle economy. "Pittsburgh then was very cheap to live in," remembers Susan Kirshenbaum, the daughter of the founder of Ivy. "Its culture was pretty redneck, kind of 'mill hunk' culture. There was even a newspaper that began in the late seventies, on the North Side, called the *Mill Hunk Herald*." Making do could be rough, and Keith took advantage of the discarded materials

on the city's unkempt streets to recycle butcher paper or broken plaster he might use for his art. Scavenging took some effort, as Pittsburgh is a vertiginously steep city, many of its neighborhoods with "Hill" or "Heights" in their name, joined together by more than seven hundred sets of wooden or concrete steps, some doubling as sidewalks. In earlier times, workers would trudge back up them after twelve hours in the mills. Just as exigent was the weather during his time there—the two summers were hot and muggy, the winters marked by historic snowfalls. An ink drawing from one of Haring's sketchbooks, *January 1978 in Steel City Snowstorm*, combines the weather and terrain as its formal pattern of black-and-white stripes (a motif in many of these abstract works) evokes steps.

The Ivy School of Professional Art, set on Perry Hilltop, on the North Side of Pittsburgh, in a working-class neighborhood troubled by street crime—"There were always murders, rapes, and thefts," one student recalls—afforded some of the most sweeping views of the bustling city below, many of its more than four hundred bridges visible from the rare vantage point. Ivy—framed by Haring later in life as an "obscure little art school"—was a handsome enough, retooled, one-and-a-half-story former vo-tech academy built into the side of a modest hill. Its look and feel were industrial, with open staircases and big plateglass windows, and its classrooms were all open art studios. Its year-round, two-year program included classes designed to mimic a work environment, as each was daylong and devoted to ongoing projects. "Ivy provided a foundation for art, but it was definitely job-focused," Susan Kirshenbaum explains. This emphasis on commercial goals could disappoint some of the students—like Keith—having expected to land on the subtler, more fine arts side of the equation. "For two people like us who wanted to be fine artists, the Ivy School of Professional Arts was limiting, like living as a liberal in a conservative town," reminisced Kimberly Kradel, a friend and classmate. "It was a technical, structured school in a blue-collared city where working hard was respected. We learned to spec type by hand. We learned color theory, advertising, illustration, commercial photography. We learned to meet deadlines. Even our painting classes were technical and based in realism."

Because Ivy lacked a traditional campus, incoming students were put up at a Point Park College dorm in downtown Pittsburgh, a long bus ride or a challenging uphill walk away. As classes were not scheduled to begin until October 5, Keith's father had dropped him first at a YMCA nearby. ("I picked him up later that day and he came to stay with me," Susan Maskarinec says.) At the start of the quarter, Haring then moved onto the twentieth floor of the converted former hotel, with elevators that stopped between floors. "There were lots of ballerinas from a dance school at Point Park College on the floor with us," Kimberly Kradel recalls. Though he shared Room 2008 with a roommate who, he decided, was "a disaster" because "he's the only one who doesn't party on our floor," by the first day, Keith had made his area his own—a neatly kept bed covered with a patchwork quilt stitched by his grandmother; a prominent hi-fi with speakers and headphones; a Homburg hat he was sporting tossed here or there; beside the RCA wall poster from his great-grandfather's store, a photograph of Nixon hung upside down; and a Mount Rushmore poster that included in the stony lineup the Indian chief with the single feather emblematic of the ecology movement. By December, Keith had seemingly come to feel his roommate was not such a total disaster, as he retouched a black-and-white photograph taken by him. Tinting it with Dr. Ph. Martin's watercolor dyes, he titled the work *Tripping at Pt. Park*. It showed him on a rotary phone, with blue skin, tangerine hair, and vermillion eyeglasses—classic dorm art except for the Aztec maze he had drawn with a Rapidograph pen as the background.

Haring's daylong classes at Ivy, fall quarter—meeting from nine to three, Monday through Friday, October through December—were all basic, with nondescript titles, and his grades were decent. He took Drawing and Painting I (and received a B-plus); Letterforms I (A-minus); Marks on Paper I (A); Art Production I (C-minus); and Color and Design I (C-plus). The second quarter, he took mostly continuations of the same courses, with similar results. At odds with his later surety that he was always bent on fine arts, Susan Kirshenbaum points out, "Those names, courses, indicate that he was choosing, at first, a commercial art direction." She adds, "To do poorly in a class means you probably didn't show up. There was a lot of festivity going on, wine drinking in the af-

ternoon. When these kids got to art school, it was their big chance to blossom and to find themselves. The contrast to where they were from was extreme, and people often went wild. Many kids went to art school and came out of the closet. Ivy was known for its outrageous Halloween parties."

While his grade in Color and Design first quarter was one of his lowest—in the spring, he received a stronger B-plus—the course's professor, Philip Mendlow, stood out for him. A local painter and sculptor, Mendlow had attended the Sorbonne on the G.I. Bill after World War II and enlivened his talk with anecdotes of friendships in his bohemian past with Allen Ginsberg and Philip Glass. Short, solid, and strong, Mendlow had a gravelly voice and a somewhat curmudgeonly strictness about grades. Haring not only took his Color and Painting course, but also monitored (for no credit) an art history elective Mendlow taught, titled Cubism to Computers, where he featured his enthusiasms, which ranged from Italian futurism and Jackson Pollock to "environments, happenings, and earthworks." When he applied to the School of Visual Arts in New York City the following year, Mendlow was the only Ivy professor he asked to write a recommendation—and the professor was forced to explain Haring's lukewarm grades against the bigger picture of his talent, "innate curiosity," and enthusiastic commitment to art: "While his attitudes do not always reflect in a grade average, I rank Keith among the more interesting students I have instructed. He is constantly probing and trying to extend himself. He is very well self-motivated . . . I recommend him most highly."

Much of Haring's most interesting artwork took place outside the classroom. He engaged in at least one public art project at the school that is remembered by more than one of his fellow students, using Post-it Notes, a recent invention at the time. "He would draw little figures on sticky notes and put them on odd places throughout the building," Corliss Cavalieri recalls. "As I was walking one day up the stairs—you could see a second tier and a third tier, though you were basically still on the first-floor area—I could see in the distance this little yellow note stuck underneath the stairs. As I walked up the stairway, I bent down and took it. Keith was there with his cadre of girlfriends. He was like, 'That guy.

I've talked to him. He gets it. He picked it up.' He was monitoring who was noticing his little drawings that he put around and who took them. He wanted to know who 'got it' and who 'didn't get it.' I had that drawing for the longest time, in an old wallet. It was a figure with a bubble head and may have been a diver or an astronaut."

For many of the art students at Ivy, Pittsburgh was a commuter bus school, and luckily for them, the transport system in the city was vast, well promoted, and widely used, including trolleys attached to overhead electric cables. Keith was a "bus gypsy," as they were called, and with a simple bus pass, he could get pretty much anywhere on buses that ran all night. The random comings and goings of passengers, the publicness, the sense of being involved in a rhythm of motion—all inspired his creativity. On the buses, he made a series of drawings, with labels such as "QF Trafford." He penciled into his sketchbook as an explanation: "The names written up the sides of some of these drawings are bus route names. These are done while riding the bus." He experimented in one, letting the bouncing bus direct his hand. He also wrote a few stories of reportage, such as "Kleenex Climax," which he sent to Janice Eshleman, detailing a woman dropping a dirty tissue on the bus floor, with a diagram of the riders, including him, in the backseat with his portfolio. "Just call them bus stories," he wrote to her of his "true actual accounts of what happened to me on the Public Transportation System of Pittsburgh." And he made new friends. "I originally met him on a bus," Eric Mendlow recalls. "He was drawing with a Rapidograph, popular in the seventies, and I had one, too, and we bonded on that basis. I was about fifteen. He recognized my name, as his teacher Phil Mendlow was my uncle. He thought that was cool. We became friends and started hanging out and drawing and painting." One carefree minor project Mendlow remembers Haring showing him in a sketchbook on the bus—but that he worked on off the bus as well and on single sheets of paper, scrap paper, and magazine pages, all numbered—was a series Keith titled *Ladies at Midnight*. He sketched at least sixty satiric quick takes on hookers, crooners, disco divas, nudes, and female bodybuilders. Far from abstract, they were most akin to his early work *Peterson & Co. & Friends*.

Missing in Haring's life those first months in Pittsburgh was an

obsession—one of the sudden passions he would seize upon regularly and construe as life-changing, giving him a special feeling of excitement and significance. Ironically, one of these galvanizing life clues showed up not in art school, but at a flea market outside Kutztown, when he returned home for Christmas. He picked up a used book atop a pile and started reading a couple of sentences, chosen randomly. "It was talking to me, like a friend," Haring remembered. The oracular little volume was *The Art Spirit*, written in the 1920s by Robert Henri, a founding member of the Ashcan School of American realism, a group of urban artists painting counter to a fashionable tide of impressionism and its subtle surfaces to create, as one critic put it, "as real a human product as sweat." Like the painters of the East Village whom Haring would soon join, the artists of Henri's circle had reveled in the verve of urban street-scapes and tenement life and valued their independence. Henri had also been a charismatic teacher at the New York School of Art, where one of his students was Stuart Davis, whose paintings "of interrelated abstract shapes," hanging at the Carnegie Museum, Haring came to admire as "brilliant," seeking them out due to the Henri connection.

The Art Spirit was not a manifesto for the Ashcan School, though, or for any style—Haring's art school works in Pittsburgh were far from the art verité of the realist painters. Rather, as the title announces, it is a manifesto for a quality of spirit, a way of being and seeing. Written in the epistolary style, as if addressed to "Dear Art Student," the book spoke to Haring's main concerns of the moment. Its first sentence is an appeal to art for everyone, the stuff of the Post-it Notes project: "Art when really understood is the province of every human being." Unmistakable was an implicit answer to Haring's pressing question of whether Ivy was for him: "Art study should not be directed towards a commercial end." Haring's love of Whitman's poetry began with Henri, who, in his wish for an authentic American painting, felt akin to Whitman in his striving for an American idiom in poetry that was alert to ordinary life. Most seductive—and relevant later on—was Henri's humanist stress on the hand and brushstroke at the moment of contact as a living record of the spirit of the artist, an insight that caused Henri, when writing of the line, to break into his own lyric poem:

You should draw not a line, but an inspired line.
Yours should be the drawing of strong intentions.
Every line should be the universe to you.
Every line should carry a thousand pounds.
A line expresses your *pride fear and hope.*
A line that has come from a line. Lines give birth to lines.

Returning to Pittsburgh for the winter quarter, beginning January 3, Keith moved into a shared house with lots of roommates, mostly young women, on Perrysville Avenue, a winding residential street across from Ivy on the North Side. Theirs was one of a series of nearly indistinguishable funky Victorian-era homes, with spindles busted out on the porch, yet graced with the niceties of sunrooms and massive second-floor parlors with bay windows. Haring had retained his Long Beach Island nickname "Swee'Pea," which fit the winsome, little-brother ambience of his relations with his housemates. "To me, he was like a real friend," says Barbara Wohlin Clarke, perhaps the closest to him of the group. "I don't want to say 'girlfriend.' He wasn't real femme. But he was like me." Clarke still has an experimental portrait Keith sketched of her in February 1977 at the Perrysville apartment: he drew without looking down at the lines, focusing only on her sitting on the couch talking about herbal tea remedies. The two enjoyed taking acid together beneath a bridge in Oakland at twilight. "It was fun when we listened to the grass when we were tripping," Haring wrote to Barbara in a letter. She recalls one Sunday morning, as they were walking around Pittsburgh, when Keith zeroed in on a hand-painted grocery store ad for bananas, saying, "They could really pull a nice line."

The standout class for Haring that quarter, and the most useful, was Silk Screen. "Silk Screen class was really smelly," recalls Julie Sullivan Brace, who was in the same class. "That was back in the day when we were using lacquer thinner rather than water-soluble inks. We used to print with these heavy, toxic inks and make our own screens. Keith was really into it, cutting out all those tiny, weird little shapes he would make." The class provided a technical jump for Haring. In high school, he silk-screened using the more arduous method of hand-cutting into

a sheet of plastic-coated paper adhered to a silk screen and dragging a squeegee across the stencil to create an image. At Ivy, he learned a simpler, photographic method—he could photograph any image he drew, print onto acetate, and expose the screen to light. Many of Haring's silk screens in Pittsburgh were T-shirts with Grateful Dead imagery, such as the cover of the album *Europe '72*, featuring a goofy guy with rainbow hair smashing an ice-cream cone onto his own head.

From the moment he picked up *The Art Spirit*, Keith's days at Ivy were numbered: "After I found this book, I *knew* I had to leave the Ivy School." His resolve to drop out only strengthened as he read and reread the book's many pithy pronouncements, such as "I am not interested in art as a means of making a living, but I am interested in art as a means of living a life." Winter quarter ended March 26, his time at the school having amounted to merely six months. While Henri's book was the deciding factor in the decision, he was influenced as well by all his conversations and experiences at the little outlier school defined by its twin vision of art mixed with commerce. He never had any second thoughts, and his choice held its own logic, even if his actual career as an artist would turn out to be just such a blend of art and commerce:

Within six months I came to realize that no matter what, I wasn't going to be a commercial artist. I mean, a lot of the students and a lot of teachers were saying that they were becoming commercial artists only to support their own work as real painters and sculptors. But I saw through that right away. I realized that if I spent the whole day doing mechanicals and pasteups, I wouldn't have any interest left in doing my own work afterwards. Well, I decided that if I was going to be an artist, that's what I was going to be.

He had some hard moments that April, following his dropping out of Ivy. He acted among his friends as if he knew exactly what he wanted and gave all appearances of taking off at full speed on his quest to be an important artist with something to say. Yet, without even the lightweight

support of the art school to bolster him, he found he had many doubts about his chances of success at making his mark. "I guess it's because I'm afraid," he confessed in his journal. "Afraid I'm wrong." He worried that he compared himself too much to the styles and life stories of more established artists. This insecurity was not softened by his financial situation. He had come to the end of his savings. His parents were shocked that he could have decided within six months to drop out of Ivy and that he was quitting with no backup plan that made sense to them. Making clear to their son that life was not a free ride, they cut off all support as a lesson to him.

Keith's response to a lack that month of any evidence of "a certain magic that some call 'Fate'" was to create his own opportunity to encounter his destiny by hitchhiking across the United States. Ever since he was a kid, one of his fantasies had been to hitchhike across the country, a fantasy that grew only stronger when he began emulating a hippie lifestyle, as the trust and openness of the haphazard hippies of the sixties had come to be telegraphed in the imagery of backpacks, scribbled destination signs, and an outstretched thumb. He "inveigled"—his word—Suzy into accompanying him. The pretense was to check out art schools he felt might be more suitable and ambitious in the fine arts, such as the Minneapolis College of Art and Design and the California College of Arts and Crafts, in San Francisco. He and Suzy took backpacks; a tear-shaped, army-style sleeping bag they would share; and a small pup tent. "The Robert Henri book came with me," Haring said, "because that was the handbook—that was the Bible."

Their round-trip odyssey was tirelessly completed during the month of May 1977, some of its highlights and low times recorded in quick drawings and jottings in a handy nine-by-five-inch spiral-bound dirty-brown notebook. On its front cover was a Grateful Dead logo, a distended skull pierced by a thirteen-point lightning bolt, and a cut-out printed slogan, "There's nothing like a Grateful Dead concert." Their hopeful scheme for financing the trip was to produce several dozen silk screen T-shirts in two designs that they carried with them in an extra duffel bag, planning to sell them along the way. The first design was of the classic skull pierced by lightning, meant to convey "mind-blowing"

to those in the know. Haring's touch was to fill in the space around the bolt with a pattern of abstract shapes, some of them recognizable as tiny stars, but most not. "In my little drawings at the time," Haring explained, "I was trying to create an all-over surface where your eye was seeing evenly instead of seeing particulars." The second was a silk screen of a blown-up photograph, taken from a book on marijuana, of Richard Nixon and of a kilo of pot. (Haring did not seem overly concerned with topicality, as Nixon had been out of office for five years.) Underneath, in press type, putting his commercial art training to use, he laid out the words "San Clemente Gold," a play on Nixon's "Western White House" and a popular strain of marijuana, Acapulco Gold, punctuated by a tiny sketch of a marijuana leaf.

Although Haring had not read Jack Kerouac's *On the Road*, his itinerary made just such a squiggle across the road map of America. If he was allowing the rhythm of the Pittsburgh buses to jostle his drawing hand, hitchhiking, too, was an exercise in randomness, as the luck of the ride determined the quality of the day and, especially, the locations of the nighttime stopovers. On May 4, 1977—his nineteenth birthday—he found himself at a rest stop in Zanesville, Ohio, still just one hundred and thirty miles from Pittsburgh, sleeping bag stained from a spilled bottle of ink, with free tickets for roast beef sandwiches and a free balloon from a McDonald's. In his trip notebook, he drew an oval-shaped birthday cake topped by nineteen candles and wrote in all caps, "TODAY IS MY BIRTHDAY! WHO WILL SING?" (That question would be more than answered in New York City, where Haring's annual "Parties of Life" for his birthday at Paradise Garage and the Palladium were memorable and packed.) The next day, they scored a ride to Milwaukee, Wisconsin, "and into another time zone." A sheriff drove them to Madison, and they continued to Interstate State Park, where they sold a few T-shirts: "Met people going to see the Grateful Dead in Minnesota. The Grateful Dead in Minneapolis!! We're going to see the Grateful Dead!"

The one destination set and timed on the trip was Minneapolis–St. Paul, where the Dead were scheduled to give a concert at the St. Paul Civic Center on May 11. Grateful Dead concerts were hardly a first for Keith, as he had been a dedicated fan of both the albums and the live

shows of the mellifluously mellow down-home band—true north for cannabis culture—his entire time in Pittsburgh. He had spent many hours with his Ivy housemate Barbara Wohlin listening to *Workingman's Dead*, *Blues for Allah*, *Steal Your Face*, and Jerry Garcia's side project, *Old & in the Way*. "We were Deadheads," Barbara Wohlin Clarke says. "Not everyone was, especially in Pittsburgh. It was nice to find each other. At one point, we made T-shirts and sold them at a Grateful Dead concert at the Spectrum, in Philly. If we sold one, we would get really happy." Suzy was party to such evenings, too. "We sold Grateful Dead T-shirts walking up and down the street in front of one of their shows in Pittsburgh," she recalls. "Keith was infatuated with Jerry Garcia, and he got in the back to give Jerry a T-shirt. Somehow, he got through security. That was a huge thrill for him."

The attraction was not simply musical. The Dead was also a traveling time capsule for the communality of the hippie movement of the 1960s—the band had been formed in Palo Alto in 1965. At least since his Jesus Saves days, Keith, the "different" kid, had been seeking to belong to something larger than himself. (Even in reading *The Art Spirit*, he dwelt on Henri's notion of artists as "a great Brotherhood" and returned to the idea a decade later, imagining a brotherhood of gay artists.) The Grateful Dead movement was conceived as a creative expression of just such a utopian way of life, in tuneful and psychedelic music, in social life, and even in commerce. The freethinking band encouraged a bootleg economy of concert tapes that circulated among their followers without fear of copyright infringement, produced thousands of posters and stickers to be given away, and eliminated the middleman by handling their own ticket sales. (Suzy and Keith bought their tickets for $5.50 apiece at the Minneapolis College of Art and Design, where they were put up for two nights as prospective students.) In a catalog essay for the show *Keith Haring: 1978–1982*, held at the Kunsthalle Wien (Vienna), in 2010, the curator, Raphaela Platow, would later draw an intriguing connection between the Dead's "viral marketing" and Haring, "who in the early stages of his career found new channels of distribution for his works and consciously circumvented the established structures of galleries and museums to communicate directly with his audience."

The concert in St. Paul was one of a string of concerts in May that have gone down in the annals of true Deadheads as "mythical for [their] excellence." At the band's previous appearance in town four years earlier, the drummer wound up tackling a security guard. This time, the mood was far more benign and looser, darkened only by the occasional explosion of cherry bombs and bottle rockets. "The Dead was great," Keith wrote in his notebook. "They did lots of things they didn't do at Phila. or the Capitol Theatre." A special touch that evening was the band's front man, Jerry Garcia, playing alone onstage with just a spare cymbal accompanying him. Keith copied down his favorite lines from an encore of "Brokedown Palace," a ballad of journeying, from the *American Beauty* album: "By the waterside I will lay my head, / Listen to the river sing sweet songs to rock my soul." "We saw the people we met at the campsite, sold T shirts, got high," Haring wrote, summing up the rest of the night. They caught a ride back to their college dorm rooms, ". . . from some good Dead Heads! There's nothing like a Grateful Dead concert!!!"

Keith and Suzy next took a northern route to California. They left Minneapolis on a bus to Interstate 94 and then hopped a ride in a truck all the way to the border of North Dakota, where they ate three cheeseburgers and drank some beers at a bar: "It was all farmers and when I went to the bathroom, they all talked about my hair . . . Rednecks!" On a lonely road outside Goodrich, North Dakota, they were stopped by the chief of police. In his write-up, he mentioned Suzy's attire: "T-shirt with no brassiere." On Friday the thirteenth, they found themselves in an A&W Root Beer stand in Montana, as Keith confided in his diary, "Suzy is beautiful but sometimes she drives me nuts, but I love her." From Seattle, a quick in and out, they caught a ride to Sacramento, California, with a layover in a motel room watching *Paper Moon*. After a night camping beside a herd of threateningly big cows, one last van ride landed them in San Francisco.

"Being hippies," said Haring, their first stop was the "infamous" Berkeley campus, where they walked about with their backpacks, selling T-shirts until they were stopped by a policeman, who evidently took pity on them. He bought them a lunch of Mexican food and gave them

a lift to Oakland, where Keith visited the California College of Arts and Crafts. "The school is really amazing," he decided. "Better than Minneapolis and not even comparable to Ivy." They then rode a BART train—described by Haring as "space trains"—to a crash shelter, where they could eat and sleep for free. The place was run by a minister and advertised in a Yellow Pages alternative they found at the campus center at Berkeley. Keith brusquely recorded the evening in his journal: "It turned out he was gay, I think," he wrote, referring to the minister, "and his friend took us to Polk St. where we saw more faggots than I saw in my entire life. It was weird, but we got fed well and no hassles."

The actual chain of events was more colorful and life-changing than he let on in his brief entry. The minister had entrusted Keith and Suzy to the care of his assistant, a young Latino man, who showed them where they could sleep on the floor and where the pillows were kept and who cooked them dinner. The assistant asked if they would like to take a walk and offered to lead them to the nearby Castro district, the most active gay cruising strip in the city, if not in the nation. "Well, this cute guy was being incredibly friendly towards me," Haring later explained in an interview. "I was so naïve! I had no idea this kid was coming on to me, and he was taking me there to make his intentions even clearer. It made me cling even more to Suzy! Little by little it became obvious to me that while I was still sleeping with Suzy, I'd been fantasizing more about men." Suzy was aware of the tug she was witnessing. "That's when Keith started figuring out maybe he was gay, when it started clicking with him," Susan Maskarinec says. "You would never have known. I had no clue. Who does? He was just very interested in the whole culture." Others appear to have guessed. Their young guide must have picked up some signal from Keith. Ivy friend Laurie Zook, too, tells the story of once having brought Keith to her family's cabin in Central Pennsylvania and his painting a Westinghouse refrigerator in Pepto Bismol–pink enamel paint. Her father was angry. As he unloaded the violated refrigerator at a local dump, he complained that her friend was "light in the loafers," an old-fashioned slur against homosexuals.

The next morning, Keith and Suzy continued their journey, hitching down to Los Angeles with a vague plan of staying with a friend of Keith's

from Ivy. Unfortunately, the friend was living in a Jesus movement commune outside the city. "I've already been through this long before and I'm totally out of it," Haring recalled. "But this was like a California-style serious hardcore Jesus freak commune." The men lived on one side of the house, and the women on the other, and once Keith and Suzy were divided from each other, the members began working on them separately to "save" them. Southern California was steeped in cults in 1977, and these born-again Christians were cultlike in many of their tactics, which both Keith and Suzy found disturbing. "I don't think we'll stay here," Keith wrote. "I'm thinking a lot, though. I'm really scared cause if I stay here too long, I don't know, man, I'm all mixed-up." Says Susan Maskarinec, "We went there, and it was really bizarre. I can't remember all the details, because we were high all the time. We stayed for a week maybe. They were trying to recruit us, to separate us, and talking about us to each other. It was super crazy weird."

Their sole escape was to visit Disneyland, where Keith's earlier infatuation with its creator, Walt Disney, proved more durable than his infatuation with Jesus had. "Yesterday me & Suzy took a bus to Disneyland," he wrote, recording the pilgrimage without mentioning his visits as an infant. "It was like another world. We did everything we could possibly do in 9 hours. We saw some amazing things, and everything was like the pictures you always see. I expected it to be a letdown after seeing it on T.V. and hearing about it, but it was better. Except the castle is only about 3 stories high and it always looks gigantic in pictures. We went to Haunted Mansion 2 times." The next day, back at the commune, Suzy was crying. "They're messing up her head real bad," Keith wrote. "We're getting out of here tomorrow. People that preach love should practice love." With their funds depleted and T-shirt sales rare, the only viable destination left was Pittsburgh.

Their return route was less action-packed than the voyage out. They passed through Las Vegas, where they spent a night, and then on to Salt Lake City. Most surprising was Keith's response to the natural wonders of the Far West. He dreamed of living in Park City, Utah, "nestled in mountains and ski resorts": "This is the best place I saw yet." He was just as euphoric camping the day after a snowfall in a national forest

in the Rocky Mountains: "I am sitting across the creek from our tent drinking a beer and getting high on the scenes. Rocky Mountain High! There are 60–100 ft. pine trees everywhere and the sky is bright blue with a few clouds." For such a preeminently urban artist, the last pages of his trip book are filled with lovely, slight, pencil or blue-pen studies from nature: a riverbank; a rock among rocks; clouds made of hatched lines ("It's cloudy clouds that have no end and no beginning"); their tent in a forest "bridged by many fallen pines."

By Memorial Day 1977, Keith and Suzy were back on the North Side of Pittsburgh, Suzy making French toast, Keith composing the final entry in his journal. While the people he met and the places he saw had left an impression, the substance of the trip for him had been Robert Henri's *The Art Spirit*, which he admitted to never reading in its entirety, but consulted randomly as people treat divination books like the I Ching. His search for a pearl of wisdom to salvage from the last month owed much of its idealistic spirit to Henri's work, if translated into hip, contemporary vernacular:

> Through all the shit shines the small ray of hope that lives in the common sense of the few. This ray of hope shined brightly in parts of the country I visited, and people, and it lives in the Arts. The music, dance, theatre, and the visual arts; the forms of expression, the arts of hope. This is where I think I fit in. If it's alongside a creek in the Rocky Mountains or in a skyscraper in Chicago or in a small town called Park City, Utah; it is always with me. Art will never leave me and never should. So, as I go into the next part of the trip I hope it will be more creative and more work involved and less talk and more doing, seeing, learning, being, feeling, loving, maybe less feeling, and just work my ass off cause that, my friend, is where it's at!

"The Next Part of the Trip"

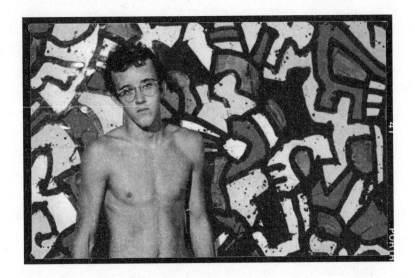

Soon *after their* sudden return to Pittsburgh—broke, briefly on welfare—Keith and Suzy arranged to spend a month or so in the fall of 1977 at the Mattress Factory, a visionary arts center in an abandoned mattress factory in the Mexican War Streets neighborhood. It was a steep staircase of a walk down from Perrysville Avenue, where they were staying. Founded by the sculptor Barbara Luderowski, the Mattress Factory would go on to become an important international

art museum for installation art, including permanent works by Yayoi Kusama, Greer Lankton, and James Turrell. At the time, Luderowski had just received nonprofit status and was solely conceiving of a living space for artists as well as a theater company and a food co-op. The empty shell of a building was cavernous, full of plaster dust, with long, echoing hallways and one freight elevator. From its upper floors, you could see junkies shooting up on nearby rooftops.

"We did live at the Mattress Factory right when Barbara opened it," Susan Maskarinec confirms. "She let people work there, pay some rent to use the space, but Keith talked her into working there for free, because he had no money ever. He was very good at that. It was just a bare-bones space. We were staying there because we had no other place to stay. We were sleeping on the floor. He was trying to get Barbara to give him a show, but she did not." (In *Site Specific*, a documentary about the Mattress Factory, Luderowski later revealed, "Keith Haring came and unrolled a drawing. He didn't have a space big enough to roll out and draw. Boy, do I wish I had a piece of that now.") Keith's friends from Ivy mostly remember visiting them at dinnertime, as the food co-op downstairs served vegetarian suppers with brown rice each evening at five thirty for two dollars a meal. "The girls always have to remind me that it was called Mattress Factory, not Spaghetti Factory," says Julie Sullivan Brace. "My memory is of group spaghetti nights where artists would get together to eat food and hang out. It was a funky place."

After the Mattress Factory, Keith and Suzy found a modest apartment at 328 Atwood Street, in the Oakland section of Pittsburgh. Taking up the front half of the second floor—above Cornucopia, a natural foods restaurant, where Suzy worked making sandwiches early in the morning for distribution to GNC stores—the apartment was small and smelly, if charmingly ramshackle. They liked to give parties, putting out kegs on the roof of the building next door. When Julie Sullivan opened an invitation to one of these parties, out fell a shower of one-inch cut-out paper hearts in different colors. Keith's serigraphs (silk screen prints) were scattered around the apartment, but he did not have a studio, as he kept using a Mattress Factory studio vacated by an environmental artist who taught in Florence that fall and into the spring of 1978. The

great plus of the new apartment was its location in a student neighborhood close to the campuses of both the University of Pittsburgh and Carnegie Mellon University. "Oakland was cool, with a free clinic we used, and a food co-op," Julie Sullivan Brace remembers. "Pittsburgh had these little pockets of hipness." Still unemployed that September, Keith volunteered his services as an art teacher at the Youth Learning Center, an alternative academic high school that was located nearby in West Oakland.

Keith finally found a job that fall that allowed him to go off welfare and food stamps—as an assistant cook in the cafeteria of Fisher Scientific, a chemicals company on Forbes and Fifth Avenues. (He also fit in a gig frying chicken and fish in a Woolworth basement at the Diamond Market.) He was not skilled labor and had no desire to use his graphic skills commercially, so he was fine with the basic work, rising each morning at five to take a bus downtown. His duties were not taxing, and he spent a good amount of time idling in a gallery and conference room decorated with murals, prints, and sayings devoted to the alchemists, early medieval scientists whose quest to turn base metals into gold was also magical and spiritual. "The air was full of excitement," Keith wrote in his notebook, ever ready to soak up new ideas. "All of the paintings contained a feeling of mystery with confidence." His favorite learning aid was a typed index card reading "'Chance favors the prepared mind,' Louis Pasteur," an aphorism he would repeat numerous times in interviews in the decade to come. He divined just such a chance for a prepared mind when he was invited by his boss to put up a show of his small drawings on a large cafeteria wall. The menu that month bore the announcement "Keith Haring, Lithography, Ink and Other Media—opening Tuesday, December 13, 1977." And typed at the bottom: "Keith is employed in our cafeteria." It was his first show.

As Keith turned his day job into an exploration of alchemy, he used much of his free time to take advantage of the many resources for learning within a one-mile radius of his apartment. "From the time I got back from California, I was on this mission to educate myself," he said. "Because I was more or less living on the campus of Carnegie Mellon University and the University of Pittsburgh, I was behaving as if I was a

student there." He hung out at the student center, frequented the librar-
ies, and, when instructors allowed, sat in on life-drawing classes. One
curiosity led to another, and he soon found his way into the Carnegie
Library, to the text of a speech, given in 1951 at the Arts Club of Chi-
cago, by French artist Jean Dubuffet on "Anticultural Positions." Haring
was already communing with Dubuffet's large-scale motorized painted
construction in the lobby of the contemporary wing of the Carnegie Art
Museum: *Free Exchange* (1973–74) was very much in the style of the art-
ist's cycle of *Hourloupe* drawings, interlaced biomorphic bold red and
blue shapes outlined in black and replicating at a rapid pace. "It was
at the bottom of the main staircase, and Keith would go there just to
hang out with that piece," Kimberly Kradel recalls. "I was more into the
Impressionists, so I left him there. He really studied that work." Haring
would later downplay the influence, saying he found in it resonance with
work he was already making. Kermit Oswald says Keith's response was
mostly to Dubuffet's palette: "I think he loved black and red as much as
he loved any individual work." Yet Haring never denied the influence
of Dubuffet's words and ideas, especially in "Anticultural Positions," a
forceful statement of the artist's antipathy to Western culture and its
elite, arbitrary notions of beauty and of his fondness for works primi-
tive, juvenile, or insane. Three years later, Haring would include a block
of typed text cut out from "Anticultural Positions" on an invitation to
a Club 57 show of *Anonymous Art*: "For myself, I aim for an art which
would be in immediate connection with daily life, an art which would
start from our daily life and which would be a very direct and very sin-
cere expression of our real life and real moods."

Haring wrote in his journal in 1986 that Dubuffet's speech and Hen-
ri's *The Art Spirit* were "the literary references of my philosophy," both
discovered during this reflective phase in Pittsburgh. Discovered, too,
in this period were the artists—some of them new to him—who were
the visual references behind his emerging works. He was enamored of
the "idea and the attitude" of the drip paintings of Jackson Pollock,
relying as they did on the intentional splattering of paint onto canvases
placed on the ground and approached from all sides to create an all-
over dynamic. And he "even and especially" admired Pollock's earlier

paintings, "the really abstract expressionist ones with these kinds of shapes." An idea he pulled from Dubuffet was of Western culture as "a coat which doesn't fit him anymore" and sympathy for the influences of Eastern art, especially calligraphy, in which drawing is a kind of writing and writing a kind of drawing. He responded to qualities he felt to be Eastern thought made visible in the works of Paul Klee and Alfonso Ossorio, and in the "Meditation Art" of Mark Tobey. "I started to be affected by this whole connection to the East I had seen in these other artists' work," Haring said. "I was starting to see how my things fit in, though, at that point, in a way that was respectfully distanced." All these artists, except Ossorio, were represented in the permanent collections of the Carnegie Museum.

An artist he had not yet come across and who was mostly unknown to him was Pierre Alechinsky, a Belgian painter at the center of the CoBrA movement in Europe—a group akin to the abstract expressionists, yet with more figuration and more interest in the aesthetic dimension of graphics and comic strips. This gap in Haring's art education was radically filled in October 1977, when an enormous retrospective of more than two hundred paintings and drawings tracing Alechinsky's career opened at the Carnegie Museum of Art. Alechinsky was the sole artist chosen to be represented that year in the prestigious Pittsburgh International Series Exhibition (known as the Prix Carnegie in Europe). "He and I and Eric Mendlow went to that show together," Susan Maskarinec remembers. "Somehow we got free tickets for the opening; Keith could be very persuasive." All the important members of the Pittsburgh art scene were there, yet Keith's attention was entirely focused on the work on the walls, which caused him to feel transported and validated, at a pitch extreme even for him. "He came to my place immediately after he saw that show," Kimberly Kradel says. "He was out of his skin, and so excited. I was sitting in a chair, drinking tea. He paced back and forth. He was so animated and full of energy when he left that he went to somebody else's house and did the same thing. He couldn't stop talking about it!"

The Alechinsky survey was up for ten weeks, and Keith's zeal for learning rarely let up. "I went to that exhibition I don't know *how* many

times," Haring said, as was attested to by several of his Pittsburgh friends who went with him. He bought the substantial accompanying catalog and read all Alechinsky's essays. He watched the videos included in the exhibition documenting the painter lying on top of planks of wood to get into the middle of large works he was making flat on the floor with ink on paper. Emulating Alechinsky, Haring bought cheap rolls of paper from printing plants and much bigger brushes for applying ink. Obvious to him was Alechinsky's "Eastern connection," as Keith termed it, with the other artists he was admiring; Alechinsky had even shot a film on Japanese calligraphy in Tokyo and Kyoto in 1955. Keith warmed, as well, to the affinity with children's drawings. As art critic John Gruen wrote in a piece in *ARTNews* that year, Alechinsky was like "a man who, at last, grew up to be a child." Yet Keith's excitement was mostly in seeing traces of his own work in this mature artist achieving renown for his intense swipes of brushwork, clotted-ink outlines, livid colors, and teasing rebuses of emerging faces or figures.

"I couldn't believe that work!" said Haring.

It was so close to what I was doing! Much closer than Dubuffet. It was the closest thing I had ever seen to what I was doing with these self-generative little shapes. Well, suddenly I had a rush of confidence. Here was this guy, doing what I was doing, but on a huge scale, and done in the kind of calligraphy I was working with, and there were frames that went back to cartooning—to the whole sequence of cartoons, but done in a totally free and expressive way, which was totally about chance, totally about intuition, totally about spontaneity—and letting the drips in and showing the brush—but big! And this huge obsession with ink and a brush! And an obsession with paper! And all those things were totally, but totally in the direction I was heading!

Haring also claimed that seeing the Alechinsky exhibition "was one of the things that helped push me out of Pittsburgh and take the final step of coming to New York." If so, the response had been swift, as he was in New York City for an admissions interview at the School of Visual

Arts, or SVA, by Halloween 1977, just three days after the Alechinsky opening.

By early 1978, Keith was working at the Pittsburgh Arts and Crafts Center, in a job that fit his broader ambitions better than Fisher Scientific, though his actual day-to-day chores remained menial. He had found the position at the center, later renamed the Pittsburgh Center for the Arts, in a bucolic section of the Shadyside neighborhood of Pittsburgh, a twenty-minute bike ride from his apartment in Oakland, through CETA, a Comprehensive Employment and Training Act program for youth. Housed in a seventeenth-century-style Carolean mansion built in 1912 by the president of Bethlehem Steel, Arts and Crafts was the main venue for local artists to show outside the museum; it also offered art and ballet classes and children's programs. "It was *the* buzzing place," Pittsburgh artist Kathleen Zimbicki recalls. "It was everybody's mother house. All the gilt belonged to it. It was a special hangout for everybody." Keith's job was custodial and included painting the outside of the building and doing roof work and repairs. He took advantage of its many workshops to study printmaking and to create new lithographs and etchings.

Keith's supervisor, an older man named Rom, and the group of young men in his maintenance crew came to figure rather importantly in his development. Keith had been dragging cardboard tubes, leftover pieces of foam cuttings, and big sheets of factory paper from a recycling center, along with tempera paint sticks, back to the Arts and Crafts Center, and during time off or lunch breaks, he would paint on the floor—including using drips, Alechinsky's style. "They didn't have the fluidity of his abstract line," Haring said of his own work, stressing their differences. "Mine had a boxy edge to the line—a sort of constrained look but still liberated." Rom watched his employee working relentlessly and invited him to use a large room in the basement. "You can do your big stuff here," he said. Keith felt, as well, that he was gaining access to bigger worlds simply by working alongside the mostly Black crew from racially

segregated neighborhoods in Pittsburgh. "I was working very intimately with maybe five or six of these Black guys, and I realized I felt sexually drawn to some of them," he explained. "With others, it was a camaraderie sort of thing . . . I was being exposed to a whole other culture, which was completely different from the sixties, the leftover hippie thing that I was still living out."

One day on his way to work, Keith stopped at a McDonald's and spotted on the floor a strip of notebook paper with "GOD IS A DOG" written in all caps on one side and, as he picked the piece of paper up and turned it over, on the other side, "JESUS IS A MONKEY." The hard-edged, confrontational, yet entirely whimsical note, randomly discovered, became one of Keith's triggers, and he treated it the way he had the Henri book, as if it were an intentional message. He responded to its attitude of daring and filed it away in his rapidly accumulating mind as exhibiting the telltale signs of punk, the anarchic movement in music and culture he was just beginning to hear more about in the news as it was cresting in London, New York, and L.A. Keith had been feeling decidedly unhip around his fellow workers on the maintenance crew and the music they listened to. "As a white boy I was not necessarily wanting to be funky, just more up to date," he said. He decided punk was his ticket. He cut his hair very short and went shopping in record stores for discs to accompany his new lifestyle. Soon blaring from the stereo on Atwood Street was "Mongoloid," a single released in 1977 by Devo, an art punk band with a purposely robotic sound, coming out of Ohio. If Keith had been a half generation behind in his embrace of peace, love, and the Grateful Dead, he was right on time with his response to punk.

Just as pressing was his coming to terms with his sexuality. He clearly knew that he had a strong attraction to other men as well as to the steadily visible—and audible, in disco music—gay lifestyle he had first observed timidly in the Castro in San Francisco. The gay scene in Pittsburgh in 1978 was lively, if cautious, mixing the festive with the furtive, in its handful of gay bars and cruising parks in Oakland and along a strip downtown around Liberty Avenue. Nearly comically, Keith made coming out into a project, an item on a to-do list. He and Suzy were no longer inseparable, and they were becoming more roommates than

lovers. One night, he pushed himself to go to a gay bar he might easily have found in a listing in *Gay Life*, the Pittsburgh gay newspaper. "I went to this bar and just waited until somebody came up to me and asked me to go home with him," said Haring. "And I *went* home with him. At the time, it didn't matter to me what he looked like—at that point, I would have gone home with anyone." As he later admitted in an interview in *Columbia Art Review*, "The first time I tried it, I didn't even really like it. Then a few more times, and I started finding people that were nicer and more my age."

He was a quick study in Pittsburgh gay life and soon developed a routine. The first bar he began going to regularly was Holiday, the only gay bar near campus, housed in a windowless and unmarked box of a building with a colored concrete façade. Holiday was used mostly by students, professors, and workers from the nearby hospital system, and in advertisements, it billed itself as "collegiate." Haring also learned the byways of the nearby Dithridge Street cruising area, which stretched from behind Carnegie Art Museum across several blocks onto the grounds of Pitt's Cathedral of Learning. "Like similar locations in other midsize American cities, Dithridge Street's night community existed precariously in the half light of the streetlamps," a local gay historian wrote. "Queer bashing on Dithridge always was a possibility, a risk." Keith also went to Schenley Park's Prospect Drive, better known as "the Fruit Loop." He would make this circuit on his bike returning from work until, eventually, he arrived at the dead-end lane where men of color cruised. "For me, cruising became more and more of a thing," Haring said. "You went through this thing of 'the look' and followed this or that person." From Holiday, he graduated to the downtown bar Venture Inn, owned by a drag queen, Vera Venture, who dressed as the Queen of England. At last, he found his favorite, the Tender Trap, a Black dance club in the basement of a piano bar. Inside this fire trap with a more fun-filled, urban spirit, Keith discovered his body as a dancer, moving to Donna Summer, Sylvester, and "Flashlight," by the popular funk band Parliament.

"The Tender Trap in particular is where I used to see Keith," says his Pittsburgh friend Tomé Cousin. "We met at the Holiday, and we

made out a few times, but seeing him on the dance floor at Tender Trap was where I thought, 'Oh, he's kind of hip.' It wasn't just like 'white folks.'" Cousin, who was attuned to Haring's special affinity for music and dance, had himself come from Baltimore, Maryland, to study dance at Point Park College, and he would go on to study at The Alvin Ailey School of American Dance in New York City and to teach dance at Carnegie Mellon University. "He was painfully awkward and innocent," Cousin says of Haring. "But if you were dancing with him, he was one of those people who had a bottom beat, which was unusual. A lot of guys put on a lot of attitude, but he had a bottom beat in him." By "bottom beat," he meant that Keith had natural rhythm. Keith went with Cousin as well to a dance class on Saturdays in Oakland that used the Katherine Dunham technique, a modern African dance form: "That school was racially mixed, but heavily Black, with children loving to move to the big drums."

While Keith was expanding his social life in Pittsburgh, his productivity as an artist expanded, too, and his work grew in scale and in the liberties that he was taking with style and brush. Alechinsky was a strong influence, yet so was the release of Haring's sexuality and his adventures in a gay social life defined at the time by the word *liberation*. His painting was also beginning to exhibit a "bottom beat" and to relax from the tightness of his more controlled abstract sketches. Impressed by the intensity of his employee's work, Rom brought Audrey Bethel, director of the Pittsburgh Arts and Crafts Center, to the basement studio, and she shared his enthusiasm. Keith had taken a class in lithography at the center with Martha Shepler, who wrote a strong recommendation to SVA: "Talent is a word I seldom use, but every now and then a student comes along with the extra ingredient, 'talent.' This I believe Keith to have as I have watched him learn, work, and grow." All this goodwill made possible the next step—an artist canceled a show scheduled for the end of June, and Audrey Bethel invited Keith to take his place. "So, I was having my first real show in one of the most coveted spaces in Pittsburgh," Haring explained, accurately. "Besides the museum, it was the most important place to show."

The deadline for the show caused him to work even harder, as he was

painting simultaneously at the Mattress Factory and in situ at the Arts and Crafts Center. The first week in June, at the Mattress Factory, he applied acrylics to a long scroll of slick industrial matte paper to create *Everybody Knows Where Meat Comes From, It Comes from the Store*— a dense, optically vibrating synthesis of a jigsaw of abstract shapes rendered in Dubuffet reds and blacks and covered in splatters of drip marks. Tall (over twenty feet high) and narrow (three feet wide), the piece would become a dominating presence in the show. Most of the rest of the pieces were created at the arts center, where Corliss Cavalieri dropped by one day as Keith was working on large brown-paper drawings. "He definitely was busy and didn't have time to talk," Cavalieri recalls. "When Keith wanted to hang and be casual, he was on. But when he was working on something, and in his zone, that was hard to penetrate. He had a very intense work ethic."

All the work was done on paper, a practical choice, yet increasingly a passion of Haring's, as he was encouraged by Alechinsky's preference for paper over canvas, as revealed in the show. "Oil painting no longer holds the slightest temptation for me," Alechinsky wrote in his often-hilarious catalog essay "The Means at Hand," feigning horror at "the immaculate canvas—ready for conception—waiting white and sly on the easel, an instrument which resembles Guillotin's invention." After twenty years of "using the wrong material," Alechinsky had discovered his ideal medium: a simple sheet of the onion-skin paper used by tailors, called "cutting-out paper," which he would remount with glue to canvas. "Around this time, 1977, I had a real obsession with paper," Haring said. "As I started to expand to do bigger things, I had this real aversion to canvas. I didn't want to do things on canvas. I wanted to work on paper, partly because paper was inexpensive, but partly because it was interesting." According to Kermit Oswald, Keith's sure sense of line and composition on these large industrial sheets owed much to "the ten thousand drawings he had been doing on little postcard-size pieces of paper before he left home. The ones in Pittsburgh were huge compared to what he had been doing his whole life."

Keith took a break on a Friday evening two weeks before his opening to attend a lecture given by Christo at the Carnegie Museum of

Art Theater. The talk was followed by a screening of *Running Fence*, a documentary on the artist's work by the Maysles brothers, with Albert Maysles in the audience. This exposure to Christo and to his contested project of running an eighteen-foot-high fence of billowing white nylon fabric held up by steel poles, like a sinuous string of lightness, across twenty-five miles of rolling Northern California ranchland, was an important final lesson in Haring's self-taught studies in contemporary art in Pittsburgh. The film made much of the resistance to the fence by angry local ranchers, yet Keith was struck more by the work's embrace by others—the homemaker who compared the artist's care in creating his project to the joy she took in cooking, or the farmer in overalls who woke up early to watch a sunrise reflected on the fence. "I can trace a lot of my serious interest in the philosophical and theoretical idea of public art and the intervention of an artist into the public and into real events to that evening," said Haring, who wished to engage the public yet "didn't have any idea how."

Long after the announcement cards were mailed and the flyers (illustrated with one of his ziggurats of geometric shapes and signs) were posted, Keith worked with manic focus up until the last moment to create his show. He had been awarded a fine venue, the Clifford Gallery, two adjoining rooms on the second floor, reached by a grand staircase that led up from the entrance foyer. In the smaller of the rooms, he mounted about thirty black-and-white Rapidograph drawings from his dismantled sketchbook that dealt with positive and negative space— some just completed recently in Laundromats on Atwood Street. The second room—in flux until the evening of the opening—was devoted to large paintings and a paper construction. On the same scale as *Everybody Knows Where Meat Comes From* was a painting seven feet tall by fifteen feet long displayed beneath ceiling spotlights that was very much in the Alechinsky-meets-Dubuffet manner and considered, by Keith, his best to date—he outlined shapes in sumi ink and filled them to create red, yellow, and green cells of solid color. Pieces of butcher paper hung from the ceiling, painted in calligraphic designs that were ripped, splattered, or held together with pins, creating a small room. "You *would* be the one to get lost," Keith joked to his friend Eric Mend-

low, who stopped by the day before and could not find his way out of the maze.

The preview viewing on June 30, from six to nine, was lively and well attended. The art crowd of Pittsburgh turned out. "He was a young rising star, which was exciting," Kathleen Zimbicki remembers. "The work was not the creeping babies. That, I guess, came later. It was abstract-y." Keith was able to add to the mix friends he had met in Pittsburgh, at Ivy, in drawing classes at Carnegie Mellon, or in lithography classes at the center, as well as some of his new friends, gentlemen at midnight, from the gay bars. Suzy's mother supplied wine and food for the reception—an artist who graduated from Carnegie Tech, she and Keith had grown close, even though his widening social circle did not always include her daughter. His girlfriends from Perrysville Avenue showed up, too. "I remember us all going to that show," says Julie Sullivan Brace. "We had been to other openings there, but they were smaller events. This was probably the biggest one. There were a lot of people all dressed in black." In the mood of Keith Haring openings to come were the supporters who showed up from the Tender Trap and Venture Inn, including two trans friends, Diana and Candi, in subtle rather than flamboyant dress. "That was such a clean environment, and he had drag queens in there," Tomé Cousin says. "There was a lot of weird culture there. It wasn't like a party or anything, but people came to see art for the first time. There were Black people in that place, and gay men in particular, who had never been in that building before. It was an open space with a lot of white walls and bright lights. So, you were exposed. Keith didn't suit up. He wasn't a street homeboy, but in between."

Family and friends from Kutztown made the trip. Keith's parents and two of his sisters, Karen and Kristen, drove out; family photographs show both sisters smiling, in summery shorts and sandals, with Kristen, as she says, "goofy, acting like Vanna White pointing to the drawings." "It was the kind of art that we didn't understand would be appreciated by anybody," Allen Haring admits. "For the longest time, we felt that way about his art. It was impressive that he got to hang it there." Also driving from Kutztown was Kermit Oswald, who brought with him a fellow art student studying at the college, Drew Straub, and two girlfriends

of theirs. Oswald filmed the entire road trip and bits of the show in Super 8. When he went upstairs and saw looming *Everybody Knows Where Meat Comes From*, he remembers thinking to himself, "All right. Now he's getting a little clever here." The show was not a commercial success. Only two drawings sold, both for under a hundred dollars. The work was stored in the arts center basement after the show and mostly disappeared, including the untitled large painting. "A lot was done with cheap paint and paint brush on butcher paper," Susan Maskarinec explains. "When it got rolled up, the paint cracked off. Some probably just got pitched." Yet Keith was pleased, and everyone was proud. "It was all very close to Pierre Alechinsky, but you could see the seeds of everything that would come later," Haring said. "I consider this my first really important show. And I was only twenty."

By then Keith had been accepted to the School of Visual Arts for the fall 1978 semester, and his choice to move to New York City forced a decision with Suzy over their unresolved relationship, which was no longer satisfying to either of them. "When we came back from the West Coast, we both secretly started seeing other people while we were still living together," Maskarinec admits. "It was sad for both of us. But it was fine. It just happened. It was what it was." Haring characterized the cleaving apart as rougher, with fights and scenes of crying in the streets: "It was a really, really difficult and horrible breakup." Haring later told *Rolling Stone*, "She said she was pregnant. I was in the position of having to get married and be a father or making a break." Suzy absolutely denies this claim, saying, "I never was pregnant. I would tell you if I was. Why would I tell him that? I never said it." Following the success of his show, he was certain the only place for him to find the intensity and challenge he needed as an artist was New York City, and having come out of the closet, he wasn't about to go back in. "I remember our sharing a glass of wine on a bench outside the Arts and Crafts Center," Barbara Wohlin Clarke says. "He told me that he was gay. That he had left Suzy, had to go, and was packed and leaving town the next Tuesday. That was the last time we talked heart to heart."

By mid-August, Keith was gone from Pittsburgh. He rarely looked back. Later, he would like to play up that he was a small-town boy from

Kutztown and to take some of his more colorful New York friends there to enjoy the high contrast between what was and what had become. Yet, except for his one-man show and his infatuation with Alechinsky, he hardly ever mentioned Pittsburgh in magazine and broadcast interviews, as if those two years were a detour rather than a crossroads. The city of Pittsburgh has been complicit in this silence, as visits to the Mattress Factory, the Pittsburgh Center for the Arts, and the Carnegie Museum of Art turn up no mention (in captions, talks, or brochures) of a shared history. Yet Keith's sentimental education took place in Pittsburgh—no believer in accident, he would have needed to agree that he found his way to the dance floor of the Tender Trap at the right time and place. And his art education, too, went in directions that his fallow free time and menial jobs allowed him to take without prompts or clues. As art critic Robert Pincus-Witten has pointed out, Dubuffet was at the "nadir of his consequence" when Keith was under his spell, and Alechinsky had been rejected by conceptualists and minimalists alike for his "unrepentant expressionist bias." Within five years, their work would make sense once again in an art world Keith Haring helped to create. In the apt words of his Ivy friend Kimberly Kradel, Pittsburgh had been both Haring's "cocoon" and his "incubator."

CHAPTER 5

SVA

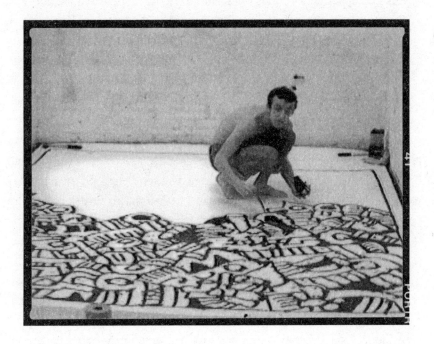

By *late August* 1978, when Keith Haring arrived in town, New York City was just recovering from a long, hot summer. Daily life had not been easy. Temperatures felt as if they had hit the one hundreds, and many window thermometers said so, though no one knew for sure, as the Central Park measuring equipment had been vandalized and not yet fixed. Policemen sweating in their blue uniforms were assigned to hydrant-closing duty because so many kids were flooding their

blocks with the welcome spray of gushing water—doubly so, as city beaches, a subway ride away, like Jacob Riis Park near the Rockaways, had been closed for overcrowding. Audiences for summer blockbusters were relegated to *Grease* or *Jaws 2*. A newspaper strike begun in mid-August lasted for three months, so no one needed to read about economic "stagflation," yet along with the papers had gone all the ads for jobs and apartment rentals. Magical interludes were available, but only if you were free to go out into the cool of the evening, and knew where to go, or were lucky enough to catch sight of the transvestite Rollerena, on skates, with wand, on her way to the opening of the discotheque Xenon, in Times Square; or, downtown, to be pressed into the squeeze box of CBGB the night the B-52's, from Athens, Georgia, debuted "Rock Lobster," the lead singer Fred Schneider giving at least the illusion of a breeze in his chino slacks and Hawaiian shirt.

Knowing no one in the city except a high school friend's aunt he had no intention of contacting, Keith had no weekend plans on the Saturday afternoon he showed up. Again, as in Pittsburgh, his father drove him and his boxes to town and, again, left him off at a YMCA, this time the McBurney Branch on West Twenty-Third Street near Seventh Avenue, in Chelsea. The Y was on a list of residence halls provided by SVA, as the school was not residential. Also on the list was the Chelsea Hotel, directly across the street. Keith chose the cheaper Y, which charged forty dollars a week for one of its nearly two hundred single-room-occupancy residences spread over nine floors, with shared kitchen and bathroom facilities and a pass to the popular neighborhood gym on the lower floors. Allen Haring would come to feel that the drop-off was perhaps too abrupt. "I still have nightmares about that," he says. "I can't believe I did that. I parked the car in front of the YMCA, and he unloaded the couple boxes that he had. That's pretty bad, just dropping your son in New York City and not helping him to get set up." Keith did not appear to share these worries. He unpacked his cherished stereo first, then his few belongings, and he was finished.

On his first night in the city, Keith made his way ten blocks down Seventh Avenue to a small and easily missed neighborhood gay bar, Barbary Coast. After drinking a few beers without—as he said—"Meeting

anybody or anything," he returned to the Y to sleep. The next day was more eventful. He made his way to Christopher Street, in the West Village, as flamboyant a boulevard as the Castro he had witnessed in San Francisco. On parade that day were all the types copied by the Village People in "Y.M.C.A.," their dance single released that fall and inspired by the McBurney Y: the Biker, the Construction Worker, the Cowboy. The collective look of the jostling crowd was classically masculine, with beards and mustaches, flannel shirts, Levi's 501 jeans, leather jackets, boots, keys, and cowboy bandanas, an antidote to earlier stereotypes of homosexuals as lisping, limp-wristed, or fey. "It was like landing in a candy store or, better, a gay Disneyland," said Haring, rating the experience with one of his highest compliments. He then walked west on Christopher Street, crossed the West Side Highway beneath elevated train tracks, and on to the collapsing Hudson River Piers. It was the end of summer and still warm. The waterfront was full of men sunbathing nude or having sex in a twilit, barnlike structure on Pier 46 (the loose scene captured for posterity in haunting, gelatin silver photographs by Peter Hujar).

Keith met someone on the pier, and they went back to the apartment the young man shared with other gay men in the basement of a large, six-story residential building at 207 West Tenth Street, near Bleecker. Over the course of the evening, Keith's new acquaintance introduced him around, and after talking to the young man's landlord, "a wonderful old gay guy," Keith decided to move in. The next day, some buddies of his new "just-friends" roommate helped him to collect his belongings from the Y, where he had stayed less than forty-eight hours. He never allowed his family to visit this apartment, though he lived there for three or four months. Among the handful of friends invited inside was the painter Frank Holliday, whom Keith met early on at SVA. "To get into the apartment you had to go down some stairs on the side of the building into an alley," Holliday recalls. "There was a fountain outside. You'd go in, and there was this older guy who was like Fagin from *Oliver Twist*, with all these romantically lost gay boys around him, in lots of rooms. The guy sold pot, too. I remember going down there one night with Keith to buy some."

On the same Monday that he moved into his basement apartment, Keith started classes at the School of Visual Arts, located in two cleanly functional, contiguous buildings on East Twenty-Third Street, between Second and Third Avenues. The school was a half-hour walk from the West Village, a walk he would often make that fall, keeping his eyes trained, as in Pittsburgh, for tossed detritus he might use. Keith was excited by SVA both for its location in New York City and for its faculty. "It seemed like their faculty was good because they were working artists," he said in an interview in *Drawing* magazine. "It seemed like the right school." The cost worked for him, too, as the yearly tuition of $2,800 was basically covered. He had been surviving on his own, and any grants received were based on his income, not his parents', though they were willing to loan him money, as he was enrolled in a degree program. Helpful in this had been a pretty strong report from his admissions interview. The applicant was rated as "good" (one step below "excellent"), yet his interviewer noted "self-discipline—works on own a lot—original work—experiments with different supplies—geared toward printmaking—seems seriously involved."

As far as its physical plant and equipment, SVA was still rough. Though founded thirty years earlier (as the Cartoonists and Illustrators School) by Silas H. Rhodes, now its chairman of the board, it wasn't a fully accredited college until that fall semester of 1978. The more established New York City art schools of the time were Pratt and Parsons. Without any sort of formal campus, SVA was oriented toward the urban streets, with most students and teachers milling about on busy Twenty-Third Street or in the laxly guarded first-floor lobby. Upstairs in the main building were classrooms and, just as significantly, a popular lounge that Ron Barbagallo, a student at the same time as Haring, remembers as "very like the cantina in *Star Wars*." Blaring reliably from its New Wave–stocked jukebox would be "Red Hot" by Robert Gordon or percussive punk by the Clash or the Ramones, and scattered on the tables and chairs along with the *New York Times* or *ARTNews* were downtown papers such as the *Village Voice* and the gay publications *The Advocate*, *Blueboy*, and *Mandate*. Past a series of café booths was a stairwell that led steeply upward to where students smoked pot and took out thick

Magic Markers and tagged. "It was this private tower of graffiti and radical visual culture," Frank Holliday recalls.

As Haring recognized in his explanation of his choice of art school, the faculty was the true value, the draw of SVA. His instructor in Semiotics, Bill Beckley, colorfully described its corps of teachers as "all professional artists, writers, and poets who are happy for the discourse and happy for the extra funds to buy red paint and white wine, or the other way around. The SVA lives within the tradition of Black Mountain College in the thirties and forties, and the Kunstakademie Düsseldorf." The art world and its emerging movements were all represented in this intimate setting with about three hundred students in each graduating class. "SVA was considered at that time to be a 'hotbed' of conceptual art, which attracted many students interested in that particular approach," fellow student Charles Imbro recalls. Teaching Theory Art Workshop was Joseph Kosuth, a leading figure in the conceptual art movement. Even more of the moment was Performance Art, taught by Simone Forti. Although the school owned only a couple of video cams and portable light units, Keith Sonnier's course Interaction, on art and media, was popular. Elizabeth Murray was teaching Painting, and Haring's Fine Arts instructor, Lucio Pozzi, brought in the young painters Julian Schnabel and Ross Bleckner as guest lecturers. Tales were told of instructors smoking joints or having sex with students, yet such behavior was not unusual even at more academic institutions of the era.

Keith's first class that Monday was Drawing, taught by painter and sculptor Barbara Schwartz and meeting weekly from 9 a.m. to 3 p.m. in a studio on an upper floor of an annex building on lower Park Avenue. While he had been able to transfer some of his credits in Printmaking and Media Communications from Ivy, his first year was spent mostly in such required foundation courses as Drawing, Painting, Sculpture, Literature, and Art History. Schwartz was personable, bright, and well dressed, a fast thinker always on the lookout for students she felt were highly motivated. That first morning, she brought in boards, pencils, and paper and told the class to choose someone to draw. "I was very shy indeed, and from the other side of the classroom this guy came toward me with a fold-up chair and sat opposite me and said, 'Hi, I'm Keith.

Can I draw you?'" recalls Samantha McEwen, daughter of Scottish artist Rory McEwen. "I don't know why he wanted to draw me. I think I was wearing very different clothes from everyone else in the class. I was from London, and I was wearing secondhand vintage clothes, and I had long hair. The rest of the class was quite from high school, I think, very American. I'd barely ever seen a puffer jacket." The resulting portrait was more abstract, like a Picasso profile, than either she or the instructor had expected. "I had been hoping he'd draw something really flattering," said McEwen.

Schwartz and her new pupil had a number of standoffs in those early days in September. As she might have learned from his Kutztown art teachers, Keith was not about to simply follow directions. When models were brought in to pose for figure drawing, he flatly refused to draw in a representational way. "Barbara made a general announcement to the class after seeing Keith's drawing, 'As much as I appreciate your personal interpretations, I would prefer it, for the moment, if you could draw what you actually see,'" Imbro, also a student in the class, recalls her saying. "Keith was having none of it. He told me in one conversation that he *couldn't* draw like that and he had no desire to learn." Keith's favorite perch was a window ledge, where he preferred to draw cityscapes: "He just wanted to sit on the ledge and be left alone to draw. I don't remember what floor, but high enough to kill you if you fell." One day, Barbara Schwartz made her way over to the ledge in a conciliatory gesture, as she came to appreciate his drive. "Just the two of us looking down at the busy street below," Schwartz wrote over twenty years later in a catalog essay for the show *Keith Haring: The SVA Years*, held at the school's museum: "He said he was unhappy with some of his classes and he didn't feel that most of his teachers took him seriously enough. Even though I had only known him for a few weeks, I felt there was something genuine and profound about him. So, I told him that I thought he was an artist—the sort of independent thinker that not everyone was going to recognize. What was important, I said, was not to be discouraged and not to worry too much about the pressure to conform." Rather than feeling exasperated by him, Schwartz came to look upon Haring as a "poetic lost soul."

Keith was clearly not conforming in his foundation class in Painting and Color, taught by Peter Heinemann, who had studied at Black Mountain College in North Carolina and was a perennial instructor at SVA. "We were supposed to be doing different exercises where he taught us how to use oils and make canvases and stretchers," Samantha McEwen says. "Then we would do paintings that were color exercises. I remember Keith over in the corner painting this super geometric picture. It was pale bright green, pale bright pink, and pale bright yellow, really not romantic at all, not muted, but super in-your-face colors. I remember either him or the teacher being cross, but Keith was not interested in painting like that. Maybe he had a tiff with the teacher." In a journal entry in October, Haring wrote of his mixed feelings about the class, channeling Alechinsky in spots: "I curse my painting class 24 hours a day except when I'm in class, and then it seems it might be valuable to my education in some way. But when I leave, I start cursing again . . . canvas and oil paint repulse me. I hate them more the more I use them."

He was troubled, too, by his foundation Sculpture course—enough that Barbara Schwartz tried to help: by now, she "got Keith, and started setting everything free for him," Frank Holliday says. (He and Keith first met when Holliday, attending a History of Dance class across from Drawing and hearing a lot of noise, emerged from the classroom to find Keith hanging up repetitive film strips all the way down the hall as a class project.) "I suggested that he might like to join my foundation Sculpture class, which he did," Schwartz wrote. "He seemed especially happy working there because the space was big, and his work could expand to fill it." Her class met in a former warehouse on East Twenty-Second Street that included an area opened onto the street, with garage doors rolled up to allow work to be done inside and out. On his way back to the West Village after school one day, Keith discovered in the Flatiron (aka "photo") district huge rolls of discarded nine-foot-long photographic backdrop paper that amazed him enough for him to drag it back to the studio. In the next weeks, working near the doors to take advantage of sunlight pouring in, he painted in ink a series of large floor pieces in his most liberated Alechinsky style, while absorbing the random comments of passersby. "The kids and the winos would wander in

and look at them and talk to me," Haring later told the *New York Post*. More thoughtfully in his journal, he assessed the importance of this experience building on his excitement from the Christo screening a few months earlier: "They were not, for the most part, gallery-goers and not people who generally frequent MOMA, but they were interested. There is an audience that is being ignored, but they are not necessarily ignorant. They are open to art when it is open to them."

Haring quickly adopted and adapted the various innovative movements and styles of the art world to which he was being exposed at SVA. Within weeks of his arrival, he filmed his first video, *Painting Myself into a Corner*, which was not only a video but also a painting and a performance piece and was graced with a title that was at once witty and literal, a metaphor for his feeling the limitations not only of painting but perhaps of a particular *style* of painting, A lithe, shirtless, bespectacled Haring performed his video action painting to a frontal camera set up to record, on black-and-white half-inch tape, him first mapping out a black border on the white floor and then drawing a frenetic labyrinth in reverse, painting his way out of it until he came to sit hunched in the only space remaining, the corner, waiting for the twenty-minute tape to run out. He laid over the visual an audio track of the New Wave numbers "Uncontrollable Urge" and "Shrivel Up," from Devo's debut album, *Q: Are We Not Men? A: We Are Devo!*, newly released in August. The video invites comparisons to Hans Namuth's famous footage of Pollock painting, though Haring's version is a self-portrait and, choreographed to synth pop, more an artist's music video.

Also enrolled in Barbara Schwartz's Sculpture course that semester was Kenny Scharf, another twenty-year-old first-year student. Looking like a long-haired surfer, he had just arrived from Southern California, where he, too, had been a self-styled hippie and where he, too, had grown up infatuated by the bright colors and zany storylines of sixties Hanna-Barbera TV cartoons as well as by the futurism of space-age dreams of intergalactic travel and extraterrestrial beings—the stuff of the *Star Trek* TV series. The two young artists were aware of each other and of each other's work before they met. Keith had already spotted Kenny in the sculpture studio using a hot glue gun to stick together pieces of broken

television sets and electronic tubes. "So, there was Kenny—this nut—gluing all these things," Haring recalled. Scharf—who had been born in the San Fernando Valley, graduated from Beverly Hills High School, and gone on to study art history, printmaking, and painting for two years at the University of California at Santa Barbara—was feeling let down by the suburban tenor of the students at SVA: "My first impression was that it was a lot of kids from Long Island. They looked the same to me as the kids in the Valley in L.A." Then, one day, he heard loud music coming from down the hall and, when he went to investigate, happened upon Keith filming *Painting Myself into a Corner*: "I stopped and stared, and I instantly knew that I had found someone who I was looking for."

Much as Keith and Kermit had bonded in high school, Keith and Kenny became art pals. "For whatever reason, we instantly hit it off," Haring said. "Later that day," Scharf confirmed, "Keith helped me drag ten or twenty discarded television sets from Seventh Avenue all the way to class . . . The image of the two of us using a rope and literally dragging all those TV sets across town embodies the spirit of our times together. We would do anything for each other in the name of Art." Observing the two friends in class during that first year, Barbara Schwartz enjoyed their synergy while also viewing them—again, similar to Keith with Kermit Oswald—as a study in contrasts. "I would say that Kenny Scharf was always more ambitious than Keith," Schwartz said. "Kenny had his mind on a career. Keith was more of a primitive. Kenny had a more conscious desire to succeed. But they were both adorable in class—very endearing. They were good energy to have around. I think that what Keith got out of the School of Visual Arts was a sense of community—a sense of other people who participated in a like way. Keith always loved interaction."

By day an art student, Keith, by night, became a tireless West Village gay guy. The neighborhood was at its most intense in 1978 as a libidinous playground for young men who had come from somewhere else to find adventure, release, friendship, or perhaps even love. "Everything was very exciting at the beginning—the apartment, living in the Village, and going to school," Haring said. "And the whole gay thing was everywhere. I mean, it was almost too much. You couldn't go to the post

office without cruising or being cruised—without being totally aware of sex. So, I fell into this whole thing very easily . . . In the beginning this was all strange to me, but ultimately it became a way of life—and it lasted for a long time, certainly for the first several years in New York. It just became part of a nightly routine." He would begin his evenings by going to the Ninth Circle, just two blocks from his apartment, and then on to International Stud, a backroom bar with porn movies playing and lots of groping and anonymous sex, the setting for the first of Harvey Fierstein's plays in *Torch Song Trilogy*. With him often would be Frank Holliday, who found their exploring in the West Village scene spirited, if somewhat forced: "Keith and I didn't fit into the seventies, macho gay thing. We weren't like hardcore punk rockers, either. We were these gay art boys who didn't even fit into the art world."

Keith soon found a way to wed his nighttime cruising and his daytime ambitions: he began drawing penises, obsessively. One day, Barbara Schwartz gave as an assignment, "Choose a subject and develop it," to get her students to keep notebooks. Keith chose as his subject the penis and developed it fully by creating a notebook on a single Saturday— November 19, 1978—filled with seventy different takes on the penis and titled *Manhattan Penis Drawings for Ken Hicks*. (Schwartz later remembered three hundred penis drawings, perhaps the sort of exaggeration that occurs around the erotic.) This drawing version of the Wallace Stevens poem "Thirteen Ways of Looking at a Blackbird" cleverly jumps from a fire hydrant penis; to barely discernible minimal penises; to a Paul Klee–like study of penises and triangles; to phallic buildings, phallic doors, and a phallic church window; to a series of self-portraits of his own penis, "actual size" and "erect," in different proportions. These variations on a theme also constitute a map of his Saturday, as he titled drawings done on "Subway Car" that make their way downtown from "Central Park" to "'Horse Dick'—C. Park. S."; to "Drawing Penises in Front of Tiffanys"; to "Gucci Penis"; to a half-dozen versions of "Drawing Penises in Front of the Museum of Modern Art"; to winding up at the Hudson River Pier, "The Best Place to Draw Penises"; and finally home, with the constructivist, angular penises of "207 W. 10th St. (Steps)."

Haring's theme of the penis did not end with Schwartz's classroom

assignment. Within the year, he made a work for Kenny Scharf that was a half-blank sheet of graph paper with the other half filled in with tiny penises. "Like millions of them," Scharf said. "And becoming at two inches away just a solid mass of texture." Keith created a mail piece for Kermit Oswald, a single penis drawn in red ink, crayon, and wax and covered with semen-like Liquitex acrylic, on a sheet of forty detachable postcards he then mailed, one by one, to Kermit to reassemble. He made a large work on black paper with more realized penises with small pink glandes. Another friend remembers penises drawn in an overall pattern that "ended up looking like butterflies." As at other key moments in his life, Keith was approaching "coming out" as a visual exercise. "All those little abstract shapes I was doing became completely phallic," he later said. "It was a way of asserting my sexuality and forcing other people to deal with it." Radiant or winged, weaponized or dressed in blonde wigs, the penis would remain a motif in Haring's work, though not in his subway works or most murals, as he was sensitive to children possibly viewing them.

The titles in Haring's *Manhattan Penis Drawings* series reveal a young artist who not only "spent 90 percent of my time being totally obsessed with sex and that became the subject of my work," but who also continued his self-education in art by seeing every show everywhere. New York City was a "candy store" not simply of gay liberation but also of contemporary art. Haring was drawing multiplying penises sitting in front of MoMA—a gesture one critic later described as "radical acts against the establishment"—but he was also often inside the institution. A month earlier, he had carried on an animated discussion there with Kermit Oswald about whether silicon computer chips were a new life-form. And number twenty in the penis series was titled "Max Protetch Gallery," referring to a contemporary art gallery on West Fifty-Seventh Street, caricatured by a penis framed on a gallery wall. His entire fall was taken up seeing shows in museums and galleries, though he admitted to himself, visiting SoHo, "I start to look at the gallery spaces as spaces for my art instead of looking at the art being shown." Most profound for him was a retrospective of the paintings of Mark Rothko that opened at the Guggenheim Museum in November. "I feel enlightened," Haring wrote

in his journal. Rothko's work, he wrote, "represents a commitment to an idea that he pursues to its fullest extent. It proves once again that there can be an infinite number of variations on any given idea. There is no end to possibilities." He was also seeing exhibitions by artists new to him, such as Vito Acconci and Robert Morris.

Haring's own work at SVA in the fall of 1978 was all pulled from video art, performance art, or installation art, rather than simply drawing or painting. Following on *Painting Myself into a Corner*, he made another "video painting," recording himself rendering his hieroglyphs in quick strokes, encircling the stool of a young man reading from Gertrude Stein's *A Circular Play*. He also documented, in the video *Two-Handed White to Black*, a painting he made with two three-foot-long brushes while dancing until his feet and hands were covered in ink. "I was performing as much as I was painting," Haring said. In late November, he created *Painted Environment* in the SVA Student Gallery. Viewing this work as the "third generation" of installations made in the basement and at his show at the Pittsburgh Arts and Crafts Center, he covered the walls and floor with immersive painting and hung ripped drawings from the ceiling with metallic red tape. Finally, Drew Straub—Kermit's friend from Kutztown State College—videotaped him squirting white latex from squeeze bottles over the entire construct. "I was like, *Wow*," remembers artist Rodney Alan Greenblat. "The abandonment and joy were more inspiring than most of my teachers."

Within just a few months, Haring was impossible to ignore at SVA. He not only had plastered any blank space with photocopies advertising his show in the SVA Gallery, but he had also hung his artwork everywhere, without asking anyone's permission—much as he had covered Kutztown as a teenager with One Way stickers and drawings. When he had classes in the Park Avenue annex with Barbara Schwartz, he would bring along drawings and hang them in the hallways. One time, they were torn down, and he simply hung the torn pieces back up. "I remember a lot of students were getting upset and saying, 'Oh, he's just a self-promoter,'" Kenny Scharf says. "He was doing stuff constantly, and they were waiting for someone to ask *them* to do something. Keith didn't need permission. That was what was so great about him." Sa-

mantha McEwen, who was at SVA for only nine months, affirmed this: "Keith seemed to have a big problem with staying within the confines of his classes," she said. "You couldn't open a broom closet that he hadn't painted or transformed. You couldn't walk down some passage that he hadn't employed for some video location. I mean it was completely out of control. Nobody knew what to do with Keith Haring!"

The signal cultural event of his first semester did not occur in a classroom or gallery but at Entermedia Theater, on lower Second Avenue, where he and Drew Straub chanced upon the Nova Convention, while *Painted Environment* was still up at SVA. "We just stumbled into the theater while walking down the street," Haring said. The three-day postmodern festival of writers, poets, musicians, and performers was in honor of William Burroughs, the sixty-four-year-old author of *Naked Lunch* and the just-published *The Third Mind*, coauthored with the artist Brion Gysin. Labeled in popular journalism as "the granddaddy of punk," Burroughs was introduced that evening by novelist Terry Southern as "perhaps the most influential writer of our time, grand, groovy, and beloved," and described backstage by singer Patti Smith as "up there with the Pope, you can't revere him enough." The mood in the hall was closer to a rock concert than a poetry reading, and the musical acts—Frank Zappa, the B-52's, Laurie Anderson—were enthusiastically received. Yet the high point was Burroughs, dressed in his anonymous business suit and green velour trilby hat, seated at a teacher's desk and reading with a purposely flat affect. "The Nova Convention proved to be a turning point," said Haring, struck by Burroughs's use of random language cut up into strips and rearranged by chance. "We both started reading Burroughs non-stop." Drew Straub said. "And writing, ripping things up, and putting them back together." They also moved together into an apartment in the neighborhood of the Nova Convention: the East Village.

If New York City was distressed and fiscally anemic in late 1978, the East Village was one of its more graphically bombed-out neighborhoods, increasingly so when one walked eastward from the Bowery and Third

Avenue below Fourteenth Street and above Houston toward the "Alphabet City" of Avenues A, B, and C. (Some of the newer, artier residents began calling it "Alphaville," after Jean-Luc Godard's 1965 film set in a bleak, futuristic metropolis.) Once home to the social, political, and artistic experiments of the Yiddish Theater; to Emma Goldman and her circle of anarchists; and, later, to the bohemian poets, artists, and musicians of the mid- to late 1960s, the entire neighborhood, long run-down, had decayed more steeply in the early 1970s. Overcrowded tenements gave way to abandoned buildings, vacant lots, and a million-dollar drug trade. Keeping the blocks—once filled with Jewish immigrants—livable was a sizable Puerto Rican population who knew the Lower East Side as the more Spanglified "Loisada" and whose bodegas were the neighborhood grocery stores; and Eastern Europeans, with their social clubs, Eastern Orthodox churches, and diners (such as Veselka or Kiev) serving borscht and pierogies.

The silver lining in the ratty peacoat of the East Village was low rent. By the time Keith Haring moved there in the late 1970s, the neighborhood was filling with a new crowd of young people who were just fine with railroad flats with bathtubs in the kitchen, often no phone, and empty of furniture except for the tables, chairs, and even mattresses found curbside—as long as they could pursue their own brand of art. The poet James Schuyler once described the art scene of fifties New York as "a painter's world: writers and musicians are in the boat, but they don't steer." The dominant art form in the East Village in the mid-seventies was New Wave music, and bands such as Television and the Talking Heads—especially the Talking Heads, as all its members had come from art school, the Rhode Island School of Design. "Storefronts lining the Bowery and the Lower East Side were plastered with posters for all the new bands," wrote critic and art dealer Jeffrey Deitch. "These posters were art works in themselves." Soon arrived the indie filmmakers—Amos Poe's *Unmade Beds* (1976) and Jim Jarmusch's *Permanent Vacation* (1980) endure as much for their vintage documentation of the emerging scene as for their New Wave narrative. And with them came painters, poets, and students (many from SVA) with a fashion sense lifted from thrift stores along St. Mark's Place and a garage band

aesthetic. "You could always tell who the cool people were because they wore all-black and pointy-toed shoes," said the performer Ann Magnuson, who also compared some of the bleaker of the Lower East Side's more "desolate" blocks to "London after the blitz."

"Nineteen seventy-eight was an incredibly fertile year to arrive in New York for several reasons," Haring explained. "The social scene, as far as the East Village, was starting to come to life, there were a lot of people coming to New York from all over the country again, and the East Village was starting to become something again—the thing that happened in the '60s had died out and the East Village during the '70s had become barren, and then for some reason people began to come back again and there was a whole scene starting. It was cheaper, but there were a lot of other things attracting people to New York again. At that time, it was mostly bands. Everyone was in a rock band." As Keith got his bearings, he realized that a cultural shift was occurring as much by neighborhood as by mentality or attitude. East versus West became a style war. As his fellow SVA student Kristoffer Haynes confesses, "I lived over in the West Village, which I didn't want anyone to know. Everybody frowned on the West Village, where all the gay clones lived. The real cool people lived in the East Village." Haring humorously betrayed his starter neighborhood in 1980, when he began his own sarcastic, insider's joke of a one-man organization, F.A.F.H., "Fags Against Facial Hair," and stenciled "Clones Go Home" in reddish powdered pigment on street corners.

The apartment he and Drew Straub secured for themselves was one of the standard railroad flats, in a brownstone tenement at 21 First Avenue, near First Street, where they split the $240-a-month rent that neither could afford on his own. The apartment had plywood floors painted red, a bedroom at the front claimed by Drew, and a small room in the back usually described as a "closet," where Keith began by spending his nights in a sleeping bag he needed to roll up in order to move around the space. "I had the bedroom," Straub says. "I'm just like that. Keith's not. It didn't matter to Keith where he was sleeping. It wasn't like he was ever there, unless he was doing drawing or something in the apartment." Keith livened up their shared kitchen by creating

a wallpaper design of flying penises. Resistant to decoration were the teeming cockroaches remembered by anyone who visited the place, and a toilet that would flush only when someone poured in a bucket of water. "You could cut off the crud on the floor of that apartment with a putty knife," Kermit Oswald says. "But Keith's room was very well organized. All his apartments were like that. He was meticulous. He wouldn't leave anything lying around."

The two new roommates were not temperamentally similar, as Drew was quick and caustic and liked a lot of witty repartee, while Keith came across as earnest and on the quiet side. "I don't like anything unless it's third degree," Straub says. "I don't want to see a play. I want to talk about the *review* of the play. Keith wasn't like that. Keith was very immediate. He wasn't very ironic." In town on an internship to the sculptor Ken Floeter, Drew created art that consisted of chalk drawings of circles on concrete sidewalks in front of galleries. He was also deeply into reading the French literary theorists Jacques Derrida and Roland Barthes. "He was a really brilliant kid, heavily into post-minimalism and post-conceptual art," as Haring later described him. With its inhabitants fresh off the Nova Convention, Apartment 18 became a laboratory for language art and performative living. Keith labeled himself a "terrorist poet" and dressed in a black beret and black clothes, while Drew dyed his hair bright blue and began wearing a yellow fluorescent raincoat. (The hair dye was from Manic Panic, a punk rock store recently opened on St. Marks's Place.) They subsisted on mushroom dill soup and bread from the Polish diner across the street.

Amid all the sharing of heady concepts about art, the two friends neglected to share anything with each other about their sexuality. In a gay remake of a French bedroom farce, this irreducible fact was soon revealed. Next to a Hispanic funeral parlor directly across the street was the Club Baths, the first openly gay-owned national chain of bathhouses, which Keith began frequenting: "The baths were literally just twenty steps from my front door." Despite its name, Club Baths was not a private club; anyone who could pay for a locker could belong. Keith preferred Buddy Night, on Mondays and Fridays, when you could meet someone in the line outside, say they were your buddy, and pay only half

of the five-dollar admission price. Inside, the fanciful managers soft-
ened the slam-bang setting by installing live palm trees, exotic flow-
ers, and cawing parrots, enhancing the narrow hallways lined by dim
rooms where men roamed about clad only in towels, hooking up at ran-
dom. Keith enjoyed the erasure of class distinctions in nakedness and
the unreality of the situation and was soon a regular. One night, he saw
his roommate, Drew, likewise wrapped in a towel, walking toward him.
"That was the surprise," Straub said. "We ran into each other at the Club
Baths, and we were like, 'Oh, hi!' But I was never involved with Keith
sexually. We were just friends."

During winter break from SVA, all Keith's art energy was focused on
his new apartment. Drew steadied himself whenever Keith put on the
B-52's single "Rock Lobster" while drawing at the kitchen table, as he
would let the disc replay for eight or ten hours nonstop. In his tiny bed-
room, Haring also produced an ambitious combination of painting and
Matisse-inspired paper cutouts—he wrote in his journal of the cutouts
that "They are also derivative of Drew's work with chalk and tar paper
'squares.'" He liked the interplay of his walls, covered with sheets of
plastic—he also covered his single window in three sheets of plastic—
with three "black paintings" he made on brown wrapping paper and
attached to the plastic with tacks and masking tape. He then worked
on twenty-five "red form" drawings with red gouache. In a coincidence
that thrilled him, he opened his copy of Kandinsky's *Concerning the
Spiritual in Art* to a paragraph on the effect of the color red on form.
In SoHo, he found a bright-red poster printed with Asian ideograms,
several rolls of ripped paper, and about two hundred pieces of white
mat board he brought home to make forty black-on-white calligraphic
drawings. Spending some time doubting the relevance of his method,
and his motives, he took heart from a discussion by one of the new art-
ists he was discovering, Dorothea Rockburne, on "drawings that make
themselves." After a month, he was living within an installation rather
than a mere room, a space as distinctively his own as the navy-blue
room in Kutztown where he first drew abstractly.

Never flagging in his steady survey of galleries, museums, and per-
formances, uptown and down, Keith made the subway his usual mode

of transportation, and it quickly began to upstage his destinations. He would sit on a bench in a station and let several trains pass by: "You could go down in the subway for fifteen minutes and see fifty incredible paintings." These artworks on wheels were brought to the New York public by graffiti artists, originally known as "writers" and, later, as "bombers," who were at work as far back as the late sixties, when a Greek boy named Demetrious began writing "Taki 183" in Magic Marker throughout the city—his "tag" formed by his nickname and the street where he lived. Graffiti markings made with felt-tips and spray cans had only grown in daring and grandeur by 1978, when Haring first saw bubble letters on the sides of trains and the complex layering of the "wildstyle"—whooshes of fluorescent sweeps and arresting cartoon characters in thick black outlines. As Calvin Tompkins observed in *The New Yorker*, "The most admired or whole-train pieces often have a highly professional, commercial design look as if the bombers had all studied with Walt Disney." Graffiti writers averaged in age at around fourteen or fifteen (after sixteen, they could be charged as adults for the crime) and were a surprisingly diverse group. Among the star craftsmen were Crash, Futura 2000, Lady Pink, and Zephyr.

The train art had a following among SVA students, with everyone seeing something slightly different, as with art in general. For Kenny Scharf, the subway art in New York City evoked the surf vans of the West Coast: "The surf vans were airbrush-painted rather than spray-painted," he said, "but the bubble letters looked similar to what you'd see on the trains. It was something I was already doodling in my sketchbook in grade school, so I felt akin to what was going on in the subways." Keith Haring was probably among a sharp minority of viewers who saw in the wildstyle the brushwork and spirit of Alechinsky and Dubuffet: "This calligraphic stuff reminded me of what I learned about Chinese and Japanese calligraphy. There was also this stream-of-consciousness thing—this mind-to-hand flow that I saw in Dubuffet, Mark Tobey, and Alechinsky." He was keen on the luminous colors, a palette he instantly recognized from his years sitting in front of a TV set: "A lot of the paintings on the outside of cars had this incredible pop cartoon sensibility that came from kids who had grown up with cartoons and Technicolor

and had a concept of color learned through television, which is the way I learned color. I was fascinated because it was coming from my generation, and younger." He admired the mastery and the necessary speed of the drawings, the hard-edged black lines tying the bright exclamations together—and, of course, the public access on a scale he dreamed of emulating.

The 1979 spring semester at SVA began late in January. Keith was signed up for elective classes that excited him, as he had learned to navigate away from less sympathetic instructors, though his grades of nearly all As the first semester did not reflect much conflict. "SVA wasn't the kind of place that forced anyone to do anything," fellow student Charles Imbro explains. "You weren't going to lose points for being original." In contrast to his performance in high school and at Ivy, Keith received a letter from his adviser full of praise for his record: "Congratulations on your fine achievement in your Foundation year. Earning a cumulative index of 3.76 shows a blending of scholarship, talent and effort. I hope you continue this high level of achievement in your studies at the School of Visual Arts." His favorite classes that spring were Barbara Buckner's Video Art, the painter Lucio Pozzi's Fine Arts Workshop, and, again, Barbara Schwartz's Drawing. He also took Intro to Video; Basic Photo; and World Art.

Keith would remain in Barbara Buckner's Video Art for three semesters, as hers was the course aligned most closely with his work at the time—she was creating her own experimental videos using computer technologies to achieve painterly effects he referred to as "poetries of videotape." On the first day of class, Buckner read aloud a letter from Theo van Gogh to his brother, Vincent, about self-doubt in the artist's life. "It came at an important time and was very helpful to me," Haring wrote in his journal. "I got the book out of the library, as well as Paul Klee's diaries." Buckner also discussed the importance of the spiritual involvement of the artist. When Keith showed interest, she lent him her copy of Jerome Rothenberg's *Technicians of the Sacred*. Also enrolled in the class was Kenny Scharf, whose presence heightened both friends' collaborative impulses. "We were both making videos," Scharf says. "Often, if he's in them, I was behind the camera. If you see me in them,

Keith was behind the camera." Says Barbara Buckner, "I remember one video they made together of three or four guys in the shower sudsing up. I can't recall if they were actually masturbating. This was the seventies, after all." In April, Keith made the three-minute video *Lick Fat Boys*. Shirtless and in jeans—as in *Painting Myself into a Corner*—he filmed himself taping up block letters from a stack of thirteen he had found at a little shop selling signs on Canal Street, in scrambled order. In this homage to the cut-up method of William Burroughs and Brion Gysin, he began with the anagram "Art Boy Sin" and kept rearranging letters, winding up, as if the letters were spun in a raffle drum, with "Lick Fat Boys." He found in cut-up a way to treat words as meaningful sounds as well as purely visual glyphs.

Lucio Pozzi took a far more conceptual approach to painting than the oil-and-canvas approach in Keith's Painting and Color course in the fall. On the first day, he announced to his class, "I cannot teach anything," and invited students to play an Inventory Game, with arbitrary matchups of a material (Masonite), a concept (political), and a color as ingredients for a painting. Keith responded to Pozzi's open-ended approach and to their dialogue. "He was this very lively young fellow, extremely thin, eternally surprised, with humor about himself and the work," Lucio Pozzi says. "But you also got a sense of the pain of existence. I don't know where it came from. He was very young, and how could he have it?" In class, Haring painted in acrylics on door-size scrolls laid on the floor, reminiscent—Pozzi felt—in their loose, squarish brushstrokes of the fifties' abstract expressionist patterns of Bradley Walker Tomlin. One day, Keith invited Pozzi to the school's video room to show him the many short black-and-white videos he had been shooting that year, often in his First Avenue apartment. "One was of him and his friends in the kitchen going around all nude," Pozzi says. "It was lively and fresh. It wasn't self-conscious or self-congratulatory humor, just plain being there, which is rare in the art world."

One day, while Keith was on his way into SVA, a teenage kid with severely cut hair and a look that registered with him as "cool in a way" asked Haring if he could walk him past the security guard. Keith said, "Sure," and they chatted so the guard would know they were together.

Keith disappeared into his class, and when he emerged an hour later, he noticed fresh tags and scrawled poems on the corridor walls. He recognized that they had been done by Jean-Michel Basquiat, the street artist of Haitian and Puerto Rican descent who, along with his partner, Al Diaz, went under the name "SAMO," short for "Same Old Shit." "I only knew him by his things on the street, and was sort of worshiping him from afar, and having many discussions with people about the work, but not really knowing who he was," Haring said. "But later that day I saw all these fresh SAMO pieces in the hall and I knew it was him." Haring felt that some of Basquiat's best work was done on the walls of SVA, and he wrote down his favorites: "SAMO as an attitude toward playing art"; "SAMO as Vincent Van Gogh"; "They made you a second-class citizen." He thought of these tight maxims as "literary graffiti" or "potent poetry."

Keith was not the only student who helped Basquiat with entrée to the school. Jean-Michel was a known figure of fascination at SVA. The graffiti-filled stairwell was a favorite hangout of his, and, says Ron Barbagallo, "When he was passed out, stoned, in one of the booths in the cafeteria, there was just something about his body language that commanded a lot of attention." The next time Keith ran into Basquiat, they discovered that Kenny Scharf was a mutual friend; Jean-Michel had met him in the SVA cafeteria. "I was just smitten with Jean," Scharf says. "We used to go around when I first met him drawing in the street. He would do the SAMO, and I would do a TV set, and inside the screen was the word 'Jetsons.' That was my tag." Keith and Jean-Michel decided to visit Kenny in the apartment he was renting in Chelsea. At the time, all three were working on color Xeroxes, as color photocopying machines had just become widely available. Basquiat was selling his color Xerox postcards in front of both the Museum of Modern Art and the Patricia Field boutique on East Eighth Street. He had recently spotted Andy Warhol in the W.P.A. restaurant in SoHo and walked in and sold him a postcard. "From the moment I saw Jean-Michel's drawings and the things he did in the streets, I knew he was a great artist," Haring said.

Another SVA student Keith met that spring semester was a young man from Long Island who had matriculated under the name "John

McLaughlin." His first semester at SVA, McLaughlin was writing serious poems about Tristan Tzara and carrying around a huge portfolio with illustrations of the works of Ezra Pound. Soon enough, he reinvented himself as John Sex, wearing Day-Glo pants, his hair in a blond pompadour, and he was brilliantly silk-screening pop-influenced posters. His girlfriend, Wendy Andreiev, likewise transformed herself into Wendy Wild, their stage names a direct influence of earlier punk rockers such as Johnny Rotten and Siouxsie Sioux. Sex lived up to his marquee name. "He picked you up and took you home and had sex with you," Drew Straub says. "I don't know if Keith did, because that's not his type. But Kenny and I both did, and that's how we met. We were all sleeping with John Sex." Among the "performers" in at least one "sudsing" video were Keith, Drew, and John Sex. In the SVA cafeteria, John Sex also met Jean-Michel Basquiat, who was then in and out of all their lives in his aleatory, shambolic manner. "Jean-Michel had shaved his hair into a real severe V," said Sex. "We weren't punks, but we had a very punk attitude. We were into outrage. We used to make postcards together."

On Friday evening, May 4—not by accident, his twenty-first birthday—Keith Haring staged a finale performance in the SVA amphitheater of a video-dance piece titled *Video Clones* that he created in collaboration with choreographer and dancer Molissa Fenley. He had first met Fenley in Kutztown, where she performed a dance piece and befriended Drew and Kermit. "He wanted to work on a piece with dance in it," she says. "The only time he could get the camera was after midnight. So, the other dancer, Joan Frost, and I would show up and work until five in the morning. He was practically living in those studios, all day long, all night long. He worked on the technology and video, and we did the live performance." Haring trained one camera on the geometric patterns the dancers' feet made when they scuffed the floor in their black Mary Janes, and he and Fenley recited in close-ups a pattern of words: "circle, square, circle, square—diagonal." At the performance, eleven video monitors and four cassette decks were set before the audience. The dancers performed on the narrow stage of the lecture hall, while Haring, an innately watchable performer, jumped from ramps to steps, his ankle bells jingling. "I remember that they worked with passing an

image from one television to another," says Simone Forti, who attended the performance. "You would see a person, or legs, go from one screen into the next."

When Keith had returned to Pittsburgh from hitchhiking across the country two years earlier, he wrote of his excitement for all "forms of expression." At SVA, he had begun to fill in the contours of that inclusive vision with actual works, such as *Video Clones*. He cataloged in his journal during the school year the affinities he was discovering: "My constant association with writers, dancers, actors, musicians, forces me to compose my intentions/concerns with theirs." With contemporary dancers, he shared "the same concerns for space and movement and structure." Like musicians, he considered "spontaneity, improvisation, continuity, and harmony." He found a common bond with theater and performance artists as he made "painting as performance" videotapes and with the "visual concerns" of filmmakers in all his multimedia works. "I feel as though the arts have all gravitated to a central plane on which we all operate. The same (or similar) concerns apply to all of the arts." He was at the start of a productive summer away from art school, yet, when he looked back four months later, the most defining of its surprises would turn out to have been "not painting all summer except maybe once or twice."

Club 57

SVA *classes usually* let out by four in the afternoon, when Keith Haring, Kenny Scharf, John Sex, and Drew Straub would often head over together to the "cool street to hang out on," St. Mark's Place. They would dip in and out of narrow bars, or drink Heinekens and eat slices from Stromboli Pizza on the front steps of John Sex's apartment building opposite Theatre 80 St. Mark's, a revival film house. On one of those afternoons in the spring of 1979, they had drinks at the nearby

Holiday Cocktail Lounge, formerly a speakeasy and still a shadowy dive where you could buy bracingly strong cocktails for fifty cents. Back on the street, they spotted a basement doorway that looked like the entrance to some sort of social club and decided to investigate. They entered a small, dim room with low ceilings and an old wooden bar to the left, similar to other Polish bars in the neighborhood, but smaller. The place was empty, as it was still daytime, and appeared dark, musty, and unpromising. Yet, in one corner was a gleaming jukebox that Kenny quickly discovered was filled with Motown and go-go numbers. He put in his nickel, and a single by the Supremes began to play. "We all started dancing together," Scharf recalls.

Club 57 was still in its early days on the late afternoon the four friends wandered in. A Polish immigrant, Stanley Strychacki, had been charged by the Holy Cross Polish National Church at 57 St. Mark's Place, between First and Second Avenues, to make a social space out of its basement—mostly used for unsuccessful polka parties—to raise some revenue for the church. Beguiled by the youth culture he saw burgeoning around him, Strychacki first brought in punk bands, yet they proved too noisy for the neighbors. Renaming his club East Village Students Club, he then sought out Tom Scully and Susan Hannaford, the organizers of a short-lived, successful "New Wave Vaudeville" variety show at Irving Plaza. When a manager was needed, they chose to bring in Ann Magnuson, a young actress finding her way in performance art and the downtown scene. Scully suggested they use the space to show grade-B horror movies, an attraction he felt would also draw the young punks in the neighborhood. They cleaned and painted black the twenty-by-fifty-foot room and, beginning on Tuesday nights in May 1979—the month Haring and his friends appear in the records of events at the club—launched their "Monster Movie Night," with films such as *She Demons* and *Hercules in the Haunted World*.

Tuesday night became every night as the movie screenings were filled out with theme parties, antic one-night let's-put-on-a-show productions, and gallery-style art exhibitions. The pace was almost silly, given the rapidity of the turnover of events, with members kept exhilarated by sheer youth alone as well as by drugs—mostly, hallucinogenic

magic mushrooms. A "Putt-Putt Reggae Party" involved constructing a miniature golf course out of cardboard boxes to resemble a Jamaican shantytown. For the "Model World of Glue," Susan Hannaford handed everyone a plastic model to assemble, along with glue and a paper bag (for sniffing). On Twister Night, players contorted themselves on the floor, rolling around and squealing for hours. Ann Magnuson enlisted fifteen women into her "Ladies Auxiliary of the Lower East Side," a send-up of the Junior League, and they held slumber parties and a Mini-Prom. "We were having a prom for kids who didn't even go to their prom because they were too misfit," Magnuson says. "We went to the Staten Island Ferry at dawn with champagne." As most were "creatives," as one member described them, they were influenced by the bohemian Dadaist scenes and "Happenings" (a forerunner to performance art) that went before, especially Warhol's Factory and his absurdist home movie–style sixties films. "It was approached as an art project," said Kim Hastreiter, then style editor at *SoHo Weekly News*.

Club 57 was "*the* neighborhood hangout," Haring said. "We hung out there almost every night and it could get pretty wild." He and his three friends, who discovered the spot almost the minute it opened, were soon helping to run the place. Keith was member number thirty-five (memberships cost two dollars), and his first appearance on its cramped stage was in mid-May, when he read aloud his eulogy "The End of SAMO. Dedicated to SAMO," as Basquiat had begun writing the slogan "SAMO Is Dead" on the streets of SoHo, signaling the end of his partnership with Al Diaz and of the "condensed poetry" Haring so loved. Drew Straub invented a role for himself as house critic for Monster Movie Night, shouting out his hysterical takes as the projector whirred. "Half the time he was more entertaining than the film," said Susan Hannaford. Also a doorman, Straub whimsically charged friends and enemies unequally. In September, Kenny Scharf showed SVA paintings he had made of Hostess Snoballs at the first art exhibition held at the club, *Celebrating the Space Age*, with Space Food Sticks and Tang served. John Sex went full-on Las Vegas glitter onstage, mixing bits of Liberace with bits of Tom Jones. He advertised himself widely on posters promising "Coming Soon." "Everything was done the Polish way," Sex said of

Club 57. "If a leg fell off a chair, Stanley would go searching for a piece of fruit crate to hammer on it. If a bulb went out, he'd put any old bulb in. Maybe that's how the black light got there."

That summer, for Haring, was all about poetry and experimental writing, especially the cut-up experiments of William Burroughs, whose *Naked Lunch* he was reading. In bookstores, he found himself drawn to poetry chapbooks rather than the arts section. "This new information I got all kind of came to me this summer under one big label called PO-ETRY," he wrote in his journal. "I have been enlightened. I have fallen into poetry and it has swallowed me up." Club 57 was also having a poetry summer. St. Mark's Church-in-the-Bowery—long home to significant readings by downtown poets—had burned in a terrible fire the year before. Its Poetry Project was holding its reading series for the summer of 1979 on Wednesday nights at Club 57. Nearly every Wednesday, Haring stood up and read variations on *Lick Fat Boys*, with lots of media and performative touches. (His notes for the readings—with mathematical patterning of the thirteen letters—look most like the pages of secret code in his boyhood notebooks.) One week, he read with two tape recorders playing alternate words simultaneously. The next week, dressed all in black, he read a poem taped to a black piece of sheet metal. The next, he read a mimeographed version with scattered text by silently counting time to correspond to the random spacings. He was making "Xerox Pattern Pieces" of *Lick Fat Boys*—the words falling on the page like the rain in Apollinaire's picture-poem *Il Pleut*—that he then pasted to street walls and lampposts.

Haring's poetry readings were not entirely successful. One night, he was heckled while reading his mimeographed piece with handouts for the audience. "The older poets were not having it; they were boo-ing him," Ann Magnuson remembers. "He came up to the bar, and he wanted a beer. He seemed a bit defeated, and he was a shy guy anyway, initially. I said, 'You don't have to pay; you're my favorite poet.' Because he was younger, and they hated him, made him a total hero to me." Yet, according to Drew Straub, even Haring's poetry performances before a more sympathetic and younger Club 57 crowd could fall flat: "He wasn't struck by that horrible irony that everyone else at Club 57 was honing.

He tried to do his spoken word poetry things, and people still talk about how horrible it was. Because it wasn't fun. It was repetitive wordplay, but unless you were studying them, you didn't care." Haring wrote in his journal of loving "Talking to poets, being a poet at Club 57." Yet, reminiscing in *The World*, a publication of the St. Mark's Poetry Project, a few years later, he was more detached: "I haven't done any performances since then, really. I was never really comfortable in front of an audience, performing. I'm comfortable drawing in front of an audience. The things that I was doing then, I guess it was good for me at the time, but it seemed that there was a lot of people doing it, and there were enough people that could do it better. My main talent, which I was ignoring at that time, was my drawing."

Most new friends Keith met that spring or summer were either Club 57 members or became members through his enthusiasm for the venue he talked up as a "private secret club, which was really just artists and performers and musicians and people from the neighborhood." One of those succumbing to its "gravitational pull on misfits," as one member put it, was Tseng Kwong Chi, who met Keith while walking down First Avenue. Keith spotted him wearing high white corduroy pants and thought he was "so eccentric looking that I knew I had to meet this person." They cruised each other and exchanged phone numbers, while Keith learned that Tseng Kwong Chi was a Hong Kong–born photographer and artist who had recently arrived in town from Paris. Soon after, he got a call from Keith.

"Would you like to go to a poetry reading tonight?"

A poetry reading? Oh dear! Kwong Chi thought.

To his surprise, when they met up at the club that night, Keith handed him a Xerox with lines of poetry. "You're going to have to help me read my poem on the stage," he said. "What? I've never done this before!" Kwong Chi complained. Keith assured him the reading was no big deal. "So, we went on stage and we took turns reading Keith's poems, which made no sense at all, but I had the greatest fun," Tseng Kwong Chi said. At the time, he was creating a series of photographs of guys in feathered stripper outfits, and he asked Keith to pose. Tseng Kwong Chi went on to become a great documentarian not only of the scene at Club 57, but

also of Haring's entire art career, especially hundreds of his evanescent chalk subway drawings.

Most of the SVA circle was there, too, brought in by Keith, Kenny, John, or Drew. One day, in a key cutting store on Second Avenue, Samantha McEwen ran into Keith carrying flyers for an event at Club 57. He insisted that she stop by. "Club 57 wasn't a nightclub," McEwen observes. "It was a drama club. It also fit this video thing. All these performances could be videos. This was before Francesco Clemente showed up as an artist and way before Jeff Koons. Minimalism was de rigueur, the art world was Carl Andre, and then there was Club 57." Keith brought along the Brazilian artist Bruno Schmidt, who was studying graphic design at SVA with Bea Feitler, a former art director at *Harper's Bazaar.* "Keith and I used to go in there every day after school," Schmidt says. "Then we'd have dinner at Veselka." The two visited Wendy Wild, who worked at an art supply store on Third Avenue: "Keith would get those beautiful two-hundred-dollar sumi brushes, and she'd ring up like two dollars." Clothing designer Carmel Johnson, who would marry Bruno Schmidt, was a regular, too, and a model for life drawing classes at SVA, as was Jean-Michel Basquiat. (A Basquiat painting of a policeman hung for some time behind the small bar, though the artist always kept some distance from this scene that felt a bit too silly for his taste.) All stressed the casual bisexuality of the club. "It was one big orgy family," Scharf said. "Sometimes I'd look around and say, 'Oh my God! I've had sex with everybody in this room!'"

Often, during the afternoons, the activities of the club would spill out the front door, as no natural light was available inside. On the stoop would be its core members brainstorming the next theme night or rehearsing and practicing. "It was like a comedy writers' team," Magnuson says. On one of those days in June, Keith and John Sex sat hunched on the brick steps reading aloud from a 1940 manual titled *Sex Guide to Married Life* they had discovered at the Strand Book Store on Broadway. "There was a chapter on homosexuality, and it was so absurd," Haring recalled. "It had really funny descriptions of typical male and female homosexuals. Like, 'big hips for men.'" As "Gay Rights Weekend" in the West Village was approaching, Haring blew up a photostat of one

of the cliché definitions of homosexuality from the book—a work he titled in his SVA files *Propaganda Paragraph*—and he and John Sex wheat-pasted two hundred Xeroxed posters along Christopher Street and around Sheridan Square. "We did it as a joke," Haring said. "But some people didn't think it was funny. It was the first time I got to see how something on the street could really affect people. They were freaking out and ripping it off the wall."

The "no labels" attitude at Club 57 resonated with Keith. Though lots of the young women at Club 57 were attracted to him—"Keith was so cute, tall and lanky," says Min Thometz, who created Bongo Voodoo Night—he was one of the members who tilted mostly gay. On the morning he met Samantha McEwen at SVA, Keith made a conscious decision to put their relationship on a friendly footing in spite of her obvious beauty. Having just broken up with Suzy a few weeks earlier, "I didn't want another girlfriend." His search for gay sex and love was still taking him mostly to the Club Baths, but all was not going so well. He worried he was not attractive, and he was thin-skinned in the face of rejection. As his medium for expression that summer was poetry, he wound up writing several anguished poems, more confessional and less cerebral than his cut-up works. In the middle of August, he wrote a ballad beginning, "I fell in love in my imagination again last night," on cruising someone at the baths, winding up near him at a neighborhood bar, and drunkenly stalking him and following him home, to no avail:

> build me up, set me up for a heavy blow
> knock me down, and I'm lying alone in my
> bed and I'm crying, and I know I think about
> it too much. And I know that I'm blowing
> it out of proportion and it's just my paranoia twisted imagination
> but that doesn't make it hurt any less

In early September, after just over a year in New York City, Keith found himself back home in Kutztown, jaundiced and recuperating from hepatitis. The shadow side of the pleasures of promiscuity among gay

men—as among "swinging" men and women at seventies bath clubs such as Plato's Retreat—was exposure to a cluster of sexually transmitted diseases, including hepatitis, gonorrhea, and even syphilis. Confined to bed, he had time to think back on the mad rush of events that had made up his summer, including a favorite job teaching "Art"—the quotation marks his—at a day care center in Brooklyn. He flashed on reading Allen Ginsberg's *Howl* for the first time; and Sartre's *Saint Genet*, on the subway on his way to another odd job in Queens, delivering houseplants; and Rimbaud's *Illuminations*, in a café eating cremolata and drinking Perrier; and Carl Andre's poems, at the MoMA summer sculpture show. He missed seeing Fellini films with Tseng Kwong Chi, a panel on performance art featuring Meredith Monk and Laurie Anderson, and Joseph Kosuth speaking at the Leo Castelli Gallery on concept and context. Of course he missed Club 57, especially open-mic poetry nights, when everyone was reading in top form and in the best of moods. And he missed the mysteries of anonymous encounters, of smiles on the street followed by second glances—even if the flirtations often ended in frustration or fantasy. His life had become a busy crossword of people, life, sex, and art, which he believed "fit together so perfectly that it appears predetermined." Of his sincere longing to get back to the excitement of life in the city, he wrote sarcastically in his journal, "I am also missing that wonderful New York City air. That deadening pace that won't quit. Derelicts and other human wastelands. The impending New York FEAR that is always a factor in whatever you are doing. Dirty air, dirty streets, dirty looks."

Absent the first few weeks of the SVA fall semester, Keith busied himself in Kutztown as best he could. He sat in the Kutztown State College library reading excerpts from *The Tao of Painting and Chinese Calligraphy* and from *The New Television/A Public Private Art*, a collection of essays and statements by Vito Acconci, Nam June Paik, and Robert Pincus-Witten, among several other artists and critics driving the conversation in the art world in the late seventies. (Nam June Paik was also a visiting artist at James Carroll's art series in Kutztown that month.) He designed cut-ups and collages from whatever raw materials he had at hand—a computer instruction manual for ELECTRONIC

DIGITAL COMPUTER; a "Guide to Visual Aids and Teaching," from a college course taken by his mother; and Kristen's worksheets from the third grade on "WORD MEANING/CONTEXT, ETC." Yet he was feeling enthused about the more conceptual courses he had signed up for at SVA, and he was restless to get started. As he wrote in his journal, "The two main classes which are timely and seemed that they were important information sources that fit into place, now, are Semiotics with Bill Beckley and a Visual Science course that deals with universal coordinates/patterns and underlying connections between all forms of life." He was also registered for Performance Art with Simone Forti, Sculpture with Richard Van Buren, and a second semester of Barbara Buckner's Video Art.

The most relevant and revelatory of the classes he took that semester turned out to be Semiotics, with Bill Beckley. By the beginning of October, Keith had returned to school, and he was regularly seated in class on Wednesday and Friday mornings alongside Frank Holliday and Drew Straub, who was unofficially auditing. They knew of Beckley, as he had grown up in a town twenty miles from Kutztown and had even attended Kutztown College as an undergrad. His most important education, though, had come at the Tyler School of Art in Philadelphia, which had led to his inclusion in 1970 in *Art in the Mind*, the first exhibition of conceptual art in the United States. Beckley created *Silent Ping Pong* with tabletops and paddles covered in foam as a conceptual work and was now making large photo-narrative constructions in color. He took over teaching his SVA course from Vito Acconci at an opportune moment, as the field of semiotics (the study of signs) was expanding from merely dealing with linguistics and literature to including visual signs and the entire culture of photographs, performance, and painting as well as fashion, advertising, and love—as proven by Roland Barthes in his study of the signs signifying love, *A Lover's Discourse*, translated into English by the poet Richard Howard in 1979, the year Haring took the course. At the top of Beckley's list of required reading was Umberto Eco's *A Theory of Semiotics*, which Keith would keep with him through all his various apartment moves. He and Drew were already avid readers of

Semiotext(e), a journal edited by French literary critic Sylvère Lotringer, one of the producers of the Nova Convention.

"He had an iconic face," Beckley recalls of Haring as a student. "Before I ever saw any of his work, what struck me right away was the way he looked visually and different things he said in class. He was skinny and unique, and what I really remember are his eyebrows, which seemed to be permanently raised in amazement. The other thing I really liked about him before I saw his work, which took a while, was that he was totally positive. I was annoyed about all the cynicism in the postmodern era. A lot of cynicism and a lot of appropriation. Keith wasn't like that. He was genuine." Of the subject matter he was teaching, Beckley says, "Keith ate it up. I never coached him with respect to his work. It wasn't a studio class." Yet Beckley had been stimulated in his own work by the writers he was teaching—Ludwig Wittgenstein, Susan Sontag, Claude Lévi-Strauss, Georges Bataille—and he hoped the young artists in his class would be similarly inspired. His assignments tended to the creative, such as examining the cultural codes implicit in the lyrics of Elvis Costello's "Alison" or in disco roller-skating; or making a two-page model of something you could express both visually and verbally. Emphasis was placed on deconstructing the contemporary art world as a system of subtle signs, signifiers, economic barter, and codes.

Keith and Frank Holliday teamed up for one such assignment. "Beckley gave us a project to deconstruct signs," Holliday says. "We chose to deconstruct the gay signals of keys on the right, keys on the left, the handkerchiefs, the ultra-masculine stereotypes. It was interesting that we got to look at a scene, and become intellectual about a scene, and we shared that." The keys and handkerchiefs—a popularly agreed-upon code for signaling whether you were sexually active or passive, dominant or submissive, as well as advertising an array of sexual fetishes—were more a trait of the "clonish" West Village than the half-generation-younger East Village scene. Keith wrote a class paper in October analyzing the "object-oriented" art world. "If there is a limited amount of work available, as in the case of deceased artists, the value increases," he wrote. "Because the art system is based on ideas of ownership and

possession, value is determined by how much money these items are sold for in relation to how many of them exist." Semiotics class was giving him the tools and vocabulary to think critically about the system of the art market, galleries, collectors, and audiences that would be key to his work as an artist. He was also beginning to understand visual images as forming their own alphabet and language.

By the time he took Performance Art, his professor, Simone Forti, was already an important influence in the world of performance and postmodern dance, having been involved earlier in the Fluxus movement and in Happenings. The year before, she had been featured in the exhibition *Simone Forti: Movement Holograms*, at the Sonnabend Gallery in SoHo. Haring's main work for her course was *Japan-Iran*, performed by him at the SVA Amphitheater on Pearl Harbor Day, evoking that year's Iranian Revolution, as he held up the letters *I-R-A-N*, illuminated by a red spotlight, while running frantically upstairs and down. "I was working on performances with moving and speaking and the news that I eventually started calling 'News Animations,'" Forti says. "Keith was involved with current events as well. My initial assignment was to make some connection between yourself and something else, and he took off from there. He seemed serious in his interest, not in a frowning kind of way. He seemed relaxed." That semester, Haring also did a twelve-hour performance in a small sculpture studio, mostly while wearing a red blindfold, with two tape recorders playing simultaneously, even when he took bathroom breaks. Molissa Fenley stopped by: "I remember, as I looked at him, thinking I should get him some dinner." He occasionally staged guerrilla performances throughout the school, in the spirit of the sixties' Happenings. "One of my most vivid memories was of flying up a staircase in the Twenty-Third Street building, late for class, and Keith standing pigeon-toed on top of the banister with his arms outstretched, so it was almost impossible to get by him," says Ron Barbagallo. "It had a very Elvis Costello *My Aim Is True* vibe to it. It was kind of cute and engaging. His placement was strange but very public."

The class that meshed most seamlessly with Keith's own work remained Video Art, as he was creating so much video work that any distinction between pieces done *for* class and *outside* class was lost.

All Haring's courses were turning into either video or printmaking courses. His instructor in Sculpture, Richard Van Buren, wrote a letter of request to the administration, explaining, "He is not involved with making objects and thus does not use any of our equipment or materials. He would like permission to use the Xerox machine, instead." Barbara Buckner's fondness for Keith held steady. "He was a golden heart," Buckner says. "That guy had a lot of love in him. He was quite humble, and he never put on airs. He was just consistently a kind person." Likewise, Keith and Kenny followed Buckner's work—one night, they went to see her videotape *Pictures of the Lost* at the Donnell Library and then went on to make Polaroid photographs in Times Square. For Keith, video was always about self-exploration and performance. "I've maintained that schools should teach video *not* as a video class, but as a psychology or philosophy class," he later said. "Video really gives you a whole other concept of self and ego, and an objective way of looking at and being comfortable with yourself in a way that might not have existed before." His work that semester was psychological, such as *Open the Door*, for which he filmed himself lying nude in front of a monitor showing his naked shower footage; and philosophical, as in *Boxes*, playing Wittgensteinian language games while turning his head. "It's talking about turning," he says in a voiceover. In *Dedicated to Vincent van Gogh*, he contemplates van Gogh's suicide in quick-cutting face shots and text.

Keith wore his knowledge lightly. His demeanor was cheery and upbeat. Yet he was quite serious about pondering the significance of his art and life, and he often used milestones to stop and consider such questions. On the cusp of the New Year, 1980, and the beginning of a new decade, he sat down and pounded out, on a clunky manual typewriter and in a combination of all caps and lowercase letters, a rambling, imperative meditation on identity, chance, and art. He titled the confession "AUTOBIOGRAPHY—SELF PORTRAIT THE LAST DAYS OF 1979." "MATISSE PAINTED TILL HE DIED," he wrote, "they have einstein's brain in a bottle NO ONE HAS EVER DIED WITH ANSWERS only questions." He was still studying the I Ching and wrote of being conscious of trying to make his way while "always letting things happen as they will." The climax was a New Year's resolution, a renewal of his private

vow to his vocation as an artist, the sort of affirmation he had come to after traveling across America: "I WON'T STOP CAUSE I'M STARTING TO THINK I KNOW WHAT I'M DOING . . . ART IS CHANGING I am not prepared to write of it articulately BUT I KNOW I FEEL IT SEE IT. I AM PART OF IT." After three intense pages, he signed off, "I am tired i am tired of typing hungry I want sex I will go for a walk MAYBE TO KIEV, maybe this isn't a self portrait but it says something to me about what i thought i thought on the LAST DAYS OF 79 SO WHAT."

By the beginning of the New Year, their one-year lease was up. Keith moved into a new apartment, one even sketchier than his previous two, while Drew moved into the same building as Kenny Scharf, on East Ninth Street. As far as real estate, Keith was on a downward trajectory. His new address was a large, presentable enough building with ornate window treatments, at 193 Second Avenue, at the corner of East Twelfth Street, a block from St. Mark's Church. Yet he was living in a lady's apartment subdivided into small, unattractive rooms she leased mostly to much older men, one of whom died while Haring was living there, with everyone sharing a kitchen and bathroom. "It was like an SRO, single-room-occupancy, apartment for old men," Club 57 member Deb Parker recalls. "Keith was the youngest one in there by a gazillion years. His room was like a prison, with just a bed, a table, and a desk, and it was filled with art books. He didn't really care about having a home and making it nice." Keith's main complaint: "I used to bring boys home from the baths, and it was disgusting to bring people there because the bathroom smelled like old men in the shower." When Vince Aletti, a music writer for the *Village Voice*, interviewed Haring a year later, the reporter revealed to him that he had first noticed him while they were living in the same Second Avenue building: "I didn't know who this skinny, nerdy kid was, but I'd run into him at odd hours of the night (coming in at three in the morning, I'd pass him heading out.)"

Keith could turn any space, no matter how confined, into an immersive room of his own. Soon enough, this little cell, painted green, was unrecognizably transformed. Though he had no room for making

paintings, he did work on a novel (stopping after ten pages) and filmed some videotapes. Mostly, he focused on creating an installation of a bedroom, as he covered every available inch with: a drawing given to him by Rodney Greenblat, with dinosaurs stapled to it; some drawings on construction paper he found on the sidewalk on his way home; a plastic baby's head in a plastic bag that Janice Eshleman had given him a long time ago; three monoprints (red, white, and blue) by Samantha McEwen; three large photos of a sculpture he made in Barbara Schwartz's class, of sheetrock arranged on the floor of the Twenty-Second Street sculpture studio; a Xerox of a print of a boy lying on his stomach with a hard-on, from a magazine in the library; a picture of a man force-feeding a canary, from a canary book he found on the street; a piece of slate attached to a foam core board with gold paint that Kermit had sent in the mail; a plastic duck bought in Queens while he was working over the summer at the foliage outlet; a plastic TV from Kenny; a painted papier-mâché snake his sister Kristen had made in third grade; four mirrors found on Canal Street; a piece of clear orange plastic given to him by his father; a gay rights pin with a pink triangle on a black field; a box of wooden blocks; and on and on. "THESE THINGS MAKE THIS SMALL ROOM SEEM LIKE A VERY BIG ROOM," he wrote in one of his typed statements. "THIS ROOM STRETCHES ALL OVER THE WORLD AND SPANS SEVERAL YEARS. THESE THINGS THAT I HAVE. THE THINGS I KEEP WITH ME. WHAT I CHOOSE TO KEEP AROUND ME. WHAT I LIKE TO LOOK AT. WHO I THINK ABOUT. WHAT I THINK I AM."

His winter 1979/80 semester at SVA turned out to be the most stimulating so far. He wrote a paper for Amy Taubin's Twentieth Century Film course positing video as being closer to actual time than film, which relies on the illusion of montage editing. For a pass/fail workshop with Joseph Kosuth—Haring recalled it as "more of a seminar talking about things happening in New York at that time"—Keith was crucial in inviting Jenny Holzer to visit the class as a guest artist, as he had been finding her one-line "Truisms" posters on the streets as inspiring as SAMO's graffiti. "Keith had invited me to be a visiting artist, and it was a nice loop, because Kosuth's work had interested me when I was in school," Holzer said. "To be with Joseph and Keith in the same

place was not dull." Bill Beckley's sister Connie Beckley was Haring's instructor in a course on the interrelation of music and art, where Keith re-created Hugo Ball's performance, at the Dadaist Cabaret Voltaire in Zurich in 1916, of his sound poem "Karawane." After being carried into the room on the shoulders of classmates, Keith read his own version of the poem, with videotape elements. (He and Ann Magnuson often talked about Dada theater as parallel to Club 57.) He even took Cosmology. "I missed COSMOLOGY class—I completely forgot," he wrote in his class notes. "I never thought about it the whole day till I saw Kenny and he said 'GOD IS LIGHT.'"

Most open-ended and, so, most conducive to Haring's wish to pursue his own projects was Keith Sonnier's Interaction course, on art, performance, and media. "Keith Sonnier's was one of the more interesting classes that I had," Haring told a TV interviewer of his SVA experience a few years later. As an artist, Sonnier had introduced a fresh combination of materials in the sixties, using plastic, aluminum, or glass—played upon by pale pink, green, or gray neon and fluorescent light—to create undefined sculptures that were delicate, humorous, and sexy. Haring already knew of Sonnier's work before arriving in New York City, having read about him in Robert Pincus-Witten's *Postminimalism*, a collection of essays Haring described as "the textbook of art at the time." Yet Sonnier had more recently videotaped himself reverberating between two mirrors as an "infinity trough" and, intrigued by television as a "narcissistic vehicle," had devised this new course to explore such ideas. "Most people didn't really understand what I was getting at until much further into the class," Sonnier said. "Keith Haring understood what the class was about—instantly! By that time, Keith was already an artist." Sonnier responded to his student's "just hatched look" and to videos Keith had brought into class of a very sexual nature: "Everybody was sort of shocked by the content . . . The images were of himself—his body parts—his cock and ass."

By the spring of 1980, Keith was showing less of his work at SVA and channeling more of his energies into Club 57, whose up-for-fun membership was not only the liveliest audience for his work but also often its cast and crew. His videos segued from serious black and white to more

colorful productions in a lighter mood. Haring's most semiotic work that season was *Phonics*, with an all–Club 57 cast, starring Drew Straub, Min Thometz, and Kenny Scharf. Keith had found a pile of phonetics flash cards in the trash and filmed his friends reading phonemes like *iv* and *th* in front of written text equivalents on a back wall. The effect was of an elocution lesson gone berserk. An even more amusing decon-struction was *Tribute to Gloria Vanderbilt*, a faux homage to the designer and her widely advertised line of high-end blue jeans. Looming into a fish-eye lens, Haring, dressed in a pink shirt, disco-dances lurchingly, smooching the camera in pink lipstick to the tune of the Flying Liz-ards' "Money (That's What I Want)." "It was so obvious how Madison Avenue was using sex to sell jeans," Haring said of his satire. Frank Holliday and Keith had birthdays two days apart, and *Tribute to Glo-ria Vanderbilt* was the centerpiece of a celebration thrown by them at Club 57 on May 4, 1979, Haring's twenty-second birthday. As the club calendar cheerily announced, "It's birthday time for #35 Keith Haring and #133 Frank Holliday." As Holliday remembers, "We all wore Gloria Vanderbilt jeans, and her picture was everywhere"

Keith and Kenny Scharf also showed video works, made together and apart, at Club 57, at a party for an exhibition titled *Video a Go Go!* The flyer for the event collaged each of their faces, staring bug-eyed, from classic Zenith TV consoles—fitting, as so much of their work was propelled by a shared fantasy of taking over the small screen of their childhoods, to be inside rather than outside the box. (On an "Acts of Live Art" night, Haring spoke into a microphone while holding a TV frame up to his face.) In his videos, Scharf relied on the same ensemble cast as Haring. His *Boy from the City* stars Drew Straub as a worshiper of Hydrogen in a city "of clubs and gas stations." Filmed by him in Straub's apartment was the German New Wave opera singer Klaus Nomi, sing-ing "Lightning Strikes." (Within a month of Scharf's filming, Nomi, with his heavily made-up, alien look and otherworldly countertenor voice, and downtown performer Joey Arias would appear on *Saturday Night Live* as backup singers for David Bowie.) The most ambitious of Scharf's works then was *Carousel of Progress*, filmed on the grounds of the 1964 World's Fair, in Flushing Meadows, Queens. Haring and Scharf

are both credited in the video with "Camera Fun." And in a final, posta-pocalyptic dance scene before the fair's Unisphere, Keith cavorts in a bright yellow slicker worn over a blue jumpsuit.

As in Pittsburgh, where he parlayed his custodial position at the Pittsburgh Arts and Crafts Center into his first one-man show, Keith was a case study in blooming where you are planted. His ability to make the most of face-to-face opportunities could turn a belief in chance and accident into a self-fulfilling prophecy. One of the more eventful coincidences that spring led him to a weekend job painting walls for the art dealer Tony Shafrazi, who had recently opened a gallery in his small apartment on the fifteenth floor of a Lexington Avenue building near SVA. Haring had been brought along to help by his childhood friend Kermit Oswald, now living in the city on a six-month internship with Bill Beckley arranged by James Carroll at Kutztown College. (Shades of Kutztown Junior High, Kermit was now sitting with Keith in Beckley's Semiotics class.) "The artist Bill Beckley, a friend who was teaching at the School of Visual Arts, sent over two students to paint the walls," Shafrazi said. "One was Keith Haring. While he worked, I noticed that he was remarkably agile. The way he painted was so organized and systematic, efficient and fast, washing all the tools and brushes afterward, laying them on the floor in an orderly fashion. That impressed me no end."

Though thirty-seven-year-old Shafrazi had just opened his unconventional at-home gallery in 1979—most galleries were in SoHo or uptown, not in an anonymous urban stretch of the East Twenties, and few, if any, required hiding the mattresses before an opening—he was well known in the art world as more than simply a gallerist. Of Armenian descent, Shafrazi had grown up in a modern oil refinery town in southern Iran and attended art school in London, at the Hammersmith College of Art and the Royal College of Art. His most notorious gesture as a conceptual or political artist occurred in February 1974, when he ran up to Picasso's *Guernica*, at that time still hung in the Museum of Modern Art, and sprayed in red paint the words *KILL LIES ALL* across the canvas. He had conceived the act as a protest against the ongoing brutality of the Vietnam War, to release "the dynamic raw energy that it once conveyed now lying behind varnish" of a canvas created as a pro-

test against the bombing of a Basque village during the Spanish Civil War. The coat of varnish mentioned by Shafrazi allowed the curators to wipe the painting's surface clean, but the memory of the aggressive act stuck to Shafrazi's reputation, at least in museum circles, for some time. "I would never stand up for it in any way," Haring later said of the defacement. "I guess the only thing I respect about it is that he had the balls to do it if he knew he wanted to do it." At the time of the *Guernica* incident, Shafrazi was already a well-known SoHo presence and friends with the artists Robert Smithson and Richard Serra, who sent his lawyer to ensure that Shafrazi would not be extradited. Shafrazi resurfaced successfully in Tehran, where he helped the Shahbanu, the wife of the Shah, gather a contemporary art collection that included works by de Kooning, Johns, and Warhol. He also started his own gallery there, but on opening night in 1979, tanks rolled down the streets of Tehran as the Iranian Revolution was intensifying, and Shafrazi left the country, returning to New York.

Alert to Keith's self-possessed manner of painting a wall and his obvious work ethic, and intrigued by the younger artist's presence— "He had the peculiar habit of looking at something and doing a double take," Shafrazi said—the gallery owner invited him to stay on as his assistant. The position was a catchall, with tasks ranging from writing press releases and mimeographing to buying glasses for the kitchen and serving drinks at openings. Since the gallery's launch the year before, Shafrazi had shown works by Bill Beckley, Olivier Mosset, and Sarah Charlesworth, among others. One of the first shows Keith worked on at the gallery was *Pictograms*, an exhibition of the neon sculptures of his favorite instructor, Keith Sonnier, presented in cooperation with the Leo Castelli Gallery. "I helped Keith Sonnier install some neon pieces at Castelli gallery," Haring said. "I actually ended up stepping on one of the pieces in neon and we had to go and get another piece made at the last minute. But he was really sweet about the whole thing." Shafrazi taught his assistant how to handle art, including wrapping paintings and exercising caution with a painting or piece of sculpture, and Keith was impressed by the dealer's belief in the artists he represented. Haring also developed a reverse admiration for Shafrazi's failures as

a businessman, as at the time, the older man "wasn't doing that great" financially, yet he balanced his missteps with such total honesty and loyalty. Keith did chafe, though, under a chaotic management style he viewed as "neurotic."

Small, fledgling, and neither here nor there in its location, the early Tony Shafrazi Gallery had a novel energy. Dressed in a fine suit, with a warmly charged manner and a cosmopolitan accent, Shafrazi projected an attitude somewhere between uptown and down, money and art. "Tony had a kind of charisma about him," says Bill Beckley. "His small apartment with a bunk bed kind of thing was filled with people out into the hallways whenever he had an opening." The dealer Mary Boone was a regular at the openings, as was her artist Julian Schnabel, whose broken-plate paintings, shown at her gallery the previous October, were celebrated in the *Village Voice* as a "tantrum in painting" and a break from austere minimalism and helped prime the aesthetic for artists such as Haring. "Tony was one of the first to have a sort of an uptown social thing going on in the downtown art world," Jeffrey Deitch observed. "His apartment had a terrace, so you felt like you were on Fifth Avenue even if you weren't. And actual bartenders. Of course, Tony did this with almost no money at all. Keith was working the bar. He was at the prime of his unique look with very close-cropped hair, and really thin wiry, and these big thick glasses. He looked like no one else on earth. You knew just by looking at him that this guy had something." Shafrazi was impressed with the infectious social energy of all the friends Keith brought into the gallery. "Jean-Michel Basquiat would come by, I remember, in many different guises," Shafrazi recalled, "with his Mohawk hair and his long overcoat splattered all the way to the floor in paint." Drew Straub often bartended. Always in the mix was Kenny Scharf, "crazy and fun and delightful."

Keith felt himself to be very much an observer at these openings, taking advantage of the voyeuristic distance of being a member of the waitstaff to learn more about the art world he was becoming a part of through school and the underground scene. Rather than filling him with excitement, though, his experience as a bartender at the Keith Sonnier opening led to "the most terrific disillusionment." He loved his instruc-

tor's wonderful artworks, yet he found the people standing around or walking back and forth in front of them and making superficial or even sly comments not to match his idealistic hopes and dreams about the life of an artist. He imagined that Keith Sonnier did not look very happy, either. "At one point during the opening, I went out of the gallery and sat on the stairway and just cried and cried," Haring said. "It lasted for almost twenty minutes. And I remember thinking that even if you got to be a success, it didn't mean very much. There seemed to be no answer at the end of the rainbow. Afterwards, I went back in the gallery and continued my tasks as though nothing had happened. Even if Sonnier's opening had been successful, it just didn't seem very fulfilling . . . There had to be some other reason for making art beside looking for success within the art world. Of course, I kept all this more or less to myself."

Probably not by coincidence, at the same time as he was working at the gallery, Keith decided to try his own hand at curating. That season, he became as interested in reinventing the formalities of the gallery system as he was in discovering his own inventive style, and he grew remarkable as an artist in beginning to expend so much energy in getting other artists seen. The first such exhibition, where he was credited as "Guest Curator," was the radically inclusive *Club 57 Invitational and Xeroxes*, up for one night only at the club at the end of May—"The first East Village biennial," as Ann Magnuson put it. As Shafrazi's assistant, Keith pointedly never talked about his art or showed any of his work to his employer. "He never bugged me, never shuffled his feet and asked me to see his slides," Shafrazi said. Yet he did give him a flyer for the exhibition, and Shafrazi did stop by, finding "an extraordinary assemblage of downtown art—as lively as it could be." Haring invited a diverse group of more than sixty artists, painters, poets, dancers, musicians, sculptors, photographers, designers, writers, and filmmakers and asked them to bring one work of their choice, with the results skewing to color Xeroxes. Haring put up an extreme close-up of his grandmother's face and "test shot" self-portraits; Drew Straub, a cut-up writing piece, *Uni/verse*. Basquiat fished a drawing on a crumpled piece of paper out of his pants pocket and taped it to the wall. "Jet" Scharf (often Scharf's tag name, evoking *The Jetsons*) contributed a *Fun Machine*. "Keith would call out to

artists and say, 'Come in, we're doing a one-night show, and this is the theme,'" Kenny Scharf said. "Everyone would show up and slap up what they had made or make something on the spot. Some people came back to get their work the next day, some people didn't."

Haring went on to curate an *Open Color Xerox Show*, which was "open to anyone" and boasted "the largest collection anywhere"; a more personal show, *Anonymous Art*; the vividly remembered *Club 57 First Annual Group Erotic and Pornographic Art Exhibition*; and *Black Light Art Show*, held over a second night, rare in the annals of the club. *Anonymous Art* was a show Haring chose from his "private collection" and could easily have been culled entirely from the walls of his bedroom. The bright spot of color on its invitation was an orange "Free Mandela" sticker. Included in the show of pieces Dubuffet would have called art brut was children's art, art found on the street, propaganda art, and "raw art by unknown authors at 57." "SOME OF THE MOST INTERESTING, MOST INSPIR-ING AND INFLUENTIAL ART I HAVE SEEN IN THE LAST TWO YEARS IN NEW YORK CITY HAS BEEN ON THE STREET," Haring wrote. "MANY OF THESE THINGS REMAIN UNTOUCHED, UN-DOCUMENTED, PERHAPS UN-NOTICED." Ann Magnuson deemed the "Erotic Art Show" the biggest success of all Haring's exhibitions, "with art critics and legitimate buyers showing up (not to mention the bishop from the church upstairs whom I had to diplomatically usher out before he had a chance to see the giant silver phallus that hung at the club's entrance!)." David Wojnarowicz contributed a striking drawing of a naked man with the head of a dog. (Wojnarowicz would later claim that Haring stole his dog's head image for his own barking dog series.) The *SoHo Weekly News* reviewed the "multi-sexual" show in its casual, knowing house style, with one of the first mentions in print of its young curator: "Wonderful congratulations are due to Keith Haring who cu-rated the show and is rather a cutie in the bargain. He has a great under-played look."

The trend in the downtown arts community was toward such group shows taking place outside a SoHo gallery system they were criticizing as an elitist echo chamber. In January, Colab, a cooperative of artists, broke into an abandoned building on Delancey Street to stage *The Real*

Estate Show, a highly political exposé of landlords and the Lower East Side real estate market that included an abstract ink drawing by Haring. In the spring, Colab and Jenny Holzer organized *The Manifesto Show* on Bleecker Street, with walls crammed full of posters and polemics. Making the most impact for Colab—in collaboration with the Bronx-based storefront Fashion Moda—was *The Times Square Show*, which ran all through June in an abandoned massage parlor near Times Square. The works of more than one hundred artists were shown on its four floors and up and down its narrow staircases, in a frenzied display of "guerilla gallerizing." At once humble and ambitious, Keith, eager to participate, wrote "A Proposal of Flexibility," which was more a job application, volunteering for "physical labor" such as cleaning or painting. He and Kenny Scharf wound up in a side room on the second floor. Kenny customized a big electrical box, while Keith pasted "Art Boy Sin" letters on the wall, surrounded by pink spray paint and little penis drawings—a piece Robert Pincus-Witten later wrote was "rather lost in the vivifying grunge." They also presented *Videotapes by Keith Haring & Jet Scharf* at a midnight show near the end of June. Haring's later Pop Shop could be traced back to that show's Souvenir Shop, replete with an artist cashier. For the shop, Haring created a series of *Businessweek* magazines with gay porn collaged inside.

The greatest thrill of the show for Haring turned out to be the presence of graffiti artists, who until then had rarely been shown together with downtown artists. In a moment of spastic excitement, he went up to "one Black guy and one Puerto Rican guy" looking at some Basquiat drawings and began a monologue about graffiti art and the success of the subway artist Fab 5 Freddy with a show in Italy. Noticing that the tall Black guy had a "piece book," a sketchbook in which graffiti artists made preliminary drawings, he asked if he might take a look and discovered that he was talking to Fab 5 Freddy himself, his real name Fred Brathwaite: "He totally stayed silent the whole time and let me totally put my foot in my mouth just to see what I was going to say." Fab 5 Freddy was most famous for covering a subway train top to bottom with Campbell's Soup cans in the pop style of Warhol. Brathwaite's friend turned out to be Lee Quiñones (his tag, "LEE"), who did monumental

works on handball courts all over the Lower East Side. Haring's mistake turned out to be fortuitous, as he and Brathwaite started hanging out, and Keith gained entrée to uptown communities of graffiti artists and rap musicians. "It was great," Haring said, "because Lee and Fab Five Fred were the kings—the kings of this graffiti world."

Keith lasted for about five months at the Tony Shafrazi Gallery. While he found much to admire about Shafrazi, he knew that being an employee in an art gallery was not the right fit for him. One summer day, he came across an ad in the *Village Voice* for harvesting wildflowers. He answered the notice and soon found himself getting up at seven in the morning a few days a week and riding in a van out to New Jersey to pick flowers, like Queen Anne's lace, by the roadside and returning to Manhattan, where his boss would sell the flowers to expensive shops. "He always had all these scratches all over his arms," Min Thometz remembers. Yet the "quite bizarre" job appealed to Keith. The fields, familiar to him from the green fields surrounding Kutztown, gave him some breathing space, allowing him, in the words of one of his favorite poets, Walt Whitman, to "lean and loafe at my ease observing a spear of summer grass":

This episode was really important to me, because when we took a break from cutting wildflowers, I'd sit in the fields and contemplate things. It was very calming and beautiful and there was time to just think. What I was thinking about was what to do with my life and with my art. I was beginning to be frustrated about doing only these word things and performances and videotapes—I had been doing this for almost a year. Now, I had this longing to draw again—to create things physically on paper. The question was how to incorporate that into what I was already doing, because if I were to start drawing again, it had to have a reason. There would have to be a purpose. Also, it could no longer be abstract drawing, because that wasn't really communicating to the outside world. More than anything, I wanted to communicate!

Chalkman

When *he decided* to draw and paint again, Keith Haring created an arbitrary deadline, forcing himself to paint his way out of a corner. Considering his friend Frank Holliday "the only real painter I found at the School of Visual Arts when I was there," he approached him about having a show together at Club 57. Holliday agreed, and they set a date: July 21. Flyers and posters went up advertising a one-night-only exhibition of "PAINT(INGS)." Club 57 billed the event on its collage of a

monthly calendar as an "exhibition and dance party." "Keith and I were famous dancers," Frank Holliday explains. "We would violently go-go dance for hours to the B-52's. So, they called it a dance party." The glitch was that Keith had no "paint(ings)" to exhibit and was still living in his tiny SRO with no space to make any. His solution was to ask a young German painter showing in November at the Shafrazi Gallery, Bernd Naber, if he might work for a couple of days in an abandoned building in the Flatiron district where Naber kept a studio. The building was about to be foreclosed, and all the other tenants had left. Naber, staying for one more week, lent Keith the keys, and for two days, he had the entire floor to himself, with only four days remaining until his show.

On the first day, Keith showed up with a full roll of oaktag, a heavy-weight industrial paper like tagboard. He found the roll in a bargain retail bin at Gem Paper, a wholesale paper company in SoHo. Cutting from the roll sixteen pieces of buff-colored paper about four by five feet, he taped them down on the huge studio floor to work on in a group. For drawn lines, he used black sumi ink, and he applied cheap latex paint he mixed into a pinkish-gray color and red spray paint, the medium of graffiti artists, which he had been wanting to try ever since meeting Fab 5 Freddy. Half these drawings were reminiscent of the abstract style he had made his own since at least his time in Pittsburgh. Yet, on some sheets, he began creating recognizable images of his own invention, awkward and tentatively rendered—as he had not drawn figuratively in a long time—some with decorative abstract patterning behind them. Two nights earlier, he had seen "*Forbidden Planet* in Cinemascope!" at the Monster Movie Night at Club 57. The 1956 sci-fi film featured a classic fifties conception of a spaceship as a sleek, domed frisbee, and Keith began drawing this saucer—which looked, in his version, like a sombrero-shaped UFO—zapping, with a downward beam of radiant red lines, a creature resembling a dog with a square nose. He went on to draw the invasive saucer striking grazing cows and sheep glowing with its reddish energies.

The next day, the imagery turned more wildly sexual. He drew one person penetrating a dog from behind, then two people reenacting the same doggy scenario, the spaceship beaming from overhead; a feature-

less man receiving a blow job recharged by the vibrant extraterrestrial rays; and a dolphin, likewise irradiated, swimming in the waves. These imaginings began to unfold into loose scenarios of storyboards in sequences. The charged dog stood bold and strong on a rectangle of a pedestal being worshiped, golden calf style, by a crowd of upstretched arms. The man's glowing penis was stuck through a glory hole and likewise worshiped by a crowd. All these drawings made on the second day were basic black line sketches with red spray-paint dabs and streaks. The rough figures were cartoonish yet original, and emptied of verisimilitude, as the persons, unless endowed with penises, were simply silhouettes of humans; and the dogs or cows, simply animals, like signs or symbols or even little myths. While the drawings suggested plotlines, no straightforward story was told: Was the spaceship divine? Were the humans and animals now radioactive? Except for penises (a drawing obsession of Haring's since he arrived at SVA), all the visuals were new, the only true appropriation from cartooning the accent lines that, from that day forward in his work, could variously indicate joy or stress, movement or noise, love or fright. His extended break from painting had been generative, as he had returned with a visual lexicon.

"At the beginning I didn't know what they meant," Haring said of the images, "but after they existed, just by their existence and repeating them and elaborating on them, the meanings developed one step at a time. The more of that I did, the more clear it became what they could mean. I still don't have specific definitions for any image. I still approach them like they're more related to spontaneous automatic writing or to gesture and intuitive spirit than as literal translations of information into images. I still think it's poetic and I want to keep it on that level." He credited the cut-ups of Burroughs, with their multiple-choice narratives left to their arrangement as well as to the imagination of the viewer, and he later expressed their importance with even more finality: "Out of these drawings my entire future vocabulary was born. I have no idea why it turned out like that. It certainly wasn't a conscious thing. But after these initial images, everything fell into place, and after that everything else made sense." Says Drew Staub of an ensuing flow of drawing, "He never stopped. It was nonstop creativity, one following the next."

The show at Club 57 was held in the middle of the summer; few saw the exhibition. Yet Keith's own surprise and excitement at his images were matched by those who did, beginning with the other featured painter, Frank Holliday. He invited Keith over to see his works for the show, a series of black mirror paintings, shiny, blowtorched, but not reflective, "like vampire mirrors," Holliday says. Keith responded in kind and asked him by Naber's studio to see his own new paintings for the show. "It was a tall industrial building, and he was on the eighth or tenth floor," Holliday says. "I remember looking up from the street, and I could see a Day-Glo dog through the window, and I went, 'Shit, he stole the fucking show from me.' He was funny because he didn't know he was doing something great. He was like, 'What do you think?'" In the wake of a thunderstorm, after a hot day with temperatures over one hundred degrees Fahrenheit, enough of the friends who mattered to them showed up, including Jean-Michel Basquiat and the artist and curator Diego Cortez, who was at work on a *New York/New Wave* show for the P.S. 1 Contemporary Art Center, housed in a former public school in Queens. The response to the drawings Haring was selling that night for twenty-five dollars each was strong. "I remember sitting out on the steps of Club 57 with my roommate, the painter Carl Apfelschnitt," Holliday says. "He said, 'Frank I hate to tell you, but this is Keith's moment.' I knew it was Keith's moment."

In the weeks following the show, with all these new images colliding in his head, and still no space to make drawings and paintings, Haring decided to take advantage of the available spaces on the streets, his first time doing actual graffiti, as he recruited his evolving animals and crawling humans as tags. (Until then, he had only been painting pure color fields or pasting painted pieces of paper onto outdoor walls.) The more he drew his four-legged animals, the more doglike they became; and the more he drew his crawling persons, the more they turned into crawling babies and were referred to as babies by passersby. He was drawing with standard, thick Pilot Markers on the bases of light poles, as the black ink took well to metal surfaces, and on wooden fences around construction sites. A baby crawling on the side of a newsstand in SoHo was left untouched for months. "I was looking at those things and almost thinking

them through as a cutup," Haring said. "If it's a baby facing the dog it's one thing: if it's a row of babies being followed by a dog that's another thing." He would draw his rows of babies and dogs on walls already busily covered with tags, fitting his work into blank spots or along the sides or bottoms, hoping for attention from other graffiti writers. "He located those four-sided angled lamppost bases that nobody else was using," the artist Donald Baechler says. "The lampposts were covered back then with band notices, party notices, want ads. Jenny Holzer's 'Truisms' were always at eye level. It got to the point where if you looked down, you would see a Haring drawing or collage. I think that was a big part of his early strategy."

The heat of the summer of 1980 was political as well as meteorological, and Haring responded with political street art—his cut-up headlines situated aesthetically between graffiti art and the Jenny Holzer "Truisms" posters he admired. He started creating them the month of the July Republican National Convention in Detroit at which Ronald Reagan was nominated for president, running on the theme "Let's Make America Great Again"—a nostalgic, reactionary slogan that sent a chill through the Club 57 crowd. Dread of and disdain for Reagan became an obsession in their skits and theme nights. Haring then began wheat-pasting the five hundred Xeroxes he had made of them around town during the week of the Democratic National Convention in August, at which President Jimmy Carter was renominated, a weakened candidate amid the Iran hostage crisis and a related drop in global oil production. These works were also inspired by materials on hand, as Haring's was ever an art of the available. One night, the former newspaper boy, with an eye for headline news, found ten copies of the *New York Post* stacked on the street. He took them home, cut them up, and rearranged them into five deranged headlines with new pictures. The influence was Burroughs. He had been reading *The Electronic Revolution*, in which Burroughs counsels the scrambling of news media messaging to resist "brain wave control" and to liberate consciousness.

Haring created a series of eight of these headline works over three months. The first was *REAGAN SLAIN BY HERO COP*, the words stuck with adhesive tape onto paper, along with a newspaper picture of an

accused murderer arraigned at the Brooklyn DA's office. He intercut *REAGAN: READY TO KILL*, with a photo of a robed Ku Klux Klan grand wizard. He enhanced the *Post* letters forming the collage *RONALD REAGAN ACCUSED OF TV STAR SEX DEATH* with a subtitle in smaller letters from the *National Enquirer*, "Killed & ate lover." The other news story he disrupted was Pope John Paul II's July 1980 tour of Brazil, turned by Haring into *MOB FLEES AT POPE RALLY* and *POPE KILLED FOR FREED HOSTAGE*. Like Reagan, Pope John Paul II was a conservative figure and a threat to gay rights who would loom darkly for Haring over the decade.

Speedy on his bicycle, Keith pedaled uptown and down to plaster these activist provocations everywhere. (One of his random jobs was as a bike messenger.) Ann Magnuson witnessed a man tearing one off a lamppost base on St. Mark's Place: "He was fuming mad, and no doubt a Republican." The writer Glenn O'Brien caught sight of a "really political" one at Sixty-First Street and Broadway. Tempers ran high, with the words *Reagan* or *Slain* crossed out. "It's fun when you're putting them up and people get outraged and try to peel them off while they're still wet," Haring said, "because then they get wheat paste all over their hands, and they get even madder."

A month or two into making a play for a street presence, Haring, to his delight, began to meet more and more graffiti artists. He was "getting up"—the term on the street for making a distinctive mark. "They started noticing the work and wanted to know who did it," he said. "And after I met one person, it led to another and another, so within a few months I knew hundreds of graffiti writers and was operating within that social structure. From the beginning it was important to me to have their respect if I was going to do something in what I felt was not really my territory or my right really. It was important to do it in a way that I had their respect as a graffiti writer, and not as an outsider who was trying to copy them or rip them off." On Monday nights, Keith could often be found uptown with the Soul Artists crew, at a sign-painting shop at 107th Street and Columbus Avenue that, once a week, was opened to "writers" to paint and nurture a sense of community. Here, he met leading subway artists, including Eric Haze, or "Haze," and Leonard Mc-

Gurr, or "Futura 2000," who had taken his street name from the vintage model Ford.

Haring became familiar enough with the Soul Artists community that he was able to correct misconceptions when he began giving interviews to some downtown writers: "The stereotyped idea of a graffiti writer is a Black or Puerto Rican kid from the ghetto. It's not really what it turned out to be at all. There are equal amounts of white, Black, and Puerto Rican graffiti writers, or Chinese or whatever . . . Most of them grew up in the city. If I had grown up in the city, I probably would have been doing it also." He met a few female writers—Lady Pink, Jiggs, Heart—though the scene was "pretty much a male thing." His reporting matched closely the impressions of an NYPD arresting officer who was quoted as saying, "Some of the kids apprehended—their fathers were professors at Columbia, NYU, some were CPAs, some were doctors, architects. They live in a thousand-dollar house, apartments, some are living in a $1.98-a-month ghetto. There's no generalizations." The issue vexing Keith at the meetings was not worry about arrest. As Basquiat had with his SAMO project two years earlier, and Jenny Holzer with her social broadsheets, Haring needed to find a fresh mode to relate his art to the urban graffiti he admired without being a mere late-style imitator.

His other problem was space. The experience of drawing and painting again in a studio was a thrill he was eager to reproduce: he felt as if he had been caught mid-sentence exploring his new vocabulary. Earlier in the summer, he applied for a studio in the newly founded Performance Space 122, or P.S. 122, located in an abandoned public school building on First Avenue and Ninth Street, a block from Club 57, in its first year serving as an alternative space for artists working on all sorts of projects. At the time, the focus of his work was video, and he applied for a video project. His proposal languished until a few of the organizers of "Painting Space 122"—affiliated with and in the same building as Performance Space 122—were in Club 57 on the night of his show in July and called him soon after to say that they had a temporary studio he could rent for a month for a small fee, as they knew, having also seen some of his work by then, on the streets, that he worked in a temporary way. He went over and showed them new slides, and they invited him

to take a high-ceilinged converted classroom as his studio and, eventually, to stay on for a second month to be included in an open-studio exhibition taking place weekends in October and November. The school gymnasium was given over to dance and performance, and one of the performance artists in residence at the time, Tim Miller, fondly recalls a month or so of collaboration as well as a romantic dalliance with Haring. "The roofs of the Lower East Side, especially P.S. 122, were a favorite spot for me for such shenanigans," Miller says. "I think Keith was more my cup of tea than I was his. Nerdy boys in glasses are my perma-type. He was sweet and responsible. When he was exposed to an STD, he said I should have a blood test and took me over to a public clinic in Chelsea that I had no idea existed."

An interruption in this flow, like a dull school bell ringing in the background, was a reminder from SVA that it was time to register for the fall semester. When Keith finished school in the spring, he fully intended to return in the fall. Meeting at the start of the fall semester with the fine arts chairperson, Jeanne Siegel, he told her about all he had done over the summer and suggested SVA give him credit for the work he was doing outside art school, such as the show he was creating at P.S. 122. She told him that SVA did not grant independent credit. "All of a sudden it dawned on me!" Haring said. "What am I doing going to school? I was totally hooked up in the underground art scene, and I was involved in the New York art scene. I had worked for Tony Shafrazi. I knew artists like Keith Sonnier, and I had discovered the graffiti artists. Furthermore, I was discovering my *own* work in a way that was just starting to totally explode." In Haring's version, Jeanne Siegel suggested that perhaps SVA had nothing more to offer him. She has refuted this account: "I really tried to encourage him to stay. I might have ended up saying that he should leave, because he was so determined. He kept saying, 'I don't think there's anything more here for me.'" Either way, he thanked her and ended his formal schooling and art training. Trying to recoup a shortfall in grant money, he made sandwiches in Chelsea and worked as a busboy at the club Danceteria, on West Thirty-Seventh Street, alongside the artist David Wojnarowicz and the poet Max Blagg, with whom he was handcuffed and held in a cell after a police raid on the club.

Waiting all summer for the chance to work again in the SVA studios, Keith now took advantage of the good luck of his P.S. 122 studio, at whatever hour possible, to produce the "top-to-bottom installation of my drawings" that he proposed as a replacement for a video project. The art critic Roberta Smith, two years later, wrote of Haring that "it becomes apparent that this art could actually cover the world, every inch of it"—not entirely intended by her as a compliment, as she complained of wishing for more "visibility" for his best work and accusing him of "overkill." Though installations of his abstract works in Pittsburgh and SVA were equally immersive, he first displayed this urge for retinal overload as a presentational style using his newly discovered deep cartoons in the salon-style hanging of his work at P.S. 122. The large drawings from Club 57 were all there, identifiable by their red spray-paint bursts of energy, enhanced now by stark pyramids and nuclear reactors, teleporting bodies and birthing vaginas, trapezoidal skyscrapers and blaring boom boxes, while an actual boom box played in a corner. "At the P.S. 122 show, there were lots of these drawings on paper, not as assured as he became and quite fragile," Samantha McEwen recalls. "Somehow you could feel the step he had taken. It wasn't a step made with any certainty. It was an experiment. The room was electric. The drawings were so powerful. Still, when I see those drawings, I get an incredibly weird feeling, like, whoa! He got to his visuals through this intellectual road he took through language, poetry, performance, and abstract painting, and all of those influences crystalized in these pictures."

Covering the open-studio exhibition for the *SoHo Weekly News*, art critic William Zimmer found in all the studios taken together evidence of a "Lower East Side sensibility": "The best art on view here shares a kind of physical zappiness and good humor, a quality shared not incidentally by much of the music heard in nearby rock clubs." He commented on the "deadpan realist style" of the updated allegorical paintings of Mark Tansey, yet he singled out Keith Haring. Zimmer's article, the first serious response to Haring's art in the New York press, was illustrated with a quarter-page photograph of a wall of Haring's studio. (Keith proudly sent the clipping back home to Kutztown, yet, as the photo showed some prominent penises, his embarrassed parents hid it from

his little sister, Kristen, and the neighbors.) "Keith Haring's art makes the most immediate impact," Zimmer wrote. "The human figures on his posters, based on the international symbols employed in airports, do unspeakable things. But because they are faceless, near-automatons, their functions don't seem to arise from their own desires. One rutting couple might claim, 'UFO's made us do it.' Along with the humans are dolphins, our would-be boon companions and rivals in intelligence. Haring provokes the question: what is willed and what is reflex?"

By December 1980, Keith and Kenny Scharf had moved together into a two-story loft in a gutted town house wedged between two skyscrapers across from Bryant Park, on Sixth Avenue and Thirty-Ninth Street. Kenny found the place—perfect for a couple of artists needing space to work—through another SVA painting student, Johnny Rudo, who had lived there briefly until, said Haring, "Kenny more or less terrorized him and got him to move out." Scharf then invited Keith, saying, "Please get out of that hole and come live with me." Haring was only too happy to comply, as "it was the most space I ever had." Kenny was subletting the curious dwelling—never forgotten by anyone who ever visited—from Jimmy De Sana, an artist best known for his S/M photographs of bondage and gel-lit sexual contortions, with lots of latex and masks, who used the space as a darkroom and staging area for his lurid New Wave tableaux. Some of De Sana's equipment was lying around, yet the cavernous space could absorb any amount of stuff without inducing claustrophobia. "It was above a hairdresser and was very smelly," Joan Haring recalls of the family's one visit to the funky loft.

The second floor, above the beauty parlor, where both Keith and Kenny painted, had no walls except for those for a kitchen and a bath. One section was covered with anything Keith could find to paint, including big doors; and the other, with Kenny's color palettes, which he was sticking to the walls. A small, rickety wooden staircase with no banister led to a third floor and an intact Victorian-era apartment of three little rooms at the front and three at the back, with the original nineteenth-century wallpaper—the whole divided into two living spaces. Kenny's

rear rooms were always chaotic, says Bruno Schmidt: "It was like underwear hanging from the ceiling. Everything was an incredible mess." While Keith's, like all his living spaces, were neat and punctiliously, if humbly, arranged. In one very small room, he slept on the floor in a sleeping bag. In another, facing the street, with a working fireplace, he painted the floors white and set up a sitting room with a few bookcases and a welcoming, if not entirely comfortable, row of chairs for guests to sit on. He put magazines on a low table to display them. All was very tidy, spare, and purposeful.

"Keith and Kenny moving in together had a lot to do with what happened later," said Samantha McEwen, who by now was Kenny's girlfriend and spending much of her time there. "When you get two people like that together, they attract so much. Their place didn't function like an apartment—it was more like a nursery. A lot of people were up there all the time. Kenny had a long fringe of blond hair that he'd jell to stick straight out. I remember him showing me his refrigerator. He was so proud of it. He kept sticking his palettes on the fridge. This was his main piece of art—the ongoing saga of the refrigerator." In an unused walk-in closet upstairs, Kenny, with Keith's help, built the first of his "cosmic closets," a black-lit room with black posters and a ceiling on which he painted a fluorescent orange and blue spiral, designed to enhance trips on mescaline or LSD. "It was the beginning of the whole black light era," said Fred Brathwaite. "Everyone would take mushrooms, go in Kenny's closet and bug out. Kenny would play psychedelic music and Keith would bring out paper and say, 'Let's draw.'" One Club 57 member recalled going uptown after a party to trip in Kenny's psychedelic closet: "Keith went off and read a book about Andy Warhol, which I thought was a strange thing to do on acid."

Keith was displaced from downtown, yet the Times Square neighborhood and its raw romanticism intrigued him. Just one long city block to the west was a seedy demimonde of peep and burlesque shows, kung fu posters and giant marquees for triple-X movies, cheap hustlers and drug dealers, the stained streets awash in neon pinball light— the location both geographically and aesthetically of *The Times Square Show*, held in a massage parlor earlier in the year. (The organizers of

that show had invited Basquiat to paint its front signboard, yet when he painted the words *FREE SEX*, the sign was taken down for fear that it would attract even more of the area's usual street traffic of pimps, prostitutes, winos, and junkies.) *Rolling Stone* magazine described the main boulevard of Forty-Second Street as "the sleaziest block in America." All his time living in the East Village, Keith had kept a regular routine for obtaining his drugs, mostly pot. He would go to various, ever-changing addresses (spread by word of mouth) and slip his money through a blue door or a black door or a red door, and out would emerge a hand holding a brown envelope of drugs. In Midtown, he found procuring loose joints or nickel bags even simpler. He just walked one block east to the steps of the New York Public Library, a reliable drug exchange. "I smoked pot all the time," he said, "more or less."

As Samantha McEwen was spending so much of her time at the loft, their life became more about the three of them together, a bit like the bonding of the unusual kids Jim, Plato, and Judy in *Rebel Without a Cause*, in a multivalent relationship with something for each. "I fell in love with her," said Scharf, who admits that his "fluid" liking of both boys and girls at the time could perplex people. "She was an artist, and she knew Keith, and we partied all the time. So, Samantha would be at the loft, too—and now it was the three of us. Often, it would be the three of us in bed watching TV. It was real cuddly—and a little like a family. The fact is, Samantha and I loved Keith. And he needed love." After watching the afternoon soap opera *All My Children*, they would go out to a local diner for a late breakfast. "Then the sun starts to set," Scharf recalls, "and then you start your day." One favorite destination featured a display of pop-colored menus and revolving chiffon pies that inspired Keith to nickname it "the Pop Art Café." Sometimes, Kenny would take along a vacuum cleaner he had customized, as if taking a pet for a walk. He also began customizing Keith's eyeglasses: "I would give him a new coat of paint and a new design every week. We would take Polaroids. Toward the last few, with so much paint, they were changing shape." Said McEwen, "It was a hilarious house. There is nowhere you would rather be."

Keith was not involved sexually with either Kenny or Samantha.

"Keith and I would have experiences in the same room," Scharf says. "We loved each other, but not sexually." Instead, Haring kept pursuing love on the active streets and in the bathhouses and subway trains of New York City, with a gambler's share of hits and misses, if not much reliable satisfaction. "The problem with Keith was that he just fell in love every day—but he went after the unattainable," Scharf said. "I mean, he liked this boy or that boy, but mostly, he was rejected. He was often desperate about it, because he thought he wasn't good-looking and that he couldn't attract people. He had trouble with his self-image. So, he made this scene of sex for the sake of sex, going to the bars, going to the baths, cruising—living in a world that was then. It was only after he got famous that he could get the boys he couldn't get before." As Keith wrote in his journal:

> These fucking beautiful boys drive me crazy. This guy in the subway sitting with his legs wide open in front of him—on purpose. glancing at me and just enjoying being looked at. This guy in the cafeteria. gorgeous. I just stand there and say "gorgeous" to myself over and over again. I find a reason to use the phone so I can stand there near him a little longer just a little longer. pretty. pretty. pretty boys. And I just look and I know it's just as bad because I only look and I have an incredible imagination . . . writing it out of myself. stop thinking about it and take this energy into another form. this energy, sexual energy, may be the single most strongest impulse I feel. more than art? (!)

Adding a few more hours to their already late nights, the director of the Mudd Club, Steve Mass, at about the same moment, began poaching talent from Club 57, offering to pay its core members to take jobs as coat checkers, doormen, and bartenders. Among them were Keith, Kenny, and Samantha. "One day, Steve Mass . . . approached me and said he wanted to buy the talent of Club 57," Haring said. "He wanted to put fresh blood into his own club. This was good, because people at Club 57 really needed jobs." Started in 1978 by Mass, along with cofounders

Diego Cortez and punk fashion designer Anya Phillips, in an old textile warehouse on White Street, below Canal, the Mudd Club had always been a darker and more seriously punk club than 57. The building belonged to the painter Ross Bleckner, who lived on the top two floors and was working on stripe paintings that would be shown at the Mary Boone Gallery. To convince him to allow them to sublet, Cortez promised "artsy cabaret" music with Laurie Anderson–style performances, though once the contracts were signed, to Bleckner's shock, Mass brought in huge speakers, and Brian Eno helped to design a sound system. Says Bleckner, "The stripe paintings became my way of dealing with the Mudd Club, something hallucinatory, like strobing, pulsating lights." The "Mudd Club was based on the Lou Reed aesthetic: everyone wore black," says Cortez. In Scharf's words, Mudd "was more for the down type."

Mass's move to bring in the Club 57 crew was a surprise maneuver in club politics at a moment when club politics could be a matter of some import in the downtown culture. "The regulars, the old ones, didn't really like it when we took over," Scharf says. Mass was interested in Haring, as he was planning to open an art gallery on the fourth floor and was aware of the group shows Keith had put together at Club 57. These exhibitions took a while to realize at Mudd, so Keith also picked up beer bottles and worked the entrance to the VIP lounge, on the second floor, deciding whom to admit—"To draw my friends and the energy from that group of people." Mass recruited Kenny for the bar and the door, Samantha as a basement coat check, Min Thometz to bartend, Dany Johnson to deejay, Sur Rodney Sur to show his videos, and Ann Magnuson to recreate her Playboy Bunny theme night. The results could be hapless. One night, Haring and Basquiat drew with markers all over a new Plexiglas deejay booth, and Mass was so furious that he had the entire structure dismantled the next day. Scharf lasted only one night at the front door, as he had kept waiting in the cold someone who, he felt, was trying too hard to look like David Bowie . . . only to hear shouts of "Bowie! Bowie!" when he finally admitted the man. "To me, David Bowie was like seven feet tall. My favorite star in the world, and I wouldn't let him in!"

Among those more comfortable with the cool vibe of Mudd, as opposed to the "gay-ish kitsch" of Club 57, was Jean-Michel Basquiat, who

was at the club seemingly every night both before and after the new
staff arrived and whose noise band, Gray, played there. "I think Jean felt
both superior and jealous of all those SVA artists," said Jean-Michel's
girlfriend Suzanne Mallouk. "He often told me art school 'ruined my
eyes' and the eyes of all these Club 57 people." Basquiat was now es-
tranged from Kenny Scharf, whom he had begun to think of as a "rich
Beverly Hills kid, and carefree and everything." Yet he came to Keith's
performances at Club 57 and participated in several of the group shows
Haring curated. The two saw each other in and around the Mudd Club
and had an easy bond. "I began seeing a lot of Jean-Michel," Haring said.
"When Jean-Michel and I spent time together, we'd usually smoke pot.
We didn't talk all that much because there's wasn't anything to talk
about. I mean, I knew what he did, and he knew what I did."

When Keith was alone at the end of a work shift, especially if wired
on cocaine—doormen tended to be bribed with coke—he would usually
make his way to the Anvil, an after-hours gay club on the West Side,
sliding home to Times Square at sunrise, to sleep all afternoon and then
start the cycle once again.

Living at Times Square, Keith found subways even more of a mainline
than they had been in the East Village, the only affordable transport
downtown, thrumming and crowded in the daytime, slow and sparse
at night, covered in a second skin of colorful graffiti, and ever cruise-y.
Around Christmastime 1980, an unavoidable ad for "Chardón Jeans/
PARIS" on the prime board above the steps leading down into the Forty-
Second Street subway station featured an ass shot of a guy in blue jeans
with a kneeling young woman leering around and stroking his denim
with her painted nails. Like the Gloria Vanderbilt jeans Keith had al-
ready spoofed, these were expensive jeans marketed with blatant sex-
ual come-ons that attracted, as Haring said, "my young semiotic mind."
Even more attractive was a stroke by an anonymous wit who had
blacked out the C, leaving only the words "hardón jeans." Keith, now
always carrying a marker in his pocket, decided to copy the gag on the
many such posters he encountered on his travels. "The advertisement

company and Chardón were completely freaked out by this and would come and change the ad the next day," Haring said. "But since I lived in Times Square, I would walk every day past the thing and change it back. It was white letters and a black background, so the 'c' would totally disappear."

Another of the seasonal print ads Keith noticed in the subway stations was a Johnnie Walker Red Scotch poster displaying a little house in a snowy landscape with a train track running through and the message "Come Home to Red." He did not want to alter the ad but saw the white space created by the snowfall as a perfect spot for a row of the babies he had been drawing on the streets aboveground. So, he drew them to scale and, in a top corner, added one of his flying saucers zapping down into the snow to hit a crawling baby. "People wrote that the baby has radioactive energy," Haring later complained, in a rare case of intervening in the interpretation of his work. "That wasn't so. The rays from the flying saucer gave this glowing power." That month, in an important article in the *Village Voice*, "In Praise of Graffiti," Richard Goldstein, almost as an afterthought, brought up Haring's street work: "A number of young artists are undertaking phantom installations that can only be called graffiti. Keith Haring began by drawing crawling people and dogs in black marker; lately, he has taken to embellishing Johnny Walker ads with flying saucers." Another critic would describe the series as "alternative ads."

One late-December day, on his way to work, entering the F Train station at Forty-First Street and Sixth Avenue—right next to the entrance to his and Kenny's loft—Keith noticed for the first time a lone, empty panel covered in soft black matte paper on a station wall. Such fallow advertising panels had been there all along, though they were only briefly vacant. Expired ads would be pasted over, awaiting replacement by new ones in these square spaces considered prime visual real estate, vying for attention from the millions of daily travelers in the city's vast underground subway system. Though the panels were ubiquitous, and in use since 1905, they had remained—perhaps due to the sublimity of the dark hue of the coverings—hidden in plain sight to Keith, to subway riders, and even to those experts on subway spaces, the graffiti writers.

Like the lamppost bases on the streets, the black squares were on the periphery of vision. "He was taking advantage of the space of something that graffiti artists really never even realized existed," said Leonard McGurr, the subway artist Futura 2000. "Here is this black paper just asking to be drawn on." Often remarked by Keith's friends were his double takes—or, as Tony Shafrazi put it, his "rubbernecking," or startled eyebrows, all exclamation points in his body language triggered by the sort of discovery he had made that day: "I immediately knew I had to draw on top of them," Haring later said.

When Keith looked at the blank panel, he saw only a big, clean blackboard—and of course, every clean blackboard asks to be brought to life with white chalk. So, he quickly resolved to go aboveground and buy some. At the time, white Magic Markers were popular with graffiti artists, yet Keith knew that black matte paper would absorb the marker, and he would not achieve the tactile, sharp, crisp white line he was imagining. Chalk was not foreign to him as a material: Kermit Oswald had drawn in chalk all over the Kutztown campus during art school, and Drew Straub, while Keith's roommate, was known for drawing chalk circles on the concrete in front of art galleries and on the floor of P.S. 1. Sprinting up the street, Keith found the closest stationery shop, bought some school chalk, and returned to the subway. "I drew on one of the panels," Haring later said. "It felt incredible!" The chalk was crumbly and broke easily, yet he soon discovered the answer to this technical problem when he moved on to low-dust Crayola Chalk: "50 cents, 30 works," he said. In his first drawings, he stuck with his street logos— the crawling baby, the barking dog, the UFO. Treating the drawings as a diversion on his way to the Mudd Club, he would hop off the F Train if he spotted a blank panel—most of these drawings wound up at downtown stations, especially Broadway and Lafayette. "Keith's subway panels greeted you like welcome mats at each downtown stop," wrote Ann Magnuson, "personalized petroglyphs that spelled relief from the piss-soaked wreckage of the Lower East Side."

When he checked in a week or so later, Keith was most surprised to discover the drawings usually still intact. The turnover time for the ad spaces was two or three weeks, yet none of the drawings had been

smudged or drawn over. No one had tried to clean them off. "I mean the drawings seemed to have this protective power that prevented people from destroying them," Haring said, power that imbued them with a talismanic nimbus that matched his understanding of them as a "primitive code." He also began realizing how many people the drawings were reaching, a random public sampling far beyond the stragglers who had wandered into his SVA sculpture studio while he was working next to the street. When he created another round of drawings in the same station, someone would invariably walk up to him and say, "So, *you're* the guy who did these drawings!" The absence of a signature only heightened the mystery. This lively response emboldened him to undertake the drawings as a more intentional project and to develop a route from station to station, scouting for new opportunities. He began more often exploring the 6 Line—fittingly, the line connecting the Lower East Side to the South Bronx. From B&R Promotional Products, he ordered a thousand little white buttons with radiant babies on them that he would pass out to anyone who came up to him. Soon, they were a downtown fashion statement.

The imagery of these first drawings remained simple, starting out as variations on the flying saucer theme, almost all including a baby with radiating rays as a signature. Increasingly front and center were genderless and featureless outlines of humans—limber "Gumbylike figures," wrote Jeffrey Deitch, referring to TV's animated clay character—as much in the mode of signage as life drawing. The pace of Keith's activity grew more rapid, and the drawings executed in an even more manic and self-possessed manner. He often finished thirty or forty in a three-hour shift, with no possibility of revising, as erasing created a cloud of a smudge. Very much on the clock, a clock with a ticking minute hand, he found the late afternoon rush hour best, as he was able to hop trains with less wait time and visit several stations at a stretch. Such daytime drawing was also safer, as more people gathered to watch and, often, would warn him if a transit cop was lurking. In 1980, the MTA anti-graffiti budget was $6.5 million, subway cars were being buffered clean, and apprehending graffiti artists was a Transit Police priority. Even if Haring's fragile chalk and temporary installments were debatable in-

fractions, he experienced his share of summonses, handcuffs, and bookings. He preferred the makeup of the daytime crowds, too, as he came to understand this public drawing as a performance art: "It was a performance for whoever was watching at the time and the whole idea that you were doing it immediately and illegally and quickly . . . it was really a sort of event."

Every two weeks, Keith would add new elements or, from station to station, devise entirely new drawings. To remain inventive, he needed fresh ideas and was steadily finding them in a flow of imagery coming to him as if in a dream or, at times, in actual dreams. Early in December, someone came into the Mudd Club and announced that John Lennon had been shot in the archway of the Dakota apartment building on his way home from a recording session with his wife, Yoko Ono. In Times Square, when Keith arrived back uptown, people were walking about crying, numbly listening to news on radios, mourning together, while others went to the Dakota to hold vigils and sing "Imagine" and other Lennon songs. The next morning, Keith awoke with a burning image in his head of fierce dogs jumping through a hole in a man's stomach. He had drawn dogs and a man with a hole in his stomach, but he had never put the two together. He associated the image with the death of Lennon and began drawing it on subway panels. He was also drawing television sets, a square with an oval within, his figures filling the screen—Scharf had made the TV image his own, too, in his paintings and in a TV logo he designed for the Club 57 newsletter. As with the dogs and the man with the hole in his stomach, this splicing of images created a new sensation and teased Haring with a new idea. A barking dog and a TV emitting electromagnetic waves soon merged to become a single broadcasting TV dog. "I used to watch out the windows of the train his pictures go by in stations I didn't stop at," said Club 57 artist Kurt Thometz. "On the morning after a rambunctious night of drawing by Keith you could see as many as five new pieces on the Lexington Ave #6 between Astor Place and 68th Street."

When Haring's friend Tseng Kwong Chi saw the subway drawings for the first time, he knew he needed to make a photographic record of them—a common practice among subway artists was to return with

cameras to document their work before the MTA buffing machines re-
duced everything to a pale blur. "It was while Keith was working at the
Mudd Club that he started drawing in the subways," Tseng Kwong Chi
said. "At first, he told no one, so I actually missed photographing the
earliest ones." Yet, within two weeks, Keith told Kwong Chi what he was
up to, and he then rode the subways trying to spot them. "Here's this
guy dispensing all of this energy and effort to go in the subway and draw
on black paper with white chalk, which is absolutely brilliant," Tseng
Kwong Chi said, adding "And they are even framed!" as all the panels
were neatly framed in metal. Because Keith did not have much money,
Kwong Chi offered to photograph them, pay for the film and the pro-
cessing, and give him prints. "At that time, a picture was just a picture,"
Tseng Kwong Chi said. "Nobody was thinking copyright." But when
Haring began drawing more widely throughout the subway system, he
would call Kwong Chi on a payphone when he finished for the day and
tell him the locations. "I called it my 'weekly torture session,'" he said.
"It's not fun to ride the subway for four hours. I'd ride at the front of the
car to see if they were the same images and not worth getting off the
train." Occasionally, Kwong Chi, camera in hand, would be stopped for a
permit and pretend to be a clueless Japanese tourist. "New York subway
very interesting," he would say. His earliest photos show Haring's chalk
drawings in dialogue with the posters next to them—figures boogying
beside an ad for Bob Fosse's *Dancin'*, or arms high, mimicking Eva Perón
in *Evita*.

A common nickname for Haring in the subways—as he did not pro-
vide an alias—was "Chalkman." Also not provided was much of a clue
for interpreting the cryptic graphics juxtaposed next to ads with much
blunter messaging. ("It's hard to compete with those other advertise-
ments," Haring admitted. "They sit around in their office for hours
trying to think of this thing that is going to have some impact. I had
like a minute to do the same thing.") When he began drawing his wily,
elongated striped snakes—the symbol of Alechinsky's CoBrA movement
Haring had so loved in Pittsburgh—a man ran up to him on the Grand
Central Station platform and said, knowingly, "I hear ya. We're all get-
ting swallowed up by some fuckin' snake!" Haring's response to ques-

tions or answers about his artworks' meaning tended to be "That's your part. I only do the drawings." Another of his nicknames, used among the corps of Transit Police tasked with enforcing graffiti violations, was "Michelangelo." An article in the *SoHo News* that spring concocted yet another epithet for him in its title, "Artful Dodger," as Haring, while drawing an off-the-hook telephone, pointed out to the writer of the piece a squad of Guardian Angels, the self-styled "street patrol" who rode the New York City transit system and made citizen's arrests. "The subway vigilantes patrolling an adjacent platform," he said, "will hold me for the cops." Within a few months of starting his subway project, he had been served two summonses for defacing property and handcuffed in the SoHo double-R station. He had his share of admirers willing to shield him from the police, but others were staunchly on the side of the cops. As one subway rider complained in a letter to the *Daily News*, "Who are the deranged nuts who are making drawings of surrealistic, crazy pictures with chalk on the idle black spaces for advertising on the subway walls? Those drawings are sickening. People should carry rags and a small bottle of solvent in their handbags for erasing those sick drawings."

Still, the darkly whimsical chalk drawings were passing entertainment for commuters noticing the artist's quick takes on figures a bit like themselves—with clocks for heads, or running up and tumbling down zigzags of stairs. For Haring, they were a peak breakthrough in his quest for an identity as an artist in the early eighties in New York City—a time of emergent pluralism, with many movements and styles vying for recognition, styles he had tried on for size throughout his time as an art student. "He was like a sponge," Tony Shafrazi says. "He was ready to suck all the intelligence, all the comments." In the subway drawings, he found ways to synthesize these current movements into a surprisingly new form. The drawings were clearly a response to the work of the graffiti writers, with babies as signatures rather than tags, yet equally, in Norman Mailer's phrase, "advertisements for myself." Their placement on commercial panels was cleverly semiotic, as well as pop; and their live creation before an audience, an act of performance. Haring's message widened the political activism of Colab, and his cartoons quirkily

reflected a return to figurative painting in SoHo. They also followed a logic in the history of art that so absorbed him. "Artists did chalk on found objects in the Dada period," says Diego Cortez. "So, that's what Keith's work was. It felt rich and historical even if the imagery was new."

The chalk drawings also propelled Haring forward in finding a solution to some personal artistic dilemmas he had been posing to himself since adolescence. The boy who drew cartoons had grown into a young man convinced that real art was abstract art, the direction of much of his art in Pittsburgh and during his first year at SVA. He now retrieved his first passion, and his preternatural talent for drawing, while making peace with the pull between abstraction and figurative life studies, as his imaginative cartoons were at the exact meeting point between realism and abstraction, alluding to something real yet clearly not real. "My drawings don't try to imitate life," he said; "they try to create life, try to invent life." He was also the boy who had covered the sleepy town of Kutztown with Jesus Saves decals. This early inkling of public art found its ultimate expression in the city subway system. Within the next five years, he would make more than five thousand chalk drawings throughout New York City's five boroughs, realizing one of the largest public art projects ever conceived—as one critic said, "his urban and underground equivalent to the public and participatory art of Christo's 'Running Fence.'" Haring judged the project "the most important thing I ever did." By the end of the decade, his hero William Burroughs would comment with an eye to Haring's works' indelibility—and accurately, at least for the downtown art world of New York City in the 1980s: "Just as no one can look at a sunflower without thinking of Van Gogh, so no one can be in the New York subway system without thinking of Keith Haring."

On the evening of January 20, 1981, Club 57 in exile at the Mudd Club "celebrated" the inauguration of Ronald Reagan by holding its own Inaugural Ball. This convex-mirror version of the formal ball being held that same evening at the floodlit Kennedy Center on the Potomac was dreamed up, of course, by Ann Magnuson, who, the month before, was

also the art director of "It's a Reagan World," a preposterous and giddy fake lifestyle spread in the *SoHo Weekly News*. "We were fully convinced Reagan was going to start a nuclear war with Russia," Magnuson wrote of a palpable quickening of the pulse downtown, "so we were creating at a frenetic pace and living every day like it was our last." Photographed by Tseng Kwong Chi, the *SoHo News* piece presented Keith Haring and Dany Johnson as "the Bothroids," a yuppy suburban couple in L.L.Bean-style fashion, in front of their split-level home, espousing "the New Heterosexuality" as "the Moral Majority meets the 'In' Crowd." (Other faux-Republican couples included filmmaker Jack Smith and Stacey El-kin as "the Glicks," and Kenny Scharf and Ann Magnuson as "the Van Der Heuvels.") The Mudd Club Inaugural Ball received surprising cover-age in the *New York Times*, which mentioned the "Ladies Auxiliary of the Lower East Side and the Moral Majority Singers, who drew cheers and whistles for their rendition of 'Thumbs Up America'!"

If a sudden uptick in the pace of life, a nervous energy, was a sign of the times, Keith Haring was fast becoming its highly visible embodi-ment. During winter and spring 1981, he was seemingly everywhere on the underground subway grid, while also beginning to appear in more group shows aboveground and to be covered in downtown and art pub-lications, if not in full features, in the use of his graphic-friendly imag-ery to frame other general interest stories. The simultaneous bite and goofy smile of his images found an equipoise between the serious and the silly that was often the tenor of the early responses to a radical shift in the political environment. Reaganism, to Kenny Scharf, "felt really dangerous," and for Haring, it signaled a "desire for conformity in every walk of life." His subway dogs could turn menacing, his nuclear reactors apocalyptic. When he drew crosses in a Times Square station, a woman walking by pronounced, "It's anti-Reagan. It's a warning about the Moral Majority." About the time of the inauguration, he had begun new "studio work" (sumi ink drawings on vellum) of men wielding rods, like police batons, exploding the heads or piercing the stomachs of black-dotted figures hung by their wrists. These drawings—also deployed in his subway "testing ground"—concerned raw and violent power.

As the chance visit of a few P.S. 122 curators to Haring's Club 57

show had led to his studio fellowship, so a chance visit to the open-studio exhibition at P.S. 122 by Michael Keane, who ran the exhibition *Des Refusés* at the Westbeth "Painters' Space" gallery, resulted in Haring's first solo show in New York City, on February 10. The Westbeth Artists Housing had been providing more than three hundred affordable live/work spaces for artists in an old Bell Lab building in the Far West Village since 1970, and Keane, a young painter, used half his space as a seven-hundred-foot gallery to show the work of mostly East Village artists. "I was always on the lookout for new talent and walked into the classroom at P.S. 122 full of Day Glo drawings of dolphins that were fun and immediate," Keane says. "A quiet, slim young man was sitting at a children's desk in the corner and I asked if the work was his. I could barely hear his response. It was Keith." Haring was enthused when he saw the eighteen-foot-high ceilings of Keane's Westbeth space and hit upon a plan of creating two wall-size "graffiti murals" and showing seventeen of his large drawings on vellum parchment along with blueprint copies he titled "black-blue prints." He designed a crawling baby flyer for the show and wrote in a curlicue, "All Proceeds to Benefit Nancy Reagan Moral Majority Fund." According to Donald Baechler, he and another artist who would show at the Shafrazi Gallery, Ronnie Cutrone, "physically had to drag Tony into a taxi one day to get him to go to Keith's opening, as he wasn't yet taking him seriously." Shafrazi found the work "vivid and very original," though he was startled to discover later that Keith had copied names from his Rolodex for the invitation list. Several blueprints were sold and no drawings, but Keith made photostats of all the works and, in the last year of his life, at the urging of Kermit Oswald, turned them into prints at Durham Press. He found them "a perfect time capsule of my beginning in New York City." (*Des Refusés* also cosponsored a *Monumental Show* at the Gowanus Memorial Artyard in Brooklyn in the spring, where Haring did a Magic Marker drawing on backdrop paper over sixteen feet high.)

Keith had agreed to repaint the two walls of his murals white when the show was over on Valentine's Day, but Diego Cortez's *New York/New Wave* show was opening the next day at P.S. 1 in Long Island City, and having little time, Haring instead gave Michael Keane one of the three-

by-four-foot drawings from the show—a drawing Keane later tried to erase in imitation of Rauschenberg's famous *Erased de Kooning Drawing*. Like many in Haring's circle, Cortez, having grown up in the suburbs of Chicago as "Jim Curtis," invented his tag of a street name. His purposely aslant show at P.S. 1 of more than 600 works by 119 artists, with no frames or labels, was designed to feel more like an East Village block party than a SoHo white cube gallery. Keith's sense of anticipation and need to be there were proven right. Thousands made the trip to Queens on opening day, with a line two blocks long to get in the front door of the former elementary school—where they quickly found themselves overstimulated by an entry hall covered floor to ceiling with panels by a dozen graffiti artists (including Haze and Daze, Lee and Lady Pink), the cornices filled with celebrity photographs by Andy Warhol. Other rooms held photography and artwork by rock stars (David Byrne, Chris Stein, Alan Vega); photographs by Robert Mapplethorpe (of Patti Smith) and Nan Goldin; works by the venerable (William Burroughs and Ray Johnson); and one gallery devoted to twenty artists associated with Club 57, the first exhibit to acknowledge the club's importance in the art scene. (Also enshrined in a timely memorial of photographs was John Lennon.) Haring had ten or fifteen works in the show, including a long scroll of abstract, curvilinear shapes that Cortez covered in Plexiglas and laid across the floor for everyone to walk over. The final, prime gallery was given over to Jean-Michel Basquiat, with fifteen paintings on canvas, wood, paper, or steel, in paint and crayon.

New York/New Wave drew in the public; the numbers were very good. The director of P.S. 1, Alanna Heiss, remembered it as "the most excessively crazy and successful show we had ever organized." Yet many ostensibly hip art critics remained ambivalent. John Perreault, in the *SoHo News*, wrote a piece titled "Low Tide," as a joke on "New Wave": "It may be a neo-Neo-Dada, a raspberry delivered with thumb to nose. If this is the intention—a dare to the art world, a youthful critique—I'm afraid it is a failure. The art itself is not ambitious enough." In the *Village Voice*, Peter Schjeldahl's sharp title was a review in itself—"New Wave No Fun." To Kay Larson, in *New York Magazine*, the show was "an advertisement for a Club Med–Mudd Club Party." A sole exception—and

more in line with later reassessments of the exhibition as seminal—was Glenn O'Brien in *Interview*, who restored the sheen to the show's New Wave label: "This is a tidal wave of art, about to reduce the entire art world to limp rubble, particularly the stuff that floats. Here's a whole new art world ready to replace the old." O'Brien singled out for the most extreme praise Jean-Michel Basquiat and Keith Haring. He devoted a paragraph to Basquiat's "wild and perfect paintings and drawings . . . charging the atmosphere with art ions." Of Haring, he wrote, "Another of the Great Artists of Our Time sort of debuting here is KEITH HARING, yet another who trained on unauthorized surfaces, whose dog people cartoons make our streets a funnier place to walk. His line drawings of dogs saucers, etc. look just as good indoors as out, and his bold stroke should be an example to most of us."

The ire provoked by *New York/New Wave* in the usually friendly downtown press was surprising, especially given the great reviews for *The Times Square Show* the year before. Some of the judging may have been a misunderstanding. *New* was a term often used that season in the art press for the return to painting, the "neo-Expressionism" of young painters such as Julian Schnabel, David Salle, and Eric Fischl, at the Mary Boone Gallery, daring to apply brush to canvas and explore figure and color after a decade of minimalism and conceptualism. (Of the seventies, Cortez said in an interview at the time, "You'd go to openings and find white walls, white people, and minimal white art.") Yet none of the young Mary Boone painters had appeared in *New York/New Wave*, conceived by Cortez as "neo-pop," an exploration of the cross-influences of punk music, club life, and art and the mixing of high and low mastered in the sixties by the presiding genius of the show, Andy Warhol. "Keith and Jean fell outside that eighties painting thing," Cortez says, "and were more connected with the radical inventions like public art and graffiti. When we think of the eighties, we think more about the music than the art in popular culture. We think about Madonna. Keith and Jean were right there with Madonna, Bowie, Eno. That may be the core of the eighties. I think my show said that and predicted that."

Sometime after seeing the work of SAMO on the streets, Diego Cortez had offered to be Basquiat's agent, showing his works privately to

various clients such as Henry Geldzahler, Jeffrey Deitch, and Eugene and Barbara Schwartz. When Cortez began selling some of Basquiat's work, even if not for much money, Keith asked if he would also represent him. "I agreed, as I loved his work. Keith was likewise a genius." Yet their brief arrangement was not as successful as Cortez's with Basquiat. Keith gave Cortez a tube of twenty parchment drawings that Cortez proceeded to lose, to his horror, while getting off a D Train: "I kept shouting to the other end of the train, but the driver wouldn't open the doors. I never saw the drawings again." Showing the earnestness of a lesson learned—he had similarly lost his drawings at the Jersey Shore—Keith said, "Oh, don't worry about it. I'll make more." More disruptive was Cortez's less tolerant reaction to Keith's intensity about his career, which Cortez interpreted as "micromanaging": "He was constantly asking me if I sold anything. He was asking impatiently. So, I said, 'You can always take the drawings back,' which he did. It strained my relationship with him. Keith wasn't money-grubbing. He wasn't super-competitive. He was just very hyper. He was hands-on from the start. Jean was more laid back with me. Keith was a perfectionist as far as his career went."

A week after the opening of *New York/New Wave*, the fourth-floor gallery finally came together at the Mudd Club, with Haring curating the *Lower Manhattan Drawing Show*, an exhibition with nearly as many artists represented as at P.S. 1, and much overlap. (*Overlap* would be the operative word in describing the frenzy of art shows beginning to multiply in the downtown art scene then.) All the Club 57 artists were there, and the graffiti artists Jean-Michel Basquiat (with his *Flats Fix* drawing, which Keith felt was "incredible"), Donald Baechler, Jane Dickson, Frank Moore, James Brown, and David Wojnarowicz. "Kenny always said Keith was the only artist who encouraged other artists," says Samantha McEwen. "I remember him saying to me, 'Yeah, you've got it. You've got that thing, whatever it is.' He was always putting me in shows, like the drawing show." Keith's brief run as art curator at Mudd came as he was trying to find alternatives to the runaround of artists toting their slides, trying to find acceptance from dealers committed to established artists. It also gave him a kind of soft power among his peers, as he was inviting them into these shows. The press release for

the three-week show promised "the works of some of the most talented young artists in lower Manhattan, many as yet unrepresented by dealers," and club hours for viewing were given "as late as 2:00 a.m." In a *Village Voice* review, Kim Levin wrote that if P.S. 1 was "full of the glamour and grotesquerie of the music scene," the drawings at Mudd "get closer to the sound." "Anyone can draw," Haring told her. "If I had gotten drawings from people off the streets they probably would have fit in just as well." A month later, he was curating *Kwong Chi: East Meets West*.

The last show at Mudd that Haring was involved with was *Beyond Words*, billed as a survey of "what Graffiti has created and how its influence continues." Opening night, April 9, was a "Music Jam," deejayed by Afrika Bambaataa, with "some of the top rap vocalists of the South Bronx scene." Keith invited Fab 5 Freddy and Futura 2000 to guest curate, as he wanted credibility and did not feel right choosing among the graffiti artists. The street cred of the exhibition soon became almost too solid. Every night, more teenagers with cans of Krylon, from the Bronx as well as the nearby Jacob Riis housing projects, would show up not just to look at art but to hang out, have their books signed by the masters, and "sign" the Mudd Club, until its walls and staircases were covered in tags, the busy markings spilling onto the neighborhood streets. As turf wars were a feature of the graffiti world, and as that world converged nightly on the club, so did its conflicts. One night, the front door was locked shut to keep out someone threatening to kill a graffiti writer inside. "It turned out to be not just a graffiti exhibition," Haring said, "but a graffiti convention." As Brathwaite recalled, "Nobody had heard or seen anything like it. These clubs were 95% white on any given night, so when you had a lot of young African American males and Puerto Ricans in the mix it just changed the dynamics—and that was a good thing."

Steve Mass was not so sanguine, and the goings-on, including complaints from neighbors, made him, from Haring's point of view, "paranoid." He began painting over the Mudd's hallways, his anger targeted at his employee. Mass had never been the ideal boss for Keith or for any of the Club 57 crew. "We were young kids who didn't like authority," Magnuson said, "and he was an authority figure." Brathwaite felt that "Steve Mass treated Keith so bad. I remember one day he was going to

be paid. Steve lived around the corner but he did not want to see Keith so he would leave his money outside the door." Bleckner recalls the issue of the graffiti in the building's freight elevator predating *Beyond Words*: "Keith would often go up and down the elevator during the day doing work for Steve, like cleaning. So, he would do graffiti in the elevator shaft. Eventually, it all got covered with his work."

For Haring, the rift felt welcome: "Suddenly I realized I could quit, because weeks earlier I had sold some of my drawings—and I had been paid well. I realized I could probably start living from my work. I also realized I didn't ever have to do menial work again. And so, I quit. I think that because of the graffiti show, I went out with glory. I didn't know it then, but working at the Mudd Club would be my last job where I would ever have to work for someone else."

CHAPTER 8

"Love Sensation"

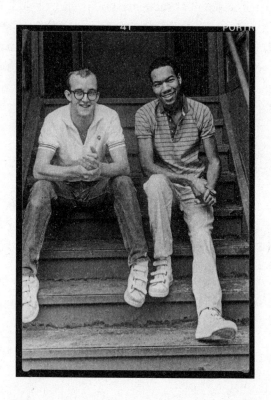

The eye-popping panopticon of Times Square, with its alluring, tawdry commercialism, left its mark on Haring's art during the six brief months he lived in the neighborhood, which constituted one of his work's many moments, or identifiable milliseconds of "periods." The subway project may never have been realized if he had not lived at its inception in the nerve center of all the train lines with the most empty advertising panels. Aboveground, too, Times Square was

an extended come-on, advertising cheap sex, pricey jeans, and popular current Broadway shows such as *Oh! Calcutta!* with its scenes of total nudity. Haring tried to reflect this mix of the raunchy and the slick in a series of drawings begun in the loft on March 30, 1981, the day Ronald Reagan was shot and wounded by John Hinckley Jr., who was trying to impress the actress Jodie Foster—a confluence of Reagan, violence, and a teen actress somehow weirdly predicted in Haring's collage *RONALD REAGAN ACCUSED OF TV STAR SEX DEATH*. Tracing images from one of the most visible ad campaigns around Times Square—Brooke Shields bent over unbuttoning her shirt while wearing a tight pair of Calvin Kleins, shot by Richard Avedon—he superimposed tracings of a pinup boy from *In Touch* magazine. The last of the ten Day-Glo drawings on plastic was simply Brooke Shields with the pinup boy's big dick, like a hermaphroditic goddess, advertising not unisex jeans but unisexuality itself. The erotic center of the drawing, for Keith, though, was clear: "The pinup boy was up until that time the most beautiful boy that I had ever seen. I was starting now to appreciate and become more obsessed with Puerto Rican and Black boys. And I was hanging out with graffiti artists who of course I wasn't sleeping with but who I was more attracted to."

Catching his eye, too, in April, shortly after quitting his job at the Mudd Club, was a tourist shop selling commercially printed posters of instantly recognizable celebrities, the sort of souvenir a teenager might buy for a few dollars to pin above his bed. Keith chose to buy posters of Marilyn Monroe and Elvis Presley, knowing they were among the most famous images silk-screened by Andy Warhol in the 1960s, in his early innovations in pop art. Already a student of the textures and concepts of pop art, Keith—on his daily walks through the glare of the marketplace of the neighborhood—was now only put more in mind of Warhol. He admitted that his exact tracings of Brooke Shields were "working in the manner of Warhol, repeating them." Homage was also an element in the dozen or so printed posters he marked with sumi ink along with tempera and gold marker. "There were these great posters of Elvis and of Marilyn that were archetypal, great, red-white-and-blue photo pictures of Elvis and Marilyn that I had drawn on top of with marker and

Sumi ink," said Haring. "Very much in the manner of Warhol, redrawing on top of paintings, so they were still pictures of Elvis, but they had been embellished." Yet Haring's were as different from Warhol's elegant silk screens as the two were alike. His were hot, rather than cool, as he attacked them with his marker, raining down black dash marks, even scarring. One Elvis head is so enmeshed in a spiderweb of dark lines that he is defaced. The effect, as with the Brooke Shields drawings, looks as much primitive as pop. "Precious differences announce independence from the master," the art historian Robert Farris Thompson would write of the *Marilyns*. "The film star is updated with New Wave makeup and the background seethes with 80's grafitero tagging,"

In May 1981, a week after his twenty-third birthday, Haring once again made a one-night exhibition at Club 57, this time mostly of the new Times Square works. His solo show was the main pick in the This Week section of the *SoHo News*, illustrated with his dogs, babies, and an off-the-hook phone: "When he's not drawing in the subway or on the street, Keith Haring is drawing in the studio. His new drawings are on all kinds of surfaces, from black vinyl to Elvis posters. See them one night only at Club 57." The biggest change from his two-artist show exactly a year earlier was the presence of collectors. Haring's work was beginning to sell. An oaktag piece from *New York/New Wave* was bought for $350 by Harrison Rivera-Terreaux, who worked with Christo. After the *Beyond Words* show, Haring was discovered by the London art dealer Nicholas Logsdail, owner of the Lisson Gallery, who came by his studio one day and bought a group of ten drawings. "This is the first time I got over a thousand dollars in my hand, in crisp hundred-dollar bills," Haring said. "Of course, the first thing I do is buy cocaine." (As a curator of *Beyond Words* as well as a contributor, Haring sold the graffiti artist Crash's first work for him, too. "We go upstairs, and unbeknownst to me, it was Ross Bleckner who bought the piece," says John "Crash" Matos. "He paid me cash, so I was really happy. Before I left, Keith asked me if I would lend him five dollars. He wrote on an index card, 'IOU $5 KEITH HARING.' I still have it.")

The first, and most loyal, of the collectors in Haring's life would turn out to be the Rubells—Donald, a gynecologist and the brother of Steve

Rubell, the cofounder of Studio 54; and his wife, Mera, who owned a tennis store uptown. Keith had just met them a month earlier at the *Beyond Words* show. The couple had heard of the graffiti show at Mudd and traveled downtown only to find themselves disoriented in a poorly lit fourth-floor gallery. "We saw this strange looking man-boy sitting on a swing at the far end of the gallery," Don Rubell said. "We looked at the graffiti pieces, several of which were quite interesting, and went over to the man on the swing at the far end of the gallery who introduced himself as the cocurator—never mentioning his name." Picking up on their interest, the "man-boy" offered to take them uptown to meet some of the artists when the gallery closed at 1 a.m. They went together on the train to Spanish Harlem and spent a few hours visiting storefronts, meeting several graffiti artists, and eating at Kentucky Fried Chicken: "We were amazed at the sophistication and erudition of our guide and after an hour or two he finally volunteered his name—Keith Haring— and reluctantly admitted that he was an artist. We were so impressed with him that on the subway ride back downtown we asked if we might see his work. He said his work was not yet ready to be seen (this was a first for us) but took our number and said that when he felt the work was ready to be seen he would give us a ring." After a few weeks, he called to tell them of his Club 57 show.

When they walked into Club 57 shortly after 6 p.m. that Tuesday, the Rubells said they were "overwhelmed" by the energy and audacity of the work covering the walls in such an intimate setting, expressing, they felt, "a new idea." Don Rubell was just sorry he had stopped for an egg cream at Gem Spa on Second Avenue, allowing Jeffrey Deitch, not only a writer about art, but also a curator and the manager of the Art Advisory Department of Citibank, to buy two pieces before they "bought everything else for sale"—not everything, as Haring had also painted the walls and the record player. "We were fortunate enough to know Andy Warhol at that time, and when we walked into the basement of the church on St. Mark's Place, the first thing that really struck us was that an artist would dare to revisit what appeared to be Warhol's territory," Mera Rubell said of the *Elvis* and *Marilyn* series, which would prove to be atypical of Haring's work, as he rarely appropriated images afterward,

other than Mickey Mouse or Smurfs. "He was literally putting his mark on these images. It was a very aggressive action." They also bought a large, awkward piece on wax paper, of lines that wound in and out of hints of babies or dogs yet never resolved into a settled design. "It was torn, a very strange piece, and I think Keith just figured he would roll it up again and take it home with him," Mera Rubell said. "When we told him that we wanted to buy it, he asked, 'Will you frame it?' I think he was testing how insane our commitment really was. The frame cost four times everything that we bought." When the Rubells found a summer home, their requirement was a door nine feet high to accommodate the work.

Soon after the 57 show, the Rubells visited the loft on Times Square, wondering what else this young artist, who had at first presented himself to them as "very vague and very modest," might be creating in his studio. Yet these studio visits—and others by interested dealers and collectors—began to frustrate Kenny Scharf. "So, the Rubells come to the studio and they're buying my stuff, but not Kenny's, which is all over the place," Haring recalled. "This is now putting a wedge between me and Kenny. I try to show the Rubells Kenny's things, but they don't want to see it—they walk right past it." Scharf confirms this: "I can tell you stories about what the Rubells put me through and never bought anything. At Club Fifty-Seven, I had my customized manicure set you plugged in that looked like a UFO from the sixties, with like a million attachments for your cuticles. As part of the show, I was giving manicures free, but was selling the art for fifty dollars. I sat there and gave Mera a goddamned manicure, and still they didn't buy it."

Life in the loft for the young and naïve threesome had begun to fray from all the sudden stress. Tensions around career, with the introduction of money and dealers, were increasing—a dynamic that Haring would experience more acutely in the coming months and years. It was the snake in the garden. "As bright as the light cast by Keith, the shadow behind him was even darker," says Kermit Oswald, no stranger to the dynamics of rivalry with his friend. "It became nearly impossible to exceed the attention he started to get. It was nearly insurmountable odds. I think Kenny was certainly aware of that." Scharf began feeling

miserable—fearing Keith was overshadowing him—as the competition caused problems in their friendship. At the same time, he and Samantha were coming undone. "For whatever reason, I could no longer handle it," McEwen says. "But then we were sort of breaking up and getting back together for quite a while for over a year."

Any sticky choices about how to proceed were spared them. Early in the summer of 1981, Keith, Kenny, and Samantha were kicked with finality out of their Times Square sublet, and the incident triggering their hasty departure was bloody. "We would have these parties with lots of people, right next to Bryant Park, which back then was very dangerous," Scharf explains. "We're having this party, and some guy got stabbed in Bryant Park and wanders into our party, and there's blood on the floor, and people thought it was an art performance and just watched him wander around. Within minutes, we had like twenty cop cars and cops inside the place, and basically that's when we got kicked out." Kenny returned to the East Ninth Street apartment he had been subletting to a tenant, likewise on his way out. Samantha had held on to her apartment on Broome Street and Chrystie—a cramped street with a shop display outlet and some warehouses a few blocks from Little Italy—yet her studio was being consolidated by her landlord into a larger apartment occupying the entire floor. She needed a roommate to help with the higher rent. Keith volunteered to move in.

Rather than a clean break, Samantha and Keith's apartment at 325 Broome Street at first simply felt like the Times Square loft in a new location. Samantha kept her bedroom and kitchen at the rear of the railroad flat, they shared a bathroom, and Keith took the two front rooms, which he used as a studio and a living room, in addition to another closet of a room. "I decided that I'm going to sleep in this tiny room because I like small, enclosed spaces," he said. He set up the living room with vinyl diner chairs for guests, metal shelving found on the street, his stereo, and crimson-red-painted window shades. "Kenny got very odd about coming to see me after Keith was living there," McEwen says. "I think it was literally like this sort of territory thing." Even though Scharf was

less present in the apartment, he painted everything he could get his hands on, including a clock radio, rotary phone, turntable, and speakers. Soon, the front door was tagged by many friends, with a Jane Jetson caterpillar by Scharf and Basquiat's angular crowns.

The block was lively by day, with lots of moving of merchandise, anything from shop mannequins, to mirrors, to plastic champagne glasses, to antiques, to drugs. After dark, the commerce shifted from wholesale to street prostitution, the working girls at Christmas, McEwen remembers, "wearing tinsel bikinis in the snow." On the first floor of the apartment was a gaudy lampshade store they passed each day going in and out. Muggings were common, as on many blocks of the Lower East Side. Yet the location was attractive, as the East Village was just a short ten-minute walk along Chrystie or the Bowery, and SoHo even closer. (Though Haring needed to take the subway much less, his subway riding by then was intentional, his pace of working on his project not letting up, as he introduced into the lexicon, during the summer of 1981, lightbulbs with sparking filaments, dancing chickens, and snakes snaking through stomach holes.) Across the street was the basement dance studio of Muna Tseng, Kwong Chi's sister, for whom Keith made dinosaur, pharaoh, and pyramid drawings for her dance piece titled *Epochal Songs*. "It wasn't exactly rough, just very Lower East Side," McEwen says. "I used to walk home at night from Bruno and Carmel's flat on Second Avenue down Chrystie, which was just warehouses and a completely derelict park. On the corner of Delancey and Chrystie was a very full-gay Puerto Rican girls' nightclub, all very scarves and crew cuts, seriously tough. On the other side of Delancey were the hookers, being picked up by truck drivers on their way to the Delancey Street Bridge. Even though it was completely deserted, it was humming with activity. I would have thought Keith would have moved on from there, but he didn't for quite a long time."

The party scene from the loft followed Haring downtown. "He was constantly bringing everybody together, involving everybody, and celebrating everything," McEwen says. "There were so many industrial kitchen shops on the Bowery. He'd find a new champagne glass, and so, we'd have a party." Often hanging out were the two guys living down-

stairs, one a Cuban SVA design student and his English boyfriend. While Haring largely stayed away from heroin, he was availing himself of lots of grass, mushrooms, and cocaine. Fab 5 Freddy and Basquiat were often in and out of the kitchen Keith and Samantha shared. "I don't know if Jean-Michel was shy or just creating a sort of mystery about himself," McEwen says. "If Keith wanted to tell you something, he would just tell you right there. Jean-Michel would never tell you anything. If he did, it was always sideways; he wouldn't be looking at you. He was always a little hunched over, interesting looking, in worn old men's clothes and dreads." Keith continued his habit of bringing home one boy after another: "Keith would bring home all these people—I mean, the place was mostly just packed with guys—or there'd be a different guy there every night. Keith was already becoming quite well known, and a lot of the guys didn't know who Keith was until he had gotten them home. They'd see the art, and they'd say, 'Oh, you're Keith Haring!' To many of them, you just wanted to say, 'Go away!' They all wanted something from Keith; they all took advantage of him. That seemed to be the extent of Keith's private life."

Keith was earning just enough money that he was now able to rent a narrow room in the basement with a large, dirt-smeared window overlooking the street—his first studio where he could be completely on his own. Here he worked over the next year in the bleakest of basement rooms—lit by bare lightbulbs, with floors of broken concrete and spotty wooden planks, exposed wiring, and rats running along the pipes—tunneling through his art with single-minded passion while his life and career transformed unrecognizably around him. Through the bleary window, or on his way up or down the couple of Club 57–style lower-level steps, he was able to take in a parade of sheer materiality on display each day, some finding its way as innovation into projects he was developing belowground. Across the street was a warehouse of colored tarps (especially ultramarine-blue tarps) being carried in and out all day long, and evidently noticed by Haring, who would use large tarps instead of canvas in his first big gallery show. Next door, among the blow-up Dalmatians and mice, hanging rails and mirrors, of the shop display outlet, were fiberglass vases of the sort he would soon paint. "He started

doing maybe his best work, really amazing work in that studio," Bruno Schmidt says. "He changed a lot. He became more focused. He gave me a beautiful painting I still have of an angel in orange and black from Broome Street. The work was just more punchy or strong. I remember that everything became very graphic."

Samantha came home one day not knowing whether Keith was in the apartment. She called out, "Anyone home?" As the apartment was set up, the entry door led into her rooms at the back of the building, so she walked up a hallway to Keith's rooms at the front, rounded a corner, and came upon an unusual scene. Keith had pulled a chair into the middle of his tidy living room—the only other item out of its normal place the telephone, which he had placed on the floor in front of him. He was simply sitting there, staring at the phone, unfortunately not yet ringing—unlike all the telephones he was always drawing on the subways. "What are you doing?" Samantha asked. "I'm waiting for a phone call," he answered. He had met someone at the New St. Mark's Baths, on St. Mark's Place, the night before. The guy had written down his number on the baths' stationery. Keith called and was waiting for a return call. As he did not own an answering machine, a rare commodity, he did not want to risk missing the callback. "It was so beautiful, visually such an interesting thing to have seen," McEwen says.

The young man at the baths was Juan Dubose. He did call back, and Keith kept the piece of paper with his number written on it for the rest of his life.

The two had met near the end of the night, after Keith had already been fooling around with a few others, here and there, on the three floors of locker rooms, group showers, and long hallways of cubicles with pallets and towel hooks. The St. Mark's Baths was still mostly clean and well kept, having just opened in 1979, claiming to be "the largest gay bath house in the world," with its own café, steam rooms, even some of the sheen of a nightclub, as gay men were beginning to expect more creature comforts from their clubs and bathhouses. "I had great sex with him and just decided that he was the right person for me," Har-

ing said of meeting Dubose that night. "I mean, he was Black, really thin, the same height as me, his dick was the same size as mine, and he was almost the same age as me." After three years of making the scene nightly, doing the baths and cruising, Keith had been aching to find someone if not exactly to settle down with, then to run with. He was frustrated that he did not have a lover and remained insecure about his looks and lovability. While promiscuity was the coin of the realm in gay life of the period, as for many of the younger, "out" generation, Keith's most powerful drive was still the romantic impulse to find a lover. "We ultimately fell madly in love," Haring said passionately. The personal at the time being necessarily political, he and his generation were also knowingly remaking society and their own lives by treating the once-private or even secretive as public. The mere gesture of hand-holding or embracing and kissing on the streets was the equivalent of a proudly raised fist. Like the penises in his drawings, his new relationship was both casual and a statement. "Having found this person—having finally found someone I was completely crazy about—I felt as if I was starting a whole new life."

For the first month, Keith spent a lot of time in the Bronx, near Riverdale, where Juan was living with his sister, Desiree. Juan was less than a year younger than Keith, having been born at Harlem Hospital in 1959 to parents listed on his birth certificate as "colored." His father was a postal worker from North Carolina, and Haring was told that the family had come to America from the West Indies several generations earlier. While Juan would eventually be taken in by the Haring family, too, and was given presents at Christmastime, on his occasional visits home to Kutztown for holidays or special family gatherings, Keith coyly described him to his parents as his "bodyguard." Desiree Dubose, though, was welcoming from the start. When Keith rode the train to the Bronx to meet Juan, he often stayed the night. "His sister, who I become great friends with, is very cool, and knows he's gay, and it's alright for me to stay over," Haring said. "It's everything that I wanted. He's totally butch and it's the best sex I ever had. We totally love each other." Juan had a job in Brooklyn installing and repairing car stereos, suitable for him, as the rest of the time he was devoted to music and loved to deejay.

In the mornings, the two needed to get up early so that Juan could get to work on time. He would drive Keith downtown in his beat-up car and drop him off at Broome Street on his way to work.

After a few months of seeing each other, Keith and Juan decided to move in together. Samantha was agreeable enough to the new room-mate. "In moved Juan, and in moved the sneakers," McEwen says. (They both wore sneakers almost exclusively, and between them owned many pairs.) Yet the new living situation required some shifting. As the only door was at the rear of the apartment, Keith and Juan were always traips-ing through Samantha's bedroom. The kitchen was also in her section. Though she rarely cooked, Juan loved cooking, and even his mother was known to appear and cook paella for everyone. So, they decided to flip the layout, with Samantha taking the front rooms, and Keith and Juan the rear. To ensure some privacy, Keith, no stranger to tents from hitch-hiking across the country, put up a huge tent made for four people, with a foam-rubber mattress inside, where he and Juan could be alone in their romantic stage set. "The two of them slept in a tent like kids do," Tony Shafrazi remembers. "And they were both tall! I would look at this and say, 'What is that for?' They'd just laugh. It was plainly different."

Keith never explicitly discussed his sexuality with his family, though the tent was a tip-off when they visited the apartment. "The first time we went there, we realized there was one tent for the two of them, and my mother said, 'Do you think he's gay?'" Kay Haring says. "I said, 'I don't know, I guess.' Then life went on, and nothing else was ever mentioned, because you didn't talk about those things." In a later *Rolling Stone* in-terview, Haring said, "Though we never talked about it, after coming to New York and visiting me when I was living with Juan, my parents fi-nally accepted him as part of the family. And, by the way, the fact that he was Black was an added thing for them to deal with. Although they're a very open-minded family, I heard nigger jokes at the Thanksgiving table growing up. Not in the last years, but when I was a kid."

Juan was extremely quiet, generally monosyllabic, yet he and Keith were bonded in their passion—their style of being together every bit as clinging as Keith's first love with Suzy. A photograph from 1981 shows them smiling together on the front steps of the Broome Street building

wearing matching white Velcro sneakers. They appeared at a Valentine's Day party at Deb Parker's in matching white running suits, and at an Anselm Kiefer opening both in formal black tie and tails with informal sneakers. Early on in their relationship—Keith's first vacation off the mainland, and his first time in an airplane since infancy—he and Juan traveled to Puerto Rico with Dan Friedman and Tseng Kwong Chi. "Juan was super lovely, naughty, beautiful," says Desmond Cadogan, a mutual friend of theirs. "He's the person you'd want to chill around. There was nothing too extroverted about him, no attitude." Says McEwen, "Juan was the most beautiful guy. Very slim, like a reed, very serious, didn't smile much, and very focused on Keith and their kind of life. Juan used to cook every night, and Keith would come back from his studio, and Juan would have made something absolutely delicious. Keith was so happy to have this home life." Carmel Schmidt recalled Juan "exuding this very quiet dignity." Juan was never around without the sounds of musical beats, as he moved his deejay equipment in and spent much time making cassette mixtapes for Keith of the latest disco and house music, which Keith painted to. Friends would also bring by tapes of freestyle dance music. "At the time, you could make copies of street jams by putting a boom box right next to the speaker," says John "Crash" Matos. "If Grandmaster Flash was playing on the street, you put in a blank tape and recorded like two hours of music. I brought mixtapes over every couple of months." Says Kermit Oswald, "Rare that you went in there and it was quiet. He's got a boyfriend creating hundreds of tapes a month, the soundtrack of his life. And he's handing them out like they're candy to everybody."

One night, Keith was out with Fab 5 Freddy, having dinner at a Chinese Creole restaurant on Avenue C, where a tall, good-looking Colombian guy seated nearby caught Keith's eye. An hour or so later, Keith and Fred found themselves walking the streets of the West Village, high on mushrooms, and came across Paradise Garage, a dance club in a former parking garage on King Street. Keith was aware of the club from his days going in a van to New Jersey to pick flowers, when he would see the place emptying out at ten or eleven on a Sunday morning. Fred had been to the club a few times early on; it was mostly Black and Hispanic,

straighter on Fridays, gayer on Saturdays, but mixed, and already famed for the music spun by deejay Larry Levan. "If you weren't homophobic, you could experience very hot women," said Brathwaite, "and hear the most amazing dance music that has ever been made on the most incredible sound system ever." The Garage was a private club and strict about allowing in nonmembers, yet—"By quote, unquote, accident," Haring said—the doorman turned out to be the handsome young guy from the restaurant, who recognized them and let them in. After walking up a long entrance ramp, Haring found himself in the hottest dance club he had ever experienced, filled with men of color and boasting the most sophisticated light and sound system of any club in the city. "He walked in and was like 'wow, wow, and wow,'" Brathwaite said. "He had that whole boyish glee." Ingrid Sischy, editor of *Artforum* at the time, later wrote in *Vanity Fair* that Haring's discovery of Paradise Garage was akin to Gaugin discovering Tahiti.

While Keith first went to Paradise Garage with Fred Brathwaite, going to the club on Saturday nights became a steady ritual in his relationship with Juan Dubose. "Juan and I go there every Saturday night for five years," Haring said. "We dance and we drink fruit juice, because there's no alcohol being served—and the juice is free. But many, many people are on hallucinogenic drugs—and it's the closest thing to being at a Grateful Dead concert, except that it wasn't this hippie thing, but taking place in a totally urban, contemporary setting. The whole experience was very communal, very spiritual." Keith loved the immersion that the club and Juan allowed him in other cultures of color: "The love I had for people of color was the reason Juan and I hung out at the Paradise Garage." Of course, Haring and his friends stood out. "The Garage was like nothing else," Drew Straub says. "It approached a whole tribal, spiritual level that neither of us should have really been able to experience, because there were like ten white people and three thousand Black people, and it wasn't for us, and we weren't really expected. Keith really let loose dancing on mescaline every Saturday for years. He would be flying around the world and make sure to be back by Sunday at two in the morning to go." According to his friend Desmond Cadogan, "At the Garage, Keith would be the brightest dressed, and he'd be in the middle

of the dance floor doing the Pogo, like jumping up and down, which Sid Vicious invented. He was in a sea of Black people. Four or five white people in the middle of them, jumping around in Day-Glo clothes. Keith could be showoff-y, a bit narcissistic, even." As with the graffiti artists, Keith found an acceptance with the regulars at the Garage that might not have come so easily to another; it was helped by his closeness with the respected deejay Juan Dubose. He also became reacquainted at the Garage with Tomé Cousin, his dancer friend from Pittsburgh, who saw the club through a different lens: "It was closer to the basement of the Tender Trap. If you were anything other than Black or Latin, and you were there, you had to know how to dance. That was vicious dancing."

For its devoted card-carrying members, the Garage was church, and its high priest, elevated in his deejay booth, was the trend-engendering Larry Levan, whose discography made his club as influential in the music and art culture of downtown as CBGB, 57, or Mudd. In 1981, the year Haring showed up, Levan took an obscure new release, "Heartbeat" by Taana Gardner, and by slowing down the beat in his club mix to a heavy ninety-eight beats per minute and letting the previous record fade before playing it, giving the record its own moment, he created a dance hit. His knack for triggering what, at the Garage, were called "eargasms" was noticed not only on the dance floor but by record producers, like Seymour Stein, who would rely on Levan's love of Madonna's debut twelve-inch "Everybody" the following year to break her in this club that was so important to her success. (The "Everybody" music video was filmed at the Garage.) In 1981, Levan also released a Garage version of "Ain't No Mountain High Enough"—a risk, as the song was felt to be owned by Diana Ross, who released her definitive version in 1970, and because of its ten-and-a-half-minute length. "It'll never work, it's too long," vocalist Jocelyn Brown told Levan. "Larry said, 'Watch!' He took the song where it had to go and put it in another market altogether. It became the theme song at the Garage." When Brown performed it on King Street, the crowd broke into shouts of "Jesus, baby, baby, baby!" Another favorite call-and-response with a song or singer for the crowd was "Work it!," taken from the Black and Latin drag balls. (Levan was a onetime member of the drag House of Wong, and kids from the balls

hung out at the Garage.) The deejay Junior Vasquez recalled a dance floor so soaked in sweat that baby powder needed to be spread around.

Keith would do installations, throw parties, and often hang with Levan in the deejay booth as a sort of artist in residence, much identified with the club. Its lasting significance for him was the influence on his art. The songs Keith was dancing to—"Rapture," "Walking into Sunshine," "Love Sensation"—fit a tenor of joy in his work, and he began drawing more dancing figures and painting more like a dancer. "Haring's fluid compositions, with their figures dancing inside abstract curves, paralleled the rhythm and freeform composition of the dance floor," Jeffrey Deitch said. "The paintings also embody the sensuality of the communal dance experience. Like the Paradise Garage, they are permeated with sexual energy."

Walks about town with Fab 5 Fred were often consequential for Keith. About the time the two of them chanced upon Paradise Garage, they also made their way one balmy August evening through the East Village beyond Avenue B, one of the most desolate neighborhoods in the city, wandering around, hoping to score some dope. "I was just as terrified as Keith was because not many people went that far east," Brathwaite said. On Avenue D near Houston Street, Fred said, "Yo, I smell spray paint!"

"Really?" Keith said.

"Yo, money!" Fred answered, and followed the scent into the courtyard of Public School 22, where they saw, already under way, an invitational project of leading graffiti artists painting giant murals on the sides of the building. As Haring was respected in the community for his buttons, tags, and subway drawings, he managed to get hooked up to participate in the effort—his first public commission. At work already were Zephyr, Futura 2000, Crash, and other subway writers, making big, abstract tags with 3D block letters and huge pop art renditions of a Skippy Peanut Butter jar or a Krylon can. Returning during the day, the first chance he got, Keith chose to make one of his sly borderline statements rather than competing directly with the blaze of wall murals. Standing atop his well-tagged ladder, shirtless, wearing love beads and yellow zigzag-pattern glasses, he filled in a continuous band of wall

at the second-story level, just above eye level, with his dogs, two-headed snakes, power rods, and telephones, creating a narrow frieze eight inches high and a thousand feet long.

Ever since he moved back to the Lower East Side, Keith had been noticing the graffiti signature "LA II" everywhere—on the streets, on sanitation trucks rolling by. Usually, it was a classic lowercase *l* and *a* followed by a giant Roman numeral two down the side, but sometimes all capital letters, or the Arabic numeral two, or "LA ROCK" or "LA LES," for "Lower East Side." The tag always stood out to Keith because of its simplicity and beauty, reminding him of Arabic calligraphy. "It was like discovering SAMO all over again," he said. "It was like finding another Jean-Michel." Of course, he was eager to meet the mystery artist. He mentioned the tag to Futura 2000 when they both were working in the P.S. 22 courtyard. Futura knew of LA II, and with the help of some of the kids from the neighborhood hanging around that day, they got in touch with him. LA II turned out to be Angel Ortiz, a fourteen-year-old Puerto Rican boy living in the nearby Baruch public housing project— "LA," it turned out, stood for "Little Angel," as he was only five feet, four inches tall; and the "II," in his mind, for New York, because Los Angeles was number one. A friend searched him out, and they headed to the schoolyard. When Keith came down from the ladder, Angel said, cautiously, "Yo, why you lookin for LA?" "Back in the day," Ortiz explains, "graffiti writers had beef with other graffiti writers about their spaces, so you can't just go over to a person, because if you went over, he might punch you in the face."

"You *know* LA2?" Keith asked.

"Yeah, it's me!"

Keith didn't believe him at first, so he asked him to write his tag with one of the Pilot markers he was using. "And *boom!*" said Ortiz. "Right there, he said, 'I can't believe it's you!'"

The project took two days to complete, and on the second day, Keith asked Angel if he would help him carry his ladder and supplies back to Broome Street. Angel said yes, if he could bring his friend Richie, a fellow tagger, as he was a little scared, being young and not knowing Keith. They brought the equipment to Keith's studio, where he happened

to have a primed yellow metal square hanging on the wall. "If you don't mind, can you write your name on this?" Angel wrote his name and drawings all over the surface. "Then *he* did drawings on it," Ortiz said of Haring, "and he blended my stuff with his stuff, and it looked real nice." A week later, Keith sold the piece to a psychiatrist for $1,400 and called Angel to invite him to come over to collect his half. "I said, 'Wow, that's a lot of money,'" Ortiz recalls. "I went shopping on Delancey Street, and bought my Adidas tracksuit, Adidas sneakers, fat laces." He later gave a portion to his mother, who was suspicious that a painting could be sold for such an amount and worried, as many young men on junk in the neighborhood were picking pockets or stealing chains for fast money. To allay her fears, Angel asked Keith over to dinner, and he was only too happy to accept. She liked him, and Keith loved the Puerto Rican food she fixed, and he charmed her by speaking in his broken Spanish. At the end of the evening, after Angel left the room so "the grown-ups" could talk, Keith called him back in.

"Would you like to keep on drawing with me?" Keith asked.

"Sure!"

Angel began going over often to Keith's studio, where they worked on found shelves and wood. "He and me, we just clicked," Ortiz said, "and we worked there a lot."

At first, Keith tried hanging with Angel's circle of tagger friends: "I wanted to be with LA2 and his friends, because, like Fab Five Fred and Futura, LA2 was the veritable graffiti king of the Lower East Side. He was king by virtue of the amounts of tags he had drawn. The sheer numbers alone were staggering, and they assured him a permanent place in the graffiti universe." Keith even went with them once—his only time—to the Bronx, to sneak into a train yard to draw his babies and dogs on subway doors and windows. Yet he worried that if he were caught with a marker rather than chalk, and because he already had summonses, he could face jail time. He also felt awkward and vulnerable among a group of teen subway writers: "I was the oldest and tallest person out of all these kids, plus the white boy. I look like I'm the cub scout leader. If we had gotten chased, they would have gone right for me first as the ringleader." Says Ortiz, "Keith was bugging. He was comfortable writing

with chalk on the platform, where people could see him. The train yards were very scary, very dangerous, and you had to watch your back." Angel was also getting questions about his unusual friendship and whether he was making money by sleeping with Keith. "I'd say, 'No, it's not like that. He shows me respect. We're both men.'" Haring described their relationship as "paternal, brotherly, we just become friends." Most solid was their partnership in the studio, which would go on for five years, as they saturated the surfaces of taxi hoods, terra-cotta vases, wood columns, cribs, fake Egyptian sarcophagi, kitsch garden statuary, tarps, and murals with LA II's calligraphy and Haring's subway figures, buzzing with nonspecific little scratch marks, taking him back to his earlier all-over, immersive Pittsburgh work: "We'd do enamel pieces together and they came out looking incredibly beautiful. So, the lines and squiggles I'm doing take me back to the abstract period I had left behind—this, inspired by LA2."

Ever since the Keith Sonnier show, which he observed from the vantage of a bartender at the Shafrazi Gallery a year earlier, Keith was resolved not to follow the same path as the artists who were his teachers at SVA. He was going to be his own dealer rather than be corrupted by the ways and means of the art world. He was going to maintain his integrity and not sell out. Yet one result of trying to be his own dealer was the quick transformation of his basement on Broome Street into a showroom that fit the cliché notions of some collectors as just the right ill-lit, ill-ventilated hole ideal for a starving bohemian artist. Without the protection of a gallery front desk, he found the foot traffic of "people with fur coats" trying and not at all as inspiring as the passersby he had engaged working street side at SVA or in the subways: "I began to become very frustrated by collectors who come to my studio, look through everything, and often haggle over prices. Then there are people I don't even want to talk to, because they're creeps. I can tell they want to get the work so they can resell it for more money—and they're trying to rip me off."

Not all were unwelcome, though. Impressed by Haring's work at P.S. 1,

Henry Geldzahler asked Diego Cortez if he would introduce him to the fresh young artist. (He asked Cortez for an introduction to Jean-Michel Basquiat át the same time.) Geldzahler was the commissioner of cultural affairs for New York City under Mayor Edward Koch, yet his great credential in Haring's eyes, when he stopped by the studio on an arranged visit, was a famed centennial show he had mounted in 1969 as a thirty-three-year-old curator at the Metropolitan Museum of Art—*New York Painting and Sculpture, 1940–1970.* "Henry's show," as it came to be known, was a grand moment of bringing together on the museum walls some of the most controversial contemporary art of the prior thirty years from Gorky to Pollock to Warhol and the pop artists. Geldzahler was recognizable around town in his full beard, wire-rim spectacles (as in a portrait by David Hockney), a wide-brimmed fedora (as in a silk screen by Warhol), or smoking a cigar (as in a photograph by Robert Mapplethorpe). Happily, for Keith, Geldzahler bought a couple of *Marilyns* and a good-size painting. More transformative, he left the studio a determined champion of Haring's art. When he returned to his offices on Columbus Circle, he called together his staff of sixty people, held up the few works he had just purchased, and said, "This artist is twenty-three years old. His name is Keith Haring, and he's a genius. If you can do it, go out and buy yourself one of his paintings. If not, just keep him in mind."

Another introduction made by Diego Cortez at the time was to the Italian painter Francesco Clemente, who was in New York City for the first time in the spring of 1981, staying with his family in a little room of the Sperone Westwater Fischer gallery on Greene Street, preparing for his first show. A young painter of sensuous, magical, poetic, and mysterious imagery—written about by Edit deAk in *Artforum* as one of the "new imagists" and "a chameleon in a state of grace"—Clemente was hoping to make a group of portable frescos. "Each fresco," he said, "should have been a sort of Tarot card, a sort of emblematic image." Helping find poets and painters to pose for him was Cortez, who brought in Taylor Mead, a poet and actor in many early Warhol films; Rene Ricard; and from among the younger artists, Julian Schnabel, Sandro Chia, and David Salle. Keith Haring was painted as *Man Crossing*

Fig 12 K 100%

Fred Brathwaite (Fab 5 Freddy),
December 24, 1981

Drew Straub,
March 20, 1982

Fig 1P K 100%

Samantha McEwen,
May 27, 1983

Bruno Schmidt,
September 14, 1983

Kermit Oswald,
September 14, 1983

John Sex,
September 14, 1983

Angel Ortiz (LA II),
October 29, 1982

Keith Haring and Patti Astor at Fun Gallery,
February 19, 1983

Rene Ricard at Keith's studio

Bill T. Jones in London,
October 1983

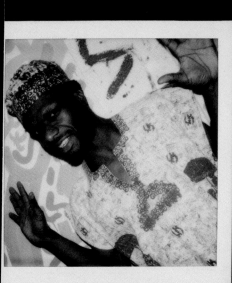

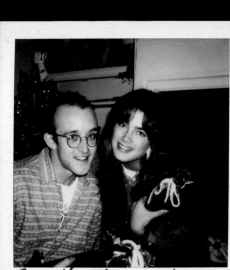

Larry Levan,
1985

Keith and Brooke Shields,
December 13, 1984

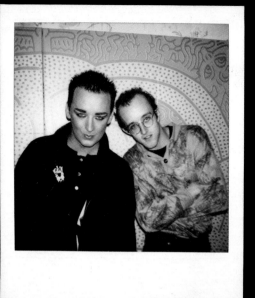

Keith and Boy George,
January 22, 1985

Zena Scharf

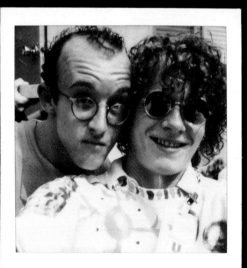

Keith and Martin Burgoyne at Live Aid,
July 13, 1985

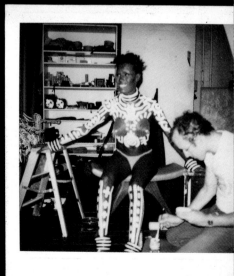

Keith and Grace Jones at Robert Mapplethorpe's
studio, July 28, 1984

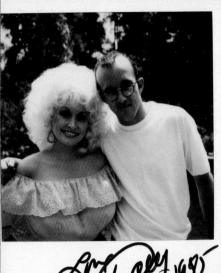

Keith and Dolly Parton,
August 16, 1985

Bobby Martinez,
1986

Adolfo Arena at Keith's studio, 676 Broadway

Keith and Run-D.M.C.,
April 1986

Keith and Jean Tinguely,
July 9, 1986

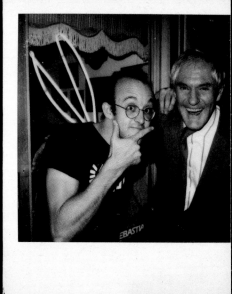

Keith and Timothy Leary,
October 1986

Tina Chow,
October 1986

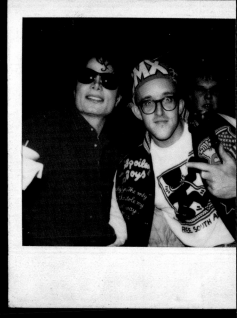

Keith and Michael Jackson after a concert,
March 5, 1988 *(photograph by Emmanuel Lewis)*

7i9 57 K 100%

Keith and Sean Lennon,
June 27, 1988

Keith and George and Anna Condo,
August 1988

Keith and Madison Arman in Monte Carlo,
August 1989

Francesco Clemente and family in Italy,
August 1989

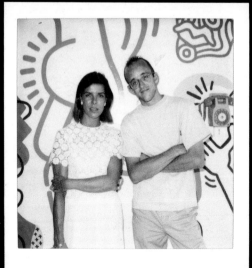

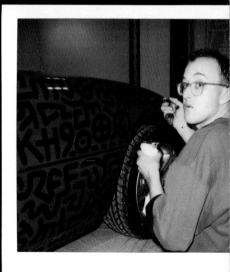

Keith and Princess Caroline,
August 1989

Keith painting a BMW in Düsseldorf,
January 1990

the Bridge. "I was there, pregnant with Nina, and this adorable young man was sitting with me at the table waiting for Francesco to prepare the fresco," says Clemente's wife, Alba. "I chatted with him for maybe half an hour, and he was playing with my daughter Chiara, who was four years old. He started to draw with a marker. The way he would draw, and the speed, where there was no way back, I was like, wow. He made about twenty drawings for Chiara and left behind this great pile of tiny drawings he did for her, one after another. I discovered he had a passion for children. Chiara was totally taken by Keith—and then, later, Nina and everyone else."

As Haring's absolute need to control his art by acting as his own dealer began to wane—and as more influential voices, such as Cortez and Geldzahler, were heard praising him—interest from dealers grew. By finding his own audience, especially on the subways, he had eliminated a middle step for many young artists of, as Jeffrey Deitch put it, "Getting bogged down in the swamp of art politics." Said Haring, a biased, if rarely false, teller of his own story, "Suddenly, I hear dealers fighting over me—from a flame there was a fire, because people saw the potential." Brooke Alexander included Haring in a small group show in his gallery on West Fifty-Seventh Street and commissioned a vase—a frequenter of the antiquities' galleries of Greek vases at the Met, Haring was now doing his own jumbo-size fiberglass vases, the one for Alexander an "archaic" design from blue enamel paint and black and gold markers. The Italian-born art dealer Annina Nosei invited Haring into a group show, *Public Address*, at her SoHo gallery, which was to debut Jean-Michel Basquiat. Hal Bromm offered Haring a solo exhibition at his second-floor gallery on lower West Broadway. Perennial was Tony Shafrazi, now clearly intent on representing his former assistant: "I remember going to his studio on Broome Street, and the energy and the work were spectacular. I had to try very hard to get Keith to join my gallery. I had to win his confidence with my commitment and my dedication to his work."

At the beginning of October 1981, Haring was in a group show, along with Donald Baechler, Ronnie Cutrone, and Jonathan Lasker, at the Tony Shafrazi Gallery—not the gallery where Keith worked on lower

Lexington, but a new, rented SoHo Gallery at 163 Mercer Street, in the space of a former wagon house with a large roll-up garage door. With the help of modest investments from a group of backers, Shafrazi was working to fulfill his vision of a gallery that would share in the more established aura of SoHo yet would feel raw and full of potential for experiment and change. "It had a half inch of dirt and grime on the floor," recalls the artist Robert Hawkins, employed by Shafrazi to help in the renovation. "We sanded and sanded and painted and painted." Says Annie Plumb, who worked as the sole staff person until she left to start her own gallery, "We didn't have any heat. The place was a wreck. I had a desk that was a piece of plywood on a couple of moving crates. Tony's was the same, at the other end of the room, and we would just yell back and forth to each other all day." Keith was impressed by the volume of the space, its access to the street, and its fifteen-foot-high walls. "At that point, it was the most interesting space in SoHo," he said, "especially since Castelli had not yet opened his big space on Greene Street." Haring had returned recently to the circles and ovals he had learned from his grandmother's how-to book to draw Mickey Mouse, but he broke down the familiar by pairing the rolling eyeballs and gleeful mouth, framed in a black border, with a new pug nose and teeth, "turning the painting into a cartoon." For the show, he mounted his striated smiley face painted on red-and-white-striped vinyl—in typical Haring placement—above the garage door.

The two-eyed smiling face evolved further when Haring took part that same month in *Public Address* at the Annina Nosei Gallery, the show conceived as art meant to engage public issues while remaining poetic and intimate. For this group exhibition, opening on Halloween 1981, the front room of Nosei's gallery at 100 Prince Street was given over to a few works each by Barbara Kruger, Jenny Holzer, and Keith Haring, with the back room devoted to six paintings by Jean-Michel Basquiat. Nosei was especially fond of Haring's imposing new vases—poking fun, their bands of drawings often as homoerotic as any Attic Greek vase, yet serenely classical, too. After discovering Canal Plastics, Haring had been toting lots of the store's lightweight fiberglass reproductions of vases, about four and a half feet tall, back to Broome Street to imbue with his

own hieroglyphs, sometimes working along with LA II. "Keith's made me think of the Etruscan or Ancient Greek vases at the Metropolitan," Nosei says. "I was so amused. I loved them. I took them right away in the gallery and immediately sold them all." He also chose to paint on a wall in the front room a hot-pink version of the smiling Mickey face he had showed at Shafrazi. "We'd been dancing all night at Paradise Garage, and we stopped by Annina Nosei's for him to do the installation," Drew Straub recalls. "Keith did one eye and then the other eye and realized it was off-center. So, he painted a third eye. We'd done psychedelic drugs all night, seeing with the third eye, and he painted it without realizing at first." Said Haring, "All of a sudden it's a profound thing about the third eye and about the subconscious and being one step beyond the normal." The three-eyed smiler cartoon became as synonymous with Keith Haring as the baby or the dog. "The wall was a great piece," Nosei says. "Everybody was without words, they liked it so much."

If Haring's show with Frank Holliday had turned out to be "Keith's night," the group show at Annina Nosei's turned out to be Basquiat's. Jean-Michel worked for weeks in the basement of Nosei's gallery to prepare the show, and Keith was often around. "All three of us would be smoking pot and snorting coke," says Straub, "while Jean-Michel would be walking all over his own canvases." Keith brought the Rubells around: "Of course we were curious. We went downstairs. And there was this stunningly beautiful person with a Cy Twombly book in one hand, and painting with the other." They immediately bought two paintings. Word on the street was that Basquiat was being treated "like a slave," though Haring, who would soon be working in the basement of the Shafrazi Gallery without any such slurs, found the comments themselves racist. The Basquiat paintings in the show included bristling portraits of a Native American, a rabbi, and a policeman. The works made a strong impression on the art world, as did Basquiat's wandering around in his paint-spattered pinstripe Armani suit, smoking a blunt, while a tape of the rap artist Spoonie Gee played on a cassette box. Annina Nosei had to admit, of the amount of attention paid during the opening to the entire group, "It became Jean-Michel and the others."

A few weeks later, Haring was in yet another show, a solo show at the

Hal Bromm Gallery. Bromm and his friends, like much of New York City, had been talking about the chalk drawings in the subway. "Everybody would keep saying, 'Well who is it?' 'I don't know, who is it?'" Bromm says. By chance, he had dinner with Lucio Pozzi, who revealed the unidentified artist to be his former SVA student and encouraged Bromm to do an exhibition. Haring agreed, and Bromm stopped by the Broome Street studio to choose works: "It was morning, and soon after I arrived, the bell rang, and it was Jean-Michel. I don't know if he knew I was scheduled to be there, but he quickly pulled out a cigar-size joint and lit up. He was quiet but very interested to see what we would put in the show. We focused on large, sumi ink on paper drawings, with all the beautiful drip marks. That was a nice contrast to the subway drawings, as chalk does not allow drips." Haring added surprises by bringing in found objects from the street, such as a painted desk drawer. The night before the show, he carried in a found baby crib that he had painted in the overall style inspired by LA II, with a tender inscription to "Juan, who I love so much, oh so much." Bromm talked with Haring about perhaps becoming his dealer, but the proposal did not go far: "Keith said, 'Well, I want to work with all my friends.' That was a group of artists he had great respect for—Kenny Scharf, LA Two, Daze, Crash. I said, 'I understand, but I'm not in love with their work the way I'm in love with your work, so I don't want to do that.' I think Tony [Shafrazi] would turn out to be just the right sort of go-along, get-along dealer for Keith."

All the ambient talk in town about Keith Haring—both the knowing sort by Geldzahler and Cortez and the more populist "Who is it?" of subway riders—was finally put in print and codified in a crucial way for Haring's career by Rene Ricard in an article in *Artforum* in December 1981 titled—and forever dubbing Haring as—"The Radiant Child." Having appeared in several 1960s Warhol films, including *Chelsea Girls*, Ricard was also a poet self-consciously in the tradition of poets among painters—like Apollinaire and, most recently, Frank O'Hara, whose chatty remaking of the poetic line into a thing of wit and felt American life, with much gay idiom, Ricard emulated with an even meaner tongue. His personal style was flamboyant. Tseng Kwong Chi described him at a poetry reading at Club 57 as "all over the place and very exaggerated."

And in his art writing of the early 1980s, Ricard was both sassy and brilliant in uncovering the new.

The "Radiant Child" article in *Artforum* was a survey of a group of his favorite new radiant children, artists such as Francesco Clemente, John Ahearn, and Judy Rifka. Yet the boon was Basquiat's and Haring's. Ricard knew he was being a kingmaker when he wrote, "Yet the crown sits securely on the head of Jean-Michel's repertory so that it is of no importance where he got it bought it stole it. It's his. He won that crown." Still, Ricard titled the piece after Haring's radiant baby, punctuated its conclusion with an illustration of one of Keith's crawling-baby buttons, and, along the way, praised Haring's "immediacy" in creating an iconography that is "faux graphic and looks ready-made, like international road signs," while articulating for the first time the urge for legibility in his art: "The ubiquity of Jean-Michel's *Samo* and Haring's baby Tags has the same effect as advertising: so famous now is that baby button that Haring was mugged by four 13-year-olds for the buttons he was carrying (as well as for his Sony Walkman). The Radiant Child on the button is Haring's Tag. It's a slick Madison Avenue colophon. It looks as if it's always been there. The greatest thing is to come up with something so good it seems as if it's always been there, like a proverb."

Art for Everybody

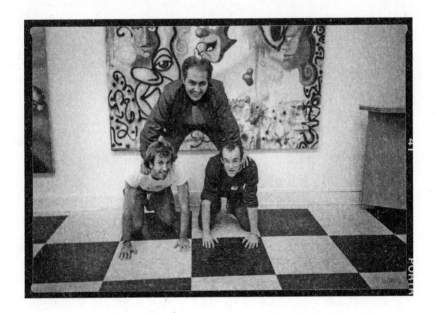

F *ittingly, the New* Year of 1982 began for Keith Haring with his name in bright, white incandescent lights—as tall and product-like as the TDK Cassette advertisement on an electronic sign nearby— a third of the way up the One Times Square building, where the ball had dropped just two weeks earlier on New Year's Eve. The lights were those of the *Messages to the Public* art project put together by Colab artist Jane Dickson—on the Spectacolor sign, the first computer lightboard

in Times Square—featuring eleven artists, including "Crash" and Jenny Holzer. "It was art meant to reach tourists and thousands of people a day who didn't care about art," says Dickson. "It had to be art that was legible in a few lightbulbs." Haring's thirty-second piece within *Messages*, running every twenty minutes for a month, consisted of his subway drawings gone digital in an animated storybook of leaping dogs, pyramidal stairs, crosses as truncheons, and babies crawling. In nighttime photos taken of Haring at the site, wearing a favorite motocross jacket with motor oil tags, his grin seems broader than usual. Yet the season was pleasing not only for his beginning recognition as an artist but also because of his satisfying personal life—his love for, and home life with, Juan and his immersion in the paradisical Paradise Garage, with its house music, freestyle dancing, street fashion, and social and sexual stimulation, which became not just his fun but his material. (Haring did his first installation at the Garage in 1982.) Some of the commentary from Haring could sound exaggerated. "I'm sure inside I'm not white," he would write in his journal. Yet he was obviously entirely taken with a life unrecognizable compared to his adolescence in the homogenous Kutztown, Pennsylvania, which he had left behind just five years earlier.

Also running through or across his 1982 was a lengthening shadow. It was called GRID, for "gay-related immune deficiency." (It would not be officially named AIDS by federal officials until July of that year.) While the general public remained unaware of the mysterious cluster of sometimes fatal symptoms covered by the term, gay men in New York City and San Francisco were beginning to spread the word, more with apprehension and curiosity at this point than complete panic. The symptoms, including a rare type of cancer, Kaposi sarcoma, were more prevalent in young gay men than older, and the medical community responded to this odd pattern with bafflement. The *New York Times* first reported on the "gay cancer," as it was more commonly being called, in a short, chilly piece that ran on page A20 of the paper in July 1981. Titled "Rare Cancer Seen in 41 Homosexuals," the article numbered deaths from the "rapidly fatal" cancer at eight. Twenty of the forty-one known cases were in New York City, and many of those had been treated for sexu-

ally transmitted diseases such as hepatitis B and had self-reported us-
ing amyl nitrite and LSD to heighten sexual pleasure. Conjecture was
putting the blame perhaps on cooling systems in gay clubs and bath-
houses, a possible conduit for fatal Legionnaires' disease a few years
earlier. Haring may or may not have read the article in the *Times*, but
the talk, and growing shock, around the sci-fi-sounding disease soon
became inescapable, especially among those who frequented backroom
bars and bathhouses, as Haring had. A for-whom-the-bell-tolls sensa-
tion took hold, one that only tightened with each passing year. AIDS
would not touch Haring's circle of friends for another year, yet it was
already closing in. By the end of 1981, 213 cases of AIDS were diagnosed
in New York City, with 74 deaths. In April 1982, at Paradise Garage,
a fund-raiser, called Showers, was held for the Gay Men's Health Cri-
sis, recently cofounded by the writer Larry Kramer, and Haring created
huge, unfurled drawings in sumi ink that hung over the dance floor.
"As early as 1982, we were starting to hear rumors of these mysterious
deaths of gay men," Haring later said. "As soon as people found out this
thing existed and heard how it was transmitted, they stopped going to
the baths. The patterns of anonymous sex and the backroom anony-
mous sex became impossible to do. You had to start being selective and
much more aware of what you were doing, and who you were doing it
with." As for Keith, his current relationship with Juan was "not com-
pletely monogamous, but pretty much so."

By the spring of 1982, Haring had settled on Tony Shafrazi as his
dealer, a decision that followed naturally enough from the logic of their
knowing each other and from both now projecting themselves in more
ambitious ways as artist and art dealer. "I never liked that word *dealer*,"
Shafrazi says. "I'm not a coke dealer. I'm not an art dealer. I might be
a gallerist and an artist, that's all." Said Haring, "The hardest decision
was whether I should go with Brooke Alexander, who is much more or-
ganized, and calm, with a very businessman look, and who I genuinely
liked also. Except that his gallery was on Fifty-Seventh Street and, to
me, there was a need to be in SoHo at this time. Brooke was established,

and I would be one person in a group of established artists. With Tony, I was going to be the one pulling the strings and be in control. That seemed more interesting to me. And I had seen this whole other side of Tony, the way he handled the art, and wrapped it, and took care of it." Haring's only misgiving was Shafrazi's defacing of *Guernica*, which he still saw as an "assault": "It was one of my favorite paintings, actually. I would go to the Museum of Art just to look at that painting." Haring asked Shafrazi about the incident point-blank, and they talked about the action many times, agreeing to disagree. Yet the subject never entirely went away. The opening of the gallery only revived the *Guernica* question as Keith worried that someone might assault a work of his "as psychological retaliation for what [Shafrazi] did to Picasso." The word on the street was that the Museum of Modern Art would never show the art of Keith Haring, or add him to their collection, if Shafrazi was his dealer. Yet Shafrazi shared an almost mystical understanding of the nature of Haring's work that matched Keith's and was certainly not being voiced by any other dealer or art critic in New York City. "I identified with Keith's tremendously pure connection to the source of art, which was coming through him," said Shafrazi, an outside and outsize personality. "It wasn't an acquired thing. He was a vessel."

With Shafrazi, Haring began planning for his one-artist show, yet the gallery was not ready. (In her *Village Voice* review of the first group show, Roberta Smith described the gallery as a "funky, half-finished space which harks back to the area's more modest post-minimal beginnings.") Shafrazi arranged for Haring to have an exhibition in April, through the Rotterdam Arts Council, at Galerie 't Venster. Keith was thrilled to be going to Europe for the first time, traveling more like an American backpacker than the international art star he was soon to become. In his studio, he worked on six-foot drawings on seamless photographic backdrop paper that he rolled into a tube. Packing smaller drawings in a portfolio and lugging his duffel bag, he flew to Brussels on a cheap flight. "The train from Brussels to Rotterdam was a comedy, to say the least," he said. "Here's this young American, first time here, obviously. People were nice about it, but it was very difficult." The show was well received, with work bought by the Museum Boijmans Van

Beuningen in Rotterdam and by several collectors from Amsterdam. On his way back, he stopped at the Stedelijk Museum in Amsterdam. On May 4, 1982, his twenty-fourth birthday, he found himself in a reflective mood riding past tulip fields to the Brussels airport.

At the airport, he bought a little orange notebook that he dedicated to his birthday with drawings featuring the number "24" and the first journal writing he had done in some time. He had already come a long way from the rest stop in Ohio where he spent his nineteenth birthday. "So today is my birthday and I am sitting in an airport in Brussels waiting for a flight back to New York," he wrote. "The show in Rotterdam went fine and I also enjoyed Amsterdam. Drawing in the street with chalk in Amsterdam made me realize I can do it anywhere in the world (and with similar results). But I miss New York and especially Juan . . . In one year my art has taken me to Europe and propelled me into a kind of limelight." Yet a note of mortality had seeped into his consciousness, shared by many young urban gay men for whom dying was suddenly neither romantic nor remote. Keith was now reconsidering his ambitions with a deadline in mind:

Today I am 24 years old. 24 years is not a very long time, and then again it is enough time. I have added many things to the world. The world is this thing around me that I made for myself and I see for myself. The world will, however, go on without me being there to see it, it just won't be "my" world then. That is what interests me most about the situation that I am in now. I am making things in the world that won't go away when I do. If this "success" had not happened, then maybe the world would not know these things after I go away. But now I know, as I am making these things, that they are "real" things, maybe more "real" than me, because they will stay here when I go.

Shafrazi liked to encourage his artists to keep reimagining materials and scale. "Tony used to say he was 'like a football coach,'" Donald Baechler says. "Keith and I commiserated about Tony wanting us to make

paintings when neither of us wanted to. We both had piles of work on paper." Said Shafrazi, "When I told Keith he should think about painting, he reacted very aggressively at first. He said, 'I don't want to be a painter. I don't want to be like an old-fashioned painter.'" Some months before Keith went to the Netherlands, and after many of these debates with Shafrazi about his aversion to painterly canvas, Haring discovered a solution that satisfied the two of them. As he was walking down the street one day in the rain, he spotted some Con Edison workers covering manholes in yellow vinyl tarpaulin sheets. He instantly visualized the tarps as canvases, definitely free of any patina of art history, and after inspecting them and doing some research, he found his way to the Acme Canvas and Rope Company in Brooklyn—doubly delighted, as Acme Corporation was the name of the fictional company churning out exploding tennis balls and other outlandish devices in the *Road Runner* cartoons. From Acme, he ordered vinyl drop cloths with metal grommet holes—mostly yellow, a few bright red—and from a wholesaler on Canal Street, he bought silk screen ink that could bite and melt into plastic. As the tarps were nearly twelve feet high—too tall for Broome Street—Shafrazi opened his raw, damp basement space, where Haring painted on the tarps, always upper left to lower right, a giant fan whirring in the back to draw out the toxic lacquer thinner fumes. Later the same month, Haring received a surprise invitation to the prestigious *Documenta 7* show in Kassel, Germany, and decided to exhibit two of these new tarpaulin paintings—one a "John Lennon thing" of dogs jumping through a stomach hole and another, more complex life cycle mandala of vaginal births and dives into a hole of oblivion, which was bought by the Swiss dealer Bruno Bischofberger, who was about to represent Basquiat. Keith traveled to the show, his second time in Europe in as many months, bringing along Juan and accompanied by Tony Shafrazi, who was traveling with his girlfriend. "At the very last minute, they asked Keith and Jean-Michel," Annie Plumb recalls. "I think it was just days before the catalog printing. That was a gigantic honor for both of them."

During a week's stay, Keith not only exhibited in the show—along with artists including Donald Judd, Anselm Kiefer, Richard Serra, Cy Twombly, and Andy Warhol—but he also visited a few castles, painted

a mural at a local restaurant, and made new drawings exhibited on the streets of Kassel. "Nearby there was a coffee shop with lots of young people, and Keith started doing these drawings," Shafrazi says. "He was giving things away left and right. The performative nature of drawing for him was very important. Already, that form of producing and giving was beyond any form of management. He had to let it flow. He couldn't limit it. Even then, you had to accept that, because it was such a natural part of the way he worked. To understand his fluidity is very important to get his art right." In a staccato essay for the exhibition's catalog, Haring wrote, "I learned from studying other artists' lives and studying the world. Now I live in New York City, which I believe to be the center of the world. My contribution to the world is my ability to draw. I will draw as much as I can for as many people for as long as I can. Drawing is still basically the same as it has been since prehistoric times. It brings together man and the world. It lives through magic."

Throughout the summer of 1982, Haring, back in New York City, was immersed in creating work at one studio or another, sometimes alone, sometimes with LA II, yet never at the expense of his public art. He simply doubled his output, setting up a syncopated rhythm that persisted throughout his career, as he would usually accept invitations to galleries or museums at home or abroad—when the offers began to multiply— only if a mural or other (usually unpaid) public project could be set up, too. His main public access channel in 1982 remained the subway, and his chalk creations did not lag. They were often responses not only to adjacent ad posters but also to the front pages. "I began to use the cross," Haring said, "when the Pope started supporting Solidarity and the Moral Majority in America started backing Reagan." The week of the invasion of the Falkland Islands by Great Britain in April, he drew his six-armed "octopus man" grabbing human victims. His dancing figures, inspired by break dancing, began performing head spins, handstands, pyramids, backward bridges. He received nearly one hundred summonses during the entirety of the subway project, but also a few arrests. The most extreme around this time took place at the Fiftieth Street/Seventh Avenue station, where an officer unfamiliar with Haring's profile on the subways insisted on handcuffing him. Before going upstairs to call a patrol car,

the cop locked Keith inside a subway bathroom, leaving him to wonder what would happen if the cop were shot and no one knew where he was. "I'm thinking ten years later somebody will come in and find this skeleton wearing handcuffs and little wire-rimmed glasses," Haring said. Yet the officer's arrest misfired. When he booked Haring, the cop at the desk said, "So *you're* the guy who does those drawings—hey, Joe, hey, Mike . . . this is the kid who does the subway drawings!" They took off his handcuffs to shake his hand. The arresting officer felt foolish, though Haring was still served with a summons.

Haring's public art was often activist art, and a favorite medium for this political art, the poster. The first of his glazed-paper posters was designed and printed in a run of twenty thousand, for rolling and handing out at a huge nuclear disarmament rally with hundreds of thousands of protestors that summer in Central Park. Militarism was on the rise globally, with the ascendence of conservative governments. Margaret Thatcher had been elected prime minister of the United Kingdom in 1979. Helmut Kohl came to power as the chancellor of the Federal Republic of Germany in 1982. Under Reagan, the United States was beginning to experience the largest defense buildup during peacetime in history, and Cold War tensions around a nuclear war ran high. Exploding bombs and atomic symbols often appeared in the paintings of Kenny Scharf, who likewise felt, nervously, that "soon we will all blow up." Keith's connection was even closer to home. He had been visiting his parents during the 1979 meltdown of the nuclear power plant on Three Mile Island, only about seventy-five miles from Kutztown, the worst nuclear accident in American history—within days of the event, he and Kermit threw a Trash Bag Party, where everyone wore trash bags to express their outrage over the devaluing of life. Keith often talked about how close and scary the disaster had been—it released radioactive steam into the atmosphere—and he responded by joining the first antinuclear rally in Washington, DC, on June 12. For his black-and-white subway drawing–style posters for the Central Park rally, he made novel use of his radiant baby, hovering it atop a mushroom cloud surrounded by a tumble of three high-voltage apocalyptic winged angels. (He first came across the mushroom cloud as an end-of-the-world symbol in Hal

Lindsey's *The Late Great Planet Earth* while he was still a Jesus freak in Kutztown.) Keith paid for the printing of the posters out of his own pocket: "I was starting to return some of the money I got from selling works." On the morning of the rally, he and a few friends—Juan, Juan's sister, Kwong Chi, Samantha, Bruno and Carmel, Min Thometz—were dropped off by the printer at the park with a big wooden dolly, "tons of rubber bands," and stacks of posters they rolled as rapidly as they could. By day's end, they had given away 14,000 posters and, soon enough, all of them.

Haring had a knack in his public art for making the overlooked visible—from his Post-it Notes stuck beneath the staircases of Ivy, to his headline collages on lamppost bases, to, unmissably, the chalk drawings on blank subway ad panels. One such piece of devalued visual real estate that kept calling to him that June on his walks from Broome Street to the East Village was a freestanding concrete wall on a triangle of abandoned land at the corner of East Houston Street and the Bowery. Leftover from a handball court, the lot featured three feet of garbage piled in front and held in place by a small fence. "It was an eyesore in a neighborhood where an eyesore wasn't a problem," Haring said. He was envisioning a brightly colored mural that would work its alchemy on the forlorn corner. Yet, because he was thinking of painting even a remnant of a handball court, and painstaking about street etiquette, he asked permission of "LEE" Quinones, who painted lots of courts on the Lower East Side. "Keith, it's not my wall," Quinones answered. "Get a ladder, and get some balls, and go up there!"

On a hot summer day, Keith and Juan filled fifty bags with the garbage, clearing the space, and then painted the wall entirely white, with fluorescent Day-Glo enamel on top. The mural took two days to paint, as Keith drew two three-eyed faces in fuchsia blocks on either side above and two atomic signs with three nuclei each below, framing four break-dancing b-boys "in cool lime over gold," the "visual climax," wrote Robert Farris Thompson, not only of the wall but of the head spins Keith had been practicing drawing in the subways: "Balancing on both hands or propelling their bodies with one hand, they spin on the tops of their heads. As they do so, their legs pretzel in a direct citation of

hip-hop choreography." In a frieze beneath were lots of frontal running figures. When sunlight hit the wall, the monolith glowed fluorescent. LA II claims that "black and orange were the colors of me and my crew, so it gave him street cred, being down with a certain crew, so people respected the mural on Houston and Bowery." Because of works such as the East Houston Street mural, Robert Farris Thompson would describe Haring as the "Degas of the B-Boys." Keith saw the work as a collaboration with Juan, and he painted their initials, *KH* and *JD*, in the same lime green, in the lower left-hand corner—the lines of the *K* and *J* turning into Cupid's (or perhaps simply LA II–style) arrows. A shot of Haring—in jean shorts, shirtless and tanned—painting the mural was the cover image for *ARTNews* in October.

Following the painting of the East Village mural, Haring devoted himself for the next three squeezed months to preparing for the October 9 opening of his show at Tony Shafrazi Gallery, where he hoped to bring into collision the studio-to-gallery sensibility of SoHo with the open-invitation street sensibility of his public art. ("The best thing about art exhibits is the opening," Haring said.) To do so, he relied on skills learned over four years of taking part in or curating alternative exhibitions and installations, from the Pittsburgh Arts and Crafts Center to Club 57 and from the Mudd Club to Paradise Garage. The first step in making the kind of statement both he and Shafrazi hoped to make was the designing of the *Pink Book*—the spiral-bound catalog resembling a comic book or a cheerful grade-school notebook. As he was beginning to sell work at modest prices, Haring split its forty-thousand-dollar cost with Shafrazi. At over a hundred pages, some yellow and orange, with a pink cover sporting a three-eyed smiling face; color photographs with wall label information on each work; photo montages by Tseng Kwong Chi in magazine layout format, documenting Haring's entire life from Kutztown to Broome Street; archival photos of many subway drawings from January 1981 to July 1982; and even a Keith Haring coloring book of thirty images as a coda—the catalog exhibited both museum-quality weight and fanzine-casual entertainment value. Of its three essays, Haring's favorite was "Why the Dogs Are Barking," by Jeffrey Deitch. Some "heavyweight gloss," says Deitch, was added by the respected art critic

Robert Pincus-Witten, though Haring was annoyed by the latter's safe tone: "What I objected to was that he had written several critical escape hatches, so that if my work *did* bomb, he wouldn't look like a fool." New York School poet David Shapiro typed up questions for Haring to answer, yet he kept wandering off in his usual style into bright patches of erudition about how the work reminded him of the poetry of Hart Crane or Dubuffet's art brut, or simply into answering his own questions. According to Annie Plumb, "Keith sort of scratched his head and said, 'Let's just publish the questions.'"

The talent behind the catalog's high-concept design—its spiral binding, cover colored to glow under black light, and much else—was Dan Friedman, hired at the insistence of Haring. Friedman had studied design in Switzerland, taught for several years at Yale, and, most recently, had designed the new Citibank logo, improving on a more conservative original with a subtle misalignment of graphics that added some punch. When Jeffrey Deitch first met Friedman, Deitch handed him his card from the Citibank Art Advisory Department, and Friedman said, "You know, I designed your card." Friedman had been introduced to the Club 57 group by his close friend Tseng Kwong Chi, and although he was about ten years older than everyone else, he found the club liberating and began making Day-Glo furniture and bricolage and painting the walls of his apartment at 2 Fifth Avenue bright acid colors. He also became a valued provocateur for Haring's art. It was Friedman who first suggested that Keith draw on vases (the original one, with lots of priapic action, was made for him) and who pointed him to Canal Plastics, where Keith bought the cast fiberglass knockoffs of Botticelli's *Venus*, a mermaid, and the Statue of Liberty—all painted with LA II—that were appearing in the show. "I thought to myself that isn't this an interesting possibility to do a catalog on this young artist who basically is still quite unknown," Friedman said. "And to approach the book in the same way that I approached creating corporate image-making. This coincided with Tony's realizing that to do a catalog would be the vehicle that would give this artist instant international credibility." The catalog, the show, like much else in Haring's career, was a group effort. "It was never just Keith; there was always a circle around him," Deitch says. "He was like a Pied Piper.

There were talented younger kids like LA Two. There was Tseng Kwong Chi, who took thousands of photographs. There was Dan, always there to do the graphics. There was me, writing essays. I think of the phrase 'la bande à Picasso,' of Picasso, Apollinaire, Max Jacob. With Keith, there was the Keith Haring Band. I traveled around with the whole Keith party. He was a real energizer who built community around him." Their collaboration—and gamble—on the catalog paid off. "It was an early use of a catalog for an art gallery," Annie Plumb says. "Today, every gallery has a catalog at the desk to give or sell to you. It was certainly the first time it was done at the level of an unknown gallery on Mercer Street."

Haring covered the entire gallery, floor to ceiling, with drawings of his pictograms of barking dogs, radiant babies, TV sets, pyramids, halos, atomic silos—leaving strategic spaces for twelve-by-twelve-foot tarps in black, white, yellow, and red. He then added a whole series of newly enameled painted steel squares with rounded edges that resembled stretched canvases. Dominating the far wall was a giant white vinyl tarp with a recent image adapted from the subways (surprisingly, using red chalk) by a Haring in love—a glossy red acrylic radiant heart being hoisted aloft by two frontal dancing figures. The only remotely untouched spaces were the wide, white wood frames of vertical rows of drawings that he had not had time to customize before the show opened. In his basement studio in the gallery, he then constructed, as part of the show, an entire black-light installation, as he was becoming interested in fluorescent paint. The main piece was the giant reproduction of the classic *Venus*, humorously retitled by Haring *Venus on the Half Shell*—he and LA II had covered the sculpted fiberglass figure with drawings—as well as wood pillars and other three-dimensional objects saturated in fluorescent enamel paint. On the night of the opening, children were given the pages of the coloring book at the back of the *Pink Book*, along with fluorescent crayons, and they sat in the violet light on the floor in the clublike basement gallery coloring, while the Prince-produced "Nasty Girl," by Vanity 6—meeting resistance that month on mainstream American radio for its raunchy lyrics—played on a boom box. "That was really one of the highlights of my life," said a very pleased Haring. "There were five or six little kids from all different nationalities,

two deaf kids, two Italian kids, a Puerto Rican kid. They were all sitting together and only communicating by coloring with crayons."

As Haring so ardently wished, the opening (upstairs) was a scene as well. "I'd never seen a crowd like that in a gallery," Donald Baechler says. "I remember Edit deAk showing up for the opening. She was writing for *Artforum*. At that moment, she and Rene Ricard were the energy of the art world." That evening, he says, "she entered like royalty, with the crowd parting. She dropped her coat off her back, and someone ran after her to pick it up." Several more established artists were at the opening as well—Sol LeWitt, Richard Serra, Francesco Clemente, Roy Lichtenstein, Robert Rauschenberg. Yet most startling was the fusion of people from the club scene, the art scene, the graffiti scene—three or four thousand in a party atmosphere. "I had girls serving Coca-Cola in little bottles, because Tony and I were obsessed by Coca-Cola in little bottles," Haring said, "and I didn't want alcohol at the opening." Cobbled Mercer Street was blocked off. Lots of street kids brought boom boxes. Juan Dubose was set up at a deejay table in the basement, where he spun records all night. The mix and match was captured on tape by a *CBS Evening News* segment on Haring, introduced by Dan Rather and narrated by Charles Osgood, that aired on October 20. A TV crew trailed the artist, in round horn-rimmed glasses and his sleeveless bright yellow T-shirt printed with a red radiant baby, as he signed *Pink Book* after *Pink Book* and gave away stickers and pins throughout the jostling crowd. "I'm a Southern painter, it's mah-velus," one woman told him, pushing her catalog toward him for a signature. "I vant to buy a few of those little wooden things," said a man with an indeterminate accent. "Within the first few days of his show, about a quarter million dollars' worth of his pieces sold," Osgood, in a voiceover dubbed later, incredulously informed a viewing audience of fourteen million. "Not bad for a twenty-four-year-old kid from Kutztown."

Among the faces in the crowd that evening were the Harings, faithful in attending all their son's Shafrazi Gallery shows. "We were there looking like we were from a small town in Pennsylvania and lost, and yet Keith really wanted us to be there," says Kristen Haring. Mera Rubell picked up on the Haring family's state of bewilderment. "We felt that

Keith had invited them because he was desperate to have them recognize what all this meant," Rubell said. "But it was too overwhelming for them." So, she invited them uptown, where she made them a spaghetti supper and where they could see their son's works in a place of honor on the Rubells' town house wall. Downtown, the opening unwound on club time rather than gallery time. Keith kept vigil all through the night by going about picking up empty bottles, cigarette butts, and trash. "Most people were out on the street, because there was no room to go inside, where there was a cool D.J., break dancers, and the sweet smell of ganja," Shafrazi said. The party ended for him at around 7 a.m., when an uninvited guest slipped on beer-splattered steps leading to the basement. Shafrazi took him to Bellevue Hospital, "thankful nothing serious happened to this young man no one knew."

The most exciting viewer, for Haring, of the thousands who saw his show did not attend the opening, but stopped by briefly on closing night. Keith did not meet Andy Warhol that evening and heard only later that the artist—labeled by Ricard, in his *Artforum* piece "The Radiant Child," as the "culture parent" for all the artists he wrote about—had visited the first floor of the exhibition, though not the basement, where a wilder party was devolving. Warhol had been brought there by the young photographer Christopher Makos, often at the Factory and by Warhol's side, who had hooked up with Keith at a bathhouse over a year earlier and had since become a friend. "Keith was full of energy," Makos says. "That was the kind of energy I had, and Andy had, and all the people around the Factory had. That's why I thought, 'Andy needs to meet Keith.'" The closing marked the first of Haring's many appearances in Warhol's *Diaries*—a sort of pillow book dictated on morning calls to his diarist, Pat Hackett, archiving the silly and the serious of his days and nights:

> *Chris had invited us to the Shafrazi Gallery for the closing of the Keith Haring show, he's the one who does those figures all over the city, the graffiti. His boyfriend is black, and so he had 400 black kids there, so cute, so adorable. Just like the sixties, except (laughs) black . . . Then*

there was a party for the show in the basement where it was all in blue
light and they wanted me to go down, but I knew my hair would turn
completely blue, so I didn't go.

The irony of Keith's missing Warhol's short visit was his history of
admiring, if not outright stalking, the man he would call, in his own dia-
ries a few years later, "the most important artist since Picasso, whether
people like it or not, and a lot of them don't." In a life defined by the
hot pursuit of his obsessions, Haring's obsession with Warhol was one
of the enduring top few. Samantha McEwen felt its heat during their
first year at SVA, when her older sister, Flora McEwen, who had just
signed a modeling contract with the Zoli Agency, was on the cover of the
March 1979 *Interview*. Both sisters had social cachet, as they were great-
granddaughters of John Jacob Astor IV. "I remember Keith coming into
class one day with a copy of *Interview*," McEwen says. "He walked over to
me and said, 'Is this your sister?' Yes. 'Do you know Andy??' No." When
the three were living together at Times Square, Flora McEwen, who had
just flown in from Brazil, phoned from Kennedy Airport to ask if she
might stop by: "I think, based on the fact that she'd been on the cover of
Interview, you've never seen two boys more thrilled. She arrived blond,
beautiful, dressed to the nines. I don't know what she was expecting.
Not to be taken out to breakfast in Times Square by Keith and Kenny.
And Kenny took along his vacuum cleaner, which he'd customized, for
a walk." This infatuation with Warhol was shared by the entire Club 57
crowd. "At Club 57, Andy Warhol and the Factory were always at the
back of our minds," Scharf explained. "All we wanted was for Andy to
walk in. He didn't." Scharf clarifies that "It was the sixties Warhol we
were most excited about. The Studio 54 Halston Warhol wasn't the one
we were into. We were emulating our group fantasy of making it at the
Factory."

Yet Haring's personal appreciation for the artist extended beyond
the sixties and into the present. While his was not a Studio 54, disco
sensibility, all the clubbing, society portrait painting, and fame was of
a piece for Haring, with the blurring of the lines between life and art
as they had been practiced and of reinventing the idea of the life of the

artist as Art itself. He got Warhol's concept of "Business Art" while carrying it forward. And he would continue to find brilliance in Warhol's paintings of the late seventies and eighties, such as the camouflage and *Last Supper* paintings. The first time he saw the artist, while at SVA, Warhol was sitting in a coffee shop near the Museum of Modern Art. Keith wanted to go in and say something, but he had no idea what to say. He paced in front of the coffee shop several times. "I then decided that was ridiculous and left," Haring said. He saw his idol again, at an exhibition in 1979 of Warhol's painterly *Shadows* series at the DIA Art Foundation. When the artist walked into the opening, he was surrounded by photographers and stood still in the flashbulbs for seemingly ten minutes. He then began to sign and give away the copies of *Interview* he was carrying. "He gave me a copy," Haring remembered, "but again I was totally speechless. I didn't know what to say."

Makos kept trying to matchmake Warhol and Haring as artists. (In a later diary entry, Warhol would record—concerning a talk between Kenny Scharf and Keith Haring for *Interview* editor Gael Love—"Gael told me she took out the part where Kenny asked Keith if it was true that he went to bed with Chris Makos in order *(laughs)* to meet me.") Two months after the Shafrazi closing, Makos brought Warhol by Haring's new fifteen-hundred-square-foot studio on the fourth floor of the Cable Building, on Houston and Broadway, a block from the Shafrazi Gallery—a studio memorably outfitted with a Mickey Mouse push-button telephone, its companion a Kermit the Frog phone he gave to Kermit Oswald, so they could carry on their boyhood friendship and talks in boyish style. The day Warhol visited, Keith and LA II were preparing for a show at Fun Gallery, in the East Village, where they were working to give the entire gallery the spray-paint Candyland ambience of their Shafrazi basement. Warhol was puzzled by the collaboration: "He rents a huge studio without a bathroom for a thousand dollars and it's great. And there was this Puerto Rican kid sitting there, and I asked what he did and Keith said the kid does the writing in Keith's graffiti paintings, so I got confused, I don't know what *Keith* does. He paints *around* the words, I guess."

The friendship with Warhol truly clicked with the opening of the Fun

Gallery show. Haring either skipped over the earlier studio visit in telling the story or simply misremembered, often dating his first meeting with Warhol to the opening of the Fun show on a wintry night in early February 1983, with snow piled in front of the double storefront on East Tenth Street near Second Avenue. Fun Gallery was run by Patti Astor and Bill Stelling and named by Kenny Scharf, who held the gallery's first show in September 1981, followed later by Jean-Michel Basquiat in November 1982. Patti (born Titchener, in Cincinnati) Astor, with her platinum hair, high-gloss lipstick, and marquee name, was something of a movie starlet in the underground film scene, having starred in Eric Mitchell's *Unmade Beds* and Charlie Ahearn's recently wrapped *Wild Style*, in which she played a "lady reporter" whose unlikely beat was the uptown graffiti and hip-hop scene. Astor claimed as inspiration Haring's "one-off" shows at Club 57 and Mudd, as he "never cared if anything sold, or if the works were on paper, or if people turned up or if they didn't." She was especially inspired by the *Beyond Words* show at Mudd, as Fun was mostly a graffiti gallery, an underground railroad station connecting the East Village with the art space Fashion Moda and the South Bronx, and many of her costars from *Wild Style* showed at the gallery, including Fab 5, Futura, and LEE.

When Fun opened in 1981, few other galleries could be found in the East Village. The concept of an East Village art gallery was jokey. Yet, within two years, twelve galleries appeared—Piezo Electric, P.P.O.W., Pat Hearn—and the following year, twenty more. By 1984, at the height of an East Village art boom, more than seventy commercial galleries were operating in the neighborhood. One of the first to name this trend, and contribute to its spiking, was, again, Rene Ricard, in an essay—titled "The Pledge of Allegiance" and loosely pegged to Kenny Scharf's second exhibition at Fun Gallery—that appeared in *Artforum* in November 1982. Ricard was not a neutral critic. He had dropped by Fun Gallery each morning for a coffee and had convinced Basquiat to show at the gallery, saying, "Jean, chill with Patti. Come home. Come on. She'll be straight with you." (Basquiat spent most of his opening in a corner, arguing with his new girlfriend, Madonna, known for her performance at Haoui Montaug's *No Entiendes* cabaret at Danceteria.) Yet the point of

Ricard's piece was that only a charmed circle of insiders, a "conspiracy of excellence," could report from the cultural front. "Patti Astor is a beautiful example of what John Ashbery would call 'An Exhilarating Mess' in operation," he wrote. "She isn't a businesswoman. Her opening of the gallery coincided with (or caused) a definite shift in the social pattern of the last two years. . . . Fun is the apotheosis of what Edit deAk has called 'Clubism,' but just happens to be taking place in an art gallery."

Keith did not need to show his work at Fun Gallery. His big opening at the Shafrazi Gallery had been just four months earlier. Yet he wished to support Patti Astor and her new space. He had given her a painting to help her survive the early months. "I held firm on the price that Keith and I had agreed upon, and we sold it for the asking price of $1,800," Astor said. Even the installation leading up to the show at Fun was entirely in the spirit of "Clubism." Said Haring, "My exhibition at Fun Gallery was really a reference to the whole Hip-Hop culture," as he and LA II "bombed" the gallery in spray paint and were so carried away that they even spray-painted the snow piled out front and Astor's white hoodie sweatshirt. "Every day, there would be forty young graffiti artists from the ages of ten to eighteen hanging out in the gallery, smoking pot and chewing grape-flavored bubblegum," said Bill Stelling of the week or so before the opening. "That's what I remember: the gallery smelling like bubblegum and marijuana." Haring and LA II collaborated on a batch of plaster-cast Smurfs—viewer favorites, as Smurfs were not only TV cartoon characters but also the name of a new move in break dancing, "the Smurf," or "Smurfing."

Haring wanted to use the opportunity to show something new, so he decided to work with synthetic leather hides. Recently at Paradise Garage, he had met Bobby Breslau, who introduced himself and offered to share a joint. A "short, interesting-looking Brooklyn guy," as Haring described him, Breslau was friendly with the "godlike" Larry Levan and brought Keith up to his deejay booth for the first time. The occasion was an installation by Haring of painted walls in a room off the dance floor, and Breslau said, "What? You have this thing here and you haven't even met Larry?" Breslau also turned out to be a friend of Warhol's as well as being the designer who made Halston's leather handbags

in the seventies. (A framed letter from fashion editor Diana Vreeland in Breslau's apartment praised him: "You are to leather what Cellini is to gold.") More than a decade older, and wiser in the ways of art, social life, and fabrication, Breslau was soon a valued member of the Keith Haring band. "He becomes my Jewish mother!" Haring said. Whether cause or effect, Breslau was perfect for helping Haring with the works on leather he exhibited at Fun, as he led him to the pelts and hides he covered with marker and acrylic paint and hung over the graffiti'd walls. Haring also showed diagonal, hard-edge wood tables carved by Kermit Oswald that he and LA II painted pink-red and suffused (as they did the office telephone) with their nervy marks.

The opening turned out to be "even more funky than the Tony Shafrazi opening had been," Haring said. A thousand people jammed into the single-story building that was shaking from the overcrowding, most winding up in the cold backyard, where Juan Dubose was deejaying. At the height of the opening, Stelling turned to Astor and said he thought their little gallery was going to either levitate into the sky or crash into the basement. "The opening attracted a remarkable mix of Puerto Rican kids from the neighborhood and the elite of the art world," said Jeffrey Deitch. Haring's simple invite was a nod to break dancing, illustrated with three bodies twisted into the letters *F*, *U*, and *N*. He also printed posters to be given away. Yet, during the evening, someone came running in and said to Patti Astor, "The neighborhood kids are selling Keith Haring posters up the street for five dollars!" She needed to go outside and tell them to stop. When Andy Warhol finally arrived, he instantly twigged the art and the scene, as he was now seemingly as much in search of the sixties as the Club 57 kids who were imitating him: "Then to the Keith Haring opening (cab $4). It was on the Lower East Side, at the Fun Gallery, it's called. So we walked into the place and there's Rene Ricard, and he's screaming, 'Oh my God! From the sixties to the eighties and I'm *still* seeing you everywhere!' . . . And Keith's show looked good, it was his pictures hanging on a background of his pictures. Like my Whitney retrospective show was—all hung on top of my Cow wallpaper."

To some people's surprise, though, nothing from the show sold. "Just

one freakin Smurf," said Astor, who felt the work too adventurous for her collectors, who showed up in their limos the next morning.

Soon after the show, Warhol invited Haring up to the Factory, and they talked about trading artworks. "He let me look through his prints, and I saw a series of really erotic prints—guys fucking guys and closeups of dicks," Haring said. "I chose one print of a guy fucking another guy, and he said, 'I'll make you a painting of it.'" Warhol printed the image in black on a white canvas in close-up, as a near abstraction but with the subject matter still evident: "That was my first Warhol painting. For it, I had to trade him I don't know *how* many things, because the trade was sort of value for value—and his stuff was very expensive. So, his manager, Fred Hughes, arranged all that, because Andy didn't want to be involved in this part of the trade." Haring then hung the Warhol above the toilet in the bathroom at 325 Broome.

According to Makos, "Andy was just so impressed when Keith was giving out those buttons of the baby. He was jealous of how Keith was like an advertising agency unto himself. That was the cleverest thing any artist at the moment was doing. Whenever you went to anything, whether it was Paradise Garage, anywhere you went, Keith was there, and he had a bag of those buttons, and everybody wanted one of those buttons. He made everyone aware he was a player. That was something that Andy loved and admired about him." Of Haring's developing friendship with Warhol, Scharf said, "It was another loop in the roller coaster he was on, and it rode him pretty high."

Three days after Warhol attended the closing of Haring's show at Shafrazi, he recorded in his diary, "Jean Michel Basquiat who used to paint graffiti as 'Samo' came to lunch, I'd invited him." Like Haring, Basquiat had a tremendous art crush on Warhol and was even more of an active stalker. Although Warhol occasionally bought postcards and T-shirts from him, when Basquiat tagged the front door of a building Warhol owned on Great Jones Street with "Famous Negro Athletes," Warhol gave instructions that he not be let inside. His mood began to soften when his own Swiss art dealer, Bruno Bischofberger, started promoting Basquiat and when Basquiat became romantically involved with Paige Powell, the advertising director of *Interview*. Soon, Basquiat was

Warhol's tenant in the loft in the Grand Street building, where he lived for the rest of his life, and he challenged Warhol to take up painting again. "They exercised together, ate together, and laughed together," Haring said. They even began to paint together. Although Haring and Warhol collaborated a couple of times, Haring said, "By then Andy had been working with Jean-Michel and I didn't want to step on that or get in the way of that." Ever a figure of fascination, Warhol saw his reputation fluctuate in the early eighties, and he could be viewed as overly commercial—an attitude hardened by his cameo appearance on the long-running TV show *Love Boat*. Yet debates in the art world were offset by high interest in the art schools where Warhol's message of the aesthetics of fame and success was clearly being heard. The energy of Warhol's growing friendship with Basquiat and Haring went both ways and helped both sides. "Jean brought back a much-needed touch of mischief which had been disappearing from the Factory agenda," Haring would write. "The ramifications of this investigation left obvious traces in Jean Michel's later paintings and many people believe that Jean was the sole reason Andy returned to his brushes. Both of them benefited immeasurably."

In March, less than a month after his first visit to the Factory, Keith realized his dream of going to Japan. It was a dream that began when he was a boy staring at snapshots of his father in marine uniform in front of the Great Buddha statue and that held steady as he grew fascinated with Eastern philosophy, calligraphy, and sumi ink drawings on paper as well as with the more pop Japanese wind-up toy robots and mechanized Shōgun warriors available as collectibles in New York City. Enticed by the prospect of traveling to Tokyo, Keith accepted an invitation to sign a one-year exclusive contract with the Watari Gallery. His plan was to re-create the hip-hop installation he had just realized at Fun. To truly capture that spirit, though, he needed LA II. A review of the Fun Gallery show in *Flash Art* was titled "Keith Haring and L.A. Rock" and noted how "L.A.'s elegant, even nervous calligraphy melds with, but never overpowers Haring's vocabulary of images." The poet Gerrit

Henry went further in a small piece on six Haring prints published by Barbara Gladstone, where he described LA II as "a kind of Braque to Haring's Picasso." Yet Angel was still only fifteen, and Keith needed to return for supper with his mother to ask for her blessing. She said, "Just promise me one thing, you take care of him. He's a young kid." "Keith set up a little trust fund for me," Ortiz says. "I said, 'Who's paying for this?' He said, 'You're paying for this. From the paintings we're selling, this is how we get to travel.'" Juan Dubose went, too. "The night before we left for Tokyo, Keith spent the whole night hanging out with Larry Levan at Paradise Garage, dancing, partying," Ortiz recalls. "They had helicopters at Fourteenth Street back in the day, so we took the helicopter to the airport. That was kind of cool. It was a thirteen-hour nonstop flight to Tokyo." As soon as they landed, Angel called his mother from the airport.

The graffiti scene was just beginning in Tokyo, and the Japanese were eager to learn more about pop and hip-hop. Word of Keith Haring and his subway drawings was already out. Yet even without any advance press, these three young men looked so much the part that they quickly became a sensation. "Almost immediately," said Haring, "the three of us—this Puerto Rican kid, this Black kid, and this white kid—become media stars." The first night they spent in a traditional hotel, sleeping on mats and bathing in stone tubs. "It's very beautiful but a little too weird for us," Haring said. Angel was not enjoying the traditional Japanese cuisine. The next day, they moved into two separate rooms in the Tokyo Hilton in the Times Square–like Shinjuku district, where Angel could get cheeseburgers and swim every day in the hotel pool. Juan used his New York City smarts to learn his way around the subway system and go shopping, while Angel stuck closely to Keith's side. Each day, they went to the gallery, and Keith channeled his love of Japanese painting into drawings with sumi ink and paintings on tarp. "There is a respect for gesture and for a line that is embodied with a kind of personality and a kind of meaning," he would say of Japanese brushwork. He and Angel re-created their Canal Street foraging as they visited a maker of folding screens in the suburbs and found fans and small kites on which to draw and paint. When the gallery owners, who also owned a three-

story building across the street, asked them to spray-paint its façade, the event was covered live on national Japanese television.

On opening day, the line of gallerygoers extended down the street, with a two-hour waiting time, as mostly young people waited patiently and quietly for an autograph and, in the Japanese tradition of gift giving, presented Keith with giant oranges or pretty little dolls. "They were really beautiful and really sweet and really shy and timid and totally treating us like we were gods," Haring said. Tony Shafrazi flew in for the opening—fortunately, as he preempted a seemingly very one-sided contract the Watari Gallery had intended for Keith to sign for the publication of a book of interviews and photographs compiled from Haring's trip. After the opening, Keith threw a twenty-fourth birthday party for Juan Dubose at the Tamatsubaki Club. When they entered, the club owner greeted them with a silver platter holding rows of spray cans and a surprise request that the visiting artists spray-paint a wall of the club. "OK, we'll do it," Haring said, a bit reluctantly, as their energies were taxed. When they attempted to paint, so many flashbulbs were going off that they were blinded and could not see the wall. They were even photographed at the club's urinals, and then pursued by photographers and journalists to the airport, where they made a grand exit.

When Keith stepped off the plane back in New York City, he was not met by any such frenzy of attention. He was, though, just in time for the Whitney Biennial, where he rapidly created two large-scale drawings directly onto the museum walls, in the spirit of his subway drawings. Jane Bell in *ARTNews* cleverly labeled the 1983 Biennial "a more heavily budgeted and sanitized Times Square Show." Among other young downtown artists showing for the first time in the museum were Jean-Michel Basquiat, Jenny Holzer, Barbara Kruger, David Salle, and Cindy Sherman. "It's sure different than when I used to go in the fifties—then it was small paintings and—now it's—well, it's an interesting show," Warhol noted in his diary. "Keith Haring is the only one of the young artists in it that I know." (Warhol had somehow missed Basquiat's two paintings, *Dutch Settlers* and *Untitled* [*Skull*].) Many of the earliest critics to pick up on Haring's work were the poet-critics, beginning with Rene Ricard—understandable, as Haring's roots were in the poetry world,

and poetry his road not taken. Poet-critic Peter Schjeldahl, in a review in the *Voice* of a group *UFO Show* at the Queens Museum, confessed that while he had written off Haring's "winsome scribbles as monotonous chic emblems," his resistance was now crumbling—Haring's "demotic creativity" was proving "intense and tenacious." As fine an eye as any was the poet John Ashbery—if Warhol was a silver eminence for young artists, Ashbery was so for young poets. Writing as art critic for *Newsweek*, Ashbery gave Haring an important backhanded compliment in his take on the Biennial as too "newsmaking": "This sort of media-baiting succeeds best with artists whose work is almost the stuff of media anyway. In their case, more is more, and overkill really kills. Take Keith Haring, the 24-year-old graffiti artist who may be the hottest property in the international art world today. His 14-by-10-foot mural contains some of his now well-known iconography—a dog restraining a tiny figure with a noose around its neck and an airborne TV. But on this gigantic scale Haring's always electric graphism is riveting."

The summer of 1983 began as a summer of love, if not far and wide, then at least at 325 Broome Street. Samantha McEwen finally decided to move out, leaving her entire apartment to Keith and Juan. "I remember being there one evening, and the whole place was full of guys, a lot of the graffiti kids, like ten of them, and Keith and Juan," McEwen says. "I remember thinking, *I don't think this is the right place for me. I should move now.*" Keith and Juan pitched their tent in the front room, and the apartment came together as Keith's long-wished-for clubhouse, a party pad. "The apartment itself was a scene and a half because it was totally covered with art," Haring said. His private art collection was growing, with more Kenny Scharfs, more Basquiats, more graffiti paintings by Futura, Dondi, and Fab 5 Freddy. The lemon-yellow kitchen turned into an explosive paint bomb of graffiti by LA II and fellow street artist Crane, with blender, waffle iron, and wall clock bedazzled by Scharf and hanging Japanese paper lanterns painted with red Smurfs. As a popular style in break dancing that summer featured choppiness and mechanical jerks—as well as electrical charges passed body to body in the "elec-

tric boogie"—Crane painted gray robots on the walls, and Keith began drawing them on the subways. "Bobby Breslau was also becoming important in Keith's life," says McEwen, "and so, the flat was no longer as bare bones. When I went to visit, there was now a big leather sofa, and leather bean bags, and leather poofs on the floor." Said Haring, "It was my 'in' scene. It wasn't the Schnabel-and-Salle painters set. And it wasn't the Mudd Club scene, but more an extension of Club 57, which by now was defunct."

Partying went on not only in the evenings but also in the afternoons, the tenor always set by Juan Dubose, the resident deejay. Juan was mostly into Paradise Garage–style disco dance songs, which he mixed with an easy mastery that came from constant practice. His underlying theme, the theme of much gay club music from the seventies on, was love. A partial list of the contents of one of Juan's mixtapes from July 1983—the month Haring painted a mural on Avenue D of a robot deejay spinning records with four arms—tells the tale: "Doctor Love"; "Ooh, I Love It (Love Break)"; "Now That We Found Love"; "You Can't Hide (Your Love from Me)." Many of the records he was spinning were mastered by Larry Levan on Island Records. And one of the regulars in this at-home club—even though he had never set foot in Club 57, he often did so at 325 Broome—was Andy Warhol. As he told his diary on July 1 of his first visit to Keith's place:

Cabbed to Keith Haring ($8.50). And he had such beautiful painted kids there, all like Li'l Abner and Daisy Mae. Wearing earrings and punk fun clothes . . . This was a party because Keith just broke through into another apartment. He's just got a tent in it where he and his black boyfriend sleep. We're going to photograph it for Interview. *Keith was such a good hostess . . . John Sex was there who has the beautiful hairdo. I took about fifty pictures. I shot without my contacts and I took one of a girl in the bathroom and she almost beat me up, and then when I left I found out I didn't have any film in the camera.*

In August, Warhol invited Keith and Juan to come by the Factory so he could take color Polaroids of the couple—intimate double portraits

of the two of them, always touching, standing shirtless, skin to skin, Juan's naked front folded into Keith's back, two pairs of bedroom eyes staring into the camera. "They were so lovey-dovey in the photos," Warhol said, "it was nutty to see." These candid shots, printed in Polacolor, were studies by Warhol for several forty-by-forty-inch unique painted silk screens he then made—the fluorescent orange version he gave to the couple prominent on the living room wall at 325 Broome.

In the mix, too, was Madonna. During the summer of 1983, Madonna was very much on the East Village scene. It was her turf, much like the crackling New Wave chick in a miniskirt, rhinestone boots, and junk jewelry she would play a few years later in Susan Seidelman's film *Desperately Seeking Susan*. Madonna's boyfriend was now "Jellybean" Benitez, the deejay at the Fun House, a Latin club in the West Twenties, where she would sing and dance and choreograph sexy scenarios. She was revolving around the hip-hop scene and hung out at the Roxy, the main downtown dance floor for break dancing, the "home of hip-hop." "Keith and I are sort of two sides of the same coin," Madonna said. "And we were very supportive of each other in those early days. I remember Keith coming to watch my first shows." Haring affirmed this: "We all circulated, went to the clubs, and I'd go hear her sing. She and 'Jellybean' were real close—he wrote songs for her—and it was the beginning of her incredible success. The parties I gave in the Broome Street apartment were a mixture of all these scenes—and people." Madonna was still on the verge. Not until the fall did she release "Holiday," her pop-disco single that Jellybean had been promoting in heavy rotation at the Fun House. It became her first pop hit, reaching number 16 on the Hot 100 chart—the biggest downtown crossover since Blondie's rap-inspired "Rapture." "She was definitely on the rise, and she knew it," says Paige Powell, who recalls Madonna at Keith's parties. "She knew that she was really going up. You could just feel that exuding out of her." Warhol confided to his gossipy diary, "Keith said that when Madonna was staying at Keith's, sleeping on his couch, the stories he could write about the people she had sex with."

"Andy and I would go to Keith's parties down on Broome Street," Paige Powell said. "Juan Dubose would be there with his huge tape deck,

and the music was really fabulous. The whole downtown crowd would be there—Kenny Scharf with his wife, Tereza; and John Sex with his boa constrictor; and Jean-Michel—and Andy had a good time." On a plane to Carnival in Brazil, Kenny Scharf had met the yoga teacher Tereza. He soon married her, and by 1983, at Keith's parties, she was pregnant with their first daughter, Zena. Inspired by the pregnant Tereza, Keith, who would become Zena's godfather, began drawing pregnant women in chalk on the subways—pregnant with babies, hearts, or clocks. "The big chalk drawing of a pregnant woman on 53rd and Fifth that we thought was his—it turns out it is his, and we're trying to get it," Warhol said in his diary in August. In 1983, with printer Alexander Heinrici, Haring also made his first silk screen edition, *Fertility Suite*—five Day-Glo drawings of speckled pregnant women and bouncing babies. "When he came over to sign them, I said, 'Keith, did you bring some coke?'" Heinrici says. "He said, 'Oh, I forgot,' and ran back to his studio to get some. I told him, 'When you sign, you need some energy.' That was the times. Nothing unusual." The permanent record of Haring's parties, its guest register, turned out to be the white enamel door of his modest Lantz refrigerator. Madonna scribbled in red "Madonna Loves Keith." Presumably the initials *J.M.* were Basquiat's, and the initials *A.W.* Warhol's. Also tagging were Fab 5 Freddy, LA II, Futura, "Crazy Legs" (a Rock Steady Crew break-dancer), and Pulsallama, Club 57's all-girl band. The next tenant of the apartment inherited the refrigerator, and when the landlord threw out the appliance, she retrieved the door, selling it at auction in 2021 for $25,000.

The high spirits, and pleasures of mounting success, at 325 Broome— if Madonna knew she was "definitely on the rise," so did Keith—came with a cost, though. Many other struggling East Village artists were growing restive and envious. "What stays with me is that very early on, when Keith and I were just beginning to soar, our contemporaries and peers showed all this hostility," Madonna said. "Of course, it's what *they* want too! It's so transparent!" Kwong Chi took a photo of a subway drawing scrawled over with "Sell Out!," "Promo Toy," and "Peter Max of 1983!" As Peter Max's rainbow-colored psychedelic and pop imagery in posters, paintings, and ads (the sinuous 7UP bottle of the "Uncola"

campaign) were like wallpaper in the 1960s, the charge was that Haring was likewise an illustrator or commercial artist rather than a "serious" artist. "Before I understood Keith's work more, I, too, felt like he was more of an illustrator," Paige Powell says. "I used to get in these conversations with Andy, early, in eighty-two or eighty-three. He really defended Keith. 'No. He's a *fine artist*,' he would say." Most hurtful was the defacing of the East Houston Street mural. Respected by graffiti artists, the mural was, ironically, done in by bohemian types, its surface streaked with the slogans "Big Cute Shit," "KEITH: WHITE HO," and "9,999." (When asked about the prices for his art for an article in the *Voice*, Haring had said he would not sell any painting for more than $10,000.) After repainting it seven times within a single year, Haring gave up on the mural and, he would say, on the East Village: "It was a personal attack and was getting really obnoxious. I went by myself and painted the entire thing silver and destroyed it, and I said, 'Okay, fuck you. This is the end of the East Village. I will never do another mural in the East Village.'"

By the end of 1983, 1,851 AIDS cases would be diagnosed in New York City, with 857 deaths. All these sudden casualties were becoming a ghostly presence within the hard-hit arts community downtown. Citywide, paranoia was at a pitch, with many people afraid of being in the same room with anyone with AIDS or even touching a door handle they had touched. On August 6, 1983, Klaus Nomi died at the age of thirty-nine. He was the first in Keith's circle of youth and talent to go, having been part of the core Club 57 group, his performance style captured in the early Haring and Scharf home movies. "They gave me a paper jumpsuit to wear," Joey Arias says of his last visit to Nomi in the hospital. "He was in a room, covered in a plastic bag, with air tubes. Klaus looked at me from under the plastic and said, 'I can't see you. Who is it? My body hurts.' I ripped off all the plastic and got into the bed and held him and kissed his cheeks and massaged his back, with all the Kaposi bumps. They were banging on the glass. I walked out, and the doctors wanted to keep me and get me tested. I said, 'For what?'" No blood test had yet been developed for identifying the HIV virus, and mild indications of a compromised immune system, such as low T-cell levels, swollen lymph

nodes, and night sweats, would soon be clustered under the umbrella term *ARC*, for "AIDS-related complex."

According to Kenny Scharf, Keith was already showing such alarming early warning signs, which indicated that he had already been exposed to the virus. "Around the time Klaus Nomi died, Keith was having some symptoms that were later to be called ARC. He had these enlarged lymph node glands. They were so big. You're going to the doctor, but nobody knew what it was. Me and my friends were all freaked out. 'Oh my God, Keith has gay cancer, too. Oh my God, oh my God.'" As Haring later said, "Throughout the eighties, I always knew I could easily be a candidate for AIDS."

The bipolarity of the eighties—its best-of-times, worst-of-times bait and switch—was being felt in full force by the fall of 1983, and not simply by gay men at risk. Police violence was covered by the *Voice* in a series of front-page articles. Homeless people were increasingly visible on the streets citywide, not simply on the Bowery, as limos with dark tinted windows, the power vehicle of the decade, drove by. Under Mayor Edward Koch, race tensions were as high as ever. "It was hard to get taxis with Jean-Michel," Paige Powell remembers, as many drivers refused Black passengers. Keith's parties had become so notorious that he needed to keep the front door locked and run down three flights of steps whenever the bell rang, doubling as host and doorman to keep out crashers. On one such evening, a Wednesday, September 14, he opened the front door and found himself faced with Michael Stewart, a twenty-five-year-old Pratt student and artist he knew; the artist George Condo, whom Haring did not yet know; and a third person, who had been involved in a scam that cost Haring a thousand dollars. Because of the third person in the group, said Haring, "I thought up an excuse [not to let them up], the party was getting out of hand, which it was." Some hours later, Stewart was arrested in the First Avenue L Train station for spray-painting graffiti, though, Haring said, "he was an artist, but no one ever heard of him doing graffiti." Within an hour, he was delivered by cops to Bellevue in a coma and died without ever regaining consciousness. The police claimed that Stewart, handcuffed, had suffered a heart attack while trying to flee. A bystander reported a methodic

beating by police, and autopsy reports would suggest strangulation by a chokehold.

Keith first heard the terrible news the next night, from Basquiat at the Roxy. "He was completely freaked out," Haring said. "It was like it could have been him." Stewart had indeed been emulating Basquiat, as he was a middle-class Black kid, a painter, who wore his hair in dreads, worked at the Pyramid Club, and was dating Basquiat's ex-girlfriend Suzanne Mallouk. He was also close with Madonna and briefly appeared in her "Everybody" music video. After informing Keith, Basquiat went with Paige Powell to her apartment, where he drew red and black skulls in crayon. "I know it was a weeknight," Powell says, "because Jean-Michel was drawing on the floor and shouting next to the bed, so I didn't sleep and had to be at *Interview* in the morning. It was tragic, surreal, and horrific." Keith was outraged, and troubled by having turned Stewart away from his party, since allowing him in might have changed the trajectory of events: "Other things happened that night that meant it might not have happened either, but it was horrible." Warhol told of Keith stopping by in the aftermath: "Then Keith Haring came by after getting a B-12 shot from Dr. Giller . . . And Keith was ranting and raving about this black graffiti artist that's in the papers now because the police killed him—Michael Stewart. And Keith said that he's been arrested by the police four times, but that because he looks normal they just sort of call him a fairy and let him go. But this kid that was killed, he had the Jean Michel look—dreadlocks."

Kenny Scharf was sure he knew the cops who had beaten Stewart, as he had been arrested just a week earlier in the same neighborhood for spray-painting on Twelfth Street and First Avenue by a group of police in an unmarked car. They had tried to catch him earlier in the evening, and he had taken off on his bike, but when he was riding home hours later, they spotted him, followed him down an empty street, knocked him off his bike with their car, and ran over the bike several times. "One guy came over and threw me onto the hood," Scharf says. "With one hand he's breaking my arm and, with the other, shoving his gun down my throat, making me gag." The cops took Scharf to the East Fifth Street precinct station, where they kept him for three hours, shouting,

"You're *stupid*!" until he agreed to confess to "assaulting an officer." On his way out, the cop who had shoved the gun down his throat grabbed his own crotch and said, "Thank you." "It hit me so hard when Michael Stewart was killed," Scharf says. "I realized if I was Black, they easily could have killed me."

Suzanne Mallouk started a campaign to investigate Stewart's death and bring the police officers to trial, raising money from many artists, including Haring. A benefit concert took place at Danceteria, headlined by Madonna and David Wojnarowicz's band, 3 Teens Kill 4. Yet the enduring cenotaph for Michael Stewart were three works of art done in response by Warhol, Basquiat, and Haring. Warhol silk-screened a page of the *Daily News* with a brief article on the Stewart case, headlined "ARTIST COULD HAVE BEEN CHOKED: DOC," amid a clutter of other transitory headlines, blurred by over-inking the black type on white canvas, the topic reminiscent of his *Death and Disaster* series of the sixties. Not long after Stewart's death, Basquiat came by Haring's studio on Broadway and painted in acrylic and marker on a plasterboard wall a dark, faceless shadow, like the shadows being painted on downtown walls by Richard Hambleton, with two bloodred-faced cops in blue streaks of uniforms, batons raised, and the word *DEFACIMENTO* written above. (The cop figures may have owed something to David Wojnarowicz's poster for a Union Square protest held while Stewart lay dying in the hospital.) In a couple of years, when Haring moved studios, he cut the image from the wall and eventually had the piece, now known as *Defacement (The Death of Michael Stewart)*, mounted in a gilt frame and hung over his bed. "This makes it, for me, at best," Schjeldahl later wrote in *The New Yorker*, "a Basquiat relic turned into an artwork by Haring."

The brutal killing remained fresh for Haring for a long time. He kept a newspaper clipping of the story stuck to his studio wall. When the police were finally acquitted at trial, Haring ranted—Warhol's word—in an apoplectic entry in his journal: "Continually dismissed, but in their minds they will never forget. They know they killed him. They will never forget his screams, his face, his blood. They must live with that forever. I hope in their next life they are tortured like they tortured

him." His fury found its fullest expression in a large-scale painting, *Michael Stewart—USA for Africa 1985*, bringing together apartheid with the martyrdom of Stewart. Monumental, stretched across the canvas tarp, is a long, naked umber figure being strangled by a billy club held by two peach-tone fists, his feet skimming a river of blood flowing from a cracked egg of a globe, while hands of many colors stretch up, drowning, as inverted crosses fall from the sky and as a skeleton offers the victim a key, the only possible release from his gray handcuffs. Like Edvard Munch's *The Scream*, the sight without the accompanying sound of a scream gives the work its tension, but in Haring's violent protest painting, the stifling of the scream, rather than being psychological, is physical and brute.

Party of Life

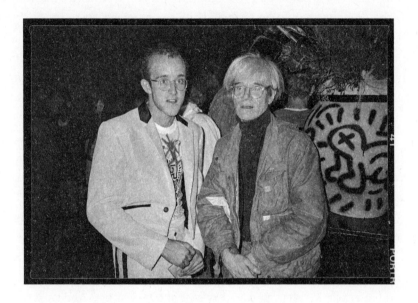

The body painting took about four hours. Keith was applying cold, white acrylic paint with a medium-size brush onto the living canvas of the naked Black skin of his friend, the dancer and choreographer Bill T. Jones, covering every inch, from head to toe, making pulsating patterns along the way, in the dynamic spirit of the tribal markings of the Maasai warriors of East Africa. The standard photographic studio he rented for the day was drafty on that Saturday morning in

October 1983, in London, where he and Juan had traveled for the opening of his one-man show at the Robert Fraser Gallery, and where Bill T. and his lover and dance partner, Arnie Zane, had come for a dance performance. Yet Jones generated his own heat, as he was moving constantly, striking poses on instructions from Tseng Kwong Chi, who was photographing him from every angle, while Arnie Zane videotaped. Jones splayed his hands and was being flatly hieroglyphic with his body, so the drawings would be visible, while the paint began to crack and flake, giving an even more authentic look of mud painting. As a final touch, Keith, with a mischievous smile, knelt in front of him and went flick, flick, flick with his brush on the tip of Bill T.'s foreskin, making three white strokes, as the two shared a playful moment. "He turned into this African god," Haring said.

Without any warning for Jones, the door then opened and in came about twenty British tabloid reporters to cover the event. "They're wise-cracking and I'm standing stark-naked in front of all these British journalists," Jones said. "Such was my trust for Keith, or my brazenness."

"Hey bloke!" one of them taunted him. "Did you forget to put on your pants this morning?"

Jones understood Haring's motives for arranging the publicity, as he shared the same drive: "He wanted to be a household name. The art world in Lower Manhattan was very cool and he was not. And we didn't feel cool, we felt hot, as well—engaged and ambitious. We wanted everything, as did he." Jones was aware, though, of the racial dynamics at work, undeniably more so than Haring. "As a Black man whose body was his primary instrument there was always this uncomfortable feeling that one was on display, somehow or other complicit in an odd kind of meat show wherein people were given permission to look and fantasize, but never had to express their desires publicly." To ensure that the stark photographs were not misunderstood, he laid down a few ground rules: "I said to him, 'Keith, these pictures will probably appear everywhere, and your name will always jump out. I want to make sure that every time these pictures are reproduced that my name is there as a choreographer, not just some Black dude who you painted.' And he got the message, and to this day, my name appears with those pictures."

Keith and Bill T. had collaborated before, if never quite so strikingly. Like Molissa Fenley, Keith's earlier partner in dance at SVA, Jones had been invited by James Carroll to be part of Carroll's Visiting Artist program in Kutztown. There he met "this amazing young guy," Kermit Oswald, who told him of Keith Haring and showed him some of his friend's drawings—a lot of them erotic, some of Mickey Mouse with no ears, all appearing to Jones to be "wild stuff." At about the same time, Bill Katz, a designer and friend to many artists, came to a rehearsal of *Social Intercourse: Pilgrim's Progress*, which Jones was staging in June 1982 at Downstairs at City Center, in New York. Katz had been seeing Haring's subway works and suggested he would be perfect to make a performance poster. "Bill connected the flatness of the dance moves I was making with Keith's drawings," Jones says. Arranging to stop by Haring's studio, Jones found the artist easily agreeable to making three sumi ink drawings, which he dedicated to him: "It was very generous and typical of Keith, and he and I became friends." Within months, the two fully collaborated on a dance piece, *Long Distance*, at the Kitchen performance space, where Haring drew live onstage as Jones danced, the only music the sound of brush on paper, timed to the choreography, and Jones's feet scuffing the floor, and breathing. "It was very physical and sexy," Jones said, and "produced an intimacy between us that I prized. And it felt sexual."

As Jones predicted, the performative body paintings they created in London were soon everywhere and much identified with Haring's style that fall and winter of 1983. Jones's well-tuned instrument of a body was not Haring's first. Keith had shown Jones a copy of *Frigidaire*, a teen magazine, with pictures of a young architect posed inside a large vase. The architect had volunteered at Haring's recent show on his previous European trip, at the Galleria Lucio Amelio, in Naples, to have his body painted from the waist up. The young man was naked for the painting, and one of these nude photos found their way into the magazine, European magazines being more liberal about nudity. When Keith proudly showed off the racy layout, he first proposed to Bill T. doing the full-body version. He had also been marking skin with crawling baby tags at clubs and openings in New York City. Both he and Jones were familiar

with sixties body art, especially Keith, from the hippie culture around the Grateful Dead. Unlike the tie-dye sunburst look of much sixties body painting, though, the designs he created on Jones's skin were as meticulous as his sumi ink drawings on paper—rendered in spare black and white, their graphics extreme—as urban pop as they were primitive.

Within a few days of their body painting, or paint embodying, on October 19, Keith's show opened at the Robert Fraser Gallery—"A major show," recalled Bill T. Jones, who appeared, along with Robert Mapplethorpe, in Tseng Kwong Chi photos of the opening. The show had much to do, for Keith, with its gallerist, Robert Fraser, an old friend of Shafrazi's from the sixties, when he was an art student at the Royal College of Art. Haring gravitated to solidly adventurous dealers. Lucio Amelio's gallery in Naples had given early shows to Warhol, Twombly, Joseph Beuys, and the "Arte Povera" artists (who created works with everyday materials) and was credited by Francesco Clemente, as a Neapolitan teenager, with his first exposure to contemporary art. Nicknamed "the Queen of Naples," Amelio cut a flamboyant figure on the streets, with shop owners shouting his name as he walked by. Haring had stopped on his way to London in Milan, where he and LA II fast-painted the walls, desk, and dressing rooms of the Fiorucci boutique behind Piazza del Duomo at the invitation of Elio Fiorucci, whose store in New York was an early revelation for Haring of art, fashion, and commerce in a louche blend and where Kenny Scharf first showed his paintings. Warhol had suggested Haring to Fiorucci. Fraser fit easily into this group of European impresarios, and Shafrazi was following the model of Leo Castelli and other American dealers in contemporary art by connecting Haring with important European galleries. In the sixties, Fraser's Duke Street gallery had been "*the* place to be," Shafrazi said, and "Keith worshiped him, was very impressed with him." Known as "Groovy Bob," Fraser was, says Shafrazi, "the best-dressed man from here to Saint-Tropez." His gallery was the first in England to show the more pop American artists—Andy Warhol, Ed Ruscha, Jim Dine. Indeed, it was at her Fraser-sponsored show at Indica Gallery that Yoko Ono first met John Lennon in 1966. One of the more infamous pictures from Swinging London was of Fraser and Keith Richards of the Rolling Stones being led out hand-

cuffed together on drug possession charges. Fraser's jailing and heroin addiction caused him to close his first gallery. He had just reopened this new gallery, in May 1983, on Cork Street, in London's Mayfair district. "All the figures who are now accepted figures in the art world, who were thought of as ridiculous pranksters then, were showing at Robert's," British artist Brian Clarke said of the slowness of London in picking up on younger artists, including Haring, Basquiat, and Italy's Sandro Chia: "He was the only one who wanted to show Keith Haring. Nobody else was interested, they thought he was a joke."

Ever since his first show with Frank Holliday at Club 57, Haring had stuck with a way of handling exhibitions that worked best for him—scheduling a show and then scrambling to make art in his studio and on-site to meet a deadline, the tighter the better. He was capable of procrastinating, and deadlines—or live audiences—kept him on point. As he began staging these shows as much in Europe and Asia as in New York City, his work itinerary was rapidly becoming his life. Happily, the next show on the books was at the Tony Shafrazi Gallery, opening the first week in December 1983 and stretching into January 1984, allowing Keith a couple of months back in New York before leaving again for a month in Australia. An uptick in the number of homemade tapes Juan Dubose had begun producing—five in the first week in November—suggests that the packed house parties at 325 Broome Street were starting up again. In Juan's mix now were dance-oriented singles he had likely picked up in London and, perhaps, used when he was the deejay for Keith's Fraser Gallery opening ("Tonight's the Night [All Right]," by Take Three; and "Get Out of My Mix/Dolby's Cube," by Thomas Dolby), Jamaican reggae ("Third World," by Lagos Jump), and very current pop hits such as Lionel Richie's "Love Will Find a Way." Influential deejays like Larry Levan were always being given tracks to play six months before their release, and Juan was early to pick up on "West End Girls" by the English synth pop duo Pet Shop Boys. Keith loved serving everyone bottles of Orangina, a carbonated fruit drink he had discovered in Italy. Guests at his and Juan's apartment were not only seeing fresh art on the walls but also hearing music, often for the first time, especially those not regulars at Paradise Garage.

Keith was also back in the subways, where he drew four-legged boom boxes with dogs' tails and where his pregnant women began giving birth—his radiant baby was now held in a Madonna and Child embrace in time for "Merry Christmas New York City 83" messaging and for the birth of Zena Scharf in January 1984. (Haring's mother and child in yellow against midnight blue would appear on the cover of the European art magazine *Flash Art* in March 1984.) His social life was more than ever enmeshed with Andy Warhol's, whom he had just seen in Milan. On a typical Sunday evening back in New York in November 1983, Warhol invited Keith to dinner with the handsome young Swiss art dealer Thomas Ammann, a protégé of Bruno Bischofberger, with a perspicacious eye for the new art and a taste for bespoke European suits: "I've been trying to get Keith Haring and Thomas Ammann together for a dinner because Thomas wants to have it, and so I called Keith and he was just getting up, he and Juan had been to Paradise Garage until 8 a.m. and they'd slept all day." The dinner with Ammann at the restaurant Van Dam included the actor Richard Gere, then famous for his roles in *American Gigolo* and *An Officer and a Gentleman*. "Richard was wearing a little hat and a mustache, and that's his look from *The Cotton Club*," Warhol said. "He said he only came because he wanted to meet Keith Haring. He's buying art."

With only weeks left until the opening of his second show at Tony Shafrazi Gallery, the question at the top of Keith's mind was "How can I top the first one?" He began with a title—*Into 84*. While looking at Tseng Kwong Chi's photographs of the painted body of Bill T. Jones, he next decided to make the flatly alive images—appearing as close to illustrations as photographs—a leitmotif for the exhibition. (His shows often flowed together: key pieces at the Fraser Gallery, fiberglass busts of neoclassical women with ruffled collars and periwigs, painted by him and LA II in Day-Glo colors, were afterimages of the earlier show in Shafrazi's gallery. Haring thought of them as suitably "sort of English.") He mounted the blown-up photographs on Plexiglas with the intention of cutting them out, but the cutting proved too time-consuming, given the fast-approaching deadline, and he began to prefer the effect of the figures set against the stark white background, so he kept them.

He painted the white walls of the gallery with red paramecium shapes dabbed with white brushstrokes, and he and Shafrazi together chose a new black-and-white-checkered linoleum floor for the gallery. When the photographs were finally mounted on the walls, the effect was vibratory. Instead of a catalog, Haring printed at least seven thousand posters of the Bill T. Jones image—a backside pose, red on black—against a maze of line shapes.

The other element of surprise in the show was a series of totem poles, large and sculptural, somehow evoking both Dubuffet and Native American art of the Pacific Northwest. These were collaborations with Kermit Oswald, who was now living in a studio in Greenpoint, Brooklyn, building frames for a living in his woodshop. Kermit had recently introduced Keith to a router, the tool that allowed him to push across and glide through wood to incise drawings. "You can use it like a pencil or a pen," Haring said, "but it's really a modern way of carving, because there's a metal bit spinning around." Kermit had once shown him drawings he made in India ink of eerie totem poles he had seen in a dream. Keith put the two together and proposed making such poles for the upcoming show, reviving some of the old-time's-sake spirit of the two teenagers making stuff in Kermit's studio over the garage in Kutztown. Haring could also now count on another collaborator, like LA II, helping to produce content on short notice for a show. "I went out and bought these big slabs of raw wood that I cut with a Bosch jigsaw," Oswald remembers of their process. "There were four big totems and wall pieces, too." They then rolled the surface of the wood with shimmering black paint and lined the grooves with surprising fluorescent paint.

Not yet entirely satisfied, Keith convinced Tony Shafrazi to rent a space behind a former Blimpie a block away on Houston Street to expand to a two-gallery, two-level show. "Tony in his ever-growing eccentricity," Haring said, "agreed to rent this extra space around the corner that was available for a month." Upstairs, Keith mounted new tarp paintings, one measuring sixteen by twenty-two feet, and more wood pieces, like jigsaw puzzle pieces, on the wall. Downstairs, he and LA II concocted one of their ultraviolet black-light environments with walls of fluorescent solid colors covered in sprayed graffiti lines and drawings.

Keith asked Juan to move all his deejay equipment into the basement, where he set him up on a dais, to spin nightly to bring to life his vision of a monthlong "kind of breakdance disco." In photos, Juan Dubose does have a Larry Levan presence. Wearing a light green scarf, like a vestment, over a dark green sweater topped by a golden medallion, his head nearly up into the hot water pipes overhead, he takes a star turn as a deejay. The entertainment value of the exhibition was kept high. On opening night, as expected, thousands showed up, while a spindly white-chrome robot moved among them exchanging pleasantries in English and Spanish. Haring's vision came true on Saturday afternoons, when the space became a spot for break-dancers to get down, not always invited, and where crowds would gather to watch them. At a Christmas party in the black-light space, Keith dressed as Santa Claus and gave away small woodcuts. Not since Andy Warhol's *Exploding Plastic Inevitable* of the sixties had an artist been so involved in framing his art in a club atmosphere.

In a tough review in *Artforum* of the sort Haring was coming to expect, if not usually from *Artforum*, the art critic Kate Linker faulted the show—and those of other graffiti artists now exhibiting works on canvas in galleries uptown, such as Sidney Janis—for "mostly tepid work, as if desiring more focused spotlights, unmindful of that great group show that is the subway." She found the Bill T. Jones photographs "deathly dull" and the totems too "arty." Kim Levin in the *Voice* begrudged that the work "occasionally really falls flat, but sometimes it transcends itself." By other metrics, *Into 84* was a mad success. Haring, with relief, felt it "another leap forward." "The show sold out on opening night," says Kermit Oswald. One of those deeming it successful, though with mixed feelings, was Andy Warhol, who once again cabbed to a Haring closing ("$8"). In 1982, he had shied away from the downstairs black-light party. This time, out of fondness for Juan Dubose, he descended the steps—to his regret. The moment he walked into the ultraviolet light, his wig started to glow, as if on fire. No one said anything until Rene Ricard rushed over and exclaimed, "Andy! Your hair! It's glowing! It's incredible." Mortified, Warhol quickly left. Yet his worries on his way home were not about his wig, but about the opening, which had left him

feeling sorry for himself. "Went all the way down there to see what people are doing and I got jealous," Warhol said. "This Keith thing reminded me of the old days when I was up there."

Five days after the closing of his show, Keith sat down and wrote "Keith Haring by Keith Haring," a cover piece commissioned by *Flash Art* for its March 1984 issue. Distracted by mounting demands on his time, Keith was writing in his journals less and less. He was submerged in making new work and in curating the moveable scene he had created around himself. A jumpy videotape of a New Year's Eve party he threw in the *Into 84* annex, recorded by Nelson Sullivan, who was chronicling the downtown scene on VHS, shows Keith less as the life of the party than as a hands-on host, with an eye for detail, manning the door as guests arrived, hopping in as bartender to serve a spiked punch, making sure Juan was okay at his deejay table downstairs. He was the party's detached ringleader until much later in the evening, when he let loose on the dance floor, displaying his innate moxie as a fancy dancer to Juan Dubose's beats. Derrick Smit, a sometime graffiti artist who had met Haring when he was doing a mural at Smit's high school uptown and who was now studying at SVA, noticed a similar detachment from Haring in the studio, where he liked to paint with a party going on around him: boys smoking joints and a boom box playing loud. "There was a circus going on around him," Smit remembers. "Sometimes it seemed he wasn't particularly interested in the circus. There were a few moments, because I was in art school, I could see where there was something art historical in the work. If I looked straight at him and asked him, it was 'Bing!' He suddenly had plenty to say. The thinness someone might assume about his work was dispelled in that instant by the seriousness with which he took art."

The *Flash Art* assignment gave Haring a chance to dip into his flow of thoughts. He wrote as he painted, in the manner of Jack Kerouac and William Burroughs, in "spontaneous prose," yet as for both Beat writers, his internal logic tracked as surprisingly consistent. He began by going back to his basics as an artist, the stirrings he first put down in

adolescent writings. His urge to explain, he wrote, was triggered as "I have read very little real critical inquiry into my work, besides the ongoing obsession with the phenomena of money and success. For this reason, I decided to note a few of the things that nobody ever talks about, but which are central (I feel) to my work." He wrote of chance and the influence of the CoBrA group and Eastern calligraphy, of automatic writing and gestural abstraction: "The artist becomes a vessel to let the world pour through him." From chance, he went on to performance, because if the artist was a vessel, he was also a performer: "I find the most interesting situation for me is when there is no turning back. Many times, I put myself in situations where I am drawing in public. Whatever marks I make are immediately recorded and immediately on view. There are no 'mistakes' because nothing can be erased. Similar to graffiti tags on the insides of subway cars and brush paintings of Japanese masters, the image comes directly from the mind to the hand." To be relevant, he felt he needed to be open to whatever innovative tools and media were available: "Living in 1984, the role of the artist has to be different than fifty years ago, or even twenty years ago. I am continually amazed at the number of artists who continue working as if the camera were never invented, as if Andy Warhol never existed, as if airplane and computers and videotape were never heard of."

Haring's take on computers in the essay was expansive, as fascination with the morphing machine was expanding in the early eighties—within weeks of writing his article, on January 24, the first Apple Macintosh personal computer was launched. Haring had been toying with computer art for several years. He had worked on a video-text machine at NYU in 1980. In Tokyo, in 1983, he created a layout in pixels for *Brutus*, a Japanese men's magazine, which rented him a computer graphics studio for a day for the experiment. Of its technical limits, he complained, "My main problem with the computer is the restriction of the image, in that it is always trapped inside this box (and a screen) and, except in the printing, is very limited in its scale." Yet he was mostly driven to think and draw about its unintended consequences. Haring was sensitive to communication technology in his work—frantic phones and lit TVs were among his earliest imagery. He was aware that 1984 was the

Orwellian year and that screens were the eyes and ears of Big Brother. The largest of the tarps in his show had debuted a caterpillar with the head of a computer, straddled by a ride 'em bronco figure wielding a rod with three headless figures marked with Xs, soon to be deleted, below. He was drawing the caterpillar-computer centaur on subway walls, too. (Its billowing body may well owe something to Haring's early hookah-smoking caterpillar from *Alice's Adventures in Wonderland*.) Although he insisted "an artist is not the best spokesman for his work," his essay was as close to a screed on the untitled computer tarp and many computer cartoons to follow as we have from "What does it mean?"–resistant Haring: "The rise of technology has necessitated a return to ritual. Computers and word processors operate only in the world of numbers and rationality. The human experience is basically irrational."

A month later, on February 18, Haring arrived in Melbourne, Australia, after having drawn in chalk for his fan base in the subways a kangaroo with a baby in its marsupial pouch (riffing on his mother and child) and a message: "See you in 3 weeks . . . I'm going to Australia, Keith." Still jet-lagged from the long flight, he set to work on his most monumental project of the trip, creating a temporary mural on the Water Window, a huge glass wall in nine panels with streams of water running over it, located at the entrance to the National Gallery of Victoria. The curtain of water was shut off while he completed the mural in two days, painting up and down the glass on a scissor lift. With Haring having just written of his work as comparable to drawing "with a stick in the sand," the mural looked even more primeval and worthy of a cave wall than ever. In white paint, he created a totemic figure giving birth, with a head composed of red concentric circles, surrounded by humans and robots with snake heads or extremely elongated necks. Unbeknownst to Haring, though, Melbourne was the homeland of the Boon Wurrung and Wurundjeri Aboriginal tribes, and some viewers saw appropriation of their native art in his mural. "I didn't even know what Aboriginal art was!" Haring said. Interviewed while painting a mural for schoolchildren on the side of Collingwood Technical College, he tried to explain: "I was already drawing a lot of the things before I came here, the snake things. One of the most interesting things I saw in the aboriginal work were

the X-ray drawings where you could see right through the animal . . . I started drawing these kangaroo monsters here. This is the first time I ever put lion legs on the front of the computer worm, so it's almost like a sphinx." Perhaps instigated by the controversy, someone threw a brick through the Water Window at night, using the red concentric circles as a target, causing the entire piece to be dismantled months ahead of schedule. Haring also painted a mural in the foyer of the Art Gallery of New South Wales, in Sydney. Yet, mostly because of the unpleasant incident in Melbourne, he wrote off his Australian trip as not "all that hot."

The projects he returned to in March were either commissions or invitations involving children. Three days after flying out of Melbourne, he was at the Walker Arts Center in Minneapolis, Minnesota, for a week-long artist's residency, where he painted on the center's Concourse his computer-headed caterpillar in green and orange. As part of "Children's Festaville," he also worked with pupils from the Alice Smith School in nearby Hopkins to create set pieces for a dance-theater work by New York City Ballet principal dancer and choreographer Jacques D'Amboise. "Keith was taking requests for drawings from the kids," the manager of the program recalled. "At one point, he noticed that I was a little appalled at how the kids were casually coloring in his drawings. He smiled and said, 'That's why I'm giving these to them.'" Near the end of the month, timed with the show *Keith Haring in Iowa City*, he was artist in residence for two days at Ernest Horn Elementary School in Iowa City, simply because one of the teachers, Colleen Ernst, had written to say she was teaching a class about him. He did a drawing workshop with children from kindergarten through sixth grade, and after keeping in touch with the teacher and her students over the years, he returned to the school five years later. "You are one of the kindest, most generous souls I have ever met," Ernst wrote in her touching thank-you note. Typical of letters sent—and often answered—from students he encountered at Horn was one Keith received just before his return:

Dear Mr. Haring

I'm one of the kids at Horn School (that's the school you're coming to in Iowa City.) I'm in the 6 grade. I think you are a very cool guy.

If you could, I would like an autograph. I still have a pin from when you came here last and a neon green sticker with three eyes and a big smile. I'll see you when you come to Iowa City.

Your friend,

Giff Laube

Many artists of the twentieth century were fascinated by the immediacy of children's art, an influence felt in the tonal drawings of Paul Klee, the dreamlike box constructions of Joseph Cornell, and the crayonlike figurative paintings of Philip Guston. Another "culture parent" of Haring's, Jean Dubuffet, wrote of his "persistent curiosity about children's drawings and those of anyone who has never learned to draw." Haring's special bond with children, though, went far beyond the aesthetic to the deeply personal, having begun with the rapport he felt with his little sister Kristen. "I was totally in love with this little girl!" Haring said. "And I loved teaching her things, and being with her, and being sensitive to her." In Pittsburgh, while working at the Arts and Crafts Center, he spent time at their little nursery school class: "I met a wonderful woman there named Dorothy Kaplan, who had this amazing philosophy about teaching art to children in a way that would stay with them for the rest of their lives." He described the job he held as an arts and crafts instructor at a day care center in Brooklyn during his first summer in New York City as "one of the best jobs I ever had." Haring said of the teaching experiences, "I found out that I could make any kid smile. It's probably from having a funny face to begin with—and looking and acting like a kid. And kids can relate to my drawings, because of the simple lines."

When teaching children to make art, Haring relied on many of the same games his father used to play with him and his sisters and cousins while he was growing up. The most basic of these involved his father drawing a line or a squiggle or a circle or a face and passing it over to Keith to make his own response in a shape or a form. Haring adapted this back-and-forth drawing game into the elementary art exercise he used in Iowa City and wherever possible. "I roll out this big roll of paper," he later explained. "All the children sit around it. I do some drawings

on the paper. Then they start making drawings with markers or pens. I have music going and, as in 'musical chairs,' when the music stops, everyone moves to another part of the paper. When the music starts, everyone continues to draw. It's a way of filling the paper in an interesting way. I've done this project in Japan, all over Europe, and America—and it works every time. It never gets boring." He sometimes surprised interviewers by saying, "I'd like to be a schoolteacher."

A fond wish of his, of course, was to be a father, though little about his life and times made a path to having children obvious. Just a year earlier, in 1983, in an interview in *Upstart* magazine, he had said, "I don't think I'm going to have a wife, but I would like to have a baby sometime. I really like babies. I'm not sure when or how but it would be great." That desire, and his obvious chemistry with children, his ability to communicate with and charm them, made him a clear choice as a godparent among his friends who were beginning to have babies. First was Zena, the daughter of Kenny and Tereza Scharf. Keith also served as an official godfather, recognized in a church ceremony, for Colin, the son of Kermit and Lisa Oswald; and in other cases, he was a more casual godfather, or the term was simply used with family, or with children who felt "like family." "He was so sweet with Zena," Kenny Scharf remembers. "When he was hanging out with kids, he would always be at the table with the kids, not at the table with the adults at the party. He had a quality of realness and innocence to him that was like a child. He could definitely tap into that."

The best reflections on Keith's involvement with children were his own. He responded to their imaginations, to an honesty and freedom of expression, surprisingly sophisticated senses of humor, and reliable instincts in responding to energy coming from adults. He enjoyed having them take turns riding on his shoulders, flying kites, holding hands, balancing on a fence, simply having a good time playing. In his journals, he wrote of a "silent bond between me + CHILDREN. CHILDREN can sense this 'thing' in me. Almost all children have a special sense of this 'thing' in other people. THEY KNOW." In another notebook, in 1987, he wrote, philosophically, "Whatever else I am, I'm sure I, at least, have been a good companion to a lot of children and maybe have touched their lives in a way that will be passed on through time and taught them

a kind of simple lesson of sharing and caring. I really wish I could have my own children but maybe this is a much more important role to play in many more lives than just one."

Springtime was Haring's favorite season, in no small part because his birthday fell on May 4, and he was always sentimental about his own birthday, and reflective. Birthdays were also a heartbeat of his art—with his life cycle paintings of women graphically giving birth; his mother and child drawings, with radiating lines for halos; and the symbol he chose as the stand-in for his own name, his tag, the crawling baby. In 1984, turning twenty-six, he had all the pieces in place to mark his birthday more extravagantly than by simply drawing candles on an oval of a cake in a pocket notebook. "I want to make this into quite a grand affair," he said. "The fact is, I'm now making a certain amount of money and I feel a certain guilt about it, and I want to share it with my friends . . . you know, sharing the wealth!" Even though he left most of his works untitled—so as not to force interpretations—ever the poet, he was quite good at titles. He decided to call his birthday event the Party of Life, implying a celebration not just of his own birth but of everyone's birth and of life itself. The basics were set up early on. He got permission to throw the party at Paradise Garage on a Wednesday evening, when the club would otherwise have been closed; they just lacked a liquor license. As Juan Dubose and Larry Levan had become close friends, they would deejay together. LA II would help spray-paint the banners.

On his actual birthday, Haring was still in Europe for a show of his work at the Galerie Paul Maenz, in Cologne. The opening at one of Germany's most important galleries was on May 3, with an after-party at the Coconut Cub, Cologne's largest gay disco. One advertisement featured a photo of a boyish Haring, in round-framed glasses (unpainted) and a white T-shirt, with punchy copy—"Graffiti Kunst: Keith, der Wunder-Knabe." Fresh from his *Into 84* show, he created a poster by painting a model's body and photographing him against one of his paintings in a variation on his Bill T. Jones poster. At the show as well was another leading German dealer, Hans Mayer, who first heard of Haring in 1979,

when Bill Beckley told him of his "wonderful young student," and again when Andy Warhol, an artist shown in Mayer's Düsseldorf gallery, said, "Hans, you should meet Keith Haring—he's a wonderful artist." Looking at the work in the gallery, Mayer regretted not having paid more attention. "I became very jealous because I looked at Keith's work, and I was really excited," he said. "I realized that a new artist was creating a new art for a new generation. Well, Paul Maenz did great things for Keith, because after 1984, Keith was all over Europe. I was really off the mark. I was not on top of things." Mayer remedied the situation three years later, negotiating to show Haring's paintings and sculptures in his gallery. The most impactful work in the Paul Maenz show, *1984*, a one-hundred-square-foot painting in four joined panels, not on tarp but on yellow muslin with a red borderline, foregrounded a triangle of a body with a personal computer for a head, its screen face revealing a hypnotic swirl of circles. While spinning on one arm a plate of brains, the figure is being worshiped by upstretched hands. (Had the hypnotic computer displaced the human brain?) In sporadic combinations, like horrific decorations, robots, missiles, snakes, and batty angels animate the canvas with more than the mind can hold. The waking nightmare marks one of the dawns in Haring's work of his satiric cartoonery taking on the look and feel of Hieronymus Bosch's *Garden of Earthly Delights*.

Back in New York City, Haring's gallery was conducting a search for him for an office manager. The feeling at Shafrazi Gallery was that with the artist's career exploding, and with "too many irons in the fire" for work he was committed to outside the gallery, he needed help. Answering their classified ad in the *New York Times* was Julia Gruen, a twenty-five-year-old woman who had grown up in the city the daughter of art writer and photographer John Gruen and painter Jane Wilson and had worked briefly as an assistant at the Charles Cowles Gallery at 420 West Broadway. She worked a couple of weeks at the Shafrazi front desk awaiting Haring's return. On the day of her interview with the artist, she found her way there by walking to the end of the block from the gallery and looking across Houston Street, up to the easily spotted giant red fan in the arched window of Keith's studio in the Cable Building.

"We sat down at a little square table that only had on it a telephone in the shape of Mickey Mouse with his four-fingered glove as part of the receiver," Gruen recalls. "The first thing he said after hello was 'I'm not sure what I'm supposed to ask you.' He didn't give a hoot if I could type forty words a minute, which is the kind of thing people would ask back then if you went for an office job. We had this stilted conversation. Somehow, we got onto my background and how I'd grown up around artists and poets like Bill de Kooning and Frank O'Hara, as my parents were in the arts. These were some of his heroes, so, he became more alert than in the stop-start beginning. It came out I grew up in the East Village, and we went to many of the same clubs—Club 57, Mudd Club—though we never met. That and my background sealed the deal." Gruen stayed on as studio manager throughout Haring's life and was the subject of a painting (*Keith and Julia*) as well as a sculpture (*Julia*).

Gruen's first assignment was to scope out the paraphernalia for Madonna's performance at the Party of Life. In the lead-up to the party, Madonna had stopped by Keith's studio to play for him cuts from her new album, *Like a Virgin*, not to be released until November. Keith immediately liked "Dress You Up" and "Like a Virgin," and she agreed to sing both songs at his birthday party. While they were listening to the album, he painted white stars and babies on Madonna's black leather jacket, which she wore to the party. She decided she wanted to perform the songs on a brass bed covered with frilly material and strewn with flowers. "There were a number of prop houses on lower Broadway where I found a brass bed for rent," Gruen remembers. "I went to Paterson Silks for the frilliest possible white bedcoverings, pillows, shams. I was asked to get a huge amount of white Casa Blanca lilies, which remained among Keith's favorites in his life. He often bought them himself in the Flower District, he'd pick up tons of them." The invitations were yellow handkerchiefs, or bandanas, with a drawing of a totemic alien and, printed on them, the date and time—"May 16 1984, 9 PM till ?" Said Gruen, "All of us—Bobby Breslau, maybe Kermit, and there were a lot of girls in the group—sat on the floor of the studio stuffing envelopes with handkerchiefs, drinking beer, finishing at eleven at night, and running to the main post office to dump bags of invitations as Keith invited like

two thousand people." He also made fluorescent tank tops, to be given out at the door, along with Day-Glo necklaces by jewelry designer David Spada. The fashion designer Stephen Sprouse offered to create suits in fluorescent pastel colors for Larry Levan, Juan, Bobby, and LA II. For Keith, he made a yellow velvet Day-Glo tuxedo that looked to Bill T. Jones like "a kitsch reference to a prom." One photo shows Haring, a lone figure in his yellow tuxedo, wandering among the sweaty bodies gyrating on the dance floor.

About three thousand guests showed up the night of the party, a thousand or so above the maximum occupancy of Paradise Garage. In the meantime, after the mailing, Keith had been passing out invites to attractive people he saw at the Garage and on the street: "We picked out the hottest people that we saw and were inviting just really gorgeous people and street kids." With the help of Andy Warhol inviting his friends, the celebrity quotient was high—Halston, Steve Rubell, actors Matt Dillon and Richard Gere, Alana Stewart, Calvin Klein. Haring painted lots of banners with snakes, robots, exploding penises. One large totem loomed. Dan Friedman lent the early vase Haring had made for him, covered with priapic figures, which was filled with white lilies. The kickoff of the event, as the hall went dark and as Juan opened with a mix of the Garage house music classic "Can You Move," by Modern Romance, was a message in a crawl line of *Pac-Man* video game–style lettering projected onto a screen: "GREETINGS EARTHEANS OF THE NEW YORK QUADRANT. I AM ROBOT 'SICO.' MY MISSION IS TO INVITE HUMANS TO 'THE PARTY OF LIFE' AT THE PARADISE GARAGE. MUSIC BY L. LEVAN AND JUAN DUBOSE. ART AND VIDEO BY KEITH HARING AND L.A. 2. GET DOWN." Promising that "Right after we get offstage, the one and only Madonna will be out," John Sex, with a towering pompadour—"Let's have a big round of applause for my hairdo"—performed a song he pointedly claimed was Keith's "favorite song of all time": the theme song from the James Bond film *Goldfinger.*

For "Dress You Up," Madonna wore a bubble gum–pink leather skirt and jacket designed by Hector Torres and embellished by Haring and LA II, before changing into something more diaphanous to vamp on the brass bed to debut "Like a Virgin." "But her reception isn't exactly ec-

static because her album hadn't come out yet and people are hearing those two songs for the first time," Haring said. "Six months later, they would hear those same songs six times a day on the radio!"

"Who is *that* singing?" Bill T. Jones asked.

"Andy says she's the next big thing," Keith answered.

Suddenly, at a corner of the stage, in the audience, appeared the surprise guest of the evening, Diana Ross, who was recording in the same studio as Madonna and had decided to stop by. The crowd began to erupt, as no greater diva existed in the pantheon of the Garage than Diana Ross. Grace Jones, not performing that evening, was standing backstage with Keith when Ross appeared. As Madonna finished her act, Jones stuck her head out the curtain, wishing to cut across the stage to greet Diana Ross. "Don't do that," Keith said, pulling her back. "They're gonna think you're gonna perform now." Jones went instead out into the audience and pushed her way to Ross through the surge in front of the stage. Keith had the experience of having Diana Ross—at least, in spirit—sing him "Happy Birthday" for his twenty-sixth birthday.

While the party went on well into the promised question mark hours, Warhol—often home in his town house on the Upper East Side earlier than might be supposed from his reputation as a socialite—left early, but not so early as to miss any of the more important details of the evening:

> There were kids outside selling tickets to it, although it was a free party. John Sex performed. Madonna didn't start until so late that I only heard the beginning. And that kid Bobby who lives with Madonna was there, the one I got the job for in Paul's movie. And he's in the hospital for a leg operation—he had his hospital bracelet on—but he snuck out for (laughs) this party. And all these kids were wearing Stephen Sprouse outfits, I don't know where they get the money. Keith's Juan was in Day-Glo and it was like the sixties. And they have a phrase that's like "Mark me," when they want you to sign their stuff. Maybe it is "Mark me."

The "Bobby" with the injured leg was Bobby Martinez. The film Warhol had pitched him for was Paul Morrissey's 1985 release, *Mixed Blood*, a tale of a Hispanic gang of teens selling heroin and cocaine on the

Lower East Side, with Martinez playing a member of a rival gang. A few months later, Martinez returned into the plot of Warhol's diary when he went to the movies with Andy and Keith: "Went to the movies with Keith and Bobby, Madonna's ex-boyfriend who's sort of Keith's friend now." Warhol had cause and effect backward, though, as Martinez had long been the shared point of a double triangle, first with Keith and Juan and then with Madonna and Jellybean Benitez, his presence at the Party of Life adding an undercurrent between them all.

Around the time he first met Bobby Martinez, Keith had begun frequenting a hustler bar called the Phoenix, on West Fourteenth Street, that featured break dancing by dancers wearing only jockstraps, young men spinning their butts into the air or grabbing their crotches at the end of a set. The bar held dance contests with prizes, and most of the dancers competing were young Latino and Black street kids. One of these was Bobby Martinez, met first by another denizen of the Phoenix, Rene Ricard, who brought him along to one of the parties in the basement of *Into 84* being deejayed by Juan Dubose. Martinez knew of Haring, as he had grown up in the East Village, on East Tenth Street, and had been a graffiti artist and gone to openings at Fun Gallery. Keith found him to be "completely and incredibly adorable" and the fulfillment of many of his most cherished fantasies: "He's a really tough-looking kid—the perfect image of the kind of street kid I want to be with." Their tight connection was not easily labeled, as Martinez was at least primarily straight, and Keith, in a single sentence, could ensure that "we didn't really have sex" but also that "it wasn't really a secret that he was my boyfriend." Keith had strayed into this no-labels territory with other young men, yet Martinez stood out. Among the other guys Haring and Dubose were seeing separately and together, Bobby stood out, too: "So not only do we start hanging out together, we're inseparable. Of course, this presents a major threat to Juan because it's cutting into the time that's been exclusively his. He now gets the message that I only want to share my time with my new guy."

One evening, Keith had taken Bobby to a party and introduced him to Madonna. "I was at Keith's," Martinez recalled, "and he said, 'Do you want to go over to Madonna's apartment?' I said, 'Who's that?'" The two

hit it off, danced late into the night, and the next day, Bobby brought her a painting he had done, as a gift. "Madonna falls for Bobby, and she starts having an affair with him," Haring said, "while Bobby is supposed to be my boyfriend, sort of, and she's supposed to be lovers with Jellybean, and I'm supposed to be with Juan. When she starts having this affair with Bobby, I'm not interested and just remain friends with Bobby and still spend time with him. There's this weird competition going on. But what kind of competition could there be between me and Madonna? Of course, he's going to choose to be with this beautiful, gorgeous, talented girl who is becoming more famous by the minute. Madonna, 1984, we're talking meteoric, and on MTV every minute with the video for 'Borderline.'" Given the times, and the personalities involved, the three-way dynamic "never becomes a source of anxiety or fight between us," and Martinez remained a player in both their lives throughout the decade. Writing to Keith from detention, Bobby informed him, "Some people really admire your work in here because you have some guys who're artists themselves." Signing off, he included a nickname the two men used for Madonna: "Don't forget I really love you in a lot of ways. If you see or hear from Boytoy tell her I said hello."

Less sanguine about the turn of events was Juan Dubose, not so much from the introduction of a third party, as there had been a few on both sides, but from the increasing loss of Keith to a life that Juan was less and less able to play within as an equal. "I remember visiting Keith and Juan Dubose in their funky little apartment on Broome Street—they looked so much like little boys," said Bill T. Jones of his first visits two years earlier. "There was beauty in that. And there was tenderness between them. In a way, they started out as emotional equals. I always felt that Juan had even a little more maturity than Keith—and he was a perfect foil for Keith—and he sort of understood what was happening to Keith and his career." Yet fame and money were beginning to upset this delicate balance. "Juan was a very simple person," said Carmel Schmidt. "He had dignity and within his little world, which was installing radios in cars, he felt good about himself. And then, he was swept up into a world that was *so* over his head that he lost all footing."

Bill T. Jones was seeing a lot of Keith Haring during this period, as

they went on from the London body-paint photographs to working on *Secret Pastures*, a collaboration they would stage at the Brooklyn Academy of Music in the fall, with choreography by Bill T. Jones and Arnie Zane and sets by Keith Haring. "Keith told me he wanted a relationship with our company," Jones says, "like Bob Rauschenberg with Trisha Brown." Jones and Zane had been lovers for over a dozen years—Zane was a white, middle-class, Italian American Jew; Jones, a Black country boy born in the South to migrant workers who moved to Upstate New York. So, Bill T. was especially sensitive to issues of race and class that seemed obvious to him in Keith's relationship with Juan. As outspoken in his life as in his work, he was one of the few to confront Keith directly about such matters, if not with great success. "Keith loves people from a class lower than his own," Jones said. "Well, there's a responsibility that goes with that. And that responsibility is not just how generous you are, but how you can bring that person up through his emotional perils and feelings of inadequacy. Does Keith really know what it means to set up house with someone who is not as educated as he and is more emotionally and financially handicapped? So, I talked to Keith about these things. But you can only push Keith so far until he's finally not there . . . So I called him 'The Iceman,' and because he's an iceman, he loves hot and passionate people."

Keith Haring's life during the summer and early fall of 1984 was a tale of two continents. In New York City, he was excited mostly about producing public artworks. His favorite was created for George's candy store on Avenue D, as he knew the owner. With its lone video game machine and Pepsi cold-drinks freezer, the store was mostly devoid of candy but was a known hangout for drug users. In July, Haring painted on the walls a black-on-orange phantasmagoric mural filled with mutant imaginings—a six-breasted computer-headed beast straddling the fuselage of a jet plane with a dog's phallus for a nose was one of its dozens of vanishing points. "At this time, in eighty-four, I had started doing these really detailed, almost surreal, scary monster paintings that had all these weird configurations," Haring said, in one of the better de-

scriptions of his new work. "They were combinations of science fiction and this strange nuclear aftermath." By the fall, he was deploying his ogres, freak shows, or simply disturbing tableaux into acrylic on canvas or muslin. The decibel level of shriek was highest in *Cruella De Vil*, as the villainess of Disney's *One Hundred and One Dalmatians*—in Haring's version too far removed in sheer grotesque distortion from the perversely charming original to be an "appropriation"—burns dark red spots into her puppies with her cigarette holder. In *Saint Sebastian*, in the same mode, a scarlet figure tied agonizingly to a tree, with cubist eyes askew on the front and back of his head, a nose for an ear, and a curved erect penis, is pierced by jet planes, rather than arrows, his halo a hot burning yellow circle of sun. (The *Saint Sebastian* proved to be a trial run for his martyrdom of Michael Stewart painting done the following year.)

In July as well, Haring reprised his body-painting of Bill T. Jones in an even more extravagant production, this time painting Grace Jones at fellow artist Robert Mapplethorpe's nearby Bond Street studio for a photograph for *Interview* magazine. A regular performer at the Garage, the Jamaican-born model—in Paris for Yves Saint Laurent and Kenzo—and singer had been performing at the top gay discos since the 1970s, when her song "I Need a Man" was a timely expression of outright libidinous honesty. Haring had long been desiring to paint Jones's muscular panther's body set off by long legs, angular cheekbones, full lips, and a stage presence as intense as Edith Piaf's, whose "La vie en rose" Jones had covered. The shoot was arranged by Warhol, who knew enough of Jones's notorious lateness to fill in some time by stopping by the Avenue D candy store to look at Haring's latest mural. "Keith said he wanted to be around 'hot kids,'" Warhol said of the inspiration for the project. Waiting two hours in the studio was Keith, who had brought along Bobby Martinez, while Mapplethorpe grew increasingly "antsy." Jones finally arrived on the back of a motorcycle driven by her boyfriend, the Swedish actor and martial artist Dolph Lundgren. She disrobed down to her bikini underwear as Haring began to paint her, and David Spada fixed a steeple of a crown to her head and rubber jewelry to her breasts. (Haring and Spada teamed up again a year later to paint and accessorize Jones for the Her Grace at Paradise concert, and Haring painted a voluminous

skirt for her "I'm Not Perfect (But I'm Perfect for You)" video. She was very calm, and the session went smoothly, the final photographs making a dancelike diptych with the Bill T. Jones works. Their diva was hosting a dinner at a restaurant later that evening, and Keith was thrilled when Jones made her entrance. She had gone home to wash the acrylic paint off her face and then had changed into a clinging backless Azzedine Alaïa dress that showed off her wildly painted arms, back, and legs.

Even given the pinball pace of the previous few years, Haring felt that 1984 was "one of my most active, craziest years." The same month he painted the candy store and Grace Jones, he was commissioned by the New York City Department of Sanitation to create a logo for posters, stickers, pins, and television advertisements for an anti-littering campaign. He instantly came up with a "Don't Be a Litter Pig" campaign based on the pigs he had been drawing since high school, distant cousins of Looney Tunes' Porky Pig. The sweet irony for Haring was the invitation that followed: to City Hall, to be thanked for his public service in person by Mayor Ed Koch. Haring had recently published *Art in Transit*, a book designed by Dan Friedman of Tseng Kwong Chi photographs of Keith's subway drawings. In his introduction, Henry Geldzahler praised the subway works as "a tuneful celebration of urban commonality." Yet Koch was the leading enemy of subway graffiti, the force behind the city's 1984 Clean Car Program that was mandating regular chemical washes for "bombed" subway cars. When Haring (in a three-eyed T-shirt) was introduced to the mayor, he quickly gifted him with a copy of *Art in Transit*. Tseng Kwong Chi was at the ready to snap a strained photograph of Koch flipping disapprovingly through the pages as Haring flashed a thumbs-up and a rascal's grin for the camera. "It was fun to do something that was officially sanctioned instead of illegal," he joked at the news conference that followed at City Hall.

A source of more serious animus for Haring, though, was the mayor's apparent indifference to the AIDS crisis. In the previous year, New York City's entire budget for AIDS services and education had been $24,500, while San Francisco, a city one tenth its size, had, in the same year, spent $4.3 million. In a fiery polemic in the *New York Native*, "1,112 and Counting," Larry Kramer denounced the mayor's refusal to declare

an emergency: "With his silence on AIDS, the Mayor of New York is helping to kill us."

A sign of his friendship with Warhol, Haring's social life was rapidly filling as well with more and more boldface names, the stuff of Page Six, the gossip column of the *New York Post*, much read in the 1980s. He was no longer simply "downtown." At the beginning of August, Keith went with Warhol and Basquiat to meet Michael Jackson at a hotel near Madison Square Garden before Jackson's performance. The crowds were so intense that a simple "backstage pass" was no longer viable, and anyone invited—Calvin Klein, Rosanna Arquette—needed to go to the hotel anteroom. Impressed by Jackson as "totally Walt Disneyed out," Keith presented him with a bunch of T-shirts. Warhol was cooler, shaking his hand. "The sequined glove isn't just a little sequined glove. It's like a catcher's mitt," Warhol wrote in his diary. "Everything has to be bigger than life for the stage." A few evenings later, Warhol invited Keith, Juan, and Basquiat to dinner at the Four Seasons with Philip Johnson and David Whitney. (Johnson would soon interview Haring for *Interview* at the Glass House, his home in Connecticut, while Halston interviewed him at Warhol's weekend house in Montauk, in a duet of a double feature.) After dinner, Keith wished to go to Rounds, a hustler bar nearby. Basquiat, though, said he used to hustle when he needed ten dollars, and he did not wish to be reminded. Keith and Jean-Michel took a cab back downtown.

The social event most relevant to Haring's art and life was a birthday party for Sean Lennon, who was turning nine. Keith brought Kenny Scharf as his date. Because Sean and John Lennon shared the same October 9 birthday, a vigil was being held by Lennon fans outside the Dakota in honor of the day. Among the guests at the party were Warhol, Walter Cronkite, John Cage, Louise Nevelson, and Roberta Flack. Invited by Yoko Ono, Keith had never met Sean, yet he was such a natural with children that he and the boy hit it off. Haring also spent much time on the floor chasing after a crawling baby with a stuffed animal. As a birthday present, he had painted for Sean an orange "9" on a blue background that was still wet when he came through the door. "I loved it a lot when I was a kid," Sean Ono Lennon says. "The painting hung in

the hallway my whole life. It was really meaningful because the number nine has a special numerological meaning and was my mom's favorite number and my dad's favorite and was the day of our shared birthday."

After dinner, the party moved into Sean's bedroom, where Steve Jobs, who looked to Warhol "so young, like a college guy," was down on the floor setting up his own gift—a Macintosh personal computer. "I was a computer geek and already had an Apple II Plus, an Apple IIe, a modem, I was on CompuServe . . . like Matthew Broderick in *War Games*," Lennon says. "All computers up to that point had just been a cursor at the bottom of the screen. Obviously, Steven invented this windows interface, which changed the world. None of us had ever seen anything like it." Jobs wowed them by demonstrating the first version of MacPaint, and everyone took a turn. Warhol dragged a mouse in a straight line that transformed into a perfect circle. "Oh look, Sean, I made a circle," Warhol said, excited. Sean tried to draw Boy George, from a favorite band, Culture Club. "And then Keith and Kenny used it," Warhol said. "Keith had already used it once to make a T-shirt, but Kenny was using it for the first time, and I felt so old and out of it with this young whiz kid right there who'd helped invent it." Jobs gave Keith his phone number, and Keith got a message to him, saying he was "excited to be in touch and keep talking." Sean invited Keith to return the next day for a kids-only party with friends his own age.

Sean became one of Keith's best young friends, like Zena Scharf and Nina Clemente. "Andy was like a cool uncle," Sean Ono Lennon says of Warhol. "He was very sweet to me. But his work was not in the language of childhood. My brain hadn't grown enough for me to understand it. At the time, I was just really attracted to the aesthetic of Keith's style. I thought of him as more of an older brother. Andy was at Mr. Chow, and he'd always have a nice blazer on. He was very chic, but I didn't understand what chic was. Keith would be in tennis sneakers and jeans and a T-shirt that was all painted. He felt closer to this fashion and style I related to growing up in New York. We'd be at dinner with all these people at some big restaurant, and Keith would just be quiet and start drawing, and that's what I liked to do. You couldn't take me to lunch without a drawing pad." As a precocious boy allowed to stay up late to meet the

adults, Sean would get to see Haring also at his mother's parties at the Dakota. "It was a very intellectual, very progressive, very gay, hip and wild and cool crowd. She was considered by them very important intellectually, culturally, and artistically. Keith and Jean-Michel were the crown princes, Andy was the emperor, and my mom was the queen, probably, and they all were thriving together."

As often as Haring was in New York City that summer and early fall, he was in Europe for weeks at a time. Befitting the more serious exposure his art was being given there, these trips focused more decidedly on shows and installations. In June, he spent three weeks in Italy, which became one of his favorite countries, devoted mostly to creating all the works for his first show at Galleria Salvatore Ala, in Milan, and his installation for the summer *Aperto '84* exhibit, associated with the Venice Biennale. He followed his preferred mode of producing all the art on location, using the materials and resources available—a sort of purposeful tourism on his part. "A jolly Italian fellow who had this important gallery in Italy," as Annie Plumb describes him, Salvatore Ala flew both Keith and LA II to Milan to create the show together. Haring began by visiting a workshop, on the outskirts of Milan, fabricating terra-cotta vases that he and LA II sanded, washed, and covered with marking ink. Keith's favorite vases were several small samples he found similar in shape to nuclear cooling towers. In Turin, he and LA II scouted plastic sculptures, painted them Day-Glo, and covered them with "tags." "I only wish Michelangelo could see them," Haring wrote in an unpublished catalog essay. "But then again maybe he will."

At the Pedano woodshop in Milan, Keith made totems and other wall pieces for the show. He had brought his router from New York to execute two-handed carvings into large sheets of wood, created directly, without any preliminary drawings or plans, as always. The main event of the show was a swirl of paintings in the "scary monsters" style, among his first works with acrylic paint on stretched muslin. "I chose to begin painting with acrylic because of the wide range of color I had been ignoring in my previous works on vinyl," Haring wrote. "I think I also just wanted to prove that I could paint, or do anything, if I wanted to. I chose muslin because the surface was smoother and more delicate than

canvas." One of the paintings was done live on an Italian TV show, *Mister Fantasy*, where he was awarded an "Oscar" along with David Byrne and other random celebrities. At the airport in Milan, he had run into Roy Lichtenstein, who stopped by before the show and was struck by the deadline against which the younger artist worked. "The gallery had stretched all these canvases for him, and he was painting a show that would open in two days!" Lichtenstein said. "Keith has a very interesting sense of humor. For example, those vases—those pseudo-Greek things, with Magic Marker on them. They're quite convincing and charming and funny. And much of the stuff is quite sexy, yet it's hardly pornographic. It's quite happy sex . . . there just isn't a false move. It's all so beautifully drawn."

For his contribution to the *Aperto* show in Venice, Haring chose an untitled work on white tarp dominated by a lascivious Mickey Mouse, his tongue wagging and his bare butt invitingly stuck in the air in the direction of an elongated gummy figure with an elongated penis. Haring mentioned the piece in an interview as evidence of the more open attitude toward the sexuality in his work in Europe than in America: "My painting that was in the Venice Biennale, which was in magazines and newspapers all over Europe, was Mickey Mouse getting fucked by E.T." Yet the work was not simply a celebration of "happy sex" in the mood of his penis drawings at SVA or much of the rest of the work he was showing in Milan—the erect E.T. holds a red devil's trident, a carpenter's screw marked with Xs looms overhead, as does a cautionary hovering angel. A message of "safe sex" was now beginning to infiltrate his work, joining his broader warnings about racism, bigotry, and nuclear weaponry. Exhibiting in the summer show in Venice, too, was Richard Hambleton, who had been painting threatening shadows on walls in New York City, playing on the public's fears of being mugged. Although Haring did not really like the shadow works, he and LA II hung out some with Hambleton. "When we went to Venice," Ortiz says, "Richard Hambleton was there, and he said, 'All right, let's go tag the walls,' and I said, 'Oh, that sounds cool.' I asked Keith, and he said, 'LA, no, no, no, these walls are like history. Don't tag up on these walls.' So, Richard went, and he tagged up the walls. Keith and I then went to Spain. We

went to a bullfight. That wasn't cool, seeing a bunch of bulls get stabbed up. So, we left."

In September, Haring was back in Europe, creating a sixty-second animated commercial for Big, a department store in Zurich, and taking part in a group show in Rome of graffiti artists. On the day after the opening in Rome, he created, in ink on paper, *The Story of My Life in 17 Pictures*, dated "May 4 1958–Sept 12 1984"—presenting his autobiography in the genre of a graphic narrative. All the cartoons were arranged neatly into four boxes by four boxes on a balanced grid, with one lone frame, the seventeenth, set off on the bottom row. The Kutztown frames tell a clear story (a woman giving birth, Mickey Mouse smoking a joint, an LSD daydream), as do the Pittsburgh frames (a Grateful Dead skull, a cock in a vagina, a white man pressing into a Black man) and those for New York City (a barking dog and a crawling baby, a figure with a dollar sign head, Andy Warhol). Less available for a simple push-pin label was the final, outlier frame, where a figure on the ground heaves into the air a levitating horizontal body surrounded by an aura of ray marks. Is the body ascending into fame and fortune? Or being tossed up into heaven with a shrug?

By late 1984, despite his successes, Keith was feeling just this uncertainty about his future. His great love with Juan was threatened. "I'm now having all these boys around me what with more travel, more notoriety," he admitted. "I'm constantly surrounded by temptation and it's hard to pass that up." Pressuring himself always to top his last show with novel inventiveness, he sensed his art was often being put down as facile by the New York art establishment. "The critics seem to resent me, museums pay no attention to me, and the art world in general kind of looks askance at what I'm doing." Anxieties about the mounting AIDS crisis and his own health were multiplying and increasingly impossible to ignore, as a third of the beds in St. Vincent's Hospital in the Village now belonged to AIDS patients. From the vantage of a rare moment of quiet in Rome, the destiny of his life and art truly felt up in the air.

A Political Line

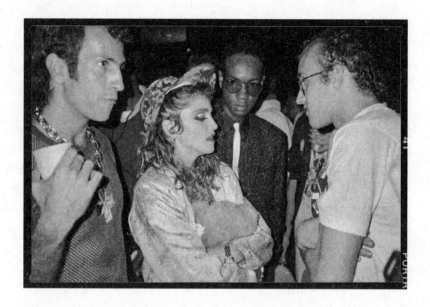

For *the last* few days. I've grappled with the idea of how to con-
vey the feeling of what's happening now with Reagan," Haring
worried aloud during the run-up to the 1984 presidential election, in an
interview with *The World*, a mimeographed poetry magazine published
by the Poetry Project of St. Mark's Church. "Just because the media's
pushing his way right through this election, he's obviously going to win.
And everyone knows it, and everyone's talking about it. But it's still go-

ing to happen because America's *so* vulnerable and so stupid. Someone who knows how to use the media can take over . . . Now how to convey that in images is a little difficult." The political satires of Haring and his circle of Club 57 friends during the first Reagan election four years earlier had been mean, yet filled with spiky hilarity—in Haring's spoof headlines, Reagan killed TV starlets, and his death squads hunted down the pope. (This over-the-top tabloid absurdity was matched by the actual *New York Post* in its famous 1983 headline "Headless Body in Topless Bar.") At Ann Magnuson's Inaugural Gala at the Mudd Club, the women had worn mimosa-yellow gowns, and the men cowboy outfits in homage to the new president. Yet the mood around the election this time was far more serious, as grim fears of militarism and the rise of the repressive religious right were felt to have come true. Most threatening was the refusal of Reagan, as of late 1984, to have even once mentioned AIDS in a public address.

Haring's testing of relevance for his art drew him back into the subways in a sprint of "messages to the public," his most sustained immersion in the transit system in some time, leading him as far uptown as the George Washington Bridge stop and to outdoor elevated platforms in the outer boroughs. "I did drawings today with a TV with dollar signs, and then a tube coming out of it that was going through someone's head and going back out the other side and then turning into a hand that was pushing a ballot lever that said on it 'Vote,'" he told his interviewer, the poet Cliff Fyman, reporting on some vanished imagery not even caught in Tseng Kwong Chi's tireless archive. "Another drawing today was this guy with a TV head, waving an American flag, which is what Reagan's really doing with this campaign, talking about being patriotic no matter what awful things he's doing behind everybody's back. He has a cross in his hand. In the other hand, he has missiles. He was stepping on all these people, all these little people, he was stepping on them. And on his chest, it said 'Ronald Reagan, '84.' It was pretty obvious what it was about. It was hard not to be obvious. I guess it was so obvious that by the time I got back to the other side—I went uptown, turned around and came back downtown—and that drawing had been destroyed already. Some Reagan person, I'm sure, was offended by it,

and ripped it up." Haring's campaign was of a piece with much of his 1984 art. He was disturbed by Reagan the screen actor lending himself easily to the power of screens controlled by dollar signs.

On the streets, Keith participated in an election installation, *Sign on a Truck*, created by Jenny Holzer, inspired in part by Jane Dickson's Spectacolor project. Researching other types of electronic signs, Holzer came across a truck with a giant TV screen mounted on its side, of the sort seen in sports stadiums. "The truck had only been in New York once, for a Diana Ross concert," says Holzer, who parked the truck at the southeast corner of Central Park at Fifth Avenue and Fifty-Ninth Street, broadcasting artists' videos that served as a warm-up to a live mic where pedestrians could talk about their choices for president while seeing themselves on-screen. Holzer contributed texts—"Stuff like 'YOU WANT TO LIVE' that seemed germane relative to surviving maybe a bad president," she says. Vito Acconci and Barbara Kruger also made segments. Haring drew live on lime-green paper his phantom voter hooked up to a TV and a hot-pink GOP elephant labeled "REAGAN 84," covered in Xs, stomping a pile of humans beneath its feet. "I was grateful for Keith's contribution because he's a man who understood and represented subject matter so well in a kind of shorthand," Holzer says. "His drawings weren't just cute, they also managed to show Reagan as frightening and less than generous. It was also important that he continue to work in the subways as life got tough for so many people in the city. I have a vivid memory of seeing a homeless family, a woman and a couple of kids, on a bench in a crummy Lower East Side station, with Keith's art behind them."

The expected thud came on November 6, 1984, as Reagan handily defeated his opponent, Walter Mondale, and Mondale's running mate, the first female U.S. vice-presidential candidate, Geraldine Ferraro, winning 525 electoral votes and 58.8 percent of the popular vote, a decisive tally unmatched since. As Haring admitted, his takes on Reagan were "obvious": "Watching Ronald Reagan talk double-talk, you don't have to be intelligent to see someone is lying to you," he said bluntly. Yet Haring's response in the subways to the election results was subtler. He began to introduce a figure with legs aslant held upon a crosspiece

formed of the arms of two friends on either side. The point of the hint of a crucifixion scene as a comment on the election was clear to at least one subway rider, who scrawled on one panel in blue ink, "Impeach Ray-Gun Yesterday!" As Christmas approached, Haring sometimes added a radiant baby ascendent atop the frame, making the message more hopeful and seasonal. (Haring's attitude to the religious symbols of his youth remained ambivalent, though engaged, unlike his clean break from the die-hard Republicanism of his parents. "I didn't like that he was insulting Reagan, because I was very much for Reagan," complained Joan Haring, who fondly recalled taking Keith out of high school so that he could climb a tree to catch a glimpse of Richard Nixon when he appeared in Kutztown during his 1968 election campaign.) Haring sometimes added a triangle of a nativity shed above the three figures, helping and helpless, with a message of mercy in block letters: "SHELTER THE HOMELESS."

Keith kept up his political commentary as 1984 turned into 1985—a year he welcomed for his glancing passersby with the un-Hallmark greeting, "STILL ALIVE IN 85," expressed by a long, stilt-legged figure with "85" on its chest, flanked by a boogying little "83" and "84," each hovered over by guardian angels ready to whisk them away. The election lost, Haring turned from candidate Reagan to the policies Reagan was fronting, including militarism and inequality. He rolled out Tank Head, a muscled torso with an armored tank on tracks and a swivel gun turret for a head, marked with five-sided stars, or "USA," wreaking havoc. In a mischievous touch, he added a Star of David when drawing the figure beside a poster for the Hollywood epic *King David*, starring Richard Gere. He also told a two-part story of a giant led about by a choke leash held by a diminutive man beneath him only, in the second frame, to squash his captor with his big feet in an act of rebellion. Keith used this lopsided encounter to expose all sorts of inequality—in race, income, power politics. "The other drawings were this inflated head that's so big it's sort of floating away, and all these people grappling with it," Haring said. "So, it could either be about inflation or it could be about Ego, it could be about me, I don't know. I try as much as possible to do things that make people think, and to deal with these things that maybe they're not thinking about, that they should be thinking about. And it works."

Haring's cleverest cartoon for the start of Reagan's second term was a zero-dollar bill—bills of zero value that invariably went up in flames, whether held by Tank Head or a Statue of Liberty burning them in her torch or simply in a conflagration of a campfire, an image anticipating, in spirit, the 1987 novel that was likewise a social and political satire on the Reagan years, Tom Wolfe's *Bonfire of the Vanities*. Reagan's neoconservative program of cutting taxes and welfare, deregulating financial markets, and using other methods of monetary contraction was enabling an economic recovery that favored those of the financial class who fancied themselves "builders" (Ayn Rand's glorifying term for entrepreneurs) and often shafted the already poor. Nowhere was this economic stress test more marked than in New York City, its excesses acted out in the 1987 film *Wall Street* by Michael Douglas's near-allegorical character, the corporate raider Gordon Gecko, remembered for his famous line "Greed is good." (On a trendy penthouse wall in the film hangs a Haring "Burning Skull" mask.) On the November 1985 cover of *Manhattan, inc.*, a new magazine designed to articulate the moment and its obsessions with surface image, was the property developer Donald Trump, whose Trump Tower, on Fifth Avenue, with its pink marble atrium, was another symbol of the times. In his conversation with Keith Haring for *Interview*, Philip Johnson spoke of his failed pitch to "mad" Donald Trump to surround a Trump building with a moat to be crossed by a drawbridge. "Were there going to be alligators in it?" Haring asked.

Like a reporter finding himself a part of the story, Haring soon was awash in the very cash he was deriding. Along with the worlds of finance and real estate development, the art market was rapidly turning into a showplace of conspicuous consumption, and works of art were being revalued as leverage, tax shelters, and status symbols. "If someone has a $10 million art collection, we would generally loan them $5 million," Jeffrey Deitch told the *Wall Street Journal* of a practice that had begun at Citibank in the early eighties. In 1970, New York City had about two hundred art galleries. By the mid-eighties, the number had nearly tripled. Like the inflated-head balloons Keith drew in the subways and hinted were self-portraits, Haring's face and name were

expanding along with, and becoming code for, the art bubble. Writing in *Time* magazine in June 1985 of a trickle-down taste for art among the mass public, who were visiting Manhattan's Museum Mile in larger numbers than ever before, critic Robert Hughes, in his review of the 1985 Whitney Biennial, homed in on Keith Haring, "with his thin doodles of barking dogs and radioactive babies," breaking out a snide tone he would reserve for Haring going forward: "The new mass public for art has been raised on distorted legends of heroic modernism: the myth of the artist as demiurge, from Vincent van Gogh to Jackson Pollock. Its expectations have been buoyed by 20 years of self-fulfilling gush about art investment. It would like live heroes as well. But it wants them to be like heroes on TV, fetishized, plentiful and acquiescent. If Pollock was John Wayne, the likes of Haring 'n' Basquiat resemble those two what's their names on *Miami Vice*." Haring was less irate about his treatment in print than by Hughes's putdown of Basquiat as an "art-world Eddie Murphy," a typecasting he found to be "completely racist."

"When Jean-Michel came back from Italy, he was making all this money," Ann Magnuson remembers. "Before that happened, everyone was in the same boat. Then Jean-Michel changed the equation and made it uncool to be poor. Jean-Michel was the first. Keith came not long after. With Keith, it was just explosive. It wasn't just getting by. It was a massive amount of money. That was part of the tsunami that came in with Reagan's second term. Jay McInerney published *Bright Lights, Big City*. The go-go yuppie thing happened. The tenor of New York City changed. It was a new ballgame, at which Keith excelled. He was hitting home runs all the time. We were all thrilled for him. He wasn't a snob about it." Haring was not alone. One of Julian Schnabel's plate paintings, *Notre Dame*, sold for $3,500 in 1980 and resold at Sotheby's in 1983 for $93,000. "They buy art like lottery tickets," Schnabel's early dealer Mary Boone said of a species of collector buying art as "the latest get-rich-quick scheme." In December 1984, Kenny Scharf had a one-man show at the Tony Shafrazi Gallery. All the works in the show were sold, and he basked in the sort of success he had so envied his flatmate Keith just three years earlier. "Kenny's paintings are now going for $30,000," Warhol said, "and so Keith felt funny because they're both with Tony's

gallery, but Keith's never wanted his prices to be too high. His go for eight, ten, fifteen."

Twinned with fortune was fame. Fame was a cultural obsession of the eighties, with the 1979 movie and subsequent TV series *Fame* tellingly going strong through most of the decade. Another popular fairy tale for the time was *Flashdance*, starring Jennifer Beals, about a young female welder who realizes her dream of admission to a dance conservatory with some unclassical dance moves—a stunt double for a break-dancing sequence was Haring's friend from the Rock Steady Crew, Crazy Legs. Keith enjoyed becoming famous, his open desire for his name and style to be recognized akin to that of the graffiti artists who wanted to "have fame" by seeing photos of their work appear in newspapers (known as "coming out") or simply by producing hundreds of "star" works. "Keith loved being famous," Julia Gruen attests. "He reveled in it, he glowed." Yet he rarely allowed the pleasures of fame to change his demeanor with his old friends. "I never felt ignored by him, even in situations when he was with important people," says Min Thometz-Sanchez—a sentiment voiced by many. Haring was also aware that handling fame was one of the tools that any artist engaged with popular culture (like Warhol before him) needed to master: "You have to not only be a good painter, but you also have to deal with being photographed, and all of a sudden you become a model and a performer, and all these other things. Sometimes I enjoy, sometimes I don't. It doesn't matter. You have to do it. I've gotten much more at ease with it than I was in the beginning."

Less mindful in his response to fame was an unjaded pursuit of other famous people—like an unsophisticated fan, the boy from Kutztown, with his collection of Monkees fanzines, often appeared unaware that he was as famous as some of the celebrities he was eager to catch a glimpse of or speak with. His celebrity hound side could be annoying to his friends. "He had gone jet-set, and everyone had one name," Drew Straub says. "It was 'Brooke' and 'Michael' and 'Madonna' and 'Grace' and 'Bill T.' and 'Yoko.' It was his one-name period, when he was completely starstruck and everyone was a celebrity. He was so excited to be there." Says Julia Gruen, "He tried to be cool about meeting famous peo-

ple, but there was this grin of *elation* on his face." His excesses around fame challenged even the Warhol circle. "We'd be in a car, usually a limo, back in the eighties," Paige Powell recalls. "I always carried a camera to make Polaroids, and I would take pictures, some of Keith with Andy, and Keith would just grab a stack from me and say, 'Andy, sign these for me.' He would just snatch them from me. That was really annoying. Or we would be in a limo driving up to an event, and Keith wouldn't stop talking about what celebrities he was going to see that night. It was over the top. He'd say to Andy, 'Is Prince going to be at the party?' In retrospect, I get it—he was still a kid in his heart, whereas Andy kind of grew out of it."

Haring's excitement around celebrity—his own and others'—might seem "Warholian," yet Warhol himself, in some of his diary entries, sounds occasionally impatient with it. Of an evening at the *MTV Video Music Awards* at Radio City Music Hall, Warhol wrote, "Jean Michel arrived in a limo. He said he didn't want to go with Keith because Keith was too pushy. And it did get sick later on—Keith just wanted to be photographed *so* badly. And he wanted to go with me, so he'd be sure to be photographed." Warhol relished reporting that a big mob gathered outside Radio City but that "the TV cameras had already left so Keith was really upset." Afterward, Andy, Jean-Michel, and Keith went downtown to the Odeon for dinner, yet Keith kept wanting to leave for another, better party, where Cher was meant to appear: "He said he wasn't hungry, he said, 'I've already eaten,' but we knew he hadn't, because we'd all been together not eating for *hours*. I mean, I like Keith, but it was so sick."

The implied rift with Basquiat was subtly ongoing and had been building for some time as their careers grew in tandem. The two were ever being paired and compared. They remained friends, yet without some of the easy camaraderie of the early days. "We were always sort of checking up on each other," Haring said a few years later. "I always felt he was doing more than me, and he always felt I was doing more than him. In actuality, we were both in a very similar place. I was always jealous of the attention he would get in some circles—and he had similar feelings about me. It sort of balanced itself out."

A more profound casualty of this "so eighties" fame and fortune were Haring's subway drawings. Long gone was the mystery of the identity of "Chalkman," the stealth purveyor of hit-and-run chalk drawings of joyfully inventive barking dogs and flying saucers in jarringly apocalyptic settings, seen by everyone, yet not always comprehended. Not only did many subway riders seeing the drawings now know the name of the artist, but they began looking at them differently, as they read in newspapers of works by Haring with the same imagery selling for thousands of dollars. Haring enjoyed the pointed joke of his double art market, yet others saw real dollar signs rather than zero-dollar signs and began stealing the subway art to sell to collectors, a trend that saddened Haring, as he was losing control of a pure expression of his art that had been the soul of his career. (After Keith died, Rene Ricard declared in *Out* magazine, "The most beautiful work he did was the subway work," an opinion that was not his alone.) "I would do a drawing, Kwong Chi would go back to photograph them, and two hours later they would be gone," Haring said. "People were following the routes and collecting them. So, it was totally defeating the whole purpose of why I was doing them." Of a rumor circulating at the time, Robert Hawkins says, "Richard Hambleton would go on Keith's route, that he found out from Rene or someone, and put up black paper panels. Keith would draw on them, and Richard would then cut them out and collect them afterward. He had a lot of them." After the spring of 1985, only a few chalk drawings by Haring appeared on the advertising panels of the transit system of New York City.

Leaving off drawing in the subways, Haring was not giving up on using his art pulpit to communicate ideas on politics and the abuses of power to the masses. He had a plan B, or several of them. Even before the theft of the chalk works, he sensed the waning of the project: "These drawings had run their course, because they had achieved what I wanted them to achieve and that was getting the work out to the public at large." After five years, the subways were far from his sole means of reaching a wider audience. "I had now almost replaced the network of information in the subways with an international network of distri-

bution," he said. In December 1984, visiting Paris for the group show 5/5, *figuration libre, France/USA*, held at the Musée d'Art Moderne de Paris, Haring drew on approved paper covering advertising spaces at the Alma-Marceau and Dupleix Métro stations. One of his final subway drawings, the puny captor lassoing a giant, was retooled by Haring in a "Free South Africa" protest poster, copies of which he once again rolled for passing out at a rally in Central Park, this time a Free South Africa anti-apartheid event, the Goliath now black, the little tyrant white. While cautious about sloganeering, he included a slogan on the poster, "FREE SOUTH AFRICA," as he had done in his 1985 acrylic-on-canvas tarp painting *Safe Sex*, of two violet figures covered in orange spots, Xs where faces should be, arms crisscrossing in mutual masturbation. (A self-portrait of his own face dotted red from the same year perhaps hints at contagion as well.) Had Haring continued drawing in the subways, themes of AIDS may well have dominated, as they had begun to suffuse much of his work.

While Keith was in Paris in December 1984, doing his drawings in the Métro, he became friendly with the painter Brion Gysin, whom he met by chance at the huge Paris discotheque Le Palace. As Gysin had collaborated with William Burroughs in developing the concepts behind the cut-up method, both he and Burroughs were idols of Keith's, and Brion and Keith grew to cherish a special friendship. "From the beginning," Haring said, "he takes on the role of a kind of teacher for me—this incredible genius who is a member of the underground brotherhood of gay artists." On that trip, Keith drew with Magic Marker on an alley wall near Gysin's home, close by the Centre Georges Pompidou, finding space amid the tangle of local French graffiti that had sprung up recently in emulation of New York City. "Lines can be drawn or pulled or written or scribbled or scrawled or, nowadays, be sprayed out of a can," Gysin wrote in a catalog essay for Haring's upcoming show in Bordeaux, describing the drawing he had witnessed. "Keith Haring's line is something else. It looks a bit like an engraved line or a sculpted line, but it is not either of them. It is a carved line like the one man made when he first used it to cut what he wanted out of the air in the back of

the cave." Haring's line never felt more carved than when he was draw-ing with passion to right wrongs or to urge timely political action.

By 1985, Club 57, like Haring's subway work, was a memory. The club had closed its unobtrusive basement door to the public permanently two years earlier, in the spring of 1983, as some members took their acts on to the Pyramid Club, on Avenue A; to the Limelight, a converted sanc-tuary in Chelsea; or to Danceteria. The Mudd Club shut down the same spring. By then, Haring and Scharf were long gone, yet the concept they and their friends had introduced—of clubs by and for artists, for art, with revolving theme nights and DIY performances (Keith's Clubhouse meets Cabaret Voltaire)—was now being taken up by venues with far more popularity and media exposure than their more obscure proto-types. The first and most compelling of these new art clubs was Area, a tabula rasa of a space with a tabula rasa name, occupying 13,000 square feet of former Pony Express stables four blocks from the Holland Tun-nel, at 157 Hudson Street, in Tribeca. Advancing the logic of the night another half step for the downtown world were Area's owners, four high school friends in their twenties from Northern California who had come to New York to make movies, enroll in art school, and club nightly—Eric Goode and his brother Christopher, Shawn Hausman, and Darius Azari. Within months of the closing of Club 57, in September 1983, they had opened Area, with an ambitious plan to build up and tear down their fungible space every six weeks for revolving installations on themes ranging from "Fashion" to "Faith."

Yet before opening the high-concept space—"An art museum posing as a nightclub," in the words of *Village Voice* columnist Michael Musto—they put in their time exploring the enmeshed worlds of downtown art and nightlife, especially in the early a.m. hours. Eric Goode, who had gone to Parsons, was in the drawing show Haring curated at the Mudd Club in 1981. He credits his place in the show to "a lot of connective tissue between the Mudd Club and Club 57, and Keith Haring was very much in both those places." In her review in the *Voice*, Kim Levin had singled out Goode's Etch A Sketch art, for "the extraordinary idea of

making a line by turning a knob," and Haring as a "one jump ahead" curator, as she felt that Diego Cortez had found most of the artists for his *New York/New Wave* exhibition at Haring's one-night exhibitions at Club 57. Goode had also painted some backdrops for Ann Magnuson at Club 57, and he and Shawn Hausman had worked six months on a faux-Grecian grotto for Steve Mass in the basement of the Mudd Club. "Sean and I were obsessed," Goode says. "We really became connoisseurs of nightlife."

Connoisseurship—and a talent for opening a successful night spot, described by one nightclub owner as "building a better mousetrap"—was evident in the invites to opening night for the mysteriously named new club. A mailing list of five thousand invitees received a black velvet ring box containing a blue capsule with instructions to drop the pill in hot water to release a one-inch square of plastic film with the party information on it. On opening night, the club was less than prepared—paint was still being sloshed onto the walls, no one knew how to use the cash registers, and bouncers were ready, but no ropes or stands had been set up—yet, when the organizers looked outside, they saw the most interesting mob waiting. "The pill worked," Chris Goode said. Waiting along with everyone else was Andy Warhol. "Somehow Andy Warhol got caught in the middle of the crowd all squished and screaming," said doorman Joe Brese. "I have never seen him scream; in fact, that was the only time I've ever heard his voice, I think." Inside, they all experienced the first of the classic Area theme treatments, "Night," with a live shark tank; a Museum of Natural History window display of a swamp with an alligator and boa constrictor; bats ordered freeze-dried from Carolina Biological Supply, a source they would use many times; a Mack Truck with champagne served through its windows; and taped lounge music provided by Mudd Club deejay Anita Sarko—altogether, wrote Stephen Saban, nightlife reporter for *Details* magazine, "a kind of adult science fair a go go." Warhol liked the club so much that he returned two nights later with his friends Steve Rubell, Bianca Jagger, Ryan O'Neal, and Farrah Fawcett, and he became a loyal regular.

Keith Haring, likewise, quickly became a reliable presence at Area. "I remember Keith at Area *a lot*," Eric Goode says. "I remember him

being generous with his participation." As for many, Keith's favorite area of Area was the men's room, like the women's room, a unisexual playground with stalls convenient for having sex and doing drugs. Part of its attraction for Keith was the familiarity of seeing his friend Desmond Cadogan, who was the bathroom attendant, selling cigarettes, condoms, and gum and running the place like a VIP room. "Andy would come and sit there all night, almost every night, to the point where I'd go, 'Oh Andy, I love this song, will you watch my stuff?'" Cadogan says. "I came back a half hour later one night, and he said, 'Look, somebody bought a pack of cigarettes, and they gave me two hundred dollars.' He was very pleased about that." Said Haring, "I remember I had sex in the bathroom one night. That was one of my favorite times there: in a stall in the Men's bathroom with two other people." (He presumably had learned by then the practices of condom use and "safe sex" he was promoting on his canvases.) As at Paradise Garage, Haring became the resident artist, or one of them. For a "Once Upon a Time" theme, he enacted a Wicked Witch with broom in a *tableau vivant*. A slide for the "Obelisk" theme was his Bill T. Jones poster with a moving obelisk poking at Jones from behind. One evening, Haring body-painted another friend, Ludovic. For "Fashion," he painted a custom mannequin of the famous sixties model Carmen Dell'Orefice in body paint. In a large group photograph for the theme, he burst through a hole in a white plastic cube. "Someone asked me if I wanted to paint the ramp," Haring said of his contribution to a skateboard ramp for the "Gnarly" theme. "I came back to take pictures a couple days later and someone else had decided to paint over it."

The theme that most engaged Haring—and was clearly hidden in plain view from the inception of Area—opened on May 8, 1985: "Art." "The art theme was kind of tongue-in-cheek," Goode says. "We really wanted to do anything but 'art' quote, unquote. We mixed it up, so we had high art and low art and illustrators, contemporary art, but we made sure we had Peter Max and LeRoy Neiman. The idea was to kind of make fun of the whole thing. I don't think people realized it entirely at the time." The satire could easily have been missed, as the mix of artists and works brought together was as forceful as any grouping in a serious Manhattan gallery. For this theme photograph, the shoot was held at Mr.

Chow, a black-lacquered Chinese restaurant full of mirrors and Lalique glassware, on East Fifty-Seventh Street, rented by the Area owners for a champagne dinner for the artists. Keith did not need to be convinced to show up. "When I asked Keith if he would come to whatever studio for a shoot, he often said to me, 'Who's gonna be there?'" Goode says. "I figured out very quicky with Keith that all I had to say was that Warhol was one of the people and he'd say 'OK.' Everyone wasn't like that, but Keith was." The photo taken that evening by Michael Halsband has lent itself to being reproduced often, in the manner of the famous 1951 *Life* magazine group portrait of "the Irascibles," the abstract expressionist painters. It includes John Chamberlain, David Hockney, Michael Heizer, Andy Warhol, Julian Schnabel, Alex Katz, Red Grooms, Francesco Clemente, Kenny Scharf, and Robert Mapplethorpe. Levity was added by Haring with his mouth stretched wide in a silent scream and by Basquiat balancing a plate on his hand like a waiter. For the dinner, the tables were covered with butcher paper, wax pencils, and party favors, placement made difficult by all the egos in the room. Haring, who Etch A Sketched as soon as his gift was out of its box, was seated next to Hockney, who made his party favor of a funny tie look entirely normal when he put it on. Mapplethorpe was gifted with Harley-Davidson panties. Area partner Darius Azari was irate to discover that Basquiat, who, he believed, had been running his fingers up Azari's back, had ruined his new Charivari white shirt: the artist had in fact been using a wax pencil.

Warhol designed the silk screen T-shirts for "Art," and everyone invited to the dinner contributed work (except Julian Schnabel)—including artists who did not attend that night—Chuck Close, Jenny Holzer, Marisol, Sol LeWitt, Nam June Paik, Larry Rivers. In an interview with the *Wall Street Journal*, Rivers said, "It's a great installation. The Museum of Modern Art should come down here to see how to install a show." Sol LeWitt painted the long entrance hallway, where a giant black disc roughly constructed out of plywood by the Area team was delicately painted by Basquiat into a rendering of a 45 rpm vinyl pressing of Charlie Parker's bebop composition "Now's the Time." Barbara Kruger's installation carried a site-specific message: *When I hear the word culture I take out my checkbook.* Warhol's Duchampian contribution was

an empty pedestal titled *Invisible Sculpture*, and Clemente's, a tattoo on deejay Johnny Dynell's arm. On opening night, Warhol modified his piece by standing beside it all night as a living artwork. Haring decided to paint a *Pyramid Wall* on the dance floor, a few feet away from Michael Heizer's sculpture made of three volcanic rocks. Watching him paint gave Eric Goode a new appreciation for Keith's art: "I realized it was so fluid. It was amazing how he was able to paint an entire wall in one sitting and have it so perfect." Said Haring of the yellow pyramid wall, "It wasn't about money. It was about making an event. It was a pure kind of moment—let's do this stuff just for the sake of doing it. Even this painting, which obviously was going to be destroyed. It didn't matter. Enough people were going to see it." Not all the artists were so relaxed about the handling of their work. Chuck Close was annoyed when they hung his *Mark Diptych* in the men's room, simply covering it with a Plexiglas sheet and drilling screws right through the work into the wall. Yet recklessness was the mood of the place, if not its ethos. "When the theme was done, like so many things in that theme, we took a sledgehammer and destroyed Keith's wall," Eric Goode says. "We painted over the David Hockney pool. I remember some of Jean-Michel's stuff going in the dumpster. Area was about ideas and about keeping things ephemeral. In those days, we didn't think of art as a commodity, or as precious."

Taking mental notes at the "Art" opening on May 8 had been Steve Rubell, brought there by Andy Warhol. "The installations were great," Warhol said. "And Steve Rubell was walking around saying, 'Great, great,' being so jealous, wishing it were his club." Rubell was feeling especially competitive, as his own new club, the Palladium, housed in the once-grand Academy of Music on East Fourteenth Street—built by movie mogul William Fox and not to be confused with the original Academy of Music opera house built in 1852 across the street—was opening in six days. The building had reverberated since 1926 with the voices of artists ranging from Enrico Caruso to Mick Jagger. Rubell and his partner, Ian Schrager, who had both spent time in federal prison for tax evasion at Studio 54, had recently opened the boutique hotel Morgans, on Madison Avenue at Thirty-Seventh Street, and had hired Japanese architect Arata Isozaki to turn the cavernous, crumbling space, ten times the size

of Area, into a discotheque. Their concept was to merge the glory days of Studio 54 with the dynamism of the downtown art scene—or, as one writer put it, to "swallow the art scene whole." "Now the scene is downtown, and stars of the eighties are the artists," Rubell told Tony Shafrazi, by way of enlisting his support. Borrowing his novel job title from Haring's at Club 57 and the Mudd Club was Henry Geldzahler, who was hired as the club's salaried "art curator" and who commissioned his favorite artists to make works for the space. Haring painted a forty-foot-high tarpaulin of pastel Aztec-inspired dancers that could be raised and lowered from the ceiling at the back of the dance floor. As the piece was too large to paint in his studio, Bergdorf's department store allowed him to use part of its seventh floor as his temporary atelier. "If it isn't any good, we just won't bring it down too often," Rubell said, with a shrug, to Warhol. Francesco Clemente painted a circular fresco on a chapel-like vaulted ceiling atop the main staircase. Basquiat painted a mural behind the bar of the "Michael Todd Room" (in a space that was once the office of the Hollywood producer) that Tony Shafrazi felt was a "way of reenacting what he had done in Club 57 only a few years before." Kenny Scharf customized a row of phone booths with splattered Day-Glo and glued plastic toys in a fluorescent, mirrored basement hall.

Not all the seasoned nighttime connoisseurs were impressed with the Palladium. "They tried to copy the creative element of Area, but it just didn't work," said performer and journalist Chi Chi Valenti. "With the Mudd Club, art merged organically into the club, whereas at Palladium, it was just tacked on." Warhol decided that "the funny thing about putting art in a disco is that in the end, when you pack all the people in, it doesn't make a bit of difference. You don't even see things." Andy spotted Eric and Shawn from Area "there looking glum." Yet an endorsement for the artists, and for their curator, Henry Geldzahler, came from an unexpected direction. Calvin Tompkins, the official art critic of *The New Yorker*, covered the Palladium in his Art World column in the magazine, engaging with the artistic vision at play while walking a razor's edge in prose that was both art critical and full of poking fun as Tompkins stretched to define "disco art" as "a new form whose time has clearly come." "The truth is that in this environment the art looks

sensationally good," Tompkins wrote. "Basquiat is not the only artist to surpass himself; even Haring seems to have risen to a new level . . . His forty-foot canvas at Palladium struck me as something else: decoration of a fairly high order." The caveat for the praise was Tompkins's uneasy suspicion that "East Village work" might "look a little silly outside the East Village," as disco art, "a new branch of public art," might outside the disco. Yet, he decided finally to let a hundred flowers bloom: "High art is not really threatened. Ellsworth Kelly, Jasper Johns, and a few others will continue to tread their difficult private paths, with neither help nor hindrance from Schrager and Rubell. Disco art, meanwhile, building on the early work of Haring, Basquiat, and Scharf, may yet produce a new academy of the baroque while at the same time absolving the art establishment from having to deal with it. There is something to be said, after all, for cakes and ale."

The opening took place during Keith's birthday month, by now a club theme unto itself. Feeling the same need to top his birthday parties as he felt to top his gallery shows, Haring chose to throw his twenty-seventh birthday party at the Palladium a week later, on May 22, 1985. Invitations for the Second Annual Party of Life were picture puzzles of a black-and-white drawing, mailed in a small square box with buttons to be worn at the door for entrée. He invited five thousand people this time, made five thousand T-shirts for them, and everyone seemed to have shown up and then some. As at Paradise Garage, he set up totems and other Haring artworks around the strobic space. Boy George volunteered to sing "Happy Birthday," though, as Haring recalled, he *"sort of* sings 'Happy Birthday' to me—he kind of speaks it." Afterward, a huge drop of balloons was released onto the dance floor. A random collection of celebrities was identified by one guest or another—the French actor Gerard Depardieu, the photographer Francesco Scavullo. Though in a leg cast, Bianca Jagger struggled to make her way through the crowd at the front, as Fourteenth Street was nearly closed to traffic because of the party. Keith was pleased to see the nearly twenty-year-old model Brooke Shields, as they had recently worked together on a not entirely successful poster of her posed teasingly nude behind a big red cardboard Haring heart, photographed by Richard Avedon. (As their friendship

warmed up, and she found him "like an angel," Keith felt the need to take her to dinner to tell her, before she found out from someone else, of his earlier drawings of her with a huge erection.) "Went down to Keith's party at the Palladium and it was packed, that huge place—*packed!*" Warhol wrote in his diary. Michael Musto's column in the *Voice* ran a photo of Haring and Shields, captioned, "There goes the neighborhood." Musto also reported on "a door crush so intense a woman had a seizure while waiting and *still* had a tough time getting in. I hope she doesn't try harder next time." If Area was "Club 57 with money," as Patti Astor observed, the Palladium was Club 57 turned into a disco and funded by junk bonds.

"I really love to work," Haring wrote in his journal. "I swear it is one of the things that makes me most happy, and it seems to have a similar effect on everyone who is around me while I work." He described his life as mostly "working obsessively and constantly every day." This unchanging sense of himself as a sort of calligraphic brush soaked in sumi ink—in the throes of creativity, freed from having to plan or edit, letting his drawings "happen by themselves"—contributed to the personal paradox of someone who was so vibrantly present (often, kindly, generously present) and yet also often palpably "not there." "Keith does outrageous art," Bill T. Jones said, "but he's not extremely warm nor is he an extroverted person. It's all in what he does—it's all in his art." Present with him at dinners at the homes of wealthy collectors and gallerists, Julia Gruen noticed that "if he and his art were the topic, he could expound comfortably. Otherwise, he wasn't very good at chitchat at a dinner table with twenty other people, most of whom he didn't know." A friend describes his "myopic focus, without suggesting he was unable to navigate social cues. He understood parties, dancing. Yet his art was the language he spoke."

Rather than being distracted by nightlife and high life in general, Keith was distracted from all the distraction by his work, his first love. His obsessive-compulsive internal order, present from early childhood, a given rather than a choice and channeled by him into drawing and

art, allowed him to tunnel through even the most hectic glamour, envisioning and creating new works. The summer of 1985 was exceedingly hectic and exceedingly glamorous. Backstage at Madonna's Virgin Tour concert at Madison Square Garden in June, he was photographed with John F. Kennedy Jr. At a Live Aid benefit concert for African famine relief, held at the John F. Kennedy Stadium in Philadelphia in July, with headliner musicians Tina Turner, Michael Jackson, and Mick Jagger, Haring painted, live onstage, two hands cradling a big red heart with planet Earth at its center. In August, he flew to Los Angeles with Andy Warhol, Fred Hughes, and Steve Rubell, staying at the Beverly Hills Hotel, for the Malibu wedding of Sean Penn and Madonna. Employing near spycraft in its secrecy apparatus, including a last-minute phone number for guests to call to learn the location, the cliffside ceremony was covered by the press from helicopters armed with long-range lenses. "It was like being in *Apocalypse Now*," said Haring. As a wedding gift, he and Warhol made a silk screen painting of a *New York Post* cover with a picture of Madonna and the headline "MADONNA: 'I'M NOT ASHAMED': Rock Star Shrugs Off Nudie Pix Furor," in synthetic polymer paint and Day-Glo. The collaboration was clever; both artists had done headline works. Yet when a photo of the gift appeared in *People*, Madonna was annoyed. Warhol blamed Haring: "They'd called me and I said no but then I told them if they wanted to try Keith."

As compellingly on Haring's mind throughout the summer and fall of 1985, though, was sculpture, a new medium for him. As with many of the plot points of the emerging story of his oeuvre, he hit on the notion of sculpture in a chance moment of receptivity, the ground prepared, as with his discovery of industrial tarps, by a timely comment from his dealer, Tony Shafrazi. Haring clearly had long been toying with the third dimension, the world beyond the flat gallery walls—most recently, in the totems in his last show. Yet he had not seriously considered the daunting art of sculpture until, while he and Tony were sitting around the gallery one day, Shafrazi picked up a small present Keith had given him, a piece of found wood about six inches tall that Haring had painted—the red outline of a barking dog against a shiny green background—and said, "Keith, check this out, close one eye." Given to

expressing his excitements in a cascade of language, Shafrazi continued: "Can you imagine with a landscape behind how big that'll be? Visualize it. With one eye closed, it will help you fantasize. Can you imagine your drawing becoming something thick, even three-dimensional, whereby it could stand, it could be ten, fifteen, twenty feet tall? And it would be there forever, even after you die."

"What?" said Keith. "How can that be?"

"You can make it out of steel," Shafrazi answered.

"I don't know how to make a sculpture."

Ignoring that detail, Shafrazi encouraged him: "Put your alphabet in the landscape, out there in the real world."

As Haring recounted, "At the prodding of Tony Shafrazi, I now become interested in the challenge of producing large outdoor sculptures—public sculptures." Finding a way into the medium that fitted his own comfort with the juvenile, he began by cutting out drawings with a pair of scissors, art class style, making stand-ups of his favorite homemade cartoons, starting with the barking dog. He then retried them in plastic, wood, or aluminum. Invested in the outcome of this experiment, Shafrazi arranged for the financing of a first pending series of sculptures and also persuaded Leo Castelli to present the results at his Greene Street gallery in SoHo, along with his own companion show of Haring's new paintings at the Mercer Street gallery in the fall. He then took Keith up to North Haven, Connecticut, to introduce him to Lippincott Inc., a fabrication space opened in 1966 by Donald Lippincott expressly for large-scale works. Known simply as "the shop," its 22,000-square-foot main workroom, with twenty-five-foot ceilings, overhead cranes, giant bay doors, and crews of dozens of workers, had the sort of history that appealed to Keith. Sculptor Barnett Newman had fabricated *Broken Obelisk* and Marisol *Three Figures* there during the sixties, and a decade later, Louise Nevelson, *Sky Covenant*; and Claes Oldenburg, *Standing Mitt with Ball*. Keith came to know Oldenburg while working at Lippincott, and Oldenburg stopped by and loved the *Boombox Mural* Haring painted that August in the schoolyard of P.S. 97 at Houston Street and the FDR Drive. Works by Alexander Calder were sometimes restored on the premises, and Keith was able to enjoy a more intimate view of

sculpture that he had admired as a boy, sensing that "the work has spirit, comes from the spirit."

"He was like a kid in a candy store," says Alfred Lippincott, who partnered with his brother, Donald, in the business. "You can imagine it might have been overwhelming to come into the shop with all kinds of huge equipment and workers grinding in a hive of activity. Keith was not intimidated at all. We laid out inch or inch-and-a-half heavy steel plates for him to work on, and he got up there and sketched in soapstone what he wanted cut out, full scale, without having to draw it small and then use proportional geometry or projection methods to get it enlarged. He was a bit like Louise Nevelson in that respect. She would work at the shop without models, drawings, or sketches. We would lay stuff out on the floor for her, all our scrap. Keith had that same ability to work full scale. He could visualize what he was doing, and it didn't intimidate him to make that jump." The resulting works were clearly experiments in translating a graphic idiom—as if the subway drawings, now abandoned, were coming to life in a new, enlarged medium. His insistence on smoothing and rounding edges added the soft texture of a chalk line rather than the hard edges of steel. "I think of those early sculptures as two-dimensional," Kermit Oswald says. "The big red dog Lippincott made was simply a flat cutout. And there was one backstretch, in dark blue, bent, with a hole in the stomach." As Haring went along, his ideas evolved to stacked figures. "That involved bolting," Lippincott says. "He was readily able to engage fabrication-oriented details. He liked things streamlined and straightforward." Of a spectrum of paints that were available, Haring "zeroed in" on the brightest urethane colors.

The exhibition at the Tony Shafrazi Gallery that would immediately precede his double painting-and-sculpture show in October was *Warhol-Basquiat Paintings*, presented by Tony Shafrazi and Bruno Bischofberger and opening, along with a dinner and party at the Palladium, on September 14. Shafrazi's spunky poster for the show, in yellow, black, and red, cast Warhol and Basquiat as boxers, one pale as moonlight, the other shirtless and fearsome in his Everlast shorts, both roundly gloved. Their "match" was photographed by Michael Halsband, who also shot Warhol landing a fey punch to Basquiat's chin, used as the invite to the

Palladium—an image that proved too soft a target when the critics filed their reviews. The sixteen paintings were all collaborations. "I remember them painting together, not simultaneously, at Andy's studio," Paige Powell says. Warhol would paint a General Electric logo, or a *New York Post* headline, and Basquiat a spontaneous jazz riff of response with dead cartoon figures, a black mule, or Spider-Man heads. Warhol had set brush to canvas for the first time since 1962 for these paintings, and Basquiat had marked his clear evolution from his early color Xeroxes to silk screen. Yet Vivien Raynor, writing in the *New York Times*, found the work slick. She accused his "mentor" Warhol of turning Basquiat, who "had a chance of becoming a very good painter," into "an art world mascot." Her zinging verdict was "Warhol, TKO in 16 rounds." Warhol read the review when the papers appeared late on a Thursday night at the Odeon. As soon as he read the word *mascot*, he groaned and said, "Oh God," anticipating Basquiat's reaction. "The next day, Jean and I went to the Odeon and had lunch," Halsband said. "He was blown away by the article where they attacked him for being completely manipulated by Andy. Jean was . . . so far away. He was so angry at Andy." The review led to a rupture in their friendship, though an awkward distance had already set in before the opening. By December, Basquiat and Paige Powell were no longer together.

Haring's show, opening on October 26, fared much better, though his work was never entirely free of controversy. The fifteen paintings at Shafrazi were all works on canvas. "I no longer feel inhibited about using canvas," Haring said, "because I now have the money to buy it as if it were paper." He was also starting to worry about the mortality of his materials and, so, of his legacy, and he was concerned that plastic would become brittle in fifty years and be difficult to store or roll. Most of the paintings at Shafrazi were large, strident statements with socially conscious themes, such as South Africa, the Moral Majority, and safe sex—his political line translated by brush onto canvas—including his searing and horrific depiction of the police choking of Michael Stewart. Many of these unstretched canvases were dominated by monstrosities, showing despair and hopelessness, yet all were rendered in bright violet, yellow, and red acrylics, with black outlines in oil, as if Walt Disney

were illustrating the Book of Revelation. Most intimate with the inescapable horror stalking his own life and the lives of his friends was a one-hundred-square-foot lemon-yellow painting with a rare titling, *AIDS 85*, its unspooling central drawing depicting a tortured soul losing the narrative of who he is to surrounding flying skulls, hyena heads, and gryphons emanating from a Veil of Veronica face, a red X on a tag hanging from his bony neck.

Haring's new sculptures were to be shown at Leo Castelli's gallery at 142 Greene Street, the largest gallery space in SoHo at the time, opened in 1982 as an alternative to the gallerist's main space at 420 West Broadway. It was a peak experience for the young artist. Haring considered Castelli untouchable for having represented Warhol and Rauschenberg and so many of his heroes, and Shafrazi felt him to be "like my American father." "Having my sculptures shown at the Castelli Gallery really blows me away, because . . . well, it's like this holy space!" Haring said. "I mean Johns had done a show there, Lichtenstein had done a big mural there. Rosenquist had worked within the space." Yet his own show was unmistakably "Haring," as he foregrounded the childlike, conceiving of the grand space, with its sixteen-foot-high windows and doors and its row of Grecian columns running down the middle, as an adult-scale playground, a half step to one of his longtime dreams of making a commissioned playground, as he told the *New York Times*, "with landscaping, different heights of connecting hills, with swings and seesaws and sliding boards." He had admired Vito Acconci's plans for a playground with oversize athletic equipment painted in shocking pink. The four sculptures in the show included the red barking dog, standing thirteen feet high and weighing three tons; a yellow steel version of a break-dancing move, "the bridge," where a dancer arches his body upward while both arms and feet stay flat on the ground; and another break-dancing move of "the totem," comprising colored figure upon figure piled atop a dog's back. To ensure that the installation was properly appreciated, he arranged for an entire class of schoolkids to come see the show, insisting that they be allowed to climb all over the sculptures.

To free himself of the inhibiting "sacred sanctuary of art" mystique of the gallery, Haring felt the need—beyond the installation of his bright,

toylike sculptures—to "do something totally irreverent." He decided
to paint a frieze all around the walls of the gallery based on cartoons
he had made between the ages of ten and sixteen. He had reached into
his childhood for these characters—familiar to anyone from Kutztown
Junior High who remembered his fractured fairy tales or his drawings
around fifteen feet of the walls of the school gym—for decorations at day
care centers, hospitals, and contributions to *Scholastic News*, but never
in a "quote unquote serious art context." In the space of a single day,
he created on the walls of the gallery a wild, black-and-white nursery
room run-around mural of goggle-eyed, barefoot revelers, long-limbed
TV heads, mischievous cat-baiting mice, waving eggheads, duck-billed
platypuses, bunnies and puppies and bears, kangaroos and caterpillars,
all winding down to a crowned frog with Mickey Mouse eyes, a dedi-
cation in a secret language to his best boyhood friend, Kermit ("the
Frog") Oswald. Leo Castelli usually worked at the main gallery, but he
came by Greene Street on the day of the installation and was startled
to see Haring and his paintbrush in action. "The sculptures were quite
marvelous," Castelli said, "but the great surprise was when Keith said,
'I want to paint a frieze all around the gallery.' The way he did it was
fantastic—I should have filmed it. He painted these cartoon characters
all along the walls, which measure over 100 feet, and he did this in one
day. Incredible. I saw him at work just inventing as he went along."

On the day of the opening, Castelli, along with the art collector Bar-
bara Jakobson, Keith, Keith's parents, and his friends Joe Dietrich and
Derrick Smit, were making their way to the front door of the Shafrazi
Gallery when they were accosted by three young men, apparently dis-
gruntled East Village artists, who tried to "tar and feather" Keith by
throwing a bucket of roofing paint mixed with feathers at him. Al Har-
ing, with trigger-quick reaction time, called out to his son to warn him
of the attack, though Joe Dietrich was struck. "I was walking with him,"
Al Haring says. "I was sort of hanging behind, and that's why I saw it.
Something didn't look right to me." Says Club 57 friend Kitty Brophy,
"I walked up right when it happened. The look on his face. He was so
hurt. I thought he was going to start crying. But then it changed to
'Fuck all of you!'" Nan Goldin caught the melee in a photograph taken

moments afterward. "We were trying to figure out what that meant—tar and feathers," Warhol said, reporting the event in his diary. "When do you do that and what kind of person would do that? What was the message?" Some immediate critical reaction to the show likewise felt like a tarring and feathering. The *Village Voice* coverage began, "It's a doubleheader for the Peter Max of the 80s," a comparison meant to dismiss Haring as an illustrator rather than a serious artist. Holland Cotter, writing in *Flash Art*, was wary of the serious social and political content in the paintings, though Haring had been dealing with apocalypse, nuclear disarmament, authoritarian control, and technological manipulation since his first show at Club 57 in 1980, albeit in deceptively wholesome cartoon imagery. Cotter felt that the "kindergarten aesthetic" on display in the sculptures at Shafrazi "worked well enough." But "it was a different story at Shafrazi," he went on, "where we had the better part of a floor devoted to Haring in the more serious guise of political, or at least topical, spokesman, the other half, as it were, of the artist we used to know. . . . Haring seems to have tripped up the simple, synthetic populist beat his art once had, and much of its remembered pleasure seems to have gone."

Yet several important notices and reviews were remarkably positive. Writing in an Art People column titled "A Growing Potency," in the *New York Times*, Douglas C. McGill found the new canvases "far more complex than his early pictographs, most of them brightly colored allegorical scenes on such subjects as information overload and other perils of modern technological life." In her review in the same newspaper, Vivien Raynor wrote of the "artist nobody doesn't love," "If the impression is of a Haring machine at work, the machine is nonetheless perfectly tuned and immensely efficient." Describing Haring as "probably the most brilliant populist artist now working," Donald Kuspit in *Artforum* concluded on a discerning note, "At heart a 'Protestant,' Haring has given protest punk/hedonistic form, creating an art that, while full of social necessity, exists for its own sake." (Castelli, too, spoke of Haring as "a moralist . . . He could be the most effective preacher, much better than Falwell or one of those evangelicals.") The most welcome response for Keith came with the installation, after the

closing of the show, of three of the sculptures in the Sculpture Garden of Dag Hammarskjöld Plaza, near the United Nations. Haring helped with the installation, and the next day, a picture of him climbing with a polishing rag on his totem of colored figures balanced on the back of a dog appeared on the front page of the Sunday *New York Times*. The photograph was taken by staff photographer Dith Pran, the Cambodian photojournalist who was the subject of the 1984 British film *The Killing Fields*.

A mere two weeks after the closing of the Shafrazi-Castelli show, Haring's first one-person museum retrospective opened at CAPC Musée d'Art Contemporain de Bordeaux, in southwestern France. Keith had flown for a brief visit to the museum, housed in a former shipping warehouse and renovated, just two years earlier, with loftlike minimalism by the designer Andrée Putman. To his surprise, its director, Jean-Louis Froment, described by Shafrazi as "a tall, handsome gentleman with lots of energy and enthusiasm," invited Haring to take over the entire museum for the exhibition, an invitation no other artist had received since the venue's opening in 1973. Haring and Froment settled on devoting the first floor to a survey of Keith's drawings, "Dessins: 1980–1984," selected from his private collection and the second floor to "1983–1985, Peintures et Sculptures," mostly the recent political paintings he had shown at the Shafrazi Gallery and including some of the totem works made with Kermit Oswald. Yet Haring was strongly drawn to the museum's cavernous lower level, a huge space with five enormous stone arches, and he expressed interest in painting on both sides of stretched canvases to be custom-built into the spaces, though he had no idea of their subject matter. With his European trips now timed around Saturday nights at Paradise Garage, the night before his final departure for Bordeaux, still facing the dilemma of the arched canvases stretched and awaiting him, he came to a solution in the heat of the ecstatic dance floor: "I'm at the Garage dancing, when an idea jumps into my head. It's so obvious! Since it's five arches to be painted on both sides, that comes to ten paintings—so why not the Ten Commandments! So, while I'm dancing, I try to think of as many commandments as I can but I can only think of a few. So the minute I get to Bordeaux, I ask for a Bible!"

Even with a concept set, the execution turned out to be far from simple. The Romanesque arch–shaped canvases had all been cut to the same size, yet installation stalled when it was discovered that the stone arches were not uniform, and the canvases needed to be recut. The drawings, too, had been held up in customs. When they finally arrived, Haring was given a white-gloved assistant to hang them in chronological order. Yet he soon felt he couldn't work in such a formal manner and called Kwong Chi to fly over to help him hang the drawings, with push pins alone, and no Plexiglas covers, on walls with figures painted like those in the Castelli Gallery. With just three days until the opening, and the museum staff quite nervous, the canvases were finally ready, and Haring set to work around the clock, needing to take amphetamines for the final stretch. In a theatrical manner, he played off the religious resonances of the space. At the entrance to the exhibit, he chose to display a drawing of the Stations of the Cross done by Matisse for the Chapelle du Rosaire de Vence, on the French Riviera. The two rows of nineteen-by-twenty-five-foot canvases glowed with some of the transcendent coloration of the stained glass windows of medieval cathedrals. Yet, close up, they were far from pious and certainly antifundamentalist. "The way I worked on 'The Ten Commandments' is: even though it says 'Thou shalt not steal,' the picture I show is someone stealing: the antithesis," Haring said. "I present what not to do instead of saying 'This is what you should do.'" With the final pictures in mind, he worked on the several canvases simultaneously, painting the red areas first, then gray, green, and yellow. The commandments were presented in a shuffled order, their messages color-coded—towering red giants dominated more sympathetic pale-blue sinners reaching for zero-dollar bills or sucking on the penis-like arms of an inverted cross. More faithful to cut-up theory than to the Book of Exodus, Haring's work told one of his multiple-choice tales of control and horny desire. "If you did not know that they are the Ten Commandments," Haring said, "you would probably read a different story."

The opening in Bordeaux rivaled in glamour some of his recent New York City events. Haring wore a high-sheen black-and-gold tuxedo designed for him by Hector Torres and was photographed for *Vanity Fair*

by Helmut Newton, who was wearing a Haring-designed Swatch watch. Flying in from New York were Julia Gruen, Bobby Breslau, Tony Shafrazi, and Jeffrey Deitch. Arriving from Paris: the designers Agnès B.; Patrick Kelly and his partner, Bjorn Amelan; Andrée Putman, with a Haring "Free South Africa" button pinned to her jacket; and the painters George Condo and Brion Gysin. Others traveled from Belgium, the Netherlands, Switzerland, and Germany. In their coverage of the opening, *Vanity Fair* noted "numerous decorative boys in parkas and sneakers." Jacques Chaban-Delmas, one of France's major political leaders and the mayor of Bordeaux, gave an oysters-and-champagne reception at City Hall. "I remember Chaban-Delmas taking out his pocket handkerchief and Keith drawing a design on it," Jeffrey Deitch says. "It was quite wonderful seeing this high-level bourgeois French politician putting the handkerchief back in his pocket." The next day, Madame de Philippe de Rothschild hosted a luncheon for Haring and about thirty guests at the family's chateau and winery. "On a column at the gateway is a Brancusi bird sculpture, the real deal," Tony Shafrazi says. "They asked Keith if he would design one of their wine labels. Andy Warhol had done one. Salvador Dalí did. Keith was lucky that the year of his label turned out to be a very good season. It was a fluke." Bjorn Amelan recalls that "Keith was being his dreamlike self that day. He was animated, but there was always a seeming kind of absentmindedness about him that I found striking. He was so enthusiastic at all of Patrick Kelly's shows. It wasn't that he was disconnected . . . but he was."

Haring's retrospective then moved on to the Stedelijk Museum in Amsterdam, one of the most prestigious contemporary art museums in the world at the time, where it opened in March 1986. The museum's director, Wim Beeren, was known for introducing American artists to a European audience. The exhibition was nearly identical to that in Bordeaux, though the *Ten Commandments* were too large and irregular to transport, and Haring, instead, made a few new pieces—he spray-painted a vellum scrim beneath a skylight in the museum's atrium; created on the spot one of his very long drawings, covering the entire length of a continuous circular room and titled *Amsterdam Notes*; and in one day, between eleven in the morning and six in the evening, painted the side

of a huge museum storage warehouse located among several factories, a mural forty feet high, which has since been restored. Most dramatic, though, on the evening of the opening was the disappearance of an early Haring drawing of a white man penetrating a Black man laid over a table in a series that had first been shown in his P.S. 122 show. "In a way, it was about whites ripping off Black culture, among other things," Haring said.

The theft made national news the next day as a masked man identifying himself as a member of Stad Kunst Guerilla (or "City Art Guerrilla") appeared in newspaper photos holding up the drawing that was raw and edgy even for Haring, a photo that would never have appeared in the American press yet was accepted in Amsterdam with little shock. As Haring's work was often overtly political—and all depictions of gay sex were automatically political—his tampering with the world invited tampering back, though with motives, as with his attempted tarring and feathering, not always clearly defined. "Then the head of the Hell's Angels heard about it and contacted me because he's a fan," Haring told Page Six of a curious resolution to the incident. "He arranged for a trade so I could get that particular drawing back . . . I don't understand what their point was—maybe an attack on American cultural imperialism." Judging the sensational stunt closer to blackmail than political theater, Haring still felt a need to agree to the demands of the group that claimed to "move" rather than steal art: "I make a small drawing, belligerently, not really wanting to give in to them, but really wanting this drawing back." The work, now bent and cracked, on glossy JAM paper Haring had been able to buy inexpensively near SVA in 1980, was returned, having traveled far from the walls of P.S. 122.

The Pop Shop

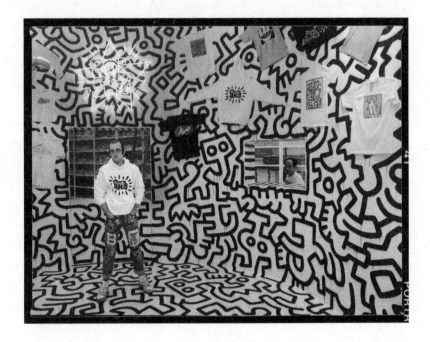

Juan Dubose was feeling down. Ever since he and Keith found each other at the baths four years earlier, their shared life had been permeated with a kind of poetry, as they slept in their boyish summer camp tent on the floor of Broome Street. They would have Thanksgiving or Christmas dinners at Juan's mother's house in Harlem, and Keith was accepted as part of the Dubose family, just as Juan became an expected guest at holiday gatherings in Kutztown. While neither of

them was overly talkative—at least not in public, together—they created a warm feeling around food, sex, partying, music, and art. Of all the clubs downtown in the early eighties, their floating house party on Broome Street was among the finest. In those early days, Juan was a solid, knowing, if sphinxlike presence, a "real dude, a mensch," with his feet seemingly on the ground, among many club kids who were less firm and sweet than he. Yet Keith's swift launch into wealth and celebrity was now putting a strain on their bond. "Juan lost his soul somehow," says Bruno Schmidt. "I don't know how else to say that. He became 'Mrs. Keith Haring.' He was a consort. Suddenly, he had free money floating in front of him. It put him out of sync. Juan was doing heroin as well, and the coke and heroin began to take a toll."

"I was certainly unfaithful to Juan," Haring admitted. "I was bored with Juan's inability to do anything with himself. And I didn't like Juan's involvement with drugs, which was partly spurred by my rejection of him." Whether the drugs came first or Keith's pulling away and falling out of love did, a vicious circle took hold, leading to some horrible fights.

Juan's recourse—then, as always—was music. The mixtapes he spun in 1985 tell a tale of the ups and downs of love, like an extended sonnet sequence. The roller coaster of love was of course a standard story told by popular song lyrics in all times, places, and genres. Dubose was guided, as he had ever been, by the latest releases, whether new dance remixes on 45 rpm vinyl discs by Larry Levan or current Top 100 hits: "We Don't Need Another Hero," Tina Turner; "Love Is the Seventh Wave," Sting; or "Dare Me," the Pointer Sisters—a harder edge of cynicism marking a lot of eighties lyrics that had traveled some distance from the love hangover sweetness of the disco music of the decade before. Yet the last extant Broome Street tape mixed by Dubose and dated October 10, 1985—the day the music stopped?—sounds undeniably like an intentional, bittersweet poison valentine for his lover, filled with pointed messages, some of anger, some of loss and regret. Side A opens with a strong Garage favorite of the moment, "No One Can Love You More than Me," by the Weather Girls ("You want the freedom to love someone else") and segues to "Hit and Run," by Total Contrast

("Now you see him, then you don't"). The first third of side B belongs to Grace Jones, "Slave to the Rhythm," Jones a big figure in their lives since Keith painted her body a year earlier. Mixing hip-hop with pop rap, Juan reached back to 1981 for Phil Collins's acerbic "In the Air Tonight" ("It's all been a pack of lies"). The tape winds down with a fleeting, loose cover of "Who's Sorry Now," its closing disco lyrics left floating in the air: "I didn't mean all the things I said / I must have been out of my head."

Juan and Keith kept living together for a few months after the tape, though Keith was spending more time, and often spending nights, at his new, expanded studio at 676 Broadway, near Great Jones Street, which he was fully moved into by September 1985 and was renting for $2,200 a month. He at least claimed that his plan was to "start spending time on my own. I wanted to be a bachelor. I wanted to play the field. I didn't want to fall back on another hopeless love affair." Coincidentally, at about the same moment, his friendship and art partnership with LA II was waning; the last of their major collaborations would be completed by 1986. Like Juan Dubose, LA II had succumbed to and been swept into a force field of celebrity, money, and drugs unimaginable to friends and family members—some living on welfare around him in the projects. The allure of this rich lifestyle contributed to his dropping out of high school his junior year without informing Keith, who felt a breach of trust. "I'm splitting the money directly in half with him, and he should be saving the money, but he's not," Haring said of his personal disappointment with LA II, a disappointment at once clear-eyed and naïve. "He's starting to lie to me that he is still going to school. He's not really treating me with the respect that he should have. So, after a certain point the relationship begins to break down. We eventually don't work together anymore." Haring had also moved on to different styles of painting and different statements. At the time, LA II was hurt, but he understood "he had to do stuff by himself, you know." Yet, later, he would complain, "From his will, all he gave me was two drawings."

Keith's resolve that his separation from Juan would result in a reflective time of living alone and not losing himself too quickly in another intense love affair lasted a few weeks at most, until one rainy Saturday

night, January 18, 1986, at—where else?—Paradise Garage. The night already had a good-omen feeling, as Bobby Breslau had rushed onto the dance floor earlier with a copy of the Sunday *New York Times* with Keith and his sculptures on the front page. Larry Levan was completely proud of Haring, and in celebration, Keith dropped acid, spending much of the night honored in the disco booth and having "an incredible hallucinogenic experience." Throughout the night, both he and Levan were completely mesmerized by one young man on the dance floor, who, by the early hours of the morning, as Keith was subtly standing in a corner, tripping, appeared to him as "totally angelic looking and totally glowing": "I convince myself that should he look at me and come over and talk to me, then *that's* going to be *it!* I will have found my new love. Well, he does look at me, and he does come over and talk to me." Truly, they had met once before, and danced for two hours, though without talking. On this night, Keith, truly, first sent over a friend, who nervously said, "I have a friend who's a famous artist and he wants to meet you." Yet the outcome was the same. Keith decided he had met his new love. He invited the man back to his studio, along with a studio assistant, Adolfo Arena, and another friend, which led to some group play in the shower. The next day, they went to Mr. Chow for dinner and to see the movie *Brazil*. Within two weeks, Keith had invited his new friend—awkwardly, also named "Juan"—Juan Rivera, to travel with him to Brazil.

Juan Rivera was a striking-looking young Puerto Rican man, twenty-eight years old, with some of the posturing of a macho street guy mixed with a classical beauty, the stuff of Florentine portraits of young princes and soldiers of the Renaissance. In the words of Drew Straub, still, like Keith, faithfully dancing at the Garage every weekend, "He was a raving beauty." Susceptible to love at first sight—with the emphasis on *sight*—Keith responded first to the visuals, even Juan's appearance as both man and boy: "He looks like a baby, except for the fact that he was losing his hair, even then. With a hat on, he looked 17 or 18 but he was a year older than me." He described him elsewhere in his journals as "a walking sex object." Rivera had a natural sense of style that helped him fit into scenes both high and low. "He had an aura about him, and he was comfortable in his own skin," says his friend Arnaldo Cruz-Malavé, an author and

professor who interviewed him on his life story a decade later. "He had a way of dressing and walking that was very street, but he could just as easily have been on the runway. He could go to the cheapest store, pick up a few cheap things, and look as if he were a fashionable model."

Juan Rivera was a survivor. He had grown up in the Hill section of New Haven, Connecticut, an impoverished Puerto Rican neighborhood with a deficient public high school, where learning disabilities that were ignored left him functionally illiterate for the rest of his life. As a young gay kid growing up in a homophobic, religiously fundamentalist environment, he was a runaway in the late 1970s to New York City—like Keith, a migrant to the city, escaping a repressive adolescence, yet with far fewer resources at his disposal. He survived by working the desperate streets of Times Square as a male hustler. He tried to struggle upward by taking jobs as a house painter, an apartment construction worker, a maintenance man, and a driver and partner in a limousine company. Before he met Keith, he was involved as a victim in a dangerously abusive relationship ("S&M," he would describe it) with a second-generation West Indian American who had recently come out of the closet. All through these years, "Juanito" hung out with and was often taken care of by the founding posse of the House of Xtravaganza, one of the main drag ball houses uptown in El Barrio, or East Harlem.

"I was attracted to him as a person," Rivera said of his first impressions of Keith. "And I thought he was cute. In a Woody Allen dorky sort of way. And after we went to his studio and there was all this passion brewing . . . *todo se fue a juste!* As I've gotten older, I've learned there are some people who have these vibes you can pick up on . . . and Keith was one of them. He had this *aura* . . . And with Taurus men it's always like that—*fast and furious*." Keith liked to know everyone's astrological sign, too, and they both made much of his Taurus sign being mismatched with Juan's. "I looked in astrology books," Rivera said, "and I found out that Leos and Taurus don't get along, it's not their nature." Overcoming their astrological destinies, at least for a while, the two found comfort in each other and in sharing simple pleasures. Keith responded to the childlike quality in Juan. "That is why I love him, I'm sure," he later wrote. "I've always been attracted to these special people." Rivera was

able to fit easily into his life: "When we met, he didn't have a job, and he was eager to fall into the position of being . . . well, Mrs. Haring." Juan would joke that he was Keith Haring's maid, butler, or wife, yet with a dose of sarcasm or irony. He slyly flipped the gay code for sex roles when trying to describe their dynamic: "I was top and he was *dominant* . . . He wanted to get clocked—and so he did."

Within a couple of weeks of their meeting, Keith and Juan Rivera flew to Brazil, a trip Keith had taken with Juan Dubose twice before. Visiting Brazil always meant staying with Kenny Scharf, who had moved there for much of the year to be able to pursue his art and a healthier lifestyle. Kenny had first fallen in love with the country in 1982, while visiting their Brazilian friend Bruno Schmidt. "The first time we were in Brazil, Kenny couldn't hold on to his passport, and he lost his shoes on the plane," Schmidt says. "I have a photo of him coming out of a plane without his shoes. How can a man leave his shoes? He was really out of it." On a plane ride on that first trip into the interior from Rio de Janeiro to Salvador, where Bruno and Kenny were going for Carnival, Kenny had met Tereza, and she became his guide to Bahia, the lush Afro-Brazilian state on the northeast coast of Brazil, where she had grown up in the small port city of Ilhéus. In 1983, the couple purchased 160 beachfront acres that came with a humble two-bedroom house in the remote fishing village of Serra Grande, a three-hour trek by car from Ilhéus, on a bumpy road.

Keith visited the Scharfs, now married, in Serra Grande during four winters from 1984 to 1987. "Zena was born in Brazil," Scharf says, "and the first year, all my friends came down to check out that somebody actually had a baby in our circle." Among the first to arrive was Keith, instantly a loving figure in Zena's life, giving her lots of attention and enjoying his role as her godparent. While interviewing Kenny Scharf for the February 1985 issue of *Interview*, Keith observed fondly, of Zena, "She's been sitting, watching you paint since the day she was born. Even in Brazil she was sitting beside you in a little stroller watching you paint." He always timed these visits with the high season of Carnival—a reminder writ large of the topsy-turvy Kutztown Halloween parades of his adolescence. "Keith loved Carnival for good reason," Scharf says. "In

Rio, it's more of a Las Vegas show; the floats are very produced. But in Bahia back then, it was a party for the people in the street. They had these *trios elétricos* that would drive by with bands, and everyone would dance in the street and follow the trucks. It's like getting together with thousands of strangers, sweating, dancing. It was so much fun." Keith also loved the boys. "I remember him going back in a swampy area of the rain forest with some guy and coming back covered in mosquito bites," says Min Thometz-Sanchez, another of Zena's godparents. "He was al-most hallucinating, he had so many mosquito bites. No one had cala-mine lotion, so I carefully touched each bite with my face mask mud. He looked like one of his paintings, all polka-dotted."

Keith was not at the beach long on his first trip before painting a mu-ral on an outside wall of the Scharfs' home. He chose to redraw a crea-ture he had first done in the subways in 1982 and imagined as a "sort of dolphin-mermaid-angel." The drawings attracted the attention of the Scharfs' Black and white neighbors, many of them fishermen, as the fan-tastical hybrid resembled Yemenjá, a beloved Yoruba Brazilian mermaid goddess of the seas and protector of sailors. "They'd ask us to do some-thing on their houses or their boats, and we would," Haring said. He would walk up and down the beach, passing out bright Haring T-shirts to kids and drawing crawling babies, barking dogs, and three-eyed faces on shacks. "He made a huge impact," says Bruno Schmidt. "He'd walk in the street, and people would go, 'Whoa, whoa, whoa!' In New York, he didn't have that." On the streets of Ilhéus, he was electrified by see-ing capoeira, an Afro-Brazilian form of martial arts performed by two dancers in a circle of other handclapping dancers to the steady beat of a musical bow, the *bermimbau*, with some added percussion. He made drawings of these movements, so close in look and spirit to break danc-ing, and spoke of the flexible motions that impressed him, of the dancer athletes "dipping underneath each other," trading hits and lunges with "arms going through their bodies." In 1987, he cast these balletic head-stands and high kicks in steel in three large metal sculptures of festive combat.

Inviting Juan Rivera to Brazil had been a last-minute impulse, in keeping with the antic pace of much of Haring's life in New York City—

a pace he enjoyed escaping on these cherished monthlong visits. "I'd been putting a carpet in my mother's house earlier that day when a friend of mine came up from the City to visit," Rivera remembered. "And he'd asked me if I wanted to go down to the City, and I said, 'Yes!' And I told my mother I was gonna go out for a ride, but didn't come back for about two weeks. And when I got back home my mother looked at me like saying, 'Where have *you* been?!' And I said, '*Brazil.*'" Says Scharf of the surprise second guest, "I was happy for Keith. I was a little bit sad about the first Juan, because I was close to him and thought he was a real sweetheart. But I wasn't going to be opinionated about who Keith was with. I thought Juan was fun. Keith was obviously completely into him. I was more worried about Keith's health, as I knew that he'd had early symptoms of being sick years before. A lot of people were dying. I was so freaked out I had gone three hundred sixty degrees opposite and came to live the healthiest life possible in nature. It was hard for me to witness Keith's attitude about partying. He loved the Garage so much. He did a lot of drugs to stay up all night, and that's not healthy. That was my concern. It had nothing to do with Juan personally."

When they returned to New York City, Keith was still living on Broome Street with Juan Dubose, and Juan Rivera was staying mostly at the studio on Broadway. The setup was clearly untenable, so Keith put Juan Rivera about the task of finding a new apartment where they might live together. Rivera found a third-floor walkup at 321 Sixth Avenue and Third Street, just south of the Waverly movie theater and across the street from a popular public basketball court. Although Keith could now afford a somewhat grander space, he was keeping his Lower East Side lifestyle going, while focusing almost entirely on his studio and remaining uninterested in most of the trappings of domesticity. "It was a very sterile one-bedroom with not an ounce of charm, a few boxes strung together," Julia Gruen says. "Keith's main reason for wanting to live there was liking to watch the guys play basketball across the street, especially in the summertime, when they had their shirts off." He personalized the place by choosing a scheme in primary colors, with a red kitchen, yellow living room, and blue bedroom, all

spackled and painted by Juan Rivera, who also built bookcases and some furniture. A dance friend of theirs from the Garage, Lysa Cooper, whose style was compared to Josephine Baker's and who worked as the maître d' at Brian McNally's restaurant Indochine, an important post in downtown society, found the Sixth Avenue apartment "super cozy." Yet Keith never re-created his Broome Street lounge in this far less rambling rental. Among friends invited by, and often surprised by the home's understatement, was deejay Junior Vasquez: "I think that it wasn't just Keith's artwork at that time, it was the entourage, the boys, the girls, the women, that were around him. If you didn't know Keith, you were always fantasizing about what was going on in his loft and in his apartment. When Keith got his apartment on Sixth Avenue, right next to the movie theater, I went there after the Garage one time, and I remember walking up those stairs, being really impressed that this guy who could have friggin' anything, but he has this walk-up leading into this yellow box."

The Sixth Avenue apartment was a hideaway, an intimate wormhole, its pleasures simple. Again, as with Broome Street, an adolescent sexiness charged the air. "For me, the physical part was so overpowering that I just let it lead me around in this really obsessive way," Haring said. Just as sensual, though, for Keith was Juan's cooking, which was simple yet spicy and Puerto Rican. "Keith always *loved* my cooking, and it was always an honor seeing him *ohhhing* and *ahhhing* my food." On the menu were canned Goya red beans, Puerto Rican white rice, avocado salad, fried pork, or chicken. "I cooked and kept the house clean," Rivera said. "Keith seldom spoke about what he was doing. He came home to have peace of mind and some home-cooked meals. He liked to watch cartoons, and he loved to watch *Mr. Ed* and *The Honeymooners*." The glow of the television screen was as hypnotic and soothing on noisy Sixth Avenue as years earlier in his grandmother's quieter Kutztown living room—a through line of Haring's life. "He was into a lot of what we called 'L.A. television,'" Rivera said, "like *The Simpsons*, because you could watch really good TV in California, and that was one of the things we liked about going there." Their shared pleasure of pot smoking in the

evenings while kicking back and watching TV sitcoms and giddy cartoons, anywhere in the world, was no minor affinity.

One day in early fall 1984, Keith had been walking down a stretch of Lafayette Street below Houston, not far from his studio, when he noticed a hand-painted For Sale sign in the window of an empty storefront at the corner of Jersey Street, a dogleg of an alleyway. His reaction was a double take, as he had been thinking for some time of opening a space that would be "a combination art gallery and store" with "an amusement park atmosphere," as he told the *New York Post* that November. Treating the sign more as a cosmic signal than a mere advertisement, he phoned the landlord, Alan Herman, an artist, who kept half the floor for himself and had been trying for over a year to rent the other half—a 700-square-foot space with 1,200 square feet of storage in the basement. The next day Haring, who had not given his name, stopped by. "I saw Keith riding a big cruiser bike down the street in the wrong direction and up to the front door," Herman recalls. "I thought, *Wow, that's cool; it's him,* recognizing him immediately, as I knew him from his subway drawings and was very aware of who he was."

In a "pretty quiet," almost shy manner, Haring explained that he was thinking of opening a store with branded merchandise and that this space would fit his plan well. Herman was confused: "Next door was an auto parts store, a taxi garage, and then a gas station. There was no other retail except for an outlet that sold diamond-tip drill bits for the industry. The alley was still the refuge of Bowery bums, who came to use it as their bathroom. It was rough. It was definitely out of the mainstream." The Puck Building, a redbrick pile and former printing plant, loomed across the street, mostly still filled with unrented offices and party spaces.

"Why in the world would you want to be here?" Herman asked, evidently as much of a "horrible businessman" as Haring described himself. "Why don't you want to be on West Broadway, where all the galleries are?"

"That's the last place I want to be," Haring answered. "I want to be apart from that entirely."

The bleak no-man's-land block between a fading East Village gallery scene and SoHo appealed as much as the raw space—most recently a warehouse for industrial belts and chains that hung from its high ceilings. They spoke for about twenty minutes and agreed on the rent: $1,500 a month.

While quick to write a check to secure the deal, as he was leaving for Europe the next day, Haring allowed nearly a year and a half to pass before the official opening of his Pop Shop in April 1986. Some of the delay was logistical—building out the store, sourcing fabricators, hiring staff. He also needed to put $500,000 of his own money into the venture, which required some fund-raising. He applied to Chase Manhattan Bank for a short-term loan of $100,000 to realize the project. In the application, he estimated the value of his own art collection at about $700,000 and predicted that $1 million in artwork would be shown and sold at his upcoming joint show at the Shafrazi and Castelli Galleries. At about the time of his application for a loan from the bank, he also received an $80,000 personal loan, a contribution to setting up the Pop Shop, from George Mulder, a Dutch art dealer and collector of Haring's work. The loan was to be paid back with interest within a year, though Mulder was willing to forgive it if Haring sold him five paintings, two of them marked "NOT FOR SALE," meaning that Haring did not wish them sold to anyone. Keith did, eventually, sell Mulder the paintings he desired, and the debt was canceled. The working titles of the paintings Keith did not wish sold were *Homage to Paul Klee* and *Andy Mouse*, and Mulder promised not to turn around and sell the works immediately.

In February 1985, Haring took advantage of the fallow space to mount an exhibition titled *Rain Dance*, for the UNICEF Emergency Relief Fund for Africa, to help curb hunger from a drought in Ethiopia. For the benefit, he designed a poster with, and showed works by, Basquiat, Warhol, Yoko Ono, and Roy Lichtenstein. "I got to sit there and take the money like a little match girl," Julia Gruen says. "I was not happy about it, not because it was beneath me, but because it was freezing." Some delay, too, came from Haring's worries about the optics of trying to cross art with commerce, not as a dealer but as an artist. "Andy practically 'convinced' me to open the Pop Shop when I started to get

'cold feet,'" Haring wrote. Yet even Warhol, in his diary, voiced mixed feelings. "Keith told me that he rented a store for $1500 across the street from the Puck Building," Warhol wrote when he first heard the news. "So I guess he *is* a little like Peter Max. But then Peter Max never did get in the good art collections that Keith is in. And he said he won't sell his stuff to any other store, it'll just be in his own store." When he visited the realized shop, Warhol had doubts about the location, too: "The store is hard to find, it's a little bit out of the way[;] that makes a big difference. I don't know if people will go, but there were people in it."

Keith's adolescent side won the debate in his own mind. He often found resolve by mining the original cartoons and even the play spaces of his boyhood—in this case, the backyard toolshed clubhouse, which had occasionally doubled as a store, its Dutch door allowing "customers" to be served as at a cash window. There, and at sidewalk tables or penny fairs, ten-year-old Keith had reveled in selling dried gourds, Kool-Aid, and painted rocks to the neighbors. "For me a store is an extended performance," Haring said. "It's like playing store when I was a kid. I always wanted to play store." This penchant for moving merchandise surfaced throughout his career as an artist: "Of course, I knew I'd get a lot of criticism for it, but I also knew that it was what some of the work called for—and *had* to become." Haring had worked shifts in the Souvenir Shop of the *Times Square Show*—required of anyone selling work there—where he displayed his porn collage zines on a newspaper rack. By 1985, the creator of original Grateful Dead T-shirts had produced T-shirts for the fashion designer Willi Smith; displayed and sold a winged television T-shirt in the 1983 Whitney Biennial gift shop; and hung T-shirts in the annex of his *Into 84* show at Tony Shafrazi. "I said to him, 'What are you going to do with those T-shirts?'" says Patricia Field, whose boutique on Eighth Street also sold white jumpsuits and sweatshirts painted by Basquiat. "'Bring them to my store.' So, they lived at my store, and then he opened the Pop Shop and had the T-shirts there. My shop was a catchall for all the creatives. I'd be flattered to think it influenced the Pop Shop, because Keith was my favorite." Haring also collaborated with the British fashion designers Vivienne Westwood and Malcolm McLaren for their *Witches* collection for Winter 1983/84. He knew he had a fine line

to navigate—"A tightrope, and dangerous on either side," as he put it. He was hoping to earn popular appeal while avoiding crass commercialism and keeping the respect of the artists he admired.

Another motive for opening the Pop Shop was simply a desire to get out ahead of all the knockoffs of his work multiplying at home and abroad. Envelopes had begun arriving at the studio stuffed with bootleg T-shirts friends had come across while traveling as far away as Thailand, Japan, India, and China. "I remember driving from Goa to the middle of nowhere in the back of a taxi," Donald Baechler says. "Some farmer was plowing his field with an ox and some medieval sort of thing, and he was wearing a Keith Haring T-shirt. I thought, *That is just amazing that this is here.*" Haring had been turning down offers from big firms like those that licensed the cartoon characters Snoopy and Garfield—"Almost to the level of being in a Sears and Roebuck catalog," he said. He wished instead to follow a specific artistic vision—his desire for quality control keeping pace with his desire for sharing. Yet he was flattered by imitations and never sued to protect his brand, his friendliness to the general concept of licensing artwork as commercial product helping to make him a pioneer in overcoming this dichotomy and leading to his own posthumous ubiquity as an art "brand." "Keith would collect his fakes," Lysa Cooper says. "He would buy them and come back with a suitcase full. He loved it." Ever a believer, though, in the hand and mind of the artist, the human touch, he did not wish the fakes and the originals to be confused. He hoped the Pop Shop would educate the public. "I decided to participate in this flow of fakes," Haring said, "and the way I did this was to show people the difference between the real thing and the imitation. Because you *can* tell the difference between a fake Keith Haring and a real Keith Haring. You don't need an artistic eye to tell you the difference, because twenty people can draw the same Japanese character, but each one will be endowed with its own power and spirit."

Haring's was not the first artist's store. Other such provocative, often lightly sarcastic projects had been in development among downtown artists for at least twenty-five years. For two months in 1961, Claes Oldenburg repurposed a storefront in the East Village as "the Store," where he displayed papier-mâché sculptures mottled with enamel house

paint, imitating items sold in neighboring shops, such as gym shoes, blouses, dresses, and pies, though his would never be mistaken for discount merchandise. As Haring said of the distance between his Pop Shop and Oldenburg's Store, "This is certainly a very different kind of store. Oldenburg was selling one-of-a-kind things. I'm trying to deal with mass production in a way much closer to what Andy did." After the *Times Square Show*, Colab artists opened a pop-up holiday shop each December between 1980 and 1985—in a storefront near Haring's old address on Broome Street and then at the gallery White Columns—called "the A. More Store," where Kiki Smith sold severed-finger earrings, and Jenny Holzer "Truism" T-shirts. Fashion Moda constructed an installation of A. More Store at *Documenta 7*, in 1982, including for sale fifty Haring radiant baby T-shirts. In a catalog essay for Haring's show at the Stedelijk Museum the same spring as the opening of the Pop Shop, Jeffrey Deitch identified more antecedents—from the Russian avant-garde productivist movement to elements of Bauhaus and De Stijl philosophy—while arguing, of Haring's "latest and most radical project," that "Even Warhol never ventured this far into the commercial arena."

By investing in a brick-and-mortar store and stocking it with art multiples, Haring was launching his own line of art merchandise at prices, as low as one dollar, available to anyone. In the novel guise of a small-business owner, though, he found himself, months before the opening of the Pop Shop, in urgent need of help with—in Warhol's phrase—"Business art." For expertise, he turned to his friend Bobby Breslau, who became the first manager of the Pop Shop before there was even a store. Many of Haring's most memorable art productions were collaborative—like the Day-Glo walls and fiberglass statues he painted with LA II and the wood totems with Kermit Oswald. Pop Shop at its start was often a collaboration with Breslau, whom Haring would look back on as "the guiding light behind the Pop Shop" and cast as Jiminy Cricket to his Pinocchio, his "guardian angel." For Haring, Breslau was a one-person fan base, clipping any mentions of the artist in the press and greeting any Haring paintings he admired upon entering the studio with a little dance, jumping up and down and saying, "Way to go, kid!" It was Bre-

slau who had first introduced Keith to Larry Levan and Grace Jones. As a veteran of the garment industry, Breslau had street-deep knowledge of sourcing and fabrication, his strongest fit with the Pop Shop. "Keith wanted all kinds of things, like little AM-FM radios with three-eyed faces," Julia Gruen says. "He had Bobby sourcing China to find factories and having to send letters of credit. This was the era of telexes, and we had that funny tape rubbing on all our fingers." In the run-up to the opening of the store, Breslau helped to oversee a mail-order catalog, a billboard at the corner at Houston Street, and ads in *Interview* magazine.

The popcorn atmospherics of the store that Haring finally built, and had envisioned as "this really fun place," were more game board than retail, conjuring such make-believe spaces as Pee-wee Herman's Playhouse or Bill's Candy Shop in the 1971 film *Willy Wonka and the Chocolate Factory*, rather than the Gap or Blockbuster video rental. "It was like going into a toy store," says the poet David Trinidad, a regular customer when he lived nearby in SoHo. In the *Village Voice*, Guy Trebay wrote of a floor plan "shaped like a Beatle boot knocked on its side and painted in black and white with Haring's designs." To help construct his vision, Haring had brought in the architecture firm Moore and Pennoyer—who were working at the same time on his new top-floor art studio nearby, rebuilding walls, installing a skylight, and hanging intense parking lot lamps Haring hoped would highlight his ongoing sermonizing and political anti–Moral Majority Jerry Falwell fluorescent paintings. (Experimenting in public at the shop, he was experimenting more privately just a few blocks away.) The architects defined the store space with a spine of a double-curved wall down its center and suspended a piano-shaped sheetrock ceiling overhead—decades later, the drawn-upon *Pop Shop Ceiling* would be reassembled over the entrance lobby of the New-York Historical Society. "The wall seemed natural here because his work was all about shapes," Peter Pennoyer says. "The idea was to give it a sinuous, long curve with a mirror at the end to extend that illusion." Over twenty straight hours, Haring painted the walls, ceilings, columns, and even the hardwood floor with thick black, somersaulting lines, drips included, in the style of his all-over environment painting at the Pittsburgh Center for the Arts and SVA, the black-white design like a set he had painted

for Duran Duran on an MTV spot months before. With an orange-and-yellow neon star mounted on the long wall flashing the name "Pop Shop," the sculptural room took on a suffusing gold-and-rose texture.

Every game board needs a game plan, some instructions, and a pair of dice. Haring was just as programmatic in drawing up a tight set of rules for his game store, which had been designed "almost intentionally," Julia Gruen says, "not to be a big money maker," even though he had invested a sizable amount of his own money in its launch. (Although Haring had projected monthly sales of $100,000 in his bank loan application, the store in 1987, its first full year of operation, netted less than that before taxes.) The Pop Shop had no racks of clothes, no dressing rooms, no carousel of items for sale, no price tags or stickers. When customers entered the store through a single glass door—after passing store windows filled the first month with inflatable crawling babies (the display underscored on an exterior base wall by an elegant "LAROC" tag done by LA II)—they found themselves in a vertigo zone with T-shirts, sweatshirts, even a silk jacket pinned to hand-painted walls that nearly camouflaged any merchandise. A cassette blared tapes of happening music—a favored band was Run-D.M.C., as the poster for their My Adidas tour was shot that April at Haring's studio, the hip-hop group's members, in their Shell Toe Adidases, sweats, and Kangol hats, shot against his spray-painted backdrop. (A couple of times, when the music grew too deafening, Alan Herman, forced into the role of an urban apartment dweller, stopped by to request that the volume be turned down.) Upon their entrance, customers were handed a clipboard with an order form. The goods on the checklist included $12–$25 T-shirts, $5–$12 magnets, 50-cent buttons, $5 coloring books, and $55–$155 skateboards. The evolving inventory was numbered, and one example of each pinned to the walls or displayed in vitrines, so the numbers could be written down and taken to a cash window. Visible through window number one were floor-to-ceiling shelves, with a rolling ladder, where clerks in white fabric jumpsuits drawn on by Haring in black Magic Marker hunted down the requested items, often to hold up, as trying them on was not allowed. A second window (both counters inset in the curved wall) was for pickup, as at the double drive-through fast-

food restaurants appearing across America in the 1980s. Most items fit neatly into a Pop Shop plastic bag, available for $2 plus tax.

On the official opening day of the Pop Shop, April 19, 1986, marked later in the evening by a party at Area, the overall mood was exuberant. Keith's own mood was downgraded only slightly by the slur word *CAP-ITALIST* spray-painted on the store's threshold—a menacing reminder of the botched tarring and feathering he had narrowly escaped at Castelli Gallery six months earlier. "The opening was an incredible event as far as the people who came," Haring said. "Many of them said they just wanted to buy a postcard so they could have a receipt marked with the first day of the show. The sales from that day were amazing. I said from the beginning that Pop Shop was an experiment, and if I lost interest, I would not think twice about closing it, or if nothing would sell, which didn't happen." Proving most popular were "Debbie Dick" T-shirts, of cartoon penises with cheery smiles and blond wigs. Selling, too, were the four watches Haring had designed in a licensing deal with Swatch. In the spirit of Club 57, items by other artists were on display, too—by Scharf, Eric Haze, Stephen Sprouse, LA II, Futura 2000—including Warhol, with a line of T-shirts from a recent series of self-portraits. In and out, opening day, were some recognizable faces of 1986—the model Ariane; the designer Abbijane; the actor Howard Hesseman; and a group of Guardian Angels. (Ironically, Keith had feared the Angels vigilante group during his early days drawing on the subways.) Haring and Breslau mostly had poured themselves into hiring a staff that would draw the Garage crowd, including Adolfo Arena, who reported, among his friends, "*everybody* wanted to work there." Says Desmond Cadogan, "The staff was cute, young Latin boys, usually, maybe a couple of girls, but they were all young and ethnic. I don't remember any Caucasian people working there. And always a Larry Levan cassette playing." Of the opening, Pennoyer recalls, "A lifeguard chair to the left of the door, and an African American man sitting there, higher up, as security. I'd never seen a store do that. You would never see that at Tiffany's." (As barter for his fee, Pennoyer got Haring to paint a design on his vintage 1963 Buick Special, which has since been exhibited at the Petersen Automotive Museum in Los Angeles.)

Bobby Breslau proved skilled at plying the press with quotable comments. "Standing in the shop is like being in his head," he said of the immersive artwork of the store. Asked whether Andy Warhol would be stopping by on opening day, Breslau answered amusingly, "We're waiting for him to come in and bless us." Haring was more shuffling in his responses. At times, he stressed the fine art, likening the T-shirts to "a wearable print" or even to the work of "conceptual artists and earth artists . . . participation on a big level." At other times, he stressed retail, comparing the Pop Shop to an upscale, self-service home products chain store: "This is more like a Brookstone shop. Our version of fast food or fast art." Its opening was covered by a list of newspapers and periodicals (including *Vogue*, *GQ*, the *New York Times*, the *Village Voice*, the *New York Post*, *Harper's Bazaar*, and *Time Out New York*) and on TV news programs (Channel 11, Swiss TV, and ABC News). Yet the coverage in the *New York Times*, in a "Notes on Fashion" social column by Michael Gross, set the tone for the general take on the venture: "Mr. Haring, whose glowing babies are becoming a 1980s version of the 'Have a Nice Day' smiling faces of the 60s, used to offer his art free on subway walls. Now he sells it for five-figure sums. Mr. Haring also used to give away his pins, jigsaw puzzles and comic books, which are now for sale at the shop."

In an episode of the ABC News magazine 20/20 timed to the opening of Pop Shop, titled "Pop Goes His Easel," host Hugh Downs promised that Keith Haring's art was sweeping the nation: "If you're not familiar with it yet, chances are you soon will be." The show's official talking head on Pop Shop and all things Haring was Mark Stevens, a young art critic for *Newsweek*. "Is this spiritually, intellectually, morally forceful stuff?" Stevens asked, adopting a different tone altogether from that of Downs. "I think you have to say that Keith Haring's work, while fun . . . no . . . it's fast food, it's a good time, it's boogying on a Saturday night, it's alive, but great, no." Stevens's earnest appraisal of Haring on national television turned to vitriol when taken up by more steeled critics of his. The conservative editor of the monthly review *The New Criterion*, Hilton Kramer, said at a panel discussion, on "The Art Supermarket: Connoisseurship vs. Consumerism," organized by the professional

visual arts organization ArtTable, "It's proper for Keith Haring to open a shop. Maybe if he had been able to open a shop from the start, we wouldn't have had to deal with him as an artist." In a satirical poem penned for *The New York Review of Books*, Robert Hughes ridiculed the artists "Keith Boring" and "Jean-Michel Basketcase." Asked about the shop newly opened by "disco decorator" Keith Haring, Hughes commented, "People will look back to Haring and say, 'So that's the kitsch people were buying. Good Heavens!'" In these characterizations of Haring as a shopkeeper, disco bunny, and kitsch decorator, stereotypes of homosexuals abounded. Thomas Hoving, former director of the Metropolitan Museum of Art, said Pop Shop "doesn't carry great significance" other than as "a natural extension of the Metropolitan Museum gift shop." Elsewhere, Hoving remarked that "If Keith Haring had been an artist at the caves of Lascaux France, art would have stopped in its tracks."

From its first day, the Pop Shop was a crossover success, breaking even while attracting lines of customer viewers, many of them young and friends of Keith's, such as Madonna, Basquiat, and Warhol, leading to even more news items in the popular press. On weekends, Haring would stop by to sign or draw on purchases, and at Christmas, he dressed as the store Santa, in his big wire rims, holding kids on his lap, a natural role for him. Mixed in with the youthful crowd were some of the next generation of artists, exposed at an impressionable moment to one artist's ease with a Madonna-style joy amid "the material world." They would be among those who, within a decade or two, would help to make the controversies around licensing and branding that plagued "the little explosive shop" sound dated. "When I was a kid, my first introduction to art came through graffiti, skateboarding, and the Pop Shop," said Kaws, then teenager Brian Donnelly. "I remember how Keith Haring's art made me feel comfortable walking into a gallery or a museum." Takashi Murakami visited the Pop Shop on his first trip to New York City in 1989, and a direct line can be drawn from Haring's Pop Shop to his "©Murakami Louis Vuitton Store," first installed in the Museum of Contemporary Art (MoCA), Los Angeles, in 2007. A few lone voices in the art world understood the intent of the Pop Shop

from the beginning. Leo Castelli clarified, simply, in an interview, "The store itself is a work of art." Yet most tended to the response given its most extreme and sharp articulation in a column titled "Downhill from Here," by Tad Friend, in *Spy*, a new magazine started by Graydon Carter and Kurt Andersen and applying snark as a corrective in pointing out all the emperors with no clothes. Although, or because, its offices were across the street in the Puck Building, *Spy* chose, in its premier issue, to deflate the Pop Shop and call for Haring's erasure, and he was sent up in the piece as a member in good standing, with Warhol and Basquiat, of "the Matte Pack": "If the closing of the art show at Area last year marked the beginning of Haring's speedy regress from the locomotive to the caboose of cool, the Pop Shop's inaugural surely marked its end . . . What precipitated Haring's eclipse was not so much the suspicion that he had prostituted his art, but that he had nothing to prostitute."

Haring was at times rattled by the premature news of his demise from high-end arbiters of art. He experienced moments of paranoia, realizing how much sway the Robert Hugheses and Hilton Kramers of the world held over artists' careers and reputations. "You remember that you're not in this important contemporary American art show, and it's very frustrating," he said. "It's frightening how much power critics and curators have. People like that may have enough power to completely write you out of history." He was irritated, rehearsing rebuttals in his mind to those East Village artists who, for years, had accused him of selling out: "I don't know what they intended me to do: Just stay in the subway the rest of my life? Somehow that would have made me pure?" Yet Haring took heart from the support of the artists he respected and the success of the Pop Shop with the audience he had been targeting, the "real people." A few years later, in Rome, he thanked film director Francis Ford Coppola for including Pop Shop items in the *New York Stories* film trilogy, the store and its unique inventory having by then become synonymous with a time and place. The shop endured, thriving on the increasingly hip and busy block on lower Lafayette, where it remained for a full decade, until translated in 2005 into an equally trafficked website.

That spring of 1986, though, Haring was kept from too much worry or, its counterpart, emboldened defiance by an overextended schedule—his perpetual motion both productive and insulating. On May 5, just two weeks after the opening of the Pop Shop and one day after his twenty-eighth birthday (to be celebrated a few weeks later with another Party of Life, again at the Palladium), he flew to Vienna, where he was participating in an altogether different tenor of public art project. He and Jenny Holzer had been invited by the Wiener Festwochen, "the Vienna Festival," to collaborate on a mural and to design posters to be installed at bus stops. The two had been paired at the suggestion of a Viennese curator who had seen a Holzer electronic billboard exhibited in a stairwell next to a Haring installation at the 1985 Paris Biennale and had recognized that both clearly shared a passion for political messaging delivered less as slogans than as curves of language and thought. "Chernobyl had just blown up," Holzer recalls of their week together. "Keith and I found out after we ate salads that we shouldn't have, because it was 'fallout' salad. Hanging out in Mozart Square, Vienna, while under nuclear attack. Just your every day." Holzer's red, all-caps supplication on their collaborative billboard in Am Hof Square was "SCHÜTZ MICH VOR DEM, WAS ICH WILL," meaning "Protect me from what I want." Her letters marched along in tension with Haring's friezelike pileup of bodies towered over by three figures whose poses spoke in universal pictorial language, "See no evil, hear no evil, speak no evil"—figures that recurred in the next few years in Keith's works of AIDS awareness and protest.

"Once again, I was witness to Keith's boundless energy, because he would draw all day on those billboards and then wander around the city and look and work at night, too," Holzer says. "I was astonished and admiring. I think he put the world's biggest bus stop penis in Vienna. It was indelible. For me, it's still, *Wow, what a bus stop!*" The Haring penis drawings—elements of a "Safe Sex" promotion of mutual masturbation on bus stops and public billboards—led to an intervention by the municipal authorities. "I was doing it right outside the police station on a big billboard," Haring told Darrell Yates Rist in an interview for the American gay magazine *The Advocate*. "These two guys jerking each other off. And this one policeman, who was real uptight about it, made a

big deal out of it and called all these police and called his chief. So I had to change these dicks into snakes. But you still could tell exactly what it was supposed to be."

Haring returned to New York City in time for his third Party of Life, held on May 21—although, nearly every night was turning into a party of life for him, as his nighttime schedule grew easily as busy as his daytime one. The most intimate witness to all of Haring's partying was now Juan Rivera, who said that he "eventually fell in love with the guy . . . 'cause he was good to me." Often the wingman standing next to Haring, listening or helping, Rivera suspected that some of the extravagance was designed for his benefit: "Keith knew about my past—how I didn't come from no money—so he'd go outta his way to thrill me . . . And I could tell he was thrilled thrilling me . . . He'd literally do things to *impress* me . . . If we stayed in a hotel in the City, it was always at the *Plaza* . . . If we rode around town, he'd rent a *Mercedes* convertible or a *Ferrari*. And I'd be like, '*This is cute* . . . !' And he got off knowing I got off . . . Most of the time wherever Keith hung out was the scene. He'd show up with his posse of kids at an event. And the event could be a show by Clemente, a party for Jean-Michel Basquiat, or the opening of Keith's latest work, *whatever*, a party for someone famous (or almost famous) given by someone rich. 'Cause the people around him were *loaded* . . . *stupid* rich. And Keith would bring in the posse, and the music, and the *ultimate* pot. And he'd carry a b-box, decorated with cartoon figures by Kenny Scharf. And people would gather around him—graffiti artists, street kids, the hoods, and the rich." By now, Juan Dubose was on the scene only at Paradise Garage, where he and Keith were always amicable. "At the end of the day, we were all still at Paradise Garage every weekend together," Lysa Cooper says. "You couldn't be mad for that long. Juan Dubose would show up at the studio. He still made Keith music tapes sometimes. Even though they broke up, he was still Keith's friend."

As Keith's new boyfriend, Juan Rivera was privy to Haring's single-name-only friends, too. "There was a certain crowd that knew each other from the *Garage*—Iman, Beverly [Johnson], Madonna, Grace . . . —and they'd been hanging out since like the late 1970s," Rivera said. "And

as their careers flourished—as models, singers, and artists—they kept hanging out. So they'd go to each other's events . . . but they were like a *wild* and dysfunctional family." Rivera saw Keith's friendship with Madonna as "this rivalry thing . . . And it was all about *boys*. Street-looking Latino boys." He recounted one memorable dinner, while likely exaggerating the depth or seriousness of a rift between the two friends, who by then went "way back": "When I first met Madonna, I remember being warned by Keith if I even came close . . . that would be *it* for me. 'Cause Keith had this big falling out with Madonna over this Puerto Rican kid named Bobby Martinez. You see, Keith had been going out with Bobby Martinez, and one day, he'd taken him to Madonna's birthday party and said kinda jokingly and *boasting*, 'Madonna, here, your birthday present . . .' And Madonna, wouldn't you know it? *took him* . . . took him at his word, and wasted no time in snatching up the kid. And ever since then Madonna and Keith hadn't really been talking. So when I first met Madonna she was sitting there with her man Sean on one side of the table, and me and Keith were on the opposite end, and all the way across the table she'd give me these *long* lusting looks like *ummm* . . . ! And meanwhile I was spooking her man! Ha! Cause Sean was cute—and had *mucho* attitude!"

Rivera especially recalled one party, held at the Whitney—probably the "Absolut Haring" party thrown by Absolut Vodka in the fall of 1986, to celebrate Haring's design of the company's vodka bottle label—a licensing deal set up for Haring by Warhol, who had been the first artist to design an Absolut label. "I remember everyone smoking pot at the Whitney," Rivera said. "Keith had Larry Levan's music on . . . when all of a sudden Keith lights up, and people start gathering around the smell of weed. And all of those rich *viejitas* hanging out at the Museum and trying to find a *boyfriend* start shoving each other, 'Let me get in there! Let me get in . . . !' Ha! I mean it was *cool* to have *that* kind of power to go somewhere and create a *scene*. And most people loved it . . . loved the *flava* Keith was bringing to these places . . . But Keith loved the crowd; Jean-Michel *hated* it. And he'd walk around, '*Juan*, let's get away from these *fucken* white people . . . !' . . . And there were times Jean-Michel would lock himself in the bathroom, and Keith would have to go spook

him out, and he'd be like, 'This party, man, and these people—they are just not my style.'"

Many on Haring's guest lists wanted a piece of Keith during the jammed middle years of the eighties, yet there was never enough of him to go around, leading to some hurt feelings. Old friends who had known Haring when he was able to be there for them in an absolute, immediate, and supportive fashion resented that their casual closeness could not be sustained, given all the demands on Keith's time and attention. "Early on, we were all such good friends!" Carmel Schmidt said. "But when Keith got really famous, things got difficult. Suddenly, most of us old friends were relegated to second place. That's because he was swept up in the American pop scene. I mean, there was Keith with Brooke Shields and Michael Jackson—and he fell for it. It was inevitable. It was a point of weakness with him, but it's understandable. If you've been a busboy at Danceteria, how can you resist?" Other friends were wondering if the work Haring was doing was getting thin and repetitive. "At the time, I thought, 'Where's he going to take this?'" Robert Hawkins says. "We wondered, with Keith, if this was a one-trick pony, too instantly recognizable."

"The work that he produced in the early eighties had a kind of rawness that was very powerful," Julia Gruen says of the evolving Haring style in the second of his lower Broadway studios. "He did enter a period where things became a little more decorative. It wasn't that he didn't put his heart into it. He was working out other things in his head, different ways of painting. Sometimes the output was wonderful, and sometimes it was not great, but he kept going." For Jeffrey Deitch, though, the painting was not the point. "To just look at what was coming out of the studio and showing in the galleries doesn't give the full picture," Deitch says. "All during this time, he was doing phenomenal public murals, and that was his priority. A more conventional artist would have said, 'I'm busy in the studio, I have a show coming up, I'm sorry I can't travel.' Also, the Pop Shop is part of that full picture. It was a Gesamtkunstwerk, a total work of art, with the walls all painted, with this cave-like architecture, and the music there all the time, energized with the kids and their street fashions hanging out. It was thrilling to go there."

Haring did focus, through much of the remainder of 1986, almost entirely on public works—undeniable in scale, aiming for audacity, his political line blown up to wide headlines. The first was a *Crack Is Wack* mural painted in late June in a handball court in East Harlem Park at East 128th Street, along the FDR Drive—its freestanding wall chosen by Haring to be visible to the thousands of motorists driving into Manhattan from the Bronx, Upstate New York, and New England. "Crack basically started in the Bronx, and anyone going downtown on Harlem Drive can see it," Haring said. The little park was unfenced, so no one usually played there, as their balls might land in the middle of the highway. The park was also just up the street from dozens of prospering crack houses. Haring's impulse for painting this mural was as much personal as public. One of his studio assistants, Benny Soto, a shy, soft-spoken, and bright twenty-one-year-old Puerto Rican man from the Bronx, had become addicted to crack. The drug was epidemic in the city that summer. "My friends said Keith'd drop me if he found out I was addicted to crack," Soto said. "He wouldn't want the bad publicity. They were completely wrong." Keith paid Benny's medical bills and got him into treatment. Having dropped from an already skinny 125 pounds to a mere 98, Benny was along that day to assist in the painting, as was Juan Rivera, who drove a rickety truck packed with paint cans, brushes, and a ladder. (In front of Harry's Paints in SoHo, Rivera managed to smash the truck into a parked car, the driver inside, creating a brouhaha of a delay.) By sunset, Haring had completed the fluorescent orange mural, having begun with its public service message, painted within black outlining, "Crack Is Wack," sharing a beat with the popular "Coke Is It" advertising slogan of the decade. He then added in symbols of doom, such as flying skulls, burning dollars, and a man hung by his ankles above an alligator's maw. On one side of the narrow handball wall, he signed his initials, and on the other, he wrote, "To Benny + NYC." Yet, as they packed up to leave, a police car ominously drove up. Wary of red tape, Haring had never secured permission for the project. He was arrested, and all three were hauled into a precinct station, where Haring was served with a summons to appear in court a month and a half later.

Haring's day in court took off as a cause célèbre. During the six weeks

in between, the mural had been adopted by the press as a standard visual for the important current story of crack addiction in New York City. NBC made a public service announcement using the mural as a background. Three days before the trial, the *New York Post* photographed Haring beside his mural, and the reporter was shocked when Keith revealed that he had a court date and was facing a possible year of jail time. When the story ran the next morning, Haring's phone began ringing with interview requests from every local TV news station, wanting a segment for their evening news, especially as Ronald and Nancy Reagan had given their "Just Say No" war on drugs address on national television the night before. For the first time, Haring found himself as a news story within the first five minutes of the top of the broadcast hour, rather than at the end as the subject of a lightweight art segment. Asked on *Channel 4 News* about facing prison time, Haring responded, "Riker's Island could use a paint job." He wound up with a modest twenty-five-dollar fine, yet within a week, someone from the neighborhood spray-painted over the mural a *pro*-crack message, "Crack Is It," leading to an invitation to Haring from the New York City Parks Department to please repaint the public landmark of a billboard. The first day of the repainting was rained out, and a photograph ran in the *New York Times* of parks commissioner Henry Stern holding an umbrella over the artist as he tried to paint. Because Haring worked spontaneously, the second version was unlike the first. It was two-sided, with a long horizontal skeleton above corpses on one side and a snake chasing a running figure on the other. The same month, he painted a *Life Is Fresh, Crack Is Wack* mural on the playground wall of P.S. 97 on the Lower East Side. Both works were mostly left untouched by graffiti, a sign of respect by the neighborhoods. "His wonderful 'Crack Is Wack' mural in Harlem, still unmarred by graffiti the last time I saw," art critic Peter Schjeldahl observed, "has a power of credibility not to be expected in any sort of culture hero, let alone a whiteboy artist from Pennsylvania."

During the spring of 1986, shortly before the first *Crack* mural, Haring had also been approached by Laurie Meadoff, from CityKids Foundation, an organization with its own youth board of directors, striving to help young people from diverse backgrounds become leaders in so-

cial change. "It was a cold call to Keith Haring to say, 'We at CityKids want to take a thousand kids from all over and do this project on what liberty means,'" Meadoff says of their plan to mark an upcoming centennial celebration of the Statue of Liberty. "Sure, come on over," Keith surprised her by saying. Their meeting led to an ambitious concept of a banner ten stories high with a drawing of the Statue of Liberty by Haring, filled in with pictures and writings to be done by kids bused to the Jacob K. Javits Convention Center from public high schools around the city, as well as from the United Nations School, the New York School for the Deaf, and Phoenix House. On the Sunday before, in five hours, Haring painted his black outline of Lady Liberty onto a two-ply nylon banner (with flaps and grommets, as on a ship's sail) laid out on the floor of the convention center. Meadoff panicked when she noticed Keith drawing a meandering torch arm, which she felt must be a mistake. "Don't worry," he said. "Liberty is wobbly." Over the next three days, three hundred kids a day—white, Black, Asian, and Hispanic— were given different Haring pins, a dog or a baby, and sent to workshops that would ready each of them to paint their square on the large banner. Music was provided by Herbie Hancock, Philip Glass, and the boy band New Kids on the Block. The banner was then transported to Battery Park City, where it was hoisted onto a building still under construction across the Hudson River from the Statue of Liberty and covered with a blue veil. On the day of the unveiling, July 2, Haring stepped out of a limo in jeans, sneakers, and a T-shirt painted with an American flag, describing himself to a reporter as "a dropout from the School of Visual Arts." At his side for most of the day was Zena Scharf, usually playing with his ear; and Yoko Ono, wearing wraparound sunglasses beneath a steel-gray sky. Ono described the spectacle as "a younger generation's fingerprint on freedom." The governor's wife, Matilda Cuomo, spoke, a choir of children sang "America the Beautiful," and the blue veil was dropped. "This was one of the best organizational feats that I have ever achieved in my life," Haring said.

With its rampant youth energy and politics situated somewhere between progressive and utopian, the CityKids Foundation was in and out of Haring's life from then on. At a dinner at the Odeon after the

unveiling of the banner, Laurie Meadoff found herself seated between Herbie Hancock, "a Buddhist and nonverbal, it comes out through his hands," and Haring, "who just listened." Yet, Meadoff recalls, "I'll never forget Keith turning to me at one moment and saying, 'Laurie, God has acres reserved for you in heaven.'" In October, Haring led an event, with CityKids and Benetton, unfurling the *CityKids Speak on Liberty* banner for Italian schoolchildren in the Rotonda della Besana in Milan. The next year, he collaborated with schoolchildren painting a wall in South Philadelphia for a CityKids *We the Youth* mural in honor of the bicentennial of the U.S. Constitution. Some of the kids of CityKids, too, were folded into the origami of Haring's personal life. "We met during the banner as I also helped doing production stuff," says Keyonn Sheppard, at the time a fifteen-year-old Black high school student from Brooklyn. "Some of us ran an errand over to his studio, and he said, 'Yo, eat pizza,' so we sat and ate pizza and watched him paint. It became kind of a thing from time to time." On another visit soon after, Kris Parker, the rapper known as KRS-One, stopped by to share with Haring his new music video. "We didn't get that Keith was this world-renowned dude," Sheppard says. "We got the fact that it's cool he tagged up the subways. So, I was like, 'Okay, why is KRS-One so excited to bring *you* his video??'" One night, Keith said, "We're gonna go to this party at the Palladium," and Keyonn found himself hanging out with Andy Warhol and Grace Jones at a birthday celebration for Mick Jagger. He also came to know Juan Rivera and went with him to a rehearsal for a Madonna concert. "If Keith was quiet, Juan was the personality," Sheppard says. "He was bubbly and vibrant, funny to be around, a comedian. His energy was real light. He was never clogging the space or in the way." Says Meadoff, "Juan was our go-to person. We went to Juan if we ever needed to talk to Keith or get an answer." Both Meadoff and Sheppard like referring to Keith as an "artivist," mixing his art and activism.

Haring had been able to make time for the unveiling of the CityKids banner in Milan only as he was already planning to be in Europe, in October, to paint a mural on a wall of the Jouets et Cie toy store in Paris and to create Grace Jones's voluminous skirt for her music video "I'm Not Perfect (But I'm Perfect for You)." (During production, Juan Ri-

vera stood beneath the thirty-foot-tall-by-sixty-foot-wide skirt, holding Jones up on a scaffold while she teasingly called down in her deep voice, "Juan, Juan!" She talked to him about how she *should've been a man . . . instead.*")

Most consequential for Haring was an invitation from the Checkpoint Charlie Museum in West Berlin, to paint the last of his sizable 1986 public works—a three-hundred-foot section of the Berlin Wall dividing West Berlin from East, a worldwide symbol of global strife and division. "Of course, I am interested," Haring said. And on a damp, gray fall morning, he appeared shortly after ten o'clock, thin, bespectacled, and wearing a baggy cotton sweatshirt and basketball shoes, and began applying black acrylic paint to a prepared yellow surface of the concrete wall. The event was pure political theater. "It was one of the wildest publicity scenes I ever witnessed," said Haring, who by then had witnessed many. At least as illegal as subway graffiti, painting the Berlin Wall, even on the West side, was considered a violation, as East Germany technically owned both sides and an adjacent strip of land. A U.S. Army helicopter hovered in the sky, and East German border guards peered over the wall with binoculars and telescopic lenses to photograph the scene, or even appeared around the side. West German citizens, police officers, and reporters from *Time, People,* the *New York Times,* the *International Herald Tribune,* and most major European newspapers gathered expectantly on the West side.

As he began to paint, Haring was warned by a West Berlin policeman using a megaphone that he had now entered East Berlin territory without a visa. Whenever East German guards at point-blank range looked as if they were about to arrest him, Haring would leap back onto official Western soil. "I have never dealt with the fear of being shot," he told *People* magazine. By late afternoon, he had completed his mural of a chain of human figures flowingly connected at hands and feet, rendered in the red, black, and yellow of the flags of both Germanies and representing the unity of all people against the idea of the wall—a healing image. Within days, though, his segment of wall had been covered over by local artists feeling they could do better or seeking notoriety. "I think Haring was so successful that other artists could not forgive him," the

sponsoring curator said. Keith was mostly unfazed by this pulverizing of his mural into fragments, as he sincerely believed in the magical properties of painting, especially painting done in a spirit of activism, as an enduring hedge against impermanence. "For me, the Berlin wall is the most symbolic wall that one can paint," Haring said at a press conference afterward. "It is a metaphor for other walls that exist in the mind, for instance, in South Africa, Nicaragua, and Belfast." His ambition for the reach of his artistic messages had clearly and confidently become more global.

IV

"In This Life"

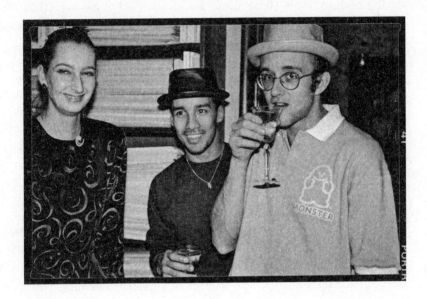

At the July 4 fireworks celebrations on the weekend of the un-veiling of the CityKids Statue of Liberty banner, Keith had been shocked to run into a friend from his earliest days in the city, Martin Burgoyne, looking pale and frail, a ghost of his former self. Younger than Keith, at twenty-four, Martin was a cherubic-looking man, tall, with curly blond hair and a sweet, kind, funny, smiley disposition. No one on the Lower East Side had an unkind word to say about him. "He's

really active, and really beautiful, and really vibrant," Haring said. Martin had attended art school at Pratt, earned his bona fides working as a bartender at Lucky Strike and Danceteria, and was now designing album covers for Warner Bros. Early on, he had been Madonna's East Village roommate, a backup dancer for her debut of "Everybody" at Danceteria, and he remained her close friend. For her wedding to Sean Penn, Burgoyne had invited Andy Warhol as his date. Martin confided in Keith of having been to a free clinic, where he was cleared of having AIDS. The nurses gave him vitamin B shots. Yet Keith's instincts, and closeness to Klaus Nomi and others who had died early on, told him otherwise: "When I looked at him, I saw death. It may partially have been the LSD I was on, but it was more than that."

Keith's instincts were correct. A month later, in August 1986, doctors informed Burgoyne that he was suffering from ARC, "AIDS-related complex," and in September, a benefit was held at the Pyramid Club on Avenue A, raising six thousand dollars for his medical and living expenses, with performances by Jean Caffeine, Wendy Wild, Lady Bunny, and John Sex and dancing to "Body Slam" and "Jungle Fever." Andy Warhol made two drawings of Burgoyne for the invitation. Martin did not dance, as he was feeling too weak and had lost more weight, but he happily greeted and hugged the more than five hundred friends who showed up, some joking about his new macrobiotic diet. The party was covered by the *New York Times* in an "About New York" column by William E. Geist titled "In the Face of a Plague, a Party," intended less to report on Burgoyne than to document the state of a downtown cultural scene in crisis. Steve Rubell said the importance of the party was to show that people could be in the same room as someone infected with the AIDS virus without contracting it. "We know many AIDS patients who have been deserted," he said, "treated like lepers by their own families." Madonna was observed speaking with Burgoyne "for a long time." Said Haring, "We have all been friends for years and years, since the days at Club 57 in the late 70s." Wrote Geist, "In a world of living up to the second, and staying up until all hours to do it, that is considered a long, long time ago." Yawning backstage at 2 a.m., Ann Magnuson said the truth was most people there hadn't been up that late in a long time.

The ending of the piece was meant to sound portentous: "By 4 a.m. the final act was over and the music had stopped. The party downtown seemed to be drawing to an end."

Burgoyne's descent was rapid. "Martin is one of my best friends at that point that gets sick," Haring said. Madonna sublet an apartment, with elevator, for him, around the corner from St. Vincent's Hospital, and took care of paying his bills and medical expenses. "I remember going there to visit Martin, and Madonna was lying in bed with him, holding him," says Kitty Brophy. "She was not afraid. This was back when AIDS could ruin someone's career. Claudia Summers took rounds helping him, and I did some stuff. During these illnesses, there were often women who would take on these roles, like angels." Keith stopped by regularly as the situation grew increasingly horrific. Martin's parents had come up from Florida to stay with their son, and Keith would call them every day from Lippincott, where he was working on sculptures for his upcoming show at Tony Shafrazi. The night before Thanksgiving, when he left town to visit his parents, he saw Martin, who was no longer able to speak. Martin's mother asked him to make a sign if he understood what Keith was saying. Martin raised his arm. Keith told him he loved him and kissed him goodbye. A few days later, Martin's parents called Keith to tell him that their son had died. "He died just when Madonna got back from L.A.," Haring said. "He held on until she got there. That was one of the hardest to watch, one of the first ones and one of the hardest." Madonna later wrote an emotional tribute to Martin: "In This Life." She sang of her best friend, dead at age twenty-three, "gone before he had his time," and ended with a prayer for the end of AIDS "in this lifetime." The ballad in a minor key became *the* statement of grief and heartbreak.

AIDS was no longer the private matter it had been in the early days, when there was no treatment and when a friend like Klaus Nomi could simply disappear into his apartment and not speak with anyone. The numbers were too staggering. By the fall of 1986, 27,000 Americans were already dead or dying of the disease. Young gay men in Manhattan would suffer a 50 percent mortality rate from the epidemic. (As Charles Kaiser points out in *The Gay Metropolis*, "By comparison, less

than three percent of the American soldiers who served in World War II died in or after battle.") Often heard was the truth voiced by clothes designer Katy K., in the *Times* piece on Burgoyne, "It's like a war is going on." A frozen panic was visible and palpable on the streets of the East and the West Village. The waiting rooms of doctors willing to treat AIDS patients were filling up with young men hooked up to IV bags on metal stands beside them, or breathing from oxygen tubes for pneumonia. To walk down the AIDS floor at St. Vincent's Hospital was to pass one crucifixion scene after another. Gay Pride marches now ended with a release of balloons over the city skyline as church bells tolled. Many of the same songs were sung at makeshift memorial services at the Friends' Meeting House, or at the Church of St. Luke in the Fields, such as Sondheim's "Good Thing Going" or, as at Martin Burgoyne's memorial at the Puck Building, "Over the Rainbow."

Keith Haring responded to Martin's illness and the closing in of AIDS by returning to writing. In the years between 1980 and 1986, his journal entries were spotty and sporadic, and there was a gap in the record of his life and art. Just a few days after first seeing Burgoyne at the celebration for the CityKids banner, he had traveled to Montreux, where he was attending the jazz festival, as he and Warhol together had designed its poster of a stave and musical notes. While in Switzerland, Haring bought a little orange ringed notebook, opened to a lined page, and dated the first entry July 7: "It has been such a long time since I last tried to write down anything about what has happened (is happening) in my life. It has been moving so quickly that the only record is airplane tickets and articles in magazines from the various trips and exhibitions. Someday I suppose these will constitute my biography . . . Now, I regret that I didn't continue to write constantly." Later the same evening, he picked up his pen once more to identify the disturbing visit with Martin as the trigger for his renewed need to record the "big blur" of his daily life and to make another mark in another medium: "I keep thinking that the main reason I am writing is fear of death. I think I finally realize the importance of being alive."

Martin Burgoyne's memorial service was held in December, and in the weeks following, Haring turned his efforts to his gallery show at

Shafrazi, opening in less than a month. As always, he left himself scant time—his painting himself into a corner at SVA eight years earlier an apt metaphor for this way of working. And, as always, he wished to introduce some art in a new medium and some art that was not a repeat of anything shown before. He included a few small steel and aluminum sculptures produced at Lippincott that were simple, light, and brightly colored figures and shapes in cheerful Haring good humor. Most successful was a series of large, scarified, three-dimensional primitive masks taking their cues from African tribal art. They were of Grace Jones; ritualized faces with long mouths or six eyes; and an "Egg Head for Picasso." The gamble was a series of red, yellow, and blue paintings—"Like a year's worth of painting," he said—completed in one week before the opening. As with the *Ten Commandments* murals, he worked on these different-size rectangular canvases all at once, on one long wall of his studio, priming them in white; systematically applying primary reds, yellows, and blues as abstract bursts and random background shapes; and as a final step, superimposing black oil paint lines.

The red-yellow-blue works did not snap into place as quickly identifiable Harings. The black lines were not all solid and graphic, but often thinner, disappearing into Rorschach blots of diffuse color stains. As he was spending more time in Europe, art historical references were surfacing in ways not so apparent since his art school days in Pittsburgh. Even he sounded surprised to step back and see "some really even DeKooning-looking kind of drawings, really different." The third of the series of at least twenty-nine canvases was an outright homage to Alechinsky and the CoBrA artists. (In 1984, Haring had visited Alechinsky's studio in Bougival and presented this seminal hero of his art with a signed T-shirt. Alechinsky, in turn, recalled on that day "dedicating to K.H. a Chinese ink work.") Breathing through the works was the spirit, palette, and overlaid lines of the late style of Fernand Léger, the populist, Communist postwar French artist who dreamed of making art for the masses. "The point is that though I may have borrowed or stolen (if you wish) his technique of color with black lines overlaid (also used by Miró), I've made it my own way," Haring explained, as he tired of questions about the resemblance. "I do not, as Léger, work out the color/line

relationship with pencil and work and rework it until it is satisfactory . . . I paint spontaneously the color shapes and then directly apply the black lines, also spontaneously, in relation to the color shapes and often inspired by them."

The opening of *Keith Haring: Sculpture and Painting* on January 17, 1987, was reliably crowded. "Keith's show was interesting," Warhol said; "the work looked different, it was as if he wanted to have a lot of things to show so he worked faster, it's not so planned-looking. Yoko and her Sam were there but Sean wasn't . . . I'm still jealous that Sean likes Keith better than me." Other kids were there—Kermit and Lisa Oswald brought their six-month-old daughter, Lily, as babies were more than welcome at Haring openings. Tseng Kwong Chi snapped pictures of everyone with his Hasselblad camera. Rene Ricard, in a light-gray suit, silver bow tie, and a Civil War cap he liked to wear, was clenching his teeth in a smile or glower, as Keith stood by him in his black leather jacket trying to gauge his response. Drinking flutes of Kristal were Ann Magnuson, Joey Arias, Steve Rubell, Palladium doorman Haoui Montaug, and Kenny Scharf. Annie Leibovitz arrived with the photographer Gianfranco Gorgoni. Leibowitz had recently made a lasting portrait of Haring that followed the logic of his body painting to its necessary conclusion of painting his own body. ("He painted his upper body in about five minutes," Leibovitz said. "When he came out of the dressing room, he was wearing white painters' pants, but it just seemed obvious to both of us at that point that he should paint the rest of him . . . It's hard to paint yourself. Keith only did the front. I loved the way he painted his penis. It was so witty, with an elongated line.") Afterward at Mr. Chow, the tables were set with white roses and freesias for a family-style dinner. Al Haring enjoyed showing off his chopstick skills—learned in Japan—on his Peking duck and dumplings to his one-year-old granddaughter, Jenna, Kay's daughter. The elegant Tina Chow bent over Keith's mother to help her disentangle her lobster from its shell.

Yet Keith was feeling somewhat distant from the celebration. While his mission to date had been for each show to top the last, he had an uneasy sense that this show was not his best. "Compared to the previous three, it was not the highlight," he said. "The critics responded

the same way. It was uneven. It was the beginning of another idea, like in the paintings in the early eighties, but it hadn't been formulated." Keith was always diligent about clipping reviews and press around his shows, yet a hole exists in his records around this 1987 Shafrazi show. Impossible for him to miss, though, would have been Roberta Smith's review in the *New York Times*, which opened bluntly—"Keith Haring's exhibition . . . shows us an artist in transition, but painfully so"—and went on to wave a matador's cape in his face: "Like Peter Max, Mr. Haring is one of the best designer-illustrators of his generation." Yet her meditation on the paintings was not so different from Haring's own assessment and showed a knowledge of the arc of his career: "The new paintings are considerably less confident, but are not without a certain courage. They show Mr. Haring refusing to rely on any of his old standbys, and searching for a new kind of mark, a different, more painterly, drawing style. Many possibilities are considered, but the artist fails to come up with a convincing alternative. Still, it is rather amazing to see him try so hard, so publicly." The artists still truly capturing the attention of the press and the art establishment as defining the decade were the Mary Boone painters. Reviewing an exhibition of David Salle's work that same month at the Whitney—just a year after the museum's solo show of Eric Fischl—Roberta Smith wrote of Salle's sharply smart paintings, by turns cinematic, wry, yet optically lush: "For American art of the 1980's, Salle painting stands out as one of its great and most paradigmatic achievements."

A further weight on Keith's spirit that night was the absence of the one guest he most relied on and most wished to see—Bobby Breslau. During the lead-up to the show, Breslau had been coughing and wheezing, finding the steps to the studio difficult to climb, and he was developing a lung problem. Shortly after the installation of the show, following an emergency visit, he was admitted to Bellevue Hospital, where he was diagnosed as having pneumocystis, an opportunistic infection that is often a marker of the AIDS virus. In the spring of 1986, a new drug, AZT, was announced that appeared to lead to fewer fevers and infections, but the expensive drug was not yet being widely prescribed, and doctors and hospitals were still mostly left treating the symptoms of the

disease—body sores, virulent pneumonia, blindness, dementia, violent diarrhea. Within two weeks, on January 30, Breslau was dead at the age of forty-four. In a hastily drawn last will and testament, Keith Haring and Hector Torres were appointed as coexecutors. Keith and Julia vowed they would never throw another Party of Life, as Bobby's élan had been so essential to those birthday celebrations. While Breslau, in his role in the Pop Shop, was irreplaceable, a series of managers filled the position over the next two decades. Three days following his death, Keith and Julia put together a memorial in the studio. Keith was feeling even more unmoored in his art by the loss of Breslau's smart advice. "That was like pulling the rug out from under me," he later told *Rolling Stone* magazine. "It was like being a little bird thrown out of a nest. *You've got to do it on your own now. And you've got to do it in a way that's going to live up to what he would have expected.*" Later, Haring wrote in his journal, "I'm not really scared of AIDS. Not for myself. I'm scared of having to watch more people die in front of me. Watching Martin Burgoyne or Bobby die was pure agony."

Keith had never been so eager to get out of town. As soon as the show was down at Shafrazi Gallery, on February 15, he and Juan were on a plane to Brazil to visit Kenny Scharf and his family. After a couple of weeks, Haring made his usual long road trip to Ilhéus to phone his gallery, as Kenny's house had neither electricity nor a telephone. First stopping by Tereza's parents' home in town, he sat browsing through books, including Andy Warhol's *America*, with its photographs from the past of Keith skinny-dipping at Andy's house in Montauk, Zena as a baby, Madonna at a dinner at Mr. Chow following the premiere of Bill T. Jones's *Secret Pastures* at the Brooklyn Academy of Music. When he got around to phoning the gallery, Tony informed him that Warhol had died nearly a week and a half earlier of complications following a routine gallbladder operation at New York Hospital. All of New York City had awakened to the news: The headline of the *Daily News* that Monday morning was "Pop Art's King Dies." The *Village Voice* followed with "Is God Dead?" In far-off Ilhéus, a displaced Haring felt numb disbelief, a dull shock compounded by the recent loss of his two other close friends.

On the drive back to the beach, Keith kept recalling his last phone

conversation with Warhol the day before he left for Brazil. Such phone calls were by then a regular, nearly daily occurrence between the two. "I always described their relationship as being like two old ladies," Kermit Oswald says. "They shared every bit of gossip worth sharing. They probably filled each other in on the blanks each had. They made that grapevine a vital part of their practice." Keith had imbued the conversation with something "surreal, mystical," perhaps simply because he had woken Warhol up from a nap and found him in a "weird state of mind." They talked about projects that Warhol, very much in his prime at fifty-eight years old, was working on. For a curtain he was creating for the New York City Ballet, he wished to do images of missing children, while the ballet company suggested flowers. Haring thought missing children the perfect choice. Warhol offered to do a new portrait of Keith with his new Juan, as the portrait with the old Juan was now awkward. They had been putting off the sitting but made more definite plans. They also discussed an MTV spot they would be collaborating on. Warhol's last mention of Haring in his diary—"Keith is going to South America for the winter." Whatever plans Keith had for an extended stay, though, were abruptly cut short. "Keith comes home with the news," Scharf says. "We were in shock. That night, we made a big bonfire on the beach. He returned to New York right away. I came back in time for the funeral about a month later."

When Keith boarded his plane in Rio, he picked up *Time* magazine, as he had not seen or heard any coverage of the death of Warhol in the secluded beach town. He leafed through the pages, searching for the inevitable story. On the last page, he found the piece he was looking for, but as he read the title, "A Caterer of Repetition and Glut: 1928–1987," and its byline, Robert Hughes, his heart sank. Confining all his compliments to Warhol's sixties work, Hughes opined that Warhol the artist truly "died 19 years ago, not last week." Hughes insulted Warhol's "bathetic collaborations with junior burnouts like Jean-Michel Basquiat" and made a scrambled comparison with Roy Cohn, legal counsel to Senator Joe McCarthy and Donald Trump—Cohn for degrading the legal profession with his "forensic brilliance" as Warhol had done to American culture. The same day as his plane landed, Keith wrote an irate letter to Henry

Grunwald, editor in chief of *Time*, on the anti-eulogy he viewed as a setup:

Andy Warhol was the first modern artist who began to dismantle and explain the phenomena of the modern world. He blurred the boundaries between art and life in a way that other artists always dreamed of. He has inspired generations of artists with his philosophy and his work. Not only was he commissioned to do the cover of your magazine, he was the subject of a cover story himself. The magnitude of his contribution is still not fully understood. Robert Hughes's tasteless summation was hardly a fitting eulogy. I am sure you were aware, as I was, of the kind of depressingly witty article he would write. So why Robert Hughes?

Haring's closing was not rhetorical, lightly raising a dark topic increasingly personal for him:

I have only one request. If I ever have the honor of being eulogized in TIME magazine, I beg of you, please give the assignment to someone else.

"I return to New York, and there's a memorial for Andy at St. Patrick's Cathedral on April Fool's Day—April 1, 1987," Haring recalled. "Thousands of people show up. Andy's loss really hits me. You see, whatever I've done would not have been possible without Andy. Had Andy not broken the concept of what art is supposed to be, I just wouldn't have been able to exist." The service at St. Patrick's was a snapshot of more than two thousand of the most significant names and faces—artists, writers, socialites, and celebrities in the cultural life of New York City and beyond as well as surviving members of the original Factory. Sadly, Warhol was not alive to properly fix the occasion for posterity in the time capsule of his *Diaries*, a prescient historical record that has gained import with the passing decades, as has Warhol's art—just as Haring predicted. Yoko Ono and art historian John Richardson delivered eulogies, and a tape of Lou Reed's voice was played. Haring was of

course present, yet he barely mentioned the formal ceremony again, as his connection with Warhol was personal and seemed far away from the stone walls of the cathedral. In a note of condolence to Paige Powell, he came closest to touching on his sense of Andy and Paige's special relationship. The written portrait he drew of Warhol was radically unlike Hughes's and—a testament to Warhol as an enigmatic mirror—sounded at times more like Haring himself. Perhaps, though, the similarities were somewhat accurate. "Only two people remind me so much of Andy, his voice, the way he would speak succinctly, his demeanor, mannerisms," says Paige Powell, "Keith Haring and Gus Van Sant":

> Paige,
>
> I just wanted to express my sympathy for the loss of our friend. I know you loved Andy as much as I did. I returned from Brazil a few days ago. Somehow, the impact of New York City without Andy is quite different. It's difficult to imagine NYC without him. I was glad Andy was really at peace with himself, though. I think the times you spent with him and his interest in health, vitamins, crystals, God, etc., were testament to his inner peace. Remember the prints he made for Christmas a few years ago? "The Only Way Out Is In"?
>
> I will always remember him, as you will, as one of the kindest, sweetest, considerate and caring individuals I have ever met. I only met Andy 5 years ago, but the impact of his friendship and encouragement has changed my life. It was an honor to have known him.
>
> I feel a particular sadness for you because I know you spent a lot of time with Andy and will miss him dearly. But, like we learned from Andy's matter-of-fact attitude toward death, Life goes on. I hope his loss will bring people even closer together.
>
> Let's try to make it better.
>
> with Love and respect,
>
> —Keith

Andy Warhol not only changed Haring's life. He inhabited the self-referential universe of his drawings. He infiltrated his imagination. In

1985, Haring had debuted "Andy Mouse" in a painting of six pink Andy Mice in shades with black and yellow dollar signs against a dollar-bill-green background, and then in a series of four silk screen prints, published in Amsterdam by George Mulder and cosigned by Warhol. As a fitting illustration for *Money* magazine, he had sketched, in black felt-tip pen, Andy Mouse as its own currency, a thousand-dollar bill with his spiky-wigged face, printed by "The United States of Art—1986." Haring had been copying the ur–Mickey Mouse since he was a boy, and those markedly astonished eyeballs live on in his three-eyed faces. Pop artists had iconized Mickey. In 1961, Warhol made a silk screen of "Mickey Mouse" for his *Myths* portfolio. The same year, Lichtenstein painted *Look Mickey*. Haring's own Andy Mouse was a hybrid of the two artists he considered titans (along with Picasso) of the twentieth century—Disney and Warhol. As he attempted to find ways in his work to splice these two strains, the cartoon was a sort of self-portrait, too. (The same year, he made a six-by-six-inch silk screen *Self Portrait*, like "an over-size postage stamp,"of himself as a sphinx, his own face atop the body of a clawed lion, another hybrid creature.) With eyes concealed by tinted celebrity eyewear (the opposite of Mickey's welcoming gaze) and a hands-on-hips stance, the Andy Mouse figure is a touch unnerving. Its wallpaper of dollar bills might have been construed as sarcastic in the hands of another artist. Yet, unlike for Warhol, irony was not Haring's métier. "It's treating him like he was part of American culture," Haring explained; "like Mickey Mouse was."

Like Basquiat, Haring had kept his aesthetic distance from Warhol. Their art could be as different as alike. Warhol treated the bumptious commercialism of Brillo boxes or Campbell's Soup cans with deadpan seriousness. Haring took deadly serious topics, such as nuclear war, apartheid, and safe sex, and illustrated them with bright cartoons as if they belonged in a children's picture book. Warhol adopted an almost camp attitude toward popular culture, while Haring, born in a different generation, was unabashedly enamored of television, Smurfs, and Jolly Green Giants. Warhol was an observer, and Haring an activist. "Even Andy Warhol, who I am often compared to," Keith wrote in his newly

revived journal, "is in fact a very, very different kind of artist." Yet he unreservedly claimed Warhol as one of his "founding fathers."

I feel like I have a responsibility to try to continue the things that he inspired and encouraged. There isn't anyone else who can pay homage the way that I can. At least, nobody I know of now. There has to be new artists coming up somewhere, but right now there is nobody. It is not an easy venture and it will be even more difficult without Andy or Bobby, but it is worth whatever risk is involved and it is an honorable undertaking, whether it is understood now or not.

Later in April, a few weeks after Warhol's memorial service, Keith left New York City for Europe, where he remained, to his own surprise, for nearly three months, the longest he had been away since first moving to the city nine years earlier. He was having trouble imagining work life both in the studio and at the Pop Shop without Bobby Breslau's strong opinions and encouragement and life in New York City period without Andy Warhol on the other end of the line. "People are disappearing," he said of the general situation. "Andy left us like he used to leave parties," he told *Details* magazine. "He'd slip out, unnoticed." Keith's break was likewise "a French leave," and not especially planned. He was mostly responding to events moving on the ground, as he was finding his work more accepted as fine art in the galleries and museums of Europe—not entirely, but more so than in the United States. He was fielding offers for exhibitions in Germany, the Netherlands, Belgium, Italy, and France. "These are the countries that first bought Pop Art in a very big way—even before America," said German dealer Hans Mayer, who signed a contract with Haring and Shafrazi for thirty-six new outdoor sculptures and would show Haring's paintings and sculptures in his prominent gallery in Düsseldorf in 1988.

Keith decamped to Europe in his usual meticulously chaotic fashion. Arriving at the international terminal at JFK stoned, after a limo ride

with his assistant Adolfo Arena, smoking pot all the way, he boarded the plane with his traveling companions Juan Rivera and Tseng Kwong Chi. He immediately took two Valiums and then slept most of the way to Paris. Arriving in the morning, he took a taxi into town to drop off an unpainted canvas tarp at the Centre Pompidou, to be finished by him for a tenth-anniversary exhibition of painters who had risen over the last ten years; and to take a meeting at Hôpital Necker, a children's hospital where he planned to do a mural on an exterior concrete stairwell about ten stories high. Some of the hospital directors were nervous because Haring worked without any preliminary plans and the tower was highly visible, so he had rushed over to draw a quick sketch for them and to explain his improvisatory technique to allay their fears. He then dropped off luggage at La Louisiane, a modest hotel in the Sixth Arrondissement, where they would be staying. Like the Chelsea Hotel, La Louisiane compensated for its lack of comfort with a colorful history. (Salvador Dalí had lived there during the Second World War, Billie Holliday had stayed there, Lucian Freud had painted there, and so on.) He then met up again with Juan and Kwong Chi, and all three caught a taxi back to the airport for a 3 p.m. flight to Düsseldorf, where Hans Mayer met them at the airport to drive Keith for a 5 p.m. meeting at a factory in Essen to approve cutouts of a maquette preliminary model for his *Red Dog for Landois* sculpture. "Looks OK," Keith said. He had been on two flights, in three countries, and in meetings at a museum, a hospital, and a factory, all while being out of New York for less than a day.

The Necker project meant the most to him. In keeping with his practice of lining up public service projects—gifts freely given—while exhibiting in galleries or museums in various cities, he had asked his French dealer, Daniel Templon, and the directors of "the Beaubourg" (the more widely used name for the Centre Georges Pompidou) to find a school or hospital in need. They had approached Hôpital Necker, one of the oldest and most famous pediatric hospitals in France, to arrange for this permanent outdoor mural. Haring's wish was simple: "I painted it for the enjoyment of the sick children in this hospital now, and in the future." Yet he was also calculating the statement he wanted to make in Paris about his life's work. The sizable canvas tarp he painted on-site for

the museum and dedicated to Brion Gysin was successful—the drooping gold eyes and affable smile of the crimson red devil dominating the canvas with his long Pinocchio penis nose vaguely resembled Gysin. Yet Haring also wished to be represented by a public intervention "more consistent with what my contribution has been to the art of the last ten years." Juan Rivera was enlisted as artist's assistant in a project that proved daunting. They painted the outdoor stairwell's concrete surface while standing on a railed platform hung by a steel cable from a crane, a mattress affixed to one side to prevent cracking when the platform banged against the concrete. The weather did not cooperate, as most days were windy, or rainy, or cold, or all three. The mural's concept basically followed from the "red-yellow-blue" paintings. Haring's works often bled into one another. He was always painting in the present tense. This time, he brushed the shape of a yellow or red cloud of color, and Juan filled in with a roller. The all-important last day—when Haring did the black lines, the defining drawing of figures seeming to climb the tower, or swim upstream in a vertical Berlin Wall composition—was the most unpleasant, with both men bundled in hooded sweatshirts and gloves against the cold and the crane operator exasperated. Keith added final touches at eight at night, as a light drizzle began, but not enough rain to cause the black paint to run.

As in New York City, the intensity of Haring's work agenda in Paris was matched only by the tempo of his social life. Midweek during the painting of the outdoor mural, he attended a dinner given at La Coupole, the popular art deco brasserie in Montparnasse where Americans in Paris, especially if involved in art or fashion, could count on running into someone they knew. The occasion was the opening of a show by the American artist James Rosenquist at Haring's own gallery, Galerie Daniel Templon. Rosenquist and Haring were seated across from each other, and because Rosenquist had borrowed techniques, brushwork, and imagery learned as a commercial billboard painter high above Times Square in his pop-identified, sometimes billboard-size canvases, and because Haring was working on the Necker mural, the two had much to discuss. "He has great stories of sign-painting days when he was working in NYC in the sixties," Haring wrote of their shop talk. "It makes my

mural sound small. Talking about 40-foot O's." The next day, Rosenquist stopped by the Necker tower to watch Haring paint. "Jim came back to the hotel blown away," recalls Mimi Thompson, who was on her honeymoon with Rosenquist in Rome and Paris. "He was just stunned that Keith could go up there and draw that image without everything being figured out and blown up in advance. Jim would do a hundred abstract paintings, and they would connect. Then he would reconnect them if something wasn't working. It was fun to see Jim so impressed with someone from the younger generation. He would often say, 'Aw, come on . . .' about some new work. But Keith, to him, was the authentic real thing."

The first phone call Keith made when he landed in the city had been to the painter George Condo. During this springtime in Paris, Haring picked up as well on an artistic friendship the two had begun in 1983 in New York City, when both were living on the far grimier Lower East Side and they would see each other nearly every week and paint in each other's studios. "I saw Keith maybe one day a week, and that day was the most important day of the week for me," Condo said of their New York period circa 1985. He had been fascinated by the spontaneous nature of Haring's "one-take idea of his art," especially given his own, more painterly wanderings through surreal mindscapes and goofy, impastoed cartoonery seeming to materialize unforced and full-blown from his riled daydreams. Condo's *Dancing to Miles*, an homage to the free-jazz method of Miles Davis as Condo riffed on the art historical styles of Picasso, Cézanne, Chardin, and de Kooning, was painted in Haring's studio on lower Broadway and shown in the 1987 Whitney Biennial. One day, Keith invited Andy Warhol to stop by the studio to meet Condo while he was painting. (Both Warhol and Haring had each bought four or five Condo paintings at a show in the early eighties at the Anderson Theater Gallery, and Condo had worked briefly for Warhol's printer Rupert Jasen Smith, applying diamond dust to his *Myths* series.) Condo was nervous, yet Warhol sprang immediately into action as a fan, fast-snapping pictures of him and the big painting he was working on as they chatted.

"What do you do, you just think of things and then you go up and paint them?" Warhol asked with faux innocence. "Is it that easy?"

"Yeah," answered Condo.

"That's great!" Warhol exclaimed.

Keith enjoyed the camaraderie of working closely with an artist buddy, as with Kermit, in his studio tucked over the garage in Kutztown; or Kenny, in their shared, disheveled Times Square loft. In Europe, Condo became Haring's prime artist buddy, a timely companion for him, as he was growing more interested again in the painterly traditions of modern European art, and Condo was the artist to emerge from the East Village scene most strikingly infatuated by those traditions, hence his loose expatriation to Paris. "His stylistic needle was stuck, as it still is, in circa–World War II Cubist-Surrealist mixology à la Picasso, Arshile Gorky, Wifredo Lam, et al.," Peter Schjeldahl wrote in the *Voice*. "Condo has trained his wrist to 'do' the mode of Picasso's 1930 'Bathers' and Guernica and also to render, with professional fluency, animation-ready versions of a pup dog apparently morphing into Yosemite Sam. Wacky rules." For Haring, Condo's pictorial free-verse brushstrokes could do no wrong. Of a show of Condo's that he had just seen in Munich, he wrote that the exhibition was "quite incredible and very *George*! He's still my favorite painter, with, of course, Jean-Michel Basquiat, still the [crown] of art . . ." Condo could be just as excitable when speaking of Haring's work. "Keith was able to plug into a free-spirited kind of *out* . . . So he expressed that freedom in his paintings . . . just the way the paint itself sat on the canvas! It was fresh and untouched in the way we admired it with Andy Warhol."

"He worked in my studio on the Île Saint-Louis," Condo recalled of their Paris times together. "He worked on the big mural for the Hôpital Necker–Enfants Malades and he was just on automatic pilot. I remember we made huge brushes together in my Paris apartment. We literally taped them onto a broomstick. We had so much fun in those days! He was incredibly systematic and inventive at the same time." Condo was also aware of the maneuvers in his paintings that Haring was wishing to learn to assimilate into his own: "Keith, after seeing my Picasso-esque works from the early 80s, went through a phase of his own Picasso-esque works. So I would say yes, we did influence each other." On this trip, they collaborated on two paintings and four

"box-top collaborations." "We took the box tops from a men's luxury clothing store called Sulka," says Condo, "flattened them out and did pencil drawings on them." They also simply hung out. One evening, Keith and Juan went to George's house; watched Keith's favorite horror movie, *The Shining*, on video; and then Keith and George did coke and painted. They rewatched *The Shining* on two other occasions. On another night, Keith and Juan and George and his girlfriend, Maria Nieves Martell, otherwise known as "Mabe"—the subject of portraits by Condo—went to Le Grand Rex for a Beastie Boys/Run-D.M.C. concert. Keith used his backstage pass to talk to both bands, and they all signed his jacket. (Keith didn't jot his thoughts in a single diaristic volume but picked up notebooks at various airport stationery shops. Pasted onto the cover of his red marbleized Europe 1987 notebook was this prized backstage pass, a memento of a "great show.")

A most inspired introduction was made by Condo when he brought Keith together with Claude and Sydney Picasso and their six-year-old son, Jasmin. Claude was the son of Pablo Picasso and French painter Françoise Gilot and the older brother of Paloma Picasso. Sydney, his wife, was American, and Claude knew New York City well, as he had attended the Actors Studio and worked as a photojournalist and an assistant to Richard Avedon before returning to Paris after his father's death in 1973 to manage the legal complications of the Picasso estate. Theirs quickly became the first among a few of Keith's adopted European families. As the Picassos lived very close to the Necker, Keith and Juan would come over almost every night after painting to share spicy meatballs out of their refrigerator, or they would all go out to dine together. Of course, Jasmin and Keith were instantly best friends and spent hours playing drawing games together while Keith created the kind of magical world around them that was his specialty. Of one dinner at a restaurant, he recorded ". . . drawing with Jasmin the whole dinner. He's really incredible, maybe he's got some of his grandfather's talent." Haring was undeniably entranced by such familial closeness to the Picasso legacy and to many works he had never seen by the man whom he considered "endless" in his progress and evolution as an artist: "It must be incredible to eat,

sleep, watch TV, etc., around these paintings. I guess the family always gets the best work."

One inheritance left for Claude Picasso was a door his father had painted. When the family moved into the apartment, they installed the door within a wall to function as a working door between two rooms, and then decided to commission contemporary artists, including George Condo, to paint other doors in the apartment. They asked Keith if he would paint the door to Jasmin's bedroom, a work Haring happily completed in less than three hours. "The way Keith painted that door reminded me very much of the way my father would work," Claude Picasso said. "They have similar energies. In painting Jasmin's door, Keith attacked the problem head on, just as my father would have done. I mean, my father would look at a blank canvas, go up to it, then start painting without stopping. When he stepped back, the painting would be finished. And that's just how Keith approached Jasmin's door. He just stayed close, close to the door, painting it from top to bottom—bending on his knees, and never once stepping back to see how it looked. Only after he had covered the entire door did he step back, and that's when the door was finished and became a marvelous painting." Claude Picasso's high praise would have been head-spinning for Keith, who, when asked by an interviewer on French television a few years later, "If you weren't Keith Haring what painter might you want to be?" responded, "The obvious answer is Picasso, right? Every painter wants to be Picasso. But if it wasn't that, then I guess Andy."

As there was to be no Party of Life for Keith's twenty-ninth birthday, a Parisian version needed to be found. Julia Gruen, whose first assignment had been to help plan the first Party of Life, flew to Paris, while the mural was still within days of being finished, to help plan a special birthday celebration at Le Train Bleu, a spacious late-nineteenth-century Belle Époque confection of a restaurant located in the Gare de Lyon, with elaborate gildings and frescos of the landscapes of different parts of France. With impossibly high ceilings, red velvet drapes, extravagant chandeliers, big booths lining the walls, and long tables set with very white napery, Le Train Bleu was far more elegant, and staid, than

Paradise Garage or the Palladium. "Lots of rococo glitz," as Haring put it. "Very French!" Keith had stopped by earlier in the afternoon to draw with frosting twenty-nine crawling babies and sign (as if on a canvas) in dark chocolate icing his birthday sheet cake. High on hashish "(a mistake)," he found the pastry chef, with his rosy cheeks and shy demeanor, extremely cute and tried to convince Kwong Chi to try his luck—to no avail. Among the invited guests that evening: Juan, Julia, George Condo, Jim Rosenquist and Mimi Thompson, painter James Brown, Donald Baechler, Daniel Templon, Andrée Putman, and Bruno Schmidt. Rosenquist arose sometime late in the festivities to recite a clever limerick of a toast he had composed for Haring, mangled by Keith in his remembering into "There once was an artist named haring, whose line was never wearing, and also daring and also intent on sharing."

During the same week, Keith was also traveling back and forth to Munich, where he was working on a carousel, amusement parks having long been a dream space for him. The amusement park project, *Luna Luna*, was the brainchild of the Viennese artist André Heller, who envisioned artists re-creating the games and rides of a traditional carnival in a "traveling museum of modern art." At least in the power of the thirty-two artists who signed on, *Luna Luna* was a succés fou. Salvador Dalí designed a mirrored fun house; Georg Baselitz, a haunted ghost house; Roy Lichtenstein, a glass labyrinth with clear tones piped in by composer Philip Glass; Kenny Scharf, a revamped 1930s dizzying carousel where riders were suspended in swinging seats; Basquiat, a Ferris wheel revolving around a panel painted with a baboon's rear end. These moving pieces were assembled at different locales. Haring had worked in a small town outside Munich with a family of carousel restorers whom he enjoyed because their yard was filled with spare parts for dragon's heads, giants, and clowns. His contribution was a fanciful merry-go-round with fiberglass seats resembling the metal sculptures he was making at the time, yellow walls, and a bluish-violet canopy festooned with his ten-year-old cartoons. All these rides were then installed in a two-hundred-thousand-square-foot temporary amusement park in Hamburg for a June 5 opening. The opening was rained out, but photographs preserved the event, and Haring remained enthusiastic. "I remember that was

something that made him light up," Fab 5 Freddy said of pictures Haring showed him. "'Yo, I did a ride! That's cool. Know what I mean?'"

Keith then flew directly from the opening in Hamburg, where Gianfranco Gorgoni had been taking a raft of photos of him for a spread in *Life* magazine, to Antwerp, where an exhibition of collage drawings was opening at Gallery 121, one of his favorite exhibition spaces in Europe. The opening was frenzied, and all the works in the show were sold. Belgium, Keith was sensing, was turning out to be one of the more supportive countries for his work, from both the people on the street and the collectors. As the home of two leading painters in the surrealist tradition, René Magritte and Paul Delvaux, the tiny yet densely populated nation on the North Sea, one of the Low Countries, was home to several serious collections of surrealist art. Though Haring was not painting dream figments or archetypes from the subconscious in the surrealist manner, the "out" quality that George Condo admired in his work, along with Haring's pop sensibility—Condo was sometimes labeled a "neo-surrealist"—provided some context for understanding his work. Tony Shafrazi was also helpful in developing relationships. "Tony had very good contacts in Europe, particularly his friend from Antwerp, Ara Arslanian, who was a backer of his gallery," Jeffrey Deitch says. "He was a prominent diamond dealer and brought in his friends from Belgium. Right away there were collectors from Europe, particularly from Belgium. Then the Japanese got onto him. Within a few years, Keith's market was global—not global as it is now, but global, then, really consisting of America and Japan, with a few Western European countries." Among the most avid collectors of his work were two young Belgians—Ara Arslanian's cousin Viken and David Neirings, a nephew of the gallerist Jenny Vandriessche, who, at only fourteen, used his allowance to buy catalogs, posters, or anything small signed by Haring. "Funny," Haring wrote of Viken and David, "that my two biggest fans in the world both live in Belgium." "Once, when we were in Antwerp, we had dinner someplace," recalls Viken Arslanian, who was twenty at the time. "Keith always had markers in his jacket. He was sitting next to me. We had taken my father's car, a Mercedes 500SEL. He started drawing on the leather on the side. At one point, he stopped, looked at me, and said, of my father, Haig,

'Oh, he's not going to be angry with me, is he? I'll write, "For Haig."' He felt then less reason for my father to become mad."

The receptivity to his work in Belgium was confirmed when Keith was invited by the painter and important art collector Roger Nellens to have an exhibition at a casino owned by him and his brother Jacques in Knokke-le-Zoute, a beach resort town between Amsterdam and Dunkirk, close to the border of the Netherlands, described by art scholar Robert Farris Thompson as "Palm Beach with a Flemish accent." Nellens's father, Gustave, had begun the tradition of art shows at the casino in 1950, with an exhibition of Picasso, followed by exhibitions by Matisse, de Chirico, Max Ernst, Joan Miró, Dalí, and Balthus. In 1953, Nellens *pére* invited René Magritte, the surrealist painter famously of green apples sporting bowler hats, or doves with clouds for wings, to decorate the gaming room with a vast cycle of panoramic murals, *Le Domaine Enchanté*. When their father died, the Nellens brothers curated their own exhibitions, of Niki de Saint Phalle, in 1985; and Jean Tinguely, in 1986. The circle was unbroken when Roger Nellens asked Tinguely, "How can I top this?" and Tinguely immediately answered, "Why don't you ask Keith Haring?" Said Nellens, "I must confess that I didn't know Haring's name at the time. Then—and I'll never forget this—Jean went into a pantomime of Keith drawing on a wall—he scurried around doing his Keith imitation and he was saying, 'Keith will make drawings everywhere, everywhere—even on the chandeliers!'"

While he was preparing for the show at the casino, Keith, with Juan, spent nearly a month as the guest of the Nellens family in their home in Knokke—the only of many homes and hotels the itinerant artist was moving through that he would later warmly record a return to as "home again." Roger Nellens and his wife, Monique, lived among a pack of hounds skilled at boar hunting, a flock of stuffed Lalanne sheep in the living room, and two stone sheep on the lawn. Rounding out the clan, and making them especially welcome as an adoptive family for Keith, was their seventeen-year-old son, Xavier, who added to the confusion by often inviting home his gang of wind-surfing buddies. By the time Keith

departed a month later, he had painted Xavier's surfboard (in his best Léger style), his windsail, and a mural at the Channel Surf Club.

As *haute bohemienne* as was life in the Nellenses' main house, the guesthouse on the east corner of their garden, where Keith and Juan stayed, was positively fantastical. "The Dragon" was a far-out sculptural habitat designed by Niki de Saint Phalle in 1971, with mechanical art added within by her then-husband, Jean Tinguely. The milk-white genial monster had rounded windows for eyeballs, a long red slide for a tongue, and a clumsy big claw and had been painted with a galaxy of lovely moons and stars. Inside, a crocodile's head had been wired by Tinguely to snap at visitors with its electronic jaw, and a free-form staircase led up to Keith and Juan's bedroom, complete with spiderwebs, where many organic openings in unlikely places, serving as windows, made the room eerily aquatic and surreal on a moonlit night. Of all the Nellenses' many guests, only Keith took to living and working in the belly of the Dragon comfortably and with such joy—enough of an event that Saint Phalle made a special trip to Knokke to see her playhouse fully realized. With permission, Haring left his own mark with a black-white mural on the white balustrade of the stairs that begins with a heart, climbs upward with male bodies (one riding a dolphin), and finishes with a display of the lithe swimmers and surfers of Knokke.

On the day of their arrival, Keith and Juan had time only to quickly drop off their luggage in the Dragon before emerging into a welcoming party on the lawn, with dinner for more than twenty critics, collectors, and friends, invited to meet Haring at the exceedingly social home. "There is a trampoline in the backyard that is really fun," Keith wrote. "Me and Juan hang out with the kids." Keith preferred the kids' company, as "the conversation is always interesting, and the humor is fresher." One grown-up guest did interest Keith, though: he was a doctor, and Keith had been suffering from acute stomach pains. When he confided his ailments, the doctor arranged for a check-up in a hospital outside Antwerp in three days' time. After debating canceling the appointment, as it conflicted with a skateboarding conference he hoped to attend in Münster, Keith finally made the mature choice, "although it is hard to convince myself." At the hospital, he informed the doctor of

the possibility of AIDS, an admission that led to many extra lab tests: "X-ray, blood (a lot of blood), urine, and some kind of scan which shows your organs right on a small monitor in front of you. I saw my kidneys, spleen, prostate, etc. Pretty weird! Kind of scary (and depressing). I hate thinking about death." Two weeks later, the doctor stopped by the Nellenses' home to inform Keith that his blood tests and X-rays were all normal. Haring was tentatively relieved, though he continued experiencing stomach pains that kept him awake, as well as sinusitis.

Life at Knokke agreed with Keith. "It is really like a country house here and kind of timeless in a way," he wrote. "They grow a lot of food in their garden and the kitchen is the center of attention. The helpers are always busy cleaning or making waffles. There is a huge juicer (restaurant size) that always has a huge basket of oranges beside it because Roger likes fresh orange juice. There are so many birds here it is amazing." A favorite late-morning routine for Haring was sitting at an outdoor table designed by Saint Phalle—which had two sculptural people sitting at it also—while writing quietly, listening to the birds, and looking across the garden to the Dragon. Even in this paradisical setting, and given his own, by then, much-commented-on rate of production, he could still write in his journal, "The only time I am happy is when I am working." His output at Knokke was unmatched as he created scores of gouache-and-ink drawings on handmade paper and sumi ink drawings on Japanese paper, a dozen at a time, for the show. He recognized the final works as very close to his original sumi brushwork from the seventies. He also made *The Story of Jason*, a series of nine drawings using baby pictures he requested from Jason Poirier dit Caulier, the teenage son of an art dealer he met when he was on Belgian TV: "This is one of the greatest 'groups' of drawings I've done in a long time. It turned into a kind of story about good/evil and Christ/anti-Christ, etc. It worked like the old series of drawings that all refer to each other, but without any obvious order, specifically. Very much like the cut-ups."

Following naturally was a further invitation from Roger Nellens for Haring to take on the challenge of painting a permanent mural in the hallway leading into the chandeliered grand salon where Magritte had painted *Le Domaine Enchanté*, intimidating all with its heroically scaled

inverted mermaids and bird-shaped primeval leaves merging into a sky of smudged pastels. (In another part of the casino, Delvaux had painted his own mural of moonstruck ladies wandering nude near a train station.) Keith began with the black lines, standing on a ladder and drafting the entire composition in one day, continually going up and down, shifting the ladder around. He declined an assistant and refused any help with the ladder. Roger Nellens observed that when Keith was painting the black outlines, the music was pounding, rhythmic rock, and on the second day, when filling in one color at a time, he played Aaron Copland violin strains. (Haring did include, among his cassettes, music by Bach, Beethoven, Copland, Mahler, Poulenc, and Stravinsky.) The mural was a gambling scene, with a deathly skeleton rolling dice while tubular figures smoke, play cards, and bet cash and a dragon spins a wheel of fortune. In an upper-left corner, he painted an homage to Magritte's apples, adding Venetian masks. Applying black acrylic quickly with a big brush, he stepped back to see results that seemed to him "very Dubuffet, or something, with a little hint of Stuart Davis." He added pastel color with "very 'Cobra' brushwork and very drippy." As he pointed out in his journal, though, he made these tricky comparisons "because of the quality of drawing; not imitation." In Knokke, Keith revisited times past and adolescent aspirations formed while living in Pittsburgh. He was full of thoughts of CoBrA and Alechinsky and—by way of Picasso—Dan and Grebo West African carved masks.

For the public opening of the show at the casino, on July 29, the Nellenses forwent their usual, more formal party plan, skipping the printed invitations to a champagne and scotch reception and, instead, opened the event to everyone and served Coca-Cola, beer, and orange juice, with very loud rock music playing. The youth appeal worked. "A day or two before, the phone began with people saying, 'We come, we come,'" Roger Nellens said. "It was like a tom-tom in Africa. When he comes, they all come. It was completely mad, an incredible thing!" Keith met one of his younger fans when he arrived early to look at the show alone and was followed in by Baptiste Lignel, a thirteen-year-old boy who "looks like a cuter, younger version of me, or maybe a cross of me and Tweety Bird." The boy shyly explained that he was the son of an

art collector from Paris and that they had come all the way for Keith's show. Without any shyness, though, the boy shared strong opinions about the work: "He was very adamant that I should continue the bold, simple style, and spend less time on the 'newer' more intricate style. He said, 'You're the only one who can do this, so you should keep doing it. Other people can paint the other way.'" Haring listened as carefully to the young Baptiste as to anyone, as he was amid a style correction: "I jokingly told him I should hire him to be my manager. Now that I think of it, a 13-year-old manager may not be a bad idea." An entry in Haring's Knokke journal reveals him contemplating other ways forward in his work: "I think thoughtful and aesthetic creative humor is needed. This could be the vehicle I am searching for to make the next transition from the subway works."

The Nellenses of course had their own reception at home, too, as the lawn filled that Sunday for a lunch in Haring's honor, thrown in a tent on a warm and sunny afternoon. Jeffrey Deitch arrived with Jean Tinguely and Jean's girlfriend, with dog. An assistant to Daniel Templon said Daniel was on his way with his wife and baby. Hans Mayer, who had just been in New York City the day before, made the trip. Plus, seemingly everyone Keith had met in Belgium the previous month, many wearing the free T-shirts from a box of samples he had been giving out for the opening. Tony Shafrazi had arrived a few days earlier to help with final touches, such as insuring, hanging, and pricing the works. "I stayed in a lovely room upstairs in their beautiful house," Shafrazi says. "Roger Nellens came with a suitcase, and he opened it and emptied it all with stacks of money in rubber bands, not like one lump, spread over the single bed. I'd never seen that. The cash was an advance, or to give to Keith, or buy some work, I don't recall." Haring wrote, understandably, "I feel more optimistic about being in Europe, and I think it might be a good idea to live longer. I think I could have a great future and be very productive."

Enhancing his optimism was relief at being away from New York City and its mood of growing doom surrounding the AIDS crisis. "That's all people were talking about in New York," Kitty Brophy remembers. "No one was talking about anything else." Keith, of course, was not entirely

oblivious. Every so often, thoughts of the disease and its casualties would wash over him. "I finish and have a wank and ride solemnly to the beach," he wrote of one bike ride. "I drive for a few miles, around the sand dunes. I keep thinking about Martin Burgoyne for some reason, except it's not sad anymore; it's something else now." Tony Shafrazi had phoned from New York on more than one occasion freaked out about rumors in the art world that Keith had AIDS. Haring dismissed the rumormongers as vultures awaiting their next victim. Yet "the Art World gossip hotline" became impossible to ignore after one late-night dinner at the Nellenses', when Keith was called away to the phone by a reporter from *New York Newsday* asking for a comment on the reports that he had AIDS: "I can't believe this could have gotten so out of hand just from being out of New York for two months! I was nervous because I was tired from painting and stoned and I didn't want to sound unsure of myself. I assured her I was fine and also assured her it was obnoxious of her to ask me in the first place . . . It seems strange coming at a time when I am working harder than ever before and doing some of the best work of my life, especially after feeling great after having had some doubts myself . . . It doesn't make me very anxious to return to New York!"

Yet return to New York he did, on July 11, on the Concorde, the exclusively priced supersonic jet—it traveled at twice the speed of sound—sleekly making the trip westward across the Atlantic in three and a half hours. "When we traveled, he'd get tickets on the Concorde or MGM," Juan Rivera said of the MGM Grand, the other elite airline of the eighties making the trip from New York to Los Angeles. The New York City to which Keith was returning was no longer the demimonde of cruising and drawing on illicit walls, of free sex and free art, that had enchanted and pulled him in a decade earlier. Its call of the wild was now muted. A health code law passed in October 1985 had made penetrative public sex illegal and had led to the clearing out of the Piers and the closing of after-hours sex bars like the Anvil and bathhouses like St. Mark's. Most painful for Keith, he was arriving within several weekends of the closing of his beloved Paradise Garage, his demotic muse. Its owner, Michael Brody, had been confirmed HIV-positive and had decided not to renew the ten-year lease. "It was really a kind of family," Haring wrote. "A tribe.

Maybe I should open a club, but I really don't want to deal with that headache. This is the worst heartache I ever felt. It's like losing a lover when everything was going just fine. It's like when Bobby and Andy died. Maybe Paradise Garage has moved to heaven . . . so Bobby can go there, now. That would be nice." Junior Vasquez made him a cassette tape, *Paradise Lost*, to remember it by.

The city did still have its consolations. One was the Cyclone, the wooden roller coaster at Coney Island. "As soon as we landed, he'd have the limo go to Coney Island because he liked the boys there," Juan Rivera said of their customary first stop upon returns to the city, like that in the summer of 1987. "And his ride was always the roller coaster . . . But that's the one ride I just wasn't crazy about, 'cause I'd always catch myself running out of breath . . . smack in the middle of it . . . I couldn't always go around the world, get off the plane, and get on the roller coaster at Coney Island, 'cause sometimes I was too tired or too upset . . . and Keith would always say, 'Oh, come on Juan, don't be such a fag! Come on, boy!' And I'd say, 'Okay, boy, okay . . .' And I'd always end up getting on it and *trying* to figure out when the next drop was coming . . . the next drop." Keith enjoyed being a big kid. The packs of young men and the seedy, run-down quality of the fairgrounds of Coney Island in the eighties appealed. He was even fonder of this public amusement park than of its art version, *Luna Luna*. And he had clearly resolved he was going to keep the thrill-seeking roller-coaster ride of his art and life going for as long as he possibly could.

Tokyo

T*he rapid clip* of international airline ticketing for Keith Haring
throughout 1987 resulted in several comic misspellings of his
surname, such as "Harding," "Harving," and "Harinck"—the final a fa-
vorite, as it combined both "Inc" and "Ink," business and art. "Harinck"
might also have made a clever logo for the fifth-floor studio at 676
Broadway, which, like Warhol's Factory, was increasingly a double pur-
posing of the financial and the commercial with a classic artist's atelier

for the creation of lines of new work. When Keith returned, midsummer, the business operation—up until then entirely the responsibility of Julia Gruen—had doubled with the hiring of a young woman from South Africa, Margaret Slabbert, who, like Julia, had answered a want ad in the *Voice*. She was now the financial manager, handling all the bookkeeping and contracts and supervising the Pop Shop, with its six or eight employees, leaving Julia free for ticketing, hotel reservations, media requests, special projects, and all the incoming and outgoing messaging. Together, the two sat in a separate office at the front of the loft, with black Formica-covered desks built for them by Kermit Oswald. On most days, Keith made a to-do list with unbusinesslike headings such as "Bitch At" or "Money—Pot," and always "Gallery Questions," as he was now, Gruen says, "increasingly the mainstay of the gallery." Margaret Slabbert found her new boss to be "very intense . . . also a terrific businessman." Keith Haring Inc. was enough of a phenomenon for *Details* magazine to run a group portrait of "The Haringtons," including Margaret, Julia, Adolfo Arena, and the Pop Shop manager, Bipo, the nickname for David Almódovar. "How it all gets presented to the world has to do with the way we put it out, from the way Julia answers the phone . . . to Bipo's smile in the Pop Shop," Haring explained. "It's beyond business, beyond esthetics. It's a spirit thing really."

Although Julia Gruen found that "as the years progressed, he came to be a very proficient boss . . . he liked being in total control," Keith also knew how to be both there and not there. As he once faxed Julia on a money matter, "You must decide about accounting issue. I will back you and Margaret up 100%. You know I know as little as possible about this end of things and want to keep it that way." Though he now employed several full-time staff in his studio, and was represented in galleries worldwide, he still liked to be as free as an East Village kid knocking around. Often, though, when he simply walked down the street, or rode his Cinelli bicycle, he would return with a new project to generate more agenda items. "Everything had the potential to be an inspiration," Gruen says, "whether eventful or visual." That August, back in his very urban Sixth Avenue apartment with Juan, Keith somehow was finding time to spend many days and evenings at the nearby Carmine Street

Untitled, 1980, gouache, spray enamel and ink on paper,
5 ft 3 ¾ in x 4 ft (161.93 x 121.92 cm)

Clones Go Home, 1980, powdered pigment and graphite on paper stencil, 20 x 26 ¼ in (50.8 x 66.68 cm)

Untitled, 1981, sumi ink on printed Marilyn Monroe poster, 38 ½ x 26 ¾ in (97.79 x 67.95 cm)

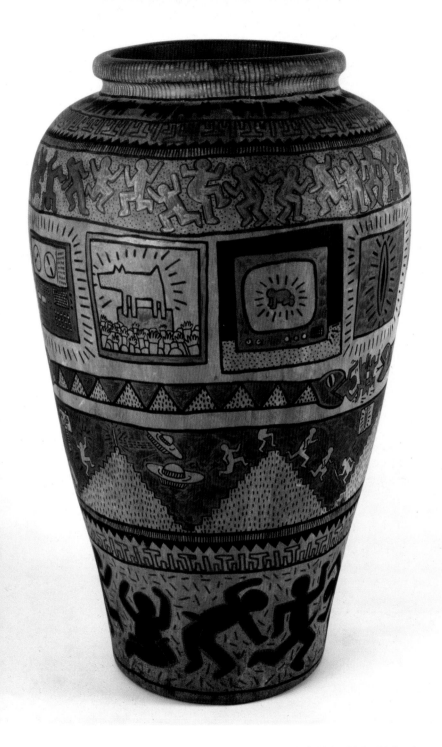

Untitled, 1981, enamel and ink on fiberglass vase, 40 x 25 x 25 in (101.6 x 63.5 x 63.5 cm)

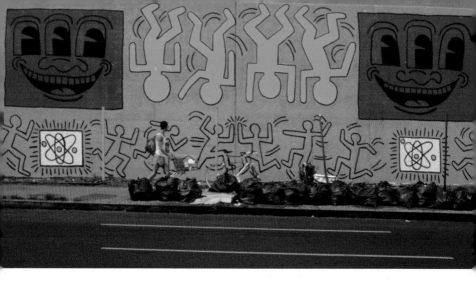

Untitled (Houston Street mural), 1982, acrylic paint on cement wall

Untitled, circa 1981–1982, ink on chalk box, 2 ¾ x 4 ¾ x 1 in (6.99 x 12.07 x 2.54 cm)

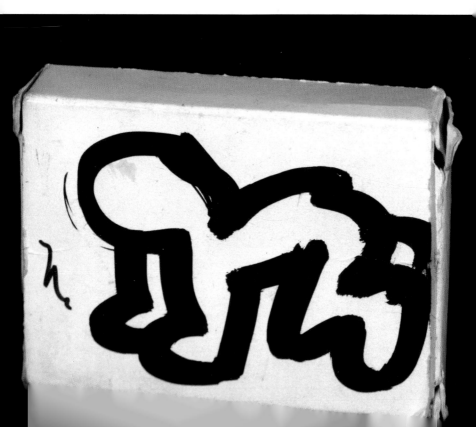

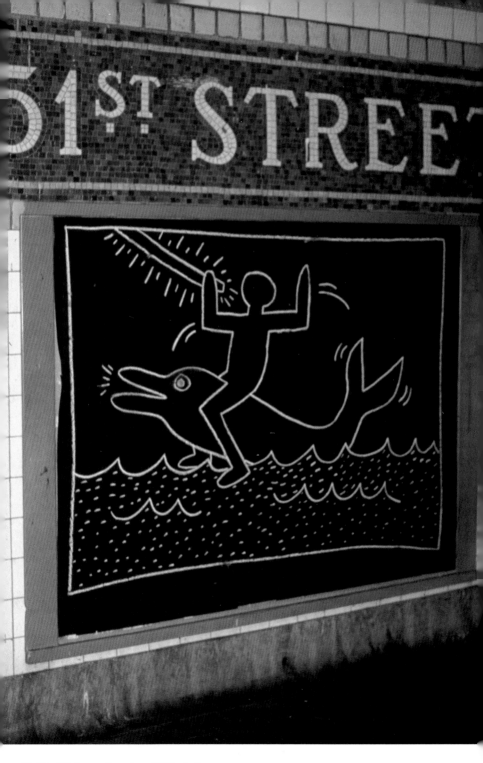

Untitled Subway Drawing, 1982, chalk on paper

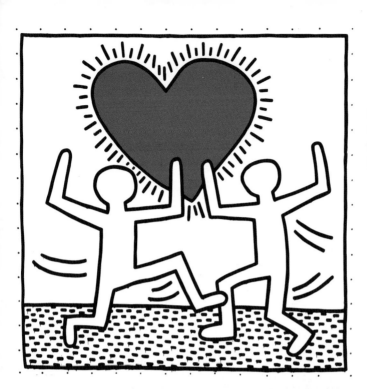

Untitled, 1982,
vinyl paint on vinyl
tarp, 180 x 180 in
(457.2 x 457.2 cm)

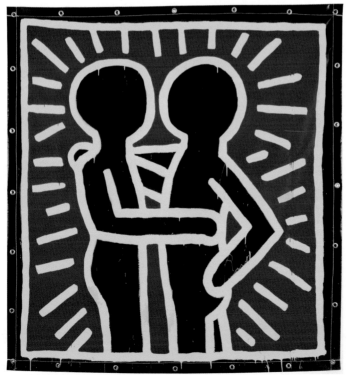

Untitled, 1982,
vinyl paint on vinyl
tarp, 6 x 6 ft
(182.88 x 182.88 cm)

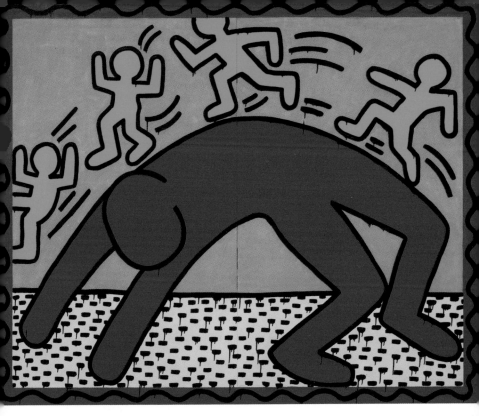

Untitled, 1982, enamel and Day-Glo on metal,
6 ft x 1 ½ in x 7 ft 6 in (182.88 x 3.81 x 228.6 cm)

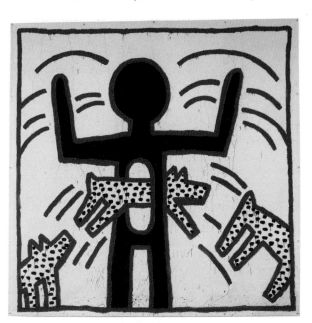

Untitled, 1982,
vinyl ink on vinyl tarp,
12 x 12 ft (365.76 x
365.76 cm)

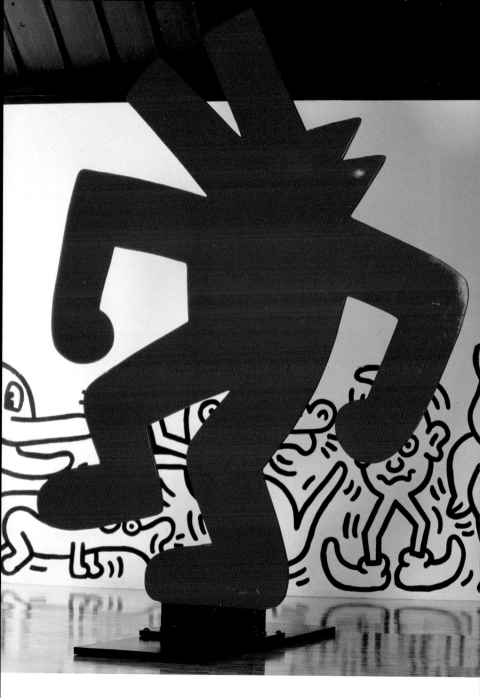

Untitled (barking dog), 1985, polyurethane on steel,
5 ft ½ in x 13 ft x 10 ft 10 in (153.67 x 396.24 x 330.2 cm)

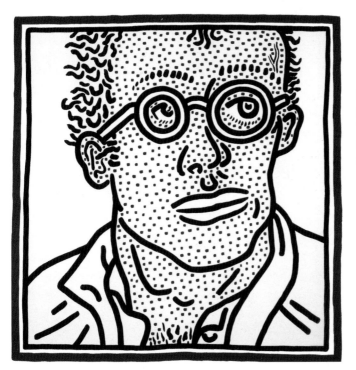

Untitled
(Self-Portrait for
Tony), 1985, acrylic on
canvas, 4 x 4 ft
(121.92 x 121.92 cm)

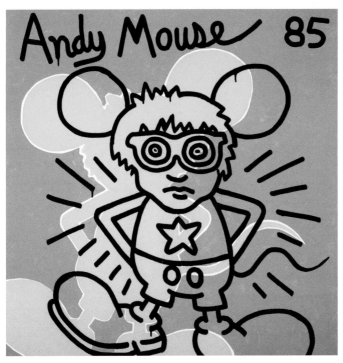

Andy Mouse,
1985, acrylic on
canvas, 5 x 5 ft
(152.4 x 152.4 cm)

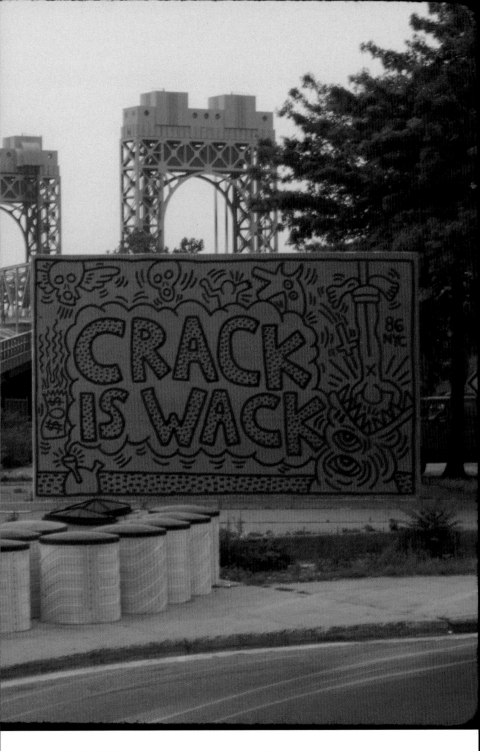

Crack Is Wack, 1986, acrylic paint on cement handball wall

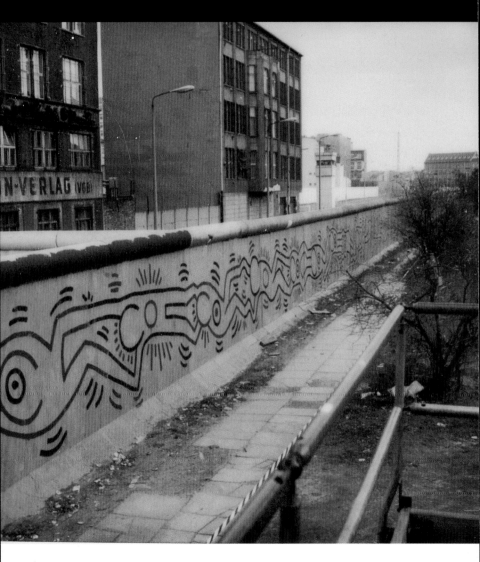

Untitled (Berlin Wall mural), October 1986, acrylic paint on wall

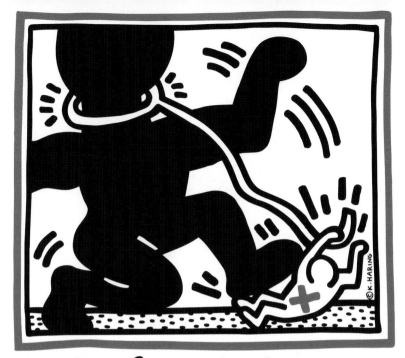

Free South Africa, 1985, offset lithograph on glazed poster paper, 4 ft ¹⁄₁₆ in x 4 ft ¹⁄₁₆ in (122.08 x 122.08 cm)

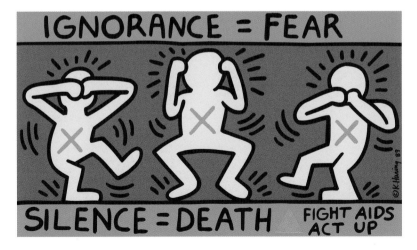

Ignorance = Fear, Silence = Death, 1989, offset lithograph on glazed poster paper, 24 ⅛ x 43 ⅛ in (61.28 x 109.54 cm)

Silence = Death, 1988, acrylic on canvas, 10 ft x 10 ft x 3 in (304.8 x 304.8 x 7.62 cm)

Red Room, 1988, acrylic on canvas, 8 x 15 ft (243.84 x 457.2 cm)

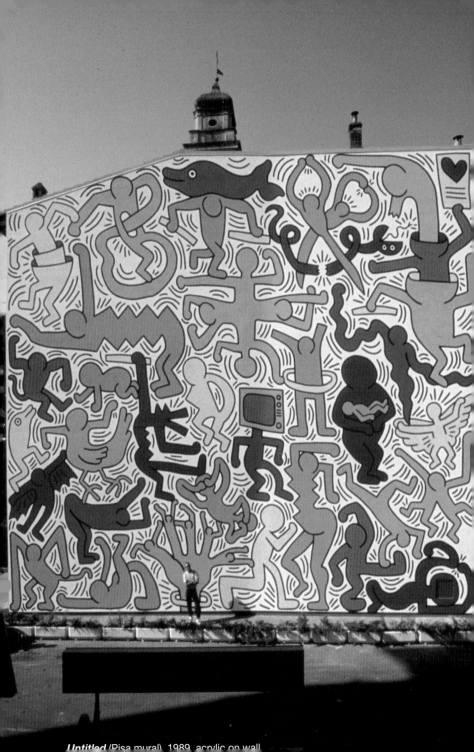

Untitled (Pisa mural), 1989, acrylic on wall

A Pile of Crowns for Jean-Michel Basquiat, August 19, 1988, acrylic on canvas,
10 ft x 10 ft x 3 in (304.8 x 304.8 x 7.62 cm)

outdoor pool, popular with neighborhood Italian American kids, as well as Hispanic youths from the Lower East Side. Never able to entirely relax, he soon felt the wall running the length of the pool crying out for a Haring, and with the help of New York City parks commissioner Henry Stern, he got permission this time to paint a mural. On one of the hottest days, Haring, in white trunks and tanned and fit from push-ups and biking, painted a light pantomime of flipping porpoises and muscly, crowned swimmers—with "references to Leger," a bit of Knokke in the lower West Village—mixing turquoise paint the color of the pool and yellow the color of its safety markings. He turned the one day of painting into a block party for "tons of bikini-clad people" by inviting Junior Vasquez to deejay. "He had the power, and he could seduce people in all kinds of ways," Vasquez said. "I got my start because I made him tapes for his painting party at the Carmine Street pool." (A deejay friend of Haring's took notice of Vasquez and invited him to spin records at the Sound Factory.) The next morning, the mural was front-page news in *New York Newsday*.

Haring's other projects in August and September were all local, regional, or domestic. He kept the turquoise and yellow color patches of Carmine Street going—cavorted on this time by blackly outlined figures reading, boxing, swimming, lifting weights, or playing volleyball—on a mural painted on a cinderblock wall of the gymnasium of the Boys' Club of New York on Pitt Street, on the Lower East Side. (Haring remained committed to the Boys' Club and wrote the organization into his will as beneficiary, along with the Children's Village in Dobbs Ferry.) At Schneider Children's Hospital on Long Island, he installed a buoyant sculpture of three tumbling red, yellow, and blue figures, constructed at Lippincott—his first official commission for a sculpture—and then painted a grinning crescent moon, an elongated dachshund, and a girl with lollipop along its ambulatory hallways. "I think there's a lot of things about art that have a lot to do with healing," he said in a video interview. "It's definitely helpful for children to be around art." After returning to Kutztown to mount an exhibition at James Carroll's New Arts Program, as an extra favor, he stopped by Feed and Read, a source during his adolescence of alternative publications such as *Mother Jones*

and *Mother Earth News*. By 1987, the store was an unofficial Kutztown Pop Shop, with Haring brand items, the line for signing that day going down the block. The next morning, he and Juan took a Bieber bus back to the city, a subway to the studio to repack, and a taxi to LaGuardia for a flight to Kansas City. While the travel and the destination were far from the Concorde and distant from Paris, Keith felt the weekend trip coming "at a powerful and important time," and by Sunday, he was judging it "a very important stepping stone in my life."

The event was the River City Reunion, a music festival–style gathering of poets, artists, and musicians in Lawrence, Kansas, in honor of William Burroughs, who had moved there six years earlier with his long-time friend, assistant, and manager, James Grauerholz. After a lifetime of cosmopolitan living in Tangiers, London, and Paris, Burroughs had surprised everyone by leaving behind his "Bunker on the Bowery," to resettle, in his mid-seventies, in a remote, two-story Sears kit house in a small, postcard-Midwest college town, home to the University of Kansas. (Grauerholz, four decades younger than Burroughs and a Kansas native, had helped finesse the move.) Keith was excited for this literary rock concert that might well have been staged in the East Village in the late seventies—like the Nova Convention, which had helped him to discover, through Burroughs's cut-up method, a new way to tell stories in ink and then chalk. An artist once again in search of a boldly revised statement, Haring was receptive to the lineup, which included Allen Ginsberg, John Giorno, Anne Waldman, Timothy Leary, Ed Sanders, Diane Di Prima, and Marianne Faithfull, many of them now friends of his. He was also following through on an anticipated collaboration with Burroughs. George Mulder had proposed a series of prints by Haring with James Baldwin, and Keith read *Giovanni's Room*, preparing to meet Baldwin in the South of France. When Baldwin was hospitalized, Keith hopefully suggested Burroughs instead. In late June, Grauerholz wrote in a letter to Julia Gruen, "William is enthusiastic about working with Keith, whom he likes and whose art he sincerely believes is important and great."

Picked up at the airport in Kansas City in midafternoon, Keith and Juan were driven to Lawrence, where they were soon hanging out on a

street corner, chatting with Matt Dillon, who was in town with Andrew McCarthy, filming the crime drama *Kansas*, as well as with the poets Anne Waldman and Jim Carroll. Suddenly, a car turned the corner and Keith heard someone yell, "Hey, Keith!" It was Allen Ginsberg, who knew Haring through Burroughs, arriving for the opening of his photo exhibit down the street. Ginsberg walked Keith through the show while the two were tailed by a German photographer from *Stern*. The gallery director asked Haring to please do a chalk drawing on the street, and Keith obliged with a brazen drawing of a dancing naked figure with a radiant phallus flashing pictures with his Instamatic camera while squeezing helpless victims in his fists. Ginsberg wrote an adjoining haiku: "TAKING PICTURES OF THE SKY / NAKED ON THE SIDEWALK—/ THE FLASHER RISES IN KANSAS—Allen Ginsberg, Sept 11 87." As Grauerholz remembers, "A couple days later, someone saw fit to spread a large bucket of water on the sidewalk and use a big push broom to remove the art. Partly because it was a naked guy with a big boner."

Juan and Keith moved on with a few of the "college art boys" to their campus house, a Haring "Free South Africa" poster on their kitchen wall, to smoke pot and drink beer and to be shown around Lucifer, a nearby fraternity building made of concrete that had fallen into disuse. Invited to add to a mess of local graffiti, Keith did some tagging that remained until the building was demolished. He also spray-painted in black on a wooden skateboard ramp a skull with its skeletal thumb and pinky raised in a "hang loose" gesture from surf culture. Keith and his growing Lawrence posse arrived, late, to a reading being given by Jim Carroll, revered by the young crowd for his memoir *The Basketball Diaries*. On the way out, Haring ran into John Giorno, whose performance poetry had intrigued him ever since the Nova Convention and his days at SVA listening to "John GIORNO reading GRASPING AT EMPTINESS for the 27th time." According to Giorno, the two had first met in a subway bathroom at the Prince Street station in July 1982. "That morning I was getting my cock sucked when a young, slightly homely but still cute kid wearing wire-rimmed glasses put his arm around me and we started kissing." He "began to realize that the kid recognized me as the poet John Giorno" and, before splitting, introduced himself as "Keith." The

two were reintroduced three years later when Haring came to a dinner at Giorno's loft, "more solid" and having "gained an aura of power," and went on to do the cover art for Giorno's 1985 LP, *A Diamond Hidden in the Mouth of a Corpse*, and to illustrate "Sucking Mud," a four-page poem dealing with the AIDS crisis. "Keith was heroic in having gay content in his work," Giorno said. "He used dick apropos of nothing. He used gay content when we all know that being a gay artist is the kiss of death. What arose in his life he used in his art."

Waiting for Keith back at the hotel bar was Timothy Leary, who had checked into the hotel in advance of his lecture the next day on a double bill with Jello Biafra, from the Dead Kennedys. Biafra had just been cleared in an obscenity case in L.A. over a poster by Giger (the artist who had designed the monster in the 1979 film *Alien*) depicting various cocks and asses. ("The poster, inserted in the record, was nothing compared to some of the images I have created," Haring thought. "I wonder if there is any possibility of me being singled out.") Keith and Leary had first been introduced by Grace Jones, at Paradise Garage, in 1985 and met again at the filming in Paris of the video for "I'm Not Perfect (But I'm Perfect for You)," where Leary was one of the celebrities, along with Andy Warhol and music producer Nile Rodgers, climbing tendrils dangling from Jones's Haring skirt. "Well, to me, Leary was this mythical figure," Haring said, "a kind of guru of the sixties, who completely fascinated me." Leary had given him a copy of his autobiography, *Flashbacks*, which he read in Montreux, Switzerland, and the book spoke powerfully to the ex-Deadhead in him. Writing Leary an effusive fan letter and sending two drawings, Keith soon became friends with "Timmy" and his wife, Barbara, in turn a fan of Haring, who had painted their dining room table in Los Angeles with running figures copied from his Swatch watch design. Viewing Haring's line as akin to pixels, Leary convinced him to contribute graphics for a computer software program he was creating based on William Gibson's cyberpunk classic *Neuromancer*. To encourage him, Leary gave Keith an Amiga computer on which he created five digital images on a floppy disk. The images were auctioned as NFTs by Christie's in 2023.

Keith found Leary's rambling lecture the next afternoon (about everything from drugs to computers) "slightly tired by comparison" with

Jello Biafra's, "yet great." Afterward, Leary introduced Keith to the audience as "the future of American art." Haring was wearing his latest T-shirt creation, emblazoned with the message "AIDS IS POLITICAL-BIOLOGICAL (GERM) WARFARE," which he was handing out throughout the weekend. He had first gone public with his belief that the AIDS epidemic was no accident, oddly enough, just a few days earlier, for a story with no mention of his homosexuality in the local Reading newspaper, accompanied by a picture of his beaming parents at the New Arts Program gallery. "I believe the AIDS virus is an invention," Haring explained angrily. "It's germ warfare and it's not accidental. It started in two cities, New York and San Francisco. The Africa thing was a plant to make it look like it started there. They used it (the virus) in African prisons, and once they realized what they had, they planted it in New York and San Francisco. It happened geographically." At the main reading that evening in Liberty Hall, Burroughs referenced an AIDS paper about germ warfare, too, and had the same poster that had inspired Haring's T-shirt—an "accident" that Keith saw as a "cosmic coincidence." Having written in *Naked Lunch* of bureaucratic "control addicts" pushing a "junk virus," Burroughs was an early adopter of theories of AIDS as government-sponsored virology, and a year earlier, in the poem "A Thanksgiving Prayer," he had written explicitly of "laboratory AIDS." With Keith, the response was both a worldview and a reflection of his own frustration and anger.

The next afternoon, Keith finally visited with Burroughs at his home in East Lawrence. Burroughs had been among those gathered in front of the Lawrence gallery when Keith made his sidewalk drawing, which the writer had found "beautiful." "He seemed shy and withdrawn—and yet he was very popular," he said of Keith. "He was never bothered by the crowds." In a rich observation coming from the writer some Spanish boys in Tangiers had once nicknamed "El Hombre Invisible," Burroughs also commented on Haring as "rather spectral—as though he wasn't there. He was strange, yet very positive." James Grauerholz agreed: "My first impression when they met was that Keith was shy and very rabbity. He was like a mouse. He'd grab a sketchbook and show William. 'What do you think of this?' He was very busy, but also shy, kind of Andy-esque,

frankly." Anne Waldman, whose animated performance of her poetry the night before Keith had found "really good," observed in encounters with him over the weekend, "In the scene around William—he was gentle modest engaged—never egoic, maybe an old soul in the guise of such youthful spirit." For both Burroughs and Waldman, the spirit that mattered most was in the work. When Burroughs first saw some large Haring paintings at a show at the Tony Shafrazi Gallery, he had felt in them "electric vitality." For Waldman, Keith's line was "like a flash of bodhicitta."

Keith was keen to move forward with his proposed collaboration, "a Keith-instigated project," according to Grauerholz, and Burroughs was equally keen to show his recent artwork to an artist he respected. "Although Keith was young, he was not immature when it came to art," Burroughs said. "Our work was of equal weight and purpose." The two had first become friendly through Brion Gysin. When Gysin died in 1986, from advanced lung cancer—Haring was named as a beneficiary in his will—Burroughs wrote to Haring, "Your enthusiasm and promotion of Brion's work meant a great deal to him and added time to his life." The English writer Victor Bockris said, "Brion's last words to me were, 'Thank you for introducing me to Keith.'" Burroughs had a guilty conscience about the world having been far more interested in his own work than in his early collaborator's, and he long had avoided Gysin's medium of paint. Now, though, he was creating paintings at an intense pace, and over the afternoon, he showed Keith experimental works of painting on plywood and paper, collaged photographs, splattered tubes of paint, and wooden boards with attached paint cans to make "shotgun paintings." Curiously, when Keith smoked a joint with Burroughs, to aid him in "seeing stuff in the paintings," he found "funny how the gunshots look so much like Brion's drawings." Three months later, Burroughs had his first solo show of thirty of these works at the Tony Shafrazi Gallery, curated by Diego Cortez and with, in Grauerholz's words, Haring's "bold and often erotic, whimsical and dark, but beautiful" drawings for *Fault Lines* (the text including omitted passages from Gysin's novel *The Last Museum*) in the basement. "Keith had everything to do with William getting the show at Shafrazi," Grauerholz says.

As the afternoon unfolded, more friends appeared—Matt Dillon, Jim Carroll, art dealer Patrick Fox, transgender model Teri Toye, editor Ira Silverberg, photographer Kate Simon, and painter Carl Apfelschnitt. A plan was made to drive out to the house of a friend of Burroughs in the countryside to shoot guns, Burroughs's favorite sport. "There was Keith with a Colt .45, one arm holding the other arm straight out, like a police officer, standing like a marine," recalls Kate Simon, "with William behind, coaching him." Said Haring, unconvinced, "Sort of fun, I guess." Keith sat around talking with Burroughs about South America (written about by Burroughs in *Queer*) and with Burroughs and Giorno about AIDS, as, says Simon, "William was very upset about it." Ever in pursuit of the liberating sixties he had missed by just a half decade—whether through Jerry Garcia or Andy Warhol or William Burroughs—Haring was most pleased with the company he was keeping, and the feeling was mutual. "Keith was both a fan boy and famous," Ira Silverberg says. "William had a twinkle in his eye around Keith, which was nice to see, as it didn't happen very often." Yet he and Juan had to leave for the airport, so goodbyes were said. On Flight 007, "somewhere over the midwest at 35,000 feet," on a cheap "Kansas City" notepad, in a tone remarkably unchanged from his young Pittsburgh diaries in naïveté, piping ambition, and vulnerable love and hope for the entire world, Haring recorded his impressions of the weekend: "Things just sort of fell in place without any effort. The 'magic' is very real. Someone was discussing healing in the car today and said something about the only healing that will help the aids virus is 'magic,' wholistic medicine, visualization, psychomedicine, etc. I hope my generation will be able to carry on the 'magic' that this previous generation has excavated and gently tried to teach us. They have liberated a part of us that is too important to be dismissed and passed over."

Haring's much-desired collaboration with William Burroughs came to life quickly. *Apocalypse*, a portfolio of ten texts by Burroughs and ten silk screens by Haring, was published in a signed edition of ninety by George Mulder Fine Art in 1988. As Keith wished, the Burroughs text, written expressly for the project, helped him articulate within his style a new expression. He already knew well the comically dystopian (in a

punk manner) Burroughsian multiverse of science-fiction interzones where hanging boys' erections are erotic, syringes contain truth serum, and no politics other than anarchy is permitted. Burroughs's text for *Apocalypse*, printed on acetate film, prophesied a world where "skyscrapers scrape rents of the final Apocalypse in the sky," assisted by artists pulling down the firmament: "When art leaves the frame and the written word leaves the page." It is a bracing screech, if familiar. Yet, when Burroughs first saw Haring's silk screens, he felt "a shock—but a good shock." Absent were any of Haring's, by then, ubiquitous three-eyed faces or barking dogs or even his identifiable jungle of interlocking shapes. Against a sparsely colored sky of reds, yellows, and blues, he had collaged Leonardo da Vinci's *Mona Lisa* with her eyes X-ed out and devotional cards of Jesus of the Sacred Heart, and he drew with a thread-thin line—more Paul Klee than Haring—dragons and hanging men. Rising like a genie from a bottle in the first frame, beside a red molten phallus exploding into a nuclear cloud, was a slithering horned serpent—Haring's demon sperm, replicated from then on in his work as the mark of a darker element entering his world. More plainly than Burroughs's text, Haring's illustrations painted the horror of the AIDS epidemic as the beginning of an apocalypse.

Throughout September, Keith was often in a Tokyo state of mind. Convinced that New York City and Tokyo were now the two "centers of the modern world," he had been actively reimagining opening a Pop Shop East. The largest city in the world, by 1987, with more than twelve million residents, Tokyo excited Haring enough for him to describe it with the superlative "like one big amusement park. Video screens everywhere and neon like you cannot imagine." Following the success of the New York Pop Shop the year before, he had been getting requests to redo his artist store in London, Paris, or Los Angeles, yet he was clear that he wanted to limit himself: "If I just do a shop here and in Tokyo, it's enough for me for the whole world." Four days before leaving for Kansas City, he had written a diplomatic proposal to begin to explore the possibilities for such real estate and retail. "Since my first visit to Japan in

1983, I have dreamed of opening the Tokyo Pop Shop," he wrote. "The people of Japan have shown an understanding of, and interest in my work, as well as an appreciation of contemporary Pop culture, which has reaffirmed my debt to Japanese calligraphy and traditional Japanese culture. Tokyo and New York recently celebrated their 25th anniversary as sister cities. The cultural exchange between our two countries is rising at an unprecedented rate. I am delighted to be able to participate in this exchange, and to further strengthen the connection between Keith Haring and Japan."

Ten days after returning to New York from Kansas City, Keith flew to Detroit, where, as artist in residence, he created a mural at the nearby Cranbrook Art Museum, in Bloomfield Hills, Michigan, and led a drawing workshop for students in a fifth-grade class at Brookside School. Completed in two days and covering all four thirty-foot-long walls of a room with sixteen-foot-high ceilings, the fluid, imaginative mural, with lots of intentional paint drips, featured fine line drawings of fat-cheeked Buddhas, doves erupting from the gullets of koi, and mandalic intestines. Suggesting, in spots, some of the more Asian-influenced and fabulist drawings of Francesco Clemente, the work, Haring felt, was "probably my best painting to date." On the first day, he painted a "fast Gysinesque color 'calligraffiti' background" with big Chinese brushes, and on the second, he painted with a black ink/paint mix, using different sizes of Japanese brushes and nailing each brush to the wall at the end of a line. "I'm obsessed with brushes anyway so somehow to sacrifice them to the painting was a kind of homage to the brushes themselves," Haring wrote. "The whole thing was a kind of sacrifice anyway. The room will be re-painted in one month." As the mural was temporary, Keith was doubly thankful for the presence of Kwong Chi, as he grew ever more aware of the significance of Tseng's photo work in preserving his art for the future. Haring had also fallen into thinking of himself in the third person: "Photography has become such an important part of my work since so much of it is temporary. It is, after all, the phenomena of photography and video that have made the international phenomenon of Keith Haring possible. How else would everyone in the world have plugged into my information? Most information about

art is conveyed through pictures now. Sometimes that's deceptive but in my case it is the means and the end. Of course, I miss the effect of scale which is lost in photo depiction, but almost all of the other information is transferable."

For his evening slide lecture at Cranbrook—after a day of painting while listening to cassettes on a wavelength ranging from Public Enemy to Grace Jones to Spike Jones—Keith wore a yellow T-shirt with a message he took time at the start of the talk to decode with delight for the packed audience of both museum patrons and admiring pupils from the group of middle schools surrounding Cranbrook, whose T-shirts and jackets he had been autographing and drawing on for two days. "I got this T-shirt in Tokyo at this store called Poshboy," Haring explained. "I've been wearing it because it says '24-HOURS/1987/DETROIT.' I have no idea why. In Japan, anything that's in English is cool, so they probably don't even know what Detroit is, but it was in English, so . . . But I thought it was so cool because it was so absurd. What does it mean? I don't know." During the day, he paid his respects to the traditional Japanese brushes and sumi ink that had inspired his painting since his student days in Pittsburgh. That evening, he shared his glee over an unintentionally funny T-shirt from Tokyo, updating his interest in the culture.

Keith had visited Japan twice before. In 1983, he and LA II, with Juan Dubose, had traveled to Tokyo to transform the Galerie Watari into the Fun Gallery with their liberating, syrupy, swirling fast painting of any available surface. In May 1987, Keith and Juan Rivera had flown from Paris to Tokyo for one week, as Keith judged a design competition sponsored by Nippon. Haring had reveled in Kiddy Land, in Tokyo's Harajuku neighborhood, "the most incredible toy store in the world," and had found a McDonald's Tokyo, where they "fold the bag as if it were origami (tucking in the edges)," far more attractive than the McDonald's on West Third Street, across from his apartment in New York City. He had been enthralled by *Akira*, an animated film set in a dystopian Tokyo of the future. "Just like being in a Japanese comic book," he wrote. "And Tokyo of the present is pretty futuristic itself." He had frequented the Shinjuku Ni-chome district, with its gay bars, bookstores, and love

hotels, and had also liked acupuncture, visiting a practitioner in the busy Shibuya district, awash in neon. For Juan, whom Keith described as "bugging out," this first trip together to Tokyo was a welcome romantic interlude for them: "The first time we'd gone to Japan he'd been so *enchulao* he'd gotten us wedding bands and we'd painted the town red." Juan was less smitten, though, by the city. "My first time in Tokyo was *cute*," Rivera said, "but after a while you just wanna get away from perfection, 'cause everything there's *perfect* and you start craving some dirt." Rivera also found all the hip-hop streetwear in Japan "*weird . . .* like at a costume ball."

This third trip to Tokyo, in October 1987, was less casual, more intent, as Haring's fame preceded him, and he was now being covered in Japanese magazines such as *Brutus*, which ran a spread on Henry Geldzahler's New York City apartment featuring a photo of a painting on the wall by Haring that showed up as a copied design on clothing in Japan almost instantaneously. When Keith disembarked from his JAL flight, he was met by a woman whose job was to escort dignitaries through customs. "That's Japan for you," he said. "I asked her if she was also the one who got to greet Michael Jackson a few weeks ago and she said she was. Now I'm really impressed." Haring had arranged to do a public art project, painting a mural at a cultural center in Tama City, a suburb of Tokyo, and designing, with five hundred schoolchildren, bells (or "fruits" or "sound fruits") to be hung from wooden "magic trees." Haring said the entire experience was "designed by me as a kind of 'peace ceremony.'" Mostly, though, he devoted his energies to the "creative business" of realizing a Pop Shop Tokyo with his new partners, Kaz and Fran Rubel Kuzui. A film producer, Kaz Kuzui had been introduced to Keith in New York by Charlie Ahearn, and they had a dinner to discuss the chances for Pop Shop Tokyo at Keith's favorite Japanese restaurant, Iso, on First Avenue, where a "Keith Haring Roll" was on the menu. Kaz was impressed by Haring's clarity on the project. "He said Seibu department store wanted the Pop Shop in their store," Kuzui remembers. "He explained to me that he did not want to work with a big department store. He was careful about not wanting to be used to make trendy fashion and then be thrown out. He wanted one shop, not a

chain." By October, Fran Kuzui, a film director, had wrapped *Tokyo Pop*, her independent feature, set in the city's thriving punk music scene. Starring in the movie were Carol Burnett's daughter Carrie Hamilton, playing an East Villager adrift in Tokyo; and Diamond Yukai, lead singer of the Japanese rock band Red Warriors. Amused to learn that Fran's first husband had been Alan Herman, landlord of the New York Pop Shop, Keith, the force of coincidence never lost on him, designed the handwritten, all-caps opening credits and logo for her film as a gift.

The Tokyo that was so taken with the Keith Haring brand, and so alluring a match for the imagination and often frenetic energy of the artist himself, was the late eighties Tokyo of the "Bubble Era," when the top ten banks in the world were all based in the city and when the value of the Imperial Palace grounds was said to exceed the value of all the real estate in California. With cameras, cars, TVs, and computer chips of superior quality, manufactured on robotically precise assembly lines, Japan was dominating the world market in exports, with the yen doubling in value against the dollar and the stock market index tripling. Often outdoing the Gordon Geckos of the world were Japanese speculators in the stock and real estate markets—known as *zaitech*, or "the money game." Businessmen wore Savile Row and Giorgio Armani suits; young Tokyo women favored Louis Vuitton and Gucci handbags; and Audis, BMWs, and Jaguars filled the streets of the Marunouchi financial district. On October 19, 1987, or "Black Monday," while Keith was still in Tokyo, watching the film *Terminator* in Japanese in his hotel room, the New York stock market crashed, tamping down almost immediately on most of the excesses of the roaring decade on Wall Street. The Japanese economy, though, was little changed, its bubble intact until 1991. Frustration over the lopsidedness of this new global picture perhaps explained Republican lawmakers, in 1987, smashing a Toshiba boom box with sledgehammers on the U.S. Capitol grounds.

Haring was no close reader of the financial pages, yet the highwire dealings in the real estate market mattered if he wanted to open a new store in prohibitively expensive Tokyo. "I knew the CEO of the Bandai toy company," Kaz Kuzui says, "and he had empty land in Harajuku, which was the hip part of Tokyo, where the kawaii aesthetic was every-

where, and all the cool stuff of Japan. He owned a plot of land that he was trying to develop, but a piece was missing, and he needed to wait one year to kick out the last holdout and build a big building. He rented a corner of it to us for ten thousand dollars a month, no deposit, but we had to agree to leave after one year. Then I found two giant shipping containers and asked for them to be welded together in an L shape, to be painted by Keith. He loved this idea because, a year later, we could move this container shop, guerrilla-style, maybe to other parts of Japan, like Kyoto or Osaka. We were basically inventing a pop-up store." Says Julia Gruen, "That there was going to be a second store and that it was in To-kyo for Keith was like a dream come true. He believed that Japan was the most advanced society he had ever encountered. He felt if there was any culture that would understand having an exclusive boutique that sold the works of an artist they were familiar with from exhibitions, and es-pecially the work of Keith Haring, whose reputation was something of a bad boy and underground artist connected to the graffiti movement, Tokyo was that place."

During his two-week visit, Keith experimented with creating art mer-chandise that would be identifiable as Japanese, if at one remove. He took a bullet train to Nagoya, a two-hour ride, with Kaz and Juan along for the trip, and visited a ceramic manufacturer's studio, working long into the evening making sample rice bowls, learning how to control the glaze pigment on the clay surface. Just in time, they caught the last night train to Kyoto, where he spent the following day visiting the ancient city, observing traditional manufacturers constructing kimo-nos by hand, and designed his own, using a resistant glue that could be steamed out, leaving white trace lines. He went on to a fan maker—"Really chic"—and a paper umbrella maker, though he finally rejected the paper umbrellas as too impractical. In Osaka, he met with fabrica-tors of eyeglasses, motorcycle helmets, and skateboards. Returning to Tokyo, he then designed Pop Shop telephone cards—instead of coins, the Japanese used prepaid cards, decorated with artworks. At Juan's suggestion, he even made slippers with Pop Shop logos for customers to wear inside the store. (Both he and Juan were acutely aware of the Japanese custom of removing shoes before entering restaurants, as they

were often scrambling to buy new pairs of socks before any formal dinners.) On the plane back to New York, Keith scribbled in his notebook, "Does it ever stop? I hope not."

Three months later, toward the end of January 1988, Keith and Juan, along with the indispensable Kwong Chi, were back on a fourteen-hour flight to Tokyo, Keith relying on a preflight joint, three valiums, and a copy of *Der Spiegel*, with a full-page photo of him in it, to flip through. Preboarding, he and Juan bought silver-and-turquoise rings at an airport shop. "Are these wedding rings?" Keith asked, speaking in a kind of code the two had developed to express Juan's growing insecurities over his place in Keith's life. (During the October trip, Juan had threatened not to come at all "unless he gets a wedding band," as Keith vacillated between his need for freedom and his need for an intimate lover.) The skeleton crew was going on ahead to get the Tokyo Pop Shop ready for its grand opening in ten days. The store was still just two and a half raw, glaringly unpainted empty shipping containers on a pricey corner of undeveloped land across the street from Brooks Brothers, along a broad avenue of smart boutiques and fashion shops, including Issey Miyake, on the border of Harajuku and Aoyama. Meant to arrive in a few days was a group of New York friends whom Keith was flying to Japan, first class, for the big event.

Pop Shop Tokyo was built on the basics devised by Keith and Bobby Breslau for the New York original, with Keith painting the interior of the containers in an allover abstract pattern, customers using a shop-by-number system to select from among items on display and then proceeding to a window to pick them up, and the bulk of the merchandise stocked in a back room. Added elements in Tokyo were large acrobatic figures painted in black on the roof and meant to be seen from surrounding tall buildings, video monitors installed to show an ongoing display of Keith Haring works and projects from around the world, and attached to an outside corrugated wall, a large, red tondo circular painting decorated with the store's name. Sorely missed was Bobby Breslau's clever know-how as Haring hunted fine artisans to add some local visual dialect. After a tour of a wholesale kitchen supply neighborhood (like the Bowery in New York), Keith bought and then personalized paper

lanterns and an outdoor paper sign box for the shop, while Kwong Chi admired displays of plastic food, a silly kick he was sharing with Juan Rivera. Kaz Kuzui gave Keith a traditional *maneki-neko* "beckoning cat," considered lucky, in plain white ceramic to paint as a welcoming charm. "I've always wanted to do things to address this culture, instead of just be the American coming in from the outside," Haring explained to an Associated Press reporter. "For me it's also paying back a kind of debt I have to traditional Japanese art. My gestures, my lines, I got from Sumi ink painting."

At the start of the following week, the rest of the crew arrived from New York City. Met at the airport by Juan—as Keith was nervously dealing with a lack of progress in the laying of stones in the courtyard and erection of a gate—were Julia Gruen; studio assistant Adolfo Arena; Junior Vasquez, who would deejay the opening and after-party; and two other friends in the orbit of Haring's entourage, Brian McIntyre and Jessica Gines. At the end of the day, Keith led everyone on a tour through Shibuya to look at the neon signs. "We're quite a group altogether," he wrote in his "Pop Shop Opening Trip" notebook. "Julia, tall and sleek looking still like a ballerina; Junior short, white and sort of comical and always snapping at everyone and everything (yes, Miss GIRL); Adolfo looking mulatto and like an adorable teddy bear; Jessica pretty, and very New York Puerto Rican; Brian: everyone thinks is Eddie Murphy; Kwong Chi: everyone thinks is Japanese but is actually not very Japanese-looking at all to me; Juan, forever handsome with a chameleon face that adapts to every place we go, making him look Brazilian, Moroccan, or in this case part Japanese; and me (no comment.)" Keith also reveled in taking everyone for a quick stop at Mister Donut—with the Broadway musical *Big River* opening in Tokyo, the store featured a promotion that month, and the entire shop was covered with Huckleberry Finn décor: "On the bags, there is a pastel drawing of Tom Sawyer on a raft with Harry Belafonte. (I swear to God, it's his face.)"

Yet some of the joy Keith took in Tokyo was lost in translation, and his generous gift of Japan to his guests was not always accepted in the spirit he had anticipated. "Keith wanted to bring his rainbow coalition to Japan," Julia Gruen says, "but you're with some people who have

never done that kind of travel before. They get to customs joking about having guns and weapons. Then everybody hated the food. I was the person herding cats." Said Juan Rivera, "The second time we went there, Keith took a nice posse of New York City kids and paid all their way. But after they walked through Shibuya and looked at the neon signs there, they got bored with Tokyo and just *hated* it . . . The New York kids were all dissing Tokyo, so he started getting frantic . . . and *pissed*. And I was like in the middle—between him and the kids. And it got to the point where he started picking on me. I couldn't open my mouth without him snapping at me . . . He'd gotten so obnoxious . . . and *cold* . . . that there was nothing I could do that wasn't wrong."

One of those fights over seemingly nothing occurred when Keith remarked to Juan on how amazing it was that the Pop Shop was coming together, and Juan replied by criticizing the staff for "cutting corners."

"Fuck you, I don't want to hear that now," Keith shouted.

Such fights were not new. During their October trip, Juan had kicked a hole in their hotel room wall after Keith got exasperated with him for losing his plane ticket. An added source of friction between them, said Juan, was Keith's need for "boys . . . boys . . . *boys* . . . to keep his creative juices flowing." Rivera claimed he was always coming across sexy Polaroids Keith had taken of boys he liked.

On the eve of the Pop Shop opening, all these little dramas came to a tense pitch at a dinner, meant to be celebratory, at a Philippe Starck–designed Italian restaurant near Harajuku. "Me and the kids were on one side of the table," Rivera said, "and Keith and his artsy friends were on the opposite end, and the waiter screwed up my order, and I went to say something when Keith blew up and started yelling at me. And everyone could tell he was *not* in the mood and was taking it out on me . . . But I had had it and wasn't gonna stick around and be humiliated like this! So I went back to the room, got up the next morning, took my passport and ticket and flew back to New York." Keith heard Juan showering in the morning, and fumbling for his clothes, but he figured he was going out for a walk or giving him a scare by disappearing for the day, so he pretended to be asleep, "subconsciously wishing he'd leave for good," Haring admitted in his notebook. When he later walked into the Pop

Shop, he realized his wish had come true, but now he felt only regret. Kaz, Kwong Chi, and Julia arrived looking distressed. Adolfo was at the ready with a bottle of Absolut. Jessica stayed on to comfort Keith while he smiled and began to sign autographs. Worried, he left notes for Juan on the message board of the Chicago airport for his stopover, but he did not hear back until the next day. The two spoke for an hour and reconciled, for the moment.

"I never felt Juan to be insecure," Adolfo Arena says of their very public fight. "You're on a trip and there's a whole bunch of us there together, so why make a scene? There's nothing on paper that says you're legally married or that Keith is supposed to act in a certain way. Juan was never like a deadbeat. He could make it on his own. So why act up in a certain way?" Julia was feeling more understanding of the situation: "With both Juan Dubose and Juan Rivera there was a built-in inequality there you can't dismiss. Whoever was with Keith always ended up being in his shadow. Juan Rivera, I know, struggled with that a lot and was outspoken about it." On their roiled relationship, Keith reflected, with self-knowledge, "I've never been good at this. I've never really understood love or had a relationship that went smoothly. I always seem to seek rejection and the more I am loved, the more I don't want to accept it because I *want* to be hurt. I like to pity myself or something. Maybe it is time for me to get married. I'm not sure I can live without Juan when it really comes down to it. I am really sickeningly jealous yet at the same time excited by the idea that he's a sex object. The whole thing was too much like destiny."

A master at compartmentalizing his work from dramas in his life when needed, Keith pulled off the Tokyo Pop Shop opening with high energy. "I remember Keith being very upset," Fran Kuzui says. "He and Juan had a very tumultuous relationship, happy and sad, happy and sad, you never knew. It was such an exciting day, but I do remember him being disappointed because he should have been happier. I was sorry it wasn't a one hundred percent happy time. Yet the people who came to the Pop Shop loved it. It was pandemonium. It was hundreds and hundreds of people descending on this little space, and it went on for what felt like days and days." Working lots of publicity shots in his BMX

bike cap, Imperial Brooklyn varsity jacket, paint-splattered ripped jeans, and battered Adidas Rivalry high-tops, Keith signed everyone's this and that and even made chalk drawings on the sidewalks of Harajuku. "The opening was another crazed media event," Haring wrote. "It looks as though the Tokyo Pop Shop should be an even bigger success than the one in New York."

He had found a level of fame in Japan that was unmatched anywhere—sometimes to comic effect, as when he came across a fake radiant baby T-shirt with the nonsensical caption "Run Away Children"; and often intensely, as when his departure from Japan, Gruen recalls, was marked by "these flight attendants running after him with roses like he was a rock star. He got off on it."

In the five months before his next visit to Japan, Keith—resigned by now to never having his own children—invested much of his time and energy into the children in his life, either the children of friends to whom he often paid more attention than their parents or, a larger audience for a sizable portion of his work, the greater public of children in hospitals and care centers, schools and playgrounds. The latest god-child in Keith's life, and a draw for much of his love and creativity that season, was Madison Arman, the daughter of Yves and Debra Arman, in Monte Carlo. When he began spending more time in Europe, Keith had been introduced to the Armans by Tony Shafrazi, and they became one of his favorite European families, along with the Picassos in Paris and the Nellenses in Belgium. The son of the French artist and sculptor Arman, Yves was a photographer and art dealer, and his wife, from Fort Worth, Texas, an occasional fashion model. Both car connoisseur and reckless driver, and described by Juan Rivera as "kinda playboy-ish . . . very handsome, debonair," Yves—named for Arman's close artist friend Yves Klein—was an unconditional supporter of Haring's work. He traded an edition of ten photographic prints Haring had made with his own hand, painted with a Japanese brush, for a Picasso etching Yves owned and Keith coveted, "where the artist was fucking the model while still holding his brush and palette," and in another trade, he gave Haring a limp-phallus sculpture in bronze by Marcel Duchamp, comically titled *Objet-dard*. According to Rivera, the Arman home was always "some sort

of *event*," as Grace Jones and her son, Paulo Goude, often stayed there, and Princess Caroline of Monaco stopped by for dinner, with Rivera once preparing for Her Royal Highness his canned beans and rice, which she found "*flawless*." "It was a fun time," Debra Arman recalls. "Keith would be there, Grace, Helmut Newton, Roberto Rossellini, Stefan Johansson, who was a Formula One race car driver, sometimes Yves's dad, Arman. We would all be out on the terrace, sipping champagne, having hors d'oeuvres, and chatting." The Armans were staying in New York when they first learned that Debra was pregnant, and they immediately went down to dinner at Keith and Juan's red-yellow-and-blue apartment (the color scheme of many of Haring's paintings of his "Juan Rivera period") to ask if Keith might consider being the godfather.

In March, a month after leaving Tokyo, Keith traveled to Monte Carlo, this time as a proud godfather, to visit (for the second time since her birth) his seven-month-old goddaughter. There, he turned Madison's nursery into an entire Keith Haring menagerie, painted in pale Monte Carlo blue, with cartoon figures outlined in a darker blue on all the walls of cows, teddy bears, monkeys, and chickens. A crawling baby emitted rays of life above the door, dedicated in red paint "For Madison" and signed in blue, "Love, Keith." He also made for her a changing table, highchair, and crib, descended from his first crib for Juan Dubose in his early Hal Bromm show in New York, though with more circuslike, *Luna Luna*, clowning-bunny-rabbit touches. "He gave her lots of kisses, fed her everything, and rocked her to sleep," Debra Arman said of Keith's routine, which he dwelled on, too, in his diaries: "The feeling of holding a baby and rocking and singing them to sleep is one of the most satisfying feelings I have ever felt. I'll never know the pleasure of having this experience with my own child, but all the times I've done it with Zena and Madison or my little sister Kristen, are deeply embedded in my memory." In a notarized statement, Haring was designated as Madison's "art father," and Grace Jones as her "soul mother."

Back in the United States the next month, Keith was invited to take part in the annual Easter Egg Roll on the White House Lawn. He agreed, while aware from the beginning of the dissonance of his being anywhere near the White House of Ronald Reagan, the subject of his early

protest cut-ups. Even more darkly, Reagan had ignored the AIDS crisis throughout his second term, to fatal effect, having addressed the issue only a few months earlier (after the death from the disease of his friend Rock Hudson), at a speech at a benefit for amfAR, the American Foundation for AIDS Research, chaired by another Hollywood friend, Elizabeth Taylor, at which the president would still not utter the word *gay*. Yet Keith's desire to create a work with children that would be given to a children's hospital prevailed. He put together a "Creative Keith Haring Fun Center," sponsored by Crayola. He also painted on-site a mural on plywood panels covered with canvas to be donated to the Children's National Hospital, in Washington, DC. As the event was a family affair, he invited his parents and four-year-old niece, Lana. "Reagan was not there, but the vice president came out on the lawn," Joan Haring recalls. "I tried to get close to George Bush, and they offered for Keith to meet him, but he said, no, he didn't want to." By late afternoon, the lawn had cleared, and Keith and Kwong Chi were helping pack the mural for transport to the hospital, where he was to appear at a ceremony in a few hours. Sensing a photo op—and as a salve to his conscience— Keith slipped on his "Free South Africa" T-shirt and raised a clenched fist high.

The three other public murals he completed within his five months away from Tokyo were all meant for children or young people. Following the DC Children's Hospital, he was in Atlanta to create a similar pro bono mural—in the style of his colorful and cartoony crib for Madison Arman—for the pediatric emergency waiting room of Grady Hospital, as well as to lecture and lead drawing workshops at the High Museum of Art. Typical, in its condescension, of much of the press coverage of Haring at the time was a piece in the *Atlanta Constitution*—to which Haring, atypically, responded, writing a letter that began "Dear Visual Art Critic," the identification in the writer's byline. Haring deemed the critic's description of his "white boy graffiti, inspired by ghetto artists" as "not only uninformed, but typically racist." Of her comparison of his "charity wall" to corporations underwriting charitable events from a publicity budget: "Maybe you just can't imagine it's possible that there are actually people (unlike you) who do things for reasons other than

their own aggrandizement." In Phoenix, Arizona, he made a street mural by drawing outlines that schoolchildren colored in. For the youth of the Lower East Side, cresting into another sweltering summer, he painted at P.S. 97 a mural inspired by Public Enemy's "Don't Believe the Hype," with safe sex and anti-drug messaging in words: "Safe Sex or No Sex," "Respect Yourself," and images of syringe stabs or a figure snatching a gold key of Knowledge.

He also created special gifts for two of his closest young friends, Sean Lennon and Nina Clemente. "I asked him to paint my guitar," says Sean Ono Lennon, who was twelve at the time. "I thought it would be cool. Jimi Hendrix and George Harrison had painted guitars. One of my favorite straps was Eric Clapton's painted strap when he was in Cream." Sean requested that Haring paint over the instrument's brand name, but when he picked up the guitar at the studio, Keith said, "Sorry, I couldn't do it, I loved that word so much." "It was a Steinberger," Lennon explains. "He just liked the font, I guess. It's a Germanic-looking, clean, minimalist font. He circled around it in a very beautiful way." For Nina Clemente's seventh birthday, Keith devised a charming, all-purpose book not only for coloring, but also for drawing, thinking, and collecting four-leaf clovers or snowflakes. Called *Nina's Book of Little Things*, it was described by Ingrid Sischy as having "a purity that is reminiscent of the glorious feeling that Matisse could give his books." Says Nina Clemente, "In addition to this book, he gave to me, in a cup, a little fluorescent-green cricket, maybe he found on the lawn. I just sat in the grass, on my seventh birthday, while everyone was partying around me, staring at this vibrant green cricket." Innocence was the west wind that blew through much of Haring's work, and he was convinced that by doing public art and making art for and with these children, he was keeping his output alive and safe from the dread curse of selling out, as he seriously considered dropping out of the art market entirely and simply making his own "things."

Keith had planned to spend more of the early summer in Europe, but he was forced to cancel a few trips due to health issues—a first for him. In June, he noticed shortness of breath. His first thoughts were of Bobby Breslau and the pneumocystis that presaged his quick and

terrible death a year and a half earlier. Keith had been having his blood tested regularly since at least 1982—not for the HIV virus, as he and many others felt there was no point in receiving a demoralizing "positive" diagnosis if they were asymptomatic and practicing safe sex—but to make sure his T-cell level was not dropping or to look for other signs of the full-blown eruption of the mortal illness. For his blood tests, Keith saw Dr. Richard Goldberg, a general practitioner in the West Village, who had taken care of (or continued to see) several of his friends, including Martin Burgoyne, Adolfo Arena, and Kitty Brophy. "He was this really cool, older, hippie guy," says Brophy. "He even came to all of our art openings." Keith was doubly concerned now, though, as he learned that Juan Dubose had been diagnosed with tuberculosis, another opportunistic infection related to AIDS. "Not that I needed anything else to tell me that I was a candidate," Haring said. "I knew I was a candidate." Doctors were then estimating that the virus had about a five-year incubation period, so Haring felt overdue. Yet, when he went for a bronchoscopy, no sign of any pneumocystis was found, and within a month, the infection had cleared. He once again had narrowly escaped a more severe manifestation of the demon sperm.

With a clean enough bill of health, Keith flew to Tokyo on July 22, his fifth trip, though one markedly different in tone from the others. Rather than trying to keep up with his own racing thoughts about exporting his pop-up store to other cities on the island nation, or of the Japanese as the only people in the world truly fit to understand Keith Haring, he found himself embarking on a damage-control mission, fearing his Tokyo Pop Shop was falling apart. On his first night in the city, he went to dinner with the Kuzuis to discuss the main problem—fakes. Keith had enjoyed coming across all the purloined Haring designs on T-shirts around the world, but in Tokyo, the copies were both more expert and part of a corporate strategy by large department stores. "People didn't understand the difference between getting a real Keith Haring and a fake Keith Haring, since many of the fakes had my name on them and were photographically reproduced from originals," Haring said. "I wanted to go against the rules as usual and didn't want to do a store with one of the big department stores. So instead they worked against

us and let the proliferation of all the fakes continue . . . The Pop Shop as an idea was supposed to be fun and was supposed to have a sensible distribution network that would not be the same capitalist model that every business follows." With all the commerce of Japan basically run by four department stores, Keith had tried to fight the system. He and Kaz visited a lawyer to discuss bringing a lawsuit against Indio, a large brand making many of the fake T-shirts. Keith wished to announce the legal action at a press conference, and he wrote to Yoko Ono to try to involve her in his crusade.

Given the specificities of Japanese law and the corporate setup, Haring did not prevail. "In Japan, copying started with taking a Ford and making a Toyota," Fran Kuzui says. "It's a tradition. It's part of the culture to copy here. So, people were not very respectful of Keith's copyrights. They just out and out copied, particularly the T-shirts, and sold them on the street. I remember Keith going and confronting them, he was so angry at them. We got a lawyer, but we were told there was nothing under Japanese law that could be done. That really angered Keith. Japan offered no infrastructure for taking care of intellectual property." Compounding the problem was his need for strict quality control, a standard difficult to maintain long distance. "What he didn't reckon with was that by insisting that a product be manufactured in the U.S., so that he could oversee the quality, by the time it was exported to Japan, the individual items were incredibly expensive," Julia Gruen says. "At the time, it seemed crazy to Keith and me that a cup of coffee in Tokyo cost four dollars. The Japanese visiting New York were willing to wait in line for hours in front of Chanel on Fifty-Seventh Street or Tiffany's to buy there, but they would not pay fifty dollars for a Keith Haring T-shirt (which is what they ended up costing) when they could go around the corner and get one for ten. The prices spiraled down. That was an enormous disappointment for Keith. He was incredibly upset, angry, hurt, frustrated, as he began to realize it might not work."

One evening, in his favorite small hotel in Shibuya, Keith sat reading Frances Fitzgerald's *Cities on a Hill*, a collection of four pieces originally written for *The New Yorker* about four visionary American communities, including a fundamentalist church, a commune, and a Sunbelt

retirement city. The book had been a gift from Julia, and Keith started with the chapter of most interest to him—about the Castro neighborhood of San Francisco, which he had first visited with his girlfriend, Suzie, in 1977. Back then a center of gay liberation, it was now the hard-hit epicenter of the AIDS epidemic. He read of one young man who kept inspecting himself every day, fearing he would discover a small purple skin lesion, a sign of Kaposi's sarcoma, the rare skin cancer that was often an early indicator of AIDS. Reading until three in the morning, Keith could not help scouring his own body. And then he found it—a purple "splotch" on his leg. He resolved to have the spot checked as soon as he returned to New York.

The next day, he went shopping in Harajuku and Shibuya while bothered by a persistent cough and, suspicious of the purple spot, worrying that he was now ill. When next he dined with the Kuzuis, to try to figure out a possible future for the Pop Shop, he stressed to them that the situation might change quickly if he was sick, and the possibility of his passing away must be faced, too. A month later, he would write to them confirming his final decision to close Pop Shop Tokyo. "You might be surprised to find out that I fully agree with you!" Fran Kuzui faxed him back. ". . . we both support you and love you."

In his last few days in Japan, Keith flew to Hiroshima, to visit the site of a historical apocalypse, the dropping by the U.S. military, toward the end of World War II, of an atomic bomb and the creation of an actual nuclear cloud—the image of annihilation that had haunted Haring's drawings since high school. He was also exploring a proposed commission to paint a public mural and was being shown several possible locations, while recorded by a TV crew and photographer. Rather than an installation in the Kisho Kurokawa–designed Hiroshima City Museum of Contemporary Art, on Hijiyama Mountain, he chose to do a mosaic-style painting on the outdoor wall of a public school across the river from, and facing, the Peace Park and the Atomic Bomb Dome, a prewar structure left partially standing after the bombing as a reminder of the vast destruction. He also visited the Peace Museum, where he was shaken by a photo of a pile of human skulls and footage of radioactivity's aftereffects that was "nothing short of science fiction horror," as well

as by reading reports of black raindrops and melted faces. Striking him most powerfully was a photograph taken of Amy Carter, the teenage daughter of the former president, Jimmy Carter, visiting the museum with her father in 1984: "The look on her face says it all. It is maybe the archetypal expression of any intelligent, sensitive American teenager upon realizing for the first time the profound reality of our fragile situation, and possibly our future. In one picture all you can see is one eye and part of her head, since she is standing behind her father. The terror in her eye is so real and so sincere that it riveted me to tears." Haring was passionate about having a personal statement included in the Peace Park, though that project, too, would prove a disappointment for him in Japan. According to Fran Kuzui, "When they later heard rumors Keith had AIDS, they canceled the mural, and he got really angry. I think at that point it was just an accumulation."

When Keith finally flew out of Tokyo, on the last day of July, he left behind a city of dreams that had turned nightmarish. With the scene of the fight with Juan (which still shaded their relationship) and the failure of both the Tokyo Pop Shop and, soon, the Hiroshima mural, Tokyo had become an accidental symbol of an abrupt downturn in his life. Most disturbing of all had been the discovery in his Tokyo hotel room of the small purple spot. When Keith returned to New York City, he checked again—the lesion was still there, as well as another, on his arm. He was about to enter more fully the universe of doctors, clinical labs, pharmacies, and repeated needle punctures and tests that constituted the world of those officially diagnosed with AIDS, a world that supplanted the radically different one that had so recently been theirs. He called his doctor, and both a biopsy and blood tests were scheduled. The biopsy confirmed within a week that the spots were indeed Kaposi's sarcoma, the rare opportunistic cancer that had been the original clue for the medical community of a mysterious new threat. His blood tests revealed that the level of T4 lymphocyte cells (helper cells of the immune system) had dropped dramatically, too. His symptoms now exactly fit those of AIDS. Upon receiving this diagnosis, he began taking AZT. Though still a primitive drug with many toxic side effects, it was the first medicine found to slow the replication of the virus and extend,

if not save, the lives of patients. "Basically, all the doctors are telling you is that there is nothing you can do," Haring said. "You take care of your health. You watch your diet. But there is no miracle drug, and no secret to the whole thing."

Two years earlier, a week after seeing an obviously very ill Martin Burgoyne and realizing that his friend would die, Keith had made a large drawing with brush and black ink on paper titled *Weeping Woman* and signed and dedicated to Timothy Leary. The drawing was always associated by Leary with Keith's response to AIDS. The lines of the weeping woman's ancient face and the outlines of her falling tears are impossible to distinguish. Whether nose or furrowed brow—all becomes a swirl, like the age rings in the trunk of an old tree or a fingerprint. Her eyes, indicated by two white squares floating in two black half-moons, convey a plutonium weight of sadness. "This work is shockingly different from Keith's usual expressions," Leary wrote. "It conveys the anguish, the terror, that he felt and that we all felt when we learned of Keith's condition. Look at this drawing. Does it not evoke in the beholder the full blast of our grief?"

Tears were a daily event in downtown Manhattan in 1988. Young men could be seen crying openly on the streets, clutching a prescription on their way to a pharmacy. "Back in New York, I would visit Keith in his studio," says Fran Kuzui. "The two of us would sit and talk and, honestly, sometimes just sit there and cry." Keith's first response to his diagnosis was tears: "At first, you're completely wrecked. You go through a major, major upset. I mean, even though I sort of expected this to happen, when it actually *does* happen, you're not prepared. So the first thing you do, is break down. I went over to the East River on the Lower East Side and just cried and cried and cried. But then you have to get yourself together and you have to go on. You realize it's not the end right then and there—that you've got to continue, and you've got to figure out how you're going to deal with it and confront it and face it."

Silence = Death

O*ne afternoon during* the early summer of 1988, between trips to Tokyo, Keith had been walking down lower Broadway in SoHo with a camera lent to him by *Spin* magazine, on assignment, along with a few artistic clothing designers of the moment—Stephen Sprouse, Betsey Johnson, Angel Estrada, Agnès B.—to record his impression of "street fashions." He was amusing himself—snapping pictures of passersby with elf-look boots, torniquet pants, and a young boy with a fake

Gucci cap—when he suddenly spotted his old friend, sometime rival, and most certainly "the most influential painter of my life," Jean-Michel Basquiat. The two were hardly estranged, yet they rarely saw each other anymore, especially since the death of Andy Warhol. Jean-Michel asked what Keith was doing, and when Keith explained his *Spin* assignment, Basquiat responded with a characteristic mix of victimhood and superiority, "People never ask *me* to do things like that!" As Haring wrote, "I knew that what I was doing was kind of stupid, but I asked him if I could take his picture. He said, 'Sure! I'm dying to be in *Spin*.'" Wearing a nautical-striped T-shirt, Basquiat instantly lay down on the street, on top of some open gratings—"Sort of like a homeless person," Haring wrote—hands behind head, eyes closed, his face suffused in a sweet smile. The picture ran as a snapshot, among a jumble of other photos Keith took that day, with the caption "Jean Michel Basquiat Coolin' on Broadway." "Jean-Michel looks great that day," Haring recalled. "He tells me he was kicking again—that he'd just come back from Hawaii and that he had definitely kicked heroin this time. And we talk about the work he's going to do." Asked if the rumors of his being sick were true, Keith lightly responded to him, "It's only as true as I look." And then the two parted.

While Haring and Basquiat had known each other for nearly a decade, and while much in their lives and careers had changed, their respect for each other remained sincere. "I once asked Jean-Michel Basquiat who his favorite artist was—not meaning Picasso or Warhol, but of his own generation," Glenn O'Brien remembered. "He didn't hesitate, but said 'Keith Haring.'" Of Basquiat, Haring told *Rolling Stone*, "From the beginning, he was my favorite artist." In 1983, when Haring was in Europe to exhibit in a group show at the Galleria Salvatore Ala in Milan and Basquiat was visiting the city with Warhol, Keith and Jean-Michel had taken an idyllic side trip to Madrid together. With their careers inflating at about the same rate, they dealt with many of the same personalities, "always sort of checking up on each other," according to Haring. Keith had been envious of the attention given Basquiat by the European dealer Bruno Bischofberger, though Basquiat's New York dealer now was Vrej Baghoomian, Tony Shafrazi's cousin, who had

worked with Keith at the Shafrazi Gallery and had recently opened his own gallery in the Cable Building. Jean-Michel complained about Leo Castelli showing Haring in his gallery and not him. Both felt left out of the important Saatchi collection, and both sensed a strange shift as the sleek, geometric modes of the Neo-Geo and commodity art movements and artists Ashley Bickerton, Peter Halley, and Jeff Koons began replacing them as the next new thing. "In a way they were pushed aside by this movement," Castelli said. Jean-Michel was more likely to voice his ire, or any resentful vying. "They still call me a graffiti artist," he told Anthony Haden-Guest of *Vanity Fair*. "They don't call Keith or Kenny graffiti artists anymore." When Warhol spoke once about an upcoming sale of his work at an estimated price lower than Lichtenstein's, Basquiat said, "I'd be mad if in 20 years, Keith Haring is $500,000, and I'm only 100,000." Keith, though, rarely veered from the "worshipping from afar" he had first felt for the creator of SAMO. A year earlier, when he sold several works to Bill Cosby, Haring's first impulse upon hearing that Jean-Michel was down and low on funds—his financial situation could rise and fall dramatically, given his free spending—was to stop by Great Jones Street to gift him some cash.

Keith's chance encounter with Jean-Michel on lower Broadway turned out to be his last, its memory staying with him as clearly as their first meeting, when he ushered Basquiat past the SVA security guard to roam freely in the halls writing SAMO tags. Within days of receiving his own AIDS diagnosis, Keith was at his parents' home, visiting with Juan Rivera, though he had not yet informed Allen and Joan of his health status. He learned the news of Basquiat in a phone call to the house from Jean-Michel's father, Gerard. On August 12, 1988, the twenty-seven-year-old artist had been found dead from an overdose of heroin in the loft he was still renting from the Warhol Foundation. He was last seen, earlier in the evening, at a party at M.K., a new club started by Area owner Eric Goode on lower Fifth Avenue, where Keith had thrown a quiet post–Party of Life party for his thirtieth birthday in May. "I remember our standing on his mom's back porch, and he was very upset," Oswald says of Keith. Casting back to his and Kenny's response to Warhol's death, Keith told Kermit that they must build a bonfire, so they

drove out to Kermit's place in the country, along with a few friends who had come with them from New York, to create a blaze of fire in honor of Basquiat. "It was really kind of somber, really sad," Oswald says. "A real Viking funeral fire." The next morning, Keith and Kermit, who had moved back to Kutztown to raise a family, walked down to the spent fire to witness the surprise of a mass of white butterflies hovering above the charcoal ashes in a large cone. "That's Jean Michel!" Keith said. Quickly upon returning to New York, Keith painted an homage to Basquiat, *A Pile of Crowns for Jean-Michel Basquiat*. On a triangular canvas ten feet by nine feet, bordered in a Stop sign shade of red and limned in black, Haring painted a vibrant pile of three-pointed crowns, Basquiat's tag, along with his familiar "©" copyright symbol. Oswald is certain that the work's shape was inspired by their "weird and spooky" sighting at the bonfire: "It was this perfect pyramid of little butterflies, and just about that size."

Over the next few months, Keith never stopped honoring his departed friend. Asked by *Vogue* to write an obituary, he composed the first of several drafts in late August, in Roussillon, at Yves Arman's family house in the South of France, where he once again visited with his goddaughter. In "Remembering Basquiat," he revealed his admiration for Basquiat as beyond simply a painter. He was a "supreme poet," who used paint like words, and a "newborn philosopher," uttering with a visual stutter "a seemingly effortless stream of new ideas." Keith wrote of classic moments—as when Basquiat smeared a couch at Fiorucci with wet paint from a canvas he was carrying, or when he threw a huge stack of dollar bills from a taxi window to a panhandler on the Bowery. The tone of the essay was at its most personal, though, when Haring spelled out the damage he felt was done by the eighties art world, clearly speaking from experience: "The last decade was not an easy time to be an artist, especially if you were young, unusually gifted and honest. Achieving success was not a problem for Jean-Michel. Almost as quickly as people began to see his work, they recognized its value and began to collect it. Success itself was the problem." Haring made the same point speaking with Phoebe Hoban for *New York Magazine*: "He had to live up to being a young prodigy, which is a kind of false sainthood. At the same time, he

had to live up to his own rebelliousness and, naturally, the temptations of tons of money. The problem of dealing with success shouldn't be underestimated." Also thinking of himself, he praised Basquiat's "obsession" with art for having "created a lifetime of work in ten years."

Haring spoke at the memorial service, which was held on a stormy November afternoon at St. Peter's Church in the Citicorp Center on East Fifty-Third Street. Hundreds attended. A eulogy was delivered by Ingrid Sischy; Basquiat's band, Gray, performed; John Lurie played saxophone; and poems were read by Jennifer Goode, Suzanne Mallouk, and Fred Brathwaite. When Keith came forward to speak at the pulpit, in front of a large portrait of Basquiat, his voice was both serious and controlled. "Jean was a true individual," he said. "He defended his right to control his own destiny. He didn't follow rules. His disdain for conformity permeated every aspect of his work and life. He disrupted the politics of the art world and insisted that if he had to play their game, he would make the rules . . . His images have entered the dreams and museums of the exploiters. And the world will never be the same." On his way out of the chapel, pulling on a light overcoat, Keith ran into Stanley Strychacki, the founder and caretaker of Club 57. To Stanley, Keith's face appeared "more oval, and it seemed more noble than any time before," and he recalled him as saying, "Stan, we loved Jean-Michel very much. He was our kid, your kid, too. He will know what we feel about him, and he will be with us forever, won't he?" Stanley touched Keith's cheek. Keith flashed back a melancholy smile and disappeared through the door.

The late summer and autumn of 1988, for Keith, involved working tirelessly to fulfill prior commitments—most pressing, an upcoming exhibition at the Hans Mayer Gallery in Düsseldorf and another of his nearly annual shows, scheduled for December, at the Tony Shafrazi Gallery— while living with the knowledge that he had crossed an invisible border in the progression of his disease. Passing through this checkpoint meant that any "magic" summoned to change the outcome would need to be extraordinary and potent. Like many others with this diagnosis, he

could be found drinking special herbal teas; ordering foul-tasting ruta-baga soup or other novel dishes prepared in crockpots and containing supposed nutritional benefits; or looking into alternative medicines, such as Compound Q, smuggled into the country from France, Mexico, or China. Researching experimental medications became an item on Julia Gruen's daily to-do list, a list begun a mere four years earlier with a very different search—for white lilies for Madonna's performance at the first Party of Life. Still suspicious of the origins of AIDS, Keith believed most wholeheartedly in the magic of art. "I really want to . . . try to heal myself by painting," he affirmed in his journal. "I think I could actually do it." The belief driving his painting bright murals in children's hospitals had not been simply that the work was happy, decorative, and distracting, but that art could be positively healing. He now applied this therapy with redoubled intensity to himself. "Once Keith got his diagnosis, he basically just ramped up everything," Julia Gruen observed. "He just worked and worked and worked and worked and worked. He created so much art."

Within a few weeks of receiving his diagnosis, and just days after finishing his memorial tag painting for Basquiat, he was once again on the Concorde, with Juan, with whom he was still living, as they had pieced their relationship back together after Tokyo. They were en route to Düsseldorf, by way of Paris, for the major exhibition of Keith's painting and sculpture at the Galerie Hans Mayer, which he felt to be "one of the best galleries in Germany." The gallery had opened in 1970 with a show of Andy Warhol, and the gallerist had been identified ever since as a dealer of pop art in Europe, a position that had always attracted Keith to him. A brilliant and successful gallerist, Mayer relied on his instincts and often reacted to work he liked by his artists with the single remark "Super!" Mayer's influence was burnished by his wife, Stephanie, who organized many of the vernissages, dinners, and garden parties at their home, introducing artists and collectors. Keith had been working with Mayer for two years, primarily on the series of sculptures that were part of the agreement between Mayer and Shafrazi. Both dealers had been involved with the Tehran Museum of Contemporary Art, and Mayer for several years was leery and envious of Shafrazi. Through representing Haring,

he had "since gotten to know him," Mayer said, "and I feel he's quite a marvelous person." "Tony and Hans were both good dealers, and both very well connected," says Klaus Richter, a sculptor who helped Haring while an assistant in the Galerie Hans Mayer. "Tony pushed Keith a lot. Hans was smart about money, and he knew how to put together a perfect exhibition quite speedily. He had it all in his head."

The first of the sculptures Haring made in Germany was *Red Dog for Landois* (later, simply *Red Dog*), finished within six months for the 1987 Skulptur Projekte Münster, presenting outdoor sculptures by fifty-three artists, including Jeff Koons, Claes Oldenburg, Jenny Holzer, A. R. Penck, and Donald Judd, at sites chosen by the artists. The prestigious exhibition had been conceived by Klaus Bussmann, the director of the Landesmuseum, the organizing institution, and Kasper König, one of the most respected curators in Europe. When Haring was shown a nineteenth-century zoo, the animals since moved to the suburbs, according to Richter, "Keith became totally angry and said, 'Wow, I don't understand! Now the kids have to go out of the city to see animals.'" He righted this wrong with a barking-dog sculpture weighing several tons, in Corten Steel, varnished red, the tip of its nose fifteen feet from the ground, described in *Artforum* as "a red-hot performer in the green paradise of the park—an altogether witty, personable character." The drawings for the four sculptures in the Mayer gallery show were done in one day, in an empty studio at the Kunstakademie Düsseldorf. "At this time, Keith was already like a pop star in Germany," Richter recalls. "He wore a blouson jacket, untied basketball sneakers, a fisherman's cap, and everyone recognized him. Nobody looked like this on the streets of Düsseldorf." Keith enlisted Kermit Oswald and Kermit's father, an expert patternmaker, to create maquettes from these drawings, and the pieces were cast at an industrial steel shop in Düsseldorf. As the sculptures were untitled, Richter used the working titles that Keith had adopted: *Boxers, King and Queen, Head Through Belly, Headstand*. The poster image for the exhibition, *Headstand*, was an orange-and-green sculpture of a b-boy with legs firmly planted on the ground, while a second flips upside down in midair to perform a headstand not only on but into his head, the two circles of their heads set at right angles, interlocking. "That's

you and me," Keith said to Kermit, presenting him with one. "It's the two of us, joined at the brain."

The paintings in the show were all unstretched canvases nailed to the wall, the largest of them, twelve by eight feet, limited to a stringent palette of thin white lines in black negative space within a white double border, looking like an early Haring chalk subway drawing. The message of this large painting was the heaviness of the burden of AIDS, a lament emerging as unmistakable in many of the paintings beginning to appear from Keith's studio. For this painful theme, Haring found he needed a new or expanded visual alphabet of signs and symbols. Starting with the demon sperm of the *Apocalypse* silk screens, he began generating images to better tell this horror story, some of the glyphs harking back to his earliest sumi ink drawings at Club 57 and P.S. 122—now looking the same, yet somehow entirely different. Much of the imagery was spilled forth on a single day, April 24, 1988, when he created, in a headlong rush, a series of red and black sumi ink drawings on paper. He envisioned his demon sperm hatched from a Sisyphean rock of an egg, strapped to the back of a man climbing stairs (the ziggurat stairs of his Club 57 drawings) to a man seated at the top, who cracks the egg with a stick and releases the inky black horned sperm to prey on a crowd with upraised arms below. In several variations, he shows the means of transmission (syringes, penises, and vaginas) and the causes (a sperm slithers from a test tube to wrap around a cross, a dollar sign, and even a four-handed swastika). The final drawing in the series, in the words of German author and curator Alexandra Kolossa, "shows a calligraphically graceful portrait of the sperm." The large painting in the Mayer exhibition was a close-up of this outbreak of disease from the monstrously sized egg on a trapped man's back.

The Düsseldorf opening was arranged as a staggered double feature, with Haring showing in a new space opened in the harbor district, while an exhibition of the American film star Dennis Hopper's photographs from 1961 to 1967 ran at the original gallery in the center of the city. The Hopper show opened the night before. Mayer then threw a big dinner party with about four hundred guests for both artists on the Saturday evening of Haring's opening, August 27, at a famous fish restaurant in

town. "It was the first I saw Keith, in a way, jealous," Klaus Richter says. "Keith came in, and people started to clap; it was fine. But, suddenly, Dennis Hopper came, and he got a standing ovation. Keith was a little bit irritated."

Any momentary competition aside, Haring and Hopper were deeply admiring of each other. As the director and costar, with Peter Fonda, of the quintessential sixties movie *Easy Rider*, Hopper embodied for Haring, in both the "wild form" of his acting and his kinetic highway photographs, the spontaneity he had hoped to emulate from the Beat writers Kerouac and Burroughs. Hopper's friendship with Shafrazi dated back to their 1966 meeting at a group show that included the actor's L.A. photographs at the Robert Fraser Gallery. When Hopper chanced on a twenty-foot-long horizontal scroll of a drawing by Haring in the 1982 *Urban Kisses* show at the Institute of Contemporary Arts in London, he got in touch with Shafrazi. "Dennis showed up in New York all crazy about Keith Haring," Shafrazi says. "Like his very early discovery of Andy Warhol, he was that excited about Keith's work."

At the artists' dinner, accompanied by his pregnant young girlfriend, the actress and ballet dancer Katherine LaNasa, whom he would marry, Hopper regaled everyone with tales of Hollywood and his colorful experiences with drugs. Photos of the two artists and two gallerists taken at the openings show them falling easily into copacetic poses. "They were a strong quartet, with an intelligent camaraderie," Stephanie Mayer says. "When they were together, you could feel their candles burning at both ends."

Back in New York City, Keith devoted most of the fall to creating work for his December show at the Shafrazi—much more than the few weeks taken to make his red-yellow-blue series for his previous exhibition. Going up after a Kenny Scharf show in October, and Ed Ruscha's early paintings in November, Haring sensed his own show's importance. "My show at Shafrazi in 1988 means a lot to me," he said. "It's the most important show to date. Because of my health situation and because of the death of Andy and Jean-Michel, I felt it was time to prove something. As it was the kind of show that would either make me or break me, there were a lot of expectations, both on my part and on the part of others.

If it failed like the last show, then I might simply be considered a failed artist . . . I felt these works were almost a summation of what I had accomplished in painting so far. I tried to show my drawings and my use of color to the very best of my ability." Haring felt pressure to make statements that would unify all that had gone before with all that was happening now in his life and art. "There's one last thing in *my* head," he told *Rolling Stone* the following year of his state of mind while working on the show. "With the thought of—of summing up. My last show in New York felt like it had to be the best painting that I could do. To show everything I have learned about painting . . . a certain sense of summing up."

Pleased with the geometry of his painting for Basquiat, he made other canvases shaped as triangles and circles and even more monumental-size squares and rectangles. Displayed across from the Basquiat triangle in the exhibition was an upside-down triangle painted shocking pink and covered with an intricately drawn veil of silver figures, their hands over their eyes, ears, and mouths—seeing, hearing, and speaking no evil. It was titled *Silence = Death*. The painting was an homage to the "Silence = Death" graphic that had been wheat-pasted onto walls and phone booths all over town: the slogan sits beneath an inverted pink triangle like that worn by homosexuals in Nazi concentration camps. The image had been designed by Gran Fury for ACT UP, a coalition of AIDS activists founded in March of that year. It was Haring's attempt to get out this message of AIDS activism by any medium available, as he had once corrected Marshall McLuhan's famous "The medium is the message" with "The message is the message." A companion biomorphic piece, charged with both sexual and racial politics, was a tall, pink, penis-shaped canvas titled *The Great White Way*, charting a rising skein of tattoo-like dollar signs, crosses, and crowns climaxing in swords, guns, and atomic symbols, an orgasm of death. In one of three circular paintings he was creating, a bloodthirsty pig-faced monster with a dollar bill for a snout, straight out of Dante's *Inferno*, chews on the scarlet bodies of damned human victims. It is a melting disturbance. (Another circular canvas, *Monkey Puzzle*, was a less topical work, playing on the double meaning of a monkey puzzle tree and a puzzle of monkeys,

a balancing act of color and forms.) "He was being very brave and very open," Sean Ono Lennon says of Haring during visits Lennon was making with his mother to Keith's studio. "If you look at his work from that time, a lot of it was very dark. He faced his situation honestly—his painted demons, his hieroglyphic language said it all."

The four twelve-by-twelve-foot square or eight-by-fifteen-foot rectangular works in the exhibition were all painted on raw canvas, with color soaking into the canvas while often allowing some white space to show through. Keith felt the technique was "a new direction," and Kermit Oswald describes the works as "the paintings I think of as being Frank Stella–esque, where he left the raw canvas in between." (Early Stella had been much on Haring's mind since he attended a MoMA retrospective that year.) Dominating the far wall, when one entered the gallery, was a close cousin of the black painting in Düsseldorf, this time illustrating the slim white lines of scissors of Fate cutting a thick, white, meandering lifeline wrapped like a strangling cord around the body of a tall figure squeezed against one side of the canvas. Seen from a distance, the wavy, white umbilical line might also be a hand squeezing its chosen victim, or a dove, or a cloud, as the painting, wrote Robert Farris Thompson, "pulls the pinstripes of Frank Stella into figuration." More comic was *Media Girl with Cigarette*, a painted assemblage of a television, a speaker, and a boom box with a telephone ear, puffing away. *Red Room* was the most ambitious of the works—a painting in conversation with Matisse's *L'Atelier Rouge*. More someone's living room than a studio, the hermetic space of Haring's rectangle suffused in Venetian red is dominated by a woman kicked back on a chaise longue with one bootie on and one off. The figure looked to the German art historian Ulrike Gehring to owe her pose and style to Manet's *Olympia*, yet she was also remarkably like the hippie chicks in disco boots Keith had been fond of drawing in Kutztown and Pittsburgh. The still life glass and fruit bowl of Matisse are updated into a telephone and a remote control. With her arms behind her head, this odalisque may well be watching an off-canvas TV. On the wall, instead of Matisse's own works in progress, hang reddened versions of a Jasper Johns *Target* and one of Stella's sixties *Protractor* paintings.

The show was the success Keith desired. Circles of family and friends were at the opening along with artists, including Julian Schnabel, Francesco Clemente, Yoko Ono, Kenny Scharf, and Donald Baechler. "The artists came and that always means something to me," Haring said. "When an artist comes to your show, it always means there's something there to look at. And when he comes to your studio, that's even better." Keith circulated among everyone—wearing a green striped jumpsuit with a medallion of a six-pointed star, like an amulet, hanging from his neck—both at the gallery and at the customary dinner of roast Peking duck at Mr. Chow, all documented by Tseng Kwong Chi. The public loved the show, too, and nearly everything sold. While the exaggerated size of the paintings on the first floor demanded most of the attention, the basement was filled with works on paper, especially collages using autographs, children's artwork, pages from periodicals, and altered *Mona Lisa* prints. "He had been hanging out with George Condo quite a lot, and you could see a huge influence in the drawing style as it got more complicated," Donald Baechler says. "He was becoming a much more interesting painter by the time of that show at Shafrazi. I definitely think the last several years of his work was done with knowledge of his mortality. He seemed to be repeating himself there for a few years. And then it started opening up toward the end of a really brief career." Bruno Schmidt agrees: "I loved the stuff from P.S. 122 and all that. But the work in that show and beyond was unbelievably beautiful. You could tell everything was coming out. He was going in every different direction. He was maturing. As art, that was his best work." For some, though, the subject matter could be a jolt. "The dark vision really worried me," says Haring's SVA friend Rodney Alan Greenblat. "He seemed angry at what was happening to him. So much of his work had been life-affirming and about happiness. At the same time, it was profoundly powerful." In the most dissonant moment of the opening, *A Pile of Crowns* came off the wall and fell to the floor. "It went *BOOM* and just sat on the floor," Tony Shafrazi says. "It showed its presence. It really shocked me and Keith, everybody, like an omen of some kind, very unusual." Keith turned to Kermit, who was standing next to him, near the canvas, and said, again, "That's Jean-Michel."

Neither the *New York Times* nor *Artforum* reviewed the show, an unusual lapse. Haring felt the reviews that did come in to be "very shallow." Yet his dismissal of them did not match the overall tone of their thoughtful conclusions about his current work or of the meaning of his career. Missing from all were the usual snide refusals to be tricked by an artist suspected of being a mere PR stunt. In *ARTNews*, Ruth Bass wrote, "This show of Keith Haring's drawings, collages and strikingly handsome monumental canvases was a lively, provocative meditation on life, death and the loss of innocence." Bass found the canvases to "reflect a new mastery of color," and the *Silence = Death* triangle, an "unpretentious combination of eulogy and humor, decoration and polemics . . . Haring at his best." Christian Leigh, in *Flash Art*, viewed the show as "presenting the sexual politics of the moment . . . The issue of AIDS appears front row and center." Leigh was most drawn to the "new collages in which beefcake and teenage suicide share the spotlight. These collages are at once intriguing, pleasing, combative, and occasionally even emotionally jarring. They bring Haring to a new juncture while allowing him room for expression that links them successfully with his signature oeuvre." Elizabeth Hess, in the *Village Voice*, was unreserved: "History may prove Keith Haring to be one of the most significant artists of his generation . . . Haring has stretched the audience for art, which ranks as one of the most innovative—and progressive—developments in the art world over the recent decade. . . . The flow of Haring's line has evolved into a confident script, like handwriting, which is legible on any surface."

By the time the Shafrazi exhibition came down in January 1989, more than satisfied with its outcome, Keith was also convinced that he was in love again—this time with a straight nineteen-year-old Puerto Rican deejay, Gil Vazquez. Born and raised uptown, in Spanish Harlem, Gil had attended Brooklyn Technical High School; Manhattan Center for Science and Mathematics; and, briefly, LaGuardia Community College in Queens, and he was trying to deejay nights while working sales jobs. They had been meeting on and off for nearly a year, after first seeing

each other the spring before, when Gil happened to walk by with a friend while Keith was loading panels into a van in front of his studio to go to the White House Easter Egg Roll. "I stopped in my tracks," recalls Vazquez, who was eighteen at the time. "'That's Keith Haring!' and kept walking. We made eye contact. I smiled, he smiled." Haring said, "He had this aura around him, and he was incredibly beautiful. I thought I was never going to see him again." A few weeks later, Keith's studio assistant Adolfo Arena had stopped by the clothing store Aca Joe and spotted Gil at work. Not knowing of his and Keith's previous encounter, Arena did some matchmaking: "I said, 'Keith, you gotta stop by this store. Don't worry about it. You'll see once we get there.'" This meeting had led to an invitation to the studio, which Gil can date to May 21, 1988, as Keith was hammering nails and screws into a kitsch *Mona Lisa* reproduction bought on the street, a dated work. "It's embarrassing to mention, but I didn't know that Keith was gay," Vazquez says. "You walked into the studio, and there were paintings of penises everywhere. It was almost obvious, though not to me. In my eighteen-year-old brain, I had an idea that all gay men were flamboyant or swishy. I didn't get any sense of that from Keith. I just felt welcome. It wasn't at all threatening to me. With Adolfo and Julia, there was just such a great energy that existed there."

"Then I saw him again, and we began a friendship *not* based on sex," Haring said. "He's smart, sympathetic, and clever. He starts to be an intellectual companion for me. For the rest of 1988 and into 1989, more and more of my time is spent with Gil . . . I didn't want to have sex anymore. I didn't want an emotional relationship that was just based on sex, which is pretty much the sum of everything I had with Juan." Adolfo had no problem adjusting to this new and rather novel relationship. "It was never a physical relationship," Arena says. "He met somebody intellectually that he was attracted to. Fact. Forget about it. After that, it was Gil everything. I'm fine with that. As long as my boss is happy, he makes the whole world happy, so I'm happy." Says Kermit Oswald, "I used to file Gil under 'Muse.' And Keith liked being around good-looking people. Gil was a cute, nice, smart kid." Yet their friendship could be tricky for others to comprehend. "Seems like it's really

hard for everyone else to deal with our friendship and everyone seems
to keep interfering," Haring wrote in his journal. "It all seems really
simple to me. All I know is he makes me feel happier and smarter than
anyone I ever met in my life. It sort of brings a lot of things to the sur-
face that are lurking just below. We can talk for hours." Says Vazquez,
"I certainly heard the whispers criticizing it. We got so close so quickly
that it rubbed some people the wrong way. In some cases, it was dear
friends of Keith's, out of concern for him. 'You're in love with a straight
kid? What's going on here?' My straight friends were like, 'Hey, yo, is
this something new?' We got it from both sides. The Jets and the Sharks.
What kept me there? Keith's energy. The way he expressed love. His car-
ing and his super generosity."

Keith told only two people at first of his HIV status—Gil and Juan
Rivera. Yet, according to Juan, Keith told him the news in the most
cursory manner, saying, "You better get yourself checked." Juan did
and discovered that he had ARC, not AIDS, with some early symptoms
such as thrush, fungus, and cold sweats. Keith was not talking with
Juan about his own illness, and "*that* really bothered me," Rivera said.
"'Cause he'd come home and act like I didn't exist." Among other sub-
jects not shared was Gil Vazquez. When Keith took Gil on a short trip
to Paris in the fall of 1988, Juan did some sleuthing to find them out,
beginning with discovering that Gil was not at his job at Aca Joe for two
weeks and then showing up at the airport upon their return: "And when
I got there, I spooked him out at a distance, and there was Gil, standing
by his side. So, I said, okay, that's *cool*, and left." Never entirely disposed
to talking about his feelings—certainly not with either Juan Dubose or
Juan Rivera—Keith was not handling the situation in the most direct or
sensitive manner. To him, Juan Rivera used to be a "mirror," and now he
was "like talking to a wall"—yet, of course, he was neither. "Something I
might have wished for Keith was more self-analysis and self-reflection,"
Julia Gruen says. "He didn't live long enough to develop a certain kind
of maturity. And yet the journals belie that, as he became very reflective
during a certain period, wise beyond his years." Keith and Juan contin-
ued living together for some months longer and never entirely quit each
other emotionally. "I was only in their apartment once," Gil Vazquez

says. "Juan was a beautiful man. He was super nice and never said a bad word to me. He probably hated my guts, and he probably had good reason. Was I a home wrecker? In my naïve young mind, Keith and I were just friends. So, what was the problem?"

In February, Keith decided to seize the moment and invite Gil to accompany him on a month-and-half-long trip to Europe and North Africa, a sort of friendship honeymoon with lots of luxury and no expense spared and with far fewer work projects slated than usual. "I'm definitely ready for a vacation," Haring said. "I need to be away with him. I need to take time off." Yet, about a week before their departure, Keith received an urgent call from Juan Dubose's mother telling him that her son was ill and that she was distraught from watching him grow sicker. Juan had checked himself into St. Luke's Hospital, where Keith immediately visited him, finding him wasting away in bed. Juan informed him that he had AIDS, which Keith already suspected, but Dubose had no regular doctor and was not being tested or given AZT. Knowing the treatments because of his own condition, Keith talked with the doctors, and they began running tests, and he arranged for a television and phone to be put in the room. As he was leaving, Juan reached up to kiss him. At the door, Keith turned and waved goodbye. The next morning, Juan's mother called to say that her son had died. One day later, February 4, 1989, Keith painted a large raw canvas in rich Matisse purples, reds, greens, and yellows—Matisse also used raw canvas as both color and texture—depicting a circular vase from which poked green stems, surrounded by a pile of purplish lilacs. The flowers had all been cut at full bloom and left ungathered below. It was an untitled elegy.

Keith delayed his trip for a few days so he could help Juan's family organize a wake and funeral. "I now call our friends, and it's very hard, because my telling them that Juan had died of AIDS is the same as telling them that I'm going to die of AIDS," Haring said. "I mean, Juan Dubose was my lover for four years . . . I hadn't even told my parents that I was sick yet, and I had to tell them about Juan. They sort of knew I was sick, but I never had really sat down and told them exactly the whole thing at that point." The funeral for Juan Dubose was held at St. Philip's

Episcopal Church on West 134th Street in Harlem, and the sanctuary was filled with the many old friends Keith had called to ask to attend. In the church's program for the service, Keith Haring was described, among the survivors, as a "special friend," and Juan was honored—"The music world has lost another 'shining star.'" Bruno Schmidt, who attended the funeral with Keith, says, "They had a lot of food and a lot of gospel singing, and it was an open casket. I remember Keith staring at the coffin and saying, 'Well, soon it will be me there.'" Haring had worried that he would be scared confronting the open casket, yet when he came forward and saw his friend lying in repose, dressed in a suit, he was relieved: "He looked so beautiful, it's incredible. And peaceful." Haring would continue listening to, and painting to, the old collection of mixtapes Juan Dubose had made for him. As he wrote in his journal, "The one thing he left forever was his spirit through the music. Even in those tapes of other people's music, somehow his presence is there. It's strange."

Two days after Juan's funeral, Keith and Gil finally boarded the Concorde for the first stop on their trip, Paris. They stayed at the Plaza Athénée; Gil recalled their innocent thrill at seeing Shirley MacLaine in the lobby. Together the two dined with the Picassos; ran into Hans and Stephanie Mayer at Galerie Daniel Templon; and attended an exhibition of the work of Jean Tinguely that Keith found "remarkable," particularly a 1967 sculpture, *Requiem for a Dead Leaf*—a huge machine designed solely to lift one dead leaf. At a club featuring house music, Keith introduced Gil to another deejay, who was wearing a Keith Haring T-shirt from Bordeaux. "Funny how all over the world I seem to have this connection to DJs," Haring wrote. "Something about rhythm?" Three days later, they traveled to Madrid, where they immediately went to see a Hieronymus Bosch exhibition at the Prado, as Keith, "totally blown away," explained to Gil the "hyper-reality" he saw in the paintings. For the next couple of days, the two were busy attending Matisse and Magritte shows, having long talks, and even sleeping in the same bed, with Keith brought back to a harsher reality only by taking AZT and Zovirax every four hours. He then phoned Yves Arman, hoping to

visit him in Monte Carlo before skiing in the Alps, yet Yves was driving to Madrid for the ARCO contemporary art fair, so he and Gil decided to wait for him.

Yves Arman never arrived. He was killed in an automobile accident while driving his father's Porsche to Madrid. Debra Arman called Keith, hysterically pleading with him to come to Monte Carlo at once. "This is terrible for Gil, because it's supposed to be our vacation and he didn't really know Yves that well," Haring later said. "Now he has to be part of this whole tragedy. But, of course, we go." When the coffin arrived from Spain, Yves's mother told Keith that her son would have wanted him to paint it—so Haring did, reluctantly. Yet the painting, done in a chapel in Vence on the night before the funeral, with light streaming in from a full moon and Debra Arman seated nearby, turned out to be a moment of outpouring for Keith rather than an ordeal. As he played peaceful jazz and ambient music on his boom box, Yves's young widow felt a weight lifted from her and the few others gathered there. Keith painted—in silver on the glossy black Spanish coffin—one of his winged angels, a Haring image Yves had taken to wearing as a lapel pin and used as his letterhead. Soon, the angel multiplied into an ascending column of three angels, and Keith tried to paint "FOREVER AND EVER," yet because of limited space, he wound up with "FOR EVE R," a pun he felt that Yves, a lover of the wordplay of Duchamp, would have appreciated. "My mom told me she was watching him and took it all in," says Madison Arman. "She said Keith wasn't crying or emotional but just very zoned in and calm as he painted the coffin of his dear friend." Says Vazquez, "All those deaths at once served to remind Keith of his own pending mortality."

Feeling confounded by death at every turn, yet "determined to make the rest of our time in Europe totally great," Keith left with Gil for Barcelona, where they first visited Gaudí's unfinished cathedral, the Sagrada Família, a mud-drip-looking structure that fascinated Keith, as Gaudí had used intuition in its construction rather than sketches and architectural blueprints. Of plans to try to complete the building, Haring wrote, "It's kind of like trying to finish an unfinished painting after a painter's death." They also visited the Fundació Joan Miró

and the Museu Picasso. Each night, the two took mushrooms and made the scene at Ars Studio, an acid house club, where Keith found someone to help him scout a blank wall in the Barrio Chino, a run-down part of the city populated by junkies and prostitutes and beset by an AIDS problem. Breaking his promise to himself not to work so much, he painted there the work he thought of as "my first AIDS mural." On a one-hundred-foot-long, prepared (meaning cleaned) concrete wall, in one afternoon, he painted a red serpent with a hypodermic syringe held like a fountain pen in its coils, labeled "SIDA," about to be sliced by giant scissors, with the rallying message "TODOS JUNTOS PODEMOS PARAR EL SIDA."

They then flew to London for George Condo's show at the Waddington Galleries, staying in a lavish pink suite at the Blakes Hotel, where Condo was also staying. A highlight for Keith was an exhibition of Leonardo da Vinci drawings at the Hayward Gallery, particularly a group of overlooked prints from da Vinci's late *Deluge* series, which looked to Haring like depictions of a nuclear explosion. "He just wanted to look at the pencil strokes an inch away from his face," Vazquez says. They went on to Marrakech, staying at the La Mamounia, where Christopher Makos, whom they had just run into in Madrid, appeared, Vazquez recalls, "wearing this tiger print suit." Keith was always wondering how Morocco might have changed or remained the same since the days when William Burroughs and Brion Gysin lived there. "He was very inspired by the mosaics he saw," Vazquez says, "and all these crazy borders everything had, and the intense colors in the spice market." When they returned to Paris to catch the Concorde back to New York City, Keith created five lithographs for film producer François Bénichou, using sketches he had made in Morocco of interlocking patterned lines and borders. The series was printed at Art Litho, Paris, and titled *Chocolate Buddha*, after a rare strain of marijuana with a piquant chocolate aroma.

Traveling with his "beautiful friend," Keith had moments of sensing some cracks. At a depressed juncture in Marrakech, he wrote in his journal of the "ludicrous situation of traveling with someone who I am desperately in love with who is not, and can never be, my lover." Juan

Rivera's blunt take was "He always wanted what he couldn't have, or be. Like Gil." Yet the uncommon ingredient for Keith was his and Gil's long, unjaded conversations unspooling until daybreak. "We had a lot of conversations about life, death, war, or whether this art was coming from him or through him," Vazquez says. "I think he felt he would receive all the information. It went through him and manifested in these things in a unique way. Being of service to his community, to humanity, was a big thing for him. He wanted fame, which folks think of as vapid and shallow, but he wanted to use fame to be of service." Keith was often in big brother mode: "When I was a late teenager," says Haring's little sister Kristen, "Keith said, 'It's so amazing that we think the same.' I just looked at him and said, 'We think the same because you taught me how to think.'" On this trip to Europe, Keith had been intentionally trying to teach Gil his ways of thinking: "I'm sort of teaching him (or trying to) to understand how I feel about everything so he can be my voice in the future. But, how do I know if he even wants this responsibility?"

Throughout the spring of 1989, Keith was back and forth between New York and Paris, sometimes with Gil, sometimes alone, always on the Concorde, always staying at the Ritz, while engaged on both continents in some of the most resonant projects of his career. On May 5, the day after his thirty-first birthday, he painted, in his New York studio, *Untitled (For James Ensor)*, an acrylic diptych on two panels of canvas— the last of his black paintings. Haring had just seen a show in Munich of the works of Ensor, the Belgian surrealist obsessed by painting self-portraits as a skeleton. In the first frame, a skeleton pees or ejaculates onto a clutch of foliage that, in frame two, erupts, like Jack's beanstalk, into tall, thriving flowers as the skeleton touches one stem with its bony fingers and smiles with joy. If the humor is dark, the message is light— the creations of the skeleton artist will live and flourish after him. The next week, he was in Chicago painting a mural on a 520-foot stretch of whitewashed plywood constructed in Grant Park across from the city's Cultural Center, with the help of three hundred students from the Chicago public schools. As De La Soul played on his boom box, he completed the underpainting of black lines in eleven hours, with timed breaks for taking his AZT. The week was declared "Keith Haring Week" by Mayor

Richard M. Daley, and a short documentary ran on local television, nar-rated by Dennis Hopper. Later in the month, Keith painted a mural in black enamel on the stark, white walls of the men's room of the Les-bian and Gay Community Services Center, in the West Village, to mark the twentieth anniversary of the Stonewall uprising. Polymorphously perverse and drawn in the sinuous style of the gay Cocteau, *Once Upon a Time*—teeming with entangled penises, cum shots, and avid, flicking tongues—was a sex-positive paean to a golden age of promiscuity that most of the men using the urinals would have known. This "amazing mural-for-a-urinal" was praised in *The New Yorker* as Haring's "*Guernica* of priapism."

Keith was in Paris often enough and enjoyed its New York level of social collision enough that he thought, "I should really have an apart-ment here." Instead, he came to treat the Ritz, on the Place Vendôme, one of the most luxurious hotels in the world, as his home away from home. Yet Paris was still far more formal than New York, and Keith's hip-hop fashion was not welcome everywhere. While the busboys and bellboys often came up to his room for autographs, and he loved the swimming pool, he was reprimanded for wearing shorts in the hotel lobby and barred from the restaurants and lounge because of his sneak-ers. He was also turned away for lack of a sport coat by the maître d' at the Hôtel de Crillon, where he was meant to meet with representatives of the City of Paris concerning one of his largest French projects—painting the side of a zeppelin to be flown over the city in celebration of the bicentenary of the French Revolution. (For technical reasons, the blimp wound up flying, in June, from London, where it was built, to Calais.) If they were not traveling with him, he might buy Julia a Chanel bag or an Alaïa dress, or go shopping for Gil at Hermès. "There's a wonderful story of Keith going to Chanel around the corner from the Ritz," Gruen says. "Because he was wearing jeans and sneakers, they kept following him around, giving him dirty looks, and asking him if he needed help. When he finally brought whatever he was buying to the counter, it came to about ten thousand worth of francs, and he pulled out wads and wads of cash. They took his money very gladly."

"Keith could see that I was going to very fancy places and living it

up by whatever means I could, and he wanted to do the same thing," George Condo says. "He decided to change his ways from being relatively humble to exploiting the potential of what you can do when you make a few bucks as an artist. That's all I was into at that point. I said to him, 'I don't understand these people who save all their money for when they are old and walking around on a cane and they can't even spend it. If we have any, we might as well spend it now.' He just laughed. We were always laughing I convinced him to get on the Concorde for the first time. He started out at La Louisiane. Then I bumped him up to Hôtel Lotti and then to Hôtel de Vendôme, which was kind of run-down, but he had a suite for the price of a one-bedroom at the Lotti. Kwong Chi took a picture of me at the Vendôme, supposedly having a breakfast that consisted of a bottle of Château Lafite and a bowl of corn flakes. Keith and I were both staying there. And then of course he ended up at the Ritz."

For the twenty-ninth birthday of Princess Gloria von Thurn und Taxis (nicknamed "Princess TNT" by *Vanity Fair*), thrown in April by Princess Gloria and her husband, Prince Johannes, the largest landowner in West Germany, at their palace in Regensburg, Keith was commissioned to design the plates and the invitations—a sleeve and vinyl recording of the princess singing the R&B song "Come to My Party" in German and English. With Julia Gruen as his date, Keith passed much of the evening signing plates for many of the five hundred guests at a seated dinner that included Boris Becker, Jeff Koons, and Bruno Bischofberger. André Leon Talley showed Haring the May *Vogue* with Madonna on the cover and pictures inside of her home with a Haring collage on the wall. Even more compelling was a chance to assist Yoko Ono in a rare performance event by the Fluxus art and music collective at the École National des Beaux-Arts in Paris in June. Keith was recruited backstage to play random piano sounds for Charlotte Moorman on cello, and then held a Chinese vase beneath a shirt to keep the shards from flying about when Ono smashed it to show solidarity with pro-democracy Chinese students. Yoko then invited audience members to take pieces and promised to return in ten years to put them back together. "It really made me rethink the stuff I was doing when I was

involved in performance in NYC in 1979–80," Haring wrote. "Somehow I think the spirit of this work is still alive in my work. I really feel an affinity to this group almost as strongly as to the Burroughs/Ginsberg/ poetry/writing group. It all overlaps."

Gil's birthday was July 4, and he and Keith returned to New York overnight—basically, to change their clothes and then take an MGM Grand Airline flight to Los Angeles. Gil had never been there, and Keith had planned this detour from their ongoing life in Europe as a special weeklong visit. They went everywhere in a rented red Jaguar convertible, which Gil wished to learn to drive, sometimes to hair-raising effect. They visited the set of Pee-wee Herman's new TV show and had dinner at Sandra Bernhard's house with Madonna and Warren Beatty, with whom Madonna was having an affair. On Gil's birthday, Dennis Hopper—"He's a real friend and I adore him," said Haring—and his wife, "Dennis's beautiful Katherine," threw a dinner for them at their home in Venice Beach. Other guests were Tony Shafrazi, Ed Ruscha, and the collector Martin Blinder, who bought two sculptures from Haring's show at Leo Castelli and, that weekend, was planning to have a third, a commissioned Haring dog sculpture, helicoptered into place on his lawn. After dinner, Hopper screened Spike Lee's new film, *Do the Right Thing.* Keith and Gil had also been invited to a barbecue at Warren Beatty's, so they stopped by there afterward, and Keith took Polaroids of Gil with Madonna, as a sort of birthday present. "L.A. L.A. L.A.," as Haring summed up the trip in his journal. A year later, he would return to Los Angeles, in a different mood altogether, to create an untitled mural for the World Health Organization's first "Day Without Art," held on AIDS Awareness Day at the Pasadena ArtCenter College of Design, a mural that has been compared, for its syncopated patterns of yellow, green, red, and black shapes, to Stuart Davis's *Arboretum by Flashbulb.* Assisting him on the mural was the multidisciplinary artist Doug Aitken, then a new student at the college. To show his appreciation, Haring gave Aitken his supply of enamel paints. Years later, while receiving an award, Aitken presented to the college, as a gift, one of those cans of paint.

The apogee of Keith's special projects in Europe was a work that

came about, as many of his did, because of a random meeting on the streets of New York. In the winter of 1988, on a Sunday morning after a druggy Saturday night, in an altered state, Haring had walked out the front door of his Sixth Avenue building and lingered by a group of Hare Krishna devotees playing soothing sitar music. As he stood listening and watching, he saw an attractive young man with curly black hair staring at him, trying to get his attention. When the man finally got up enough courage to walk over, he introduced himself as Piergiorgio Castellani, a twenty-year-old Italian who had recognized Haring from his picture in *Interview*. With Castellani was his father, Roberto, a Tuscan wine producer in town on business. Both knew Haring's work, but Piergiorgio was a deep fan who, for two years, had been making drawings in Haring's style. "Keith explained to us that he had just passed a special night in New York," Castellani says, "and that if we could come tomorrow to his studio, we could continue this conversation." At the studio the next day, Roberto proposed that Keith do a mural in Italy, perhaps in Florence, or Pisa, where Piergiorgio was attending university. Keith replied that he was always open to new ideas and to exciting projects. Within months, the father-and-son team had arranged for him to paint a permanent mural on a 1,300-square-foot rear wall of the Roman Catholic Sant'Antonio church, monastery, and convent in the historical center of Pisa, on a busy street not far from the Piazza Vittorio Emanuele II and the main railway station. Keith was impressed by the visibility and the gravity of the project.

Arriving a few days early to begin to imagine his mural, he was driven about the city in a horse-drawn carriage, accompanied by an interpreter and by Tseng Kwong Chi, who had now also been diagnosed as HIV-positive and was within a year of his own death. "They were constantly smiling," Castellani says. "To see Keith at that moment was special for me, since he had some KS spots on his body, clear signs of a very probable death, yet he and Kwong Chi were smiling going around Pisa." Showing special interest in religious spaces and art—in particular, the Campo Santo, with its medieval fresco of the *Inferno* attributed to Buonamico Buffalmacco—Keith photographed with a Polaroid everything that caught his attention and then arranged the shots in his hotel room to

create a preliminary plan for the mural. At first, he wished to do a fresco, in the medieval and Renaissance tradition, yet the wall did not lend itself to the fresco process, so he chose to use acrylic paints on a plastered panel anchored to the space by special nails, to leave a gap between the two surfaces. Piergiorgio was surprised when Keith, after he was taken on a tour of Sant'Antonio by a friar, asked to be left alone in the church for an hour. On another occasion, with Gil, he climbed the "really major and also completely hysterical" Leaning Tower of Pisa and left behind a radiant baby tag.

The week of mural painting in Pisa became a destination event for friends of Keith's from the United States and across Europe, and it turned increasingly, in his word, "Felliniesque." Barbara Leary was there; Debra Arman, Viken Arslanian, and David Neirings from Belgium; as well as young fans hitchhiking from France, Germany, and Italy, some winding up sleeping on the floor of the church. A favorite of Keith's was a group of parachute jumpers from a local military base, who showed up each evening, as he turned the top floor of his hotel into a more private VIP party, the smell of marijuana wafting through its hallways. After dark, floodlights like those illuminating the local civic monuments revealed his daily progress, all recorded by a film crew from RAI, Italian national television. Surprisingly apparent in the finished mural was the Christian symbolism in Haring's repertory—the winged angels, the Madonna and Child, the evil serpent, and the figure bowed in a crucifixion pose, this time its shoulders weighed down by a smiling blue dolphin. Keith also kept the city of Pisa in mind, turning its historic emblem, a white Greek cross on a red background, three balls at the tip of each bar, into a more anthropomorphic crossing of four figures looking more break dance-y than heraldic, the entire color scheme of the huge wall softly chromatic, reflecting the time-washed hues of the medieval city. The rhythmic mural, known as *Tuttomondo*, and described by Alexandra Kolossa as "Haring's final hymn to life," was an all-encompassing, symphonic reprise, its mood joyful and uplifting, more Paradiso than Inferno, implying not anger but, rather, acceptance. Sitting, that final evening, on the balcony of his hotel across the street, his mural completed, Keith wrote blissfully in his "Euro Trip '89" journal, "This is really an accomplishment. It will

be here for a very, very long time and the city really seems to love it . . . It's really pretty beautiful here. If there is a heaven, I hope this is what it's like."

Returning to New York City by the late summer of 1989, and feeling frustrated with the lack of response to any of his medical treatments, Keith had found his way to Dr. Paul Bellman, an internist affiliated with St. Vincent's Hospital. Just a year older than Haring, and with many artists and writers among his patients, Dr. Bellman was considered, within the gay community, one of the more sympathetic, open-minded, and knowledgeable physicians with a large AIDS practice. His office manner was calm and cool, and he shared the latest scientific research while operating from a core belief that "HIV/AIDS was a race for survival rather than a death sentence." "Shortly after Keith finally came to me, his T cells dwindled to less than twenty, which was very low, and he was getting new KS lesions," Dr. Bellman says. "He had already been given a course of AZT that was not doing much and was making him anemic. That was no one's fault. It was the reality of the situation. Monotherapy—with one agent—created resistance within four or five months, and you had the added toxicity of the drug." They resolved to cut Haring's AZT dosage in half, and Keith began taking the experimental antiviral drug ddI, or didanosine, as part of a special program to fast-track drugs of promise to AIDS patients prior to FDA approval. In September, he was injecting himself daily with alpha interferon, though, says Bellman, "the drug didn't particularly work for him." More successful was a treatment with Bactrim, to ward off pneumocystis pneumonia, also identified as "wasting syndrome." The waiting rooms of AIDS doctors were packed during those years, and Keith was regularly at Dr. Bellman's office in the West Village. "Keith had an incredibly positive attitude relative to most of my patients," Bellman says. "He was realistic. He wasn't in the clouds about it. He wanted whatever medical treatment was available that could help him. But he somehow had a resilience that enabled him to do his art, and his life, and to have that kind of radiant energy, for want of a better word, which he uniquely possessed. He would come into the waiting

room, and it wasn't because he was Keith Haring, the famous artist, it was just his energy that affected everyone."

Haring was also, slowly, and with some hesitation, beginning to put his fame, body, art, and money at the service of ACT UP, a militant commitment that focused his activist energies and fired his public art for the rest of the year and into 1990. ACT UP had come to life in March 1987, when Nora Ephron asked Larry Kramer to take her place when she needed to cancel a talk at the Gay and Lesbian Community Center. In his speech that night, Kramer channeled all the prophet's fury that had inspired the founding of the Gay Men's Health Crisis in his apartment in 1982 and his alarming siren of an article in the *New York Native*, "1,112 and Counting." A woman in the audience that night was said to have stood up and shouted, "Act up! Fight back! Fight AIDS!" Two nights later, the AIDS Coalition to Unleash Power was officially formed to bring the battle for affordable treatments and a cure to targeted government agencies and pharmaceutical companies. In its first action, ACT UP protestors blocked traffic on Wall Street and hung in effigy at Trinity Church the director of the Food and Drug Administration. By 1989, ACT UP's weekly three- or four-hour Monday evening meetings at the Center had become fully realized, strident gatherings of hundreds of young men and women, loosely held together by Robert's Rules of Order and by meeting moderators, each with their distinctive style. The revolutionary, "out" energy could be sexy and cruise-y, and though the meetings and demonstrations were far more diverse, young men in their twenties, in T-shirts, jeans, and Doc Martens, were, Kramer said, the "face of ACT UP"—all of them bound up by grief, anger, and a struggle to survive.

In the months following his diagnosis, Keith had continued not telling anyone except Gil, Juan Rivera, and Julia. He knew that once the news went beyond gossip, the already steadily mounting prices for his art would double and triple, a phenomenon he found ghoulish and disturbing. He was also sifting through choices for the right forum to make the private pubic. Meanwhile, he kept abreast of all the goings-on at ACT UP, mostly through Swen Swenson, a Broadway song-and-dance man in his late fifties, once nominated for a Tony for his performance in *Little*

Me. Keith had met Swen when he began looking for a new home. Haring wished to leave behind the Sixth Avenue flat he was sharing with Juan Rivera, and he entered a contract on Swen's town house on nearby Minetta Lane. After he was diagnosed with AIDS, though, he did not feel up to the extensive renovations required. Withdrawing from the agreement, he confided his diagnosis to Swen, who told him that he, too, had AIDS. He became an important confidant for Keith and a source of information about experimental medicines and about ACT UP. Each Monday night, Swen would take literature distributed at the group's meetings to Keith's studio, where he often stayed late into the night while the two talked and Keith painted. "He was weaned into ACT UP by a friend," said fund-raising committee chair Peter Staley. He was finally drawn decidedly to the group by a poster designed for a proposed action at St. Patrick's Cathedral, featuring two black-and-white photographic images—on the left, Cardinal O'Connor, wearing his stately miter; and on the right, a used condom the same size and shape as O'Connor, with a big, red headline: "KNOW YOUR SCUMBAGS."

"Okay, that's it. I have to check out a meeting!" Keith told Swen. "Do you think I can get some extra copies?"

ACT UP had its share of celebrities turning up. Susan Sarandon and Martin Sheen were at recent meetings, and both wore "Silence = Death" pins on late-night TV talk shows and at awards ceremonies. Yet when Keith Haring showed up at his first Monday night meeting, there was an audible buzz. "He would walk in and stand in the back, definitely trying to blend in," says George Wittman, who had assisted Haring in painting the mural at the Gay and Lesbian Community Center. "I saw him dozens of times at the Monday meetings and at the actions." The crowded meetings made Keith feel more comfortable for the first time with his sickness, as he experienced strength in numbers.

He eventually agreed to become a "public person with AIDS," coming out as HIV-positive in a fund-raising letter for a large mailing of about two hundred thousand, while also committing to an interview with *Rolling Stone* magazine, where he would be honest about his status. "I don't want to be pitied," Keith first said when approached by ACT UP. "It's not because I am sick that I think people should feel terrible

about AIDS." Yet he eventually came around, convinced from a decade of activism that "the only way to deal with something negative is to change it, turn it into positive action." Scheduling was difficult, and Sean Strub, active with Staley on ACT UP's fund-raising committee, finally arranged to meet with Haring in his white-and-gold Louis XV–style suite in Paris, where he was staying with Gil, to talk through the letter. "It was late morning," Strub says. "He was still in his pajamas. Gil came out of the bedroom once for a glass of orange juice and then went back in." Keith showed a surprising interest in discussing the economics of direct mail fund-raising and asked after a mutual friend he had heard was battling KS. "I started explaining KS to him," Strub says. "He said, 'I know.' He leaned over and pulled up his pajama leg, and he had massive necrotic plaques of KS the size of one's hand on his shins on both legs. I found that moment sobering. I knew he was positive, but seeing that was so intense." Haring's letter, which he opened by describing seeing his first KS spot in Tokyo, was written in laser font in his own handwriting—new technology at the time. It was soon completed, yet ACT UP was short the money needed for the bulk nonprofit postage rate. In such tight spots, Keith often made cash donations. Once, after he told Peter Staley, "I kind of have a cash business these days," Staley stopped by his New York studio: "He'd grab his knapsack and pull out a wad of hundred-dollar bills, the first time, ten thousand dollars, and I'd carefully walk to the bank and deposit it in the ACT UP account." Haring's direct-mail letter netted the group seventy thousand dollars. He also designed a see no evil/hear no evil/speak no evil–style "Ignorance = Fear, Silence = Death" poster and paid for twenty thousand copies of it to be printed in Queens; gave money for buses to take demonstrators to the Montreal AIDS Conference; sponsored a benefit dance at the Sound Factory; and donated artworks for auction. "Over one third of ACT UP's '89 receipts," Staley said, "can be attributed to Keith Haring." "Anytime I or anyone I knew approached Keith to do something for the epidemic," Strub says, "the answer was always yes."

The ACT UP fund-raising letter wound up dropping several weeks after the August issue of *Rolling Stone* featuring a vulnerable and honest interview with Keith by David Sheff, recounting Keith's full life story,

including his extensive drug use and, most candidly, his HIV status. Based on a half-dozen late-night conversations with Sheff, who had conducted the last major interview with John Lennon and Yoko Ono, the prominent seven-page profile was titled "Just Say Know," after a saying of Timothy Leary's stickered to the front door of Haring's studio. The wide exposure helped boost response to the ACT UP mailing, yet, in combination, the two, Peter Staley says, "cost him a lot of privacy." Said Haring, "There were many interviews before, when people would ask me, 'Can we talk about this?' and I would say, 'I'd rather not.' But now it has gotten to a point where there's no reason to say that anymore, because I do have to talk about it." He was taking the equation of silence and death seriously. Yet he needed to stay ahead of the news in informing family and friends. Advance copies of the magazine began circulating in mid-July. Page Six of the *New York Post* scooped the story in an item headlined "Sad News": "Rumors that painter Keith Haring has AIDS have been confirmed—by Keith Haring in the new issue of *Rolling Stone*." So, Keith traveled to Kutztown. He had already informed his parents, yet upcoming was a large Haring family reunion. "My brother felt he wanted everybody to know from him," Kristen Haring says. "He came home and was on this whole 'I'm going to tell people' tour. He called each of my aunts and uncles and told them directly, thirteen on my father's side, three on my mother's, probably none of whom he had ever told he was gay, and told them he was HIV-positive, and this was going to be national news." The one family member he did not inform personally was Kristen, then a sophomore at the University of Pennsylvania. Her father told her, upsetting her even more. At a dinner party at Kermit's that weekend, she ran out, distraught: "Keith followed me when he figured out I was gone. He caught up and said, 'Why did you leave?' I don't know what I said, but it finally became 'How could you not tell me?' He said, 'Because it would have broken my heart to tell you.' We were both in tears at that point."

The *Rolling Stone* profile caused a sensation, as much for its confirmation of Haring's condition as for his willingness to speak his own bare truth. "It's a totally revealing interview, and I'm getting hundreds of calls and letters from all kinds of people," Haring said. "Lots of peo-

ple were shocked and dismayed. Others thought I had a lot of nerve for spilling my guts." Haring's overall attitude in the article was philosophical rather than angry, as he claimed he had always expected to die at a young age and that the closeness of even the possibility of dying "helped in appreciating things in a way you never appreciated before." He also spoke of a friend, another PWA, or "person with AIDS," telling him that he was "probably happier than he's ever been in his life." His only fear, or regret, as a "workaholic," he confessed, was of no longer being able to work, and he devoted the last moments of the probing interview to speaking with both passion and dispassion of his plans for his work in the present and in the future. "Everything I do now is a chance to put a—a crown on the whole thing," Haring reflected. "It adds another kind of intensity to the work that I do now; it's one of the good things that comes from being sick. If you're writing a story, you can sort of ramble on and go in a lot of directions at once, but when you're getting to the end of the story, you have to start pointing all the things toward one thing. That's the point that I'm at now, not knowing where it stops, but knowing how important it is to do it now. The whole thing is getting more articulate. In a way it's really liberating."

"You Use Whatever Comes Along"

T*he artist who* stood out for the meticulous care he took with cleaning his brushes and tools and neatly arranging his paints and materials in an orderly fashion was often just as intentional with his approach to his own death. This energy around his future led him to make a phone call early in 1989 that surprised its recipient, Sam Ha-

vadtoy. Both friend and companion of Yoko Ono following the death of John Lennon, the Hungarian artist had also been the interior designer of Lennon and Ono's apartments in the Dakota and their two country homes. "Keith called and said he wanted to see me," Havadtoy recalls. "He came to the Dakota and told me that he was going to move into a new apartment and would I consider helping him decorate it. Since he was diagnosed with AIDS, he wanted to move very quickly and design a home, the dream home he wanted to have, where he would pass away. It was a very emotional conversation. Of course, I said yes. He said the only problem was that it needed to be done right away, because he was sick. I dropped everything and started to work with him, trying to get everyone to do things fast. I would go to upholsterers, curtain makers, fabric suppliers, and plead for favors, favors, favors. When I asked him, 'What *is* your dream home?' he said, 'I only have two requests. I would like my art collection beautifully displayed. And I want my bedroom to be like a whorehouse.' I said, 'Keith, you have to help me. I don't have that much knowledge of a whorehouse.' After thinking, he said, 'My idea of a whorehouse is like the suite at the Ritz in Paris.' I said, 'Well, I know the suites at the Ritz. Which one are you referring to? The Royal Suite or the Presidential Suite?' He wanted a classic French bedroom. So, we started from there."

The 1,400-square-foot apartment Haring bought for a reported six hundred thousand dollars was a duplex penthouse in a six-story con-dominium building with ten raw loft spaces, converted just a couple of years earlier from an 1897 commercial warehouse at 542 LaGuardia Place, between Bleecker and West Third Streets. The real estate was about mid-way on the walk he took almost daily from his Sixth Avenue apartment to his studio on lower Broadway, the maneuver of transforming an in-dustrial building into lofts common among artists colonizing SoHo, though, by 1989, the buyers were more often in finance than the arts.

Walking through the building's entrance one day during the reno-vation, Havadtoy had been annoyed to see the word "Pray" scratched in its new stainless-steel front door, while Haring grew volubly excited: "She's the original graffiti artist. She's been going around for twenty years scratching 'Pray' on any surface she can find. She marked my

house!" Entry from a key-operated elevator was onto a fifth-floor living room with clean white walls, lots of light from eastward-facing industrial windows, and the art of Haring and his friends. Warhol portraits of Joseph Beuys and of Haring and Juan Dubose flanked the front windows. Beside a leopard skin couch, a dinosaur-encrusted Kenny Scharf–customized TV was always turned on in any photographs of the space. A 1950s oval mirrored table that Havadtoy found served as a pedestal for a Haring-cartooned Etruscan-style vase, and on a wall of photographs were elegant Mapplethorpe portraits of Black men and of Haring. Still with him from Broome Street was his beloved Basquiat-painted box piece, and above a white fireplace mantel, one his favorite works, a framed print of Lichtenstein's *Forms in Space*, the pop artist's take on an American flag, with his blue dots for stars and diagonal red stripes. "I had plastered over the ugly brick fireplace for him," Havadtoy says. "And since he was there at the time, and it was still wet, I suggested he draw into it, so that it would become a unique artwork. He did, and it was beautiful." Of the resulting rollicking depiction of naked figures with giant penises dancing about, Debra Arman, upon first visiting the apartment, playfully responded, "Oh, Keith, really?"

Downstairs was an intimate and even more indulgent floor, with the bedroom and two sitting rooms reached by a staircase lined with photographs by Tseng Kwong Chi. Keith's bedroom fully realized his luxe bordello fantasy, with an ornate antique bed anchored by an elaborate headstand, plush drapes secured by tassels, sedately glazed walls, and mother-of-pearl corner cabinet doors. (Keith had seen a pair in Yoko Ono's apartment and admired them.) Through the windows, he could see the Empire State Building. "That's where he had the good artwork," Debra Arman says, meaning some of the art that meant the most to him. Incongruously framed in classic gold, like an Old Master, and hung above his bed was Basquiat's painting of the death of Michael Stewart, which Haring had cut out of the wall of his earlier studio on Broadway. Here he kept the art he traded with Yves Arman—the Duchamp sculpture and, over the bathroom door, the erotic Picasso drawing. Also framed in gold, above a nineteenth-century embroidered armchair with a teddy bear propped on it, was a Léger watercolor and pencil on pa-

per, *Deux Femmes*, done in 1954. Nearby: a painting of pure daffiness by Kenny Scharf, two Condos, a Francesco Clemente monoprint, and resolutely modern in the nineteenth-century setting, a mechanical sculpture by Jean Tinguely. "Well, you read my mind," Keith said to Sam Havadtoy when he stood in the completed bedroom for the first time. "This is exactly what I wanted." Adjoining the bedroom was a fantasy space out of an eighties nightclub—a sitting room painted entirely in cherry-red lacquer. A walk-in version of his *Red Room* painting, the room was dominated by a red corner Coca-Cola–dispensing machine and, above a red striped sofa, a "cookie cutter" porcelain winged Pegasus Mobilgas sign he had bought at a flea market on his way to a Haring family picnic. Warhols were everywhere in the apartment: a *Flowers* print brightened the kitchen, and in a sitting room ("one of my favorite Warhol paintings that I ever got from Andy"), a small hand-painted portrait of Jesus at the Last Supper. The apartment Haring would call his "first real home" was like no other. Part juvenile clubhouse, part sex parlor, part Pop House, part Keith Haring–curated art show—542 LaGuardia Place, too, was a summing up. "He was a self-taught little genius," Havadtoy says. "It radiated on everything, even his home."

Keith moved into the apartment in mid-August 1989, as always, fitfully, partially, and ever on his way somewhere else. In September, in Rome, he was still receiving fabric samples, Polaroids of his bed, and marbleized molding samples from his interior decorator. Amid a six-week trip throughout Europe, he had already been to Switzerland to help judge a comedy film festival, along with Grace Jones; and to Monte Carlo to paint a mural on the wall of the maternity ward of the Princess Grace Hospital. The mural featured a very pregnant woman surrounded by other emblems of joy and nativity in warm tones of yellow, ochre, and blue against a white wall. Of the primary purpose of the trip, Haring wrote in a slim orange notebook, in one of his final diary entries, "This is sort of a continuation of my see-the-godchildren trip which started in the Hamptons with Zena, went to Kutztown and baptized Kermit's baby, to big Haring picnic at Aunt Sissy's house, to Monte Carlo to see Madison, and now off to Italy to see the Clemente kids." Before going to Amalfi, he also stopped off in the South of France to see Matias, the new

baby of Bruno and Carmel Schmidt, and Samantha McEwen, who was staying with them. "That was really sweet," he wrote, "and it really feels like my family (the original New York family.)" Says Bruno Schmidt, "It was also sad, though. We were at the beach, and he was wearing a T-shirt, and I told him to take it off. 'Oh, I have my Kaposi things, it's too ugly,' he said. I convinced him we didn't mind, and when he took off the shirt, we almost fainted. He had plastic surgery on his face, but on his back, he was black. It was really horrible, and so cruel."

A ride in a skiff with the Clemente family along the Amalfi Coast, to Francesco's studio, only deepened the pleasure and meaning Haring was taking from his godchildren tour: "I think riding on the front of this boat (lying down with Nina's head on my arm) with warm water splashing my hand and the cool ocean breeze and the landscape of the cliffs of Amalfi lit up like an opera set, it was one of the most incredible moments of my life. This is why I want to be alive, for moments like this."

Back in New York City, during October, Keith never stopped drawing. His physician, Dr. Bellman, noticed that his frustration over the ineffectiveness of his AZT treatment was often expressed both for himself and for his fellow HIV/AIDS patients and friends. "He was a global thinker," Bellman says, "so he thought about everything in global terms, as far as I could tell." On October 7, in his studio, Keith made a series of twenty drawings in global terms about mortality, titled *Against All Odds*. He created the drawings in a single afternoon, while listening for hours, over and over, to Marvin Gaye's classic album *What's Going On?*—"In it, pessimistly he questions the future of the planet"—much as he used to listen, over and over, to the B-52's while drawing in his Second Avenue apartment; and then to Bob Marley's psalmlike songs of oppression and of people's struggle for freedom. Relying on simple materials—Dutch linen paper, a brush, and sumi ink he got in Japan—he began creating images that built on one another like frames of a comic book or a graphic novel, to tell a story of a globe, dripping ink-black blood, dipped in pails of muck (labeled with dollar signs) and screaming from stab wounds made by the hands of humans, who were ever ignoring a shining key of knowledge floating above. The dark, desperate, and biting piece does not

have a happy ending. Averse to explaining, even Haring had to admit, "These drawings are about the Earth we inherited and the dismal task of trying to save it—against all odds." The Rubells, who had not been buying Keith's work for some years (during the Haring phase Mera Rubell calls "the Mr. Chow period"), stopped by the studio one day soon after Keith made these drawings and found themselves compelled once again by his art. "The work became very powerful," Don Rubell says. "There was no decorative element. It wasn't sad, but it was profound. It was someone communicating certain things he felt were important." When Keith showed them the drawings, he worried the series would be broken up. The Rubells promised to buy all twenty and produce them as a book. A few months later, Keith invited them and their two children, Jason and Jennifer, to his studio to uncork a bottle of champagne and present them with a dedication page to Don's brother, Steve Rubell, who had died of AIDS in July. The drawings were published with a Dutch press, Bébert, using the same linen paper, and the same ink, to feel like the originals, though Keith never saw the final edition.

In November, much as he had gone on a godchildren tour some months earlier, he invited his parents in a valedictory way to travel with him for a whirlwind ten days to show them Keith Haring's Europe. He was giving back, sharing, and showing off all at once. Leaving for Europe just two days after signing a last will and testament and setting up a foundation designed to promote his work and to support charitable causes, especially for young people and AIDS research, Keith took his parents first to Belgium. They stayed in Antwerp, and with the Nellenses in Knokke, and then traveled to Paris for a dinner at the home of Claude and Sydney Picasso. In the Mayers' country house near Düsseldorf, where Keith was having a small drawing show at the Hete A. M. Hünermann Galerie, Hans and Stephanie Mayer arranged a special, intimate "family dinner" for a dozen people. "Keith took us to lunch in Tribeca one day and spoke of having AIDS," Mera Rubell recalls. "He said he wanted to invite people who had been supportive of him to meet in Düsseldorf, for a beautiful reunion. It was fall. There were a billion leaves outside. And there was this incredible table set with pomegranates and the biggest branch of dead leaves you've ever seen

as a centerpiece. It was very symbolic." Keith's parents still felt a spe-
cial bond with the Rubells for their having invited them the night of
Keith's first Shafrazi opening to their Upper East Side town house for
a spaghetti supper. Keith also included as guests his bookkeeper, Mar-
garet Slabbert; Julia Gruen; and Julia's father, the photographer and
art writer John Gruen, whom Keith—feeling the pressure of his legacy,
and knowing, in Warhol fashion, his art and his life to be of a piece—
had recently asked to write his authorized biography. Also present were
the gallerist Hete Hünermann and her sister, the art patron Gabriele
Henkel.

The opening the next evening was at the Hünermann, which re-
sembled a Greek temple, situated in a pastoral park with swans float-
ing on the lake. The affair was gala yet went long into the night, while
Keith grew increasingly fidgety. The main event of the trip was the next
morning—his investiture by Princess Caroline, at a ceremony in Monte
Carlo, with the honorary title of "Chevalier de l'Ordre du Mérite Cul-
turel de la Principauté de Monaco." The hour was late, and it turned out
that none of the regularly scheduled transportation out of Düsseldorf
would get Haring and his entourage to the ceremony in time. A deci-
sion was made to charter a private jet, and the next morning, a six-seat
Cessna Citation II took Keith and his parents, the Gruens, and Marga-
ret to Nice. Arriving at the Hôtel de Paris with only an hour to spare,
Keith discovered that his luggage had been misplaced by the hotel. He
finally made it to the lobby at 11:30 a.m., the start time of the ceremony,
fuming—and "looking totally adorable," said Julia Gruen, in a blue pin-
stripe Giorgio Armani suit, shirt, and tie and spotless white Nike high-
top basketball sneakers. Upon their arrival at the Palais Princier, an
unamused functionary said, "You are extremely late," as he ushered the
group into an ornately gilded and chandeliered Louis XIV salon where
two dozen elderly Monégasques stood at the far end of the room. From
then on, all proceeded at a fairy-tale clip, as Princess Caroline appeared
in a dove-gray jacket and dark skirt to bestow medals on the honorees,
smiling broadly when Keith took his turn. "Keith was the only one wear-
ing sneakers, and he was the only one who kissed her," Joan Haring said.
"It was kind of neat." At thirty-one, he was also the youngest recipi-

ent of the honor and the first American. Following the ceremony, Keith and his parents returned to Paris, stayed overnight at the Ritz, and then boarded the Concorde. "When we were at JFK, waiting for the shuttle to the parking lot," Al Haring says, "Keith said, 'Now you know how to do it,' as if the whole trip was to show us how to travel to Europe."

Before Keith had left town for this sentimental victory tour with his parents—"A thank-you journey," as Mera Rubell calls it—Tony Shafrazi had suggested that he might need a second studio, a secret place away from the increasing frenzy of speculation and the floating party at 676 Broadway, "a space to do some bloody work, uninterrupted, without all the friends coming by." The dealer was also in the planning stages of a double one-man show of Jean-Michel Basquiat and Keith Haring for the next fall, on the large top floor of the Bakery Building on Prince Street in SoHo. "Before he died, Jean-Michel came to me and wondered why he had never had a museum show, and I wanted to give him one," Shafrazi says. "It was to be two shows next to each other of the two best friends." The space Shafrazi found for Keith was the five-thousand-square-foot top floor of an office building at 11 Beach Street, in Tribeca, just below Canal Street. "We carved out a two-thousand-square-foot studio in there," says Mark Pasek, hired by Shafrazi, along with his gallery assistant George Horner, to hastily assemble a studio. "We built walls, installed lighting, portable space heaters, brushes, paints, bags of pot, rolling papers, chilled bottles of water, yoga mats for painting on the floor, whatever he needed. Our job was also to pick up books from Rizzoli of artists he was looking at, mostly Lichtenstein and Dubuffet, who used that black line—not that the work he was doing looked like theirs. We primed fifty big canvases of various sizes and put up ten. One Sunday, he called and said, 'Would you take these down? I'm finished.' So, we put up ten more, though he never got to those." Says Shafrazi, "When Keith first came to my gallery, he told me that he would never paint on canvas, and now here he was, making all these big paintings on canvas."

Keith had begun working in his mostly nocturnal Tribeca studio by the end of October, before he left for Europe, and then resumed near the end of November. The studio was seen only by a few. One of those was

Haring's young Belgian fan David Neirings. Late one evening, Keith drove David downtown in his new 1990 dark-gray Mercedes 300F sedan, which he had had tricked out with darkly tinted windows and advanced stereo equipment in the backseat, having first taken the car to a detailer and instructed him, "I want it to look like a drug runner's car." As Neirings recalls, "He said to me, 'David, not many people can see this, but I'm going to take you somewhere.' So, we went to his garage, and he popped in a tape of Queen Latifah, which was totally new then, and drove down and parked in front of the old fire station where *Ghostbusters* was filmed. The office building that he was in was a block away, and we took a lift and got out on a high floor. In the middle was a white cube. Keith had a remote control in his pocket, and when he pushed the button, a wall opened into this secret atelier where he made his last paintings. He had a big container where he could sleep or rest, if he wished." Sam Havadtoy also visited, as Keith wished to give him a painting to thank him for his help with his apartment. "There were these large, really beautiful paintings, about eight feet wide, hanging in a clean, spotless, organized space, like a museum show," Havadtoy remembers. "'That one is yours,' Keith said. It was a painting titled *Miss Piglet Goes Shopping*. It's a little pig throwing money away, which was his comment on my decorating." During the renovation, the two had visited a bank weekly, and Keith often handed Havadtoy twenty or forty thousand dollars in cash. The thematically lightweight painting was meant as an inside joke.

Keith approached the canvases in the Tribeca studio as he would have approached a Shafrazi exhibition, working simultaneously on several paintings in a similar key. He first painted all the backgrounds of the canvases in solid colors—orange, blue, red, or green. On another day, he applied a long pinstriping brush of the sort used on cars, to shape arabesques all over the surfaces. Finally, he painted solid black, graphic images on top, creating a complex layering, as if the paintings had been baked on a flat sheet pan. Like *Against All Odds*, several of these works approached mortality from a global perspective. If they were elegies, they were protest elegies. Acidly roiled and righteous was *The Last Rainforest*, representing horrors visited on the rain forests of South

America. The painting itself was a thick jungle of imagery of fish swimming in cadmium-red fires, vines akin to electrical wiring climbing and strangling life-forms, and trees smoking yellow nicotine sticks. Nearly camouflaged in the upper center, like a piece in a hidden-picture puzzle, was a beatific radiant baby seated in a lotus position. The painting was bought from Shafrazi by artist and photographer David LaChapelle, who admitted that the work hung in his living room for three months before he noticed the baby. "In Keith's earlier drawings, at first, he was always crawling," LaChapelle says. "Now it is like the baby has reached his destination and is enlightened. So, there is optimism within all of that horror. Without the baby, the painting is purely apocalyptic and does not have the sense of hope that Keith did . . . I'm embarrassed to say that it took me so long to see the baby. Once you see it, you can't unsee it." On the same day as he painted *The Last Rainforest*—October 24, 1989—Keith also completed *Walking in the Rain*, a phantasm of a scary, birdlike creature striding in blue-black rain. The painting shares a title with a cover song by Grace Jones, yet also, as Julia Gruen wrote, was "a reference to mutations generated by pollution and acid rain."

The theme of unfinishedness not only haunted but was manipulated by Haring in these late paintings, mostly done in the Tribeca studio, though he continued working at the Broadway space, too. Over ten years earlier, in his journal writing while at SVA, he had been fascinated by the ghosts of interrupted artworks from artists' lives past. "It seems that artists are never ready to die," he wrote. "Their lives are stopped before their ideas are completed. Matisse making new discoveries up until the time he could hardly see, using scissors, creating ideas that sparked new ideas until death interrupted. Every true artist leaves unresolved statements, interrupted searches . . . I am not a beginning. I am not an end. I am a link in a chain." In May, two days after his diptych *For James Ensor*, he made *Unfinished Painting*—a triangle of arabesques in purples from midnight to lilac beginning in the upper left corner, its edges flush with the margins of the canvas and stopping after a quarter of the available space is covered, allowing rivulets of paint to drip down in the manner of action painting. The titling of the painting was clever, as unfinished paintings are usually accidental rather than

willed, yet also reflective of his wish to control and frame with art his own life and death. *Brazil*, painted in the Tribeca studio, was an abstract evoking of the coastal edge of the home of the rain forests, while also made to resemble an unfinished canvas, as paint drips down into an indigo-blue lower-right corner, either the blue of the Atlantic Ocean or, blankly, of nothing. His final studio painting, *Untitled*, done in Tribeca and completed in November, was a large six-by-six-foot work in enamel and acrylic that suggests the tarps of his first Shafrazi show—the background is the artificial sunshine yellow of several of the tarps. The figures outlined in bold green lines dotted with purple circles are universal markers for humanity, seen through a veil of raining drip lines. The overall message is a choric "Hooray!" as the absence of shoulders turns all arms into wings that wrap the figures together head to head. With thick, red decorative markings crawling everywhere, the piece is not a marvel of speed, as so many of Haring's are, yet its affirmative lift is both seen and felt.

By December, while slowing down somewhat in the studio, Keith was now fully owning his public role as a PWA (his status as a marked man) and an engaged activist for the treatment, rights, and dignity of people with HIV/AIDS. "He definitely became both a champion and North Star for others," says a friend. Keith had participated in earlier ACT UP actions, even before the fund-raising newsletter. In March at City Hall, he had protested, with three thousand others, Mayor Koch's AIDS policy. A photograph of him at the event appeared on the cover of *The Body Positive* magazine, standing beside Adolfo Arena and holding up a sign with Mayor Koch's visage and a message that riffed on the mayor's signature catchphrase: "10,000 New York City AIDS Deaths. How'm I DOIN?" while Adolfo carried a sign decrying the racism of New York City's AIDS policy. He took part in a kiss-in at St. Vincent's to draw attention to homophobia in the hospital. He then donated a sculpture of painted plywood, *Totem*, for an "Auction for Action" to raise funds for ACT UP's "Stop the Church" action being planned for St. Patrick's Cathedral—the protest publicized with the "Scumbag" poster dear to Keith's heart. The December 2 benefit auction was cochaired by Annie

Leibovitz and David Hockney, and more than a hundred pieces of art were solicited, including works from the Robert Mapplethorpe Foundation, Robert Rauschenberg, Robert Gober, Jenny Holzer, and Barbara Kruger. Yet it was Haring's *Totem* that stirred the most spirited bidding. The work was originally estimated at $12,000, though, as Keith predicted, with the news of his sickness, a sudden rush of buying was driving the price for his artworks higher. "The bidding quickly went crazy high and way past the estimate," Sean Strub remembers. "Somewhere past fifty thousand dollars, the crowd started chanting, 'Act Up! Fight Back! Fight AIDS!' as a declining number of bidders were pausing, deciding whether to bid or not. Tension was building. When the gavel finally came down and it was sold for $74,000, there was mass euphoria. I don't think anyone who was there can forget the elation and excitement. It meant something beyond the money."

The largest ACT UP action that Keith joined—and one of the most controversial in the group's history—was the Stop the Church action the next weekend, at which 4,500 protestors packed Fifth Avenue on a bitterly cold Sunday morning to confront the harms done by Cardinal O'Connor and the Roman Catholic Church. Inside St. Patrick's Cathedral, more than 100 demonstrators were arrested for disrupting the service, a controversial escalation at the time. In the guerrilla theater outside, bullhorns blared, and placards were waved by protestors dressed as clowns, nuns, priests, and even Jesus Christ with a crown of thorns and a shepherd's staff. In the melee, Keith was thrown together briefly with one of his earliest SVA friends, the painter Frank Holliday. "All of a sudden, I looked up, among some 'We Hate Fags!' taunts aimed at us, and there was Keith," Holliday says. "He went, 'Frank.' I went, 'Keith.' He had on this thin little jacket. His hands were in his pockets, and he was shivering. I took off a scarf and wrapped it around him. We were walking around in a circle, and Keith was talking to somebody. A guy lit a Bible on fire. I looked across the circle, and there was Keith again, and he was looking at me. We had this weird moment. I don't know what he was thinking, but I was thinking, *What happened?* Someone dressed as the Flying Nun was being held above our heads, shouting, 'I'm flying!' I

looked back, and Keith was gone. That was a theatrical, meaningful moment. We had been such boys together, and so much had happened, and now here we were. It was haunting."

A month later, in January 1990, Keith was back in Europe on his own for his final time, to paint a BMW at Galerie Hans Mayer in Düsseldorf and to attend the opening of a drawing show at La Galerie de Poche in Paris. Hans Mayer had conceived of Keith contributing to the official BMW series of cars painted by major artists, including Frank Stella and Andy Warhol, as part of the BMW Art Cars project. Yet his proposal was delayed, as the Munich car company was already obligated to other artists. Feeling the pressure of time, and knowing of Keith's love for painting cars, Mayer simply went ahead and bought two 1990 BMW Z1 automobiles, one red and one black, and when Keith arrived at the gallery, he asked him to choose. Keith of course chose the red. "It was a weird situation," Klaus Richter says. "He was very sick. He worked with this car paint, and I think it was not very healthy for him. A lot of people came. And press. It was always packed with people." Although Keith was visibly dragging, his energy—while he was in the throes of work—remained high. Stephanie Mayer was struck by his familiar performance that day: "He was surrounded by, like, a curtain of music, with a little blaster you could hear from here to Köln, it was so loud. The whole art of his moving when he painted was really very attractive. He was not quite like a human being. He was like a dancing line. He really was." Keith then went on to Paris for a show at La Galerie de Poche of about thirty drawings he had made in a single morning for Lucio Amelio in 1983. Livid at the high prices that were suddenly being asked for his work, Keith showed his displeasure—or created a balancing pleasure—by standing in front of the gallery on rue Bonaparte making signed drawings on loose pieces of paper that he gave away freely.

If Keith was laboring more than usual, he was not stopping. "He certainly had some days that were very, very dark," Julia Gruen said. Yet the well-traveled synapses between his brain and his hand remained unsnapped and largely unaffected. Before he left for Europe, on Christmas Eve 1989, he had created a twenty-five-foot-long drawing on brown paper with seasonally red and green markings resembling a loose ver-

sion of an advanced mathematical equation, more in the manner of the unspecific scripts of Cy Twombly. The piece was done at the Broadway studio, which was filled more often than usual that winter with the sounds of classical music, especially Wagner, played at a deafening volume. On January 20, he made a whimsical light-tan terra-cotta vase sculpture banded in marking pen cartoon strips and supported at the base by three crimson alligators; it was signed "For Roy and Dorothy [Lichtenstein]." When he had carved in the wet clay of his apartment fireplace to create a Keith Haring mantelpiece, Sam Havadtoy was impressed enough to suggest they make editions together of panels and tables, done in the same medium. "Okay, but I don't really have the energy for this," Keith replied. "If you prepare everything, I'll come and do the carving."

In late January, Sam informed him that the materials were ready, and Keith went up to the Dakota, where newspapers were spread and trays of wet plaster laid out in a secondary living room/workroom within Yoko Ono's apartment. Keith snapped a tape into his boom box, sipped from a Coke, and carved into the wet clay with a loop knife, incising quarter-inch grooves in a continuous line, all without preliminary drawings, except for a sketch of a dancer for the third of the panels, which he drew first on a piece of wood.

When he was finished, Sam said, "Keith, I had one other last idea to do, if you like it." He then led Haring through a pair of sliding doors into another room, where he had laid out trays specially designed as an enlarged version of a traveling Russian icon Sam kept on his night table. The waiting triptych of panels was seven feet by five feet. "He stood there, saying nothing," Havadtoy says. "I thought maybe he was out of ideas, so I said, 'I thought you might do angels or the Virgin.' He looked at me and said, *'Could you just shut the fuck up?'*" Keith thought for a while and then set to work, down on the floor, creating a Last Judgment scene in the wet clay, an Apocalypse with no clear winners or losers. In the left and right panels, angels both soar and tumble. In the central panel, giant drops of rain, or fire, fall on the gathered humanity, with upraised arms below, as a radiant baby is wrapped in the many arms of a supreme being holding a shining ring of power. The baby is being

cradled upward toward a heart and, finally, to a surmounting cross, all longtime images in Haring's symbology. The ascendant baby traces back either several weeks to *The Last Rainforest*, or all the way back to the haloed baby in a crèche drawn in pencil by the thirteen-year-old artist in his Jesus freak phase, or to his subway drawings of same. "I was there when he did those," Sean Ono Lennon says. "It was really cool to see him work in that medium, because I'd never seen that process. It was religious looking. They turned out very beautifully."

When Keith stopped, he stood up and said, "Man, this is really heavy." He was exhausted, completely out of breath, and Sam realized for the first time how frail he had become. "When I'm working, I'm fine," Keith said. "But as soon as I stop, it hits me." They went out to a large kitchen with a comfortable couch, where Yoko received close friends. The photographer Bob Gruen was present, and he asked Keith how he was doing. "I instantly realized it was the wrong question," Gruen says. "He shook his head and said, 'Not very good.'" The piece was eventually cast in bronze with a white gold leaf patina, though Keith saw only the clay prototype. The altarpiece triptych was his final major work of art.

By early February, Julia had begun noticing a different quality to Keith's voice. At first, he was rasping. Soon, he developed extreme laryngitis that reduced him to mere screeching and scratching sounds whenever he tried to speak. His normal hour for showing up at 676 Broadway was noon. Yet his routine was beginning to slide, and often he could not get it together to appear at the studio until closer to four o'clock. He drew only small pieces, and he was clearly too weak to paint. "Not only was he not producing art, he wasn't able to communicate verbally," Julia Gruen said. "It was heartbreaking." He did continue his daily ritual of going through the mail, making notes on every piece of paper: "I'm interested in this project," or "These people are ridiculous," or "Find out more." One afternoon, the four o'clock hour came and went, and Julia phoned LaGuardia Place. "Keith, I just want to know if you're coming in today." He answered, "Actually, I think I'm not." He never regained enough strength to return. "Those last couple of weeks, he declined

quickly," Dr. Bellman says. "He was pretty much homebound, getting some hydration, had visiting nurses around the clock, and seemed comfortable. He was not in a lot of physical pain. Keith was such a gracious person, though. He was supportive of me failing to get him better, to put it bluntly. He understood that I was doing the best I could, and he appreciated that, even though his life was at stake. He may also, in the end, have developed KS in his lungs."

When his parents made their regular Sunday phone call the first weekend in February, they could hear the sickness in his voice, and Julia informed them that he was laid up in bed. Circulating among family members was an explanation for his downturn that he had contracted a chest cold while attending the inauguration of Mayor David Dinkins on the steps of City Hall on New Year's Day. The Harings decided to make a day trip to New York to see their sick son. When they discovered that he had more than a bad cold, they wished to stay longer, yet they had not packed a single suitcase, and Keith had mixed feelings about a longer stay. Still unclear was any prognosis, or the severity or duration of this episode. "He was very reluctant to have them stay around," Julia Gruen said. "He wanted Gil there with him. Not that his parents had too much difficulty with that, but Gil felt uncomfortable, and Keith felt uncomfortable. He sent them back to Kutztown, saying 'It's okay, it's okay.'" Within a few days, or a week, the situation was not improving, and his family returned, prepared for a longer stay. As Keith relaxed into the familiarity of having them always nearby, his parents moved into the red room downstairs. "It was not just red, but nauseating red," Al Haring says. "Everything red, walls, ceiling." Yet the guest room allowed them to be close to Keith without intruding on the constant social scene in the living room upstairs or in his more intimate bedroom. His father took to smoking an occasional cigarette on the apartment's roof deck, and his mother to hanging out washing to dry: "I wanted him to have clean sheets." All three sisters visited and then returned to college or to their young children.

Keith's relations with his family had never been entirely simple. "I think he was always trying to prove something to his family," Kermit Oswald says. "He was trying to move some kind of emotional ball down

the field that had more to do with them than anybody else." Their refusal in his early years to believe in him as an artist still burned. No amount of public fame ever changed his need to impress them—to say, "I told you so." One of his last paintings in the Tribeca studio, of a leggy, shrewish creature with serrated teeth and a snake for a limb, akin to the imaginary mutation in *Walking in the Rain*, was titled *Mom*. The work was not necessarily depth psychology on Haring's part, just as likely a joke on sentiment and expectation. Whistler's Mother she was not. Yet, as Julia Gruen wrote in a one-line response to the painting in an essay, "Who knows what to make of this title?" Of his being gay, Karen Haring says, "We didn't talk about it, because you don't talk about those things." His mother says, "He never used the word *AIDS* with us, even when he was sick, and we didn't, either." Their reticence implies at least some level of unresolved shame. "It's funny that he tip-toed around being gay to his family," Gil Vazquez says. "When you represented this pride, like Keith did, to be who you are, the irony is he could not be that with his parents. Whatever understanding there was, was not spoken." Yet the closeness of his family around their son at the end attested to their loving cohesion. Such support was not always a given in the deaths of many young men from AIDS, who, because of family disapproval of their lifestyle, sometimes died alone. Keith had welcomed his family into his adult life, and they were ever loyal and proud. "My parents have been so amazing about the whole thing, but in their own way—knowing but not saying," Haring said in *Rolling Stone*, on the gay issue. "I never tried to hide it from them, and they never asked me about it." Dr. Bellman observed, "Keith's parents seemed to have come to terms with him, and he with them. They were there for him. I won't say that was the exception at the time, but it certainly was not the rule."

Keith was fortunate as well in having the means and medical support to remain in his home, which had been at least partly designed in his mind for this outcome. The setup allowed the continuous coming and going of the friends who had defined his life. "It became progressively apparent that Keith was indeed deteriorating," Julia Gruen says. "Within days, word had gotten out that Keith was quite sick. There

were endless, endless phone calls, from every corner of the earth. There were many, many visitors. The doctors came daily. There were nurses. Keith's parents and his three sisters came from Kutztown and remained in the apartment. Gil Vazquez seldom left Keith's bedside." Kenny and Tereza Scharf were regular visitors, as were Francesco and Alba Clemente. Bruno and Carmel Schmidt would stop by daily. "We all used to go and take turns," Bruno Schmidt says. The children would sometimes be around—Nina and Zena and baby Matias. One evening, Tony Shafrazi ordered everyone food from Indochine, a favorite restaurant of Keith's, and they sat eating while wearing Keith Haring T-shirts. Keith's studio assistant Adolfo Arena spent most days in the apartment. A constant presence was Lysa Cooper. "I knew he was passing, but there was still so much laughter going on between us," she says. Keith also called Juan Rivera, who would come over and cook dinner for him. One evening, he called and said, "Juan, I want you to keep me company." "That night I stayed over," Rivera said.

Oxygen tanks were by now set up in Keith's bedroom, and he was receiving IV fluids. Through his window, he could watch the Empire State Building, bathed in red light, as the holiday season being marked was Valentine's Day. He began experiencing periods of delirium, though the episodes were sporadic, and would then return to complete lucidity. "One night, one of his nurses said to me, 'He's very bad tonight; he said there's a red horse in the next room,'" Joan Haring says. "I said, 'No, there *is* a red horse in the next room.' He meant his red Texaco horse." In a rueful irony, a letter arrived from Walt Disney Studios suggesting a collaboration, a lifelong wish of Keith's. Julia read him the letter at his bedside, not sure if he was comprehending its contents. He surprised her by doubting its authenticity and accusing her of trying to lift his spirits. The letter proposed a focus on "Mickey Mouse as seen through the eyes of Keith Haring." Faced with moments of heartbreaking delirium, when Keith did not know where he was or who was speaking to him, Gil began to realize the finality of the situation. One night, he had stayed over, as he often did, sleeping on the couch upstairs, and was watching a boxing match between Mike Tyson and Buster Douglas. "Tyson was favored by a lot to win and was the toast of that time," Vazquez

says. "He lost spectacularly in defeat, and everyone was in utter shock. It was jarring because Tyson was at the height of his powers and the top of his game. The symbolism was very poignant. Watching the fight at the apartment, I suddenly understood, maybe for the first time, that this was really going to happen to Keith."

On the last full day of his life, February 15, the mood in the apartment was far more subdued, yet Keith was still receiving visits from friends. "Carmel went up by herself, and I stayed downstairs with Matias," Bruno Schmidt says. "We knew it was the end. Carmel was more courageous than me. Women in that very dark time often were." The Rubells stopped by, too. "I was sitting in the living room kind of by myself," Mera Rubell remembers. "I don't think I even took off my coat. I was shivering in a way." Keith asked for Don, by whom he felt very comforted and who was a doctor. "Keith pointed to the Léger on the wall opposite his bed," Don Rubell says. "He said, 'All my life, I wanted a Léger. Tomorrow morning at five thirteen, I'm going to wrap myself in a sheet. I'm going to take the Léger, and I'm going to go away.'" Says Mera Rubell, "When Don came out of his room, he was ash white." Says Gil Vazquez, "There was a moment when the clouds parted, and he got clear and he was able to talk. He said he was aware of who was around him. He said, 'I know you've been here the whole time.' That was his last moment of thanking everyone for being by his side." Among the bedside group were Adolfo Arena and Lysa Cooper. "He had that moment of clarity, light, and full awareness," Cooper says.

Keith's genius at drawing was the last to go, and of his drawings, the radiant baby. Julia Gruen recalled the graffiti artist Lee Quiñones stopping by and Keith trying to draw a baby for him and failing. Yet he did not stop trying. "Kenny and Lysa were in the room at some moment," Vazquez says, "and they kept pulling out paper after paper as he tried to draw the baby with a black Sharpie marker. He was really struggling, toiling to have control of the line. You could see in his face how frustrating it was for him. Finally, he drew this baby that was not really completed." Kenny Scharf kept that final drawing. The last phone call Keith received was from Madonna, who wished to visit him but was still in California. "We were expecting one of the girls to call, so I picked up,

and she said, 'This is Madonna. Can I speak with Keith?'" Joan Haring says. "I walked the phone downstairs and told her I was Keith's mother and we talked." Dr. Bellman had stopped by on his way home to check on Keith, as he did most days, and stepped out of the room when Keith's mother appeared, so that everyone could have some privacy. "His voice was so weak," Joan Haring recalled. "But I remember very well what he told Madonna . . . 'You're going to Tokyo, and listen now, be sure when you get back, you come and see me.'"

By nightfall, most of the friends had been asked to take a break for the evening, with only the Clementes and the Scharfs staying on to have dinner with the Haring family. "I cooked for everyone, though it was a small group," Alba Clemente says. "The parents remember me because we Italians always feel a good meal can cheer you up." The friend who had shared so many of his first thrilled moments as a young artist, making a name for himself at SVA and at Club 57, was one of the last to go downstairs to spend time alone with Keith. "He was very agitated," Kenny Scharf says. "You could feel it. He couldn't speak anymore. He couldn't open his eyes. I sat next to him and held his hand and, basically, I said, 'I know you can hear me. I'm going to do everything I can to make sure your already amazing legacy is kept alive. I know it will grow. You're going to keep going even though you won't be here. You can just relax knowing that.' His body totally relaxed, and the agitation went away." In the middle of the night, the nurse on duty woke his parents to inform them that their son's liver and kidneys were failing. "That means that there's not much time," Kristen Haring recounted. "My parents got into bed with him and held him for the hours until he died." Keith Haring lived until 4:40 a.m. on February 16, 1990.

Family, friends, and much of New York City learned of Keith Haring's death throughout the next day, as the story was carried on all the local news broadcasts. "The radio was on in the cab, and I was so scared that it was going to be on the news, and I would just lose it," says Kristen Haring, who was arriving from the University of Pennsylvania, where she had just taken an economics exam. The iron gate on the Pop Shop

on Lafayette Street was turned into a makeshift memorial, covered in white tulips, gladiolas, and daisies. On the sidewalk, an unknown artist had drawn in white chalk a facsimile of a typically long-jawed and quizzically bespectacled Keith Haring self-portrait, mimicking Haring's materials and high-spirited street art, yet carrying the somber epitaph "K. Haring. Died of AIDS. 1958–1990." Other artists took over whatever fallow black-matte advertising spaces they could find in the subways and filled them with crawling radiant babies. At Fifty-Ninth Street and Columbus Circle, graffiti artists depicted Haring as a martyr hanging on a cross. Photos of Haring were taped onto the walls at construction sites. On lower Broadway, on a wall in front of a line of galleries, someone painted a widespread sentiment: "New York City Loves Keith Haring." That evening, an ACT UP talent show benefit and slumber party (with sleeping bags) was being held at the Gay and Lesbian Community Center. Throughout the night, singly or in pairs, members would visit the restroom to commune, in memoriam, with Keith Haring's life-affirming mural, with the now even more evocative title *Once Upon a Time*.

On March 3, the family held a small memorial service in Kutztown. Keith's wishes had been for his body to be cremated, yet no plan had been made for the final disposition of the ashes. "When they asked if we wanted the ashes, the remains," Allen Haring says, "I guess it was a dumb statement, but I said, 'We don't need to have them.'" Lisa Oswald eventually convinced him otherwise, and the family decided on a short religious church service to be followed by a scattering of the ashes. The service was intended as an occasion for the extended Haring family—a large number in itself—to gather, along with some of Keith's local friends. Of course, the closest of his New York group were included—Julia Gruen, Tony Shafrazi, Kenny and Tereza Scharf, and Don and Mera Rubell. Keith's sister Kay invited Yoko Ono, as Keith had brought Kay once to the Dakota, to a birthday party for Sean. "Yoko had talked with me about being a single mom," Kay Haring says, "about how difficult it was for her, after John died, to raise Sean alone. She signed one of her albums and gave it to me." Yoko Ono and Sam

Havadtoy drove to the Kutztown service in a limousine, and Bruno and Carmel Schmidt and their baby, Matias, rode with them. Not included in the service were other members of the vigil at Keith's bedside—Adolfo Arena, Lysa Cooper, Gil Vazquez. But Juan Rivera knew well how to get to Kutztown, and he found his own way.

The service was held at Hope Evangelical Lutheran, a modern, wooden in-the-round church in Bowers, the usual setting for gatherings of the wider Haring clan. Keith's family had been less involved over recent years in the more obvious choice, St. John's United Church of Christ, in Kutztown, Keith's boyhood church. They were also smarting from a recent incident. When Keith had come to town to take part in the baptism of Kermit's son, Colin, shortly after the appearance of the *Rolling Stone* article, some members of the congregation chose not to attend the Sunday service because a person with AIDS would be present. "In a small town, you get the little whispering behind your back every time you walk into a store," Karen Haring says. "I think my mother probably felt that more than my dad, because she was involved in a lot more groups and was a little more aware of all the gossip." After a short religious ceremony, everyone gathered for a reception in the church's community rooms, where lots of posters and videotapes of Keith Haring were displayed, including a clip of an ABC News story of a rapper performing his own tribute: "He started alone / He was the only one / Keith Haring was his name / And he was having fun." A request was made for donations to Rainbow Home, a local hospice for homeless PWAs. James Servin was covering the event for a long piece he was preparing on Keith Haring for *7 Days* magazine. "As the crowd thins out around 4 o'clock, a man in a gray suit strolls over to one of the walls and begins to peel down the posters," he wrote. "He's tall and thin, with the short hair and Gumby-like gait of Keith Haring. This man, unmistakably [is] Haring's father."

The site chosen for the scattering of the ashes was a hilltop that had been graced by an apple tree when Keith was a boy. Keith had been able to see the hill from the Harings' backyard on Whiteoak Street and had told his father he wanted to hike up there. He soon began frequenting the spot with its view of Kutztown below, meditating on things or simply getting out of the house. In high school, he borrowed a camera and

took panoramic pictures and dropped LSD there. On the late afternoon of the ceremony, as in many somber moments, comic realities kept intruding. The apple tree had since been cut down, and local kids had taken to partying on the spot, leaving behind their empty beer cans. Both Julia Gruen and Tereza Scharf wore high heels and stumbled often while trying to navigate the steep hill. Julia was carrying the ashes in a black plastic box that was tightly sealed. "Kermit, do you by any chance have a can opener?" she asked. He miraculously did. As the event went on, though, its poignancy grew. "So, that's Keith? That's Keith in there, right?" a little boy asked his mother, one of the multitude of kids, big and small, brought by the entire family of sisters, cousins, aunts, and uncles. Kermit Oswald made an impromptu speech—not religious, but thanking God for Keith Haring. He then spread some of the ashes in the shape of a Haring crawling baby. "Not planned, but it just dawned on me in the moment," Oswald says.

With the box pried open, and Kermit having drawn the baby, many of the forty or fifty gathered on the hill then participated in spreading the ashes, beginning with Keith's mother. "Each of us took a handful and walked off in various directions, strewing the ashes," Julia Gruen recalled. "It was absurdly emotional. And it was an absurdly beautiful setting, because the sun was just going down and the sky was bright red, and there were geese flying overhead." Says Kenny Scharf, "Juan and I cried deeply." Tony Shafrazi recalls that "the wind blew the ashes back into our faces. I saw Juan over by the ashes and then, suddenly, he was crossing behind me, howling like an animal, long howls." By Juan's own account, "A flock of *pajaros* flew overhead. And I couldn't help it and broke down and ran down the hill crying." Unnoticed was Yoko Ono, when she pocketed her portion of the gray-white gravel of human ash. "I have a psychic side; ghosts and spirits whisper to me," she later explained in a documentary. "Suddenly, Keith just whispered to me. 'Keep it. Hold it. I'll tell you what to do.' I went home, and Keith said that he would like me to take it to Paris and put it in the obelisk in front of the Ritz on the Place Vendôme. I went to Paris. Then Keith came again and said, 'Do it today.' The car was going to a gallery that we know, and it sort of passed in front of it, and I said, 'Stop! Stop!' I jumped out of the

car, and I just put it exactly where Keith said I should put it." If less su-
pernatural, her gesture was poetically fitting for the "artist prince"—as
Peter Schjeldahl described him in his 7 Days obituary—whose fervent
dream as a fourth grader had been to grow up to be an artist in France.

Keith Haring's upcoming thirty-second birthday, on May 4, 1990, was
then celebrated in a memorial service attended by more than a thou-
sand invited guests at the Cathedral of St. John the Divine in New York
City. The enormous, unfinished neo-Gothic Episcopal cathedral on an
overlook above Harlem on Morningside Heights had been the setting
for the memorial service for choreographer Alvin Ailey, who had died of
AIDS-related complications the previous December, though the cause
of Ailey's death was publicly given as "blood disorder"; for memorials
in the previous decade for James Baldwin and George Balanchine; and,
even further back, for the lying in state in 1947 of the former New York
City mayor Fiorello La Guardia. These public memorial ceremonies at
the cathedral were reserved for those being honored as citizens of New
York City and of the world. Unlike St. Patrick's Cathedral, the scene of
the Warhol funeral, St. John the Divine, beginning in the early eighties,
had provided sanctuary and support for those suffering with AIDS.

The coverage the event received in the New York Times was more
respectful than any of their coverage of Haring during his lifetime.
The pomp and religious circumstance were not lost on some of Keith's
downtown friends, yet ways were found to try to keep his playful wit
alive. Clutching balloons on the stone steps leading up to the entrance
to the cathedral were Keith's youngest friends, greeting those arriving.
"With the Scharf kids, we got like two hundred balloons, and we drew
a bunch of his characters and words on little labels," Nina Clemente
says. "We taped them back-to-back on these balloons and let them go,
so they would reach him. Right outside the church, we let them go into
the sky." Derrick Smit and George Wittman were stopped as they en-
tered through the great bronze portal doors. "We were grabbed by these
two priests and pulled off to the side," Wittman says. "They called Der-
rick by name. His family was somehow active in the church. They said,

'You're leading the procession.' We were given large candles to carry. I thought of it as a Black boy and a white boy together. I don't know what they thought. We wore these white robes and our high-tops, and we got killer seats in the front row."

The two-hour service began with an anthem, and collect, and readings from Scripture, two of them on Jesus preaching the need to be like a little child to enter the kingdom of heaven. Then the Frances Jackson and Co. gospel choir appeared onstage singing, or belting out, "How Great Thou Art," setting the tone for the rest of the memorial, which consisted of talks about Haring by those who knew him and songs, dances, and performances in his honor. The banner hanging from the stone lectern was a photographic portrait of Haring in his hip-hop guise—brimmed cap swiveled to the side, heavily decaled bomber jacket, white owl-rimmed glasses. Next to the lectern, the stage was decorated with white Casa Blanca lilies, purple and yellow tulips, and cherry blossoms.

Many artists attended, including Roy Lichtenstein, David Hockney, Julian Schnabel, Francesco Clemente, and Jane Dickson; along with curators, collectors, and dealers Henry Geldzahler, Don and Mera Rubell, and Hans and Stephanie Mayer; and friends famous, such as Brooke Shields and Anne Bass; and less famous, such as Keith's close high school friend Janice Eshleman. Kermit and Lisa Oswald were there, and rows of Haring family from Kutztown. Not announced, but appearing at the last moment to welcome everyone on behalf of the City of New York, was Mayor David Dinkins. "His short life was a mission," the mayor said of Haring. "It is said that service to others is the rent we pay for space on earth. Keith left us paid in full." Former city parks and recreation commissioner Henry J. Stern added another official statement: he would be petitioning the city's Art Commission to certify Haring's Carmine Street pool mural as permanent.

The main eulogy was delivered by Dennis Hopper, wearing a tan suit and easing comfortably into the lectern, relaxed as only a movie star could appear to be, speaking extemporaneously, without any notes, yet giving a cogent guide in animated language to some of the more important significances of Haring's career as an artist. He traced Haring's

inspiration to the pop art of Warhol while pointing out his departures. "Keith attacked the subways and walls of New York City with the ferocious and sure stroke of a gunfighter or a samurai warrior, bringing back the ideals of conceptual art," Hopper said. "He made his images like the radiant baby as common as the Coca-Cola bottle or Elizabeth Taylor, and yet they were *his* images. Those images went into the museums and the art galleries of the world. And then, after what Andy had started at the Factory, the next step was to bring it back to the people again. He brought it back in the Pop Shop, so everybody could have art. He brought it right back to the people. Keith Haring is one of the great artists of the twentieth century."

Hopper was followed by Tony Shafrazi, reading from a prepared text in tones unusually subdued for him. He recalled Keith first appearing "in this make-believe little sort of gallery program I had going," and spoke of witnessing Haring's art from that moment on: "With the most beautifully learned hand, he began to draw and invent a most fantastic cosmology of animated signs and palpably true images that addressed conscious and unconscious themes of human conflict and transcendence. This at a time when figurative expression was practically nonexistent in the world of avant-garde art."

Art writer and adviser Jeffrey Deitch, stressing the social consciousness in so much of Keith Haring's work, said, "His work screamed with dire warnings, but his message was optimistic." "I learned a lot from my big brother," said his sister Kay Haring. "That a wall was meant to be drawn on, a Saturday night was meant for partying, and that life is meant for celebrating." Kay's poised yet intimate talk proved to be one of the most moving moments of the day.

The performance artist Molissa Fenley, Keith's first collaborator in dance at SVA—their video-dance piece, *Video Clones*, staged exactly eleven years earlier, on Keith's twenty-first birthday—had choreographed a piece to music by the Japanese composer Somei Satoh, which she calls "Bardo." Performing as well were the New York City Ballet principal dancers Jock Soto and Heather Watts, in *A Fool for You*, a piece choreographed by Peter Martins to the music of Ray Charles. Haring had been involved with the company in recent years, creating a poster image

of an American flag with dancing figures more balletic than break dance for its 1988 American Music Festival. The painting had been projected on a drop the night the company debuted *A Fool for You*, with Ray Charles performing live. "Peter Martins suggested we do *A Fool for You* at Keith's memorial," Jock Soto says of the piece they performed while wearing Keith Haring T-shirts. "We were fools for Keith. He was our friend. And he was high on the New York City Ballet, as so many were at that time. We were sold out every night." Of the performance at Haring's memorial, Soto said, "It was a very sentimental thing for Heather and me to do. It was all so surreal, and it was just hard to see people upset and crying. I remember at the end of the day thinking it was like the end of an era, of the eighties and all those people we knew. I was thinking maybe the end of the AIDS crisis, too, but of course it was not."

Representing for the liveliness that was Keith Haring were Ann Magnuson and Kenny Scharf, who re-created some of their Club 57 "shtick and act" and, for a brief spell, attempted to shrink the cathedral down to size. They began by rambling on sincerely about how awful they felt, until Ann interrupted: "You know, Kenny. Keith would be really bored right now." Says Magnuson, "We got a laugh. We made it kind of a routine." The two joked that the celebrity-filled church felt more like the Academy Awards, and they began giving awards, all won by Keith, as Best Go-Go Dancer, Best Video Artist, Best Friend, and as the audience applauded, they wound up to "And the winner is everyone who knew Keith Haring." Magnuson says, "A few of the old New York family members thanked us for breaking the moroseness with some laughter." But, she adds, "I still felt sick. Sick with sadness." She and Scharf were followed by Fred Brathwaite, who had also spoken at Basquiat's memorial.

Fully embodying the sadness was soprano Jessye Norman, who sang the "Morgen" song of Richard Strauss, and "Dido's Lament" from Henry Purcell's opera *Dido and Aeneas*. "Her voice has a kind of sadness in it anyway," says Stephanie Mayer, who flew with Hans for just the day. "If sadness were a cake, her fantastic voice was a knife cutting through it." Bill Katz recalls that "at the end of her singing, she raised her hand and slowly moved her arm through the air, erasing any applause. There was to be no applause. That was a grand moment."

The service ended as it began, with children. The final speaker was Sean Kalish, an eight-year-old friend of Keith's who barely peeked above the high lectern in his bright pink shirt. A child actor, Sean had first been brought to the Pop Shop when he was six, by his mother, and the manager introduced him as a young fan to Keith, who invited him to his studio. "Let's draw!" Keith said to him on his first visit, and their game of switch drawing led over time to working together on some etchings done on large metal plates. Sean enjoyed drawing with Keith because he felt that Haring drew like a kid. "I miss everything about Keith," Kalish said simply, in his short remembrance at the cathedral.

Sean was followed by CityKids, the group that had engaged a willing Keith Haring in projects that evolved into the ten-story-high *CityKids Speak on Liberty* banner and the *We the Youth* mural in South Philadelphia. The CityKids Repertory Company performed "New World Youth," written by Laurie Carlos, who had won an Obie for her role in *For Colored Girls Who Have Considered Suicide/When the Rainbow Is Enuf*—her performance became the lead clip in coverage of the memorial service on news shows that evening. "I also remember that they wrote a song about Keith, and they took turns singing it," Kalish says. "This one girl, when it was her turn to sing, she burst out in tears. She completed in tears, but she didn't stop, she finished." For another friend of Haring's in the audience that day, "When CityKids came onstage, the meaning of all the work Keith had done for kids, or gays and lesbians, or his message on addiction, was front and center. That is what set him apart from any other art star that existed at the time. The CityKids performance was the embodiment of that legacy of involvement."

Closing prayers were said. The conscripted candle bearers reappeared behind a verger. All the organ stops were pulled, and the cathedral's famous State Trumpet (one of the world's most powerful organ stops) blared, rather joyfully, as the recessional began, with speakers filing out first, then Allen and Joan Haring, followed by family members. Everyone began to make their way to a reception in the Synod House, across the cathedral close, as the sounds of ceremony gave way to the low din of talking and social greetings. Left still in a haze, though, was David

Neirings, who had flown in from Belgium. "I still get chills just thinking about it," he says. He lingered afterward, gathering some autographs on a printed invitation for the event, with Haring's radiant baby and barking dog in gold set against light-gray and dark-purple block backgrounds of color on the reverse side. "Keith Rulz," Ann Magnuson wrote on it. "I love Keith," wrote Kenny Scharf. Screwing up his courage, Neirings asked David Hockney, who wrote, "Keith's work is everywhere and it always works well on every surface. (see back of this.)"

Neirings held on to the program, too, with its cover of a Haring silhouette of a baby held aloft by one of his basketball player–tall figures, the last page underscored with a golden radiating baby. David cherished the program for, as he says, the "beautiful words of Keith himself," found on its opening page and dated May 3, 1989, the eve of his thirty-first birthday. The words were taken from the transcript of one of Haring's interviews with *Rolling Stone*, yet the full quotation had never appeared in print. With his madness to explain, Keith Haring was not only the best teller of his own life but also one of the clearest explainers of his work, with a healthy dose of unfiltered bias, and he rarely spoke of the one without speaking of the other. Leading up to the weekend, exactly a year earlier, when he made two paintings about death and art—*Untitled (For James Ensor)* and *Unfinished Painting*—he had articulated with a finality his intention for a life without regrets and an art without accidents. The words chosen for the program had emboldened him, and now they perfectly emboldened his survivors:

It wouldn't matter if you lived until you were seventy-five, there would still be things that you wished you would have accomplished. You could work for several lifetimes. If I could clone myself there will still be too much work to do, even if there were five of me. And there are no regrets, really. Part of the reason that I'm not having trouble facing the reality of death is that it's not a limitation, in a way. It could have happened any time and it is going to happen to someone any time. If you live your life according to that, death is irrelevant. Everything I'm doing right now is exactly what I want to do.

Staying behind, and feeling at least as lost as David Neirings, was Gil Vazquez, who had been sitting with his girlfriend at the time, the actress Drena De Niro, daughter of Robert De Niro, a relationship encouraged by Keith. "I remember sitting very near Brooke Shields," Vazquez says. "Keith would have been tickled that she was there. She was weeping. She was inconsolable. She was very sad, as we all were." Yet weighing on Gil at the service's conclusion was not simply the pressure of sadness but also a regret. Sometime during the ceremonies, he remembered that Keith had once told him he wanted a particular song played at his funeral. "That is something I lament," Vazquez says. "I hadn't gotten it together to communicate that to anyone."

The song was "Can't Play Around" by Lace, a Larry Levan disco mix from 1982 that was a Paradise Garage classic of funk and soul, an anthem, a staple. In his final blessing, the priest had prayed, "Into paradise, Keith, may the angels lead you." During most of his New York years, of course, for Keith, "Paradise" was shorthand for Paradise Garage. And by taking place on his birthday, the memorial service was also a final Party of Life. Keith's wishful recessional might well have had a bottom beat, with lyrics that sang of love and liberation, of taking love seriously, of letting it be, letting it be, of feeling the fire and rising into ecstasy.

Epilogue

I *saw my first* Keith Haring circa 1980, though I can't say exactly when, only that from the first crawling babies spotted in SoHo, his artworks were a marker, a sort of placeholder in my memories of the decade. I do remember one evening, when my lover, Howard Brookner, a filmmaker, and I were walking from the West Village, my starter neighborhood, to the East Village, his. In the gloaming of the natural and artificial light, we saw stenciled in reddish-orange pigment, like Martian dust, at a street corner, the warning "CLONES GO HOME."

"You'd better go home," Howard said.

We knew we were looking at an inside joke within the gay community. The maker of the street art soon registered memorably, too, as I began seeing him around, though he was never a friend. Supposedly, Keith attended a party thrown for me and Dennis Cooper and our newly published books of stories on a Sunday afternoon at the club Limelight in 1984. Keith was on the list, yet I don't recall seeing him there. I vividly remember him, though, at an opening at the Apollo Theater in Harlem. Seated in a loge box, as the lights dimmed, I looked down to watch an entire row of orchestra seats, four or five back from the stage, filling with Keith Haring and his deftly outfitted posse of mostly Black and Latin young men and women. They created a quiet,

theater-wide frisson. He was a celebrity and happily a scene maker in a scenic eighties moment.

Within a few years, near-total darkness had befallen that scene and, most intimately, the gay community. Howard was diagnosed with HIV/AIDS in 1987 and lived for another two years, often confined to a wheelchair, unable to complete a final cut of his film *Bloodhounds of Broadway*. Through John Giorno's "AIDS Treatment Project," Keith gave a generous grant to pay for some portion of Howard's care. Their connection was mutual admiration for William Burroughs, about whom Howard had made a documentary. When Howard died in 1989, Keith attended the funeral, held on the date of Howard's thirty-fifth birthday. I remember looking out from the lectern, upon those gathered in the funeral home, while blearily trying to deliver a eulogy and seeing Keith standing in the rear of the crowded room. He looked spooked staring at the closed casket with a Star of David on top, much as Bruno Schmidt later described him to me as staring at the open casket of Juan Dubose. By the April of the funeral, Keith had received his own AIDS diagnosis and was clearly registering, again, that his turn would come. I was in touch with his office shortly after to arrange to be returned some of the monies Howard had not lived long enough to spend. As with donating sundry unused medications to our doctor for distributing to those still in need, such returning of unspent funds given by friends was a common gesture at the time, an attempt to be helpful while feeling helpless. For New Year's Eve 1989, Keith had sent Howard one of his annual card prints—a drawing in red and black of celebratory, boogying figures—signed to Howard. I framed the print, and it hangs on my living room wall.

Fast-forward a few decades, into a radically revised world of gay marriage and—an ardent wish of Keith Haring's—gay families. My partner and I have two boys, and when the oldest, Walter, was a baby, I used to carry him around before bedtime to say good night to the art. Invariably, as we approached the "card" animated with Haring's red calligraphic figures, graphic and exuberant, Walter would grow more excited, pointing and making sounds. The Haring was a definite favorite. After a few more years—about the number of years it takes to write a book—Walter entered elementary school. At drop-off, I kept noticing

kids in Keith Haring T-shirts and hoodies. They not only were wearing the clothing, but they often knew the artist's name. A friend sent me a photo posted on social media by a Brooklyn preschool showing his son and other four-year-olds learning to draw by copying Keith Haring drawings. If Francis Ford Coppola used Pop Shop items in *New York Stories* to evoke an eighties fashion moment, all the licensed Haring images visible on playgrounds and the streets, worn by all ages and genders, speak of the spirit of these times, too. At a pool party for her grandson's eighth birthday, an SVA instructor who taught at the school when Keith was a student said to me, with a mixture of pride and surprise, "They are getting it by osmosis. It does seem that Keith Haring is going to endure."

The afterlife of Keith Haring has been as dramatic in its downs and ups as his life in the eighties. The art market in 1990, when he died, was deflated, especially for the art of the eighties and the artists most associated with that decade, such as Haring, Basquiat, and Scharf. The scene was felt to be over. Saturday afternoon crowds at the Pop Shop had dwindled. Christie's auction house appraised Haring's estate after his death at $25 million, a number that sounds enormous yet reflected the total projected value of his art collection and the sizable number of artworks in many mediums he had left behind. "The cash in the bank was negligible," Julia Gruen says. "We had to pay so many attorneys and auction houses. The money was flying out the door." On some weeks, an open question was whether they would meet the payroll. Reluctant to sell the works of art in the inventory, the foundation was prevented by the stipulations of Haring's will from seeking outside funding. The Keith Haring Foundation was designed to be self-sufficient. Yet it was charged not only with sustaining, expanding, and protecting the artistic legacy of Keith Haring, but also with supporting not-for-profit organizations that provided educational opportunities to underprivileged children and organizations engaged in research and care with respect to AIDS and HIV infection. During its first lean years, the foundation did fulfill its charge, beginning with gifts in 1992 and 1993 to VillageCare of New

York, the Boys' Club of New York, Bronx AIDS Services, and the Children's Village.

In the decades since Haring's death, the reputation and impact of the artist have been steadily evolving. Given the strengthening of the art market, and the strong response to his work among many younger artists and many young people, works began selling for seven figures. This change of fortune has been clearly reflected in the philanthropic work of the Keith Haring Foundation. Since 1990, with—as of this writing—assets exceeding $60 million, not including the portfolio of artworks in its collection, the Haring Foundation has issued over $43 million in gifts. Grants have been bestowed upon, among a long list of others: Planned Parenthood of Greater New York, for a Keith Haring Foundation Mobile Health Center; Bard College, for an endowed Keith Haring Chair in Art and Activism; and the Callen-Lorde Community Health Center, for the Keith Haring LGBTQ+ Health Equity Endowment. A consistent grant has been to the Association to Benefit Children (ABC) for the Keith Haring School, which serves children (from infancy up to age three) living with or affected by HIV/AIDS. An unforced surge in attention to Haring's work has been provided as well by the younger generation of artists finding prescience in his art activism and populism. "Though Keith Haring died only two years after I started making street art, his art and practice already had a profound impact on me," says Shepard Fairey, who created the Barack Obama "HOPE" poster and T-shirts for the 2008 presidential election. "He also showed me that the same artists could not only affect people on the streets, they could also put their art on T shirts and record covers, as well as have their work respected, displayed, and sold as fine art."

Because of Haring, said the artist Kaws, who often visited the Pop Shop as a teenager, "It almost seems like a natural thing these days to be an artist and make products." None of Haring's innovations has more influenced the contemporary world than his bending of art and commerce in the interest of art for everybody—the direction that drew the most criticism during his lifetime. Haring was alone as an artist during the eighties in opening his own store filled with merchandise that Jeffrey Deitch has since labeled as "a new art medium: the art product." Yet

no legacy has extended Haring's concept of public art (or empowered the charitable work of his foundation) more than the licensing of his images for Uniqlo T-shirts, Coach backpacks, denim and leather jackets from Honey Fucking Dijon (the label of Black trans designer and deejay Dijon), and sneakers by Converse, Reebok, and Nike. (In 1989, Haring wrote in his journal, "I still *really* want to design a pair of sneakers.") "More people now have an opportunity to meet Keith Haring's art through the vernacular of shopping," says David Stark, whose agency, Artestar, licenses Haring products, mostly apparel—as well as Basquiat, Scharf, Mapplethorpe, Robert Indiana, and Rosenquist. "I based it on Keith's model," says Stark, who worked at Shafrazi Gallery during Haring's lifetime and at the Haring Estate for nine years afterward, before starting his company in 2000. "I used that model for Haring exclusively and then began applying it to other artists." When I visited Stark's offices, he was not shy in pointing out that "We do skateboards, jewelry, and you're sitting on a Keith Haring chair." Controversy still surrounds all the intense marketing—seen by some as fatiguing, in dubious taste, or detracting from the fine art. Yet Stark is confident: "As an artist, Keith never liked empty spaces. Some critics believe art should not be commercial, but that was certainly not his philosophy. Keith Haring feels to be on the right side of history."

While alive, Haring was frustrated at the disconnect between his popular success and his lagging acceptance by the art establishment. After visiting the Museum of Modern Art in 1988, he wrote in his journal of his sense of injustice that contemporaries of his, such as Barbara Kruger and Eric Fischl, were represented upstairs in the galleries, while he was confined to the lobby gift shop: "They have not even shown one of my pieces yet. In their eyes I don't exist." In the years since his death, though, Haring's works have begun to go global on the tandem tracks he created for them. His paintings, drawings, and sculptures have shown in about two hundred solo exhibition museum and gallery shows, and his works are held in the permanent collections of more than sixty museums worldwide. "The distinctions that would have seemed very important at the time and would have perhaps prevented museums like ours from looking in his direction with an eye to acquisition no longer seem

important," says Ann Temkin, the Marie-Josée and Henry Kravis chief curator of painting and sculpture at the Museum of Modern Art in New York. "Gone are those distinctions between so-called high art and low art, or public art and museum art, or popular art and more strictly art world–centered art. There was also a prejudice in fine art circles against art that was appealing, a late-twentieth-century tendency to gravitate toward more difficult art that implied that if you understood it, you entered a certain in-the-know circle. For Haring, that was irrelevant. They were not detecting his serious artistic sensibility and issues."

Temkin continues: "It's a sort of truism that more radical art needs about thirty years for everyone to catch up and for the work to look as if it's contemporary at that moment. The abstract expressionists were misunderstood in the forties, and by the seventies, they were Old Masters. A dramatic example were Monet's *Water Lilies* of the twenties. It was like an alarm clock went off in the fifties, and people began to understand them. Haring is at about that thirty-year mark. His work can seem timeless now."

With his early belief that art could change the world for the better, and wishing to make art accessible and affordable for everyone, Haring, against all odds, often succeeded at his democratizing mission. In our own era of engagement by so many artists with any available surface; with personal icons and licensing; with activism, collaboration, communication; and with the fostering of community, Keith Haring seems more than ever one of us.

Acknowledgments

Keith *Haring touched* lives, experimented with life, and stirred up mise-en-scènes as much as any artist of his time and place. From just my brief contact with him in the eighties, I felt inspired to write a novel about Keith someday, and I kept that flame flickering for over two decades. Yet, in 2016, when the moment came to attempt such a book, I began to feel that his *Guinness Book of Records* life and artistic output truly called for nonfiction. In the year following Haring's death, John Gruen had published *Keith Haring: The Authorized Biography*, an invaluable rendering of Haring's life entirely in his own words and the words of family and friends. Over the years, Gruen's book was my go-to for bringing back Haring and those times. Yet nearly three decades had passed, and I was sensing that some of the history and context that Haring, Madonna, or Burroughs had taken for granted in their accounts was being lost. I hoped to reconnect those dots for readers. Haring also had worn his knowledge and ambition perhaps too lightly during his lifetime. His was a major contribution still often hidden in plain sight.

I approached the Keith Haring Foundation with a not-so-modest proposal to write a full-scale biography of the artist for a new generation. John Gruen was still alive, and his daughter, Julia, was the executive director of the Keith Haring Foundation. Although her father had written

the authorized biographical work on Haring, she was generous in her immediate interest and support for my idea. (I knew John Gruen, too, as he had been an important interview subject for my previous biographies, of Frank O'Hara and Flannery O'Connor, both of whom he had known personally.) Julia took my proposal to the Board of Directors of the foundation, and after some consideration, they agreed to open to me their rich archive. Without that decision, this book would not exist in anything remotely like its present form. My experience working at the foundation, located in Haring's old studio at 676 Broadway, was remarkably positive. Essential to that positive tenor was Anna Gurton-Wachter, its full-time archivist. I like to say that Haring was "bio prepared." He never threw away anything, and the entire paper trail of his life (including doctors' reports, Con Ed bills, faxes, and daily to-do lists) is available in files, often originally put together by Haring himself. Research into Haring's life is fascinating yet labor intensive. Anna knows each file, each piece of paper, and she was my indispensable guide. When the Covid-19 pandemic threatened to shut down all research visits, she was key to setting up a digital portal allowing me and other writers and scholars to access print files, photographs, videos, and documentation of artwork. Annelise Ream, the foundation's director of collections, shared with me her unique knowledge of the materials and the provenance for seemingly all ten thousand of Haring's artworks. Fawn Krieger, the program director, kept me current on the foundation's impressive rollout of charitable gifts and guided me to the latest licensing merch, to which she invited me to help myself. During my seven years of work in the archive, Julia Gruen stepped down to be replaced as executive director by Keith's dear friend Gil Vazquez. I was told, when I first began working in Haring's old studio, that if I wished to feel Keith's presence, Gil was closest in spirit. As I completed my manuscript, I shared it with Gil and his associates. While my biography was not authorized, and responsibility for its contents is solely mine, this impressive group made suggestions, checked facts, and lent authority to the project.

Far from a solitary painter passing his days in his studio, Keith Haring was a very public artist channeling into his work the energy of the people and world around him. Such a life necessarily commits a

biographer to interviews multiple the number expected for a quieter subject. While writing this book, I interviewed or was helped in other ways by more than two hundred people. Because we are in the early twenty-first century, these conversations took place across many media, including the traditional tape recorder, iPhone, Zoom, Skype, Facebook, Instagram, texts, and emails. With apologies to anyone I may have inadvertently not included, among those I wish to thank for their many contributions are: Bjorn Amelan; Lili Anolik; Harrison Apple; Adolfo Arena; Joey Arias; Debra Arman; Madison Arman; Viken Arslanian; Massimo Audiello; Donald Baechler; André Balazs; Ron Barbagallo; Rebecca Becker; Serge Becker; Bill Beckley; Connie Beckley; Dr. Paul Bellman, Anselm Berrigan; Ross Bleckner; Christopher Bollen; Julie Sullivan Brace; Hal Bromm; Kitty Brophy; Patty and Susan Brundage; Barbara Buckner; Desmond Cadogan; James Carroll; Piergiorgio Castellani; Barbara Castelli; Corliss Cavalieri; Sherry Reigel Chappell; Angelo Ciotti; Barbara Wohlin Clarke; Bonnie Clearwater; Alba Clemente; Nina Clemente; Ricky Clifton; George Condo; Lysa Cooper; Diego Cortez; Tomé Cousin; Bob Crozier; Arnaldo Cruz-Malavé; Jeffrey Deitch; Sharon DeLano; Elizabeth Delude-Dix; Al Diaz; Jane Dickson; Adam Dread; Brent Nicholson Earle; Bret Easton Ellis; Janice Eshleman; Julie Kaiser Esposito; Molissa Fenley; Joseph Daniel Fiedler; Patricia Field; Tyr Floreen; Simone Forti; Jim Fouratt; Patrick Fox; Cliff Fyman; Judy Geib; Andy George; John Giorno; Ian Gittler; Barbara Gladstone; Nancy Glowinski; Eric Goode; James Grauerholz; Rodney Alan Greenblat; Bob Gruen; John Gruen; Julia Gruen; Susan Hannaford; Duncan Hannah; Allen and Joan Haring; Karen Haring; Kay Haring; Kristen Haring; Jed Harris; Oliver Harris; Sam Havadtoy; Robert Hawkins; Kristoffer Haynes; Alexander Heinrici; Alan Herman; David Hinkle; Phoebe Hoban; Frank Holliday; Jenny Holzer; George Horner; Terry Hummel; Charles Imbro; Eric R. Johnson; Bill T. Jones; Sean Kalish; Bill Katz; P. Michael Keane; Alek Keshishian; Susan Kirshenbaum; Beth Kleber; Kimberly Kradel; Tom Kriske; Ricki Kunkle; Fran and Kaz Kuzui; David LaChapelle; Joe Lalli; Jonathan Lasker; Deena Lebow; Sean Ono Lennon; Alfred Lippincott; Jonathan Lippincott; Francisco Liuzzi; Nicholas Logsdail; Bryan Lourd; Sarah Loyer; Ann Magnuson; Christopher Makos; David C. Martin; Susan

Phillips Maskarinec; John ("Crash") Matos; Stephanie Mayer; Samantha McEwen; Patrick McMullen; Laurie Meadoff; Eric Mendlow; Tim Miller; Ricardo Montez; George Mead Moore; Daniela Morera; David Neirings; Annina Nosei; Hiroko Onoda; Angel Ortiz; Kermit Oswald; Deb Parker; Richard Parsakian; Mark Pasek; Peter Pennoyer; the Rev. Warren C. Platt; Annie Plumb; Paige Powell; Lucio Pozzi; Alec Rauschenbusch; Klaus Richter; Walter Robinson; Liana Rose; Don and Mera Rubell; Jason Rubell; Jennifer Rubell; Jean-Paul Russell; Kelly Ryan; Michael Scalisi; Kenny Scharf; Bruno Testore Schmidt; Tony Shafrazi; David Shapiro; Ira Silverberg; Kate Simon; Benny Soto; Jock Soto; Peter Staley; David Stark; Peter Stern; Barbara Stolz; Michael Stout; Brendan Strasser; Drew Straub; Sean Strub; Amy Taubin; Ann Temkin; Kurt Thometz; Min Thometz-Sanchez; Mimi Thompson; David Trinidad; Muna Tseng; Richard Van Buren; Gil Vazquez; Princess Gloria von Thurn und Taxis; Ann Waldman; Shelley Wanger; Regina Weinreich; Tom Wessner; Edmund White; George Wittman; Alice Winn; Lisa Youse; Michele Zalopany; Kathleen Zimbicki; Laurie Zook. For help from institutions, I wish to thank: the Kutztown Area Historical Society; the School of Visual Arts Archives and Library; and William Paterson University of New Jersey, where I am an emeritus professor of English, for academic release time during the research phase of this book.

Of the superb Harper crew, I wish to acknowledge the essential contributions of: Bill Adams, general counsel; Tina Andreadis, publicity director; Edie Astley, assistant editor; Maya Baran, publicity director; Milan Bozic, cover designer; Leah Carlson-Stanisic, interior designer; Christina Polizoto, production editor; Becca Putman, marketing director; and Michael Siebert, production manager.

Involved in this project from its early days has been Barbara Heizer, whom I first met in the 1990s, when she was features director at *Harper's Bazaar*, and I was mainly writing pieces about artists for her. On this book, she has been my expert consultant, reading chapters as they were written and always available with her remarkable knowledge of contemporary art. To my brilliant publisher Jonathan Burnham, I owe gratitude for every sort of support a writer could desire. From our first discussion of my glimmer of an idea—appropriately, at a brunch at the Odeon—

his belief in this book never wavered, and he offered inspired readings along the way. My editor, Noah Eaker, rare in his profession for seeing simultaneously the big picture and the small, and even for suggesting that unimagined (unimaginable?) tweak that sets so much back on track in its wake. (I need him for that last sentence.) Joy Harris has been my dynamic agent since the days of the opening of the Pop Shop. She represented my first novel and my first biography. I believe I may never have arrived at this page without her buoying dedication.

I finally need to acknowledge Keith Haring for creating a life and making art that speaks to the heart of the matter among all ages and types. Telling his story made me relevant, for the first time in my life, at playgrounds, in schoolyards, among nannies, kids, and grown-ups alike. An object of fascination for our five-year-old son, Glenn, has been the pink-covered comprehensive volume of Haring's work published by Rizzoli in cooperation with the estate in 2014. He *does* enjoy browsing its pages alone in the early hours of the morning, yet he also gets a rousing kick out of dropping it on the floor and announcing that it has "sixty thousand pages!" His big brother, Walter, has been on a first-name basis with Keith almost since his first days of speaking actual words and names. My warm and welcoming husband, Paul, agreed to being turned into a sounding board as I read to him nightly in bed (a human audiobook) the manuscript. This book has been a happy collaboration, and Keith Haring is forever a member of our family.

Notes on Sources

Epigraph

vii "Your line is your personality": Daniell Drenger, "Art and Life: An Interview with Keith Haring," *Columbia Art Review* (Spring 1988).

Prologue: The Baby

2 "first seeing the crawling": Unpublished transcript of Leonard McGurr interview with John Gruen, Tape 13. "Leonard McGurr" was the given name of Futura 2000, later simply "Futura."

2 "At this time": Quoted in Jeffrey Deitch, Suzanne Geiss, and Julia Gruen, in cooperation with the estate of Keith Haring, *Keith Haring* (New York: Rizzoli, 2014), 106.

3 "The reason that the 'baby'": Keith Haring, entry for July 7, 1986, "July 7–16, 1989, Notebook," Keith Haring Foundation Archives (hereafter "KHFA").

3 "the first believable twentieth-century": Barry Blinderman, "And We All Shine On," in Germano Celant, ed., *Keith Haring* (Munich: Prestel Verlag, 1992), 23.

3 "Factory-fresh": Rene Ricard, "The Radiant Child," *Artforum*, December 1981.

4 "I'd never seen that before": Peter Stern, in discussion with the author, October 5, 2022.

4 "extended concept": Keith Haring, entry for October 26, 1987, "October 2–November 4, 1987, Notebook," KHFA.

4 "a condensed logo": "An Interview with Keith Haring, an Architect, a Musician in Belgium," Video Lectures and Interviews, KHA-0797, KHFA.

4 "an idealized self-portrait": Bruce D. Kurtz, "The Radiant Child (Keith Haring)," in Bruce D. Kurtz, ed., *Haring Disney Warhol*, exhibition catalog (Munich: Prestel Verlag; and Phoenix: Phoenix Art Museum, 1992), 143.

Chapter 1: Kutztown

8 "We would sit at home": Joan Haring, in discussion with the author, June 4, 2018.

8 "We couldn't have afforded": Allen Haring, in discussion with the author, June 4, 2018. The musical, *Radiant Baby*, was staged at Joseph Papp's Public Theater in 2003.

8 "completely hysterical": Unpublished transcript of Keith Haring interview with John Gruen, August 8–12, 1989 (hereafter "Keith Haring interview with Gruen"), Tape 1, KHFA.

9 "Instead of teaching me to copy": "Ten Commandments—CAPC Bordeaux Exhibition," video documentary (*La realidad inventada*, Spanish TV, 1985), KHFA.

9 "Perhaps in our drawing": Allen Haring, in discussion with the author, June 4, 2018.

9 "weirdness and absurdity": John Gruen, *Keith Haring* (New York: Prentice Hall Press, 1991), 9.

9 "The emphasis on the line": "Press Conference and Roof Painting for Pop Shop Tokyo Container," Video Event, KHFA.

10 "simple, clear, poetic": David Galloway, "A Quest for Immortality: The Sculptures of Keith Haring," in Celant, ed., *Keith Haring*, 23.

10 "Smalltown Boy": Sischy, "Kid Haring."

10 "typical little American": Keith Haring interview with Gruen, Tape 1.

11 "After visiting Germany": Steven Hager, "Keith Haring: Art on the Block," *East Village Eye*, October 1, 1982.

11 "As kids there were a lot": Allen Haring, email message to the author, January 17, 2020.

11 *rutsch*, for "squirm": Kristen Haring, in discussion with the author, April 30, 2018.

11 "I grew up in Pennsylvania": "From I.R.T. to ART: Keith Haring with Halston and Philip Johnson," *Interview*, December 1984, 129.

12 "I was a square": Michael Kimmelman, "Keith Haring's Subway Ride to Success," *Philadelphia Inquirer Sunday Magazine*, November 23, 1986, 29.

12 "The Harings weren't among": Brendan Strasser, Facebook message to the author, January 18, 2020.

13 "out in the sticks": Allen Haring, email message to the author, July 26, 2018.

13 "I guess it all started": Unpublished transcript of Allen Haring interview with John Gruen, September 30, 1989, Tape 19, KHFA.

13 "I never had any formal training": Gruen, *Keith Haring*, 5.

14 "In high school, she was dating": Allen Haring, in discussion with the author, June 4, 2018.

14 "And he always told me": Joan Haring, in discussion with the author, June 4, 2018.

14 "a smile for everyone": *The '56 Cougar*, yearbook of the senior class of Kutztown Area High School.

14 "I wanted to go to Christmas Eve service": Joan Haring, in discussion with the author, June 4, 2018.

14 "This morning I went": Allen Haring, *Via Air Mail: Excerpts from a Marine's Letters Home* (self-published), 14.

14 "Boy, this country is really nice": Haring, *Via Air Mail*, 44.

15 "Japan had a big presence": Kristen Haring, in discussion with the author, April 30, 2018.

15 might have been a Japanese painter: Keith Haring, entry for October 18, 1987, "October 2–November 4, 1987, Notebook."

15 "Under these conditions": Haring, *Via Air Mail*, 16.

15 "What do you think of the name": Haring, *Via Air Mail*, 37.

15 "I don't think I was": Keith Haring interview with Gruen, Tape 1.

16 "sunny side up": Gruen, *Keith Haring*, 3.

16 "I consider myself": Germano Celant, ed., *Keith Haring*, Sydney Museum of Contemporary Art, 1994, exhibition catalog, 178.

16 "You'll never make it": Allen Haring, in discussion with the author, November 16, 2018.

17 "I imagined": Keith Haring interview with Gruen, Tape 1.

17 "Allen could buy a ticket": Joan Haring, in discussion with the author, June 4, 2018.

18 "When we lived in the apartment": Joan Haring, in discussion with the author, June 4, 2018.

18 "It was really": Gruen, *Keith Haring*, 10.

18 "My grandmother was my": Gruen, *Keith Haring*, 10.

18 "That's Ozzie!": Joan Haring, in discussion with the author, June 4, 2018.

18 "Man, we really": Haring, *Via Air Mail*, 20.

19 "That's when": Joan Haring, in discussion with the author, June 4, 2018.

19 "Her whole idea": Keith Haring interview with Gruen, Tape 1.

19 "I was already a little nerd": Keith Haring interview with Gruen, Tape 1.

19 "One thing I specifically remember": Keith Haring interview with Gruen, Tape 1.

19 "When I grow up": "When I Grow Up," Keith Haring essay, n.d., private collection.

20 "white-shuttered and brick": James Servin, "Radiant Baby," *7 Days*, March 21, 1990.

20 "I was always obsessed": Keith Haring interview with Gruen, Tape 1.
20 He even devised an "Oath": Keith Haring, "Childhood Notebook," KHFA.
20 "my clubhouse": Peter Belsito, *Notes from the Pop Underground* (San Francisco: The Last Gasp of San Francisco, 1985), 101.
20 "At that time": Gruen, *Keith Haring*, 9.
21 "We performed": Kermit Oswald, in discussion with the author, May 28–29, 2019.
21 "It was one of the first times": Gruen, *Keith Haring*, 10.
21 "furious": Gruen, *Keith Haring*, 8.
22 "probably some of my earliest": Keith Haring interview with Gruen, Tape 1.
22 "There was always": Keith Haring interview with Gruen, Tape 1.
22 "What I *do* remember": Gruen, *Keith Haring*, 7.
22 "I remember having a trauma": Gruen, *Keith Haring*, 7.
23 "I remember watching": Keith Haring interview with Gruen, Tape 1.
23 "My parents weren't part": Gruen, *Keith Haring*, 10.
23 "helping make possible": Letter from the White House to Mr. Keith Haring, February 27, 1973, KHFA.
23 "We were active": Kermit Oswald, in discussion with the author, May 28–29, 2019.
23 "more funky, psychedelic": Kelly Ryan, in discussion with the author, June 5, 2018.
23 "I had obsessions": Gruen, *Keith Haring*, 15.
23 "We would walk": Julie Kaiser Esposito, in discussion with the author, May 13, 2019.
24 sometimes let them swim naked: Dave Hinkle, in discussion with the author, April 24, 2020.
24 "We'd be these little boys": Keith Haring interview with Gruen, Tape 2.
24 "with guys walking around": Keith Haring interview with Gruen, Tape 2.
24 "their black armbands": Keith Haring interview with Gruen, Tape 2.

Chapter 2: The Art Room

26 "fireball": Kay Haring, in discussion with the author, June 6, 2018.
26 "open game": Kelly Ryan, in discussion with the author, June 5, 2018.
26 "In seventh grade": Keith Haring, "The Crystal Ball Reading," private collection.
26 "The thing about Keith": Gruen, *Keith Haring*, 17.
27 "Allen was super creative": Kermit Oswald, in discussion with the author, May 28–29, 2019.
27 "What interested me": Gruen, *Keith Haring*, 16.
27 "Keith was very oriented": Gruen, *Keith Haring*, 16.
27 "They had this really beautiful": Kermit Oswald, in discussion with the author, May 28–29, 2019.
28 "I used a Rapidograph": Keith Haring interview with Gruen, Tape 2.
28 "He had imagination": Gruen, *Keith Haring*, 16.
28 "private clubhouse": Kelly Ryan, in discussion with the author, June 6, 2018.
28 "Kermit and I seemed to be": Gruen, *Keith Haring*, 16–17.
28 "We'd get on our bikes": Kermit Oswald, in discussion with the author, May 28–29, 2019.
28 "They were the Beavis": Brendan Strasser, in discussion with the author, November 17, 2018.
28 "dominant": Keith Haring interview with Gruen, Tape 2.
29 "A lot of the things": Kermit Oswald, in discussion with the author, May 28–29, 2019.
29 "For the first twelve years": Gruen, *Keith Haring*, 14.
29 "in some ways": Kristen Haring, in discussion with the author, April 30, 2018.
30 "My own uncomfortableness": Gruen, *Keith Haring*, 8.
30 "We were all sitting": Haring, "The Crystal Ball Reading."
31 mailbox's being "bombarded": Joan Haring, in discussion with the author, June 4, 2018.
31 "the paraphernalia": Keith Haring interview with Gruen, Tape 2.
31 "The Answer is God!": Keith Haring, "Church Camp Notebook," KHFA.
31 "He insisted I read": Sherry Reigel Chappell, email message to the author, April 21, 2020.

31 "That was the double-O-seven": Kelly Ryan, in discussion with the author, June 6, 2018.

32 "At the time": Gruen, *Keith Haring*, 17.

32 "Keith had these sheets": Kelly Ryan, in discussion with the author, June 6, 2018.

32 "It's easy to call someone": Kermit Oswald, in discussion with the author, May 28–29, 2019.

33 "My parents didn't like it": Kay Haring, in discussion with the author, June 6, 2018.

33 "It was confusing": Gruen, *Keith Haring*, 15–16.

33 "When I turned thirteen": Gruen, *Keith Haring*, 15–16.

34 "R. Crumb and Zap Comix": Kelly Ryan, in discussion with the author, June 6, 2018.

34 "When Keith was going": Tom Wessner, in discussion with the author, June 6, 2018.

34 "Updated Fairy Tails": Keith Haring, Junior High Notebook, KHFA.

34 "The best time": Brendan D. Strasser, in discussion with the author, November 17, 2018.

35 "a groovy pop name": Gruen, *Keith Haring*, 10.

35 "Mrs. DeMatteo": Keith Haring interview with Gruen, Tape 1.

35 "I was the well-behaved one": Kelly Ryan, in discussion with the author, June 6, 2018.

35 "I said to myself": Letter from Lucy DeMatteo to Keith Haring, August 3, 1983, KHFA.

36 "Our high school": Kristen Haring, in discussion with the author, April 30, 2018.

36 "When Keith": Gruen, *Keith Haring*, 18.

36 "Nita and I": Kermit Oswald, in discussion with the author, May 28–29, 2019.

37 "stressed": Kay Haring, in discussion with the author, June 6, 2018.

37 "That pissed Keith off": Kermit Oswald, in discussion with the author, May 28–29, 2019.

37 "I went in there": Andy George, in discussion with the author, May 30, 2019.

37 "really fascinated": Unpublished transcript of Nita Dietrich interview with John Gruen, October 1, 1989, KHFA.

37· "We were both": Kermit Oswald, in discussion with the author, March 18, 2020.

37 "When I started": Gruen, *Keith Haring*, 18.

38 "Andy's life and work": Keith Haring, entry for March 6, 1987, "March 6, 1987 Notebook."

38 "Keith brought me": Kenny Scharf, in discussion with the author, September 18, 2019.

38 "It was great": Keith Haring interview with Gruen, Tape 2.

39 "Keith was the kind of kid": Kermit Oswald, in discussion with the author, May 28–29, 2019.

39 "I was into athletics": Servin, "Radiant Baby," 12. Oswald's list of student activities was indeed more robust than Haring's, including Track, Class Play, Bolt and Bore, Ski Club, and Fly Tying.

39 "It was gorgeous": Kelly Ryan, in discussion with the author, June 5, 2018.

39 "stuff a towel": Lisa Youse, in discussion with the author, August 5, 2018.

40 "I remember the first time": Keith Haring interview with Gruen, Tape 3.

40 "There is too much": Haring, *Keith Haring Journals*, 141.

41 "For me, this meant": Gruen, *Keith Haring*, 18.

41 "We were kind of a group": Tyr Floreen, in discussion with the author, January 8, 2020.

41 "When I met him": Andy George, in discussion with the author, May 30, 2019.

41 "friend-girlfriend": Keith Haring interview with Gruen, Tape 3.

42 "I believe the first": Janice Eshleman, in discussion with the author, June 3, 2018.

42 "We were worried": Allen Haring, in discussion with the author, June 4, 2018.

42 "At fifteen, sixteen": Gruen, *Keith Haring*, 9.

42 "He had been playing": Karen Haring, in discussion with the author, June 4, 2018.

42 "like skunk": Kristen Haring, in discussion with the author, April 30, 2018.

42 "I'll never forget": Gruen, *Keith Haring*, 20.

43 "I saw him coming": Kristen Haring, in discussion with the author, April 30, 2018.

43 "I was a terror": David Sheff, "Keith Haring: Just Say Know," *Rolling Stone*, August 10, 1989.

43 "It all just came out": Gruen, *Keith Haring*, 20.

43 "I felt suffocated": Gruen, *Keith Haring*, 20.

44 "Keith was in the back": Ricki Kunkle, in discussion with the author, January 8, 2020.

44 "I was probably in love": Keith Haring interview with Gruen, Tape 3.

44 "All the girls said": Ricki Kunkle, in discussion with the author, January 8, 2020.

44 "These are two good stories": Letter from Keith Haring to Kristen Haring, private collection.

45 "I remember several": Gruen, *Keith Haring*, 22.

45 "artistic things": Keith Haring interview with Gruen, Tape 3.

46 "I remember specifically": Kristen Haring, in discussion with the author, April 30, 2018.

46 "the Chief Executive": Keith Haring, "Geronimo," May 1, 1973, KHFA.

46 "So, I had all the fake": Keith Haring interview with Gruen, Tape 2.

47 "He used to put": Andy George, in discussion with the author, May 30, 2019.

47 "The first thing I sold": "From I.R.T. to ART," 129.

47 "Then we got to": Vince Aletti, "An Interview with Keith Haring, 1981," in *Keith Haring: Future Primeval*, Queens Museum, Flushing Meadows, NY, September 15–November 25, 1990, exhibition catalog, 93.

48 "I freaked out": Keith Haring interview with Gruen, Tape 3.

48 "My first reaction": Keith Haring interview with Gruen, Tape 3.

Chapter 3: Pittsburgh

50 "It's like a six-hour drive": *Drawing the Line: A Portrait of Keith Haring*, documentary produced and directed by Elisabeth Aubert (Biografilm Associates, 1989).

50 "My parents": Gruen, *Keith Haring*, 23.

50 "exclusive, expensive": Susan Kirshenbaum, in discussion with the author, March 31, 2019.

50 "Keith and I": Corliss Cavalieri, in discussion with the author, May 6, 2020.

50 "They weren't too excited": Keith Haring interview with Gruen, Tape 3.

51 "I've decided": Joan Haring, in discussion with the author, June 4, 2018.

51 "applied to first": Haring's School of Visual Arts application, KHFA.

51 "a little bit of money": Keith Haring interview with Gruen, Tape 3.

51 "Suzy was": Tom Kriske, in discussion with the author, July 5, 2022.

51 "That was probably": Keith Haring interview with Gruen, Tape 3.

51 "demonstrative, lovey-dovey": Barbara Wohlin Clarke, in discussion with the author, March 15, 2019.

51 "hippie chick": Julie Ann Sullivan Brace, in discussion with the author, March 21, 2019.

51 "I liked her because": Keith Haring interview with Gruen, Tape 3.

52 "Before Suzy": Gruen, *Keith Haring*, 23.

52 "We just always": Susan Phillips Maskarinec, in discussion with author, May 13, 2019.

52 "I liked the sex": Gruen, *Keith Haring*, 23.

52 "he preferred men": Susan Phillips Maskarinec, in discussion with the author, May 13, 2019.

52 "We never really": Gruen, *Keith Haring*, 15.

53 "It was out of control": Susan Phillips Maskarinec, in discussion with the author, May 13, 2019.

53 "magnificent failure": Brendan D. Strasser, *A Most Agreeable Town: A Photographic History of the Borough of Kutztown*, vol. 1 (Kutztown, PA: Kutztown Area Historical Society, 2004), 185.

53 "Because Keith is leaving": Kristen Haring, in discussion with the author, April 30, 2018.

53 "I remember standing": Unpublished transcript of Joan Haring interview with John Gruen, September 30, 1989, Tape 20, KHFA.

54 a white shirt black: Blake Gopnik, *Warhol* (New York: Ecco, 2020), 7.

54 "If you were in a car": Corliss Cavalieri, in discussion with the author, May 6, 2020.

54 "dirty, exciting": Laurie Zook, email message to the author, July 30, 2019.

54 "smoky, but beautiful": Corliss Cavalieri, in discussion with the author, May 6, 2020.

54 "gritty": Susan Kirshenbaum, in discussion with the author, May 6, 2020.

54 "dreary and creative": Eric Mendlow, in discussion with the author, May 24, 2019.

54 "the black wishbone": Michael Chabon, *The Mysteries of Pittsburgh* (New York: William Morrow and Company, 1988), 105.

54 "Someday I'm going": Barbara Wohlin Clarke, in discussion with the author, March 15, 2019.

54 "Pittsburgh then was very cheap": Susan Kirshenbaum, in discussion with the author, May 6, 2020.

55 "There were always murders": Julie Sullivan Brace, in discussion with the author, March 21, 2019.

55 "obscure little art school": Kimberly Kradel, "An Obscure Little Art School in Pittsburgh Pennsylvania," *Kimberly Kradel* (blog), March 21, 2019, https://kimba.com/2019/03/21/an -obscure-little-art-school-in-pittsburgh-pennsylvania/.

55 "Ivy provided a foundation": Susan Kirshenbaum, in discussion with the author, May 6, 2020.

55 "For two people": Kradel, "An Obscure Little Art School."

56 "I picked him up": Susan Maskarinec, Facebook message to the author, May 14, 2019.

56 "There were lots of ballerinas": Kimberly Kradel, in discussion with the author, March 20, 2019.

56 "a disaster": Keith Haring interview with Gruen, Tape 3.

56 "he's the only one": Postcard from Keith Haring to Janice Eshleman, October 9, 1976, private collection.

56 "Those names, courses": Susan Kirshenbaum, in discussion with the author, May 6, 2020.

57 curmudgeonly: Corliss Cavalieri, in discussion with the author, May 6, 2020.

57 "innate curiosity": Philip A. Mendlow, "Teacher's Report Form," in School of Visual Arts admissions application, received November, 16, 1977, KHFA.

57 "He would draw": Corliss Cavalieri, in discussion with the author, May 6, 2020.

58 "The names": Keith Haring, Pittsburgh sketchbook, private collection.

58 "Kleenex Climax": Keith Haring letter to Janice Eshleman, January 19, 1978, private collection.

58 "I originally met him": Eric Mendlow, in discussion with the author, May 24, 2019.

59 "It was talking": Gruen, *Keith Haring*, 24.

59 "as real a human": Robert Hughes, "The Wave from the Atlantic," *American Visions*, Episode 5, aired February 5, 2002, on BBC.

59 "of interrelated abstract": Keith Haring interview with Gruen, Tape 4.

59 "Art when really understood": Robert Henri, *The Art Spirit* (1923; repr. Philadelphia and New York: J. B. Lippincott Company, 1960), 15.

59 "Art study should": Henri, *The Art Spirit*, 158.

60 "You should draw": Henri, *The Art Spirit*, 242.

60 "To me, he was": Barbara Wohlin Clarke, in discussion with the author, March 15, 2019.

60 "It was fun": Keith Haring, letter to Barbara Wohlin Clarke, December 29, 1978, private collection.

60 "Silk Screen class": Julie Sullivan Brace, in discussion with the author, March 21, 2019.

61 "After I found": Gruen, *Keith Haring*, 24.

61 "I am not interested": Henri, *The Art Spirit*, 158.

61 "Within six months": Gruen, *Keith Haring*, 24.

62 "I guess it's because": Haring, entry for April 29, 1977, "1977 Notebook," KHFA.

62 "a certain magic": Haring, notebook entry for April 29, 1977.

62 "inveigled": Gruen, *Keith Haring*, 24.

62 "The Robert Henri book": Gruen, *Keith Haring*, 25.

63 "In my little drawings": Keith Haring interview with Gruen, Tape 3.

63 "TODAY IS MY BIRTHDAY!": Keith Haring, entry for May 4, 1977, "1977 Notebook."

63 "and into another time zone": Keith Haring, entry for May 5, 1977, "1977 Notebook."

63 "Met people going": Keith Haring, undated entry, "1977 Notebook."

64 "We were Deadheads": Barbara Wohlin Clarke, in discussion with the author, March 15, 2019.

64 "We sold": Susan Phillips Maskarinec, in discussion with the author, May 13, 2019.

64 "a great Brotherhood": Henri, *The Art Spirit*, 19.

64 "viral marketing": Raphaela Platow, "Holding Up a Frame," in *Keith Haring 1978–1982*, Kunsthalle, Wien (Vienna), Austria, 2010, exhibition catalog, 91.

65 "mythical for [their] excellence": Jesse Jarnow, *Heads: A Biography of Psychedelic America* (New York: Da Capo Press, 2016), 128.

65 "The Dead was great": Keith Haring, entry for May 12, 1977, "1977 Notebook." On their spring 1977 tour, the Grateful Dead played the Spectrum in Philadelphia on April 22 and the Capitol Theatre in Passaic, New Jersey, on April 25.

65 "We saw the people": Haring, notebook entry for May 12, 1977.

65 "It was all farmers": Haring, entry for May 13, 1977, "1977 Notebook."

65 "T-shirt with no brassiere": Haring, notebook entry for May 13, 1977.

65 "Suzy is beautiful": Haring, notebook entry for May 13, 1977.

65 "Being hippies": Keith Haring interview with Gruen, Tape 3.

66 "The school": Keith Haring, entry for May 18, 1977, "1977 Notebook."

66 "space trains": Haring, notebook entry for May 18, 1977.

66 "It turned out": Haring, notebook entry for May 18, 1977.

66 "Well, this cute guy": Gruen, *Keith Haring*, 25.

66 "That's when Keith": Susan Phillips Maskarinec, in discussion with the author, May 13, 2019.

66 "light in the loafers": Laurie Zook, email message to the author, July 30, 2019.

67 "I've already been through this": Keith Haring interview with Gruen, Tape 3.

67 "I don't think": Keith Haring, undated entry, "1977 Notebook."

67 "We went there": Susan Phillips Maskarinec, in discussion with the author, May 13, 2019.

67 "Yesterday me & Suzy": Keith Haring, entry for May 23, 1977, "1977 Notebook."

67 "They're messing up her head": Haring, notebook entry for May 23, 1977.

67 "nestled in mountains": Keith Haring, entry for May 26, 1977, "1977 Notebook."

68 "I am sitting": Haring, notebook entry for May 26, 1977."

68 "Through all the shit": Keith Haring, entry for Memorial Day 1977, "1977 Notebook."

Chapter 4: "The Next Part of the Trip"

70 "We did live": Susan Phillips Maskarinec, in discussion with the author, May 13, 2019.

70 "The girls": Julie Sullivan Brace, in discussion with the author, March 21, 2019.

70 using a Mattress Factory studio: The studio had been promised to Angelo Ciotti. Angelo Ciotti, in discussion with the author, July 7, 2020.

71 "The air was full": Keith Haring, entry for September 1, 1979, "September–November 1979 Notebook," KHFA.

71 "From the time": Keith Haring interview with Gruen, Tape 4.

72 "It was at the bottom": Kimberly Kradel, in discussion with the author, March 20, 2019.

72 "I think he loved black": Kermit Oswald, in discussion with the author, May 28, 2019.

72 "For myself": Invitation to *Anonymous Art*, KHFA.

72 "the literary references": Haring, notebook entry for July 7, 1986.

72 "idea and the attitude": Keith Haring interview with Gruen, Tape 4.

73 "a coat": Jean Dubuffet, "Anticultural Positions," *Logos: A Journal of Modern Society and Culture* 5, no. 2 (Spring–Summer 2006): http://www.logosjournal.com/issue 5.2 /dubuffet.htm.

73 "I started to be affected": Keith Haring interview with Gruen, Tape 4.

73 "He and I and Eric Mendlow": Susan Phillips Maskarinec, in discussion with the author, May 13, 2019.

73 "He came to my place": Kimberly Kradel, in discussion with the author, March 20, 2019.

74 "Eastern connection": Keith Haring interview with Gruen, Tape 4.

74 "a man who": John Gruen, "Pierre Alechinsky," in *The Artist Observed* (Chicago, IL: Chicago Review Press, 1991), 297.

74 "I couldn't believe": Gruen, *Keith Haring*, 29.

74 "was one of the things": Keith Haring video interview for Broad Street Studio, KHFA.

75 outside the museum: As Haring later explained, "It was the main exhibition space for any kind of new art; the only thing besides that was the museum, and the curators at the

museum were pretty closed-minded as far as anything done after 1950." Peter Belsito, "Keith Haring," in Belsito, *Notes from the Pop Underground*, 98.

75 "It was *the* buzzing": Kathleen Zimbicki, in discussion with the author, May 15, 2020.

75 "They didn't have": Gruen, *Keith Haring*, 29.

76 "I was working": Keith Haring interview with Gruen, Tape 4.

76 "As a white boy": Keith Haring interview with Gruen, Tape 4.

77 "I went to this bar": Gruen, *Keith Haring*, 31.

77 "The first time": Drenger, "Art and Life."

77 "Like similar locations": Mike Crawmer, "To Come Out on Dithridge Street Just Isn't What It Used to Be," *Out*, May 1980, 13, from Michael Ferrucci Collection at the Pittsburgh Queer History Project.

77 "For me, cruising": Gruen, *Keith Haring*, 31.

77 "The Tender Trap": Tomé Cousin, in discussion with the author, June 18, 2020.

78 "Talent is a word": Martha F. Shepler, "Teacher's Report Form," in School of Visual Arts Admissions Application, received November 16, 1977, KHFA.

78 "So, I was having": Gruen, *Keith Haring*, 29.

79 "He definitely was busy": Corliss Cavalieri, in discussion with the author, May 6, 2020.

79 "Oil painting": Pierre Alechinsky, "The Means at Hand," in *Alechinsky: Paintings and Writings*, Museum of Art, Carnegie Institute, 1977, exhibition catalog, 86.

79 "Around this time": Gruen, *Keith Haring*, 27–28.

79 "the ten thousand drawings": Kermit Oswald, in discussion with the author, July 24, 2020.

80 "I can trace": Keith Haring interview with Gruen, Tape 4.

80 "You *would* be the one": Eric Mendlow, in discussion with the author, July 16, 2019.

81 "He was a young rising star": Kathleen Zimbicki, in discussion with the author, May 15, 2020.

81 "I remember us all going": Julie Sullivan Brace, in discussion with the author, March 21, 2019.

81 "That was such a clean": Tomé Cousin, in discussion with the author, June 18, 2020.

81 "goofy": Kristen Haring, email message to the author, July 31, 2019.

81 "It was the kind of art": Allen Haring, in discussion with the author, June 4, 2018.

82 "All right": Kermit Oswald, in discussion with the author, July 24, 2020.

82 Only two drawings sold: Hager, "Keith Haring: Art on the Block," 9.

82 "A lot was done": Susan Phillips Maskarinec, in discussion with the author, May 13, 2019.

82 "It was all very close": Gruen, *Keith Haring*, 29–30.

82 "When we came back": Susan Phillips Maskarinec, in discussion with the author, May 13, 2019.

82 "It was a really": Gruen, *Keith Haring*, 32.

82 "She said she was pregnant": Sheff, "Keith Haring: Just Say Know."

82 "I never was": Susan Phillips Maskarinec, in discussion with the author, May 13, 2019.

82 "I remember our sharing": Barbara Wohlin Clarke, in discussion with the author, March 15, 2019.

83 "nadir of his consequence": Robert Pincus-Witten, "Keith Haring: The Cross Against the Rod," *Keith Haring*, Tony Shafrazi Gallery, New York, 1982, exhibition catalog, 10.

83 "cocoon": Kimberly Kradel, in discussion with the author, March 20, 2019.

Chapter 5: SVA

88 high school friend's aunt: Janice Eshleman's aunt lived on the Upper East Side.

88 "I still have nightmares": Allen Haring, in discussion with the author, June 4, 2018.

89 "Meeting anybody": Keith Haring interview with Gruen, Tape 4.

89 "It was like landing": Gruen, *Keith Haring*, 35.

89 "a wonderful old gay guy": Gruen, *Keith Haring*, 35.

89 "just-friends": Keith Haring interview with Gruen, Tape 4.

89 "To get into the apartment": Frank Holliday, in discussion with the author, April 17, 2019.

90 "It seemed like": "P. Cummings, Interview: Keith Haring Talks with Paul Cummings," *Drawing*, May–June 1989, 8.

90 rated as "good": "Day School Interview Form," School of Visual Arts, October 31, 1977, KHFA.

90 "very like the cantina in *Star Wars*": Ron Barbagallo, in discussion with the author, October 18, 2019.

91 "It was this private tower": Frank Holliday, in discussion with the author, April 17, 2019.

91 "all professional artists": "The Alphabet of Keith Haring: Dieter Buchhart in Conversation with Bill Beckley on July 24, 2017," *Keith Haring: The Alphabet*, Albertina Museum, Vienna, 2018, exhibition catalog, 45.

91 "SVA was considered": Charles Imbro, email message to the author, January 19, 2020.

92 "I was very shy": Samantha McEwen, in discussion with the author, November 20, 2019.

92 "Barbara made a general": Charles Imbro, email message to the author, January 19, 2020.

92 "Just the two of us": Barbara Schwartz, "Remembering Keith Haring," *Keith Haring: The SVA Years (1978–1980)*, Visual Arts Museum of the School of Visual Arts, New York, 2000, exhibition catalog, 19.

92 "poetic lost soul": Gruen, *Keith Haring*, 38.

93 "We were supposed": Samantha McEwen, in discussion with the author, November 20, 2019.

93 "I curse my painting class": Keith Haring, entry for October 14, 1978, "October 14–December 28, 1978, Notebook," KHFA.

93 "got Keith": Frank Holliday, in discussion with the author, April 17, 2019.

93 "I suggested": Schwartz, "Remembering Keith Haring," 19.

93 "The kids and the winos": Jerry Tallmer, "Onto the Black, the Zap of Art," *New York Post*, December 24, 1983.

94 "They were <u>not</u>": Keith Haring, entry for December 1978, "October 14–December 28, 1978, Notebook."

95 "So, there was Kenny": Gruen, *Keith Haring*, 36.

95 "My first impression": Kenny Scharf, in discussion with the author, September 18, 2019.

95 "For whatever reason": Keith Haring interview with Gruen, Tape 4.

95 "Later that day": Kenny Scharf, "Keith Haring," in *Keith Haring: The SVA Years*, 13.

95 "I would say": Gruen, *Keith Haring*, 38.

95 "Everything was very": Gruen, *Keith Haring*, 35.

96 "Keith and I": Frank Holliday, in discussion with the author, April 17, 2019.

97 "Like millions of them": Unpublished transcript of John Gruen interview with Kenny Scharf, October 13, 1989, Tape 41, KHFA.

97 "ended up looking like butterflies": Gruen, *Keith Haring*, 43.

97 "All those little": Keith Haring interview with Gruen, Tape 4.

97 "radical acts": Dieter Buchhart, "The Endless Political Line," *Keith Haring: The Political Line*, Fine Arts Museums of San Francisco and Delmonico Books-Prestel, 2014, exhibition catalog, 35.

97 "Max Protech Gallery": Haring misspells "Protech" as "Protetch" in his index for the Hicks drawing #20.

97 "I start to look": Haring, notebook entry for October 14, 1978.

97 "I feel enlightened": Keith Haring, entry for November 12, 1978, "October 14–December 28, 1978, Notebook."

98 "video painting": Haring, notebook entry for October 14, 1978.

98 "I was performing": Keith Haring interview with Gruen, Tape 4.

98 "third generation": Haring, notebook entry for December 1978.

98 "I was like, *Wow*": Rodney Alan Greenblat, in discussion with the author, December 3, 2019.

98 "I remember": Kenny Scharf, in discussion with the author, September 18, 2019.

99 "Keith seemed to have": Gruen, *Keith Haring*, 38–39.

99 "We just stumbled": Steven Hager, *Art After Midnight: The East Village Scene* (New York: St. Martin's Press, 1986), 93.

99 "perhaps the most": *Burroughs*, directed by Howard Brookner (1983; Criterion Collection, 2015), DVD.

99 "The Nova Convention": Gruen, *Keith Haring*, 55.

99 "We both started reading Burroughs": Unpublished transcript of Drew Straub interview with John Gruen, December 10, 1989, Tape 51, KHFA.

100 "a painter's world": James Schuyler, "Poet and Painter Overture," in Donald M. Allen, ed., *The New American Poetry* (New York: Grove Press, 1960), 418.

100 "Storefronts lining": Jeffrey Deitch, "The Radioactive Child," *Keith Haring: Paintings, Drawings, and a Vellum*, Stedelijk Museum, Amsterdam, 1986, exhibition catalog, 12.

101 "You could always tell": Ann Magnuson and Kenny Scharf, "New York City's Club 57 Will Have Its Moment in the Spotlight," *Interview*, October 2017.

101 "Nineteen seventy-eight": Belsito, *Notes from the Pop Underground*, 99.

101 "I lived over": Kristoffer Haynes, in discussion with the author, August 30, 2020.

101 "I had the bedroom": Drew Straub, in discussion with the author, March 30, 2019.

102 "You could cut off the crud": Kermit Oswald, in discussion with the author, May 28, 2019.

102 "I don't like anything": Drew Straub, in discussion with the author, March 30, 2019.

102 "He was a really brilliant": Gruen, *Keith Haring*, 42.

102 "terrorist poet": Hager, *Art After Midnight*, 93.

102 "The baths were literally": Gruen, *Keith Haring*, 42.

103 "That was the surprise": Straub interview with Gruen, December 10, 1989.

103 "They are also": Keith Haring, entry for January 12, 1979, "Circa January–February 1979 Notebook," KHFA.

103 "drawings that make": Keith Haring, entry for January 21, 1979, "Circa January–February 1979 Notebook."

104 "You could go down": Belisto, *Notes from the Pop Underground*, 99.

104 "The most admired": Calvin Tompkins, "The Art World: Up from the I.R.T.," *The New Yorker*, March 26, 1984, 101.

104 "The surf vans": Kenny Scharf, in discussion with the author, September 18, 2019.

104 "This calligraphic": Gruen, *Keith Haring*, 44.

104 "A lot of the paintings": Keith Haring interview with Gruen, Tape 5.

105 "SVA wasn't": Charles Imbro, in discussion with the author, email message to the author, January 19, 2020.

105 "Congratulations": Letter to Keith Haring from Maryhelen Mayorkas, foundation adviser, SVA, February 2, 1979, KHFA.

105 "poetries of videotape": Haring, notebook entry for September 1, 1979.

105 "It came at an important": Keith Haring, entry for January 22, 1979, "Circa January–February 1979 Notebook."

105 "We were both making": Kenny Scharf, in discussion with the author, September 18, 2019.

106 "I remember one": Barbara Buckner, in discussion with the author, November 10, 2019.

106 a stack of thirteen: The letters had been those approved for typesetting the corporate name "First National City Bank," and so included only those letters.

106 "I cannot teach": Lucio Pozzi, "Lucio Pozzi, a Conversation with Gianni Mercurio," *Keith Haring: About Art*, Palazzo Reale, Milan, 2017, exhibition catalog, 277.

106 "He was this very": Lucio Pozzi, in discussion with the author, October 25, 2019.

106 "cool in a way": Keith Haring interview with Gruen, Tape 5.

107 "I only knew him": Belisto, *Notes from the Pop Underground*, 99.

107 "SAMO as an attitude": Aletti, "An Interview with Keith Haring, 1981," 96.

107 "When he was passed": Ron Barbagallo, in discussion with the author, October 18, 2019.

107 "I was just smitten": Kenny Scharf, in discussion with the author, September 18, 2019.

108 "He picked you up": Drew Straub, in discussion with the author, March 30, 2019.

108 "We weren't punks": Hager, *Art After Midnight*, 45.

108 "He wanted to work": Molissa Fenley, in discussion with the author, December 4, 2019.

108 "I remember": Simone Forti, in discussion with the author, October 30, 2019.

109 "forms of expression": Haring, notebook entry for Memorial Day 1977.

109 "My constant association": Keith Haring, entry for December 18, 1978, "October 14–December 28, 1978, Notebook," KHFA.

109 "not painting all summer": Haring, notebook entry for September 1, 1979.

Chapter 6: Club 57

110 "cool street": Kenny Scharf, in discussion with the author, September 18, 2019.

112 "We were having a prom": Ann Magnuson, in discussion with the author, December 13, 2019.

112 "creatives": Min Thometz, in discussion with the author, October 17, 2020.

112 "It was approached": Kim Hastreiter, "Funny How Things Turn Out," *Keith Haring Show*, Fondazione Triennale di Milano, 2005, exhibition catalog, 100.

112 "*the* neighborhood hangout": Gruen, *Keith Haring*, 45.

112 "condensed poetry": Gruen, *Keith Haring*, 52.

112 "Half the time": Hager, *Art After Midnight*, 67.

112 "Everything was done": Hager, *Art After Midnight*, 68.

113 "This new information": Haring, notebook entry for September 1, 1979.

113 "The older poets": Ann Magnuson, in discussion with the author, December 13, 2019.

114 "He wasn't struck": Drew Straub, in discussion with the author, March 30, 2019.

114 "Talking to poets": Haring, notebook entry for September 1, 1979.

114 "I haven't done any performances": Cliff Fyman, "Interview with Keith Haring," *The World 41*, Poetry Project, St. Mark's Church, November 1984, 77.

114 "private secret club": Keith Haring interview with Gruen, Tape 5.

114 "gravitational pull": Kristoffer Haynes, in discussion with the author, August 30, 2020.

114 "so eccentric": Gruen, *Keith Haring*, 48.

115 "Club 57 wasn't": Samantha McEwen, in discussion with the author, November 20, 2019.

115 "Keith and I": Bruno Schmidt, in discussion with the author, September 26, 2019.

115 "It was one big": Gruen, *Keith Haring*, 46.

115 "It was like a comedy": Ann Magnuson, in discussion with the author, December 13, 2019.

115 "There was a chapter": Hager, *Art After Midnight*, 75.

116 *Propaganda Paragraph*: Keith specifies the number of posters as two hundred, though he later tended to recall five hundred posters. "SVA" files, KHFA.

116 "Keith was so cute": Min Thometz, in discussion with the author, October 17, 2020.

116 "I didn't want another": Gruen, *Keith Haring*, 38.

116 "I fell in love in my imagination": Poem, dated August 11, 1979, KHFA.

117 "fit together": Haring, notebook entry for September 1, 1979.

118 "The two main classes": Haring, notebook entry for September 1, 1979.

119 "He had an iconic": Bill Beckley, in discussion with the author, May 1, 2019.

119 "Beckley gave us": Frank Holliday, in discussion with the author, April 17, 2019.

119 "object-oriented": Keith Haring, paper for Semiotics course, October 31, 1979, KHFA.

120 "I was working": Simone Forti, in discussion with the author, October 20, 2019. Haring also did a performance for Forti's class titled (and using) *Five Colored Cassettes*.

120 "One of my most vivid": Ron Barbagallo, in discussion with the author, October 18, 2019.

121 "He is not involved": Note from Richard Van Buren, November 8, 1979, KHFA.

121 "He was a golden": Barbara Buckner, in discussion with the author, November 10, 2019.

121 "I've maintained": Gruen, *Keith Haring*, 39.

121 "MATISSE": Keith Haring, "AUTOBIOGRAPHY—SELF PORTRAIT THE LAST DAYS OF 1979," December 30, 1979, KHFA.

122 "It was like an SRO": Deb Parker, in discussion with the author, October 22, 2020.

122 "I used to bring boys": Keith Haring interview with Gruen, Tape 6.

122 "I didn't know": Aletti, "An Interview with Keith Haring, 1981," 91.
123 "THESE THINGS": Keith Haring, one-page typed statement, dated March 16, 1980, KHFA.
123 "more of a seminar": "Ten Commandments—CAPC Bordeaux Exhibition."
123 "Keith had invited me": Dieter Buchhart, "Interview: Jenny Holzer," *Crossing Lines*, National Gallery of Victoria, Melbourne, Australia, 2019, exhibition catalog, 49.
124 "I missed COSMOLOGY": Cosmology course notes, dated April 24, 1980, in "September 1979–March 1980 SVA Notebook," KHFA.
124 "Keith Sonnier's": "Ten Commandments—CAPC Bordeaux Exhibition."
124 "the textbook": Gruen, *Keith Haring*, 59.
124 "infinity trough": Gruen, *Keith Haring*, 40.
124 "Most people": Gruen, *Keith Haring*, 39.
124 "just hatched": Gruen, *Keith Haring*, 40.
124 "Everybody was sort of shocked": Gruen, *Keith Haring*, 39.
125 "It was so obvious": Keith Haring interview with Gruen, Tape 7.
125 "We all wore Gloria": Frank Holliday, email message to the author, October 30, 2020.
126 "The artist Bill Beckley": Linda Yablonsky, "In Others' Words: An Oral History of Keith Haring & Jean-Michel Basquiat," in *Crossing Lines*, 152.
127 "the dynamic raw energy": Unpublished transcript of John Gruen interview with Tony Shafrazi, October 17, 1989, KHFA.
127 "I would never stand up": Transcript of Keith Haring lecture at Cranbrook Academy of Art, September 25, 1987, KHFA.
127 "He had the peculiar habit": Sischy, "Kid Haring."
127 "I helped Keith Sonnier": Keith Haring interview with Gruen, Tape 6.
128 "neurotic": Gruen, *Keith Haring*, 58.
128 "Tony had a kind of charisma": Bill Beckley, in discussion with the author, May 1, 2019.
128 "Tony was one": Unpublished transcript of Jeffrey Deitch interview with John Gruen, September 14, 1989, KHFA.
128 "Jean-Michel": "A Conversation Between Tony Shafrazi and Carlo McCormick," in *Keith Haring: The Political Line*, 76.
128 "the most terrific disillusionment": Gruen, *Keith Haring*, 58.
129 "At one point": Gruen, *Keith Haring*, 60.
129 "The first East Village": Ann Magnuson, "The Prime Time of Our Lives," *Keith Haring*, Whitney Museum of American Art, New York, 1997, exhibition catalog, 128.
129 "He never bugged": Servin, "Radiant Baby," 12.
129 "an extraordinary assemblage": Gruen, *Keith Haring*, 60.
129 "Keith would call out": Magnuson and Scharf, "New York City's Club 57 Will Have Its Moment in the Spotlight."
130 "SOME OF THE MOST": Keith Haring typed statement for the *Anonymous Art* show, KHFA.
130 "with art critics and legitimate buyers": Magnuson, "The Prime Time of Our Lives," 128–29.
130 Wojnarowicz contributed: Wojnarowicz's biographer, Cynthia Carr, cites a friend saying, "David was really kind of obsessed with what Keith was doing, but I don't think Keith was ever very friendly with David." Wojnarowicz complained that Haring had "stolen" his image of a naked man with a dog's head in the show and began to go around town drawing radiant babies. See Cynthia Carr, *Fire in the Belly* (New York: Bloomsbury USA, 2012), 165, 244.
130 "multi-sexual": David Smith, "Where the Boys Are," *SoHo Weekly News*, March 23, 1981.
131 "guerilla gallerizing": Peter Frank, "Guerilla Gallerizing," *Village Voice*, May 1, 1979.
131 "A Proposal of Flexibility": Keith Haring proposal, KHFA.
131 "rather lost": Pincus-Witten, "Keith Haring: The Cross Against the Rod," 12.
131 "one Black guy": Keith Haring interview with Gruen, Tape 6.
132 "It was great": Gruen, *Keith Haring*, 66.
132 "He always had": Min Thometz, in discussion with the author, October 17, 2020.

132 "lean and loafe": Walt Whitman, "Song of Myself," *Walt Whitman*, selected and with notes by Mark Van Doren (New York: Viking Press, 1974), 32. .

132 "This episode": Gruen, *Keith Haring*, 56.

Chapter 7: Chalkman

133 "the only real painter": Aletti, "An Interview with Keith Haring, 1981," 100.

134 "Keith and I were famous": Frank Holliday, in discussion with the author, April 17, 2019.

134 sombrero-shaped UFO: Gruen, *Keith Haring*, 57; Edit DeAk and Lisa Liebman, "Keith Haring, Tony Shafrazi Gallery," review, *Artforum*, January 1983.

135 "At the beginning": Belisto, *Notes from the Pop Underground*, 100.

135 "Out of these drawings": Gruen, *Keith Haring*, 57.

135 "He never stopped": Drew Straub, Facebook message to author, November 27, 2020.

136 "like vampire mirrors": Frank Holliday, in discussion with the author, April 17, 2019.

137 "I was looking": Belisto, *Notes from the Pop Underground*, 100.

137 "He located": Donald Baechler, in discussion with the author, January 21, 2021.

137 "brain wave control": William S. Burroughs, *The Revised Boy Scout Manual: An Electric Revolution*, ed. and with prefaces by Geoffrey D. Smith and John M. Bennett (Columbus: Ohio State University Press, 2018), 41.

138 "He was fuming": Magnuson, "The Prime Time of Our Lives," 128.

138 "really political": "Breaking Out," a conversation between Julia Gruen and Glenn O'Brien, moderated by Dieter Buchhart, in *Keith Haring*, 1997, exhibition catalog, 59.

138 "It's fun": Aletti, "An Interview with Keith Haring, 1981," 100.

138 "getting up": Craig Castleman, *Getting Up: Subway Graffiti in New York* (Cambridge, MA, MIT Press, 1982), 19.

138 "They started noticing": Belisto, *Notes from the Pop Underground*, 101.

139 "Some of the kids": Castleman, *Getting Up*, 67.

140 "The roofs": Tim Miller, in discussion with the author, January 18, 2020.

140 "All of a sudden": Gruen, *Keith Haring*, 61.

140 "I really tried": Gruen, *Keith Haring*, 61.

141 "top-to-bottom": Gruen, *Keith Haring*, 58.

141 "it becomes apparent": Roberta Smith, "Four Formulas in Flux," *Village Voice*, November 9, 1982.

141 "At the P.S. 122 show": Samantha McEwen, in discussion with the author, November 20, 2019.

141 "The best art": William Zimmer, "Schooling Around," *SoHo News*, October 29, 1980.

142 "Kenny more or less": Keith Haring interview with Gruen, Tape 7.

142 "Please get out of that hole": Gruen interview with Scharf, October 13, 1989.

142 "it was the most space": Gruen, *Keith Haring*, 64.

142 "It was above": Joan Haring, in discussion with the author, June 4, 2018.

143 "It was like underwear": Bruno Schmidt, in discussion with the author, September 26, 2019.

143 "Keith and Kenny": Samantha McEwen, in discussion with the author, November 20, 2019.

143 "It was the beginning": Hager, *Art After Midnight*, 94.

143 "Keith went off": Sean McQuate, quoted in Hager, *Art After Midnight*, 95.

144 "the sleaziest block": Mark Jacobson, "Times Square: The Meanest Street in America," *Rolling Stone*, August 6, 1981.

144 "I smoked pot": Gruen, *Keith Haring*, 64.

144 "I fell in love": Gruen, *Keith Haring*, 63.

144 "fluid": Kenny Scharf, in discussion with the author, September 18, 2019.

144 "Then the sun starts": Kenny Scharf, in discussion with the author, September 18, 2019.

144 "the Pop Art Café": Keith Haring interview with Gruen, Tape 7.

144 "I would give him": Kenny Scharf, in discussion with the author, September 18, 2019. While Scharf painted most of them, Haring occasionally had "guest appearances" by

other artists painting his eyeglasses, including Peter Schuyff, who had arrived recently from Canada and covered them with blue and gold stripes that looked very Egyptian.

144 "It was a hilarious house": Samantha McEwen, in discussion with the author, November 20, 2019.

145 "Keith and I": Kenny Scharf, in discussion with the author, September 18, 2019.

145 "The problem with Keith": Gruen, *Keith Haring*, 63.

145 "These fucking beautiful boys": Keith Haring, entry for March 18, 1980, "November 1979–April 1980 Notebook," KHFA.

145 "One day, Steve Mass": Gruen, *Keith Haring*, 62.

146 "artsy cabaret": Hager, *Art After Midnight*, 50.

146 "The stripe paintings": Ross Bleckner, in discussion with the author, December 18, 2020.

146 "Mudd Club was based": Diego Cortez, in discussion with the author, November 20, 2020.

146 "was more for the down": Magnuson and Scharf, "New York City's Club 57 Will Have Its Moment in the Spotlight."

146 "The regulars": Kenny Scharf, in discussion with the author, September 18, 2019.

146 "To draw my friends": Keith Haring interview with Gruen, Tape 7.

146 "To me, David Bowie": Kenny Scharf, in discussion with the author, September 18, 2019.

147 "gay-ish kitsch": Diego Cortez, in discussion with the author, November 20, 2020.

147 "I think Jean felt": Yablonsky, "In Others' Words," 154.

147 "rich Beverly Hills kid": Min Thometz-Sanchez, in discussion with the author, October 17, 2020.

147 "I began seeing," Gruen, *Keith Haring*, 53–54.

147 "my young semiotic mind": Keith Haring interview with Gruen, Tape 7.

148 "People wrote": Gruen, *Keith Haring*, 68.

148 "A number of young artists": Richard Goldstein, "In Praise of Graffiti: The Fire Down Below," *Village Voice*, December 24, 1980.

148 "alternative ads": Barry Blinderman, "Close Encounters with 'The Third Mind,'" in *Keith Haring: Future Primeval*, 17.

149 "He was taking advantage": Unpublished transcript of Leonard McGurr interview with John Gruen, KHFA.

149 "rubbernecking": "A Conversation Between Tony Shafrazi and Carlo McCormick," 76.

149 "I immediately knew": Gruen, *Keith Haring*, 68.

149 "50 cents, 30 works": Gerald Marzorati, "Artful Dodger," *Soho News*, May 13, 1981.

149 "Keith's subway panels": Magnuson, "The Prime Time of Our Lives," 128.

150 "I mean the drawings": Gruen, *Keith Haring*, 68–69.

150 "primitive code": Dieter Buchhart, "Keith Haring's Universal Picture-Word Alphabet," in *Keith Haring: The Alphabet*, 16.

150 "So, *you're* the guy": Gruen, *Keith Haring*, 69.

150 "Gumbylike figures": Jeffrey Deitch, "Why the Dogs Are Barking," in *Keith Haring*, 1982 exhibition catalog, 17.

151 "It was a performance": Analú Maria López, "Off the Wall: Keith Haring and the Kids," *MCA* (blog), July 8, 2014.

151 "I used to watch": "His Royal Haringness: Friends Remember Keith," *Outweek*, March 18, 1990.

152 "It was while Keith": Gruen, *Keith Haring*, 70.

152 "Here's this guy": Unpublished transcript of Tseng Kwong Chi interview with John Gruen, January 22, 1990, KHFA.

152 "Chalkman": Glenn Loney, "Magic Marker Recycles Unsold Ad Spaces: Chalkman Meets Eraserhead," February 1982 newspaper clipping, KHFA.

152 "It's hard to compete": Keith Haring, Slide Lecture, Whitney Museum of American Art, Stamford, CT, 1987, KHFA.

152 "I hear ya": Marzorati, "Artful Dodger."

153 "That's your part": "Keith Haring by Keith Haring," manuscript dated January 12, 1984, KHFA.

153 "Michelangelo": Ruth La Ferla, "The Underground Man," *Daily News-Record*, publication unknown, February 1982, clipping in KHFA.

153 "Who are the deranged": Letter from Luis Emmanuelli, Brooklyn, *Daily News*, June 12, 1982.

153 "He was like a sponge": Tony Shafrazi, in discussion with the author, November 13, 2020.

154 "Artists did chalk": Diego Cortez, in discussion with the author, November 27, 2020.

154 "My drawings don't try": Fyman, "Interview with Keith Haring."

154 "his urban and underground": Jade Dellinger, "Keith Haring: Art and Commerce."

154 "the most important thing": Kurtz, "The Radiant Child (Keith Haring)."

154 "Just as no one": Gruen, *Keith Haring*, 184.

155 "It's a Reagan World": *SoHo Weekly News*, December 10, 1980.

155 "We were fully convinced": Ann Magnuson, "It Takes an East Village," *Club 57: Film, Performance, and Art in the East Village, 1978–1983*, Museum of Modern Art, New York, 2017, exhibition catalog, 158.

155 "Ladies Auxiliary": Georgia Dullea, "Mudd Club Regulars Celebrate Inaugural," *New York Times*, January 22, 1981.

155 During winter and spring 1981: Besides the projects mentioned, in December 1980, Haring was included in the Fashion Moda "Events" group exhibition at the New Museum; he published *Drawings: Keith Haring*, a sixteen-page artist's book of drawings, with Appearances Press in 1982, a series that included Jane Dickson, Tom Otterness, and Cara Perlman.

155 "felt really dangerous": Magnuson and Scharf, "New York City's Club 57 Will Have Its Moment in the Spotlight."

155 "desire for conformity": Statement by Keith Haring Regarding Richard Serra's Tilted *Arc*, One Federal Plaza, New York City, March 7, 1985, KHFA.

155 "testing ground": Keith Haring video interview for Broad Street Studio, KHFA.

156 "I was always": Michael Keane, email message to the author, April 19, 2020.

156 "physically had to drag": Donald Baechler, in discussion with the author, January 21, 2021.

156 "vivid and very original": Unpublished transcript of Tony Shafrazi interview with John Gruen, October 17, 1989, Tape 45, KHFA.

156 "a perfect time capsule": Keith Haring, "The Blueprint Drawings," typed statement, January 4, 1990, KHFA.

157 East Village block party: I am indebted for the comparison to Phoebe Hoban, *Basquiat: A Quick Killing in Art* (London: Quartet Books, 1998), 70.

157 "the most excessively": Hoban, *Basquiat*, 70.

157 "Low Tide": John Perreault, "Low Tide," *SoHo News*, February 25, 1981.

157 "New Wave No Fun": Peter Schjeildahl, "New Wave No Fun," *Village Voice*, March 4, 1981.

157 "an advertisement": Kay Larson, *New York Magazine*, March 16, 1981.

158 "This is a tidal wave of art": Glenn O'Brien, "I Am New Wave (Or Something Like That)," *Interview*, April 1981.

158 "You'd go to openings": Hager, *Art After Midnight*, 98.

158 "Keith and Jean fell": Diego Cortez, in discussion with the author, November 27, 2020.

159 "Kenny always said": Samantha McEwen, in discussion with the author, November 20, 2019.

160 "the works of some": Press release for "Lower Manhattan Drawing Show," KHFA.

160 "full of the glamour": Kim Levin, "Anarchy in the M.C.," *Village Voice*, March 4, 1981.

160 "what Graffiti": Press Release for *Beyond Words*, KHFA.

160 "It turned out to be": Gruen, *Keith Haring*, 73.

160 "Nobody had heard": Tim Lawrence, *Life and Death on the New York Dance Floor: 1980–1983* (Durham, NC, and London: Duke University Press, 2016), 158.

160 "paranoid": Keith Haring interview with Gruen, Tape 7.

160 "We were young kids": Lawrence, *Life and Death on the New York Dance Floor*, 160.

161　"Steve Mass treated Keith": Unpublished transcript of Fred Brathwaite interview with John Gruen, n.d., Tape 4, KHFA.

161　"Keith would often": Ross Bleckner, in discussion with the author, December 18, 2020.

161　"Suddenly I realized": Gruen, *Keith Haring*, 74.

Chapter 8: "Love Sensation"

163　"The pinup boy": Keith Haring interview with Gruen, Tape 7.

163　"working in the manner": Deitch, Geiss, and Gruen, *Keith Haring*, 138.

163　"There were these great": Keith Haring interview with Gruen, Tape 7.

164　"Precious differences": Robert Farris Thompson, "Requiem for the Degas of the B-boys," *Art Forum*, May 1990.

164　"When he's not drawing": This Week, edited by Merle Ginsberg, *Soho News*, May 6–12.

164　"This is the first time": Keith Haring interview with Gruen, Tape 7.

164　"We go upstairs": John Matos, in discussion with the author, February 1, 2021.

165　"We saw this strange": "Mark Coetzee Interviews Mera and Don Rubell," in *Against All Odds: Keith Haring in the Rubell Family Collection*, Rubell Family Collection, Rubell Museum, Palm Springs, CA, 2008, exhibition catalog.

166　"It was torn": Unpublished transcript of Mera and Don Rubell interview with John Gruen, October 31, 1989, Tape 40, KHFA.

166　"very vague and very modest": Gruen, *Keith Haring*, 76.

166　"So, the Rubells": Gruen, *Keith Haring*, 74.

166　"I can tell you": Kenny Scharf, in discussion with the author, September 18, 2019.

166　"As bright as the light": Kermit Oswald, in discussion with the author, May 28–29, 2019.

167　"But then we were": Samantha McEwen, in discussion with the author, November 20, 2019.

167　"We would have": Kenny Scharf, in discussion with the author, September 18, 2019.

167　"I decided": Keith Haring interview with Gruen, Tape 7.

167　"Kenny got very odd": Samantha McEwen, in discussion with the author, November 20, 2019.

169　"He started doing": Bruno Schmidt, in discussion with the author, September 26, 2019.

170　"It was so beautiful": Samantha McEwen, in discussion with the author, November 20, 2019.

170　"I had great sex": Keith Haring interview with Gruen, Tape 7.

171　"Having found": Gruen, *Keith Haring*, 78.

171　"bodyguard": Kay Haring, in discussion with the author, June 6, 2018.

171　"His sister": Keith Haring interview with Gruen, Tape 7.

172　"In moved Juan": Samantha McEwen, in discussion with the author, September 26, 2019.

172　"The two of them slept": Tony Shafrazi, in discussion with the author, April 25, 2021.

172　"The first time": Kay Haring, in discussion with the author, June 6, 2018.

172　"Though we never talked about it": Sheff, "Keith Haring: Just Say Know."

173　"Juan was super": Desmond Cadogan, in discussion with the author, January 18, 2019.

173　"Juan was the most": Samantha McEwen, in discussion with the author, September 26, 2019.

173　"exuding this very": Gruen, *Keith Haring*, 79.

173　"At the time": John Matos, in discussion with the author, February 1, 2021.

173　"Rare that you": Kermit Oswald, in discussion with the author, May 28–29, 2019.

174　"If you weren't": Lawrence, *Life and Death on the New York Dance Floor*, 285.

174　"By quote, unquote": Keith Haring interview with Gruen, Tape 9.

174　"He walked in": Unpublished transcript of Fred Brathwaite interview with John Gruen, n.d., KHFA.

174　akin to Gaugin discovering Tahiti: Sischy, "Kid Haring."

174　"Juan and I go there": Gruen, *Keith Haring*, 89.

174　"The love I had": Gruen, *Keith Haring*, 88.

174　"The Garage": Drew Straub, in discussion with the author, March 30, 2019.

175　"At the Garage": Desmond Cadogan, in discussion with the author, February 1, 2021.

175 "It was closer": Tomé Cousin, in discussion with the author, June 18, 2020.

175 "eargasms": Lawrence, *Life and Death on the New York Dance Floor*, 393.

175 "It'll never work": Lawrence, *Life and Death on the New York Dance Floor*, 200.

175 "Work it!": Arnaldo Cruz-Malavé, *Queer Latino Testimonio, Keith Haring, and Juanito Xtravaganza* (New York: Palgrave Macmillan, 2007), 82.

176 "Haring's fluid compositions": Lawrence, *Life and Death on the New York Dance Floor*, 285–86.

176 "I was just as terrified": Unpublished transcript of Fred Brathwaite interview with John Gruen, n.d., KHFA.

177 "It was like discovering": Gruen, *Keith Haring*, 80.

177 "Yo": Angel Ortiz, in discussion with the author, April 30, 2021.

177 "You *know*": Gruen, *Keith Haring*, 80.

178 "If you don't mind": Gruen, *Keith Haring*, 81.

178 "Wow": Angel Ortiz, in discussion with the author, April 30, 2021

178 "I wanted": Gruen, *Keith Haring*, 82.

178 "I was the oldest": Keith Haring interview with Gruen, Tape 7.

178 "Keith was bugging": Angel Ortiz, in discussion with the author, April 30, 2021.

179 "I'd say": Katherine Dieckmann, "Tag Team: LA II Remembers the Guy Who 'Draws Babies on the Door,'" *Village Voice*, May 18, 1990.

179 "paternal, brotherly": Keith Haring interview with Gruen, Tape 7.

179 "We'd do enamel": Gruen, *Keith Haring*, 81.

179 "people with fur coats": Unpublished transcript of Keith Haring interview with Rene Ricard, November 1983, 6, KHFA.

179 "I began": Gruen, *Keith Haring*, 82.

180 "This artist": Gruen, *Keith Haring*, 83.

180 "new imagists": Edit DeAk, "A Chameleon in a State of Grace: Francesco Clemente," *Artforum*, February 1981.

181 "I was there": Alba Clemente, in discussion with the author, January 13, 2022.

181 "Getting bogged down": Deitch, "Why the Dogs Are Barking," 18.

181 "Suddenly, I hear": Gruen, *Keith Haring*, 82.

181 "I remember going": Gruen, *Keith Haring*, 84.

182 "It had a half inch": Robert Hawkins, in discussion with the author, January 26, 2021.

182 "We didn't have": Annie Plumb, in discussion with the author, March 17, 2021.

182 "At that point": Keith Haring interview with Gruen, Tape 8.

182 "turning the painting": Keith Haring interview with Gruen, Tape 9.

183 "Keith's made me think": Annina Nosei, in discussion with the author, May 18, 2020. Haring often visited the museum's collection of Greek vases and the Michael C. Rockefeller Wing's collection of primitive art.

183 "We'd been dancing": Drew Straub, in discussion with the author, March 30, 2019.

183 "All of a sudden": Keith Haring interview with Gruen, Tape 9.

183 "The wall": Annina Nosei, in discussion with the author, May 18, 2020.

183 "All three of us": Drew Straub, in discussion with the author, March 30, 2019.

183 "Of course": Hoban, *Basquiat*, 87.

183 "like a slave": Hoban, *Basquiat*, 87.

183 "It became Jean-Michel": Annina Nosei, in discussion with the author, May 18, 2020.

184 Hal Bromm Gallery: Prices cited on a list from the exhibition range from eight hundred dollars for an untitled piece of pink marker and enamel on wood to three thousand dollars for *Crib*.

184 "Everybody would keep": Hal Bromm, in discussion with the author, January 30, 2020.

184 Rene Ricard: When Rene Ricard confronted Diego Cortez in Keith Haring's kitchen, saying, "You don't know who I am," Cortez replied, "*You* don't know who you are." See Brett De Palma, "He Took the A Train," in "A Tribute to Diego Cortez," ed. Raymond Foye, *The Brooklyn Rail*, September 2021.

184 "all over": Gruen, *Keith Haring*, 48–49.

185 "Yet the crown": Ricard, "The Radiant Child."

Chapter 9: Art for Everybody

189 *Messages to the Public*: The series was organized by the artist Jane Dickson, who was associated with Colab and had participated in the *Times Square Show*. She also involved Haring in creating the book *Drawings: Keith Haring.*

190 "I'm sure inside": Keith Haring, entry for March 29, 1987, "Germany to NYC Notebook," KHFA.

190 "Rare cancer": Lawrence K. Altman, "Rare Cancer Seen in 41 Homosexuals," *New York Times*, July 3, 1981.

191 "As early as 1982": Gruen, *Keith Haring*, 132.

191 "not completely": Gruen, *Keith Haring*, 88.

191 "I never liked": Tony Shafrazi, in discussion with the author, November 13, 2020.

192 "The hardest decision": Keith Haring interview with Gruen, Tape 8.

192 defacing of *Guernica*: *Guernica* had been protected with a coat of varnish after its previous restoration, and the staff of MoMA was able to wipe the surface clean. For a full discussion of the incident, see Gijs van Hensbergen, *Guernica: The Biography of a Twentieth-Century Icon* (London: Bloomsbury, 2004), 276–77.

192 Museum of Modern Art: As Warhol entered in his diary on May 22, 1984, "I realized that the reason Tony Shafrazi hasn't gotten even one of the artists in his gallery into MOMA is because Tony's the person who defaced Picasso's 'Guernica.' But that's not fair. Keith Haring isn't at MOMA." Andy Warhol, *The Andy Warhol Diaries*, ed. Pat Hackett (New York: Warner Books, 1989).

192 "I identified": Gruen, *Keith Haring*, 84.

192 "funky": Roberta Smith, "Spacewalk," *Village Voice*, October 21–27, 1981.

192 Galerie t' Venster: The show was organized by the Rotterdam Arts Council.

192 "The train from Brussels": Keith Haring interview with Gruen, Tape 8.

193 "So today": Keith Haring, entry for May 4, 1982, "Belgium to NYC Notebook," KHFA.

193 "Tony used to say": Donald Baechler, in discussion with the author, January 21, 2021.

194 "When I told Keith": Tony Shafrazi, in discussion with the author, June 6, 2021.

194 vinyl tarpaulin sheets: Julian Schnabel was making paintings on canvas tarps as early as 1981. Haring also "worked on canvas tarps along with the vinyl tarps," according to gallery assistant Mark Baron, in an email to the author, March 25, 2021. The prominent Chicago collectors Morton and Rose Neuman, who collected Picasso, Léger, and Miró and had had their photos taken with those artists, came to the basement to purchase a tarp and have a formal picture taken with Haring. "It was a kind of baptism," says Shafrazi, "for them to come to see a young man who hadn't had a one-man show yet and consider him important enough to have a formal photograph taken. I tried to explain that to Keith, and he heard me." Tony Shafrazi, in discussion with the author, June 26, 2021.

194 "John Lennon thing": Keith Haring interview with Gruen, Tape 8. The entire statement from the *Documenta* catalog is from a March 18, 1982, journal entry. According to Shafrazi, the painting of the dogs jumping through a stomach hole was the first of the vinyl tarp works done in the gallery basement.

194 "At the very last minute": Annie Plumb, in discussion with the author, March 17, 2021.

195 "Nearby there was": Tony Shafrazi, in discussion with the author, April 25, 2021.

195 "I learned": Keith Haring, "Artist's Statement," in *Documenta 7*, Kassel, Germany, 1983, exhibition catalog.

195 "I began to use": Paul Donker Duyvis, "Every Station Is My Gallery: Interview with Keith Haring," in *Keith Haring: Paintings, Drawings, and a Vellum*, 46.

196 "I'm thinking": Gruen, *Keith Haring*, 83–84.

196 nuclear disarmament rally: The rally was held in Central Park on June 12, 1982.

196 "soon we will all blow up": Nathalie Phillips, "The Radiant (Christ) Child: Keith Haring and the Jesus Art Movement," *American Art* 21, no. 3 (Fall 2007).

197 "I was starting": Keith Haring interview with Gruen, Tape 8.

197 "It was an eyesore": Keith Haring interview with Gruen, Tape 9.

197 "Keith, it's not": Yablonsky, "In Others' Words," 155.

197 "in cool lime": Robert Farris Thompson, "Haring and the Dance," in *Keith Haring*, 1997 exhibition catalog, 218.

198 "black and orange": Angel Ortiz, in discussion with the author, April 30, 2021.

198 *ARTNews*: The cover photograph accompanied a feature article by Cynthia Nadelman, "Graffiti Is a Thing That's Kind of Hard to Explain" (*ARTNews*, October 1982), the title a quotation from Haring.

198 "The best thing": Peter Frank and Michael McKenzie, *New, Used & Improved: Art for the 80s* (New York: Abbeville Press, 1987), 66.

198 "heavyweight gloss": Jeffrey Deitch, in discussion with the author, February 21, 2021.

199 "What I objected to": Gruen, *Keith Haring*, 86.

199 "Keith sort of": Annie Plumb, in discussion with the author, March 17, 2021.

199 "I thought to myself": Unpublished transcript of Dan Friedman interview with John Gruen, undated.

199 "It was never just Keith": Jeffrey Deitch, in discussion with the author, February 21, 2021.

200 "It was an early use": Annie Plumb, in discussion with the author, March 17, 2021. According to the catalog, a number of the works had already been sold to various collectors, including Kamran Diba, a cousin of the former queen of Iran Farah Pahlavi and designer of the Tehran Museum of Contemporary Art; Patrick Lannan, of the Lannan Foundation; and the American television producer Douglas Cramer.

200 radiant heart being hoisted: The radiant heart on white vinyl tarp was purchased by the Rubells. The image was used for the cover of *Vanity Fair* in February 1984.

200 "That was really": Unpublished transcript of Keith Haring interview by Rene Ricard, November 1983, 31, KHFA.

201 "I'd never seen": Donald Baechler, in discussion with the author, January 21, 2021.

201 "I had girls": Gruen, *Keith Haring*, 86.

201 *CBS Evening News*: The segment included famous footage of Haring being arrested on a subway platform for doing one of his chalk drawings; in the clip, he is led away in handcuffs by a police officer. The officer felt compelled to make the arrest because of the presence of the camera crew at the site of the offense.

201 "We were there looking": Kristen Haring, in discussion with the author, April 30, 2018.

201 "We felt that Keith": Gruen, *Keith Haring*, 87.

202 "Most people": Yablonsky, "In Others' Words," 159.

202 "culture parent": Ricard, "The Radiant Child."

202 "Keith was full of energy": Christopher Makos, in discussion with the author, May 4, 2021.

203 "Chris had invited": Andy Warhol, entry for November 13, 1982, *Andy Warhol Diaries*, 468.

203 "the most important artist": Keith Haring, entry for March 6, 1987, "Barra Grande, Brazil, Notebook," KHFA.

203 Flora McEwen: "Flora McEwen: My Life Is a Dream," interviewed by Andy Warhol, Bob Colacello, and Brigid Berlin, *Interview*, March 1979.

203 "I remember": Samantha McEwen, in discussion with the author, November 20, 2019.

203 "At Club 57": Sischy, "Kid Haring.

203 "It was the sixties": Kenny Scharf, in discussion with the author, September 18, 2019.

204 "I then decided": Keith Haring interview with Gruen, Tape 9.

204 "Gael told me": Warhol, diary entry for December 1, 1984, *Andy Warhol Diaries*, 618.

204 "He rents a huge studio": Warhol, diary entry for January 31, 1983, *Andy Warhol Diaries*, 483.

205 "one-off": Lawrence, *Life and Death on the New York Dance Floor*, 165.

205 "Jean, chill with Patti": Dieter Buchhart, "Interview: Patti Astor," in *Crossing Lines*, 122.

206 "conspiracy of excellence": Rene Ricard, "The Pledge of Allegiance," *Artforum*, November 1982.

206 "I held firm": Lawrence, *Life and Death on the New York Dance Floor*, 268.

206 "My exhibition": Gruen, *Keith Haring*, 90.

206 "Every day": Yablonksy, "In Others' Words," 160.
206 "short, interesting-looking": Gruen, *Keith Haring*, 89.
207 "You are to leather": Haring, notebook entry for March 6, 1987.
207 "He becomes": Gruen, *Keith Haring*, 89.
207 "even more funky": Keith Haring interview with Gruen, Tape 9.
207 "The opening": Lawrence, *Life and Death on the New York Dance Floor*, 354.
207 "The neighborhood kids": Buchhart, "Interview: Patti Astor," 124.
207 "Then to the Keith Haring": Warhol, diary entry for February 3, 1983, *Andy Warhol Diaries*, 484.
208 "He let me look": Gruen, *Keith Haring*, 90–91.
208 "Andy was just": Christopher Makos, in discussion with the author, May 4, 2021.
208 "It was another loop": Servin, "Radiant Baby."
208 "Jean Michel": Warhol, entry for November 15, 1983, *Andy Warhol Diaries*, 468.
208 "Famous Negro Athletes": Whether this likely tag might have been another has been debated.
209 "They exercised together": Keith Haring, "Painting the Third Mind" (1988 essay), in *Warhol-Basquiat Collaborations*, Didier Imbert Fine Art, Paris, September–November 1989, exhibition catalog.
209 "By then Andy": "Transcript of Artist's Slide Lecture," Cranbrook Academy of Art, Bloomfield Hills, MI, September 25, 1987, KHFA.
209 "Jean brought back": Haring, "Painting the Third Mind."
209 "L.A.'s elegant": Alexandra Anderson, "Keith Haring and L.A. Rock," *Flash Art*, May 1983.
210 "a kind of Braque": Gerrit Henry, "Keith Haring: Subways Are for Drawing," *The Print Collector's Newsletter*, May–June 1982.
210 "Just promise me": Angel Ortiz, in discussion with the author, April 30, 2021.
210 "Almost immediately": Gruen, *Keith Haring*, 94.
210 "It's very beautiful": Keith Haring interview with Gruen, Tape 9.
210 "There is a respect": Drenger, "Art and Life."
211 "They were really": Keith Haring interview with Gruen, Tape 9.
211 "a more heavily": Jane Bell, "Biennial Directions," *ARTNews*, Summer 1983.
211 "It's sure different": Warhol, diary entry for March 27, 1983, *Andy Warhol Diaries*, 492.
212 "winsome scribbles": Peter Schjeldahl, "Spacey Invaders," *Village Voice*, September 18, 1982.
212 "newsmaking": John Ashbery, "Biennials Bloom in the Spring," *Newsweek*, April 18, 1983.
212 "I remember being": Samantha McEwen, in discussion with the author, November 20, 2019.
212 "The apartment": Gruen, *Keith Haring*, 91.
213 "Bobby Breslau": Samantha McEwen, in discussion with the author, November 20, 2019.
213 "It was my 'in' scene": Gruen, *Keith Haring*, 91.
213 "mural on Avenue D": *DJ* was painted, with the blessing of the owner, on a wall of a Puerto Rican restaurant, La Cazuela.
213 "Cabbed to Keith": Warhol, diary entry for July 1, 1983, *Andy Warhol Diaries*, 510. Warhol had suggested having Haring on the July cover of *Interview*: "I tried to get Keith on the *Interview* cover, I was thinking it would be good to have an artist on the cover, art is so big now, but they wouldn't let me. It looks like we're going to use Miguel Bose" (diary entry for May 18, 1983, *Andy Warhol Diaries*, 502).
214 "They were so": Warhol, diary entry for August 18, 1983, *Andy Warhol Diaries*, 521.
214 "home of hip-hop": Bonnie Nadell and John Small, *Breakdance* (Philadelphia, PA: Running Press, 1984), 9.
214 "Keith and I": Gruen, *Keith Haring*, 92.
214 "We all circulated": Gruen, *Keith Haring*, 91.
214 "She was definitely": Paige Powell, in discussion with the author, May 26, 2021.
214 "Keith said that": Warhol, diary entry for July 29, 1985, *Andy Warhol Diaries*, 666.
214 "Andy and I": Paige Powell, in discussion with the author, May 26, 2021.

215 "The big chalk": Warhol, diary entry for August 18, 1983, *Andy Warhol Diaries*, 521.

215 "When he came over": Alexander Heinrici, in discussion with the author, April 12, 2021.

215 Lantz refrigerator: "The refrigerator had Madonna's signature on it and Andy's signature on it." Keith Haring interview with Gruen, Tape 9.

215 "What stays": Gruen, *Keith Haring*, 93.

216 "Before I understood": Paige Powell, in discussion with the author, May 26, 2021.

216 "It was a personal": Keith Haring interview with Gruen, Tape 9.

216 1,851 AIDS cases: Larry Kramer's "1,112 and Counting" article, which marked the number of AIDS dead and excoriated the hospitals, the mayor, and even the Gay Men's Health Crisis for too little action combating the disease, appeared in the *New York Native* on March 14, 1983.

216 "They gave me a paper": Joey Arias, in discussion with the author, December 18, 2019.

217 "Around the time Klaus Nomi": Unpublished transcript of Kenny Scharf interview with John Gruen, October 1989, KHFA.

217 "Throughout the eighties": Gruen, *Keith Haring*, 185.

217 "It was hard to get": Paige Powell, in discussion with the author, May 26, 2021.

217 "I thought up": Keith Haring interview with Gruen, Tape 11.

218 "I know it was": Paige Powell, email message to the author, June 13, 2021.

218 "Other things": Keith Haring interview with Gruen, Tape 11.

218 "Then Keith Haring": Warhol, diary entry for September 29, 1983, *Andy Warhol Diaries*, 533.

218 "One guy came over": Kenny Scharf, in discussion with the author, June 15, 2021.

219 "This makes it": Peter Schjeldahl, "Basquiat's Memorial to a Young Artist Killed by Police," *The New Yorker*, July 8 and 15, 2019.

219 "Continually dismissed": Keith Haring, entry for March 28, 1987, "On a Plane from Dusseldorf to NYC," in "March 29, 1987–January 3, 1988, Notebook," KHFA.

Chapter 10: Party of Life

222 "He turned into": Keith Haring interview with Gruen, Tape 9.

222 "They're wise-cracking": Alanna Martinez, "Full Frontal Art: Q&A with choreographer Bill T. Jones About Working with Keith Haring," BlouinArtInfo (website), May 9, 2011.

222 "Hey bloke!": Bill T. Jones, in discussion with the author, August 13, 2021.

222 "As a Black man": Lawrence, *Life and Death on the New York Dance Floor*, 357.

222 "I said": Gruen, *Keith Haring*, 96.

223 "Bill connected": Bill T. Jones, in discussion with the author, August 13, 2021.

223 "It was very generous": Martinez, "Full Frontal Art."

223 "It was very physical": Gruen, *Keith Haring*, 95.

224 "A major show": Martinez, "Full Frontal Art."

224 "the Queen of Naples": Peter McGough, *I've Seen the Future and I'm Not Going* (New York: Pantheon Books, 2019), 177.

224 Elio Fiorucci: Fiorucci stripped down his five-thousand-square-foot store for the painting. On October 9, Haring and LA II painted the shop across thirteen hours to music by deejay Maurizio Marsico. Fiorucci had the installation taken down in 1984. The piece was kept in storage until undergoing restoration in 1991.

224 Warhol: Warhol was in Milan at the time, traveling with Jean-Michel Basquiat. On October 8, 1983, he noted in his diary, "Jean Michel came in when we were leaving. He said he was staying on with Keith Haring to get publicity—Keith had come in from Spain with Kenny Scharf to paint Fiorucci" (*Andy Warhol Diaries*, 534).

224 "the place to be": Harriet Vyner, *Groovy Bob: The Life and Times of Robert Fraser* (London: HENI Publishing, 2016), 120.

224 "Keith worshiped": Vyner, *Groovy Bob*, 294.

224 "the best-dressed man": Tony Shafrazi, in discussion with the author, June 6, 2021.

225 "All the figures": Vyner, *Groovy Bob*, 301.

226 "I've been trying": Warhol, diary entry for November 13, 1983, *Andy Warhol Diaries*, 539.

226 "How can I top": Gruen, *Keith Haring*, 111.

226　"sort of English": Keith Haring interview with Gruen, Tape 9.

227　"You can use it": Gruen, *Keith Haring*, 111.

227　"I went out and bought": Kermit Oswald, in discussion with the author, May 28–29, 2019.

227　"Tony in his": Keith Haring interview with Gruen, Tape 10.

228　"kind of breakdance": Gruen, *Keith Haring*, 111.

228　"mostly tepid work": Kate Linker, "Keith Haring," *Artforum*, March 1984.

228　"occasionally really falls": Kim Levin, "Ikonoklast Panzerism," *Village Voice*, December 20, 1983. Levin also wrote, interestingly, of the work as having "taken on a squared-off robotic Tlingit or Aztec—or Atari—look."

228　"another leap forward": Gruen, *Keith Haring*, 111.

228　"The show sold out": Kermit Oswald, in discussion with the author, May 28–29, 2019.

228　"Andy! Your hair!": Gruen, *Keith Haring*, 111.

229　"Went all the way": Warhol, diary entry for January 7, 1984, *Andy Warhol Diaries*, 548.

229　"There was a circus": Derrick Smit, in discussion with the author, June 26, 2017.

230　"I have read": Keith Haring, "Keith Haring," *Flash Art*, March 1984.

231　"I didn't even know": Gruen, *Keith Haring*, 112.

231　"I was already": Video footage of Keith Haring painting the outdoor mural at Collingwood Technical College, 1984, KHFA.

232　Perhaps instigated: Although Haring believed this act of vandalism occurred due to his appropriation of Aboriginal imagery, curators and scholars have found no evidence of such a motive. Any criticism in the newspapers focused on the relationship between Haring's work and ideas of "fine art" at the time

232　"all that hot": Gruen, *Keith Haring*, 113.

232　"Keith was taking": Paul Schmelzer, "Graffiti on the Concourse: Keith Haring's 1984 Walker Mural," *Walker Art Magazine*.

232　"You are one": Letter from Colleen Ernst to Keith Haring, n.d., KHFA.

233　"Dear Mr. Haring": Letter from Giff Laube to Keith Haring, KHFA.

233　"persistent curiosity": Peter Selz, *The Work of Jean Dubuffet* (New York: Museum of Modern Art, 1962), 10.

233　"I was totally": Gruen, *Keith Haring*, 113.

233　"I found out": Gruen, *Keith Haring*, 114.

234　"I'd like to be": "Alex Bennett Interviews Keith Haring," 1986.

234　"I don't think": "Keith Haring: Interview by John Romine," *Upstart*, 1983.

234　children: A list of some other children special to him in this way was included in his will, where he bequeathed each of them two drawings created by him: Madison, the daughter of Yves and Debra Arman; Timothy McGurr, the son of Futura 2000; Matias, the son of Bruno and Carmel Schmidt; Nina and Chiara, the daughters of Francesco and Alba Clemente; Lana Jo and Yenna Hill, the daughters of his sister Kay; and Seth DeLong, the son of his sister Karen.

234　"He was so sweet": Kenny Scharf, in discussion with the author, September 18, 2019.

234　"silent bond": Haring, "On a Plane from Dusseldorf to NYC."

235　"Whatever else I am": Keith Haring, entry for October 4, 1987, "October 2–November 4, 1987, Notebook."

235　"I want to make": Gruen, *Keith Haring*, 118.

235　"Graffiti Kunst": "Graffiti Art: Keith, the Wonder Boy."

236　"wonderful young student": Gruen, *Keith Haring*, 191.

236　"I became very jealous": Gruen, *Keith Haring*, 191.

236　"too many irons": Julia Gruen, in discussion with the author, July 20, 2021.

237　*Keith and Julia*: *Keith and Julia* was painted in 1986; the *Julia* sculpture was executed in 1987.

238　Stephen Sprouse: Haring had been annoyed with Sprouse, who had once asked him to collaborate. When Haring refused, Sprouse went ahead and designed clothes that Haring felt "really resemble my stuff and LA2's stuff." Sprouse invited Haring to come to his Fifty-Seventh Street studio to have suits made for the party, and Bobby Breslau

advised him to set aside his grudge. Haring was swayed, as Mick Jagger was wearing Sprouse suits. See Keith Haring interview with Gruen, Tape 10.

238 "a kitsch reference": Bill T. Jones, in discussion with the author, August 13, 2021.

238 "We picked out": Keith Haring interview with Gruen, Tape 10.

239 "But her reception": Gruen, *Keith Haring*, 120.

239 "Who is *that*": Bill T. Jones, in discussion with the author, August 13, 2021.

239 "Don't do that": Keith Haring interview with Gruen, Tape 10.

239 "There were kids outside": Warhol, diary entry for May 16, 1984, *Andy Warhol Diaries*, 574.

240 "went to the movies": Warhol, diary entry for August 9, 1984, *Andy Warhol Diaries*, 595.

240 "completely and incredibly": Keith Haring interview with Gruen, Tape 10.

240 "He's a really": Gruen, *Keith Haring*, 122.

240 "I was at Keith's": Christopher Andersen, *Madonna Unauthorized* (New York: Simon and Schuster, 1991), 106.

241 "Madonna falls for Bobby": Keith Haring interview with Gruen, Tape 10.

241 "Some people really": Letter from Bobby Martinez to Keith Haring, 1988, KHFA.

241 "I remember visiting": Gruen, *Keith Haring*, 98.

241 "Juan was a very": Gruen, *Keith Haring*, 138.

242 "Keith told me": Bill T. Jones, in discussion with the author, August 13, 2021.

242 "Keith loves people": Gruen, *Keith Haring*, 98.

243 "At this time": Keith Haring interview with Gruen, Tape 10.

243 "Keith said": Warhol, diary entry for July 28, 1984, *Andy Warhol Diaries*, 589.

243 "antsy": Keith Haring interview with Gruen, Tape 10.

243 Her Grace at Paradise concert: The concert was held on October 1, 1985, at the Paradise Garage discotheque.

244 "I'm Not Perfect (But I'm Perfect for You)": The video was directed in Paris by Grace Jones, with Haring as assistant director, in 1986.

244 "one of my most": Gruen, *Keith Haring*, 112.

244 "a tuneful celebration": Quoted in Keith Haring and Tseng Kwong Chi, *Art in Transit: Subway Drawings by Keith Haring* (New York: Harmony Books, 1984).

244 "It was fun": "War on 'Litterpigs,'" New York Day by Day, *New York Times*, August 4, 1984.

244 $24,500: Richard Kim, "Ed Koch and the Cost of the Closet," *The Nation*, February 2, 2013.

245 "With his silence": Larry Kramer, "1,112 and Counting," *New York Native*, March, 1983.

245 "totally Walt Disneyed out": Keith Haring, entry for October 3, 1987, "October 2– November 4, 1987, Notebook."

245 "The sequined glove": Warhol, diary entry for August 4, 1984, *Andy Warhol Diaries*, 591.

245 "I loved it": Sean Ono Lennon, in discussion with the author, April 19, 2022.

246 "so young": Warhol, diary entry for October 9, 1984, *Andy Warhol Diaries*, 607.

246 "I was a computer geek": Sean Ono Lennon, in discussion with the author, April 19, 2022.

246 "And then Keith": Warhol, diary entry for October 9, 1984, *Andy Warhol Diaries*, 607.

246 "excited to be": KHFA.

246 "Andy was like": Sean Ono Lennon, in discussion with the author, April 19, 2022.

247 Galleria Salvatore Ala: Haring dedicated the show to the Italian art critic Francesca Alinovi, who had recently been murdered. He had appreciated Alinovi's understanding of his work in her essay "Twenty-First Century Slang," published in *Flash Art* in November 1983.

247 "A jolly Italian": Annie Plumb, in discussion with the author, March 17, 2021.

247 "I only wish": Keith Haring, "Keith Haring in Milano," KHFA. The catalog was not finally produced, and the piece remained unpublished until its inclusion in Haring, *Keith Haring Journals*, 115.

247 "I chose to begin": Haring, *Keith Haring Journals*, 116.

248 "The gallery": Gruen, *Keith Haring*, 124.
248 "My painting that was": Belsito, *Notes from the Pop Underground*, 105.
248 "When we went to Venice": Angel Ortiz, in discussion with the author, April 30, 2021.
249 "I'm now having": Gruen, *Keith Haring*, 122.
249 "The critics": Gruen, *Keith Haring*, 123.

Chapter 11: A Political Line

250 "For the last few days": Fyman, "Interview with Keith Haring." The interview took place
 on September 26, 1984. Haring was several hours late but called Fyman upon his return
 to his studio. According to Fyman, "he said, 'I'm really sorry I kept you waiting for so
 long. I was drawing in the subway and I lost track of time. Are you doing anything now?
 Can you come now and do the interview?'" About two hundred copies of the magazine
 were printed. Cliff Fyman, email message to the author, September 24, 2021.
252 "The truck": Jenny Holzer, in discussion with the author, September 30, 2021.
252 "Watching Ronald": "Keith Haring Interview for Broad Street Studio," KHFA.
253 "I didn't like": Unpublished transcript of John Gruen interview with Joan Haring,
 September 30, 1989, Tape 20.
253 "The other drawings": Fyman, "Interview with Keith Haring."
254 "mad": "From I.R.T. to ART."
254 "If someone": Meg Cox, "Dazzling Picture," *Wall Street Journal*, November 24, 1986.
255 "with his thin doodles": Robert Hughes, "Careerism and Hype Amidst the Image Haze,"
 Time, June 17, 1985.
255 "completely racist": Sheff, "Keith Haring: Just Say Know."
255 "When Jean-Michel": Ann Magnuson, in discussion with the author, December 19,
 2019.
255 "They buy art": Cox, "Dazzling Picture."
256 "Kenny's paintings": Warhol, diary entry for December 1, 1984, *Andy Warhol Diaries*, 618.
256 "have fame": Castleman, *Getting Up*, 78.
256 "Keith loved": Julia Gruen, in discussion with the author, July 20, 2021.
256 "I never felt": Min Thometz-Sanchez, in discussion with the author, October 17, 2020.
256 "You have to not only be": "Babies, Snakes and Barking Dogs: Keith Haring in Australia,"
 1984 video, KHFA.
256 "He had gone": Drew Straub, in discussion with the author, March 30, 2019.
256 "He tried": Servin, "Radiant Baby."
257 "We'd be": Paige Powell, in discussion with the author, May 26, 2021.
257 "Jean Michel": Warhol, diary entry for September 13, 1985, *Andy Warhol Diaries*, 677.
257 "We were always": Gruen, *Keith Haring*, 190.
258 "so eighties": The phrase was the title of a book of photographs of the period by scene
 photographer Patrick McMullen: *So8os: A Photographic Diary of a Decade* (New York:
 powerHouse Books, 2003).
258 "The most beautiful work": Peter von Ziegesar, "Keith Haring Remembered," *Out*, July
 1997.
258 "I would do a drawing": Keith Haring interview with Gruen, Tape 12.
258 "Richard Hambleton": Robert Hawkins, in discussion with the author, January 26, 2021.
258 only a few chalk drawings: In 1986, Haring did a series of *Crack Is Wack* subway
 drawings.
258 "These drawings had run": Gruen, *Keith Haring*, 148.
258 "I had now": Keith Haring interview with Gruen, Tape 12.
259 "From the beginning": Gruen, *Keith Haring*, 135.
259 "Lines can be drawn": Brion Gysin, "Corrected text of statement for Museum of
 Bordeaux," October 1985, KHFA.
260 "An art museum": Eric Goode and Jennifer Goode, *Area: 1983–1987* (New York: Harry N.
 Abrams, 2013), 313.
260 "a lot of connective": Eric Goode, in discussion with the author, October 5, 2021.
260 "the extraordinary": Levin, "Anarchy in the M.C."

261 "Sean and I were obsessed": Eric Goode, in discussion with the author, October 5, 2021.

261 "building a better mousetrap": Brad Gooch, "Club Culture," *Vanity Fair*, May 1987. The nightclub owner was Arthur Weinstein of Hurrah.

261 "The pill": Jesse Kornbluth, "Inside Area," *New York Magazine*, March 11, 1985.

261 "Somehow Andy": Goode and Goode, *Area: 1983–1987*, 46.

261 "a kind of adult": Goode and Goode, *Area: 1983–1987*, 49.

261 "I remember Keith": Eric Goode, in discussion with the author, October 5, 2021.

262 "Andy would come": Desmond Cadogan, in discussion with the author, January 18, 2019.

262 "I remember I had": Goode and Goode, *Area: 1983–1987*, 75.

262 "Someone asked me": Goode and Goode, *Area: 1983–1987*, 228. The ramp was made from raw plywood, and Haring painted a black intertwining pattern. The skateboarders said, "This is not skateboard culture," and they insisted on the repainting by Pushead, an illustrator known for his drawings of skulls.

262 "The art theme": Eric Goode, in discussion with the author, October 5, 2021.

263 "When I asked": Eric Goode, in discussion with the author, October 5, 2021.

263 *Life* magazine group portrait: The photograph was taken by Nina Leen. Other examples of the genre include Art Kane's 1958 photograph of fifty-eight jazz soloists on and around a Harlem stoop and Man Ray's photo of the Surrealist Group in Paris.

263 "It's a great": Goode and Goode, *Area: 1983–1987*, 215.

264 "I realized": Eric Goode, in discussion with the author, October 5, 2021.

264 "It wasn't about": Goode and Goode, *Area: 1983–1987*, 214.

264 "When the theme": Eric Goode, in discussion with the author, October 5, 2021.

264 "The installations": Warhol, diary entry for May 8, 1985, *Andy Warhol Diaries*, 648.

265 "swallow the art": Hager, *Art After Midnight*, 127.

265 "Now the scene": "A Conversation Between Tony Shafrazi and Carlo McCormick," 85.

265 "If it isn't": Warhol, diary entry for May 9, 1985, *Andy Warhol Diaries*, 649.

265 "way of reenacting": "A Conversation Between Tony Shafrazi and Carlo McCormick," 85.

265 "They tried to copy": Lawrence, *Life and Death on the New York Dance Floor*, 468.

265 "the funny thing": Warhol, diary entry for May 14, 1985, *Andy Warhol Diaries*, 650.

265 "disco art": Calvin Tompkins, "The Art World: Disco," *The New Yorker*, July 22, 1985.

266 "*sort of* sings": Gruen, *Keith Haring*, 142.

267 "like an angel": Gruen, *Keith Haring*, 131.

267 "Went down to Keith's": Warhol, diary entry for May 22, 1985, *Andy Warhol Diaries*, 652.

267 "There goes": Michael Musto, "La Dolce Musto" column, *Village Voice*, June 1985, KHFA.

267 "Club 57 with money": Lawrence, *Life and Death on the New York Dance Floor*, 365.

267 "I really love": Keith Haring, entry for October 27, 1987, "October 2–November 4, 1987, Notebook."

267 "working obsessively": Keith Haring, *Haring-isms*, ed. Larry Warsh (Princeton, NJ, and Oxford: Princeton University Press, 2020), 22.

267 "Keith does outrageous": Bill T. Jones, in discussion with the author, August 13, 2021.

267 "if he and his art": Julia Gruen, in discussion with the author, July 20, 2021.

267 "myopic focus": Derrick Smit, text message to the author, October 16, 2021.

268 "It was like being": Keith Haring interview with Gruen, Tape 13.

268 silk screen painting: Haring and Warhol made a series of silk screen paintings featuring two different *New York Post* headlines; in this series of works, Haring painted on top of silk-screened canvases made by Warhol.

268 "They'd called me": Warhol, diary entry for September 4, 1985, *Andy Warhol Diaries*, 674.

268 "Keith, check this out": "A Conversation Between Tony Shafrazi and Carlo McCormick," 84.

269 "At the prodding": Gruen, *Keith Haring*, 132.

270 "the work has spirit": Galloway, "A Quest for Immortality," 23.

270 "He was like a kid": Alfred Lippincott, in discussion with the author, October 26, 2021.

270 "I think of those": Kermit Oswald, in discussion with the author, May 28, 2019.

270 "That involved": Alfred Lippincott, in discussion with the author, October 26, 2021.

271 "I remember them": Paige Powell, email message to the author, October 22, 2021.

271 "mentor": Vivien Raynor, "Art: Basquiat, Warhol," *New York Times*, September 20, 1985.

271 "The next day": Hoban, *Basquiat*, 273.

271 "I no longer": Gruen, *Keith Haring*, 132.

272 "like my American": Tony Shafrazi, in discussion with the author, April 10, 2021.

272 "Having my sculptures": Gruen, *Keith Haring*, 132–33.

272 "with landscaping": Douglas C. McGill, "Art People," *New York Times*, November 8, 1985.

272 "sacred sanctuary of art": Keith Haring interview with Gruen, Tape 12.

273 "The sculptures": Gruen, *Keith Haring*, 133.

273 "I was walking": Al Haring, in discussion with the author, November 16, 2018.

273 "I walked up right when": Kitty Brophy, in discussion with the author, November 17, 2021.

274 "We were trying": Warhol, diary entry for October 26, 1985, *Andy Warhol Diaries*, 687.

274 "It's a doubleheader": "Art: Keith Haring," *Village Voice*, November 1985, KHFA.

274 "kindergarten aesthetic": Holland Carter, "Keith Haring: Tony Shafrazi/Leo Castelli," *Flash Art*, February/March 1986.

274 "far more complex": McGill, "Art People."

274 "artist nobody doesn't": Vivien Raynor, "Keith Haring," *New York Times*, November 8, 1985.

274 "probably the most": Donald Kuspit, "Keith Haring," *Artforum*, February 1986.

274 "a moralist": Unpublished transcript of John Gruen interview with Leo Castelli, n.d., Tape 6, KHFA.

275 Dith Pran: Dith was working as a staff photographer for the *New York Times*.

275 "a tall, handsome": Tony Shafrazi, in discussion with the author, June 11, 2021.

275 "I'm at the Garage": Gruen, *Keith Haring*, 135.

276 "The way I worked": Sylvie Couderc, with the collaboration of Sylvie Marchand, "The Ten Commandments: An Interview," Keith Haring Foundation (website), December 1985, www.haring.com/!/selected_writing/ten-commandments-an-interview.

276 *Vanity Fair*: In April, *Vanity Fair* had spoofed the original da Vinci classic painting with a cartoon satirizing the art scene, titled "The Last Brunch," with Haring, as a "scribbling child of the populous caves," drawing "feebly, to his great enrichment," according to the caption, on the walls of the upper room.

277 "I remember Chaban-Delmas": Jeffrey Deitch, in discussion with the author, February 22, 2021.

277 "On a column": Tony Shafrazi, in discussion with the author, June 11, 2021.

277 wine labels: Labels for the Château Mouton Rothschild, a Bordeaux premier cru, were done as well by Picasso, Chagall, and Niki de Saint Phalle.

277 "Keith was being": Bjorn Amelan, in discussion with the author, November 6, 2021.

278 "Then the head": Haring quoted in Page Six, *New York Post*, 1986, KHFA.

278 "I make a small": Keith Haring interview with Gruen, Tape 12.

Chapter 12: The Pop Shop

280 "real dude, a mensch": Bruno Schmidt, in discussion with the author, September 26, 2019.

280 "I was certainly": Gruen, *Keith Haring*, 138.

281 "start spending": Gruen, *Keith Haring*, 138.

281 "I'm splitting": Keith Haring interview with Gruen, Tape 9.

281 "he had to do stuff": Unpublished transcript of Angel Ortiz interview with John Gruen, February 2, 1990, Tape 36, KHFA.

281 "From his will": Angel Ortiz, in discussion with the author, April 30, 2021. LA II continued to be part of Keith's social life and some art projects, yet much was left unresolved. It was reported in the *New York Times* in 2008 that "Mr. Ortiz contends

that he has been denied credit and profits from the sale and licensing of artwork that he helped create." Julia Gruen, as executive director of the Keith Haring Foundation, countered that Ortiz "was compensated for all the work he did with Keith Haring in Keith Haring's lifetime." Niko Koppel, "Little Angel Was Here: A Keith Haring Collaborator Makes His Mark," *New York Times*, August 5, 2008.

282 "an incredible": Keith Haring interview with Gruen, Tape 12.

282 "I convince": Gruen, *Keith Haring*, 139.

282 "I have a friend": Cruz-Malavé, *Queer Latino Testimonio*, 37.

282 "He was a raving": Drew Straub, in discussion with the author, March 30, 2019.

282 "He looks like": Keith Haring interview with Gruen, Tape 12.

282 "a walking sex object": Keith Haring, entry for October 14, 1987, "October 2–November 4, 1987, Notebook."

282 "He had an aura": Arnaldo Cruz-Malavé, in discussion with the author, November 16, 2021.

283 "S&M": Cruz-Malavé, *Queer Latino Testimonio*, 29.

283 "I was attracted": Cruz-Malavé, *Queer Latino Testimonio*, 39.

283 "I looked in astrology books": Unpublished transcript of Juan Rivera interview with John Gruen, January 24, 1990, Tape 39, KHFA.

283 "That is why I love": Haring, notebook entry for March 28, 1987.

284 "I was top": Cruz-Malavé, *Queer Latino Testimonio*, 39.

284 "The first time": Bruno Schmidt, in discussion with the author, September 26, 2019.

284 "Zena was born": Kenny Scharf, in discussion with the author, November 30, 2021.

284 "She's been sitting": "Kenny Scharf by Keith Haring," *Interview*, February 1985.

284 "Keith loved Carnival": Kenny Scharf, in discussion with the author, November 30, 2021.

285 "I remember him": Min Thometz-Sanchez, in discussion with the author, October 17, 2020.

285 "sort of dolphin": Thompson, "Requiem for the Degas of the B-boys."

285 "He made a huge": *Restless: Keith Haring in Brazil*, directed by Guto Barra and Gisella Matta (Empresa Produtora, 2013).

285 "dipping underneath": Thompson, "Haring and the Dance," 221.

286 "I'd been putting": Cruz-Malavé, *Queer Latino Testimonio*, 37.

286 "I was happy for Keith": Kenny Scharf, in discussion with the author, November 30, 2021.

286 new apartment: Juan Dubose, shattered by the outcome, remained living at the Broome Street apartment, with various roommates, for another year. The rent at 321 Sixth Avenue was $1,500 monthly.

286 "It was a very sterile": Julia Gruen, in discussion with the author, July 20, 2021.

287 Josephine Baker's: Massimo Audiello, email to the author, April 24, 2020.

287 "super cozy": Lysa Cooper, in discussion with the author, November 17, 2021.

287 "I think that it wasn't": "A Conversation with Fred Brathwaite, Fred Schneider, Jellybean Benitez, and Junior Vasquez," in *Keith Haring* 1997 exhibition catalog, 160.

287 "For me": Gruen, *Keith Haring*, 139.

287 "Keith always *loved*": Cruz-Malavé, *Queer Latino Testimonio*, 45.

287 "I cooked": Gruen, *Keith Haring*, 140.

287 "He was into": Unpublished transcript of Juan Rivera interview with John Gruen, January 24, 1990, Tape 39, KHFA.

288 "a combination": Susan Mulcahey, "Haring's Atomic Babies Going Legit," *New York Post*, November 21, 1984.

288 Alan Herman: Herman has had several gallery and museum exhibitions, including a show at OK Harris Gallery in 1993.

288 "I saw Keith": Alan Herman, in discussion with the author, December 21, 2021.

288 "Why in the world": Alan Herman, in discussion with the author, December 21, 2021.

288 "horrible businessman": Mark Fuller, "Whiz! Bam! Keith Haring at the Stedelijk Museum," *The Paper About Holland*, 1985, KHFA.

289 "$500,000": James A. Revson, "Haring's Gift: Gifts," *New York Newsday*, April 18, 1986.
289 "I got to sit": Julia Gruen, in discussion with the author, January 12, 2019.
289 "Andy practically": Haring, notebook entry for March 6, 1987.
290 "Keith told me": Warhol, diary entry for September 17, 1984, *Andy Warhol Diaries*, 600.
290 "The store": Warhol, diary entry for May 3, 1986, *Andy Warhol Diaries*, 731.
290 "For me a store": Haring, Slide Lecture.
290 "Of course, I knew": Gruen, *Keith Haring*, 129.
290 "I said to him": Patricia Field, in discussion with the author, December 7, 2021.
291 "A tightrope": Gruen, *Keith Haring*, 129.
291 "I remember driving": Donald Baechler, in discussion with the author, January 21, 2021.
291 "Almost to the level": Keith Haring interview with Gruen, Tape 12.
291 "Keith would collect": Lysa Cooper, in discussion with the author, November 21, 2021.
291 "I decided to participate": Gruen, *Keith Haring*, 128.
291 first artist's store: For a full discussion of the history of artist stores leading up to the Pop Shop, see Amy Raffel, *Art and Merchandise in Keith Haring's Pop Shop* (New York and London: Routledge, 2021).
292 "This is certainly": Keith Haring interview with Gruen, Tape 12.
292 "latest and most radical": Deitch, "The Radioactive Child," 12.
292 "Business art": Warhol wrote, "Business art is the step that comes after Art." Andy Warhol, *The Philosophy of Andy Warhol (From A to B and Back Again)* (New York: Harcourt Brace Jovanovich, 1975), 92.
292 "the guiding light": Haring, notebook entry for March 6, 1987.
292 "guardian angel": Sheff, "Keith Haring: Just Say Know."
293 "He had Bobby": Julia Gruen, in discussion with the author, January 12, 2019.
293 "this really fun place": Keith Haring interview with Gruen, Tape 12.
293 "It was like going": David Trinidad, in discussion with the author, January 26, 2019.
293 "shaped like a Beatle": Guy Trebay, "The Pop Shop," *Village Voice*, May 6, 1986.
293 "The wall seemed": Peter Pennoyer, in discussion with the author, January 18, 2019.
294 "almost intentionally": Julia Gruen, in discussion with the author, January 12, 2019.
295 "The opening": Keith Haring interview with Gruen, Tape 12.
295 "*everybody* wanted": Unpublished transcript of Adolfo Arena interview with John Gruen, n.d., Tape 1, KHFA.
295 "The staff was cute": Desmond Cadogan, in discussion with the author, January 18, 2019.
295 "A lifeguard": Peter Pennoyer, in discussion with the author, January 18, 2019.
296 "Standing in the shop": Suzanne Slesin, "An Artist Turns Retailer," *New York Times*, April 18, 1986.
296 "We're waiting": Trebay, "The Pop Shop."
296 "a wearable print": Gruen, *Keith Haring*, 148.
296 "conceptual artists": Sheff, "Keith Haring: Just Say Know."
296 "This is more": Slesin, "An Artist Turns Retailer."
296 "Mr. Haring": Michael Gross, Notes on Fashion, *New York Times*, April 22, 1986.
296 "If you're not familiar": "Pop Goes His Easel" on 20/20, ABC, 1986, KHA 0535, Keith Haring Foundation online video archive.
297 "It's proper": Revson, "Haring's Gift: Gifts."
297 satirical poem: Robert Hughes, "The SoHoiad or the Masque of Art: A Satire in Heroic Couplets Drawn from Life," *New York Review of Books*, March 29, 1984.
297 "disco decorator": Hughes, "Careerism and Hype Amidst the Image Haze," 79.
297 "People will look back": Tad Friend, "Downhill from Here," *Spy Magazine*, October 1986.
297 "doesn't carry great": Revson, "Haring's Gift: Gifts."
297 "If Keith Haring": Paula Span, "Art World Beats a Path to Keith Haring," *Orlando Sentinel*, February 17, 1986.
297 "the little": John Paul Russell, in discussion with the author, January 18, 2019. Russell was the printer for a series of Haring prints done at Durham Press and sold at the Pop Shop.

297 "When I was a kid": Carlo McCormick, "From Streets to TV to Fine Art Galleries, KAWS Is Everywhere," *PAPER* (November 2013).
298 "The store itself": *Drawing the Line.*
298 "the Matte Pack": Friend, "Downhill from Here."
298 "You remember that": Sheff, "Keith Haring: Just Say Know."
298 "I don't know what": Sheff, "Keith Haring: Just Say Know."
298 Coppola: In one scene in Coppola's contribution to the trilogy, "Life Without Zoe," the young nephew of the Sheik of Shiraz, the "richest boy in the world," flutters a Pop Shop hand fan. *New York Story* was a collaboration among Woody Allen, Francis Ford Coppola, and Martin Scorsese.
299 "Chernobyl": Jenny Holzer, in discussion with the author, September 30, 2021.
299 "I was doing it": Darrell Yates Rist, "Keith Haring: Behind the Graffiti Art, a Gay Man and His Message," *The Advocate*, August 5, 1986.
300 "eventually": Cruz-Malavé, *Queer Latino Testimonio*, 40.
300 "Keith knew": Cruz-Malavé, *Queer Latino Testimonio*, 37–38, 41–42.
300 "At the end": Lysa Cooper, in discussion with the author, November 17, 2021.
300 "There was a": Cruz-Malavé, *Queer Latino Testimonio*, 42.
301 "this rivalry thing": Cruz-Malavé, *Queer Latino Testimonio*, 43.
301 "I remember everyone": Cruz-Malavé, *Queer Latino Testimonio*, 42.
302 "Early on": Gruen, *Keith Haring*, 138.
302 "At the time": Robert Hawkins, in discussion with the author, January 26, 2021.
302 "The work that he produced": Julia Gruen, in discussion with the author, July 20, 2021.
302 "To just look": Jeffrey Deitch, in discussion with the author, February 22, 2021.
303 "Crack basically started": Jim Nolan, "Summons Whacks Artist for His Anti-Crack Mural," *New York Post*, July 1986, 1986 Press Box, KHFA.
303 "My friends said": Kimmelman, "Keith Haring's Subway Ride to Success."
304 "Riker's Island": "Channel 4 News," video news footage, KHFA.
304 "His wonderful": Servin, "Radiant Baby."
305 "It was a cold call": Laurie Meadoff, in discussion with the author, January 21, 2022.
305 "a dropout": Wil Haygood, "A Liberty Contribution from 10,000 New York Kids," *Boston Globe*, July 3, 1986.
305 "a younger": Peter Richmond, "Kids Paint a Lyrical Liberty," *Miami Herald*, July 3, 1986.
305 "This was one": Keith Haring interview with Gruen, Tape 13.
306 "a Buddhist": Laurie Meadoff, in discussion with the author, January 21, 2022.
306 "We met during": Keyonn Sheppard, in discussion with the author, January 21, 2022.
306 "Juan was our go-to": Laurie Meadoff, in discussion with the author, January 21, 2022.
307 "Juan, Juan!": Cruz-Malavé, *Queer Latino Testimonio*, 43.
307 "Of course": Keith Haring interview with Gruen, Tape 13.
307 "It was one of": Gruen, *Keith Haring*, 153.
307 "I have never dealt": Michael Small, "For a Few Fleeting Hours Keith Haring Makes a Bright Canvas of the Berlin Wall," *People*, November 10, 1986.
307 "I think": Small, "For a Few Fleeting Hours Keith Haring Makes a Bright Canvas of the Berlin Wall."
308 "For me": Associated Press, "Graffiti Artist Paints Berlin Wall," KHFA.

Chapter 13: "In This Life"

312 "He's really active": Keith Haring interview with Gruen, Tape 13.
312 "When I looked at him": Haring, notebook entry for July 7, 1986.
312 "In the Face": William E. Geist, "In the Face of a Plague, a Party," *New York Times*, September 6, 1986.
313 "Martin is one of my best": Keith Haring interview with Gruen, Tape 13.
313 "I remember": Kitty Brophy, in discussion with the author, February 11, 2022.
313 "He died just when": Keith Haring interview with Gruen, Tape 13.

313 "In This Life": Madonna, *Erotica*, Maverick and Sire Records, 1992.
313 "By comparison": Charles Kaiser, *Gay Metropolis* (Boston and New York: Houghton Mifflin Company, 1997), 283. The statistic of a 50% mortality rate among young men living in Manhattan applied to men born after World War II.
314 "It's like a war": Geist, "In the Face of a Plague, a Party"; Katy K. was the professional name of Katy Kattelman.
314 "It has been": Haring, entry for July 7, 1986, "July 7–16, 1986, Notebook," KHFA.
315 "Like a year's worth of painting": Keith Haring interview with Gruen, Tape 13.
315 "dedicating to K.H.": Pierre Alechinsky, statement for the *Confrontation: Keith Haring and Pierre Alechinsky* exhibition at NSU Art Museum, Fort Lauderdale, FL, February 27–October 2, 2022, exhibition catalog.
315 "The point is that": Haring, entry for October 7, 1987, "October 2–November 4, 1987, Notebook."
315 "Léger": *Deux Femmes*, water and pencil on paper, signed and dated '54, is now in the collection of the Museum of Modern Art in New York.
316 "Keith's show": Warhol, diary entry for January 17, 1987, *Andy Warhol Diaries*, 794. "Sam" is Sam Havadtoy, who was Yoko Ono's companion and who eventually helped Haring design his final apartment.
316 Steve Rubell: Don Rubell, in discussion with the author, September 22, 2022.
316 "He painted": Annie Leibovitz, *At Work* (New York: Phaidon Press, 2008), 62. The portrait was commissioned in 1986 by a Florida art magazine that folded before its publication.
316 "Compared to the previous": Keith Haring interview with Gruen, Tape 13.
317 "Keith Haring's exhibition": Roberta Smith, "Art: Mel Bochner Show at Sonnabend Gallery," *New York Times*, February 20, 1987.
317 "For American art": Roberta Smith, "Art: David Salles's Works Shown at the Whitney," *New York Times*, January 23, 1987.
318 "That was like pulling": Sheff, "Keith Haring: Just Say Know."
318 "I'm not really": Haring, notebook entry for March 28, 1987.
319 "I always described": Kermit Oswald, in discussion with the author, May 28, 2019.
319 "surreal, mystical": Keith Haring interview with Gruen, Tape 13.
319 "Keith comes home": Kenny Scharf, in discussion with the author, November 30, 2021.
319 "A Caterer": Robert Hughes, "A Caterer of Repetition and Glut: Andy Warhol: 1928–1987," *Time*, March 9, 1987.
320 "Andy Warhol was the first": Letter from Keith Haring to Mr. Henry Anatole Grunwald, March 17, 1987, KHFA.
320 "I return": Gruen, *Keith Haring*, 169.
321 "Only two people": Paige Powell, in discussion with the author, May 26, 2021.
321 "Paige": Letter from Keith Haring to Paige Powell, March 16, 1987, private collection.
322 "an over-size": Mimi Thompson, "Pulling Down the Sky."
322 "It's treating him": Drenger, "Art and Life," 46.
322 "Even Andy Warhol": Haring, notebook entry for July 7, 1986.
323 "I feel like I have": Haring, notebook entry for March 6, 1987, KHFA.
323 "People are disappearing": Shaun Casey, "Keith Haring: In 1981 Artists Knew What They Were Working Against," *Flash Art*, Summer 1990.
323 "Andy left us": Draft of quote for *Details*, n.d., KHFA.
323 "These are the countries": Gruen, *Keith Haring*, 191.
324 "I painted it": Keith Haring, entry for May 6, 1987, "April–May 1987 Notebook," KHFA.
325 "more consistent": Keith Haring interview with Gruen, Tape 13.
325 "He has great": Keith Haring, entry for April 29, 1987, "April–May 1987 Notebook."
326 "Jim came back": Mimi Thompson, in discussion with the author, December 19, 2019.
326 "I saw Keith": Gruen, *Keith Haring*, 126.
326 "one-take idea": Gruen, *Keith Haring*, 126.
326 Anderson Theater Gallery: The director of Anderson Theater Gallery was Patrick Fox.

326 "What do you do": Unpublished transcript of George Condo interview with John Gruen, August 17, 1989, Tape 8, KHFA.

327 "His stylistic needle": Peter Schjeldahl, "Dumb and Smarter," *Village Voice*, February 24, 1998.

327 "quite incredible": Haring, notebook entry for March 28, 1987.

327 "Keith was able": Gruen, *Keith Haring*, 126.

327 "He worked in my studio": Dieter Buchhart, "Interview: George Condo," in *Crossing Lines*, 93.

327 "Keith, after seeing": Buchhart, "Interview: George Condo," 92.

328 "We took the box tops": George Condo, email message to the author, July 29, 2023.

328 "great show": Keith Haring, entry for May 19, 1987, "March 29, 1987–January 3, 1988, Notebook."

328 "drawing with Jasmin": Keith Haring, entry for July 10, 1987, "May 30–July 11, 1987, Notebook," KHFA.

328 "It must be incredible": Keith Haring, entry for April 30, 1987, "April–May 1987, Notebook," KHFA.

329 "The way Keith": Gruen, *Keith Haring*, 175.

329 "If you weren't": *Lunettes noires pour nuits blanches*, Episode 18, directed by Dominique Colonna and Jean-Paul Jaud, Channel 2, filmed at Le Palace, Video Lectures and Interviews, KHFA.

330 "Lots of rococo": Keith Haring, entry for May 3, 1987, "April–May 1987 Notebook."

330 "There once was an artist": Haring, notebook entry for May 3, 1987.

330 "traveling museum": Contract, Luna Luna, Vienna, 1986, Special Projects, KHFA. The name "Luna Luna" was an homage to Luna Park, the amusement park in Coney Island, New York.

330 "I remember": Unpublished transcript of Fred Brathwaite interview with John Gruen, n.d., Tape 4, KHFA.

331 "Tony had very good": Jeffrey Deitch, in discussion with the author, February 22, 2021.

331 "Funny": Keith Haring, entry for June 22, 1987, "May 30–July 11, 1987, Notebook."

331 "Once": Viken Arslanian, in discussion with the author, April 1, 2022.

332 "Palm Beach": Robert Farris Thompson, "Introduction," in Haring, *Keith Haring Journals*, xxxii.

332 "How can I top": Gruen, *Keith Haring*, 177.

332 "home again": Thompson, "Introduction," *Keith Haring Journals*, xxxiii.

333 "There is a trampoline": Keith Haring, entry for June 6, 1987, "May 30–July 11, 1987, Notebook."

333 "the conversation": Keith Haring, entry for June 7, 1987, "May 30–July 11, 1987, Notebook."

333 "although it is hard": Keith Haring, entry for June 8, 1987, "May 30–July 11, 1987, Notebook."

334 "X-ray, blood": Keith Haring, entry for June 9, 1987, "May 30–July 11, 1987, Notebook."

334 "It is really": Keith Haring, entry for June 18, 1987, "May 30–July 11, 1987, Notebook."

334 "The only time": Keith Haring, entry for June 25, 1987, "May 30–July 11, 1987, Notebook."

334 Jason Poirier dit Caulier: Jason Poirier dit Caulier was the son of Marc Poirier dit Caulier, whose gallery, X-ONE, showed the work of Tony Shafrazi, as a conceptual artist, in the early 1970s. Poirier dit Caulier *fils* went on to start his own PLUS-ONE Gallery in Antwerp.

334 "This is one": Journal entry for June 19, 1987, in Haring, *Keith Haring Journals*.

335 "very Dubuffet": Keith Haring, entry for June 20, 1987, "May 30–July 11, 1987, Notebook."

335 "very 'Cobra'": Keith Haring, entry for June 21, 1987, "May 30–July 11, 1987, Notebook."

335 "because of the quality": Haring, notebook entry for October 7, 1987.

335 "A day or two": Unpublished transcript of Roger Nellens interview with John Gruen, November 9, 1989, Tape 33, KHFA.

335 Baptiste Lignel: Lignel became a photographer specializing in social reportage and portraiture.
335 "looks like a cuter": Keith Haring, entry for June 27, 1987, "May 30–July 11, 1987, Notebook."
336 "I think thoughtful": Thompson, "Introduction," in Haring, *Keith Haring Journals*, xxxv.
336 "I stayed": Tony Shafrazi, in discussion with the author, June 11, 2021.
336 "I feel more optimistic": Keith Haring, entry for July 9, 1987, "May 30–July 11, 1987, Notebook."
336 "That's all people": Kitty Brophy, in discussion with the author, February 22, 2022.
337 "I finish and have a wank": Keith Haring, entry for June 26, 1987, "May 30–July 11, 1987, Notebook."
337 "I can't believe": Keith Haring, entry for June 24, 1987, "May 30–July 11, 1987, Notebook."
337 "When we traveled": Cruz-Malavé, *Queer Latino Testimonio*, 37.
337 Paradise Garage: Paradise Garage officially closed on October 1, 1987. Haring was there on the Saturday night of the closing weekend but needed to leave at midnight to prepare for a trip to Europe.
337 "It was really": Keith Haring, entry on October 2, 1987, "October 2–November 4, 1987, Notebook."
338 "As soon as we landed": Cruz-Malavé, *Queer Latino Testimonio*, 39.

Chapter 14: Tokyo

340 "increasingly the mainstay": Julia Gruen, in discussion with the author, January 12, 2019.
340 "very intense": Gruen, *Keith Haring*, 200.
340 "The Haringtons": The Carringtons were the core family in the popular 1980s primetime soap opera *Dynasty*.
340 "How it all": "The Haringtons," *Details*, October 1988.
340 "as the years": Gruen, *Keith Haring*, 200.
340 "You must decide": Keith Haring fax to Julia Gruen, ANA Hotel, Hiroshima, July 28, 1988, KHFA.
340 "Everything had the potential": Julia Gruen, in discussion with the author, August 16, 2022.
341 "tons of bikini": Keith Haring interview with Gruen, Tape 13.
341 "He had the power": Guy Trebay, "American Graffiti," *Village Voice*, July 17, 1997.
341 "I think there's": "Schneider Hospital Sculpture Install," August 1987, Video Events, KHFA.
342 "at a powerful": Kansas City Notepad, September 13, 1987, KHFA.
342 "William is enthusiastic": Letter from James Grauerholz to Julia Gruen, June 23, 1987, KHFA. The letter might also have referred to projects they were working on together around Brion Gysin's works and estate.
343 "A couple": James Grauerholz, in discussion with the author, January 25, 2020.
343 "That morning": John Giorno, *Great Demon Kings: A Memoir of Poetry, Sex, Art, Death, and Enlightenment* (New York: Farrar, Straus and Giroux, 2020), 305–7.
344 "more solid": Giorno, *Great Demon Kings*, 308.
344 "Keith was heroic": Trebay, "American Graffiti."
344 "The poster": Kansas City Notepad.
344 "Well, to me": Gruen, *Keith Haring*, 142, 144.
344 "slightly tired": Kansas City Notepad.
345 "I believe": Marilyn J. Fox, "Keith Haring Emerges from the Underground," *Reading Eagle*, September 20, 1987.
345 "control addicts": William S. Burroughs, *Naked Lunch: The Restored Text*, ed. James Grauerholz and Barry Miles (New York: Grove Press, 2001), 19.
345 "junk virus": Burroughs, *Naked Lunch*, 200.

345 "laboratory AIDS": *Dead City Radio* album, a collection of readings by William S. Burroughs, released by Island Records in 1990 and dedicated to Keith Haring.

345 "beautiful": Gruen, *Keith Haring*, 182–83.

345 "My first impression": James Grauerholz, in discussion with the author, January 25, 2020.

346 "really good": Kansas City Notepad.

346 "In the scene": Anne Waldman, email message to the author, April 18, 2022.

346 "electric vitality": Gruen, *Keith Haring*, 182.

346 "like a flash": Anne Waldman, email message to the author, April 18, 2022.

346 "a Keith-instigated": James Grauerholz, in discussion with the author, January 25, 2020.

346 "Although Keith": Gruen, *Keith Haring*, 183.

346 "Your enthusiasm": Letter from William Burroughs to Keith Haring, August 4, 1986, KHFA.

346 The English writer: Letter from Victor Bockris to Keith Haring, KHFA.

346 "seeing stuff": Kansas City Notepad.

346 "bold and often erotic": Letter from James Grauerholz to Andreas Brown, undated, KHFA.

347 "There was Keith": Kate Simon, in discussion with the author, May 18, 2022.

347 "Sort of fun": Kansas City Notepad.

347 "William was very": Kate Simon, in discussion with the author, May 18, 2022.

347 "Keith was both": Ira Silverberg, in discussion with the author, May 25, 2022.

347 "somewhere over": Kansas City Notepad.

347 *Apocalypse*: Haring and Burroughs later collaborated on *The Valley*, with sixteen etchings drawn by Haring in his New York studio in April 1989 and text by William S. Burroughs.

348 "a shock": Gruen, *Keith Haring*, 183.

348 "centers": "Keith Haring Statement for Tokyo Pop Shop," September 8, 1987, Special Projects, KHFA.

348 "like one big": Keith Haring, entry for May 9, 1987, "April–May 1987 Notebook."

348 "If I just do": *Weekend NY: Keith Haring*, Japanese TV program interview, April 27, 1988, Video Lectures and Interviews, KHFA.

348 "Since my first": "Keith Haring Statement for Tokyo Pop Shop."

349 "sister cities": Haring made a painting, *Sister Cities*, honoring the event, in 1985, and donated it to the Tokyo Metropolitan Government.

349 "probably my best": Haring, notebook entry for October 2, 1987.

350 "I got this T-shirt": "Keith Haring at Cranbrook," September 24, 1987, Video Events, KHFA.

350 "the most incredible": Keith Haring, entry for May 12, 1987, "April–May 1987 Notebook."

350 "fold the bag": Keith Haring, entry for May 11, 1987, "April–May 1987 Notebook."

350 "Just like being": Keith Haring, entry for July 25, 1987, "July 22–29, 1988, Notebook," KHFA.

351 "bugging out": Haring, notebook entry for May 9, 1987.

351 "My first time": Cruz-Malavé, *Queer Latino Testimonio*, 48.

351 "*weird*": Cruz-Malavé, *Queer Latino Testimonio*, 47.

351 "That's Japan": Keith Haring, entry for October 13, 1987, "October 2–November 4, 1987, Notebook."

351 "designed by me": Haring, notebook entry for May 12, 1987.

351 "creative business": "Press Release: Opening of Keith Haring's Shop in Tokyo," Special Projects, KHFA.

351 "He said Seibu": Kaz Kuzui, in discussion with the author, April 22, 2022.

353 "That there was": Julia Gruen, in discussion with the author, January 12, 2019.

354 "Does it ever": Keith Haring, entry for October 29, 1987, "October 2–November 4, 1987, Notebook."

354 "Are these wedding": Keith Haring, entry for January 20, 1988, "January 20–February 2, 1988, Notebook," KHFA.

354 "unless he gets": Haring, notebook entry for October 14, 1987.

355 "I've always wanted": Terril Jones, "U.S. Pop Artist Sets Up Shop in Tokyo," Associated Press, 1987, Special Projects, KHFA.

355 "We're quite a group": Keith Haring, entry for January 25, 1988, "January 20–February 2, 1988, Notebook."

355 "looking still like a ballerina": Earlier in her life, Gruen had taken ballet classes at the School of American Ballet and the American Ballet Theatre School.

355 "Keith wanted": Julia Gruen, in discussion with the author, July 20, 2021.

356 "The second time": Cruz-Malavé, *Queer Latino Testimonio*, 47–48.

356 "Fuck you": Haring, entry for January 25, 1988.

356 "boys": Cruz-Malavé, *Queer Latino Testimonio*, 41.

356 "Me and the kids": Cruz-Malavé, *Queer Latino Testimonio*, 48.

356 "subconsciously wishing": Keith Haring, entry for January 30, 1988, "January 20–February 2, 1988, Notebook."

357 "I never felt": Adolfo Arena, in discussion with the author, May 4, 2022.

357 "With both Juan": Julia Gruen, in discussion with the author, July 20, 2021.

357 "I've never been good": Haring, notebook entry for October 14, 1987.

357 "I remember Keith": Fran Kuzui, in discussion with the author, April 22, 2022.

358 "The opening": Gruen, *Keith Haring*, 181.

358 "these flight": Julia Gruen, in discussion with the author, July 20, 2021.

358 European families: He also became friendly in Paris with the Moroccan French fashion designer Jean-Charles de Castelbajac, his wife, Kate, and his children.

358 "kinda playboyish": Cruz-Malavé, *Queer Latino Testimonio*, 44.

358 "where the artist was fucking": Keith Haring, entry for October 11, 1987, "October 2–November 4, 1987, Notebook." The piece was *Untitled* (*Bloch 1795*), dated 1968, signed in pencil, and numbered 14/50.

358 *Objet-dard*: Edition de la Galleria Schwarz, Milan, 1967, signed, titled, inscribed, and numbered 2/8.

359 "some sort of *event*": Cruz-Malavé, *Queer Latino Testimonio*, 44.

359 "It was a fun": Debra Arman, in discussion with the author, July 6, 2022.

359 "He gave her": Unpublished transcript of Debra Arman interview with John Gruen, August 8–12, 1989, Tape 2, KHFA.

359 "The feeling": Keith Haring, entry for February 22, 1989, "February 10–March 2, 1989, Notebook," KHFA.

360 "Reagan was not": Joan Haring, in discussion with the author, November 16, 2018.

360 "Dear Visual Art Critic": Letter from Keith Haring to Catherine Fox, May 17, 1988, KHFA.

361 "I asked him to paint": Sean Ono Lennon, in discussion with the author, April 19, 2022.

361 "purity that is reminiscent": Sischy, "Kid Haring."

361 "In addition": Nina Clemente, in discussion with the author, February 11, 2022.

361 "things": Keith Haring, entry for June 25, 1987, "May 30–July 11, 1987, Notebook."

362 "He was this really cool": Kitty Brophy, in discussion with the author, February 11, 2022.

362 "Not that I needed": Keith Haring interview with Gruen, Tape 14.

362 five-year incubation: The estimates for incubation have since risen to about eleven years.

362 "People didn't understand": Deitch, Geiss, and Gruen, *Keith Haring*, 474.

363 "In Japan": Fran Kuzui, in discussion with the author, April 22, 2022.

363 "What he didn't reckon": Julia Gruen, in discussion with the author, January 12, 2019.

364 "splotch": Deitch, Geiss, and Gruen, *Keith Haring*, 444.

364 "You might be surprised": Fax from Fran (and Kaz), Kobe, Japan, to Keith Haring, n.d., Special Projects, KHFA.

364 "nothing short of": Keith Haring, entry for July 28, 1988, "Summer 88 Tokyo Trip," "July 22–29, 1988, Notebook," KHFA.

365 "When they later heard": Fran Kuzui, in discussion with the author, April 22, 2022. Haring did create a poster for the Hiroshima Peace Celebration of August 5–6, 1988.

366 "Basically": Keith Haring interview with Gruen, Tape 14.
366 "This work": Timothy Leary, "One Rent in the Fabric Is All It Takes for Pandemonium
 to Sluice Through," in *Keith Haring: Future Primeval*, 12.
366 "Back in New York": Fran Kuzui, in discussion with the author, April 22, 2022.

Chapter 15: Silence = Death

367 "street fashions": Gruen, *Keith Haring*, 190.
368 "the most influential": Keith Haring interview with Gruen, Tape 14.
368 "People never ask": Gruen, *Keith Haring*, 190.
368 "Jean Michel": "Eye of the Designer," *SPIN*, September 1988.
368 "Jean-Michel": Gruen, *Keith Haring*, 190.
368 "I once asked": Glenn O'Brien, *It's My Time* (newsletter), no. 6, Benetton Group, 2010, in
 KHFA.
368 "From the beginning": Sheff, "Keith Haring: Just Say Know."
368 "always sort of": Gruen, *Keith Haring*, 190.
369 "In a way": Gruen, *Keith Haring*, 135.
369 "They still call me": Anthony Haden-Guest, "Burning Out," *Vanity Fair*, November
 1988.
369 "I'd be mad": *The Andy Warhol Diaries*, Season 1, Episode 4, directed by Andrew Rossi
 (Netflix, 2022).
369 "worshipping": Belisto, *Notes from the Pop Underground*, 99.
369 "I remember": Kermit Oswald, in discussion with the author, May 28, 2019.
370 "supreme poet": Keith Haring, "Remembering Basquiat," *Vogue*, November 1988.
370 "He had to live up to": Phoebe Hoban, "SAMO IS DEAD," *New York Magazine*,
 September 26, 1988.
371 "tons of money": After his death, Christie's estimated the worth of the Basquiat estate
 to exceed $3.8 million.
371 "created a lifetime of work": Haring, "Remembering Basquiat."
371 "Jean was a true": Typed manuscript of the eulogy, dated November 5, 1988, KHFA.
371 "more oval": Stanley Strychacki, *Life as Art: The Club 57 Story* (Bloomington, IN:
 iUniverse, 2012), 87.
372 "I really want to": Keith Haring, entry for September 1, 1989, "September 1–10, 1989,
 Notebook," KHFA.
372 "Once Keith got": Interview with Julia Gruen, in "Keith Haring: Street Art Boy,"
 directed by Ben Anthony, *American Masters*, aired December 4, 2020, on PBS.
372 "one of the best": Gruen, *Keith Haring*, 193.
373 "since gotten to know": Gruen, *Keith Haring*, 191.
373 "Tony and Hans": Klaus Richter, in discussion with the author, July 21, 2022.
373 "a red-hot": "The Critics' Way," *Artforum*, September 1987.
373 "At this time": Klaus Richter, in discussion with the author, July 21, 2022.
373 *King and Queen*: The two figures resemble pieces from a chess set. Unusual for Haring,
 he shunned his colorful palette for the natural rusty color of Corten Steel.
374 "That's you and me": Kermit Oswald, in discussion with the author, May 28, 2019.
374 "shows a calligraphically": Alexandra Kolossa, *Haring* (Cologne: Taschen, 2016), 80.
375 "It was the first": Klaus Richter, in discussion with the author, July 21, 2022.
375 "wild form": Tony Shafrazi cites the phrase in his essay "Double Standards: An
 American Education," in *Dennis Hopper: Photographs 1961–1967* (Cologne: Taschen,
 2018), 60.
375 "Dennis showed up": Tony Shafrazi, in discussion with the author, July 23, 2022.
375 "They were a strong": Stephanie Mayer, in discussion with the author, July 26, 2022.
375 "My show at Shafrazi": Gruen, *Keith Haring*, 194.
376 "There's one last thing": Sheff, "Keith Haring: Just Say Know."
376 "The message is the message": Keith Haring, entry for October 14, 1978, "October 1978
 Notebook," KHFA.
377 "He was being": Sean Ono Lennon, in discussion with the author, April 19, 2022.

377 "a new direction": Gruen, *Keith Haring*, 193.

377 "the paintings": Kermit Oswald, in discussion with the author, May 28, 2019.

377 "pulls the pinstripes": Thompson, "Requiem for the Degas of the B-boys."

377 Manet's: Ulrike Gehring, "Disegno e Colore: The Reconciliation of Two Rivals in the Art of Keith Haring," in Götz Adriani, ed., *Keith Haring: Heaven and Hell* (Ostfildern-Ruit, Germany, Hatze Cantz; New York: Distributed Art Publishers, 2001), 140.

378 "The artists came": Gruen, *Keith Haring*, 194.

378 "He had been hanging": Donald Baechler, in discussion with the author, January 21, 2021.

378 "I loved the stuff": Bruno Schmidt, in discussion with the author, September 26, 2019.

378 "The dark vision": Rodney Alan Greenblat, in discussion with the author, December 3, 2019.

378 "It went *BOOM*": Tony Shafrazi, in discussion with the author, October 7, 2022.

378 "That's Jean-Michel": Kermit Oswald, in discussion with the author, May 28, 2019.

379 "very shallow": Gruen, *Keith Haring*, 194.

379 "This show": Ruth Bass, "Keith Haring: Tony Shafrazi," *ARTNews*, March 1989.

379 "presenting the sexual": Christian Leigh, "Presenting the Sexual Politics of the Moment," *Flash Art*, May/June 1989.

379 "History may prove": Elizabeth Hess, "On Track," *Village Voice*, December 27, 1988.

380 "I stopped": Gil Vazquez, in discussion with the author, April 13, 2022.

380 "He had this aura": Keith Haring interview with Gruen, Tape 14.

380 "I said, 'Keith'": Adolfo Arena, in discussion with the author, May 4, 2022.

380 "It's embarrassing": Gil Vazquez, in discussion with the author, April 13, 2022.

380 "Then I saw": Gruen, *Keith Haring*, 188–89.

380 "It was never": Adolfo Arena, in discussion with the author, May 4, 2022.

380 "I used to file": Kermit Oswald, in discussion with the author, May 28, 2019.

380 "Seems like": Keith Haring, entry for February 10, 1989, "February 10–March 2, 1989, Notebook."

381 "I certainly heard": Gil Vazquez, in discussion with the author, April 13, 2022.

381 "You better get": Cruz-Malavé, *Queer Latino Testimonio*, 48.

381 Juan did and discovered: Juan Rivera died on June 12, 2011, in New Haven, Connecticut. He had been suffering for some time with ALS. His family was by his side during this period.

381 "*that* really bothered me": Cruz-Malavé, *Queer Latino Testimonio*, 49.

381 "And when I got": Cruz-Malavé, *Queer Latino Testimonio*, 50.

381 "like talking to a wall": Keith Haring, entry for February 18, 1989, "February 10–March 2, 1989, Notebook."

381 "Something I might": Julia Gruen, in discussion with the author, July 20, 2021.

381 "I was only": Gil Vazquez, in discussion with the author, April 13, 2022.

382 "I'm definitely": Gruen, *Keith Haring*, 195.

382 "I now call": Keith Haring interview with Gruen, Tape 15.

383 "special friend": *The Burial Office and the Requiem for Juan Aaron Dubose*, KHFA.

383 "They had a lot": Bruno Schmidt, in discussion with the author, September 26, 2019.

383 "He looked so": Keith Haring interview with Gruen, Tape 15.

383 "The one thing": Keith Haring, entry for February 14, 1989, "February 10–March 2, 1989, Notebook."

383 "remarkable": Keith Haring, entry for February 11, 1989, "February 10–March 2, 1989, Notebook." This major retrospective of Tinguely's work was staged in Paris at the Centre Georges Pompidou from December 1988 to March 1989.

383 "totally blown away": Haring, entry for February 14, 1989.

384 "This is terrible": Gruen, *Keith Haring*, 197.

384 "My mom told me": Madison Arman, in discussion with the author, July 6, 2022.

384 "All those deaths": Gil Vazquez, in discussion with the author, April 13, 2022.

384 "determined to make": Gruen, *Keith Haring*, 198.

384 "It's kind of": Keith Haring, entry for February 24, 1989, "February 10–March 2, 1989, Notebook."

385 "my first AIDS mural": Gruen, *Keith Haring*, 198.

385 "He just wanted": Gil Vazquez, in discussion with the author, April 13, 2022.

385 "beautiful friend": Gruen, *Keith Haring*, 198.

385 "ludicrous situation": Keith Haring, entry for March 7–8, 1989, "March 2–17, 1989, Notebook," KHFA.

386 "He always wanted": Cruz-Malavé, *Queer Latino Testimonio*, 49.

386 "We had": Gil Vazquez, in discussion with the author, April 13, 2022.

386 "When I was": Kristen Haring, in discussion with the author, April 30, 2018.

386 "I'm sort of": Keith Haring, entry for February 18, 1989, "February 10–March 2, 1989, Notebook."

387 "amazing mural-for-a-urinal": Art, *The New Yorker*, July 3, 1989, KHFA. The mural was part of group effort by artists creating on-site artworks to commemorate Stonewall, including Mark Kostabi, David LaChapelle, Marcus Leatherdale, and Kenny Scharf.

387 "I should really": Keith Haring, entry for June 29, 1989, "June 6–July 9, 1989, Notebook," KHFA.

387 "There's a wonderful": Julia Gruen, in discussion with the author, July 20, 2021.

387 "Keith could see": George Condo, in conversation with the author, September 7, 2022.

388 Yoko Ono: Haring also collaborated with Yoko Ono, on "Interrupted River," a dance performance, with choreography by Jennifer Muller and music by Yoko Ono, presented at the Joyce Theater in 1987. Haring did the set design and worked with Bill Katz on the costume designs.

388 "It really made me": Keith Haring, entry for June 7, 1989, "June 6–July 9, 1989, Notebook."

389 "He's a real": Gruen, *Keith Haring*, 209.

389 Martin Blinder: Helicoptering the sculpture turned out to be a fiasco. Too heavy, the sculpture fell to the ground. Finally, the piece was installed with a crane.

389 "L.A. L.A. L.A.": Keith Haring, entry for July 4, 1989, "June 6–July 9, 1989, Notebook."

389 *Arboretum by Flashbulb*: Keith Haring: About Art, 228.

390 "Keith explained": Piergiorgio Castellani, in discussion with the author, August 9, 2022.

391 "really major": Keith Haring, entry for September 22, 1989, "September 18–October 1, 1989, Notebook."

391 "Felliniesque": Gruen, *Keith Haring*, 207.

391 "Haring's final": Kolossa, *Haring*, 86.

391 "This is really": Keith Haring, entry for June 19, 1989, "June 6–July 9, 1989, Notebook."

392 Dr. Paul Bellman: Besides Bellman and Goldberg, Haring had also been under the care of Dr. Craig Metroka and Dr. Alvin Friedman-Kien.

392 "HIV/AIDS was a race": Dr. Paul Bellman, in conversation with the author, June 28, 2022.

393 "face of ACT UP": Sean Strub, *Body Counts: A Memoir of Activism, Sex, and Survival* (New York: Scribner, 2014), 203.

394 "Keith was weaned": Servin, "Radiant Baby."

394 "Okay": Strub, *Body Counts*, 221.

394 "He would walk": George Whitman, in discussion with the author, August 10, 2022.

394 "I don't want": Strub, *Body Counts*, 222.

395 "It was late": Sean Strub, in discussion with the author, September 13, 2022.

395 "I kind of have": Interview with Peter Staley, in "Keith Haring: Street Art Boy."

395 "He'd grab": Peter Staley, in discussion with the author, September 23, 2022.

395 "Over one third": Servin, "Radiant Baby."

395 "Anytime I or anyone": Sean Strub, in conversation with the author, September 13, 2022.

396 "cost him": Servin, "Radiant Baby," 14.

396 "There were many": Keith Haring interview with Gruen, Tape 16.

396 "Sad News": Page Six, *New York Post*, July 1989, KHFA.

396 "My brother": Kristen Haring, in discussion with the author, April 30, 2018.

396 "It's a totally": Gruen, *Keith Haring*, 210.

397 "helped in appreciating": Sheff, "Keith Haring: Just Say Know."

Chapter 16: "You Use Whatever Comes Along"

398 "You use": Sheff, "Keith Haring: Just Say Know."

399 "Keith called": Sam Havadtoy, in discussion with the author, September 21, 2022.

400 "Oh, Keith, really?": Debra Arman, in discussion with the author, July 6, 2022.

401 "Well, you read": Sam Havadtoy, in discussion with the author, September 21, 2022.

401 "one of my favorite": Sheff, "Keith Haring: Just Say Know."

401 "first real home": Richard Lacayo, "Keith Haring: The Legacy Lives On," *Metropolitan Home*, September 1990.

401 "He was a self-taught": Sam Havadtoy, in discussion with the author, September 21, 2022.

401 "This is sort of": Haring, notebook entry for September 1, 1989.

402 "It was also sad": Bruno Schmidt, in discussion with the author, September 26, 2019.

402 "I think riding": Keith Haring, entry for September 5, 1989, "September 1–10, 1989, Notebook."

402 "He was a global": Dr. Paul Bellman, in discussion with the author, June 28, 2022.

402 "In it, pessimistly": Keith Haring's dedication page and statement for *20 Drawings*, January 27, 1990, KHFA.

403 "the Mr. Chow period": Mera Rubell, in discussion with the author, September 22, 2022.

403 "The work became": Don Rubell, in discussion with the author, September 22, 2022.

403 signing a last will and testament: His designated executors were Julia Gruen and Margaret Slabbert. His designated board of directors for the foundation were Julia Gruen, Kristen Haring, Kermit Oswald, and Gilbert Vasquez; the two main designated charities were Children's Village, in Dobbs Ferry, New York; and the Boys' Club of the Lower East Side, KHFA.

403 "family dinner": Stephanie Mayer, in discussion with the author, July 26, 2022.

403 "Keith took us": Mera Rubell, in discussion with the author, September 22, 2022.

404 John Gruen: *Keith Haring: The Authorized Biography* was published by Prentice Hall Press in 1991.

404 "looking totally adorable": Gruen, *Keith Haring*, 212.

404 "Keith was the only": Servin, "Radiant Baby."

405 "When we were at JFK": Allen Haring, in discussion with the author, June 4, 2018.

405 "a thank-you journey": Mera Rubell, in discussion with the author, September 22, 2022.

405 "a space to do": Tony Shafrazi, in discussion with the author, October 7, 2022.

405 "We carved": Mark Pasek, in discussion with the author, October 6, 2022.

405 "When Keith first came": Tony Shafrazi, in discussion with the author, October 7, 2022.

406 "I want it to look": Kristen Haring, in discussion with the author, April 30, 2018.

406 "He said to me": David Neirings, in discussion with the author, April 11, 2022.

406 "There were these": Sam Havadtoy, in discussion with the author, September 21, 2022.

407 "In Keith's earlier drawings": David LaChapelle, in discussion with the author, October 17, 2022; Sarah Cascone, "David LaChapelle Parts with Painting Created in Keith Haring's Final Days," Artnet News (website), June 21, 2016, news.artnet.com/market/keith-haring-david-lachapelle-sothebys-521939.

407 "a reference to": Julia Gruen, "Haring All-Over," Keith Haring Foundation, November 1999, www.haring.com/!/selected_writing/haring-all-over.

407 "It seems that artists": Keith Haring, entry for November 7, 1978, "October 14–December 28, 1978 Notebook," KHFA.

408 "He definitely became": Derrick Smit, text message to author, July 10, 2022.

409 "The bidding": Sean Strub, in discussion with the author, September 13, 2022.

409 "All of a sudden": Frank Holliday, in discussion with the author, April 17, 2019.

410 "It was a weird": Klaus Richter, in discussion with the author, July 21, 2022.

410 "He was surrounded": Stephanie Mayer, in discussion with the author, July 26, 2022.

410 "He certainly had": Interview with Julia Gruen, in "Keith Haring: Street Art Boy."

411 On January 20: Other late works included four drawings in sumi ink on board for the pyramid sculptures, dated January 3, 1990, and a tent design for André Heller in ink and graphite on paper, dated January 31, 1990.

411 "Okay, but I don't": Sam Havadtoy, in discussion with the author, September 21, 2022.

412 "I was there": Sean Ono Lennon, in discussion with the author, April 19, 2022.

412 "Man, this is really heavy": Sam Havadtoy, in discussion with the author, September 21, 2022.

412 "I instantly realized": Bob Gruen, in discussion with the author, June 2, 2022.

412 The altarpiece triptych: *Altarpiece* was produced in an edition of nine, with two artist's copies. They were donated to churches and museums, including the Cathedral of St. John the Divine in New York City, Grace Cathedral in San Francisco, and Église Saint-Eustache in Paris.

412 "Not only": Julia Gruen quoted in Gruen, *Keith Haring*, 218.

412 "Those last couple": Dr. Paul Bellman, in discussion with the author, June 28, 2022.

413 "He was very": Unpublished transcript of Julia Gruen interview with John Gruen, March 17, 1990, Tape 17, KHFA.

413 "It was not just": Allen Haring, in discussion with the author, June 4, 2018.

413 "I wanted him": Joan Haring, in discussion with the author, June 4, 2018.

413 "I think he was": Kermit Oswald, in discussion with the author, May 28, 2019.

414 "Who knows what": Gruen, "Haring All-Over."

414 "We didn't talk": Karen Haring, in discussion with the author, June 4, 2018.

414 "He never used": Joan Haring, in discussion with the author, June 4, 2018.

414 "It's funny": Gil Vazquez, in discussion with the author, April 13, 2022.

414 "My parents": Sheff, "Keith Haring: Just Say Know."

414 "Keith's parents": Dr. Paul Bellman, in discussion with the author, June 28, 2022.

414 "It became progressively": Gruen, *Keith Haring*, 218.

415 "We all used to": Bruno Schmidt, in discussion with the author, September 26, 2019.

415 "I knew": Lysa Cooper, in discussion with the author, November 17, 2021.

415 "Juan": Gruen, *Keith Haring*, 217.

415 "One night": Joan Haring, in discussion with the author, June 4, 2018.

415 "Mickey Mouse": Servin, "Radiant Baby." In 2021, Disney celebrated Haring's original Mickey Mouse artwork in multiple product collaborations for purchase.

415 "Tyson was favored": Gil Vazquez, in discussion with the author, April 13, 2022.

416 "Carmel went": Bruno Schmidt, in discussion with the author, September 26, 2019.

416 "I was sitting": Mera Rubell, in discussion with the author, September 22, 2022.

416 "Keith pointed": Don Rubell, in discussion with the author, September 22, 2022.

416 "There was a moment": Gil Vazquez, in discussion with the author, April 13, 2022.

416 "He had that moment": Lysa Cooper, in discussion with the author, November 17, 2021.

416 "Kenny and Lysa": Gil Vazquez, in discussion with the author, April 13, 2022.

416 "We were expecting": Joan Haring, in discussion with the author, June 4, 2018.

417 "I cooked": Alba Clemente, in discussion with the author, January 13, 2022.

417 "He was very": Kenny Scharf, in discussion with the author, September 18, 2019.

417 "That means": Kristen Haring, in discussion with the author, April 30, 2018.

418 "K. Haring": Servin, "Radiant Baby."

418 "When they asked": Allen Haring, in discussion with the author, June 4, 2018.

418 "Yoko had talked": Kay Haring, in discussion with the author, June 6, 2018.

419 "In a small": Karen Haring, in discussion with the author, June 4, 2018.

419 "He started alone": Servin, "Radiant Baby."

420 "Kermit": Gruen, *Keith Haring*, 219.

420 "So, that's": Unpublished transcript of Julia Gruen interview with John Gruen, March 17, 1990, Tape 17, KHFA.

420 "Not planned": Kermit Oswald, in discussion with the author, May 28, 2019.

420 "Each of us": Julia Gruen quoted in Gruen, *Keith Haring*, 219.

420 "Juan and I": Kenny Scharf, email message to the author, November 3, 2022.

420 "the wind blew the ashes": Tony Shafrazi, in discussion with the author, November 5, 2022.

420 "A flock": Cruz-Malavé, *Queer Latino Testimonio*, 53.

420 "I have": Interview with Yoko Ono, in *The Universe of Keith Haring*, directed by Christina Clausen (French Connection Films, Overcom, and Absolute Film, 2008).

421 "artist prince": Peter Schjeldahl, *Hot, Cold, Heavy, Light: 100 Art Writings, 1988–2018* (New York: Abrams Press, 2019), 58.

421 "With the Scharf": Nina Clemente, in discussion with the author, February 11, 2022.

421 "We were grabbed": George Whitman, in discussion with the author, August 10, 2022.

422 "His short life": Andrew Yarrow, "Friends Memorialize Keith Haring in Song and Playful Reminiscence," *New York Times*, May 5, 1990. A partial videotape recording of the memorial service is included in "Video Events," KHA-0744, KHFA.

423 "His work screamed": Yarrow, "Friends Memorialize Keith Haring in Song and Playful Reminiscence."

423 "I learned": Gruen, *Keith Haring* 220.

424 "Peter Martins suggested": Jock Soto, in discussion with the author, November 6, 2022.

424 "You know, Kenny": Ann Magnuson, in discussion with the author, December 13, 2019.

424 "A few": Magnuson, "The Prime Time of Our Lives," 132.

424 "Her voice": Stephanie Mayer, in discussion with the author, July 26, 2022.

424 "at the end of her singing": Bill Katz, in discussion with the author, March 7, 2022.

425 "Let's draw!": Gruen, *Keith Haring*, 219.

425 "I miss everything": Partial videotape recording of the memorial service, Video Events, KHA-0744, KHFA.

425 "I also remember": Sean Kalish, in discussion with the author, October 20, 2022.

425 "When CityKids came onstage": George Wittman, text message to the author, October 26, 2022.

426 "I still get chills": David Neirings, in discussion with the author, April 11, 2022.

426 "beautiful words of Keith himself": David Neirings, text message to the author, October 22, 2022.

426 "It wouldn't matter": The statement in the program was culled from an unedited manuscript of the interview for David Sheff's article "Keith Haring: Just Say Know."

427 "I remember sitting": Gil Vazquez, in discussion with the author, April 13, 2022.

427 "Can't Play Around": Lace, "Can't Play Around," disco mix by Larry Levan, Atlantic–RFC Records, 1982.

Epilogue

431 "The cash in the bank": Julia Gruen, in discussion with the author, July 20, 2021.

432 "Though Keith Haring": Shepard Fairey, "Foreword," in Haring, *Keith Haring Journals*, xi.

432 "It almost seems": Raffel, *Art and Merchandise in Keith Haring's Pop Shop*, 196.

432 "a new art medium": Mark C. O'Flaherty, "Have We Reached Peak Keith Haring?," *Financial Times*, March 6, 2023.

433 "I still *really*": Haring, notebook entry for September 1, 1989.

433 "More people now": David Stark, in discussion with the author, November 23, 2022.

433 "They have not even shown": Keith Haring, entry for January 3, 1988, "March 27, 1987–January 3, 1988, Notebook," KHFA.

434 "The distinctions": Ann Temkin, in discussion with the author, February 13, 2023.

Illustrations

Page iii: (© ullstein bild/Getty Images)

Page 7: Allen and Joan Haring with their one-year-old son, Keith. This photograph was taken on October 16, 1959, their first anniversary, in California. (Used with permission of the Haring family)

Page 25: Keith on his bicycle in Kutztown, Pennsylvania, July 1, 1967 (Used with permission of the Haring family)

Page 49: Keith at the North Carolina Fiddlers Convention in Union Grove, North Carolina, May 1976 (© Kimberly Kradel)

Page 69: Keith in front of an untitled painting at the Pittsburgh Center for the Arts, 1978 (Courtesy of the Keith Haring Foundation)

Page 87: Still from a video recording of Painting Myself into a Corner at the School of Visual Arts in New York City, 1979 (© Keith Haring Foundation / courtesy of the Keith Haring Foundation)

Page 110: Keith and Tseng Kwong Chi reading poetry at Club 57 in New York City, 1980 (© Harvey Wang)

Page 133: Keith drawing in the New York City subway, 1981 (Photograph by Tseng Kwong Chi © 1981 Muna Tseng Dance Projects, Inc. New York, www.tsengkwongchi.com)

Page 162: Keith and Juan Dubose sitting on the steps of 325 Broome Street in New York City, 1982 (© Laura Levine 1982. All rights reserved.)

Page 189: Tony Shafrazi straddling the shoulders of Keith and Kenny Scharf at the Tony Shafrazi Gallery in New York City, 1983 (© Roland Hagenberg)

Page 221: Keith and Andy Warhol at the first Party of Life at Paradise Garage in New York City, May 16, 1984 (© 2023 The Andy Warhol Foundation for the Visual Arts, Inc. / Licensed by Artists Rights Society [ARS], New York)

Page 250: Kenny Scharf, Madonna, Juan Dubose, and Keith at the after-party for Madonna's Virgin Tour concert at Radio City Music Hall in New York City, June 6, 1985 (© 2023 The Andy Warhol Foundation for the Visual Arts, Inc. / Licensed by Artists Rights Society [ARS], New York)

Page 279: Keith and Bobby Breslau (in the sales window) at Pop Shop, 1986 (Photograph by Tseng Kwong Chi © 1986 Muna Tseng Dance Projects, Inc. New York, www.tsengkwongchi.com)

Page 311: Julia Gruen, Juan Rivera, and Keith at a party at John Gruen and Jane Wilson's apartment, December 21, 1986 (© 2023 The Andy Warhol Foundation for the Visual Arts, Inc. / Licensed by Artists Rights Society [ARS], New York)

Page 339: Keith and William Burroughs in Burroughs's front yard in Lawrence, Kansas, 1987 (© Kate Simon)

Page 367: Keith and Jean-Michel Basquiat, 1984 (© 2023 The Andy Warhol Foundation for the Visual Arts, Inc. / Licensed by Artists Rights Society [ARS], New York)

Page 398: Keith and Gil Vazquez, 1989 (Courtesy of the Keith Haring Foundation)

Insert 1: All images © Keith Haring Foundation Collection
Insert 2: All images of Keith Haring artwork © Keith Haring Foundation, except the
 following:
Page 4 (top): Photograph by Tseng Kwong Chi © 1982 Muna Tseng Dance Projects, Inc.
 New York, www.tsengkwongchi.com.
Page 5: Photograph by Tseng Kwong Chi © 1982 Muna Tseng Dance Projects, Inc.
 New York, www.tsengkwongchi.com.
Page 11: Photograph by Tseng Kwong Chi © 1986 Muna Tseng Dance Projects, Inc.
 New York, www.tsengkwongchi.com.
Page 15: Photograph by Tseng Kwong Chi. © 1989 Muna Tseng Dance Projects, Inc.
 New York, www.tsengkwongchi.com.

Index

Acconci, Vito, 117, 118, 252, 272
ACT UP, 393–396
 "Stop the Church," 408, 409
Advocate, 90, 299–300
Ahearn, Charlie, 351
Ahearn, John, 185
AIDS
 Breslau's death and, 318, 361–362
 Burgoyne's death and, 311–314
 Dubose's death and, 130, 382–383
 effects on New York City, 216, 244–245,
 313, 337
 GRID and, 190–191
 growing societal anxiety about, 249, 336–337
 Reagan and, 251, 359–360
 see also Haring, Keith, AIDS and health of
Aitken, Doug, 389
Alechinsky, Pierre, 73–75, 78, 79–80, 82, 83, 93,
 104, 152, 315, 335
Aletti, Vince, 122
Alexander, Brooke, 181, 191
Alice's Adventures in Wonderland (Carroll),
 44–45, 47
Almódovar, David (Bipo), 340
Amelan, Bjorn, 277
Amelio, Lucio, 223, 224, 410
Ammann, Thomas, 226
Anderson, Laurie, 99, 117, 146
Andre, Carl, 115, 117
Andreiev, Wendy (Wendy Wild), 108, 115, 312
Andy Warhol Diaries, 202–203, 320
"Anticultural Positions"(Dubuffet), 72
Apfelschnitt, Carl, 136, 347
Area (club), 260–265
Arena, Adolpho, 282, 295, 324, 340, 355, 357,
 362, 380, 408, 415–416, 419
Arias, Joey, 125, 216, 316
Arman, Debra, 358–359, 384, 391, 400
Arman, Madison, 358–360, 384, 401

Arman, Yves, 358–359, 370, 383–384, 400
Arslanian, Ara, 331
Arslanian, Viken, 331, 391
Art in the Mind (Beckley exhibition), 118
Art Spirit, The (Henri), 59–60, 61, 62, 64, 68,
 72, 76
Artforum, 2, 174, 180, 184–185, 201, 202, 205,
 228, 274, 373, 379
 ARTNews, 74, 198, 211, 379
Ashbery, John, 206, 212
Astor, Patti Titchener, 205–208, 267
Azari, Darius, 260, 263

Badders, Mark, 44
Baechler, Donald, 137, 156, 159, 181, 193–194,
 201, 291, 330, 378
Baghoomian,Vrej, 368–369
Baldwin, James, 342
Bambaataa, Afrika, 160
Barbagallo, Ron, 90, 107, 120
Barthes, Roland, 102, 118
Basquiat, Gerard, 369
Basquiat, Jean-Michel, 2, 107, 136, 168, 180, 182,
 184, 194, 205, 245, 255, 263, 264, 327, 330
 Club 57 and, 115
 Cortez and, 158–159
 death of and memorial service for,
 368–371, 378
 Haring and, 367–368
 Haring's fame and, 257, 301–302
 Haring's Silence + Death painting for, 376,
 379, 395
 John Sex and, 108
 Mudd Club and, 146–147, 159
 New York/New Wave show, 157, 158
 paints as "Samo," 185, 208
 Shafrazi and, 128, 405
 Stewart's death and, 219, 400
 Times Square Show and, 144

Basquiat, Jean-Michel (*continued*)
 Warhol and, 213–214, 368, 369
 Warhol-Basquiat Paintings and, 270–271
Bass, Anne, 422
Bass, Ruth, 379
Beckley, Bill, 91, 118–119, 126–128, 236
Beckley, Connie, 124
Beeren, Wim, 277
Bell, Jane, 211
Bellman, Dr. Paul, 392–393, 402, 413–414, 417
Bénichou, François, 385
Benitez, "Jellybean," 214, 240, 241
Berks County, PA, 10, 47, 51
Bethel, Audrey, 78
Beyond Words show, 160, 161, 164–165, 205
Biafra, Jello, 344–345
Bischofberger, Bruno, 194, 208, 226, 270,
 368, 388
Blagg, Max, 140
Bleckner, Ross, 91, 146, 161, 164
Blefgan, Mrs. (teacher), 19, 22
Bodnyk, Mrs. (teacher), 31
Boone, Mary, 255, 317.
 See also Mary Boone Gallery
Boy George, 246, 266
Brace, Julie Sullivan, 60, 70, 71, 81
Brathwaite, Fred (Fab 5 Freddy), 131–132,
 160–161, 169, 173, 174, 176, 205, 212,
 215, 330–331
 Basquiat's memorial service and, 371
 on Haring's art, 143
 New York City memorial service for
 Haring, 424
Brese, Joe, 261
Breslau, Bobby, 206–207, 213, 237, 277, 282
 AIDS markers and, 317
 death of, 318, 361–362
 Pop Shop and, 292–293, 295–296, 323, 354
Brody, Michael, 337
Bromm, Hal, 181, 184, 359
Brookner, Howard, 429, 430
Brophy, Kitty, 273, 313, 336, 362
Brown, James, 159, 330
Brown, Jocelyn, 175
Buckner, Barbara, 105–106, 118, 121
Burgoyne, Martin, death of, 311–315, 337, 366
Burroughs, William, 157, 229, 342–348, 385
 Gysin and, 259
 on Haring's art, 154, 345–346
 influence on Haring, 99, 106, 113, 135, 137,
 259, 430
Bussman, Klaus, 373

Cadogan, Desmond, 173, 174–175, 262, 295
Calder, Alexander, 10, 269–270

California College of Arts and Crafts, 66
Carlos, Laurie, 425
Carnegie Mellon University, 50
Carnegie Museum of Art, 54, 83
 Alechinsky retrospective at, 73–75
Carnegie Museum of Art Theater, Cristo at,
 79–80
Caroline, Princess of Monaco, 359, 404
Carroll, James, 37, 117, 126, 223, 341, 343, 347
Carter, Amy, 365
Castellani, Piergiorgio, 390
Castelli, Leo, 182, 224, 269, 273, 274, 298, 369.
 See also Leo Castelli Gallery
Cavalieri, Corliss, 50, 54, 57, 79
Chaban-Delmas, Jacques, 277
Chabon, Michael, 54
Chia, Sandro, 180, 225
Children's Village, in Dobbs Ferry, 341
Chow, Tina, 316
Christo, 79–80, 94, 154, 164
CityKids Foundation, 304–307
Clarke, Barbara Wohlin, 60, 64, 82
Clarke, Brian, 225
Clemente, Alba, 181, 415, 417
Clemente, Chiara, 181
Clemente, Francesco, 115, 180–181, 185, 201,
 224, 263–265, 349, 378, 401, 402, 415,
 419, 422
Clemente, Nina, 181, 246, 361, 402, 421
Close, Chuck, 264
Club 57, in New York City, 20, 110–111, 157, 166
 Anonymous Art show, 72
 closing of, 260
 Haring's one-night exhibition at, 164
 Haring's poetry readings at, 113–114, 117
 Haring's videos for, 121, 124–126
 Mudd Club and, 145–146, 159, 160
 "PAINT(INGS)" exhibition at, 133–136
 theme parties and films at, 111–113,
 115–116, 134
CoBra movement, 23, 73, 152, 315
Colab, 130–131, 153, 189, 292
Columbia Art Review, 77
Concerning the Spiritual in Art (Kandinsky), 103
Condo, George, 217, 277, 300, 326–331, 378,
 385, 388
Cooper, Dennis, 429
Cooper, Lysa, 287, 291, 300, 416, 419
Coppola, Francis Ford, 298
Cortez, Diego, 136, 146, 154, 156–159, 180–181,
 184, 261, 346
Cotter, Holland, 274
Cousin, Tomé, 77–78, 81, 175
Crane (street artist), 212–213
Crash. *See* Matos, John "Crash"

Cruz-Malavé, Arnaldo, 282–283
Cutrone, Ronnie, 156, 181

D'Amboise, Jacques, 232
Davis, Stuart, 59, 335, 389
De Niro, Drena, 427
De Sana, Jimmy, 142
deAk, Edit, 180, 201, 206
Deitch, Jeffrey, 128, 150, 159, 165, 207, 254, 277,
 302, 331, 336, 423, 432
 East Village in late 1970s and, 100
 Friedman and, 199
 on Haring's art, 149, 176, 207, 302
 Haring's Bordeaux show and, 277
 on Haring's circle of friends, 199–200
 Pop Shop and, 292
 "tar and feather" attack on Haring and,
 273
 "Why the Dogs Are Barking" essay, 198–199
DeMatteo, "Beauty," 26
DeMatteo, Lucy, 26–27, 32, 35–36
Des Refusés, 156
Diaz, Al. See SAMO (Al Diaz)
Dickson, Jane, 159, 189–190, 252, 422
Dietrich, Nita A., 36–37
Dillon, Matt, 343, 347
Dinkins, David, 413, 422
Disney, Walt, 8, 16, 67, 104, 243, 322
Disneyland, 9, 17, 67
Donnelly, Brian (Kaws), 297, 432
Downs, Hugh, 296
Dr. Suess, 9–10
Drawing magazine, 90
Drawing the Line (documentary), 50
Dubose, Desiree, 171
Dubose, Juan, 191, 194, 225, 245, 249, 284,
 357, 400
 Into 84 and, 240
 AIDS and death of, 130, 382–383
 background of, 171
 as deejay, 171, 173–176, 201, 207, 213–215,
 225, 228–229, 234, 240
 Haring and Martinez and, 240–242
 Haring ends relationship with, 279–281,
 300
 Haring's concrete wall mural and, 197–198
 Japan and, 210–211, 350
 meets Haring, 170–171
 music and, 280–281
 Party of Life and, 235
Dubuffet, Jean, 45, 54, 72–74, 79–80, 104, 130,
 199, 227, 233, 335

Eco, Umberto, 118
Elkin, Stacey, 155

Ernst, Colleen, 232
Eshleman, Janice, 41–42, 123, 422

Fab 5 Freddy.
 See Brathwaite, Fred (Fab 5 Freddy)
Fashion Moda, 131, 205, 292
Feitler, Bea, 115
Fenley, Molissa, 108, 120, 223, 423
Field, Patricia, 290
Fiorucci, Elio, 224, 370
Fischl, Eric, 158, 317, 433
Fisher Scientific, 71–72, 75
Flash Art, 209, 226, 229–230, 274, 379
Floeter, Ken, 102
Floreen, Tyr, 41
Forti, Simone, 91, 109, 118, 120
Fraser, Robert, 224–225.
 See also Robert Fraser Gallery
Free Exchange (Dubuffet), 54, 72
Friedman, Dan, 173, 199, 238, 244
Friend, Tad, 298
Froment, Jean-Louis, 275
Frost, Joan, 108
Fun Gallery show, 204–208, 209, 240
Futura 2000 (Leonard McGurr), 2, 104, 139,
 149, 160, 176–177, 295
Fyman, Cliff, 251

Galleria Salvatore Ala, 247, 368
Garcia, Jerry, 64, 65, 347
Gay Metropolis, The (Kaiser), 313–314
Gehring, Ulrike, 377
Geist, William E., 312
Geldzahler, Henry, 180–181, 184, 244, 265
George, Andy, 37, 41, 47
George's candy store, Haring's artwork at,
 242–244
Gere, Richard, 226, 253
Gines, Jessica, 355
Ginsberg, Allen, 117, 343, 389
Giorno, John, 343–344, 347, 430
Gladstone, Barbara, 210
Goldberg, Dr. Richard, 362
Goldin, Nan, 273–274
Goldstein, Richard, 148
Goode, Christopher, 260–261
Goode, Eric, 260, 261–265, 369
Goode, Jennifer, 371
Gorgoni, Gianfranco, 316, 330
Goude, Paulo, 359
Grateful Dead, 13, 61–65, 76, 224, 290
Grauerholz, James, 342–343, 345–346
Greenblatt, Rodney Alan, 98, 123, 378
Gross, Michael, 296
Gruen, Bob, 412

Gruen, John, 74, 236, 256–257, 404, 435–436
Gruen, Julia, 44, 286, 302, 388, 404, 431
 background of, 236–237
 Breslau's death and, 318
 Haring shares AID diagnosis with, 393–394
 on Haring's illness and decline, 372, 410,
 412, 414–415
 as Haring's office manager, 237, 340,
 342–343
 on Haring's personality, 267, 381, 387
 Haring's twenty-ninth birthday, in Paris,
 329, 330
 in Japan, 357, 358
 Kutztown memorial service and, 418, 420
 on *Mom* painting, 414
 Party of Life and, 237–238
 Pop Shop in Japan and, 353, 355–356, 363
 Pop Shop in New York and, 294
Grunwald, Henry, 319–320
Gysin, Brion, 99, 106, 259–260, 277, 325, 346,
 349, 385

Hackett, Pat, 202–203
Hadon-Guest, Anthony, 369
Halsband, Michael, 263, 270–271
Hambleton, Richard, 219, 248, 258
Hamilton, Carrie, 352
Hannaford, Susan, 111, 112
Hans Mayer Gallery, 371, 372–375
Haring, Allen (father)
 courtship and marriage to Joan, 13–15
 family background of, 12–13
 Haring and Jesus movement, 33
 Haring at Ivy School of Professional Art
 and, 50–51, 53, 56, 62
 Haring takes to Europe, 403–405
 Haring's AIDs diagnosis kept from, 369, 414
 Haring's art and, 7–10, 12, 22, 81, 88, 123,
 141–142, 201, 273, 316, 413–414
 Haring's birth and, 16
 Haring's death and, 417
 Haring's drug use and, 39, 40, 42–43
 jobs of, 9, 13, 17
 Kutztown memorial service for and
 scattering of Haring's ashes, 418
 military service of, 9, 13, 14–17, 18
 naming of children, 8
 New York City memorial service for
 Haring, 425
 Oswald and, 18
 relationship with Haring, 28–30
 visits during Haring's illness, 413, 415–417
Haring, Joan Wentzel (mother), 9, 13, 17, 360
 AIDs diagnosis kept from, 369
 courtship and marriage to Allen, 13–15

 family background of, 12, 13
 Haring and Jesus movement, 31, 33
 Haring at Ivy School of Professional Art
 and, 50–51, 53, 62
 Haring takes to Europe, 403–405
 Haring's art and, 141–142, 201, 273, 316,
 413–414
 Haring's birth and naming, 15–16
 Haring's childhood and adolescent art, 8,
 9, 19, 21–22
 Haring's death and, 417
 Haring's drug use and, 39, 40, 42
 Haring's education and, 18–20
 Haring's Pittsburgh show and, 81
 Haring's sexuality and, 172
 Kutztown memorial service and
 scattering of ashes, 418, 420
 naming of children, 8
 New York City memorial service and, 425
 politics and, 253
 relationship with Haring, 30
 visits during Haring's illness, 413, 415–417
Haring, Karen Aileen (sister), 8, 18, 29, 42, 44,
 413, 419
Haring, Kay Adele (sister), 8, 29, 33, 37, 81, 172,
 316, 413, 418, 423
Haring, Keith, adolescence and childhood of
 birth and naming of, 15–16
 ciphers developed by, 31
 clubhouses and, 20, 21
 Disneyland and, 9, 17
 drug and pharmaceutical use, 38–46, 60
 early artistic influences, 9–10, 233
 education in Kutztown area, 11–13, 25–36
 father's influence on, 7–10, 12, 22, 81, 123,
 141–142, 201, 273, 316, 413–414
 gay culture and, 45, 52, 66
 growing social consciousness and, 46–47
 hippie lifestyle and, 33–35, 38, 41–42, 51–52,
 62, 64–66, 76, 224
 Jesus movement and, 30–34, 38, 46, 67,
 154
 loss of high school art works and change
 in direction of art, 47–48
 newspaper delivery route and, 11, 28–29,
 37, 42, 43, 44
 nicknames of, 44
 politics and, 22–23
 sexuality and, 23–24, 51–53, 56, 66
 summer at Jersey Shore, 43–45
 television and, 18, 20–22
 "When I Grow Up" essay of, 19, 50
Haring, Keith, AIDS and health of
 activism and, 393–396, 408–410
 anxiety about AIDS, 249, 361–362, 366

art and, 193, 259, 272, 344, 348, 371–372,
 374, 379, 385
beneficiaries of will, 341, 403
death and memorial services, 4, 421–427
diagnosed with HIV, 4, 190, 192, 365–366,
 430
final illness and death, 410–417
goes public about diagnosis, 396–397
Kutztown memorial service, 418–421
New York City memorial service at Cathedral
 of St. John the Divine, 421–427
shares diagnosis news with very few
 people, 381, 382, 393–394
shows early signs of, 217
theories about origins of, 345, 372
treatments for, 372, 392–393
Haring, Keith, art works and
1984, 236
aesthetic distance from Warhol, 322–323
Against All Odds drawings, 402–403, 406
altarpiece triptych, 32, 411–412
"Andy Mouse" character, 322
Apocalypse, 347–348, 374
assessed value in 1986, 288
banners for CityKids Foundation, 304–307
body painting of Bill T. Jones, 221–224, 227
body painting of Ludovic, 262
Boxes, 121
at Carmine Street pool, 341–342
cartooning style, 34
concrete wall mural, 197–198
"cosmic closet," 143
Crack is Wack murals, 303–304
Cranbrook Art Museum mural, 349–350
Cruella De Vil, 243
curating of shows, 159–160
Dedicated to Vincent van Gogh, 121
Documenta 7 show in Germany, 194
Everybody Knows Where Meat Comes From,
 It Comes from the Store, 79, 80, 82
Fertility Suite silk screen, 215
Hôpital Necker in Paris, 324–329
installation at Dag Hammarskjöld Plaza,
 275
January 1978 in Steel City Snowstorm, 55
Japan-Iran, 120
"Keith Haring by Keith Haring" and
 comments on, 229–231
Keith Haring: Sculpture and Painting,
 316–317
Ladies at Midnight, 58
The Last Rainforest, 406–407, 412
leather and, 206–207
licensing of images, 433
Lick Fat Boys (video), 106, 113

Luna Luna amusement park project, 330,
 338, 359
Manhattan Penis Drawings, 96–97
Message to the Public art project, 189–190
Michael Stewart—USA for Africa 1985, 220
Miss Piglet Goes Shopping, 406
Mom, 414
Monumental Show, 156
mural at Gay and Lesbian community
 Center, 387, 393, 394, 418
murals at Checkpoint Charlie Museum,
 307–308
murals at hospitals, 359–361
museum retrospective in France, 275–277
New York State Department of Sanitation
 posters, 244
Once Upon a Time mural, 418
Open the Door, 121
with Ortiz, 177–179
other artists' resentment of success of,
 215–216
Painted Environment, 98, 99
Painting Myself into a Corner (video), 94,
 95, 98, 106
painting of Grace Jones, 243–244
penis drawings and "coming Out" as
 visual exercise, 96–97
Peterson & Co. & Friends, 35–36, 58–59
posters, 196–197
Post-It Note projects, 57, 59, 197
Radiant Baby's origins, 2–4
Rain Dance, 289
Red Dog for Landois sculpture, 373–374
Red Room, 377, 401
retrospective in Amsterdam, 277–278
robot deejay painting, 213
RONALD REAGAN ACCUSED OF TV
 STAR SEX DEATH collage, 163
at Rotterdam Arts Council, 192–193
Saint Sebastian, 243
sculpture, 268–270, 341
serigraphs, 70
Smurfs and, 166, 206, 212, 322
Stewart's death and, 217–220, 271
"Stop" game and, 9
The Story of My Life in 17 Pictures, 41, 249
subway drawings, 103–105, 131–132,
 136–142, 147–154, 195–197, 215, 226, 258
"Swinging Fairy Tails," 34
Tank Head, 253–254
tarps and, 194, 200
Ten Commandments concept and,
 275–277, 315
theft of drawing in Amsterdam, 278
theme of unfinishedness, 407–408

Haring, Keith, art works and (*continued*)
 at Tony Shaferi Gallery, 198–202, 375–379,
 389
 Totem, 408, 409
 Tribeca studio described, 405–407
 Tribute to Gloria Vanderbilt, 125
 Tribute to My Father (Da-Di-Di-Da-Da), 17
 "Tribute to My Father" video, 30
 Tripping at Pt. Park, 56
 Two-Handed White to Black (video), 98
 Unfinished Painting, 407, 426
 Untitled (For James Ensor) diptych, 386,
 407, 426
 vases, 169, 181–183, 199, 247–248
 Venus on the Half Shell, 200
 Video Clones, 108–109, 423
 videos, 98, 106, 113, 121, 124–126
 Videotapes by Keith Haring & Jet Scharf, 131
 Walking in the Rain, 407, 414
 Whitney Biennials and, 211–212, 255, 290,
 326
 work on paper, 79
Haring, Keith, generally
 affection for children and, 232–235,
 245–247, 284, 358–359
 in Australia, 225, 231–232
 in Austria, 299
 in Belgium, 332–337
 in Brazil, 282, 284–286, 318–320
 Burgoyne's death and, 314
 business operation and, 339–340
 computers and, 230
 Cortez and, 159
 decides to support himself with art, 161
 ends relationship with Dubose, 279–281,
 300
 in England, 221–225
 fame and fortune in 1980s and, 254–260, 302
 in France, 259, 275–277, 323–330, 383,
 387–388, 410
 in Germany, 235–236, 330, 372–375
 Haring's appreciation of and obsession
 with Warhol, 203–204, 322–323
 in Holland, 277–278
 in Italy, 247–249, 298, 306–307, 390–392, 401
 in Japan, 3–7, 209–211, 230, 348–358
 John Sex and *Sex Guide to Married Life*
 and, 115–117
 meets Rivera, 282, 283–284
 nicknames of, 60, 152–153
 personality and love of work, 3, 121–122,
 159, 267–268
 reputation and impact of, 432–434
 Ricard refers to as "Radiant Child,"
 184–185

 "see the godchildren trip" near end of life,
 401–402
 in Spain, 383–385
 takes parents to Europe, 403–405
 twenty-ninth birthday, in Paris, 329
 two requests for his dream home,
 399–400
 value of estate, 431
 Vasquez and, 379–382
 wish to be a father, 234
Haring, Keith, in New York City
 apartments and life styles in, 122–123,
 142–145, 162–163, 167–170, 179, 212–215,
 286–288
 birthdays and "Parties for Life," 63
 Club 57 and, 133–136, 164
 curating of shows in, 129–131
 decision to move to, 82–83
 first solo studio of, 169–170
 job harvesting wild flowers, 132
 Mudd Club and, 145–147, 154–161
 social life, 245–247
 see also School of Visual Arts, in New
 York City
Haring, Keith, in Pittsburgh
 artistic influences and development of
 style, 58–60, 71–76
 breakup with Suzy, 82, 116
 few mentions of later in life, 83
 gay lifestyle in, 76–78
 hitchhiking across country from, 62–68
 jobs after cross country trip, 69–76
 life and art work at Ivy School of
 Professional Art in Pittsburgh, 49–58,
 60–62
 show at Fisher Scientific, 71
 show at Pittsburgh Arts and Crafts
 Center, 78–82, 126
Haring, Kristen (sister), 14–15, 29, 30, 36, 42,
 44–45, 46, 53, 118, 123, 142, 233, 359, 386,
 413
 Haring's art and, 81, 201
 Haring's illness and death and, 396, 417
Hastreiter, Kim, 112
Hatt, Bruce D., 16
Hausman, Shawn, 260, 261, 265
Havadtoy, Sam, 399–401, 406, 411–412, 418–419
Hawkins, Robert, 182, 258, 302
Haynes, Kristoffer, 101
Haze, Eric ("Haze"), 138–139, 157, 295
Heinemann, Peter, 93
Heiss, Alanna, 157
Heller, André, 330
Henri, Robert, 59–60, 61, 62, 64, 68, 72, 76
Henry, Gerrit, 209–210

Herman, Alan, 288, 294, 352
Hess, Elizabeth, 379
Hoban, Phoebe, 370
Hockney, David, 263, 264, 409, 422, 426
Holliday, Frank
 Club 57 show and, 133–134, 136, 225
 Haring and AIDS, 409
 SVA and, 89, 91, 93, 96, 118, 119, 125
Hollywood Free Paper, The, 33–34
Holzer, Jenny, 123–124, 131, 137, 139, 182, 190,
 211, 252, 263, 292, 299, 373, 409
Hopper, Dennis, 374–375, 387, 389, 422–423
Horner, George, 405
Hoving, Thomas, 297
Howard, Richard, 118
Hughes, Fred, 208, 268
Hughes, Robert, 255, 297, 319–320
Hujar, Peter, 89

Imbro, Charles, 91, 92, 105
Interview magazine, 11–12, 47, 158, 203, 204,
 218, 243, 245, 254, 284, 293, 390
Ivy School of Professional Art, 49–58, 60–62, 91

Japan
 Allen Haring and, 14–15, 16
 Haring and, 4, 209–211, 350–358
 Pop Shop in, 3–7, 348–349, 351–354
Jarmusch, Jim, 100
Jobs, Steve, 246
John Sex. See McLaughlin, John (John Sex)
Johnson, Carmen, 115
Johnson, Dany, 146, 155
Johnson, Philip, 245, 254
Jones, Bill T., 226–228, 235, 238, 239, 241–242,
 267, 318–320
 Haring's body painting of, 221–224, 227
Jones, Grace, 293, 306–308, 315, 344, 359, 401,
 407
 Haring's painting of, 243–244
 Party of Life and, 239, 281
Judd, Donald, 194, 373

Kaiser, Charles, 313–314
Kaiser, Julie, 23
Kalish, Sean, 425
Kaplan, Dorothy, 233
Katz, Bill, 223, 424
Kaws (Brian Donnelly), 297, 432
Keane, Michael, 156–157
Keith Haring: 1978–1982 (catalog essay), 64
Keith Haring Foundation, 431–432
Keith Haring Inc., 340
Keith Haring: the SVA Years (catalog essay), 92
Kennedy, John F., assassination of, 18

Kiefer, Anselm, 173, 194
Kirshenbaum, Susan, 54–57
Klee, Paul, 73, 105, 233, 348
Kline, Franz, 10
Koch, Ed, 244–248, 408
Kolossa, Alexandra, 374, 391
König, Kasper, 373
Koons, Jeff, 10, 115, 369, 373, 388
Kosuth, Joseph, 91, 117, 123–124
Kradel, Kimberly, 55, 56, 72, 73, 83
Kramer, Hilton, 296–297
Kramer, Larry, 191, 244–245, 393
Kriske, Suzy. See Maskarinec, Susan
Kriske, Tom, 49–51, 53
Kruger, Barbara, 26, 182, 211, 252, 409, 433
Kunkle, Ricki, 44
Kuspit, Donald, 274
Kutztown, PA, 116–117, 342
 described, during Haring's youth, 10–12
 memorial service for and scattering of
 Haring's ashes, 418–421
 in The Story of My Life in 17 Pictures, 249
Kutztown Area High School, 8, 36–42
 Haring's art from lost, 47–48
Kutztown Elementary School, 19–23
Kutztown Junior High School, 8, 25–37, 126, 273
Kutztown State College, 12–13, 18, 24, 41, 117–118
Kuzui, Fran Rubel, 351–352, 357, 363–366
Kuzui, Kaz, 351, 352–353, 355, 357, 362
Kwong Chi: East Meets West, 160
Kwong Chi, Tseng, 117, 173, 184, 199, 200, 215,
 276, 316, 324, 349, 360, 378, 388, 400
 Club 57 and, 114–115
 Haring's subway art and, 151–152, 244
 Haring's twenty-ninth birthday, in Paris, 330
 as HIV positive, 390
 in Japan, 354, 355, 357
 photographs of Haring body painting of
 B.T. Jones, 226, 242
 Pink Book and, 198

LA II (Angel Ortiz), 177–179, 183, 184, 195, 198,
 200, 204, 206–207, 209–210, 212, 215,
 224, 226–227, 238, 248, 281, 292, 294,
 295, 350
LaChapelle, David, 407
Lady Pink, 104, 139, 157
LaNasa, Katherine, 375, 389
Lasker, Jonathan, 181
Late Great Planet Earth, The (Lindsey), 31–32,
 46, 197–198
Laube, Giff, 233
Leary, Timothy, 40, 342, 344–345, 366, 396
Léger, Fernand, 315–316, 333, 400–401, 416
Leibowitz, Annie, 316, 409–410

Leigh, Christian, 379
Lennon, John, 151, 157, 224, 245, 396
Lennon, Sean Ono, 245–247, 316, 361, 377, 412
Leo Castelli Gallery, 117, 127, 182, 272–274, 289, 295, 389. *See also* Castelli, Leo
Levan, Larry, 174, 175–176, 206, 210, 213, 225, 228, 235, 238, 280, 282, 293, 295, 427
Levin, Kim, 130, 228, 260–261
LeWitt, Sol, 201, 263
Lichtenstein, Roy, 201, 248, 272, 289, 322, 330, 369, 400, 405, 411, 422
Life magazine, 22–23, 263, 331
Lignel, Baptiste, 335–336
Lindsey, Hal, 31–32, 46, 197–198
Linker, Kate, 228
Lippincott, Alfred, 270
Lippincott, Donald, 269, 270
Lippincott, Inc., 269–270, 313, 315
Logsdail, Nicholas, 164
Lotringer, Sylvère, 119
Love, Gael, 204
Lower Manhattan Drawing Show, 159
Luderowski, Barbara, 69–70
Lurie, John, 371

Madonna, 175, 318, 389
 Basquiat and, 205
 Benitez and, 214, 240, 241
 Burgoyne and, 312, 313
 in East Village in 1983, 214, 215
 Haring's fame and, 268
 Haring's illness and, 416–417
 marries Sean Penn, 268, 312
 Martinez and, 239, 240–241
 performance at Party of Life, 237, 238–239
 Rivera on Haring and, 301
 Stewart and, 218, 219
Magnuson, Ann, 101, 261, 312, 316
 on art market in 1980s, 255
 Club 57 and, 111–113, 115, 124, 130
 on Haring's art, 149, 150
 Haring's curated shows and, 129, 130
 Mudd Club and, 146, 160, 251
 New York City memorial service and, 424, 426
 Reaganism and, 138, 154–155
Makos, Christopher, 202, 204, 208, 385
Mallouk, Suzanne, 147, 218, 219, 371
Martell, Maria Nieves, 328
Martinez, Bobby, 239–241, 243, 301
Mary Boone Gallery, 146. *See also* Boone, Mary
Maskarinec, Susan Kriske
 breakup with Haring, 82, 116
 hitchhiking across country with Haring, 62–68, 364

at Ivy School of Professional Art, 51–53, 56
in Pittsburgh after cross country trip, 69–70, 73, 76, 81, 82
Mass, Steve, 145–146, 160–161, 261
Matos, John "Crash," 104, 164, 173, 176, 184, 190
Max, Peter, 215–216, 262, 274, 290
Mayer, Hans, 235–236, 323–324, 336, 372–375, 383, 403, 422
Mayer, Stephanie, 372, 375, 383, 403, 410, 422, 424
Mayles, Albert, 80
McEwen, Flora, 203
McEwen, Samantha, 123, 197, 402
 Club 57 and, 115
 DuBose and, 172, 173
 on Haring's art, 141
 Mudd Club and, 145, 146, 159
 Scharf and, 143, 144
 shared apartment on Broom Street and, 167–170, 212, 213
 at SVA, 92, 93, 98–99, 203
McGill, Douglas C., 274
McGurr, Leonard. *See* Futura 2000 (graffiti artist) (Leonard McGurr)
McIntyre, Brian, 355
McLaughlin, John (John Sex), 107–108, 110–113, 115–116, 213, 215, 238–239, 312
Mead, Taylor, 180
Meadoff, Laurie, 304–306
Mendlow, Eric, 58, 73, 80–81
Mendlow, Philip, 57, 58
Mickey Mouse, 8, 182–183, 204, 223, 237, 248–249, 322, 415
Miller, Tim, 140
Monk, Meredith, 117
Monkees, The, 21–22, 26, 39, 256
Montaug, Haoui, 205, 316
Moore, Frank, 159
Mudd Club, 145–147, 151, 152, 154–161, 198, 251, 260–261, 265
Mulder, George, 289, 322, 342, 347
Murakami, Takashi, 297
Murray, Elizabeth, 91
Museum of Modern Art, in New York, 433–434
Musto, Michael, 260, 267
Mysteries of Pittsburgh, The (Chabon), 54

Naber, Bernd, 134, 136
Nam June Paik, 117, 263
Neirings, David, 331, 391, 406, 425–426, 427
Nellens, Gustave, 332
Nellens, Monique, 332
Nellens, Roger, 332–337
Nellens, Xavier, 332, 403

Nevelson, Louise, 270
New York Post, 94, 137, 245, 251, 268, 271, 288, 304, 396
New York Times, 52, 155, 275, 282, 296, 312, 314, 317, 379, 421
New York/New Wave show, 136, 156–158, 164, 261
Nixon, Richard M., 23, 63, 253
Nomi, Klaus, 125, 216–217, 312, 313
Norman, Jessye, 424
Nosei, Annina, 181, 182–183
Nova Convention, 99, 102, 119, 342, 343

O'Brien, Glenn, 138, 158, 368
O'Hara, Frank, 237, 284
Oldenburg, Claus, 291–292
Ono, Yoko, 151, 224, 245, 247, 305, 316, 320, 363, 378, 388, 396, 399, 412
 Kutztown memorial service and Haring's ashes, 418–421
Ortiz, Angel. *See* LA II (Angel Ortiz)
Ossorio, Alfonso, 73
Oswald, Colin, 234, 419
Oswald, Kermit, 95, 156, 173, 204, 207, 227, 273, 292, 316, 340, 373–374
 Into 84 and, 228
 chalk and, 149
 children of, 234
 on Gil Vasquez, 380–381
 on Haring and Basquiat's death, 369–370
 Haring and Jesus movement and, 32
 Haring and sculpture, 270
 on Haring and Warhol, 319
 on Haring's art, 72, 79, 395
 Haring's early drug use and, 39, 42–43, 45–46
 on Haring's East Village apartment, 102
 on Haring's parents and his art, 413–414
 Haring's Pittsburgh show and, 81–82
 in high school with Haring, 35–37, 49–50
 Jones and, 223
 in junior high school with Haring, 27–29
 memorial service in Kutztown, 420
 New York City memorial service and, 422
 on Scharf, 166
 totems and, 275
Oswald, Lee Harvey, 18
Oswald, Lily, 316
Oswald, Lisa, 234, 316, 418, 422

Palladium, 63, 264–267, 270–271, 299, 306
Paradise Garage dance club, 173–176, 183, 210, 226, 243, 266, 275, 282, 286, 300
 closing of, 337–338
 Haring's art at, 190, 191, 262, 266
 parties at, 63, 235, 237–239, 275
Parker, Deb, 122, 173

Party of Life, 235, 237–239, 266, 299, 300, 427
Pasek, Mark, 405
Pasteur, Louis, quoted, 71
Pearlstein, Philip, 50
Penn, Sean, 268, 301, 312
Pennoyer, Peter, 293, 295
Pennsylvania, noted artists from, 10
Performance Space 122 (P.S. 122), 139–141, 155–156, 278, 374, 378
Perreault, John, 157
Phillips, Anya, 146
Picasso, Claude, 329–330, 383, 403
Picasso, Jasmin, 329–330
Picasso, Sydney, 329, 403
Pincus-Witten, Robert, 83, 117, 124, 131, 199
Pink Book, 198–201
Pittsburgh Arts and Crafts Center, 75, 78–79, 82, 98, 123, 126, 198, 233
Pittsburgh Center for the Arts, 75, 83, 293
Platow, Raphaela, 64
Plumb, Annie, 182, 194, 199, 200, 247
Poe, Amos, 100
Poirier dit Caulier, Jason, 334
Pollock, Jackson, 57, 72–73, 94, 255
Pop Shop, in Japan, 3–4, 348–349, 351–354
 closing of, 362–363, 365
 fake Haring merchandise and, 362–363
 merchandise in, 354–355
Pop Shop, in New York, 3, 131, 286–298, 417–418, 431
 artists and antecedent of, 291–292
 described, 292–295
 financing of, 288
 Haring's reasons for opening, 289–291
 issues of commercialism and, 290–291, 296–297
 media's reactions to, 296–297
Powell, Paige, 208–209, 214–218, 257, 271, 281, 321
Pozzi, Lucio, 91, 105, 106, 184
Pran, Dith, 275
P.S. 122. *See* Performance Space 122 (P.S. 122)
P.S.1 Contemporary Art Center, 136, 149, 156–157, 159, 160, 179–180
Putnam, Andrée, 330

Quiñones, Lee (tag "LEE"), 131–132, 197, 205, 416

radiant baby
 Haring's baby buttons and tags with, 3, 10, 150, 185, 208, 223
 origins of, 2–3
 Ricard and "Radiant Child," 2, 3, 184–185, 202

Rapidograph, 28, 80
Rauschenberg, Robert, 157, 201, 242, 272, 409
Raynor, Vivian, 271, 274
Reagan, Ronald
 AIDs and, 251, 359–360
 artists' reaction to election of, 137–138,
 154–155, 250–254
Rhodes, Silas H., 90
Ricard, Rene, 180, 201, 205–206, 207, 211, 228,
 240, 316
 on Haring's subway works, 258
 life with Haring on Sixth Avenue, 287
 "The Pledge of Allegiance" essay, 205–206
 "The Radiant Child" and, 2, 3, 184–185, 202
 Warhol and, 228
Richardson, John, 320
Richter, Klaus, 375, 410
Rifka, Judy, 185
Rist, Darrell Yates, 299–300
Rivera, Juan
 background of, 283
 in Belgium, 332, 333
 in Brazil, 318, 319
 Coney Island and, 338
 in France, 324, 328
 on Haring and Gil Vasquez, 385–386
 Haring shares AIDs diagnosis with, 393–394
 Haring's art and, 306–307, 325
 Haring's famous friends and, 300–302
 during Haring's illness, 415
 Haring's twenty-ninth birthday, in Paris, 330
 in Japan, 350–357
 meets Haring, 282, 283–284
 travels to Brazil with Haring, 282, 284–286
 on Yves Arman, 358–359
Rivera-Terreaux, Harrison, 164
Robert Fraser Gallery, 222, 224–225, 375
Rockburne, Dorothea, 103
Rolling Stone magazine, 43, 82, 144, 172, 318,
 368, 376, 394–397, 414, 419, 426
Rosenquist, James, 272, 325–326, 330
Ross, Diana, 175, 239
Rothko, Mark, 97–98
Rubell, Don, 416, 418, 422
Rubell, Jason and Jennifer, 403
Rubell, Mera, 165–166, 180, 201–202,
 403–405, 416, 418, 422
Rubell, Ronald, 164–166, 183, 403–404, 416,
 418, 422
Rubell, Steve, 164–165, 264–266, 268, 312,
 316, 403
Rudo, Johnny, 142
Ruscha, Ed, 375, 389
Ryan, Kelly, 28, 31, 32, 34, 35, 39

Saban, Stephen, 261
Salle, David, 158, 180, 211, 213, 317
Samo. *See* Basquiat, Jean-Michel
SAMO (Al Diaz), 107, 112, 123, 139, 177, 369
Sarko, Anita, 261
Scharf, Kenny, 122, 131, 203, 224, 330, 401
 art and competition with Haring, 166–167
 Basquiat and, 107, 147
 in Brazil, 284–285, 318
 Club 57 and, 110–112, 115, 125–126
 Cold War tensions and, 196
 financial success of, 255–256
 Fun Gallery show, 205
 on Haring and Scarf's apartment, 129–130
 Haring and Warhol and, 208
 Haring at SVA and, 98
 Haring's art and, 316
 Haring's illness and, 217, 415, 416, 417
 in Kutztown, 38, 39
 Kutztown memorial service for Haring,
 418, 420
 McEwen and, 143, 144
 Mudd Club and, 145, 146
 New York City apartment of, 142–145
 New York City memorial service for
 Haring, 424, 426
 Palladium and, 265
 police and graffiti, 218–219
 Pop Shop and, 295
 Reaganism and, 155
 on Rivera, 286
 subway art and, 104
 at SVA, 94–95, 97, 105–106, 124
 Warhol's death and, 319
Scharf, Tereza, 215, 234, 284, 318
 during Haring's illness, 415, 417
 memorial service in Kutztown, 418, 420
Scharf, Zena, 215, 226, 234, 284, 285, 318, 359,
 401, 415, 421
Schjeldahl, Peter, 157, 212, 219, 304, 327, 421
Schmidt, Bruno, 115, 197, 284–285, 378, 383,
 402, 430
 on Dubose, 280
 on Haring and Scarf's apartment, 143
 during Haring's illness, 415, 416
 on Haring's studio, 170
 Haring's twenty-ninth birthday, in Paris, 330
 memorial service in Kutztown, 419
Schmidt, Carmel Johnson, 115, 168, 173, 197,
 241, 302, 402, 415, 416, 419
Schmidt, Matias, 401–402, 415, 416, 419
Schnabel, Julian, 91, 128, 158, 180, 213, 255,
 263, 378, 422
Schneider Children's Hospital, 341

School of Visual Arts, in New York City, 1, 17, 105, 133, 305
 faculty at, 90, 91
 graffiti art in subways and, 103–105
 Haring withdraws from, 140
 Haring's application and acceptance to, 51, 57, 74–75, 78, 82, 90
 Haring's classes and art work at, 91–99, 105–109, 118–121, 123–124
 Haring's gay lifestyle and, 88–89, 95–96, 102–103
 history and physical plant of, 90–91
 life and art in East Village, 99–106
 transfer of credits from Ivy School of Professional Art, 91
Schrager, Ian, 264, 266
Schuyler, James, 100
Schwartz, Barbara, 91–92, 93, 94–97, 98, 105, 123, 159
Scully, Tom, 111
Serra, Richard, 127, 194, 201
Servin, James, 419
Sex, John. See McLaughlin, John (John Sex)
Shafrazi, Tony, 149, 265, 272, 358, 378
 defacing of *Guernica* and, 126–127, 192
 in France, 331
 on Haring and Fraser, 224
 Haring and sculpture, 268–269
 Haring in Belgium and, 336
 Haring in Japan and, 211
 on Haring's art, 153
 as Haring's art dealer, 191–195
 Haring's Bordeaux show and, 277
 Haring's illness and, 415
 Hopper and, 375
 Kutztown memorial service and, 418, 420
 New York City memorial service and, 423
 plans for Basquiat-Haring show, 405
 rumors of Haring and AIDS, 337
 see also Tony Shafrizi Gallery
Shapiro, David, 199
Sheff, David, 395–396
Shepler, Martha, 78
Sheppard, Keyonn, 306
Sherman, Cindy, 211
Shields, Brooke, 163, 266–267, 302, 422, 427
Shultz, Reverend, 43
Siegel, Jeanne, 140
Silverberg, Ira, 347
Simon, Kate, 347
Sischy, Ingrid, 174, 361, 371
Slabbert, Margaret, 340, 404
Smit, Derrick, 229, 273, 421
Smith, Jack, 155

Smith, Kiki, 292
Smith, Patti, 99, 157
Smith, Roberta, 141, 192, 317
Smith, Rupert Jasen, 326
Smithson, Robert, 127
SoHo Weekly News, 112, 130, 141, 155
Sonnier, Keith, 91, 124, 127–129, 140, 179
Soto, Benny, 303
Soto, Jack, 423, 424
Soul Artists community, 138–139
Southern, Terry, 99
Spada, David, 238, 243
Spencer's Gifts, 38, 39
Spin magazine, 367–368
Sprouse, Stephen, 238, 295, 367
Spy, 298
Staley, Peter, 394–396
Stark, David, 433
Stein, Byron (great grandfather), 13
Stein, Seymour, 175
Stella, Frank, 45, 377, 410
Stelling, Bill, 205, 206, 207
Stern, Henry, 304, 341, 422
Stevens, Mark, 296
Stevens, Wallace, 96
Stewart, Michael, 217–220, 243, 271, 400
Strasser, Brendan D., 12, 34, 53
Straub, Drew, 118, 128–129, 174, 183, 282
 chalk and, 149
 Club 57 and, 110–111, 113–114, 115, 125
 East Village and, 101–103
 on Haring and fame, 256
 on Haring's art, 135
 Haring's curated show and, 129
 Haring's Pittsburgh show and, 81
 on John Sex, 108
 Nova Convention and, 99
 on Paradise Garage, 174
 on Rivera, 282
 Shafrazi and, 128
 at SVA, 98, 118–119
Strub, Sean, 395, 409
Strychacki, Stanley, 111, 371
Sullivan, Nelson, 229
Summers, Claudia, 313
Sur, Sur Rodney, 146
Swenson, Swen, 393–394

"Taki 183" (Demetrious), 104
Taubin, Amy, 123
Temkin, Ann, 433–434
Templon, Daniel, 324, 325, 330
"Thirteen Ways of Looking at a Blackbird" (Stevens), 96

Thometz, Kurt, 151
Thometz-Sanchez, Min, 116, 125, 132, 146, 197, 256, 285
Thompson, Mimi, 326, 330
Thompson, Robert Farris, 164, 197–198, 332, 377
Three Mile Island nuclear plant accident, 196
Times Square Show The, 131, 143–144, 158, 290, 292
Tinguely, Jean, 332, 333, 336, 383, 401
Tobey, Mark, 73, 104
Tokyo Pop (film), 352
Tomlin, Bradley Walker, 106
Tompkins, Calvin, 104, 265–266
Tony Shafrizi Gallery, 156, 181–182, 255–256
 Anonymous Art show, 130
 Burroughs and, 346
 Club 57 Invitational and Xeroxes, 129
 first show at, 226
 Haring employed at, 127–129, 132
 Haring exhibits at, 3, 198–202, 225–229, 240, 270–275, 290, 371–372
 Open Color Xerox Show, 130–131
 opening of, 127
 Warhol-Basquiat Paintings and, 270–271
 see also Shafrazi, Tony
Torres, Hector, 238, 276–277, 318
Toye, Teri, 347
Trebay, Guy, 293
Trinidad, David, 293
Trump, Donald, 254, 319
Tseng, Muna, 168

Valenti, Chi Chi, 265
Van Buren, Richard, 118, 121
Vasquez, Gil, 379–384, 386–387, 389, 391, 393, 395, 413–416, 419, 427, 436
 Haring shares AIDs diagnosis with, 393–394
 during Haring's illness, 413, 414, 415–416
 Kutztown memorial service and, 419
 New York City memorial service and, 427
Vasquez, Junior, 176, 287, 338, 341, 355
Village Voice, 90, 122, 128, 132, 148, 157, 160, 192, 260, 274, 293, 318, 379
Vogue, 370, 388

Waldman, Anne, 343, 346
Walt Disney Studios, 9, 415
Warhol, Andy, 10, 11–12, 50, 107, 211, 236, 268, 344
 Into 84 and, 228–229
 Area club and, 261, 263–264, 265
 Basquiat and, 208–209, 368, 369

Burgoyne and, 312, 314
Carnegie Mellon and, 54
Condo and, 326
death of, 318, 320
Diaries, 202–203
friendship with Haring, 204–209, 213–214, 218, 226
Haring and sculpture, 316
Haring's appreciation of and obsession with, 203–204
Haring's fame and, 257
Haring's first meeting with, 204
Haring's last telephone call with, 318–319
Haring's social life in New York City and, 245
influence on Haring, 3, 37–38, 143, 321–322
Marilyns and Elvises, 37, 163, 164, 165, 180
New York/New Wave show, 157, 158
Palladium club and, 264–265
Party of Life and, 238, 239
photographing of Haring and Dubose, 213–214
Pop Shop and, 290, 296
Rubells and, 165
Sean Lennon and, 246
visits to Haring's show at Tony Shafrizi Gallery, 202–203, 208
Warhol-Basquiat Paintings at Tony Shafrazi Gallery and, 270–271
Watts, Heather, 423, 424
Wendy Wild. See Andreiev, Wendy (Wendy Wild)
Wentzel, Grover (maternal grandfather), 13, 24, 30, 56
Wentzel, May Bailey (maternal grandmother), 8, 13
Wessner, Tom, 34
Westbeth Artists Housing, 156
Whitman, Walt, 59, 132
Widener, Dr. Calvin C., 16
Wilson, Jane, 236
Wittman, George, 394, 421–422
Wojnarowicz, David, 130, 140, 159, 219

Yukai, Diamond, 352

Zane, Arnie, 222, 242
Zephyr, 104, 176
Zimbicki, Kathleen, 75, 81
Zimmer, William, 141–142
Zook, Laurie, 66

About the Author

BRAD GOOCH is a poet, novelist, and biographer whose previous ten books include *Flannery: A Life of Flannery O'Connor*, which was a National Book Critics Circle Award finalist, *New York Times* Notable Book of the Year, and *New York Times* bestseller; *City Poet: The Life and Times of Frank O'Hara*; *Godtalk: Travels in Spiritual America*; and the memoir *Smash Cut*. He is the recipient of National Endowment for the Humanities and Guggenheim fellowships and lives in New York City.

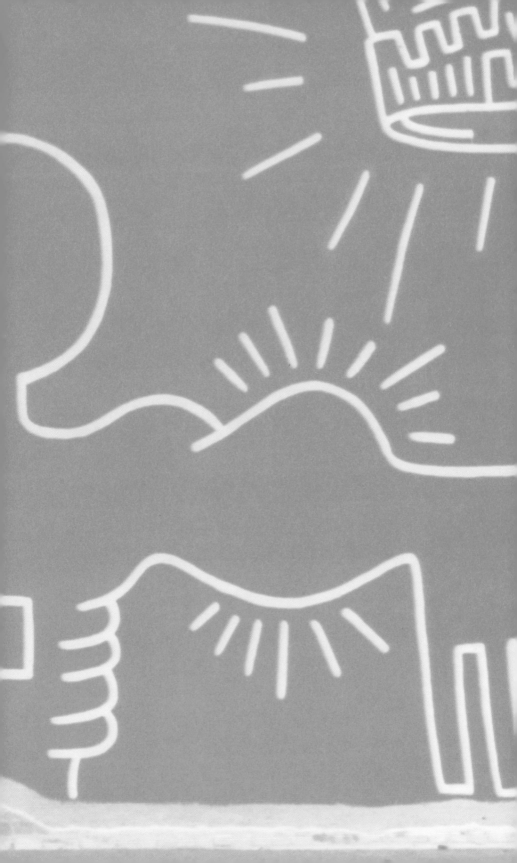